History of Art in Japan

History of Art in Japan

Tsuji Nobuo

Translated by
Nicole Coolidge Rousmaniere

Columbia University Press
New York

Columbia University Press
Publishers Since 1893
New York Chichester, West Sussex
cup.columbia.edu

This book originally appeared in Japanese as *Nihon bijutsu no rekishi* (Tokyo: University of Tokyo Press, 2005). The University of Tokyo Press retains the English-language translation rights under contract with Tsuji Nobuo and through the courtesy of Nicole Coolidge Rousmaniere.

The first edition published by the University of Tokyo Press was made possible by a grant from the Japan Society for the Promotion of Science, Grant-in-Aid for Publication of Scientific Research Results for 2016–2018, JSPS Kakenhi Grant Number JP16HP6001.

Names: Tsuji, Nobuo, 1932- author.] Rousmaniere, Nicole Coolidge, 1961- translator.
Title: History of art in Japan / Tsuji Nobuo ; translated by Nicole Coolidge Rousmaniere.
Other titles: Nihon bijutsu no rekishi. English
Description: English paperback edition.] New York : Columbia University Press, 2019.] "This book originally appeared in Japanese as Nihon bijutsu no rekishi (Tokyo: University of Tokyo Press, 2005). First English edition published 2018 by University of Tokyo Press."] Includes bibliographical references and index.
Identifiers: LCCN 2019014228] ISBN 9780231193412 (paperback)
Subjects: LCSH: Art, Japanese.
Classification: LCCN7350 .T73313 2019] DDC 700.852–dc23
LC record available at https://lccn.loc.gov/2019014228

Printed in the United States of America

Cover design: Milenda Nan Ok Lee
Cover art: *Frogs Triumphing over a Snake and Lizards*, c. 1879, Kawanabe Kyōsai.
© The Trustees of the British Museum

Preface to the English Edition

History of Art in Japan was originally published in Japanese by University of Tokyo Press in 2005. It was commissioned by the press as a text for students and also for a general audience, to be written in an accessible manner. To survey the vast sweep of Japanese art history was a great challenge and a daunting task; I nonetheless relished the project, because not only did no such book exist, but I needed one myself!

The Japanese word *bijutsu* first appeared in the late nineteenth century as a translation of the Western term "art." Subsequently, other new Japanese words were coined, including *kaiga* (painting), *chōkoku* (sculpture), *kōgei* (craft), and *kenchiku* (architecture), as well as *sho* (calligraphy), an art form somewhat neglected in the West. These terms formed the semantic foundation for the modern discipline of art history in Japan.

Since then, many excellent research projects have resulted in new discoveries in various areas, leading to further subdivision and specialization in the discipline. The effect has been to make a definitive overview of Japanese art, capturing its dynamism and diversity, ever more difficult to achieve. Nevertheless, after many years of focused work, we were able to produce a comprehensive book with full-color illustrations, which not long ago would have seemed impossible.

History of Art in Japan describes artistic expression in the Japanese archipelago from 15,000 BCE to 2005, referencing the works of art themselves. As I am relatively unfamiliar with the history of Western art and not proficient in the English language, I focused my attention in the original edition on the native Japanese reader. Publishing this work in an English translation thus presented a significant challenge.

Fortunately, I remembered Professor Nicole Coolidge Rousmaniere, a friend as well as an expert on Japanese decorative arts. She kindly offered to translate the original text into English. A former student of John Rosenfield at Harvard University, Dr. Rousmaniere holds to exceptionally high standards in her work. I appreciate how difficult it was for her to convey some of these concepts to a Western audience. Now, after ten years in development, it is a great joy to see my book published in English. I am grateful that I have lived to see its publication.

I would like to convey my heartfelt gratitude to the many people involved in realizing this ambitious project. Needless to say, first and

foremost is Nicole Rousmaniere, but I would also like to thank Sadamura Koto, Dr. Alfred Haft, Michael Jamentz, and Mizutori Mami, who were all of great assistance throughout. My thanks also go to Saito Mishio, who oversaw the editing process at the University of Tokyo Press, and the many others who were involved in the translating and publication of *History of Art in Japan*.

Art has a longer history in China and Korea than in Japan. In this book I have endeavored to convey the influences on Japanese art from China and Korea and at the same time explore the unique qualities of Japan's indigenous expression. Folk art has been given appropriate status in Japan and in Korea, while in China, with its traditional emphasis on philosophical and literary criteria, folk art and related performing arts have been undervalued. I am now very interested in this topic; I believe that with further study it will shed new light on the arts of East Asia.

Tsuji Nobuo
December 2017

Translator's Preface

It has been a great honor and an education to translate Professor Tsuji Nobuo's magnum opus, *History of Art in Japan*, from Japanese to English. It has been a heavy responsibility, calling for full appreciation of the author's voice, attention to the nuances between the lines, and awareness of the author's tremendous background knowledge. In places, the text of the original 2005 edition has been interpreted and expanded upon, particularly where it assumes knowledge that readers of the original Japanese might have been expected to know but may be unfamiliar to English-language readers. In addition, the content has been revised and expanded since the publication of the original Japanese edition. This work has taken many years, and I am grateful for the much more profound understanding of Japanese art, its aesthetics, and its cultural roots that I have achieved as a result of working on Professor Tsuji's book. I am grateful too, for Professor Tsuji's patience over the long years it has taken to complete this project.

The translation was made possible with the help and support of many gifted scholars, editors, and students of Japanese arts and archaeology. First and foremost, I thank Sadamura Koto, who has stayed with this project from start to finish, checking the translations and working closely with the University of Tokyo Press and me to ensure that Professor Tsuji's insights were accurately recorded and compellingly expressed. I owe her a major debt of gratitude.

Alfred Haft meticulously edited the initial and final chapters with unfailing grace and beautiful turn of phrase. Simon Kaner, Sam Nixon, and Jennifer Wexler, with their archaeological prowess, helped edit the first two chapters. Michael Jamentz, with his profound knowledge of Buddhism, edited the third, fourth, fifth, and sixth chapters. Mark Erdmann helped edit the figure captions and the suggested reading list. Kim Gyewon, Stefani Bennett, and Wakamatsu Yurika kindly offered suggestions to the reading list. Uchida Hiromi, Washizu Katsura, and Yamada Yoko generously helped with various phases of the book. Kazuko Morohashi created the map, timelines, and charts. Hirano Akira helped to check references, and Jane Emmerson, the figure captions for consistency.

I am especially grateful to Professor Sato Yasuhiro of the University of Tokyo for reading the entire text, offering insights and corrections; and to Mizutori Mami, former executive director of the Sainsbury Institute for the

Study of Japanese Arts and Cultures, for supporting this project on multiple levels and helping bring it to fruition. Saito Mishio from the University of Tokyo Press was unfailingly supportive from inception to completion. Saji Yasuo and Saji Mitsumasa of Festina Lente worked to produce the book and layout. Saji Yasuo also helped to bring in the cover designer TAN JC, as well as a trio of editors—Meg Taylor, Lynne E. Riggs, and Katherine Heins—to check the entire text, captions, and end matter. Finally, Lynne Riggs and Sadamura Koto worked together on the index.

This book was always intended to serve as an introduction to Japanese visual cultures from past to present. To that end, Japanese characters are not used in the main text. Key terms and names, however, are listed in the index both in Japanese and their romanized equivalents. Footnotes have been kept to a minimum, with only direct quotes referenced in Japanese. Instead, an expanded reading list has been created for each section, referencing English-language texts. Kanji for names and terms may be found in the index.

Names are given in the traditional Japanese order, surname followed by given name or artistic name (*gō*). As is standard practice in Japan, on second mention of artists' names, only the artistic or given name may be used. From the second generation in the Meiji era (c. 1890s), surnames are used for Western-style artists, while artist names or first names are used for Japanese-style artists.

It only remains for me to express my deepest thanks to Professor Tsuji, whose lectures on *kazari* (adornment) at Harvard University in 1989 changed my understanding of Japanese visual and material cultures. It has revealed new perspectives to me and has had a profound influence on my career and worldview.

The first edition published by the University of Tokyo Press was made possible by a grant from the Japan Society for the Promotion of Science (JSPS), Grant-in-Aid for Publication of Scientific Research Results for 2016–2018.

Nicole Coolidge Rousmaniere
Spring 2018

Contents

Preface to the English Edition ... v

Translator's Preface .. vii

Contents .. ix

Nengō Era Chart .. xix

Map of Archaeological Sites .. xx

Timelines ... xxii

Introduction ... xxiv

◆ Chapter 1

Jōmon: The Force of Primal Imagination

1. Jōmon Culture ... 2

2. Overview of the Development of Jōmon Pottery 4

 Incipient (13,500–9300 BCE) and Initial (9300–5350 BCE) Jōmon
 Early (5350–3650 BCE) and Middle (3650–2500 BCE) Jōmon
 Late (2500–1300 BCE) and Final (1300–500 BCE) Jōmon

3. Fertility Beliefs and the Mystery of the *Dogū* Figurines 12

4. Personal Ornamentation and Practical Crafts 14

5. Jōmon Dwellings .. 17

6. The Significance of Jōmon Art ... 17

◆ Chapter 2

Yayoi and Kofun: Influences from the Continent

I. Yayoi Art, Birth of a New Aesthetic

1. Yayoi Culture and Art ... 20

2. Yayoi Ceramics .. 22

3. Bronze Bells and Mirrors .. 26

4. Jōmon versus Yayoi Aesthetics .. 29

II. The Kofun Period: Encountering the Continent

1. Continuity with Yayoi Culture .. 30

2. Gold and Gilt-Bronze Burial Goods and *Haniwa*...................32

3. Decorative Burial Mounds ...36

◆ Chapter 3

Asuka and Hakuhō: The Sphere of East Asian Buddhist Arts

1. The Introduction of Buddhism and Continental Art40

2. Buddhist Art as Sacred Ornament41

3. The Dissemination of Buddhist Temples and Sculpture...........42

4. The Construction of Asuka-dera and Hōryū-ji Temples............44

5. Large-Scale Civil Engineering and Stonework.....................46

6. After the Great Buddha of Asuka....................................47

7. The Awesome Power of Guze Kannon................................49

8. Kudara Kannon and Other Buddhist Images52

9. The World of Hakuhō Sculpture55

10. The Arrival of Sculpture in Clay....................................58

11. Paintings and Decorative Arts of the Asuka and Hakuhō...........59

Comparative List of Buddhist Deity Names66

◆ Chapter 4

Nara: The Spread of the Tang International Style

1. The New Heijō Capital and the Influence of Tang Culture........68

2. Temple Construction and the Production of Statues...............69
 Large-Scale Temple Construction and the Bureau of Temple Construction
 The East Pagoda and the Gilt-Bronze Yakushi-ji Buddha

3. The Popularity of Clay and Dry-Lacquer Sculptures72
 Clay Sculptures in the Base of the Five-Story Pagoda at Hōryū-ji Temple
 Dry-Lacquer Statues of Kōfuku-ji Temple
 Clay and Dry-Lacquer Statues in the Lotus Hall at Tōdai-ji Temple

4. Casting the Great Buddha of Tōdai-ji Temple76

5. The New Style of Tōshōdai-ji Temple78

6. Pictorial Arts of the Nara Period82

7. Treasures of the Shōsō-in Repository 85

◆ Chapter 5

Heian: Jōgan, Fujiwara, and Insei Art

I. Esoteric Buddhist Art

1. The Arrival of Esoteric Buddhist Art 95
2. The Rituals and Art of Esoteric Buddhism 97
3. The Mandalas of the Two Worlds 101
4. The Imagery of the Mandalas 103
5. The Unique Character of Jōgan Sculpture 105
6. The Influence of Buddhism on Shinto Deities in Sculpture 114
7. Secular Painting .. 115
8. Calligraphy, Ritual Implements, and Lacquerware 116

II. Fujiwara Art: A Period of Naturalization

1. The Formation of the Japanese-style in Art 118
2. Esoteric Art of the Fujiwara Period 119
3. Seeking Rebirth in the Pure Land 125
 The Conception of the Rebirth in the Pure Land
 Reverberations from the *Essentials of Rebirth*
4. Ornamenting Paradise of Pure Land Teachings 126
5. The Development of Aristocratic Residential Architecture 128
6. Naturalization of Buddhist Sculptures and the Sculptor Jochō... 129
7. Sculptures after Jōchō: Hatchet-Carved Sculptures 134
8. Fujiwara Buddhist Paintings 134
 The Mandala in Esoteric Buddhist Iconography
 Paintings of Pure Land Teachings
 Depicting Sakyamuni
 Portraits of Patriarchs and Arhats
9. Buddhist Decorative Arts and Calligraphy 141
10. The Court Painters .. 144
11. The Birth of Japanese-Style Painting 145

12. Additional Eleventh-Century Paintings 149

13. Pure Land Gardens and the *Record of Garden Making* 151

III. Insei Art: The Utmost for Good and the Utmost for Beauty

1. Aesthetics at the "End of the World" 151

2. Paintings: The Impulse toward Total Aestheticism 155

 Buddhist Paintings

 Decorative Sutras

 Dazzling Waka Poem Booklets and Fan Paintings

 Illustrated Handscrolls: Illustrated Scrolls of Short Tales and Longer Narratives

 Paintings of the Six Buddhist Realms

 The Introduction of Chinese Song Art and Its Influence

3. Sculpture, Decorative Arts and Architecture 175

 Architecture and Buddhist Statues

 Japanese Design Sense: *Maki-e*, Mother-of-Pearl, Mirrors, Ceramics,
 Flower Containers, and Hanging Amulets

 The Emergence of Japanese-Style Ceramics

4. Refinement and "Produced Objects" 186

◆ Chapter 6

Kamakura Period: Aristocratic Aesthetics in Flux

1. Developments in Art with a View to Reality 188

2. The New Wave of Chinese Song Architecture:
 The Great Buddha Style ... 190

3. A Renaissance in Buddhist Sculpture 193

 The Appearance of Unkei, a Sculptural Genius

 Kaikei's Artistic Achievements

 Unkei's Successors: Jōkei, Tankei, Kōben, and Kōshō

 Other Buddhist Sculptors in the Kyoto and Kamakura Areas

4. New Movements in Buddhist Painting 204

 The Influence of Chinese Song Buddhist Painting

 Buddhist Narrative Painting

 New Styles of *Raigō-zu*

 Paintings Based on the Theory of Buddhist and Shinto Unity
 and Manifestations of These Deities

5. New Styles in *Yamato-e* .. 217

 Portraits and Likenesses

 Developments in Illustrated Scrolls

 Reading Medieval Lifeways from Illustrated Handscrolls

6. Court Painters and Buddhist Painters 232

7. New Art Associated with Zen Buddhism 232

 The Traces of High-Ranking Zen Priests: Portraiture and Calligraphy

 Architecture of Zen Temples

8. *Kōgei*: Bold and Robust in the Decorative Arts 238

◆ Chapter 7

Nanbokuchō and Muromachi: Zen Buddhism and Chinese Art

I. Chinese Art in Japan: Nanbokuchō Culture

1. Buddhist Sculpture and Painting, and the Development of
Japanese Art in Song, Yuan, and Ming styles 245

2. Influx of Song, Yuan, and Ming Period Chinese Art
and *Furyū* ... 248

3. Introduction and Development of Ink Painting in Japan.......... 249

4. Early Japanese Ink Landscape Painters............................. 254

5. New Trends in *Yamato-e* and Pictures Illustrating
the Origins of Temples and Shrines 257

**II. Kitayama Culture: The Golden Age of the Muromachi
Shogunate**

1. Room Decor and Illustrated Popular Narratives 258

2. The Chinese-style Ink Painting of Kissan Minchō 260

3. Poetry-Picture Scrolls, and the Art of Josetsu and Shūbun 261

**III. Higashiyama Culture and Artistic Production during
the Warring States Period**

1. Room Decor in Yoshimasa's Higashiyama Mountain Villa 265

 The Art of the Dry Landscape

2. New Movements in the Decorative Arts: Lacquer Work,
Textiles, and Metalwork .. 268

3. Early Signs of Momoyama Style: *Yamato-e* Screens and Sliding Doors, and Architectural Decoration................. 270

4. The Art of Sesshū Tōyō, and Paintings by Generals of the Warring States Period... 275

5. From Combining to Unifying Elements of Japan and China 278

6. The Beauty of Natural Ash-Glazed Stoneware, Domestically Produced Ceramics .. 278

◆ Chapter 8

Azuchi-Momoyama: The Flowering of *Kazari*

1. The Flourishing of Momoyama Art: The Tenshō Era (1573–92) .. 284

 Azuchi Castle and Kanō Eitoku
 Designs for *Wabi* Tea

2. Development of Decorative Art: The Keichō Era (1596–1615)... 290

 Hasegawa Tōhaku, Kaihō Yūshō, and Other Artists
 The Pinnacle of Castle Keep Design
 Genre Painting and *Nanban* Art
 Kabuku or "Unconventional" Spirit: From Rikyū to Oribe

◆ Chapter 9

Edo: Townspeople and the Rise of Urban Culture

I. Art of the Kan'ei Era:
The End and Transformation of Momoyama Art

1. Large-Scale Architectural Projects................................. 307

2. Kanō Tan'yū, Kanō Sanraku, and Kanō Sansetsu................. 310

3. Nostalgia for Court Culture .. 313

 Pure, Elegant Simplicity and the Katsura Imperial Villa
 Kōetsu and Sōtatsu: Forerunners of Popular Design

4. Pleasures of the Floating World: Trends in Genre Painting 317

II. Genroku Art: Art for Townspeople

1. The End of Momoyama-Style Architecture 322

2. The Merits and Challenges of the Kanō School: The Kanō
 School after Tan'yū ... 322

3. Porcelain with Polychrome Enamel Designs: The Formation
 of a Japanese Style .. 324

4. Afterglow of Momoyama Art: Kanbun Robes 327

5. Art for Farmers and Fishermen, Enkū, and Hatchet-Carved
 Religious Art ... 329

6. Stars of Genroku Art: Hishikawa Moronobu
 and Ogata Kōrin ... 329

7. Ōbaku Art and Imported Ming Art 333

8. Vernacular Architecture .. 335

III. Arts of the Townspeople: Maturity and Decline in the Kyōhō
 and Bunka-Bunsei Eras

1. New Forms of Artistic Expression Imported from China
 and the West ... 337

2. Art of the Literati: A New Mode of "Chinese Painting" 338

3. Maruyama Ōkyo and Rational Naturalism 341

4. "Unconventional Painters": The Sunset Glow of the
 Kyoto Art World ... 343

5. Ukiyo-e after Moronobu: The Golden Age
 of Woodblock Prints ... 348

6. Publishing Culture: Illustrated Books (Ehon) 355

7. The Popularization of Literati Painting 356

8. Western-Style Painting in Akita Province
 and Shiba Kōkan ... 358

9. Art in the City of Edo: Later Developments 359
 Sakai Hōitsu and Katsushika Hokusai: Rinpa and Ukiyo-e
 at the End of the Edo Period

10. Review of Late Edo-Period Decorative Arts 364

11. Architecture and Garden Design in the Late Edo Period 365
 The Popularization of Temples and Shrines: A Tendency toward
 Over-Decoration
 Turbo-Shell Halls
 Daimyo Garden Design

12. Late Developments in Buddhist Art: Mokujiki, Sengai,
 and Ryōkan.. 369

◆ Chapter 10

Meiji to Heisei: Modern and Contemporary Art

I. **New Encounters with Western Art: Early Meiji
(1868–Early 1880s)**

1. Takahashi Yuichi and the Development of Oil Painting.......... 375
2. Sideshows, the Foundation of Modern Exhibitions................ 376
3. Antonio Fontanesi and the Technical Art School.................. 379
4. Ernest Fenollosa and Kanō Hōgai 381
5. Western-Style Painting: Difficulty and Consolidation............. 385
6. The Age of "Civilization and Enlightenment": Adversaries
 and Advocates.. 387
 Kawanabe Kyōsai and Kobayashi Kiyochika

7. Vincenzo Ragusa and the Introduction of Western-Style
 Sculpture .. 389
8. Architecture in the Late Nineteenth Century: Western Style
 and Pseudo-Western Style ... 391
 Western-Style Architecture in Foreign Residential Areas and Elsewhere
 Inviting Professional Architects from Abroad

9. Promoting Industrial Arts and Fine Art Crafts..................... 395

II. **Advancing toward Modern Art: Mid-Meiji (1880s–90s)**

1. Kuroda Seiki and the New Yōga (Western-Style Painting)........ 399
2. Divisions among Western-style Artists, Romanticism,
 and Affinity for the Decorative 402
3. Okakura Kakuzō and the Japan Art Institute:
 Yokoyama Taikan and Hishida Shunsō 406
4. Painting in Kyoto and Tomioka Tessai............................. 408
5. Architecture and the Expression of Tradition 411
 Itō Chūta and His Work
 Influences from Art Nouveau and Historicism

III. In Search of Free Expression: Art of the Late Meiji and Taishō Eras (1900s–10s)

1. Self-Awareness and Self-Expression 414
2. The Later Woodblock-Print Tradition: New Prints and Creative Prints .. 418
3. Sculpture, an Expression of Life 421
4. Modernism in Architecture 421

IV. Maturity and Setbacks for Modern Art: Taishō through Early Shōwa Eras (1910s–1945)

1. Western-Style Painting Reaches Maturity......................... 425
2. Modernization of Nihonga .. 429

 In Tokyo, the Revival of the Inten (Japan Art Institute Exhibition)
 Taishō Decadence and the Association for the Creation
 of National Painting in Kyoto
 Return to Classicism and the Embrace of Modernism

3. The Emergence of Avant-Garde Art................................ 438
4. Fantasy, Surrealism, and the Approach of War.................... 440
5. Painting in Wartime ... 442
6. Architecture after the Great Kantō Earthquake 446

 "Architecture Is Not Built for Beauty"
 MAVO and Other Modernist Projects
 The Nationalist Trend in Architecture and Modernist Resistance

V. Art of the Postwar Period: Mid-Shōwa through Heisei (1945–2019)

1. The Early Postwar Years (1945–60).............................. 451

 Coming to Terms with the War Experience
 Nitten and Independent Exhibitions
 Japanese Art on the International Stage, and the Domestic Activities
 of the Gutai Art Association
 The Journal Aesthetics of Ink
 Calligraphy Today

2. The Later History of Japanese Modernist Architecture............ 460
3. Differentiating the Modern Japanese Terms for Art
 (1960s to the present) .. 461

A Society in Flux: Hi Red Center and Mono-ha
Postmodern Architecture
Rise of Manga and Anime
Bijutsu Today
Photography and Design

4. The Avant-Garde and Tradition: Creative Succession
 to Cultural Heritage... 475

Notes... 481
Recommended Reading for Further Study 491
Image Credits ... 521
Index .. 549

Nengō Era Chart

(Main historical eras mentioned in the text in chronological order)

Tenpyō 天平　(729–49)
Enryaku 延暦　(782–806)
Kōnin 弘仁　(810–24)
Jōgan 貞観　(859–77)
Nin'na 仁和　(885–89)
Engi 延喜　(901–23)
Eichō 永長　(1096–97)
Hōgen 保元　(1156–59)
Heiji 平治　(1159–60)
Jōkyū 承久　(1219–22)
Kōan 弘安　(1278–88)
Ōei 応永　(1394–1427)
Tenshō 天正　(1573–92)
Keichō 慶長　(1596–1615)
Gen'na 元和　(1615–24)
Kan'ei 寛永　(1624–44)
Keian 慶安　(1648–52)
Meireki 明暦　(1655–58)
Manji 万治　(1658–61)
Kanbun 寛文　(1661–73)
Genroku 元禄　(1688–1704)
Kyōhō 享保　(1716–36)
Bunka 文化　(1804–18)
Bunsei 文政　(1818–30)
Meiji 明治　(1868–1912)
Taishō 大正　(1912–26)
Shōwa 昭和　(1926–89)
Heisei 平成　(1989–2019)

Map of Archaeological Sites

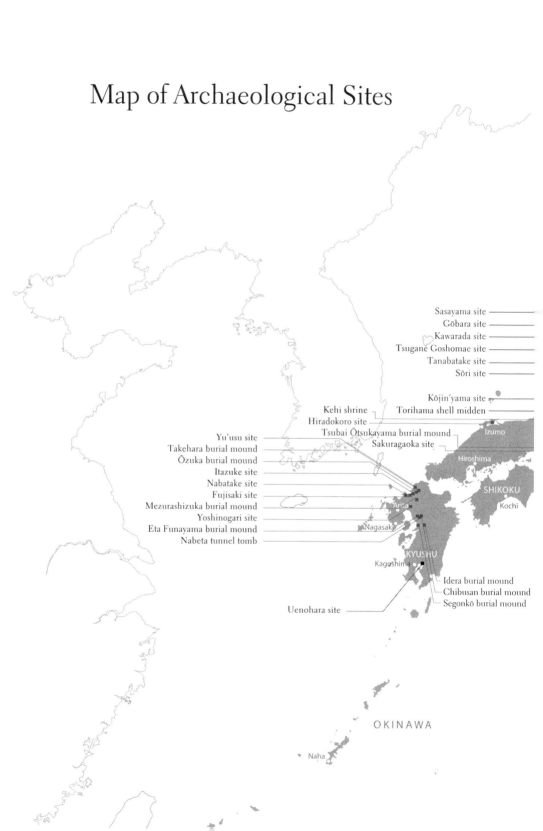

Sasayama site ———
Gōbara site ———
Kawarada site ———
Tsugane Goshomae site ———
Tanabatake site ———
Sōri site ———

Kōjin'yama site
Torihama shell midden ———

Kehi shrine
Hiradokoro site
Tsubai Ōtsukayama burial mound
Sakuragaoka site

Izumo

Hiroshima

Yu'usu site
Takehara burial mound
Ōzuka burial mound
Itazuke site
Nabatake site
Fujisaki site
Mezurashizuka burial mound
Yoshinogari site
Eta Funayama burial mound
Nabeta tunnel tomb

SHIKOKU

Kochi

Arita

Nagasaki

KYUSHU

Kagoshima

Idera burial mound
Chibusan burial mound
Segonkō burial mound

Uenohara site ———

OKINAWA

Naha

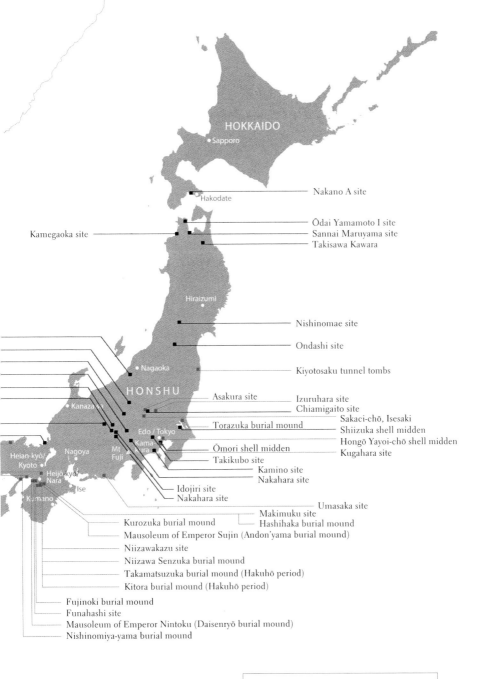

HOKKAIDO

Sapporo

Hakodate — Nakano A site

Kamegaoka site — — Ōdai Yamamoto I site
Sannai Maruyama site
Takisawa Kawara

Hiraizumi

Nishinomae site

Ondashi site

Nagaoka — Kiyotosaku tunnel tombs

HONSHU

Kanazawa — Asakura site — Izuruhara site
Chiamigaito site
Sakaci-chō, Isesaki
Torazuka burial mound — Shiizuka shell midden
Edo / Tokyo — Hongō Yayoi-chō shell midden
Ōmori shell midden — Kugahara site
Kama-kura — Takikubo site
Helan-kyō/ Nagoya — Kamino site
Kyoto — Mt Fuji — Nakahara site
Heijō-kyō/ Nara — Idojiri site
Ise — Nakahara site
Kumano — Umasaka site
Makimuku site
Kurozuka burial mound — Hashihaka burial mound
Mausoleum of Emperor Sujin (Andon'yama burial mound)
Niizawakazu site
Niizawa Senzuka burial mound
Takamatsuzuka burial mound (Hakuhō period)
Kitora burial mound (Hakuhō period)
Fujinoki burial mound
Funahashi site
Mausoleum of Emperor Nintoku (Daisenryō burial mound)
Nishinomiya-yama burial mound

■ Jōmon sites

■ Yayoi and Kofun sites

100 km

YEAR	JAPAN		
13,5000 BCE	**JŌMON PERIOD**	Incipient Jōmon	13,500–9,300 BCE
5,000 BCE		Initial Jōmon	9,300–5,350 BCE
2,500 BCE		Early Jōmon	5,350–3,650 BCE
		Middle Jōmon	3,650–2,500 BCE
1,250 BCE		Late Jōmon	2,500–1,300 BCE
500 BCE		Final Jōmon	1,300–500 BCE
300 BCE	**YAYOI PERIOD**	Early Yayoi	300–200 BCE
200 BCE		Middle Yayoi	200 BCE–100 CE
100 BCE			
100 CE		Late Yayoi	100–300 CE
200 CE			
300 CE	**KOFUN, ASUKA, and NARA PERIODS**	Early Kofun	Second half of 3rd to second half of 4th century
400 CE		Middle Kofun	End of 4th to 5th century
500 CE		Late Kofun End of 5th to end of 6th century	**ASUKA PERIOD** Asuka 538–645 Hakuhō 645–710
600 CE			
700 CE		Final Kofun End of 6th to early 8th century	**NARA PERIOD** Tenpyō 710–794
800 CE	**HEIAN PERIOD**	Early Heian (Jōgan art)	794–894
900 CE		Middle Heian (Fujiwara art)	894–1086
1000 CE			
1100 CE		Late Heian (Insei art)	1086–1192
1200 CE	**MEDIEVAL PERIOD**	Kamakura	1192–1333
1300 CE		Nanbokuchō	1333–1392
		Early Muromachi (Kitayama Culture)	1392–1467
1400 CE		Late Muromachi	1467–1573
1500 CE		(Higashiyama Culture and Warring States period)	
		Momoyama	1573–1600
1600 CE	**EDO PERIOD**	Kan'ei art	First half of 17th century
1700 CE		Genroku art	Second half of 17th to early 18th century
1800 CE		Kyōhō/Kasei art	Early 18th to early 19th century
1900 CE	**MODERN PERIOD**	Meiji era	1868–1912
		Taishō era	1912–1926
2000 CE		Shōwa era	1926–1989
		Heisei era	1989–2019

YEAR	KOREA				CHINA		
13,5000 BCE							
5,000 BCE							
2,500 BCE					Shang period	1766–1046 BCE	
1,250 BCE					Zhou period	1046–246 BCE	
500 BCE					Qin period	221–206 BCE	
300 BCE							
200 BCE					Han period	206 BCE–220 CE	
100 BCE							
100 CE	Baekje 18 BCE–660 CE	Goguryeo 37 BCE–668 CE	Three Kingdoms 57 BCE–668 CE	Silla 57 BCE–935 CE	Jin 265–420	Three Kingdoms 220–280 (Wei, Shu and Wu)	
200 CE							
300 CE						North & South 386–589	
400 CE						Song 420–497	
500 CE							Sui 581–618
600 CE							
700 CE					Early Tang 618–684 High Tang 684–756		
800 CE					Middle Tang 756–829 Late Tang 829–907		
900 CE	Goryeo period 918–1392				Five Dynasties period 907–960 Northern Song period 960–1127		
1000 CE							
1100 CE					Southern Song period 1127–1279		
1200 CE							
1300 CE	Joseon period 1392–1810				Yuan period 1271–1368 Ming period 1368–1644		
1400 CE							
1500 CE							
1600 CE					Qing period 1662–1911		
1700 CE							
1800 CE							
1900 CE	Japanese colonial rule 1910–1945				Republic period 1912–1949		
2000 CE	Republic of Korea 1945–present	DPR of Korea 1945–present			People's Republic of China 1949–present		

The timelines for Korea and China include only periods mentioned in the text.

Introduction

We are about to embark on a journey that will take us from the origins of Japanese art in the prehistoric Jōmon period through to the art of the present day. In the process, we will cover multiple disciplines that include painting, sculpture, decorative arts, craft, archaeology, architecture, gardens, calligraphy, photography, printmaking, and design. If this program seems an ambitious one to set for a reader, it was even more so for this writer, an octogenarian scholar who has spent most of his career focusing on a rather narrow slice of time: 1400–1900. It was precisely this challenge and opportunity that appealed to me, for it seemed to be a chance to relearn and to grow. In undertaking the task of singlehandedly writing a history of Japanese art, I sought to overcome my habitual conceptions, to expand my scholarly horizons, to view the world of art from a broader perspective, and, in sum, to witness the history of Japanese art as a whole.

It may be useful to begin by asking a basic question: What is "art"? More precisely, what is *bijutsu*, the Japanese term now conventionally used to refer to art? It turns out that *bijutsu* is the Japanese equivalent of the English "fine arts," the French *beaux-arts*, and the German *schöne kunst*, and implies an art of purity and beauty. The term appeared during the Meiji era (1868–1912), meaning that until then in Japan the concept "art" effectively did not exist. Instead, priority was given to *gigei*, or "skill." In premodern times, the practices of painting, sculpture, and the decorative arts and crafts could all be captured by the general concept *kō*, referring either to the act of making or to an artisan—for example, *tōkō* (potter), *orikō* or *shokkō* (weaver), *shikkō* (lacquerer), *gakō* (painter), and *chōkō* (engraver, carver, or sculptor). Painting and calligraphy could also be grouped together under the single heading *shoga*. The term *chōkoku* (now "sculpture") was by contrast rarely used, and even then not necessarily in the same sense as today. *Kenchiku* (architecture) and *teien* (gardens) were two further Meiji neologisms.

Without due consideration, then, Meiji officials used the Western import *bijutsu* to define a body of works created in Japan, and they did so in a selective manner that has had a long-term, adverse effect on the study of Japanese art history. Certain forms of artistic production, such as calligraphy, still find themselves battling for recognition. Others, such as the greatly admired realistic statues known as "living dolls" (*iki ningyō*), produced by

Matsumoto Kisaburō (1825–1891) in the later part of the Edo period, have been almost entirely overlooked, to the point of their near disappearance. For these reasons, the invention of *bijutsu* and the modern discipline of Japanese art history have emerged as contentious topics in the last few decades.

Yet the term *bijutsu* is now so widely familiar that to devise a substitute, such as "plastic arts" (*zōkei*), seems no less artificial. My solution has been to continue using *bijutsu* while extending the term's range to be more inclusive. How then can we understand the meaning of the term "art?" To quote the *Oxford English Dictionary*, "[Art is] the expression or application of creative skill and imagination, especially through a visual medium such as painting, sculpture, and works produced in this way."

To this I would only add that a work of art transcends its creator's awareness and original intention, to be continually rediscovered and recreated by others. If art can be understood in relation to these two characteristics, inclusiveness and constant renewal, then the title of this book, *History of Art in Japan*, will I hope come to seem considerably less banal, indeed considerably richer, than it may at first appear.

Patriotism has no place in my view of Japanese art. Rather, I concur with East Asian art historian Ernest Fenollosa (1853–1908), who wrote: "No national or racial art is quite an isolated phenomenon."[1] The arts are neither isolated nor immutable, but like currents of air that know no national boundaries, move through transmission and cultural exchange, and along the way acquire local qualities, as artists infuse them with their own forms of expression.

With the exception of the prehistoric Jōmon period, artistic production in Japan can be seen as an orchard irrigated by several nutrient-rich streams flowing from across the Asian subcontinent as well as down through the pipeline of the Korean peninsula. The resulting harvest has depended on the quality and volume of the water supply. Does this mean there were no autonomous developments in the history of Japanese art? When considering this question, I often return to one of my favorite books, *The Enduring Art of Japan*, by Langdon Warner (1881–1955), where the author writes: "[T]he enduring tendencies of Japan, disappearing to crop up again in some fresh but recognizable fashion, always leaving one sure that they have been there before in some other mood—elegant or angry, gay or somber."[2]

I have long been interested in trying to locate this "core of Japanese art" and, over time, have identified what seem to me three distinguishing concepts. Firstly, there is "adornment" (*kazari*). Nowadays *kazari* is treated as

equivalent to "decoration" (*sōshoku*), another Meiji newcomer. However, *kazari* is quite different, a concept long woven into the daily lives of the Japanese people, pervasive since well before the arrival of Western influence. Its deep roots mean that *kazari* is fundamental to considering Japanese culture overall and of course decorative art in particular. Secondly, there is "playfulness" (*asobi*), a theme to which the writings of Johan Huizinga (1872–1945), particularly his *Homo Ludens* (1938), have made me more attuned. Playfulness may be hidden from view, but it is ever-present, even within the seemingly regimented lives that Japanese people on average lead today. Thirdly, there is "animism," where every object is thought to house a sacred spirit. Linked to the type of nature worship still practiced in Buddhist mountain asceticism (Shugendō), animist beliefs can be identified in both the sacred and the secular arts of Japan.

We will encounter these three concepts—wondrous adornment (*kazari*), playfulness (*asobi*), and animism—throughout this book. In fact, I see them as keys to unlocking the world of Japanese art history. And so, now that we are equipped, let us begin our journey.

Jōmon:
The Force of Primal Imagination

Jōmon: The Force of Primal Imagination

"My heart skips a beat when without warning I suddenly encounter the rugged, chaotic forms and patterns of Jōmon ceramic vessels."[1] More than half a century has passed since the charismatic and influential avant-garde painter and sculptor Okamoto Tarō (1911–1996) wrote these words, expressing his admiration for the mysterious ceramics produced by Jōmon culture. Since then, in light of numerous outstanding discoveries ranging from ceramics and other artifacts to settlements, our knowledge of Jōmon life and culture has grown exponentially. For example, in 1992 at San-nai Maruyama in northern Japan, archaeologists uncovered a large Jōmon dwelling site where perhaps several hundred people at a time are thought to have lived. The implication of that discovery is that Jōmon society was far more complex than previously thought, leading to the need for us to think more in terms of a full-scale Jōmon civilization.

Regardless of this question, it is undoubtedly true that Jōmon artifacts are an important cultural inheritance and an appropriate starting point when considering the history of art in the Japanese archipelago. While this is so, Japan has yet to develop a strong scholarly tradition of aesthetic treatment of archaeological finds akin to what has evolved in the field of European Classical Archaeology, seen particularly in the study of the art of Ancient Greece and Rome. As a result, it may be some time before Japanese scholarship as a whole catches up with Okamoto's prescient enthusiasm and begins to incorporate objects that are the traditional preserve of archaeological studies, such as Jōmon ceramics, into the field of art history.

1. Jōmon Culture

Jōmon culture is generally thought to have arisen in almost all areas of the Japanese archipelago circa 13,500 BCE, when the last Ice Age (Würm glaciation) ended and glaciers around the world began to retreat. The period is traditionally considered to have ended circa 900 BCE in Kyushu and 300 BCE in eastern Japan, marked by the arrival of a new culture and new technologies, particularly those related to ceramics, metallurgy, and agriculture. A key means of defining the Jōmon period is that it corresponds to the time before the advent of metalworking. Various techniques used

to measure the age of archaeological artifacts through radiocarbon dating (including advances in the calibration of dates and the development of more refined dating methods such as AMS, or accelerator mass spectrometry) have yielded different dates for the Jōmon period, some pushing the start and end of the period back around five hundred years. Accordingly, the periodization given here should be considered widely accepted but nonetheless provisional.

For many years, scholars portrayed Jōmon people as nomadic hunter-gatherers, but recent research has shown that on the whole they were sedentary. They hunted and fished, cultivated plants, and also managed trees, such as chestnut (*Castanea crenata*) and lacquer (*urushi*; *Toxicodendron vernicifluum*). They may even have cultivated rice, a surprising new piece of historical information that has triggered debate on the differences between the Jōmon and the Yayoi culture that followed it (discussed in the next chapter).

Jōmon people were also prolific makers of ceramics, creating the oldest form of earthenware in Japan and one of the oldest continuous ceramic traditions in the world. In fact, the name Jōmon is the Japanese translation of "cord-marked," a term first used in 1877 by the American zoologist and amateur archaeologist Edward Sylvester Morse (1838–1925) to describe the prehistoric ceramics he excavated from the ancient shell middens he had discovered at Ōmori (near Tokyo). Morse had come to Japan to teach biology and physiology at the University of Tokyo, and he discovered the middens soon after his arrival. He reported his findings in *Shell Mounds of Omori* (1879), the first scientific paper on this early period of Japanese prehistory. The styles and shapes of Jōmon ceramics changed considerably over the ten-thousand-year span that constitutes the period, though the rate of change varied, depending on the time and the region of production. To codify these multiple developments, the pioneering Japanese archaeologist and "father of Jōmon studies," Yamanouchi Sugao (1902–1970), divided the period into six main stages: Incipient, Initial, Early, Middle, Late, and Final. This classification remains largely in use today, though radiocarbon dating

Incipient Jōmon	13,500–9300 BCE
Initial Jōmon	9300–5350 BCE
Early Jōmon	5350–3650 BCE
Middle Jōmon	3650–2500 BCE
Late Jōmon	2500–1300 BCE
Final Jōmon	1300–500 BCE

Table 1: Six stages of the Jōmon period

has since refuted Yamanouchi's belief that the first Jōmon ceramics dated no earlier than 2500 BCE. Table 1 gives the commonly accepted periodization and accompanying dates for the period. As shown, Jōmon culture developed gradually over millennia, a rate of change much slower than what we experience in modern life.

2. Overview of the Development of Jōmon Pottery

Incipient (13,500–9300 BCE) and Initial (9300–5350 BCE) Jōmon

Jōmon pottery is earthenware that has been fired in an open pit. (There were no kilns in Japan at this time.) It is one of the oldest types of earthenware yet discovered worldwide, the earliest examples dating back to 13,500–13,000 BCE, recovered from the Ōdai Yamamoto I site in Aomori prefecture. The development of earthenware in the Incipient and Initial Jōmon had a major impact on people's lives; it meant, for example, that food previously prepared by either crushing or grilling could now be boiled. Initially vessels were made with flat bottoms, but rounded or tapered bottoms gradually became more common, until flat-bottomed wares reappeared and became widespread. These vessels were primarily used to boil food, and their deep forms remained standard through the later stages of the Jōmon period.

Early attempts at vessel decoration can be seen in the round-bottom deep vessel with linear relief, which has raised, angled lines and mesh patterns, illustrated here [Fig. 1]. Such vessels represent the origins of Japanese art. Around this time tools made of cross-sections of bamboo were used to incise crescent-shaped fingernail patterns. Subsequently, twisted rope, or cord, was used to impress the repeating patterns that Edward Morse called "cord-marked," with some vessels being decorated using multiple cords. The designs are thought to have been inspired by the bamboo baskets used in daily life.

Yamanouchi Sugao dispelled an older notion that the patterns had been

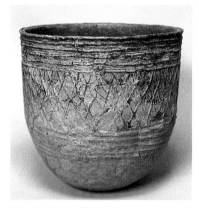

Fig. 1: Round-bottom deep vessel with linear relief, Incipient Jōmon period, Kamino site, Kanagawa prefecture

made by pressing interlaced or woven materials onto the clay. Instead, as Yamanouchi demonstrated, the patterns were produced by wrapping cords around a cylindrical wooden stick and rolling it over the still-wet surface of the clay. Altering the ways in which the cords were wrapped produced different effects so that the patterns could resemble textiles, wood grain, or mesh [Fig. 2]. Other decorative techniques included rolling incised wooden sticks over a vessel's surface to produce rouletted patterns; using cross-sections of bamboo as stamps to create split-bamboo patterns; using shells as stamps to create shell patterns; and using a pointed stick to open a pattern of holes in the body of a vessel, known as pierced patterns.

The delicate and beautiful patterning seen on the conical round-bottom deep vessel with shell appliqué ingeniously combines several techniques, including piercing, incising, cord marking, and the use of shell edges to create the dotted lines [Fig. 3]. Rather than following a prearranged plan, the decoration on this vessel suggests experimentation in how to manipulate cord-wrapped sticks and combine

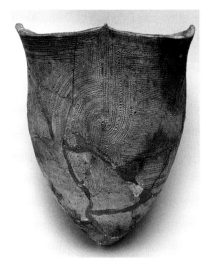

Fig. 3: Conical round-bottom deep vessel with shell appliqué, Initial Jōmon period, Nakano A site, Hokkaido

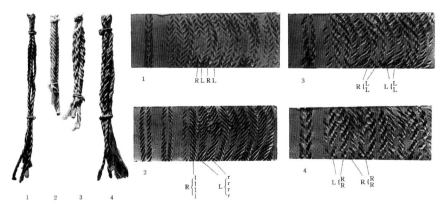

Fig. 2: Illustration of cords and cord markings from Yamanouchi Sugao, *Nihon senshi doki no jōmon* (Cord Marks on Japanese Prehistoric Ceramics; Senshi Kōko Gakkai, 1979).

different rolling movements within an overall composition—reminiscent of experimentation in the applied arts in modern times. As the archaeologist Sugiyama Sueo (1885–1946) and the archaeologist and art historian Aoyagi Masanori (b. 1944) have noted, this experimental aspect of Jōmon ceramic design would remain a fundamental characteristic of Japanese art.

Early (5350–3650 BCE) and Middle (3650–2500 BCE) Jōmon

The Early Jōmon experienced a surge in creativity. For example, while the Incipient Jōmon had produced some vessels with a wave-like shape to the mouth, now the form escalated into elaborate and powerful protrusions, evoking the feel of some elements of Baroque or modern Spanish architecture [Fig. 4]. Vessels with ornamental rims appeared, seemingly representing a necklace of shells, and others that demonstrate a high mastery of cord marking, including beautiful wood-grain patterns. These vessels, which show an increasing awareness of patterning, paved the way for the ceramics of the Middle Jōmon.

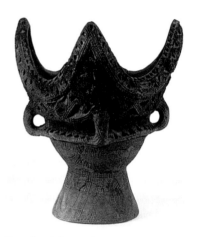

Fig. 4: Elaborately decorated vessel, Early Jōmon period, Kōjin'yama site, Nagano prefecture

During the Middle Jōmon the climate throughout the Japanese archipelago became more favorable and social conditions stabilized. It was also a time when enthusiasm for *kazari* (adornment) as expressed in the wondrous decoration of pottery vessels reached its height. Some vessels from this period feature significant use of clay in relief to create elaborate three-dimensional surfaces. Such dynamic aesthetics do not fit easily into the traditional art historical categories of ceramics or sculpture, and they carry the vessels beyond practical use into the realm of artistic expression.

The Katsusaka-type pots from the Middle Jōmon are particularly famous for their superior designs and organic structures. Excellent examples have been discovered around the Idojiri site in Nagano prefecture. The vessel shown here [Fig. 5] is an enigmatic work, with magnificent relief patterning around its mouth, a bulbous base, and circular openings

for its four handles. Two of the handles take the form of snakes, their heads raised and tails pointing downward to the bottom of the vessel. Snakes often appear on Middle Jōmon pots, the animal's vitality evidently having made it an object of worship. Other motifs prevalent during the Middle to Late Jōmon are what appear to be leeches and frogs, as well as people and mask-like faces, all rendered in an abstract manner, similar to the snakes.

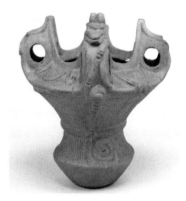

Fig. 5: Katsusaka-type pot, Middle Jōmon period, Takikubo site, Tokyo

A type of barrel-shaped vessel with pierced holes and a brim-like protuberance around the horizontal mouth seems to have been in fashion during the Middle Jōmon [Fig. 6]. The organic swirls wrapping around the vessel appear to endlessly repeat, forming a fractal pattern [Fig. 7]. This vessel has been interpreted either as having the form of a woman's body or as completely abstract.

How these barrel-shaped vessels with pierced holes were used remains a mystery. Current theories suggest they stored food or drink—for example, seeds, or alcohol made from wild grapes (*yamabudō*)—or perhaps functioned as drums. In any case, they seem to have been designed not for special festivals but as an integral part of daily life. Twelve such pots were found in a Middle Jōmon pit house in the Idojiri site that is believed to have burnt down [Fig. 8]. The pots were most likely in use at the time of the house's destruction. One is barrel-shaped with a snake motif, and several have snake and human motifs [Fig. 8, vessel no. 318]. Finds such as these indicate that in their daily lives Jōmon people used ceramics decorated with a variety of dynamic, magical symbols.

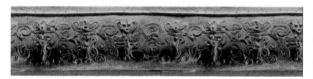

Fig. 7: Extended view of Fig. 6

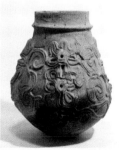

Fig. 6: Barrel-shaped vessel, Middle Jōmon period, Nakahara site, Yamanashi prefecture

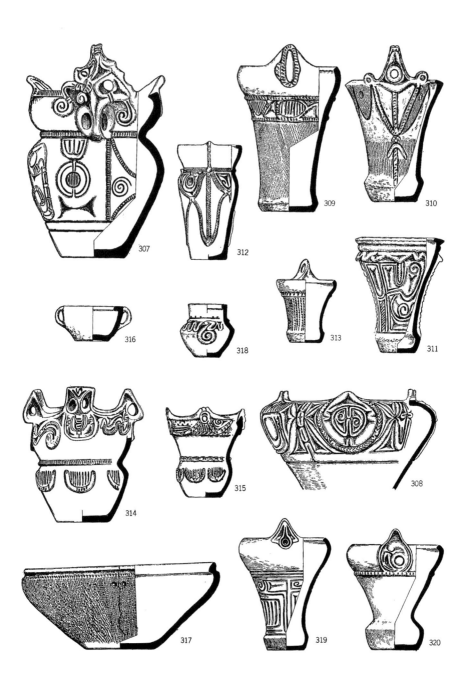

Fig. 8: Vessels found in a pit house at the Idojiri site, Middle Jōmon period, Nagano prefecture, from Fujimori Eiichi ed., *Idojiri* (Chūō Kōron Bijutsu Shuppan, 1965).

A remarkable type of vessel also produced during this period is the large, deep "placenta" pot. The example illustrated here [Fig. 9] was excavated from the Tsugane Goshomae site in Yamanashi prefecture. The applied decoration around the middle of this type of pot takes the form of human hands and feet, with tentacle-like bands. A round face, possibly a baby's, peers out from either side. On one side of the handle is a face thought to be that of a mother; the other side has two eyeball-like shapes, one with swirls that may express labor pains. Whatever the specific meaning, these symbols certainly suggest a narrative intent, perhaps a prayer for a successful harvest.

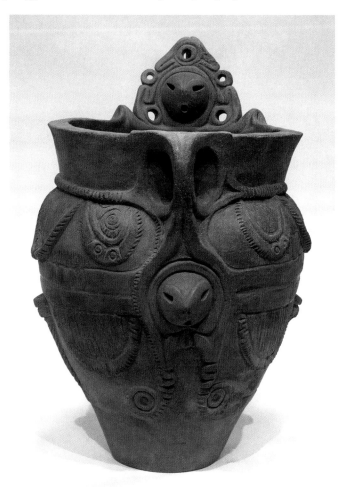

Fig. 9: Placenta pot, Middle Jōmon period, Tsugane Goshomae site, Yamanashi prefecture

Perhaps most famous among Jōmon ceramics is the type commonly called "flame pots" (*kaen doki*). With protrusions that resemble shooting flames, these vessels demonstrate a taste for extreme ornamentation, though cord marks are no longer used. A deep pot excavated from the Sōri site (next to Idojiri) has beautiful decorations that organically connect large and small swirl patterns on the top half of the body and the two handles. Another example that shows a higher degree of craftsmanship is the Umataka-type flame pot from Niigata prefecture [Figs. 10 and 11].

Among the numerous other examples of Middle to Late Jōmon vessels are the extraordinary Yakemachi vessels, named for the site near Nagano and Gunma prefectures where they were first discovered [Fig. 12].

As these few examples suggest, each and every Middle Jōmon ceramic vessel has a slightly different design, though they are unified by a highly decorative approach. This degree of aesthetic sensibility might initially resonate with the individual expression associated with modern art, but there is a fundamental difference: unlike modern art, which considers individual creativity the driving force behind artistic production, Jōmon ceramics emphasize the amalgamation of different styles. Styles that developed in a given region were transmitted through exchange, and in this way metamorphosed into yet newer forms. The range of imaginative variations is vast. Finally, it should be noted here that, throughout the Jōmon period, women may have been responsible for ceramic production—as is understood to have been the case traditionally in Southeast Asia and the Pacific Islands—and, perhaps even more important, that the vigorous forms of Jōmon ceramics were probably created by women.

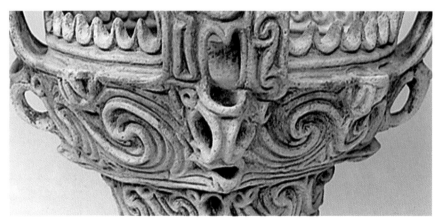

Fig. 11: Detail of Fig. 10

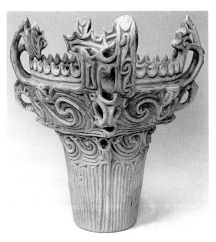

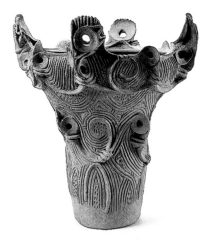

Fig. 10: Umataka-type flame pot, Middle Jōmon period, Sasayama site, Niigata prefecture

Fig. 12: Yakemachi vessel, Middle Jōmon period, Kawarada site, Nagano prefecture

Late (2500–1300 BCE) and Final (1300–500 BCE) Jōmon

During the Late and Final Jōmon, the climate cooled again, and as food and other natural resources grew scarce, the population declined significantly. Ceramic design too underwent change, with decreasing amounts of decoration; relief patterns were now applied less prominently, and decorative modeling protruding from the surface of the pot was far less common. It also now becomes possible to differentiate between wares for special use and those for daily use.

New types of pottery also appeared, such as spouted vessels resembling teapots. The surface of one Late Jōmon example [Fig. 13] was covered in soot and then burnished to give it a lustrous finish. This vessel is also covered in fine, comb-marked lines drawn in fascinating figure-eight patterns and overlapping circular swirls, with further S-shaped lines also featuring prominently. Advanced decoration of this kind suggests an influence from outside the Jōmon ceramic tradition, probably from northern Asia. A similar influence seems to underlie the "cloud pattern" that becomes popular during the Final Jōmon. A red-lacquered Kamegaoka-type urn excavated from Takisawa Kawara in Aomori prefecture has such a pattern, rendered as an "erased cord-marked design." Erased designs are created by first covering a vessel with cord markings and then polishing or burnishing away designated areas, possibly by hand or using a stone.

Red-lacquered vessels are quite common among Kamegaoka-type wares. The application of the color red or vermilion is understood to have served as spiritual protection to ward off evil; this practice would continue up to the Kofun period (second half of third century to early eighth century). A prime example from the Final Jōmon [Fig. 19] also has a pattern of meandering lines on its meticulously polished black surface. This pattern would develop into the wave pattern of the following Yayoi period (discussed in the next chapter).

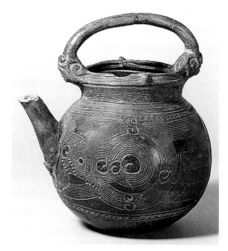

Fig. 13: Spouted vessel, Late Jōmon period, Shiizuka shell middens, Ibaraki prefecture

3. Fertility Beliefs and the Mystery of the *Dogū* Figurines

Clay faces and small sculptures of human figures were applied to vessels from the Middle Jōmon onward, presumably in the belief that they possessed spiritual powers. Individual figurines, called *dogū* in Japanese, were also produced, possibly in accordance with the same belief; however, these appear to have been made more specifically for ritual purposes, since they are usually unearthed in a dismembered state, suggesting that they were intentionally broken prior to burial. The nature of the rituals remains unknown, but some archaeologists have drawn connections with the earth mother worship practiced by agricultural peoples along the Pacific Rim, where similarly broken figurines have been uncovered. According to these belief systems, the earth goddess produces crops from her body, and burying figurines of her in pieces initiates the growing season. Alternatively, archaeologist Kobayashi Tatsuo (b. 1937) has suggested that *dogū* began as a way of giving physical form to unseen spirits.

In Japan the earliest examples of female *dogū* date back to the Incipient Jōmon. The Middle Jōmon saw the emergence of flat, cross-shaped figurines with a defined face, body, and hands; as the centuries progressed, this type was produced on an increasingly larger scale. One of the best-known Middle Jōmon *dogū* is the affectionately referred to as the *Jōmon*

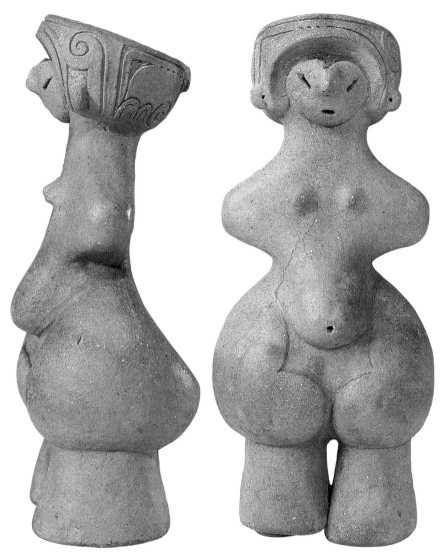

Fig. 14: *Dogū*, Middle Jōmon period, Tanabatake site, Nagano prefecture

Venus, excavated from Tanabatake in Nagano prefecture and now designated a National Treasure [Fig. 14]. The *Venus* is extremely rare for having emerged from the earth mostly intact. A voluminous coiffure crowns her head; below, her eyes are marked by upward-angled slits, and a round, child-like face recalls the figures attached to Katsusaka-type pots (for example, Fig. 9). The earlier tradition of flat figurines is echoed in the upper body, with its thin chest and abbreviated arms, but the lower body is amply sculpted

with large buttocks and a rounded abdomen that suggests pregnancy. The back area is carved out in a manner that accentuates the impression of curvature and suggests an expressive mode seen in modern sculpture. Figure 15 shows another *dogū*, discovered in 1992 at the Nishinomae site in Yamagata prefecture and designated as a National Treasure in 2012, whose legs suggest that the figure is wearing pants; the sharp drop along the back recalls the forms of sculptor Ossip Zadkine (1890–1967). In these examples, we sense not an environment of communal production, but the aesthetic decisions of a particular maker transcending the ages.

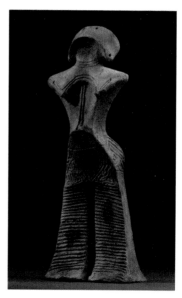

Fig. 15: Standing *dogū*, Middle Jōmon period, Nishinomae site, Yamagata Prefecture

The well-known heart-shaped *dogū* with bowed legs has barely defined pregnancy stretch marks [Fig. 16]. A few of the figurines with "horned owl" shapes have round eyes and mouths, almost toylike faces, but other figurines produced during the Late and Final Jōmon have features that defy comprehension, looking almost "alien" in appearance.

Mysterious icons such as the Final Jōmon *dogū* figurines from Kamegaoka, with their eyes shaped like coffee beans and their shriveled hands and feet, lead us to imagine the possibility that they might relate to various unnamed and unknowable gods worshipped before the arrival of Buddhism in Japan [Fig. 17]. However, there also exist considerably more realistic figures of animals, including monkeys, bears, seals, turtles, boar, and shellfish.

4. Personal Ornamentation and Practical Crafts

Apart from working clay into vessels and figurines, Jōmon people also used other natural materials to produce objects for personal ornamentation and practical craft. Shells, obsidian, jade, and metal ores were turned into necklaces, earrings, and bracelets. The craftsmanship of these objects—among them the beautiful openwork clay earrings excavated from Chiamigaito in

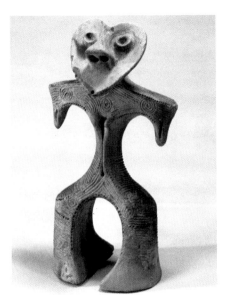

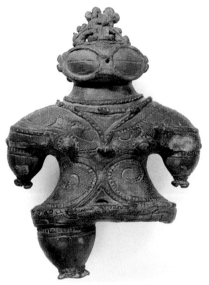

Fig. 16: Heart-shaped *dogū*, Late Jōmon period, Gōbara site, Gunma Prefecture

Fig. 17: *Dogū* with "coffee bean eyes," Final Jōmon period, Kamegaoka site, Aomori prefecture

Gunma prefecture, a Final Jōmon site [Fig. 18]—is astonishing when one considers that Jōmon people worked without metal tools. They were also skilled with organic materials. Although most of what they made was buried or gradually covered in Japan's wet and acidic soil and so has not survived, archaeologists have been lucky enough to find a few completely intact storage baskets containing acorns, as well as pieces of woven and knitted textiles made from plant fibers and bark. The textiles were most likely dyed using natural plant dyes. A few wooden artifacts, including boats, have been excavated from the Torihama shell middens in Fukui prefecture, where they were submerged in water and hence preserved.

Lacquer (*urushi*) was also an important material during the Jōmon period. The Ondashi site in Yamagata prefecture has yielded Early Jōmon earthenware objects coated in lacquer, including a red lacquer bowl with an overpainted black-lacquer design. The color scheme would be reversed in the Final Jōmon, examples being the shallow Kamegaoka pots with black lacquer ground and overpainted red lacquer cloud design [Fig. 19]. Red lacquer combs have also been discovered, quite similar to the long, narrow-toothed combs used in modern Southeast Asia. Until recently,

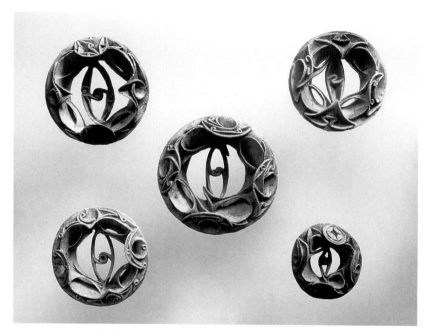

Fig. 18: Openwork clay earrings, Final Jōmon period, Chiamigaito site, Gunma prefecture

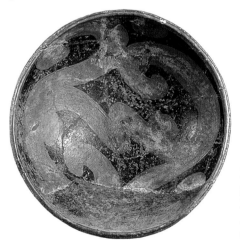

Fig. 19: Vessel with black-lacquer ground and red-lacquer cloud design, Final Jōmon period, Kamegaoka site, Aomori Prefectural Museum (Fūindō Collection)

lacquering was a technique presumed to have been imported from China, but the discoveries at Ondashi and Kamegaoka require a re-evaluation of this assumption within the context of art history. Harada Masayuki (b. 1958) notes the possibility that the development of lacquer craft in Japan may predate that in Neolithic China.

5. Jōmon Dwellings

Jōmon people lived in pit dwellings consisting of a shallow hole dug in the ground and protected by a thatched roof. The majority of the population on the Japanese archipelago would continue to use such structures through to around the fourteenth century CE. The extensive Jōmon settlement discovered at the Sannai Maruyama site in 1992 brought a new understanding of life during the Middle Jōmon. Various settlements occupied the site over the period it was in use, c. 3900–2300 BCE. Discoveries there include the pillars of a longhouse that must have stretched over 30 meters in length. Reconstruction suggests that this building may have functioned as something like a meetinghouse for special gatherings, rituals, or events. Other excavations at Sannai Maruyama have found evidence of a remarkable structure that had a framework of six chestnut-tree pillars stationed in two parallel rows of three and positioned at intervals of 4.2 meters. Each pillar measured 1 meter in diameter and perhaps originally rose as high as 17 meters. Archaeologists have found evidence of similar large-scale structures in Ishikawa, Yamagata, Akita, and other prefectures along the Sea of Japan. Whether they represent monuments or functional architecture remains a question, but it is extraordinary to think that such structures could have been made using only stone axes.

6. The Significance of Jōmon Art

Jōmon ceramics may seem inaccessible, eerie, bewildering, almost beyond comprehension to someone seeking only comfort or solace in art. Yet, along with this strangeness they project a powerful force that awakens something within us. Their contradictory nature reconnects us with the essence of ourselves as human beings. Additionally, while they disturb our preconceived notions of "what is Japanese," their fine detailing represents the early appearance of an approach to craftsmanship that will become typical of Japanese art in later centuries.

Jōmon artifacts are also important for revealing some of the major cultural and historical developments that occurred throughout the Japanese archipelago during the period. For example, in 1997, while excavating a pit dwelling at the Uenohara site in Kagoshima prefecture (southern Kyushu), archaeologists uncovered a group of shell-patterned vessels dating to the Early Jōmon period. A ritual site near these vessels yielded another set of

Early Jōmon shell-patterned earthenware, including a rare find, a spouted teapot-shaped vessel. These discoveries suggest that people residing in southern Kyushu at the time enjoyed a high standard of living, possibly a result of trade and other connections with their northern neighbors across the Sea of Japan. Their success ended, however, with the eruption of an underwater volcano, which separated Japan's western regions from those to the east.

It has not yet been possible to locate a discernable cultural center for the Jōmon population during the extended Jōmon period. There may have been an even distribution of regional forms of art and culture; active exchange networks certainly existed between regions. These exchange networks appear to have ensured that the Jōmon cultures developed at a similar level throughout the archipelago. However, the Late and Final stages of the Jōmon period show the beginnings of social and regional stratification, among other changes arising from the assertion of political power. Before long these fundamental changes in art and society would lead to the start of a new historical period, known as Yayoi.

The ten-thousand-year Jōmon period stands in marked contrast to the relatively short Yayoi period that followed it. The Yayoi period witnessed a considerable influx of new artistic and technological influences from the East Asian continent. Yet throughout the millennia, the expressive ceramic works created by the Jōmon peoples demonstrated that, despite their relative isolation from the continent, inhabitants of the Japanese archipelago developed dynamic aesthetic sensibilities that gave rise to one of the great creative traditions of world prehistory, whose influence has echoed through Japanese history.

Yayoi and Kofun:
Influences from the Continent

Yayoi and Kofun: Influences from the Continent

I. Yayoi Art, Birth of a New Aesthetic

1. Yayoi Culture and Art

In 1884, seven years after Edward Sylvester Morse (1838–1925) discovered Jōmon ceramics in the Ōmori shell middens, a new type of earthenware, different from that produced during the Jōmon period (13,500–500 BCE), was identified. This new type of ceramic was excavated from the Hongō Yayoi-chō shell middens in Tokyo. The ceramic style and period was subsequently given the name Yayoi after the location of its initial discovery. The Yayoi period corresponds to a time when these types of ceramic wares were in use, and the term applies both to the culture and to the art that developed during this time.

The debate continues over the precise dating of when the Yayoi culture actually began. In this book, I use conventional dating, which places the beginning of the Yayoi period sometime around 300 BCE. It is important to stress, however, that it would have taken a substantial amount of time for the Yayoi culture, which had its roots in northern Kyushu, to reach the northeastern region of Japan, and therefore the two cultures would have overlapped.[1]

The Yayoi period has conventionally been divided into three stages.[2] Compared to the Jōmon period, which lasted over 10,000 years, the Yayoi period was relatively short, lasting only 600 years in total. Despite this abbreviated time span, however, ceramic styles changed dramatically over the period. The difference in the aesthetics between the Jōmon and the Yayoi is quite striking: for instance, Middle Jōmon vessels have a vigorous appearance with a concentration on the decorative rather than on the practical, while the well-proportioned Yayoi pots emphasize

Early Yayoi	300–200 BCE
Middle Yayoi	200 BCE–100 CE
Late Yayoi	100–300 CE

Table 1: Three stages of the Yayoi period

the balance between the whole and the individual detail, successfully focusing less on ornamentation and more on functionality. While I would like to pay greater attention to the continuous transformation of styles rather than gaps between them, in general I agree with scholarly opinion that what we now recognize as Japanese aesthetics originated during this period.

The development of this culture was greatly influenced by the arrival of new populations, primarily from the Korean peninsula, and their mixing with existing populations created what is now identified as Yayoi culture. Many societies shifted their livelihoods to wet-rice agriculture based on paddy field cultivation. While the Jōmon had engaged in some forms of plant cultivation, rice was not a fundamental component of their diet. This marks a distinct contrast to the Yayoi people, who began rice cultivation in earnest. The use of metal was a crucial new development, and other innovations were seen, including silk weaving. The number of new settlers filtering into the Japanese archipelago is still disputed, but it is generally believed that in the initial period there was no large-scale migration replacing the existing populations. While there is evidence of conflict, the collaborative effort essential for rice farming is one of the key indicators of integration of the communities at this time.

Commonly employed tools were made of wood and stone, much as those used by Jōmon people. Plows and hoes were made of wood, and earthenware was used to store food or boil rice. It was within this milieu that both metal tools and bronze technology were first introduced from the continent. While most examples of metal in the Yayoi period were treasured objects employed in special rituals, metal swords began to be produced in great numbers and were used as weapons. Sporadic violent episodes may have occurred during the Jōmon period, but warfare did not become institutionalized until the establishment of agricultural communities that competed for land to farm. In preparation for possible future hostilities, settlements of pit houses protected by an encircling moat began to appear in the Early Yayoi period. The practice is thought to have been introduced from the Korean peninsula. Settlement size gradually increased, and structures became steadily more elaborate, including buildings with raised floor structures, festival altars, and storehouses, like those seen at the Yoshinogari site in Saga prefecture dating to the Late Yayoi. Some scholars argue that later shrine architecture in Japan can trace its roots back to the raised floor structures from this time.

2. Yayoi Ceramics

During the Yayoi period, most vessels were made in jar shapes rather than the deep pot forms that were common in the Jōmon period. Popular vessel forms include jars with constricted necks, followed by open bowls and bowls on stands. Yayoi ceramics currently displayed in museums as art objects are typically refined vessels that were most likely used in festivals or religious rituals rather than in everyday life. As in the Final Jōmon period, the practice of distinguishing between functional ceramics and ritual objects continued in an even more pronounced fashion during the Yayoi period. Yayoi ceramics first appeared in northern Kyushu during the Early Yayoi period. The earliest known example is the Yu'usu-type jar, excavated together with Final Jōmon period vessels at sites such as Yu'usu in Fukuoka prefecture and Nabatake in Saga prefecture. Soon afterwards, the Itazuke-type jar was uncovered at the Itazuke site in Fukuoka [Fig. 1].

Ceramic production in the Kyushu and Kinki regions (Osaka, Kyoto, Hyogo, Nara, Mie, Shiga, and Wakayama prefectures) reached a zenith in the Middle Yayoi period. Incised line work, primarily made from running comb teeth over the semi-dry clay surface, was used increasingly to achieve refined patterns that accentuate the shapes of the vessels. A wide-mouthed jar with red lacquer excavated from the Fujisaki site in Fukuoka is entirely covered with cinnabar-colored red lacquer and features a large rim around

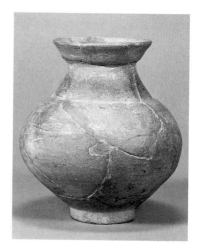

Fig. 1: Itazuke-type jar, Early Yayoi period, Itazuke site, Fukuoka prefecture

its mouth [Fig. 2]. The projecting rim is similar to those seen on jars excavated from the Korean peninsula with prototypes dating back to the Shang period (c. 1766–1046 BCE). The thick vertical bands on vessel necks were a new decorative technique, commonly found on red lacquered jars and vases for ritual use.

From the Kinki region in the same period, a more refined, independent aesthetic began to appear. A splendid example of this aesthetic is seen in Figure 3, which shows the balance between the heavy body and the long sleek tapering neck of a jar excavated from the Funa-hashi site in Osaka. Similarly, Figure 4

illustrates a jar excavated from the Niizawakazu site, Nara prefecture, which displays a design-conscious aspect, its handle placed between the body and neck, producing a jug-like shape.

In the Early Yayoi period, Jōmon ceramic traditions continued in central and eastern Honshu, meaning that distinct regional differences can be seen between the practice of new Yayoi ceramic traditions and the retention of Jōmon traditions. By the Middle Yayoi period a new hybrid style is seen that incorporates both the shape of Yayoi vessels and the vigorous patterns of earlier Jōmon examples, as seen in the jar excavated in Umasaka site in Shizuoka prefecture [Fig. 5]. The red lacquered jar from the Kugahara site in Tokyo is a superb example of a harmonious combination of Jōmon patterns and a Yayoi vessel shape [Fig. 6].

The Jōmon practice of creating modeled designs of human faces on vessels continued in the Yayoi period. A Middle Yayoi jar from Ibaraki prefecture featuring depictions of faces on the neck and mouth of the vessel is thought to have functioned as an urn for human bones. The eyes and nose are stylistically similar to those of Late Jōmon *dogū* (figurines), but the beard offers a more realistic expression. The gentle facial features seem to link this example to later expressions employed on *haniwa* figures in the succeeding Kofun culture.[3] In contrast, there are examples where the vessel's mouth has been transformed into a large "monster-like" opening, reminiscent of the preceding Jōmon culture, such as the jar with a modeled

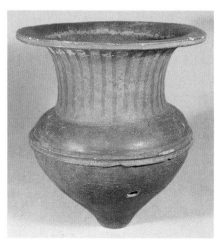

Fig. 2: Wide-mouthed jar with red lacquer, Middle Yayoi period, Fujisaki site, Fukuoka

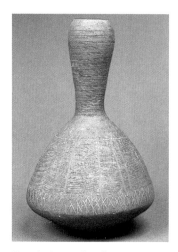

Fig. 3: Jar with a long tapering neck, Middle Yayoi period, Funahashi site, Osaka

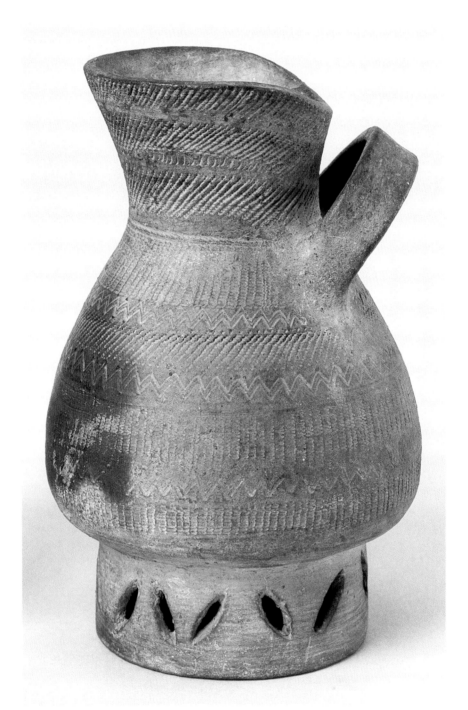

Fig. 4: Jug-like vessel, Middle Yayoi period, Niizawakazu site, Nara prefecture

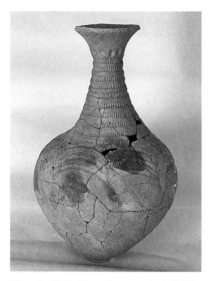

Fig. 5: Hybrid-style vessel, Middle Yayoi period, Umasaka site, Shizuoka prefecture

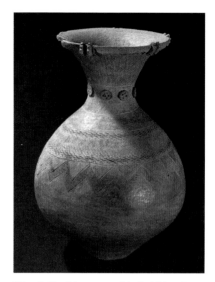

Fig. 6: Red lacquered hybrid jar, Late Yayoi period, Kugahara site, Tokyo

human face from Izuruhara site in Tochigi prefecture [Fig. 7].

Yayoi society became increasingly stratified from the Middle to Late Yayoi. Regional leaders, possibly with shamanic powers, appeared in Yayoi society and become heads of communities, and many small "countries" (or states) began to emerge. Powerful leaders come to the fore, such as Himiko, one of the first named rulers of a Japanese regional polity to be mentioned in historical documents. She is described as Queen of Yamatai in the *Wei Zhi*, a third-century Chinese text. Inevitably, wars were fought during this period as leaders consolidated power by absorbing neighboring communities. The lacquered wooden armor excavated in Hamamatsu (Shizuoka prefecture)

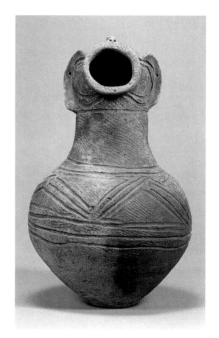

Fig. 7: Jar with a modeled human face, Middle Yayoi period, Izuruhara site, Tochigi prefecture

is thought to be part of a set of full-body, paulownia-wood armor: the fierce patterns carved into the wood and the red and black lacquered surface reflect an aesthetic that resonates with that found on earlier Jōmon ceramic vessels. In the Late Yayoi, large cylindrical earthenware vessels with a height of nearly one meter known as "special pedestaled vessels" (*tokushu kidai*) began to be made for ritual use. Their creation may correspond to the fact that rituals to legitimize the leader's authority became increasingly extravagant, as did burial sites, leading to those of the subsequent Kofun period. The special pedestaled vessels would later transform into the cylindrical *haniwa*, typical of the succeeding period.

3. Bronze Bells and Mirrors

Bronze objects, made from a mixture of copper and tin, were produced in great numbers in the Shang (1766–1046 BCE) and Zhou (1046–246 BCE) periods in China. Bronze weaponry, such as swords and halberds, were also made in Japan, in addition to ritual objects such as bells (*dōtaku*). The Yayoi people venerated these metal objects. It is also now understood that bronze was produced in Japan much earlier than previously thought. Bronze bells have become representative of the Yayoi period. A rope would have been tied to the handle on the top of the cylindrical body, and a bronze tongue suspended within the bell. When struck, the bell would have produced a beautiful sound. The origin of these bells can be traced back to the Chinese small bronze bells called *bianzhong* or *zhong* that were hung from the necks of domestic animals. These bells entered the Korean peninsula, where they were used as ritual implements, were thought to have magical powers, and were worn by shamans. In Japan, bells followed their own independent development as ritual instruments.[4]

Bells from the Early Yayoi are small in size, with a height of around 20 to 30 centimeters, and with decoration kept to a minimum. The bell size expanded to around 40 to 50 centimeters in the Middle Yayoi period, with a noticeable increase in decorative qualities such as the appearance of "fins." The Middle Yayoi *dōtaku* bells with stream patterns were found behind rocks at Kehi shrine (Kehi-jinja) in Hyogo prefecture, and sections of what are thought to be the molds for these bells were discovered at a site in Osaka. In 1964, fourteen bronze bells and seven halberds were found in the mountain ridge of Mt. Rokkō, Hyogo prefecture [Fig. 8]. Figure 9 illustrates

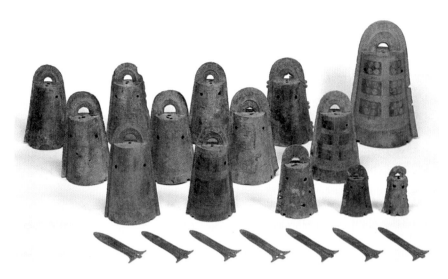

Fig. 8: Bronze bells and halberds, Middle Yayoi period, Sakuragaoka site, Mt. Rokkō, Hyogo prefecture

a detail from one of these bells. Depictions of people farming and hunting can be seen, as well as images of herons, turtles, praying mantises, dragonflies, lizards, frogs, and fish, all detailed in hairline relief in the panel between the cross bands.[5] Humans are depicted in the manner of stick figures, and there is some debate as to whether the circular head represents a male and the triangular head depicts a female.

In 1996, thirty-six *dōtaku* bells were found buried on a mountain in Shimane prefecture. Some argue that Yayoi people chose specific sites to pray for their gods to descend

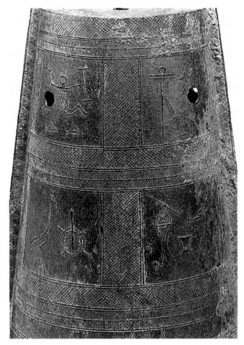

Fig. 9: Detail from one of the bells discovered at Mt. Rokkō (Fig. 8)

to earth and that the bells were deliberately placed there as offerings after festivals. The bells became larger in the Late Yayoi, and lobes began to appear. Some of these bells are as tall as 134 centimeters, and it should be noted also that some bells are found without tongues. The archaeologist Yoshikawa Itsuji (1908–2002) ascertains the reasons for this phenomenon as follows: "As soon as the Kofun culture was initiated, the peaceful and symbolic bronze art, which has lost its functionality as a musical instrument, could not survive in the new period with real warfare and therefore was literally buried away."[6] What remained in terms of this tradition was the mastery of the bronze casting technique, which became a part of Japan's cultural heritage.

Dōtaku disappeared in the late second century and were replaced by bronze mirrors distributed by regional leaders such as Himiko, who brought an end to the Wakoku war, a period of violent unrest described in the *Wei Zhi*. The exact location of Himiko's Yamatai kingdom is still in dispute, with two prevailing theories: the Kyushu theory and the Kinki theory. When the Yoshinogari area was excavated starting in 1986, there was great excitement among those supporting the theory that Kyushu was the site of Yamatai. A large-scale moated colony and graves were found; some speculated that this may have been the location of Himiko's palace. However, in 1997, thirty-three triangular-rimmed mirrors with figures of the four deities and four sacred animals were found in the Kurozuka burial mound in Tenri, Nara prefecture [Fig. 10]. Some argue that these were the actual mirrors given to Himiko from the king of Wei.[7] I will return to this point in subsequent chapters. Chinese rulers in the early and late Han period began to give bronze mirrors to the local rulers in the northern Kyushu regions by the Middle Yayoi period, with examples such as the Korean mirror with geometric shapes on its exterior, excavated from a site in Osaka.

In any case, it is apparent that relations between China

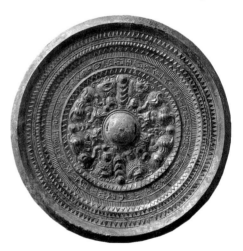

Fig. 10: Triangular-rimmed mirror, Early Kofun period, Kurozuka burial mound, Tenri, Nara; Agency for Cultural Affairs, Japan

and Korea brought bells, mirrors, swords, halberds, and other bronze goods to Japan. The bronze objects had many uses: some helped to perform magic, others symbolized authority. Certainly many were also manufactured in Japan as imitation of continental originals. Objects like *dōtaku* developed their own distinct Japanese style. The new earthenware forms of Yayoi ceramics cannot be explained without considering influences from the continent. The ripples of the continental tidal wave of art that was about to hit the Japanese archipelago could already be felt in the Yayoi period.

4. Jōmon versus Yayoi Aesthetics

The Yayoi period began with the introduction of new technologies from the continent: most importantly, rice cultivation and metalwork production. The Japanese tendency to adapt and change with each new wave of influence from the continent is evident from this period onward. The transition between the Jōmon and Yayoi periods is perhaps best seen as a phase of heightened interaction between Japan and the continent. The indigenous Jōmon populations adopted various continental traits as new people arrived through the Korean peninsula, resulting in a high degree of cultural continuity.

Artist Okamoto Tarō compares the contrasting styles of Jōmon ceramics, with their conspicuous expression of passion, and Yayoi examples, with their pursuit of harmonious balance, to the way in which the people of the two cultures lived. While the Jōmon hunted for a living, the Yayoi farmed, and this would have brought differences in how they perceived life and their environment. Okamoto argues that later Japanese art resonates not just with the "passive optimism" of Yayoi aesthetics but also with the "hearty vitality" of the Jōmon tradition, which transcends the apparent paradox of regarding animals both as prey and deities (see Chapter 1, note 1).

Okamoto's explanation of the hunting Jōmon people and the farming Yayoi people obviously should be revisited and revised. It is known that Jōmon people lived in settlements, foraged, and grew crops as supplemental foodstuff in addition to hunting. The Yayoi people worshipped deer as messengers of gods, while at the same time hunting them. Ceramic forms representing the conflicting Jōmon and Yayoi styles were in fact common in central and eastern Japan, as seen in Figure 5. There are rare instances, such as the example illustrated in Figure 6, where the Jōmon and Yayoi ceramic styles are indeed harmonized.

The relationship between the Yayoi and the Jōmon cultures reflects a transition rather than a break with the past. Stark aesthetic differences between the two periods, as Okamoto suggests, cannot be denied. However, it can be recognized that the Jōmon culture reflects the indigenous aesthetics of Japan's first people, while the Yayoi is the result of a mixed aesthetic after Japan was incorporated in an East Asian cultural sphere.

The indigenously bred aesthetics cultivated over many years by the Jōmon people did not die out altogether, even after being exposed to continental aesthetics or, more specifically, art from China and Korea. Jōmon aesthetics lie dormant, deep within the culture, and make sudden appearances from time to time. Okamoto's "discovery" can be interpreted as a secret well of Jōmon blood flowing within his veins.

II. The Kofun Period: Encountering the Continent

1. Continuity with Yayoi Culture

The term *kofun*, from which this period takes its name, refers to ancient mounded tombs that can still be seen in the Japanese landscape. These tombs were created as the Yamato kingdom developed. The construction of large-scale tombs, or burial mounds, was concentrated in modern-day Osaka, Kyoto, and Nara prefectures and surrounding regions but spread as far as Kyushu and eastern Japan. Art of this period that is extant today is almost exclusively found in and related to tomb burials.

The discovery of many triangular-rimmed mirrors with deity and sacred animal images excavated from the Kurozuka burial mound in Tenri [Fig. 10] gives rise to the possibility that these mirrors belonged to Queen Himiko. They may have been among the very items received from the king of Wei through her role in a tribute system focused on the Chinese Wei court, as described in the *Wei Zhi*. The Kurozuka burial mound is somewhat unusual for Japan. It is a large mound created by the piling up of earth and is based on continental prototypes. Some scholars label the site a burial hill (*funkyū*) to differentiate it from the typical keyhole-shaped mounds that were soon to become prevalent in Japan. Whatever it is called, these enormous predecessors to the Kofun-period tombs were clearly being built in

Japan by the end of Yayoi period (c. 250 CE). Multiple forms of continuity exist between the Yayoi and Kofun cultures, and this will certainly become clearer with future study.

The Kurozuka burial mound is located in the proximity of the Maki-muku site (Sakurai, Nara prefecture). Immediately south of Kurozuka is the less well-known, but equally important and recently much discussed, Hashihaka burial mound. The latter stretches 280 meters in length and at its widest point measures 160 meters in diameter. Dated to the second half of the third century, the enormous Hashihaka keyhole mound was originally thought to be the earliest example of a Kofun burial mound. However, a survey of objects excavated from Kurozuka and Hashihaka, including the triangular-rimmed mirrors mentioned above, together with scientific tests, reveals that the Hashihaka mound was created at least thirty to forty years earlier than previously thought. This new dating suggests that the mound's construction overlaps with the year 248 CE, when Queen Himiko is said to have died. One theory places Himiko as having ruled the Seto inland and Kinai areas which included the modern cities of Hiroshima, Okayama, Nara and Osaka, and thus she is thought to have controlled trade routes for imported resources, such as metal and mirrors, triumphing over the northern Kyushu rivals. The archaeologist Shiraishi Taichirō (b. 1938) believes it highly probable that Hashihaka is the burial site of Himiko. This suggests that Himiko might actually be the catalyst for the transition to the Kofun period, a theory that is plausible enough to silence the long-standing debate about where she actually ruled. Shiraishi's theory, however, is still not universally accepted in Japan.

If we follow conventional historical interpretations, the Kofun period is divided into four stages: Early, Middle, Late, and Final. In the Early Kofun, large keyhole mounds surrounded by moats were built, such as Emperor Sujin's mausoleum (240 meters in length), and large burial mounds started to appear in eastern Japan. The Middle period witnessed a range

Early Kofun	Second half of 3rd century–second half of 4th century
Middle Kofun	End of 4th century–5th century
Late Kofun	End of 5th century–end of 6th century
Final Kofun	End of 6th century–early 8th century

Table 2: Four stages of the Kofun period

of enormous burial mounds. The largest example is Emperor Nintoku's burial mound, which reaches 400 meters in length and whose size, at least in scale, surpasses that of the first emperor of China, Qin Shi Huangdi (d. 210 BCE). In addition, seven other burial mounds measuring 300 meters plus in length and thirty-five burial mounds of 200 meters help to define the Middle Kofun period as the peak of burial mound architecture in Japan. These large mounds formed a colony with medium-sized and smaller burial sites in their close vicinity, making the total count of burial mounds extremely high. In the Late Kofun, the construction of large-scale burial mounds decreased; round mounded tombs and rectangular mounded tombs became popular, except in the Kantō region (middle eastern part of Honshu) where impressive tomb mounds continued to be created. In addition, the Late Kofun witnessed the construction of stone burial chambers entered through a side passage resplendent with painted murals. At the end of the Kofun period, keyhole burial mounds went out of fashion and tombs were created with stone chambers that occasionally included painted images of the four sacred animals that protected and symbolized each of the four cardinal directions on the interior walls of the tomb, such as those seen at the Takamatsuzuka and Kitora sites.[8]

2. Gold and Gilt–Bronze Burial Goods and *Haniwa*

Many questions about this period and the contents of the tombs remain as yet unanswered, since most of the burial mounds have been looted and robbed of their contents. In addition, access to the interiors of certain tombs has been restricted by the Imperial Household Agency, as many of the large burial mounds are considered to be of Imperial lineage and thus under Imperial Household Agency control. Despite these challenges, a stunning collection of gold and gilt-bronze ornaments created to adorn the body have been excavated. Gold crowns, assorted ornaments, cut glass, and other extravagant and beautiful objects have been excavated from one of the burial mounds in the Niizawa Senzuka burial mounds colony in Kashihara, Nara prefecture (excavated over a five-year period starting in 1962). The objects were thought to have been imported by or for the entombed person, a man from the Korean peninsula in the second half of the fifth century. The excavation of the Fujinoki burial mound (second half of the sixth century) near Hōryu-ji temple in Nara (excavated 1985–88) brought to light an untouched inventory of gold and gilt-bronze crowns, gilt-bronze

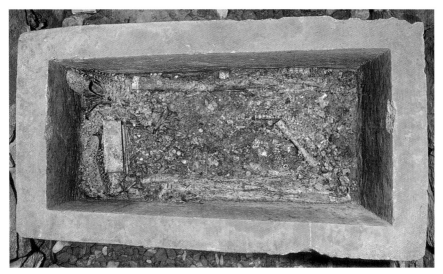

Fig. 11: Large red lacquer decorated sarcophagus (coffin interior after cleaning), second half of 6th century, Fujinoki burial mound, Ikaruga-chō, Nara prefecture

horse trappings, swords, and shoes placed in and around a large red lacquer decorated sarcophagus [Fig. 11]. Similarly, gold and gilt-bronze objects have been found in tombs built in various areas in Kumamoto prefecture, including the Eta Funayama burial mound. These magnificent gold and gilt-bronze burial accessories are similar to those found in the tomb of King Muryeong (462–523 CE) of Baekje, one of the Three Kingdoms of the Korean peninsula (18 BCE–660 CE), but are thought to have been produced in Japan. Such objects point to the close relationship of various parts of the Korean peninsula to sections of the Japanese archipelago at this period.

Techniques of goldsmithing, developed by the Lydians in western Asia Minor in the seventh century BCE and adapted by the Scythians, were brought along the Silk Road to China and then on to the Korean peninsula between the fifth and sixth centuries CE. Travelers to Japan brought these techniques with them, leaving a visible trail for us to follow in understanding how gold objects from the continent were copied in gilt-bronze to adorn members of the Yamato and Kyushu elites.

In contrast to the lavish contents discovered inside the tombs, on the exterior multiple earthenware *haniwa* (figures on cylindrical bases) stood watch. Kofun-period burial mounds were tiered and paved with small cobblestones. *Haniwa* figures were not buried but rather placed along

the flat edges of the various tiers. These terracotta figures on cylindrical bases were created to depict scenes from the life of the deceased and were used to appease the spirits of the people who had died.[9] As mentioned in the previous chapter, *haniwa* terracotta figures developed from the special pedestalled vessels made during the Yayoi period. At the beginning of the Kofun period, *haniwa* were basically cylindrical. Soon afterwards they developed more sophisticated forms, such as a morning glory shape with an open mouth, and others in the shapes of houses, vessels, and tools, representing a wide range of objects, including shields, quivers, umbrellas, and boats. Together with mirrors, bracelets, and other burial objects, the *haniwa* clearly possessed a shamanistic function. In the Middle Kofun, larger *haniwa* shaped like humans and animals began to emerge. Warriors, falconers, musicians, jesters, sumo wrestlers, maidens, dancers, and female attendants all add to the parade of faces that must have been visible from the top of these burial mounds [Figs. 12–14].

The archaeologist and art historian Aoyagi Masanori (b. 1944) describes the *haniwa* as hastily made "sketch-like" figures, the hollow cylindrical

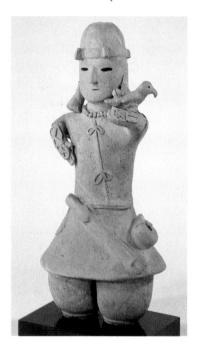

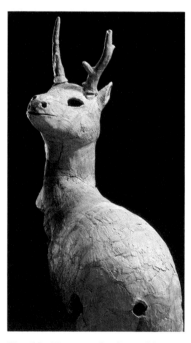

Fig. 12: *Haniwa* of a falconer, Late Kofun period, Sakai-chō, Isesaki, Gunma prefecture

Fig. 13: *Haniwa* of a deer, 6th century, Hiradokoro site, Shimane prefecture

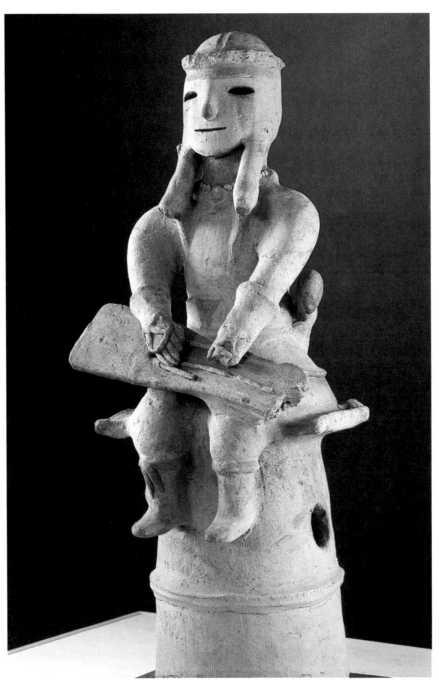

Fig. 14: *Haniwa* of a boy playing a zither, Late Kofun period, Asakura site, Gunma prefecture

haniwa lacking the realism and gravity seen in Qin and Han solid terracotta warriors. However, the faces of the *haniwa*, with their hollow eyes and open mouths, are charged with a naive but entirely human quality. They are replete with emotions similar to those seen in Hakuhō and Tenpyō period (645–794) sculptures made in the following century. The faces on the *haniwa* figurines both human and animal are charming and gentle. They are, however, in contrast to the supernatural power projecting from Jōmon figurines. Earlier vessels found in burial mounds were Haji earthenware derived from the Yayoi ceramic style, but from the fifth century new techniques and forms of the Korean Sue stoneware would dominate the ceramic assemblages [Fig. 15].[10]

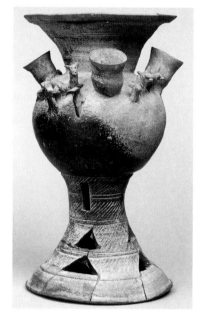

Fig. 15: Sue ware jar decorated with children, 6th century, Nishinomiya-yama burial mound, Hyogo prefecture

3. Decorated Burial Mounds

In the Middle Kofun, burial mounds often had a pit-type (vertical burial) chamber containing large chest-shaped sarcophagi. As well, a new type of tunnel tomb was introduced, which allowed for the site to be reopened for another burial. In the Late Kofun, murals were painted on the chamber walls of these side-entry tombs, particularly those made in the north and central areas of Kyushu.

Such decorative burial mounds started to appear in the fourth to the early fifth century, often with embellished lids and sarcophagi with images of mirrors, quivers, and other weaponry, as well as circular and "fractured spiral" (*chokkomon*) patterns in relief or incised lines that were believed to ward off evil spirits.[11] In the fifth century, stone slabs called *sekishō* were decorated; these were used to demarcate and house several bodies in the area below the main chamber of the side-entry burial mounds (where the main coffin is placed), such as the Segonkō burial mound in Kumamoto prefecture. By the sixth century, painted murals and incised line work

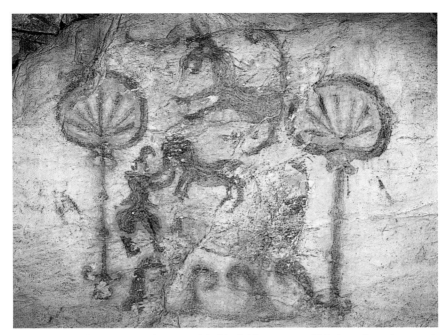

Fig. 16: Mural from a tomb, second half of 6th century, Takehara burial mound, Fukuoka prefecture

decorated and gave color to the main burial chamber and the entrance hall of the tombs. Surface decoration reached its zenith from the mid- to late sixth century, with excellent examples concentrated in the northern Kyushu area, including the Ōzuka, Chibusan, Mezurashizuka, and Takehara burial mounds [Fig. 16], and in Kantō-area tombs such as Torazuka in Ibaraki prefecture. By the seventh century, tombs were made by carving the structure directly into the hillside with murals painted on the chamber and exterior walls. Excellent examples of this type of tomb structure are the Nabeta tunnel tombs in Kumamoto prefecture, and Kiyotosaku tunnel tombs in Fukushima prefecture. Oddly though, mural-painted burial sites in the Kinki region do not appear until the early eighth century. One theory suggests that they were painted on material that might have acted as curtains and therefore have not survived.

The decorated burial mounds were popular both in Japan and in Goguryeo, Korea (37 BCE–668 CE), during the same period. It is known that there were connections between the two areas, and studies on the subject are currently being undertaken. However, the added complexity of the need to consider possible links with Chinese counterparts as well poses

future challenges for our understanding of this period's artistic heritage. What is clearly different between the murals created in Japan and those on the continent is the former's tendency to use far more abstract shapes and motifs, such as concentric circles, triangles, double opposing spirals, and *chokkomon* patterns. Portrayal of humans, animals, horses, quivers, and horse trappings are found in the Final Kofun, though mostly in abstract forms with no continuity in composition. This difference is obvious, especially when compared to Chinese murals of the same period. Stylistically, Goguryeo-period murals lie somewhere between China and Japan.

In a modern context, decorated burial mounds have current art historical value as verisimilitude is not a main criterion. The figures depicted near the head of the Chibusan burial mound coffin are strange, primitive, and alien-like; red, white, and blue are used to depict triangles, rhombuses, and circles that are freely formed and beautiful [Fig. 17]. The red gush of swirls spilling out from the shoulder of a hunter depicted in the Kiyotosaku tunnel tomb in Fukushima prefecture, the most northern of the existing burial mounds, leaves the viewer with the impression that the painter has trapped certain supernatural powers within this image. It is disappointing that most murals appear to have faded due to the pigments employed, which suffer discoloration following archaeological excavations. However, the will and the passion for adornment (*kazari*) reflected in these murals can still be felt even by contemporary viewers.

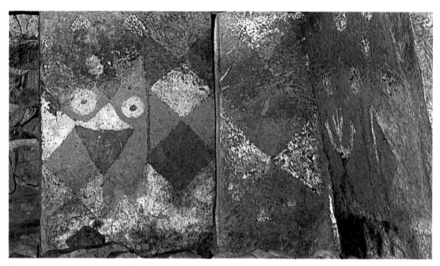

Fig. 17: Figures depicted near the head of the coffin, 6th century, Chibusan burial mound, Kumamoto prefecture

CHAPTER
3

Asuka and Hakuhō:
The Sphere of East Asian Buddhist Arts

Asuka and Hakuhō: The Sphere of East Asian Buddhist Arts

Prehistory, ancient, medieval, premodern, modern, and contemporary —these are familiar terms commonly used to distinguish historical periods. Japanese art historians tend to refer to specific periods, such as Asuka, Hakuhō, Tenpyō, Jōgan, and Azuchi-Momoyama, which have the power to conjure up rich imagery and resonances. If, for example, we were to lump the Jōmon, Yayoi, and Kofun periods into a single category such as "prehistory" or "ancient," it would leave important issues unaddressed, including where to draw the line between prehistoric, ancient, and other historical periods. In this book, we will continue to employ conventional Japanese terminology.

The period names and definitions of Asuka and Hakuhō are derived from art history. Generally, Asuka refers to the span of time between the introduction of Buddhism into Japan in 538 and the Taika Reforms of 645. Hakuhō refers to the subsequent period up until the relocation of the capital to Heijō-kyō (present-day Nara) in 710. Japan was inundated with multiple waves of highly refined culture arriving from the continent during these two periods. In terms of art history, newly introduced Buddhist art was to have a profound effect on artistic production. With the help of natural-ized continental craftsmen, Japanese artisans made great strides, eventually attaining continental standards. This development can be seen in the shift from the Asuka Buddhist sculptures produced by the Tori school with their archaic expressions, which retain a somewhat unnatural abstract quality, to the Hakuhō sculptures characterized by facial features that display an air of innocence and bodies whose contours are soft and curved.

1. The Introduction of Buddhism and Continental Art

The courtly arts of China and Korea had arrived in Japan during the Kofun period. Valuable objects such as mirrors, horse trappings, weaponry, armor, personal adornments, musical instruments, and the like were used as burial goods to embellish the graves of local kings, as ritual implements (which would be buried after a rite), or as diplomatic gifts between kings. These items were often imitated by local artisans.

The surviving objects do not tell us much about the concepts that were the basis for such funerals, where the spirit of the king would be mourned in a space opulently decorated in glittering gold and gilt-bronze. Though it is natural to presume that there was a syncretic fusion between the indigenous beliefs, which had existed since the Jōmon period, and the newly imported Daoism and shamanism, it appears that the symbolic representations in the arts of the continent were rather arbitrarily interpreted in Japan. By as early as the fifth century, Buddhist icons were already being added to the pre-existing fusion as a new variety of *kami* (spirits worshipped as local deities), as evidenced by discoveries of bronze mirrors with various sacred beasts and Buddhist icons in place of Daoist deities. An account in the medieval history *Fusō Ryakki* (Abbreviated Records of Japan, late twelfth century) also attests to the influence of the new religion: it tells how in 522, during the reign of Emperor Keitai, a Chinese immigrant artist named Shiba Tatsuto (C: Sima Dadeng) built a monk's hermitage and installed a Buddhist icon as the principal deity (*honzon*). Toward the second half of the Kofun period, in 538 (some argue 552), King Seong-Myeong of Baekje presented to Emperor Kinmei Buddhist statues and sutras, signifying the first public introduction of Buddhist sculpture recorded in Japan.

2. Buddhist Art as Sacred Ornament

The majority of the art objects that filtered into Japan during this period, whether directly from China or via the Korean peninsula, were examples of Buddhist art, which had developed and was supported by the courts of continental rulers. What then is Buddhist art, you may ask? In one word, it is the art of sacred ornament, *shōgon*.

In Sanskrit, it is called *alaṃkāra*, the act of "adorning beautifully." According to the scriptures, the world of the Buddha is one of sacred ornament. In this realm, the body of the Buddha is believed to produce a golden glow. The clothes and accessories of a buddha (Sk: *tathāgata*, J: *nyorai*), bodhisattva (J: *bosatsu*), or heavenly being (Sk: *deva*, J: *ten*), as well as the palaces, gardens, ponds, flowers, and trees, and even the ground they tread upon are all lavishly adorned with gold, silver, and colorful precious gems in multiple varieties. In order to create this wondrous imagery for our eyes, the concept of *kazari* (adornment), a synthesis of the arts—architecture, sculpture, painting, or other artistic modes—all in complete harmony, was required. Like the dazzling world seen through a kaleidoscope, this was the

true nature of Buddhist art. However, even if all the decoration and all the gilding that covered Buddhist sculptures were stripped away and the colors of the canopies, ceilings, and columns were removed, the forms of the sculptures themselves would remain.

The study of Japanese sculpture has advanced significantly to this point through the application of Western art historical methodology. Detailed analysis of the form and style of Buddhist statues as sculpture has helped to determine their dating and other aspects. We now need a reconstruction of the earliest examples of Buddhist art and a comprehensive overview of these works as the art of sacred ornament. The Buddhist statues discussed in the following section formed the core of this early Buddhist art.

3. The Dissemination of Buddhist Temples and Sculpture

The great wave of Buddhist art that swept across and transformed the cultures and art of all of East Asia originated in India. In the fourth century BCE (some say the fifth century BCE), after the death of the historical Buddha, Sakyamuni (J: Shakamuni, often abbreviated Shaka in Japan), Buddhist art proliferated primarily through the construction of stupas (the original form of the pagoda), which held the relics of the Buddha (*busshari*).

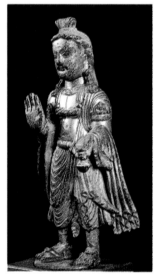

Sculptures of the Buddha and other Buddhist deities (*butsuzō*) were not created right away. However, from the first half of the first century CE through the mid-third century, images of Buddhist deities began to be produced in the Gandhara and Mathura regions during the Kushan empire. In the mid-fifth century, Buddhist sculptures in the classical style, with the folds of the robes expressed in beautiful ripple-like contour lines, evolved in the Mathura region during the Gupta period. These sculptures were brought to China either overland via the western routes along the Silk Road or directly by sea.

The history of Buddhist temples and sculptures in China began with the building of Baima Si, the White Horse temple (Luoyang, Henan province), in the first century CE

Fig. 1: Standing Bodhisattva, 3rd–4th century, China, Fujii Saiseikai Yūrinkan, Kyoto

during the Eastern Han period. Temples were called "Buddha shrines" (C: *futuci*), and sculptures were known as "golden people" (C: *jiuren*). The sculpture of a standing Bodhisattva [Fig.1] (third to fourth century) is in the Gandharan style, while the sixth-century standing figure of a Buddha [Fig. 2] is in the Gupta-period Mathura style.

Court-sponsored construction of large-scale grotto temples took place from the third to the sixth centuries during the Six Dynasties period. An assemblage of sculptures dating from the Western Qin (fifth century) to the Tang period can be seen at Binglin Si, a temple in Gansu province. During the Northern Wei, spectacular grotto temples were constructed at several locations, such as the Mogao caves at Dunhuang, Maijishan, and Yungang, before the capital was moved from Datong to Luoyang in 494. More grotto temples were then built at Longmen and Gongxian. Even after the split of Northern Wei into Eastern and Western Wei in 534, the building of cave-temples continued with the same energy. The Tianlongshan grotto built by the Eastern Wei and the Xiangtangshan cave-temple built by the Northern Qi, who had defeated the Eastern Wei, both show forms that anticipate Tang sculpture. Buddhist art in China grew to equal that of India in scale and richness with the successive building projects of these grotto temples and of many wooden temples, such as the Longxing Si in Shandong province and the Wanfo Si (Ten Thousand Buddha Temple) in Sichuan province, which no longer survive.

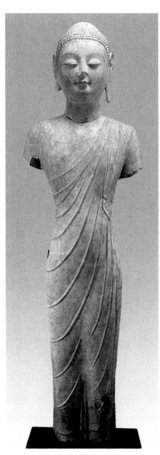

Fig. 2: Standing Buddha, Longxing Si Relic Site, 6th century, China, Qingzhou Municipal Museum, Shandong province

In the first half of the sixth century, during the years spanning the late Northern Wei to Eastern and Western Wei, Buddhism spread to the Korean peninsula, which was ruled by the Three Kingdoms of Silla, Baekje, and Goguryeo. Silla officially accepted Buddhism as the state religion in 528, but Buddhist temples, icons, and monks

had probably already become familiar features in the Three Kingdoms prior to that time. Buddhism spread to Japan just shortly thereafter.

The Buddhist statue sent from Baekje is thought to have been a gilt-bronze gleaming image of a Buddha. In the official history known as *Nihon Shoki* (*Chronicles of Japan*, 720 CE), Emperor Kinmei described the gift: "The face of the Buddha is dazzling but elegant. Nothing like it has ever been seen before" and asked, "Should we revere it, or not?" Despite opposition by the Mononobe clan, the influential Soga clan pressed for the official acceptance of the Buddha and Buddhism. However, the icon was recognized simply as a *busshin*, a term for just another unspecified deity, or *kami*.

4. The Construction of Asuka-dera and Hōryū-ji Temples

In 588, six monks, two temple architects, a master of metalwork and casting, four roof tile specialists, and one painter were dispatched from Baekje to construct the first Buddhist temple in Japan. In 609, the "eye-opening" ceremony (*kaigen kuyō*) to dedicate the main Buddhist image at Asuka-dera temple (Nara prefecture) was held. The monk Hyeja (J: Eji) from Goguryeo, who was already living in Japan, participated in the ceremony. The temple complex of Asuka-dera was not constructed in the familiar style of Shitennō-ji temple (Osaka) [Fig. 3, center], derived from Baekje,

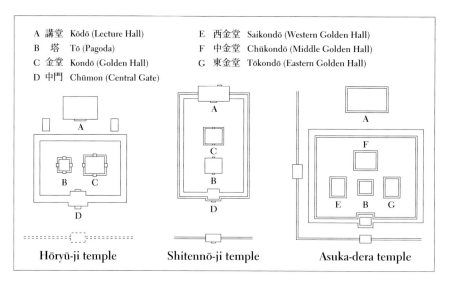

Fig. 3: Temple plans for Hōryū-ji (left), Shitennō-ji (center), and Asuka-dera (right), Nara

in which the pagoda and the Kondō (literally, golden hall, usually indicating the main hall of a temple) were aligned along the same axis. Rather the temple was designed in the Goguryeo style, where three golden halls surround the pagoda [Fig. 3, right], although individual elements, like the roof tiles, were in the Baekje style.[1] The central deity, Shaka Nyorai, often referred to as the Great Buddha of Asuka [Fig. 4], was severely damaged by fire in 1196, but some parts of the original face and the fingers remain intact. The large eyes, described as being shaped like apricot kernels, are characteristic of the Tori school of Buddhist sculptors. The sculptor

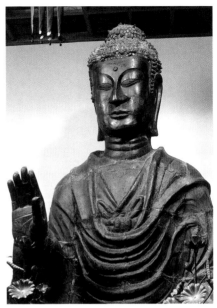

Fig. 4: Great Buddha of Asuka, 609 CE, Asuka-dera (Ango-in), Nara prefecture

Kuratsukuri no Tori, or Tori Busshi (dates unknown), is said to have been the grandson of Shiba Tatsuto who came from the continent. He is considered the founder of the Tori school, is said to have been the grandson of Shiba Tatsuto, who came from the continent and was responsible for the sculpting of the Sakyamuni Triad (Shaka Sanzon) at Hōryū-ji temple (Nara prefecture), which is discussed later in this chapter. His name appears in the *Nihon Shoki* as the sculptor of the Great Buddha at Asuka-dera.

Renowned as the oldest wooden building in the world, Hōryū-ji was built in 607 according to the inscription left on the seated statue of Yakushi Nyorai (Sk: Bhaiṣajyaguru, known as the Medicine Buddha) placed in the Kondō. The *Nihon Shoki* records that the temple was subsequently destroyed by fire in 670, and this was confirmed by an archaeological excavation in 1939 that revealed traces of a fire-ravaged temple in an area that had long been called the Wakakusa precincts. The attempt to faithfully reconstruct the original temple began with the rebuilding of the Kondō after the fire. Many dates, ranging from the 670s or 690s, have been posited for the reconstruction work on this structure. This project was followed by the reconstruction of the pagoda, which housed diorama-like tableaux of clay statues that date to 711. Hōryū-ji retains the Chinese wood-temple

building styles of the Six Dynasties period, which can also be seen in the reliefs of the Yungang grotto temple complex, but it also incorporated the newer architectural styles of the Sui and Tang periods.

5. Large-Scale Civil Engineering and Stonework

As mentioned in Chapter 1, wooden structures had been built on a surprisingly large scale during Jōmon times (13,500–9,300 BCE), the raised-floor palaces of Yayoi (300 BCE–300 CE) were an extension of that trend. Emperor Nintoku's mausoleum, built during the Kofun period (second half of third–early eighth century), would have required time and labor equal to that necessary to complete one of the great Egyptian pyramids.

The existing main building of the Izumo grand shrine (Izumo-taisha) was built in 1744. It measures 24 meters in height, but according to legend, the original building was twice as tall, towering overhead at approximately 50 meters. Based on old diagrams belonging to the family of the chief Shinto priest of Izumo grand shrine, architectural historian Fukuyama Toshio (1905–1995) made a hypothetical reconstruction in keeping with the description, resulting in a structure with inclining steps that measured over 100 meters in length leading to a high-rise shrine building [Fig. 5]. The result was so outrageous that some academics were dubious of his claim; however, in 2000, the discovery in the shrine compound of giant pillars, created by binding together three tree trunks, each a meter in diameter, made Fukuyama's theory all the more plausible. Although these pillars have been dated to the early Kamakura period (1192–1333), the first shrine built on the site may date as early as the Asuka or Hakuhō period. The

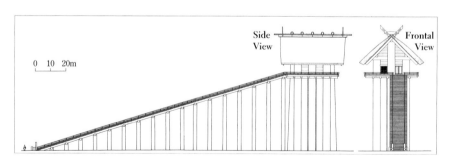

Fig. 5: Fukuyama Toshio's reconstruction of the main hall of the Izumo grand shrine, from *Yomigaeru kodai daikensetu jidai* (Reconstructing Great Ancient Architecture; Tokyo: Tōkyō Shoseki, 2002).

structure is mentioned in an ancient lesson book for children *Kuchizusami* (Verbal Amusements, 970), where it is described as the tallest in Japan, surpassing the Great Buddha Hall of Tōdai-ji temple.

The *Nihon Shoki* records large-scale civil engineering projects that took place in Asuka from 655 to 661 (during the reign of Empress Saimei).[2] Archaeological excavations have since revealed evidence of several stone structures. From the center of the stone-paved square at the Sakafuneishi site (Nara prefecture), a number of facilities for ritual performances have been found, such as a turtle-shaped stone cistern, another oval-shaped stone cistern, and a flowing fountain. Other major finds include a large garden pond from the capital, the Asuka-kyō site, and a water clock from the Ishigami site. In the vicinity of the water clock, simple and humorous sculptures of guardian deities for travelers (*dōsojin*) and a stone representing Mount Sumeru were unearthed. Such ponds and water fountains were familiar features of Korean court palaces during the Three Kingdoms period, such as at the Anapji site in Gyeongju. These also indicate the increasing presence of Daoist thought alongside Buddhism in the Asuka court. The experience and knowledge gained by large-scale civil engineering projects undertaken periodically since the Jōmon period led to the development of the skills needed to build grand temples such as Asuka-dera, Hōryū-ji, and Kudara Ōdera.

6. After the Great Buddha of Asuka

Following the Great Buddha of Asuka in the early seventh century, the production of Buddhist sculptures continued to be led primarily by Tori school artisans. Evidence is found in many of the sculptures at Hōryū-ji, which were produced at the time of the temple's founding.

According to the inscription on the mandorla (*kōhai*) for Sakyamuni, the historical Buddha in the Sakyamuni Triad in the Kondō [Fig. 6], work on the statue was begun in 622 with prayers for the recovery of the health of Prince Shōtoku (574–622) and his wife, but the statue was not finished until a year after the prince's death. Attributed to Tori Busshi, the triad depicts a seated Sakyamuni with a large lotus-petal-shaped mandorla at his back. The mandorla extends to the two standing attendants that flank Sakyamuni in a style known as "one mandorla for three deities." The central icon is seated on a two-tiered square pedestal over which his robe drapes symmetrically. The oval face is described as featuring eyes shaped like apricot kernels and

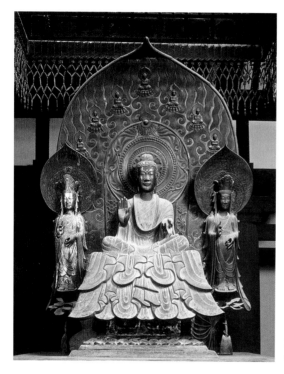

Fig. 6: Sakyamuni Triad, 623
CE, Hōryū-ji, Nara prefecture

lips that resemble the crescent moon. In seeking precedents, it has been pointed out that similarities can be found with the seated Buddha in the Pingyang cave at Yungang and the seated Buddha in the Guyang cave at the Longmen grottos from Northern Wei times, which have the same *mokakeza* style in which the robe drapes over the pedestal. However, the depiction of the mouth that is often described as having an archaic smile and the articulation of the eyes invite comparison to the sixth-century standing Buddha sculpture excavated from Longxing Si temple in Shandong province [Fig. 2].

Both these statues face straight forward and exhibit a rather antiquated style, however, the Hōryū-ji icon faces even more rigidly forward, and the entire form, including the abstract patterns of the robe, suggests a relief-like, naive simplicity. Nevertheless, the stable, well-proportioned structure is governed by a strict regularity and orderliness that symbolizes Prince Shōtoku's faith.

The Sakyamuni Triad preserved in the Great Treasure Gallery (Dai-hōzōden) at Hōryū-ji [Fig. 7], which lacks the right flanking attendant, was commissioned for Soga no Otodo in 628, according to an inscription on

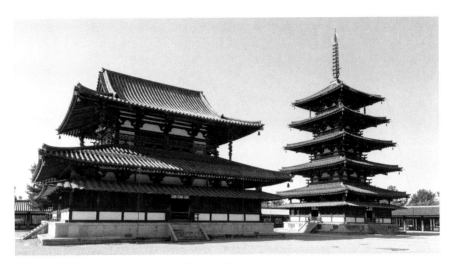

Fig. 7: Hōryū-ji temple complex, Nara prefecture

the mandorla. Compared to the triad housed in the Kondō, the modeling of the body and the robes are more relaxed, although it is most likely made by the same Tori school craftsmen.

7. The Awesome Power of Guze Kannon

The standing Kannon Bosatsu, known as Guze Kannon (World-Saving Avalokitesvara) [Figs. 8 and 9], is the most problematic work of art among all Asuka Buddhist images. Carved from a single camphor (*kusu*) tree, the gold-leafed statue standing 180 centimeters high, which holds a precious jewel, is dated to the first half of the seventh century. Concealed as a "secret Buddha" (*hibutsu*) for many centuries until unveiled by Ernest Fenollosa (1853–1908) in 1884, the statue has been preserved in pristine condition; especially striking are its exquisite mandorla patterned with flames and arabesques, and the arabesque and openwork jeweled crown.

The *Ledger of the Assets of the Tō-in at Hōryū-ji Temple* (761) records that the statue was a life-sized gold-leafed wooden Kannon Bosatsu identical to Prince Shōtoku. Furthermore, as it is said to have been the personal possession of Prince Shōtoku, presumably it had a direct relation to the prince himself.

In 1972 Umehara Takeshi (b. 1925) published a book advancing a bold theory.[3] He argues that the murder of Prince Shōtoku's son, Yamashiro no Ōenomiko, by Soga no Iruka, was actually masterminded by Fujiwara no

Kamatari, who had instructed Iruka. Umehara quotes the words of the late poet and sculptor Takamura Kōtarō (1883–1956) and attempts to read into the true meaning of the statue.[4]

Unlike other images of Buddhist deities, this statue has the feel of life and exudes the mysterious atmosphere of an incarnate being of some sort. The face has an enigmatic and almost monstrous intensity, and the interlocked hands are filled with such exquisite sensitivity that one can almost feel them quiver. . . . The overall style of this Buddhist icon is, as many have said, a faithful recreation of the Northern Wei style, and whether one looks at the balanced proportions, the folds of the robe, or the symmetry, all these are in an abstract form that follows the orthodox type, however, its head is entirely out of place. When it comes to the face, there is no trace of a link to the Gandharan style; we simply find here an archaic and naive human. The sculpture combines this primitive realism with the continental style.[5]

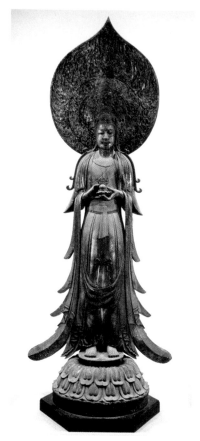

Fig. 8: Guze Kannon, first half of 7th century, Hōryū-ji, Nara prefecture

Umehara sums up Takamura Kōtarō's statement as "a real human head mounted on an abstract torso in the Northern Wei style." Umehara's opinion, backed up by Takamura's intuitive characterization, is compelling in regard to a sculpture surely made to appease the spirit of Prince Shōtoku. Renowned photographer Domon Ken (1909–1990) likewise captured the eerie feeling that he sensed by lighting the face from below [Fig. 9].

One can hardly deny the mysterious, enigmatic air evoked by Guze Kannon. The same characteristics are not found in the images from the

aforementioned Longxing Si temple. Examples from Korea might be linked to the unusual fin-like depiction of Kannon's robe. However, no similarities in the facial features can be traced to icons from the peninsula. If forced to find a related representation, only the mid-Jōmon *dogū* figurines come to mind (see Chapter 1). One cannot help but wonder whether the Tori school creator, whose ancestors emigrated from the continent, shared the shamanistic blood of the Jōmon people.

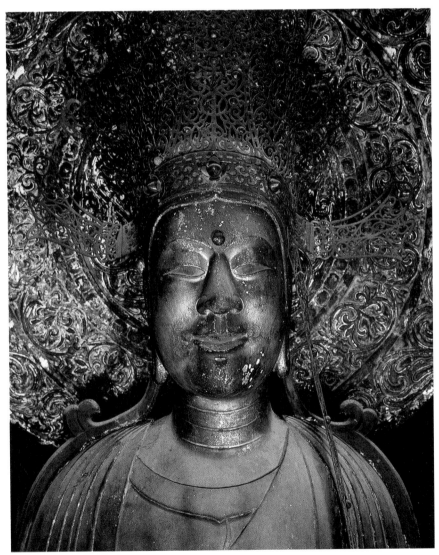

Fig. 9: Detail of Guze Kannon (Fig. 8). Photo: Domon Ken

8. Kudara Kannon and Other Buddhist Images

The standing Kannon known as Kudara Kannon, in the Great Treasure Gallery at Hōryū-ji, is another masterpiece of Asuka-period Buddhist sculpture [Fig. 10]. Also made of camphor wood, the small Buddha on the jeweled crown discovered in the Meiji era reveals that the 211-centimeter-tall sculpture is an image of Kannon. Unlike the Guze Kannon, the small face, thin arms, delicate fingers, and softly depicted ornamental scarf create graceful rhythms. The movement of the cylindrical body twisted ever so slightly is reminiscent of a quietly flickering flame. It has also been suggested that this sculpture displays characteristics of Southern Dynasties style, and when seeking precedents, the relationship between Eastern and Western Wei and the Southern Dynasties styles, which can be seen in examples from Maijishan and the Gongxian grotto, must be considered. When viewed in the context of other East Asian Buddhist sculptures from the late seventh century, these two Asuka-period Buddhist images display unique characteristics in both visual form and as expressions of religious sensibility.

On the back of the mandorla of Tamonten (Sk. Vaisravaṇa), one of the statues of the Four Guardian Kings (Shitennō) in the Kondō of Hōryū-ji, is an inscription with the name Yamaguchi no Ōguchi no Atai (dates unknown). According to the *Nihon Shoki*, this sculptor carved a thousand Buddhist images in the year 650 alone. The Four Guardian Kings are surely the product of approximately the same time. The motive behind the creation was to make

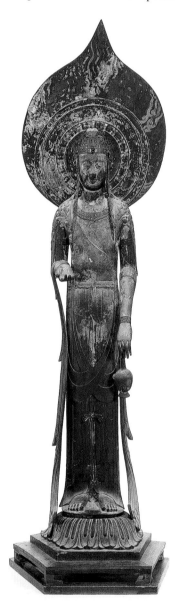

Fig. 10: Kudara Kannon, mid-7th century, Hōryū-ji, Nara prefecture

these guardians, who were responsible for protecting the realm of Mount Sumeru, also protectors of the realm of Japan. Like Kudara Kannon, they display traces of stylistic influence from the late Northern and Southern Dynasties period of China. But the rigid quality of their stout, blocky bodies seems to betray the original shape of the medium from which they were carved; this quality, together with the unusual physiognomy of the demons on which they stand, reveals their archaic character [Fig. 11].

Hōkan Miroku at Kōryū-ji temple (Kyoto) [Fig. 12] represents a pensive form of the bodhisattva Maitreya (Miroku, also known as the Buddha of the Future), seated in a half-lotus position; it is also called Jewel Crowned Miroku owing to its headgear. Since there are no other Japanese statues made from red pine, this statue may have been made in Silla and sent to Japan in 623. However, in 1968, an analysis revealed that wood from a camphor tree (*kusu*) was used in constructing the back of the statue and in

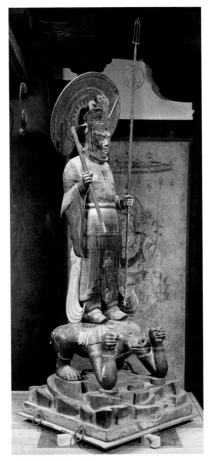

Fig. 11: Jikokuten (Dhṛtaraṣṭra), one of the Four Guardian Kings, mid-7th century, Hōryū-ji, Nara prefecture

a few other details. These suggest that the statue could have been created in Japan. Though the origin of the work is still being discussed, the existence of a similar seated Maitreya (K: Mireuk) in the National Museum of Korea invites reflection on the work's position within the larger sphere of East Asian Buddhist Art. The coating of lacquer mixed with wood powder or pieces of fiber (*kokuso urushi*) has since peeled away, and the statue is in a fragile state. However, if restored, its features would more closely resemble those of the Korean statue. Even in its current state, the expression of the meditating Miroku overflows with compassion, and a delicate sensibility resides in the elegantly posed fingers.

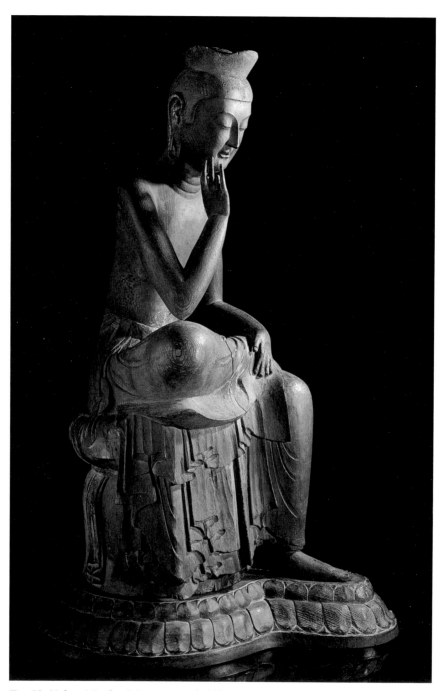

Fig. 12: Hōkan Miroku (Maitreya in a half-lotus position), 7th century, Kōryū-ji, Kyoto

9. The World of Hakuhō Sculpture

The Hakuhō period, as noted earlier in this chapter, stretches from the Taika Reforms in 645, when there was a move toward a more centralized state based on legal and criminal codes (*ritsuryō*) modeled on Chinese law, to the relocation of the capital to Heijō-kyō (Nara) in 710. The term Hakuhō was originally used in the field of art history, but it has become a standard term for cultural historians as well. The precise dates that mark the beginning and end of the Hakuhō period have been extensively debated by art historians.[6] This book uses the conventional dates employed by cultural historians: 645 to 710.

Literally meaning "white phoenix," Hakuhō has a wonderful resonance that underscores the magnificent Buddhist sculptures made during the period. The Head of the Buddha at Kōfuku-ji temple in Nara aptly represents the artistic strength of this period [Fig. 13]. The head is from the main deity once enshrined in the lecture hall of Yamada-dera temple (Nara prefecture), which was built as a memorial to the vanquished Soga no Kurayamada Ishimaro (d. 649). The casting of the statue took seven years, from 678 to 685. Centuries later, during the Kamakura period, warrior monks of Kōfuku-ji raided Yamada-dera and made off with the sculpture in question, which they installed as the central deity in the Tōkondō, or Eastern Golden Hall. The hall at Kōfuku-ji was subsequently destroyed by fire in 1411, and it was thought that flames had consumed its contents as well. However, in 1937 the head was miraculously rediscovered inside the pedestal of the current main deity. The fire had indeed damaged the bronze sculpture: the left half of the face is distorted and the left ear is missing, but the right half of the face is still intact. The word "serene"

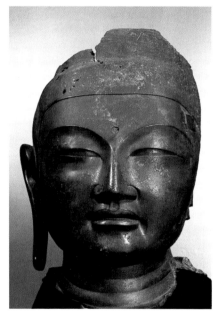

Fig. 13: Head of the Buddha, 685 CE, formerly in the Tōkondō, Kōfuku-ji, Nara

captures its expression perfectly. The prominent facial features of a young man convey the fresh passion of the budding leaders who aimed to build a new state governed by fixed principles and laws.

A new style was characteristic of this period, described as "youthful face and youthful form": deities were portrayed with childlike features, such as preadolescent physiques and innocent faces, with wider space between brows and eyes. Representative of the type is the Six Standing Kannon Bosatsu in the Great Treasure Gallery of Hōryū-ji, as well as the heavenly musicians embellishing the canopy over the Sakyamuni Triad in the Kondō, and the standing Bodhisattva (Sk: Āryāvalokiteśvara) in Kinryū-ji temple (Nara) [Fig. 14]. They are thought to have been made by craftsmen who worked together to rebuild the fire-damaged temple complex.

Compared to those prepubescent images, the Head of a Buddha at Kōfuku-ji maintains the air of a more mature young man. However, in terms of youthful freshness, it shares a strong resemblance to other examples of this period. Shō Kannon Bosatsu (Sk: Āryāvalokiteśvara) of Kakurin-ji temple (Hyogo prefecture), exuding a virginal innocence, and the Sakyamuni at Jindai-ji temple (Tokyo) both belong to the same category of youthful images. The standing Kannon Bosatsu in the Great Treasure Gallery of Hōryū-ji, worshipped as Yumechigai Kannon (Dream-Altering Avalokitesvara) because it is believed to turn unpleasant dreams into delightful ones, also expresses the appeal of the Hakuhō style [Fig. 15].

The style of Hakuhō bronzes, with their elegant contours and crescent-shaped patterns in the folds of their robes, can be linked to Gupta Buddhist art, with which the previously mentioned sculptures from Longmen grottos also share roots.[7] The Chinese adopted the voluptuous physicality of Gupta sculptures during the late Northern and Southern Dynasties period, and these were precursors of the new styles that developed during the Sui and Tang periods. The childlike appearance seen in Hakuhō sculpture is also present in Chinese and Korean Buddhist works of the same period.

It is nevertheless unclear why the people of the Hakuhō period were so enamored of portraying childlike features in Buddhist sculpture. One suspects that it is related to traditional festivals, such as the Gion festival in Kyoto, in which children are considered to be messengers of, or vessels for, the *kami* (deities or spirits). Or, as the historian of Buddhist sculpture Mōri Hisashi (1916–1987) has pointed out, it may be linked to aesthetic preferences for youthful faces seen in the "pure, innocent" expressions of some *haniwa* figurines (see Chapter 2).

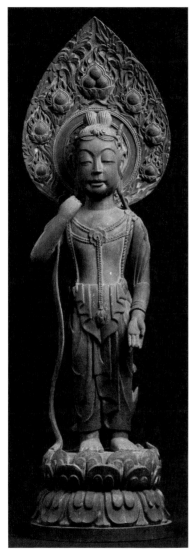 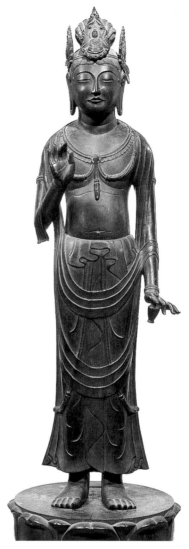

Fig. 14: Standing Bodhisattva, 7th century, Kinryū-ji, Nara prefecture

Fig. 15: Standing Kannon Bosatsu, late 7th to early 8th century, Hōryū-ji, Nara prefecture

A cabinet-like shrine (*zushi*) found in the Great Treasure Gallery of Hōryū-ji is thought to have been a private devotional shrine of Lady Tachibana. It measures 269 centimeters in height, making it as tall as the more famous Tamamushi Shrine (described below). Lady Tachibana was Empress Kōmyō's mother; her votive shrine and the bronze Amitabha

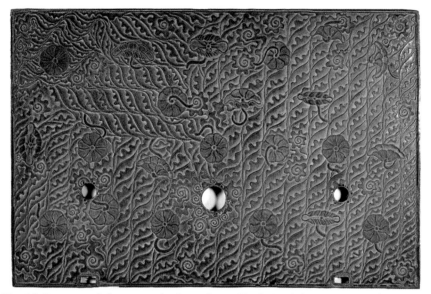

Fig. 16: Lotus-pond design on the base plate of Lady Tachibana's private devotional shrine, late 7th to early 8th century, Hōryū-ji, Nara prefecture

(Amida) Triad housed within the shrine are considered classic examples of Hakuhō-style beauty. On the screen behind the triad is a magnificent relief depicting rebirth on a lotus flower in paradise. The image is that of rebirth in the Pure Land, which captivated the hearts of courtiers of the period. Below the feet of the triad is an exquisite design of ripples on a lotus pond [Fig. 16]. On the white-painted dais of the shrine are paintings of bodhisattvas and monks.

The Bodhisattva seated in half-lotus at Chūgū-ji temple (Nara prefecture) is also a well-known wood sculpture. Similar to the Jewel Crowned Miroku at Kōryū-ji, its lineage can be traced to Asuka sculptures, although the body, face, and robe have an enhanced naturalness and softness, marking it as a splendid example of wooden Buddhist sculpture from the last years of the Asuka-Hakuhō period.

10. The Arrival of Sculpture in Clay

In the mid-seventh century, innovative techniques and materials such as dry-lacquer (*kanshitsu*) and clay-modeling compound (*so*) were introduced to create new types of sculptures.[8] Although it no longer exists, records

show that the nearly 5-meter-tall (*jōroku-sized*) Sakyamuni statue (668) at Daian-ji temple in Nara was the first statue made using the dry-lacquer technique (*kanshitsuzō*).⁹ The seated Miroku (from the latter half of the seventh century) in the Kondō of Taima-dera temple (Nara prefecture) is the earliest extant large-scale statue made from clay modeling compound (*sozō*). Its characteristic squat, neckless, "block-style" body has been compared to Sui-influenced Silla sculptures from the Korean peninsula (for example, the Amitabha Triad in Kunwi grotto). The Four Guardian Kings, also at Taima-dera, were made using the technique known as "hollow dry lacquer" (*datsu kanshitsu*) in which lacquer-soaked linen was applied to a figure made of clay or earth. Later, the interior material would be removed and replaced by a wooden core, which was used to prevent distortion caused by the shrinking of the dry lacquer. These works have an exotic, foreign look, which was influenced by Tang styles. Dry-lacquered and clay statues became even more fashionable in the ensuing Nara period (710–94).

11. Paintings and Decorative Arts of the Asuka and Hakuhō

Official histories like the *Nihon Shoki* mention painters dispatched from Baekje in 588 for the building of Asuka-dera. They describe how in 610, the Goguryeo monk Damjing arrived, bringing paper, ink, and pigments. And in 604, the records show, clan designations were awarded to four groups of painters, including painters of the Kibumi and the Yamashiro. Such accounts indicate that personnel, materials, and institutions involved in the production of paintings had been organized in Japan with the support of Korean courts. From the Asuka and Hakuhō periods and on through the following Tenpyō period (or Nara period), active production of Buddhist-themed paintings continued. Paralleling this was a bustling manufacture of Buddhist-themed embroidered textiles. In creating large-scale images to be hung on walls, the artisans who produced them may have felt that embroidered textiles were a more appropriate medium for preservation and thus superior to painted images.

The *Tenjukoku Paradise Embroidery* at Chūgū-ji is an embroidered curtain depicting a Buddhist paradise. It was commissioned by Tachibana no Ōiratsume to insure the well-being in the next life of Prince Shōtoku, her husband who had died in 622 [Figs. 17 and 18]. Six fragments survive from an embroidered curtain that depicted the prince's rebirth in a

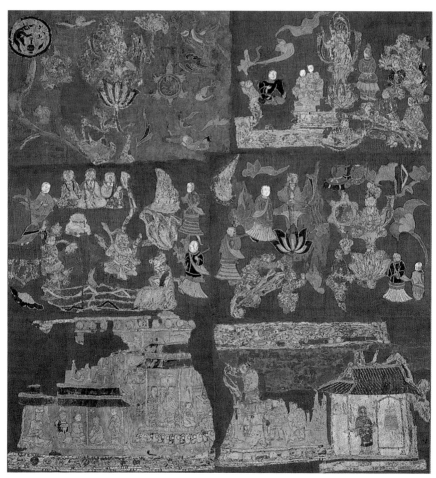

Fig. 17: Tenjukoku Paradise Embroidery, 622 CE, Chūgū-ji, Nara prefecture

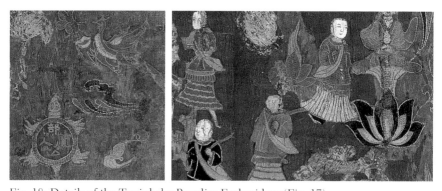

Fig. 18: Details of the Tenjukoku Paradise Embroidery (Fig. 17)

Buddhist paradise based on an underdrawing by a foreign-born painter (who may have been from either China or the Korean peninsula). The two sets of four characters inscribed on the shells of two tortoises on the curtain, however, from an early biography of Prince Shōtoku (*Jōgū Shōtoku Hōō Teisetsu*, eighth to early tenth century, completed before mid-eleventh century), record that there were 400 characters all together. Accordingly, there would have been 100 tortoises on the original tapestry, and the image must have been exceedingly large. Many of the extant sections are products of repairs done in 1275, but the most worn and abraded areas are those caused instead by restorations conducted in later periods.

Thought to be from the mid-seventh century, the Tamamushi Shrine mentioned above in the Great Treasure Gallery of Hōryū-ji rests atop a dais, and together they measure 227 centimeters in height [Fig. 19]. Iridescent wings of the jewel beetle (*tamamushi*) are layered beneath its openwork metal fittings, giving the shrine its name. On the door panels of the shrine itself are images of the Two Guardian Kings, Tamonten and Jikokuten, and four bodhisattvas. At the back is a scene of Sakyamuni delivering a sermon on Mt. Grdhrakuta. On the back of the door panels and facing the interior is a bronze plate with an image of a thousand seated Buddhist deities hammered out in relief, using the repoussé technique. The currently enshrined statue of a standing bodhisattva is not an original feature. Instead, the previous occupant was Sakyamuni, the historical Buddha. On the front and back panels of the dais are images of a Buddha relics memorial service (*shari kuyō*) and Mount Sumeru, while the side walls depict scenes from *Jataka Tales* that tell of the good deeds that Sakyamuni performed in his previous lives, such as throwing himself into a ravine to relieve

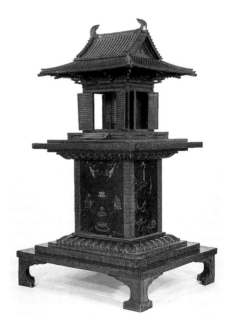

Fig. 19: Tamamushi Shrine, mid-7th century, Hōryū-ji, Nara

the hunger of young tiger cubs and sacrificing himself in order for a demon to hear a verse explicating Buddhist teaching and attain enlightenment [Fig. 20]. A technique called "different times in one image" (*iji dōzu*) is used in these two scenes.[10] The painting technique employed on the shrine is referred to as *mitsuda-e*, in which both oil-based paint and lacquer are used. The appearance of the shrine has deteriorated with age and is now completely dark gray in color; however, when originally produced, it would have been dazzling, with rich vermilion, yellow, and blue-green coloring, in addition to black, as well as shimmering gold metalwork along with the iridescence of the beetle wings. Together these embodied the concept of *kazari* (adornment), and would have had much the same effect as that of Lady Tachibana's devotional shrine.

Fig. 20: Detail of the *Jataka Tales* painted on the side panels of the Tamamushi Shrine

The sensational discovery of the Takamatsuzuka burial mound murals in 1972 [Fig. 21] and those in the Kitora tombs in 1992 revealed that new mural styles developed in the Asuka region in the last stages of the tomb period. The cut-stone slabs that line the walls (113 centimeters high) of the circular stone chamber of the tomb were plastered. Images were painted while they were semi-dry, in a method similar to that used in frescos. Each of the four cardinal gods, the Blue Dragon (Seiryū) of the East, White Tiger (Byakko) of the West, Vermilion Bird (Suzaku) of the South, and Black Turtle-Snake (Genbu) of the North, was painted in the center of one of the four walls. These were flanked by groups of men and women, while the sun and moon and the constellations were depicted on the ceiling.

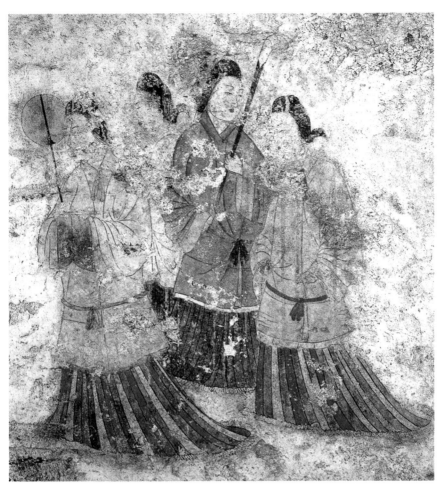

Fig. 21: Mural painting of female attendants, Takamatsuzuka burial mound, late 7th to early 8th century, Asuka, Nara prefecture, Ministry of Education, Culture, Sports, Science and Technology, Japan.

The current consensus is that the Takamatsuzuka murals were created in the late seventh to early eighth centuries, during the late Hakuhō period. This dating is based on research into early Tang murals, such as those found in the tomb of Princess Yongtai (706), and depicted costumes as well as a comparison with the murals on the Kondō at Hōryū-ji. The masterful lines that depict the elegant figures of men and women demonstrate the superior technique commanded by painters of the period, who appear in the historical record under such vague designations as "painter of the Kibumi."

These images are valuable clues for understanding the nature of Hakuhō paintings, of which very few remain. Unfortunately, after the excavation, the effects of the extremely humid environment have made it difficult to preserve the murals in the Takamatsuzuka and Kitora tombs.

The murals in the Kondō of Hōryū-ji are considered to be the oldest works that can be called true paintings in Japan, but with the exception of twenty images of flying celestials from the ceiling of the inner sanctum, all were destroyed by fire in 1949. The murals had originally adorned the interior walls of the Dharma Hall, which was rebuilt in the second half of the seventh century. Scenes of the *Pure Land Paradises of Four Buddhas* —Shakamuni, Amida, Miroku, and Yakushi Nyorai [Fig. 22]—were originally painted on the four sections of the outer sanctum walls, and one bodhisattva was painted on each of the eight smaller wall sections. The murals in the Kondō provided evidence of the strong likelihood that they were produced collaboratively within a single workshop, as some areas show repeated use of the same underdrawing. Other areas were decorated using

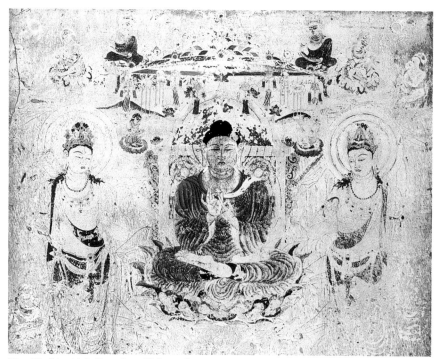

Fig. 22: "Amida's Pure Land" from the *Pure Land Paradises of Four Buddhas*, late 7th to early 8th century, panel 6 of the outer sanctum of the Kondō of Hōryū-ji, Nara prefecture (photo taken prior to fire damage)

the identical technique in which the outlines were carved out using knives or a spatula. There are signs of the use of *nenshi*, a carbon paper that was used to transfer an image from the underdrawing to the desired surface through tracing. The consistent thickness of brushwork known as ironwire lines (*tessenbyō*) is a technique also suited to copying.

The images of flying celestials that survived the fire show brushstroke lines that are softer and colors brighter than those seen in reproductions or copies of the other paintings. The loss of the large-scale original paintings was tragic. Their style and composition, as seen in the surviving sections, show the influence of the early Tang Dunhuang murals, such as that of *Amitabha Preaching* in cave 57 and the *Flying Celestials* in cave 321, which date from the first half of the seventh century. This attests to the importance of these paintings as part of the heritage of East Asian paintings.

Metalwork of the Asuka and Hakuhō periods, like sculpture, showed great technical advances, approaching the high standards of China and Korea. The intricate composition of the openwork crown worn by Guze Kannon [Fig. 9] excels the gilt-bronze crown excavated from the Fujinoki burial mound (mentioned in Chapter 2) made in the second half of the sixth century. The 5-meter-long gilt-bronze banner used in esoteric ordination rites currently housed in the Tokyo National Museum represents a masterpiece of metalwork from the second half of the seventh century.

Comparative List of Buddhist Deity Names

The following Japanese words for the basic categories of Buddhist deities are used in this book.

Japanese	English	Sanskrit
Nyorai / Butsu	Buddha	Tathāgata
Bosatsu	Bodhisattva	Bodhisattva
Myō-ō	Wisdom King	Vidyā rāja
Ten	Deva / Celestial / Heavenly being	Deva / Devi

This is a comparative list of names of major deities that appear in the text.

Japanese	English	Sanskrit
Shaka / Shakamuni	Sakyamuni	Śākyamuni
Dainichi Nyorai / Birushana / Rushana	Vairocana / Mahavairocana	Vairocana / Mahāvairocana
Amida	Amitabha	Amitābha
Yakushi Nyorai	Medicine Buddha	Bhaiṣajyaguru
Fudō Myō-ō	The "Unmovable One"	Acala / Acalanātha
Kannon	Avalokitesvara	Āvālokiteśvara
Miroku	Maitreya / Buddha of the Future	Maitreya

CHAPTER
4

Nara:
The Spread of the Tang International Style

Nara: The Spread of the Tang International Style

1. The New Heijō Capital and the Influence of Tang Culture

In 694, Empress Jitō, who had succeeded her husband, Emperor Tenmu, moved the capital north from Asuka, establishing the new capital of Fujiwara-kyō. Then, in 701, Emperor Monmu instituted the Taihō legal and criminal codes. These acts were meant to implement the dying wishes of Emperor Tenmu to build a capital city based on the Tang model of Chang'an and to establish a centralized administrative system regulated by the *ritsuryō* legal and criminal codes. The transfer of the capital to Heijō-kyō (present-day Nara) in 710 by Emperor Genmei finally fulfilled Emperor Tenmu's plans. For over eighty years, until the capital was moved once again—this time to Heian-kyō (present-day Kyoto) in 794—the arts of the Tenpyō period (also referred to as the Nara period),[1] modeled on objects imported from Tang China, flourished under a powerful monarchy.

Chinese styles are prominent in Buddhist sculpture in the Asuka and Hakuhō periods (538–710), along with traces of influence from the Three Kingdoms of Korea—and later from unified Silla, which ruled the peninsula after 668—through which the styles passed. At the same time, influences received directly from Tang China can also be detected, demonstrating complex patterns of reception. During the Tenpyō period, envoys were dispatched to the continent, at times in missions that numbered as many as five hundred, and on their return they brought back the newest techniques and latest styles. Japan benefited greatly from the almost contemporaneous import of continental trends. These imports included not only Buddhist sculptures but also other Buddhist arts and philosophy.

Among those who were influenced by Chinese culture was the monk Dōji, who had lived in China for seventeen years. He returned to Japan in 718, bringing new translations of the *Flower Garland Sutra* (C: *Huayan jing*, J: *Kegon-kyō*, Sk: *Avataṃsaka sūtra*) in eighty volumes and the *Golden Light Sutra* (C: *Jinguangming zuishengwang jing*, J: *Konkōmyō saishōō-kyō*, Sk: *Suvarṇaprabhāsa sūtra*). He also promoted the idea of "protecting the state" (*chingo kokka*) through Buddhism. After also spending seventeen

years in China, the monk Genbō brought back Buddhist statues and over five thousand scrolls of scripture. Serving at Kōfuku-ji temple in the capital, Genbō gained the trust of the imperial family. The Chinese monk Jianzhen (Ganjin) arrived in Japan in 754, helped build Tōshōdai-ji temple in Heijō-kyō, and taught the Buddhist precepts. The influence that these and other monks exercised on Tenpyō-period arts was profound.

Chinese culture was particularly cosmopolitan during the Tang period, especially under the reign of Empress Wu Zetian (690–705). Decorative arts from India and Central Asia were in much demand, both as sacred ornament (*shōgon*) for the Buddhist world and to embellish daily life at the court. These imported arts were subsequently merged with traditional domestic arts. The alluring world of wondrous adornment (*kazari*), which would later be denigrated by literati and scholar-officials as a transitory phase, was becoming mainstream. The desire for hyper-decorative objects was an exceptional development limited to this period, the only instance of such preferences in the long history of Chinese art.[2] Imbued with this spirit, the Tenpyō arts also flowered as a splendid synthesis of the ornament of the Buddhist world and beautification of the palaces and establishments of the courtiers of this world. Numerous temples and palaces were constructed, requiring the organization of large-scale government-managed workshops and a massive labor force.

Early Tang	618–684
High Tang	684–756
Middle Tang	756–829
Late Tang	829–907

Table 1: Four stages of the Tang period

2. Temple Construction and the Production of Statues

Large-Scale Temple Construction and the Bureau of Temple Construction

The development of Tenpyō arts, following on the heels of the Hakuhō, was fueled by the rapid construction of Buddhist temples. The construction of an unprecedented number of temples in the capital, Heijō-kyō, and in local regions was conducted in the name of protecting the state through Buddhism. The Great Buddha Hall (Daibutsuden) of Tōdai-ji temple in Nara stands at the apex of this movement. A bureau of temple construction (Zōjishi) was established on a temporary basis to oversee the construction of

temples on imperial order. For each project, staff were appointed. Crafts-men were hired and delegated to workshops of the sub-bureaus where they produced statues, woodwork, and tiles, and did casting, painting, and the like.

The sites of temple construction provided an opportunity for collabora-tion and a synthesis of architecture, sculpture, the decorative arts, painting, and other arts to realize the common goal of sacred ornament.

Many of the temples in Fujiwara-kyō were dismantled and moved to the new capital of Heijō-kyō, including Daian-ji and Yakushi-ji, two prom-inent government-sponsored temples of the new state. The original temple complex of Daian-ji and its principal deity, a *jōroku*-sized statue of Sakya-muni (or Shaka), were later destroyed by fire and no longer exist.[3]

The East Pagoda and the Gilt-Bronze Yakushi-ji Buddha

In 681, Emperor Tenmu commissioned the building of Yakushi-ji in the capital of Fujiwara-kyō to pray for the recovery of the ailing empress, who would later become Empress Jitō. The temple com-plex was completed in 697. After being relocated to Heijō-kyō, the new capital, it was struck by a series of disasters that caused severe damage; all that remains of these temple structures is the East Pagoda [Fig. 1]. The three-story pagoda, famed for its beautiful rhythmic struc-ture with decorative pent-roof enclo-sures, was built in 730, according to the late-twelfth-century history *Fusō Ryakki* (Abbreviated Records of Japan).

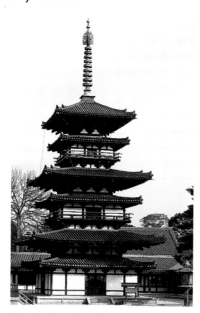

Fig. 1: East Pagoda, 730, Yakushi-ji, Nara

The main object of worship at the temple is a Yakushi Triad (Yakushi San-zon), which dates to the temple's ori-gins. It is composed of a seated *jōroku*-sized gilt-bronze Yakushi Nyorai (Sk: Bhaiṣajyaguru, known as the Medicine Buddha) and two flanking atten-dants, the standing bodhisattvas Nikkō (sunlight) and Gakkō (moonlight) [Fig. 2]. However, the debate is unresolved over whether this triad was

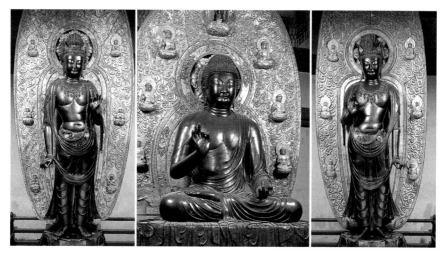

Fig. 2: Yakushi Triad, late 7th to early 8th century, Yakushi-ji, Nara

moved from the Fujiwara capital or newly commissioned after the move to Heijō-kyō; the argument involves issues of style and the date of production of the standing Shō Kannon (Sk: Āryāvalokiteśvara) in the Tōin-dō hall of Yakushi-ji [Fig. 3].

Although the surface of the Yakushi Triad has lost its gilding, and the once-glittering surface has turned a lustrous black, the triad clearly reflects the international character of Tang art. The roundish body with its gentle curves was based on a new Tang style, but its origin can be traced back to Gupta-period art. The peculiar-looking demon (*rasetsuki*) in relief on the pedestal is South Asian in origin, the vine pattern is West Asian, and the four deities of the cardinal directions are Chinese (see Chapter 2, note 9). These four deities also symbolized the authority of the *ritsuryō* state.

The gleaming black seated Sakyamuni at Kaniman-ji temple (Kyoto prefecture), with its imposing appearance, is the same size as

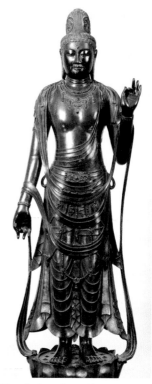

Fig. 3: Standing Shō Kannon, late 7th to early 8th century, Tōin-dō, Yakushi-ji, Nara

the Yakushi Nyorai in the main hall Kondō (Golden Hall) of Yakushi-ji, and the date is also similar to that of the triad there, or perhaps slightly later. The legend of Kaniman-ji tells of a young maiden who once saved a crab from grave danger. She was later being pressured into marriage by a great serpent when an army of crabs rescued her from her predicament. Perhaps on account of this connection with crabs (*kani*, a word that was incorporated into the temple's name), the face of Sakyamuni seems to resemble one of these crustaceans.

3. The Popularity of Clay and Dry-Lacquer Sculptures

The popularity of both clay statues (*sozō*) and dry-lacquer statues (*kanshitsuzō*) increased during the High Tang and spread to Japan from the mid-seventh century, as noted in the previous chapter.[4] Sculptures executed in these new mediums became even more common in the first half of the eighth century in Japan, surpassing the traditional wood-carving method and becoming the dominant techniques for the making of Buddhist sculpture during the period.

Clay Sculptures and the Five-Story Pagoda at Hōryū-ji Temple

The group of *sozō* sculptures arrayed in the base of the five-story pagoda of Hōryū-ji temple (Nara prefecture) was made in 711, a year after the relocation of the capital to Heijō-kyō. A mountain of clay in the interior of the structure has been carved on all four sides to form caves, each staging a dramatic scene from Buddhist scriptures. The facial expressions and poses of the monk-like figures on the north side, which depicts the demise (J: *nehan*, Sk: *parinirvana*) of Sakyamuni, reveal deep emotions of unbearable grief and sorrow [Fig. 4]. It should be noted in passing that the figure of Ashura (Sk: Asura) there shows a striking resemblance to the famous example at Kōfuku-ji [Figs. 5 and 6]. On the east side is a stately depiction of the debate between Yuima (Sk: Vimalakīrti) and the bodhisattva Monju (Sk: Manjusri). These figures are thought to be based on clay sculptures that were placed in the base of Buddhist pagodas. The ninety-plus figures exhibit a rich, expressive range of human emotions that demonstrate a profound realism combining the simplicity of the art of Kofun-period *haniwa* ceramic figurines (see Chapter 2) with the influence of Tang art. Furthermore, this expressiveness reflects the lyrical tradition of the seventh- and

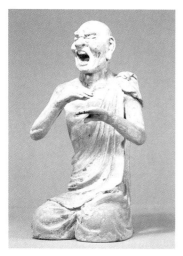
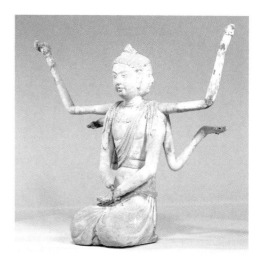

Fig. 4: Attendant, 711, Five-Story
Pagoda, Hōryū-ji, Nara prefecture

Fig. 5: Ashura, 711, Five-Story Pagoda, Hōryū-ji,
Nara prefecture

eighth-century poets of the *Man'yōshū* (*Collection of Ten Thousand Leaves*;
c. late eighth century), who sang unabashedly of the full range of human
emotions.

Dry-Lacquer Statues of Kōfuku-ji Temple

Yamashina-dera temple, built in 669 as the tutelary temple of the Fujiwara
clan, was given its current name, Kōfuku-ji, after being relocated to the
new capital. The Western Kondō was built by Empress Kōmyō in 734 as a
memorial for her deceased mother. Statues of the Eight Classes of Deities
(Hachi-bushū),[5] protectors of Buddhism derived from Indian deities and
super-beings, and the Ten Major Disciples of Sakyamuni[6] were also created
at this time, using the hollow dry-lacquer technique. They would have been
arranged around the main deity, a *jōroku*-sized statue of Sakyamuni, to
represent the Pure Land. A chime-like musical instrument used in rituals,
brought back to Japan in 718 by envoys sent to China, would have been
placed in front of the statues to complete the assemblage. The monk Dōji,
who had studied on the continent, gave the instructions for the proper con-
figuration of the statues. Officials of Empress Kōmyō's household managed
the entire construction project. The Ten Major Disciples and other sculp-
tures are the work of the master carver Shōgun Manpuku (dates unknown).
Ashura [Fig. 6], though originally said to have the non-human appearance

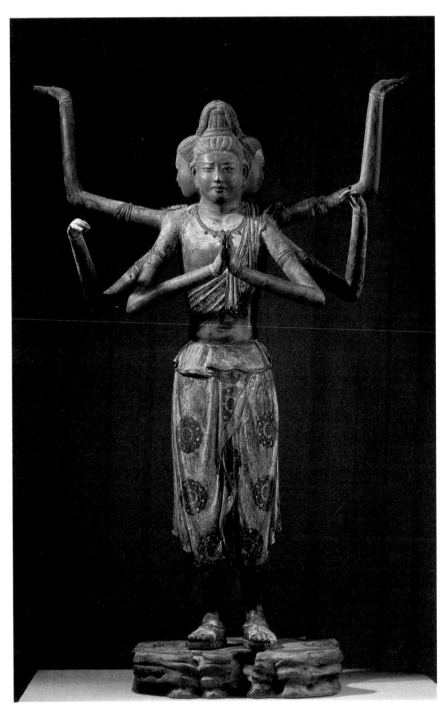

Fig. 6: Ashura, 734, Kōfuku-ji, Nara

of a supernatural being, is carved with a hint of innocence resembling a young boy, as are most of the Ten Major Disciples at Kōfuku-ji. The youthful and somewhat anxious look shows that the taste for innocent, childlike faces that characterized Hakuhō Buddhist art and that was preferred by the court was inherited in Tenpyō Buddhist arts, but with the addition of an introspective profundity.

Clay and Dry-Lacquer Statues in the Lotus Hall at Tōdai-ji Temple

The Lotus Hall (Hokke-dō) was called the Hall of Kannon's Unerring Lasso (Kenjaku-dō) during the Nara period, when it served as the principal hall of Konshō-ji temple, the precursor of Tōdai-ji. The extant hall consists of two combined structures: a Nara-period main hall and a Kamakura-period (1192–1333) prayer hall. The main deity, a standing Fukūkenjaku Kannon (Kannon of the Unerring Lasso, Sk: Amoghapāśa) [Fig. 7] atop the altar in the main hall, is surrounded by clay statues of Shitsukongōshin (Sk: Vajradhara), the bodhisattvas Nikkō and Gakkō, and Kichijōten (Sk: Sri Mahadevi) and Benzaiten (Sk: Sarasvati), accompanied by the dry-lacquer statues of Bonten (Sk: Brahmā), Taishakuten (Sk: Indra), the Shitennō (Four Guardian Kings), and Kongō Rikishi (Sk: Vajravira). Among them, the standing Fukūkenjaku Kannon and six other sculptures measure over 3 meters in height.

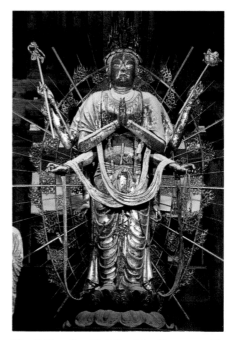

There has been much debate regarding the iconography and date of production of each statue. The generally accepted view is that the works were produced in the mid-eighth century. The dry-lacquer technique, which produced a much lighter and more fragile sculpture. required skills more advanced than those needed to make clay sculptures. The dry-lacquer works were, at that time,

Fig. 7: Standing Fukūkenjaku Kannon, mid-8th century, Hokke-dō, Tōdai-ji, Nara

the products of cutting-edge techniques. The statues of the Four Guardian Kings, however, retain an awkward stiffness, and the same can be said of the standing Twelve Guardian Generals at Shin Yakushi-ji temple in Nara.

Despite its supernatural appearance with three eyes and eight arms, which links it to the iconography of later Esoteric Buddhism, the standing Fukūkenjaku Kannon is a beautifully proportioned figure with a dignified presence embellished by its original crown exquisitely fashioned in silver openwork. Together these elements mark it as an exceptional piece that exemplifies the beauty of Tenpyō dry-lacquer sculpture. One wonders whether, in the creation of this masterpiece, there was any direct involvement of Kuninaka no Muraji Kimimaro (d. 774),[7] who was in charge of the imperial commissions of Buddhist sculptures. Clay, by contrast, is known for its malleability, which allows for a more naturally curved form. Examples that capitalize on this advantage are the Nikkō and Gakkō statues, which evoke a great sense of realism. The Four Guardian Kings, said to have been relocated from an unidentified hall to the present Ordination Hall (Kaidan-in) during the Edo period (1615–1867), are similar examples of sculpture in clay, but the bodies of these deities appear more lithe and reveal a greater sense of interiority, reflecting the zenith of the Tenpyō clay-sculpture tradition.

It is important to remember that Fukūkenjaku Kannon was originally a dazzling golden color and accompanied by vibrantly painted deities rendered in gradient colors (a method in which colors are not blended but applied adjacent to one another in bands to create a shading effect), also seen in the Dunhuang grottos and the lacquered tray in the Shōsō-in Repository, an imperial storehouse at Tōdai-ji. As a "secret," or hidden, Buddha, the clay image of the guardian Shitsukongōshin preserves its original polychrome appearance remarkably as it was kept in a sealed shrine.

4. Casting the Great Buddha of Tōdai-ji Temple

Nara, called by the poetic epithet "green/blue-earth" (*aoniyoshi*), was not as tranquil as poetry in the *Man'yōshū* might suggest. An outbreak of plague from the continent and the rebellion of Fujiwara no Hirotsugu in 740 were major blows to Emperor Shōmu, who had acceded to the throne in 724, and to Empress Kōmyō as well. The emperor fled, moving with his court first to Kuni, then Shigaraki, and finally Naniwa (present-day Osaka), and remained away for five years following the revolt.

In 743, still absent from the capital, Emperor Shōmu ordered the production of a bronze statue of a Great Buddha, Birushana (Sk: Vairocana), to protect the state. The project was carried out by a temple-run workshop responsible for the production of wooden items, dry-lacquer and clay statues, and temple accessories. The office was known as the Konkōmyō-ji temple Bureau of Buddhist Construction (Zōbutsusho), which evolved into the bureau for the construction (Zōjishi) of Tōdai-ji.

Kuninaka no Muraji Kimimaro, a grandson of an immigrant from Baekje, as noted above, was particularly influential. He created a scale model and led the project, on which the country's fate was thought to hinge, as the Master of the Great Buddha (*daibusshi*). Construction began in the ninth month of 747 and was completed in 755 at great expense, facing many complications along the way. The statue of the Great Buddha towered to a height of 16 meters, nearly equaling the five sitting Great Buddhas from the Northern Wei at Yungang and the Vairocana of Fengxian Si at Longmen, which is dated to 675 in the early Tang. It is indeed possible that the latter statue, commissioned by Empress Zetian, provided the inspiration for the building of the Great Buddha of Tōdai-ji.

The present-day Great Buddha is an Edo-period recasting; it is somewhat smaller, having a height of 15 meters. The construction of the Great Buddha Hall, 47 meters in height with a façade stretching 88 meters in length, paralleled the casting of the principal deity in complexity. The height of the current hall matches the original, but the width of the building from front to back is about 35 percent less than that of the original structure. To both the east and west of the hall stood a seven-story pagoda that soared to a height of 100 meters—three times the height of the current five-story pagoda of Hōryū-ji (31.5 meters high).[8] Records indicate that the clay statues of the Four Guardian Kings, 10 meters high, were also enshrined in the hall. In anticipation of the Buddha's completion, a magnificent "eye-opening" ceremony was held to dedicate the image on the ninth day of the fourth month of 752, though the main deity itself was only partially gilded. An Indian monk played a leading role in the ceremony, and masked dance drama (Gigaku) featuring exotic foreigners was performed. The event turned into a celebration of wondrous adornment (*kazari*) with an international flavor.

The 1180 fire unleashed by the warrior Taira no Shigehira destroyed the Great Buddha Hall. Only the lotus pedestal of the Great Buddha, inscribed with images of the *Lotus Treasury World*, remains [Fig. 8]. An

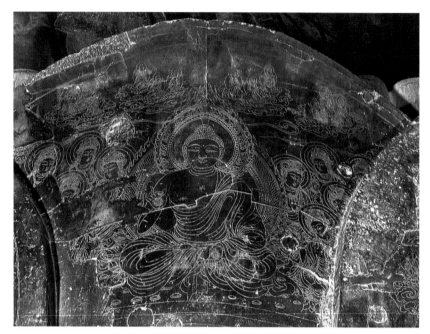

Fig. 8: Detail of the *Lotus Treasury World* inscribed on the lotus pedestal, 8th century, Great Buddha Hall, Tōdai-ji, Nara

image of the Great Buddha at Tōdai-ji in the twelfth-century *Illustrated Scrolls of the Legends of Shigisan* (*Shigisan Engi Emaki*) corresponds perfectly to the image produced by fine-line engraving on the extant portion of the original bronze base. This provides a glimpse of the sacred ornament derived from the magnificent style of the High Tang.

5. The New Style of Tōshōdai-ji Temple

The arrival of the eminent Chinese monk Ganjin Wajō (C: Jianzhen, 688–763) in 754 was met with great enthusiasm in Japan. Ganjin had spent twelve years and failed five times in his attempts to cross the perilous seas; he met with success only on his sixth try. He later administered the Buddhist precepts to the retired emperor Shōmu and others, and founded Tōshōdai-ji in 759. The accompanying Chinese artists and artisans who arrived with Ganjin brought new trends in Buddhist art from Tang China.

The Tōshōdai-ji temple complex was further developed by Ganjin's disciples after the master's death in 763. The Kondō is the only Tenpyō-period architecture of its kind to survive. The principal deity is a large-scale

hollow dry-lacquer statue of a seated Birushana [Fig. 9]. The deity was based on the description found in the *Brahma's Net Sutra* (C: *Fangwang jing*, J: *Bonmō-kyō*, Sk: *Brahmajāla sūtra*), a sutra that elaborated the precepts expounded in the *Flower Garland Sutra*, which was particularly prized by Ganjin. The head of the icon is exaggerated while the body is taut but rather ponderously fashioned in the Middle Tang style. The technique of using dry lacquer over a wooden core is particularly suited to expressing a sense of volume, and it was used for other sculptures at

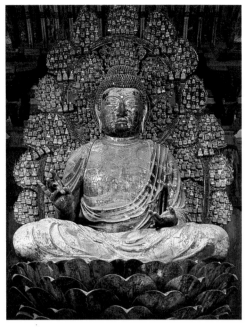

Fig. 9: Seated Birushana, late 8th century, Kondō, Tōshōdai-ji, Nara

Tōshōdai-ji. The standing Senju Kannon (Thousand-Armed Avalokitesvara) and the standing Yakushi Nyōrai are of this type. The two flanking statues of Bonten and Taishakuten revived the popular Asuka/Hakuhō technique in which carved wood and dry lacquer were used in combination. The surface was finished using *kokuso urushi*, or lacquer (see note 4 in this chapter). The Senju Kannon at Tōshōdai-ji and the slightly older seated Senju Kannon at Osaka's Fujii-dera temple [Fig. 10] are the earliest examples of this type of sculpture. The hollow dry-lacquer sculpture of the seated Ganjin Wajō enshrined in the Miei-dō (Founders Hall) is said to be an image of the prelate when he died in seated meditation, facing westward [Fig. 11]. Devotion to this great spiritual leader was expressed in his sculptural form, resembling the piety invested in Buddhist icons.

Before being moved to its present location behind the Kondō, the lecture hall was formerly an assembly hall in the Heijō-kyō palace compound. Although it was dismantled and deftly refashioned for religious purposes, it is the only surviving example of Nara palace architecture and considered a historical treasure. The statues originally housed in the hall (currently stored in the Treasure Gallery) are particularly worthy of attention as examples

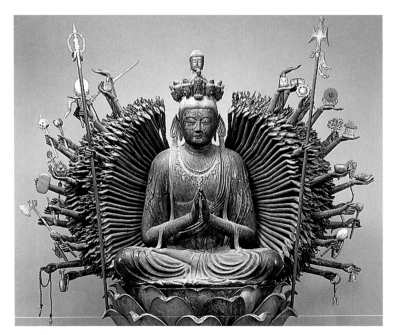

Fig. 10: Seated Senju Kannon, 8th century, Fujii-dera, Osaka

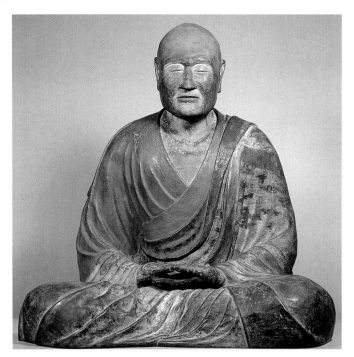

Fig. 11: Seated Ganjin Wajō, 763, Miei-dō, Tōshōdai-ji, Nara

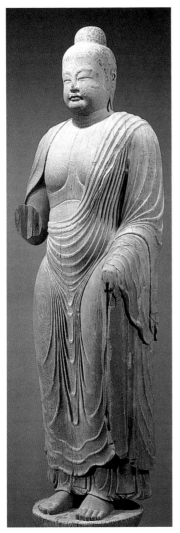

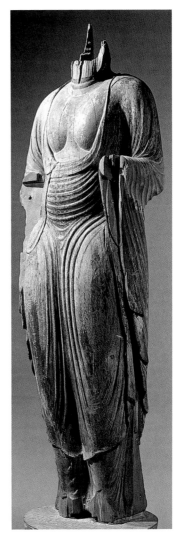

Fig. 12: Yakushi Nyorai, late 8th
century, Tōshōdai-ji, Nara

Fig. 13: Standing Buddha, late 9th
century, Tōshōdai-ji, Nara

of the emergence of a new style of wood sculpture from the second half of
the eighth century and as direct links to the next generation of Jōgan-era
(859–77) sculptures. The statues thought to be a standing Yakushi Nyorai
[Fig. 12] and a standing Shūhō'ō Bosatsu were made using the wood of the
Japanese nutmeg-yew (*kaya*), a tree found chiefly in Japan. The taut lines
of the modeling of the bodies and their solemn, foreign features reflect
the influence of immigrant artists. The robe of the now headless standing

Buddha [Fig. 13], with its beautiful ripple-like contours, shows clear evidence that the *honpa* style was already a feature of these sculptures (see Chapter 5, note 6). On the statue thought to be Shūhō'ō Bosatsu, the folds of the robe are patterned such that it appears as if round cords are affixed to the garment. This treatment bears a striking resemblance to carvings seen on Tang-period stone sculptures. Intricate detailing of the carving, like that seen on the standing Eleven-Headed Kannon (Jūichimen Kannon), suggests the influence of Tang sculptures made from aromatic sandalwood (see Chapter 5, note 7). For further discussion of the wood sculptures at Tōshōdai-ji, see the next chapter.

The Eleven-Headed Kannon of Shōrin-ji temple (Nara prefecture) is another masterpiece of wood-core dry-lacquer sculpture from the second half of the eighth century. The image was made from the wood of a single cypress over which dry lacquer was generously applied. The taut torso with its restricted waist and the heavy eyelids that give the face a meditative look suggest that this is a transitional piece, moving from the symmetrical and balanced proportions typical of Tenpyō Buddhist sculpture to the dynamism of the following Jōgan style.

6. Pictorial Arts of the Nara Period

In the eighth century, in accordance with the implementation of the legal and criminal codes, an official government office called the Bureau of Pictorial Crafts (Edakumi no Tsukasa) was established to produce paintings. It was staffed with four master painters and sixty painting assistants, and operated as a collaborative workshop. The artisans were responsible not only for the paintings but also for the coloring used on buildings and sculptures, creating underdrawings for Buddhist embroidery (*shūbutsu*) and textiles, designing motifs for mirrors, and other visually oriented tasks.

The term *shūbutsu* refers to colorfully embroidered textiles depicting various Buddhist images. These were often large, sometimes measuring over 6 meters in length. Many were displayed as the principal object of worship in a temple, as were *jōroku*-sized gilt-bronze Buddhas. The earliest of these is the *Tenjukoku Paradise Embroidery*, an embroidered curtain depicting a Buddhist paradise dated to 622 (see Chapter 3, Fig. 17). The *Tapestry of Sakyamuni Preaching* in the Nara National Museum follows the style of the High Tang, and it appears to have been produced sometime between 708 and 715. Large-scale examples of *tsuzure-ori* tapestry, which

correspond closely to Western tapestries, were also produced. The famous *Woven Taima Mandala* in Taima-dera temple, measuring 4 meters square, depicts Pure Land of Amida (Amitabha).

According to legend, the tapestry was woven by a daughter of a courtier under the guidance of Amida in disguise. A Shōsō-in document records that there was a tapestry measuring approximately 4.8 meters in height and illustrating a scene from Amida's Pure Land that hung in the Amida Hall of Tōdai-ji. The *Woven Taima Mandala* can be understood as a similar effort. It is said that among the clay statues of the Four Guardian Kings, there hung on the sidewalls of the interior of the Great Buddha Hall at Tōdai-ji two large woven Kannon mandalas that were larger than the Great Buddha itself. The magnificence of such large-scale works is easily imagined.

I would like to draw attention to other pictorial expressions from the Nara period, as there are important works executed both on silk and on paper. The *Portrait of Prince Shōtoku* (Imperial Household Agency) is an interesting example of a work painted on paper. The technique used, in which fine ink lines show the tall prince standing in the center foreground flanked by two youthful attendants, is similar to that used to render the human form in the *Thirteen Emperors Scroll* (C: *Diwang tujuan*), attributed to Yan Liben (d. 677) (Museum of Fine Arts, Boston) from the Early Tang. The blurred brushwork used for the detail of the robes resembles the "broken" ink-painting style (*haboku*) often associated with landscape paintings. In contrast, the image of *Kichijōten* on hemp in Yakushi-ji [Fig. 14] demonstrates the detailed painting technique reminiscent of that used in Chinese Buddhist paintings by Zhou Fang, an official court painter of the Middle Tang. The painting of *Sakyamuni's Sermon under the Trees on Vulture Peak*

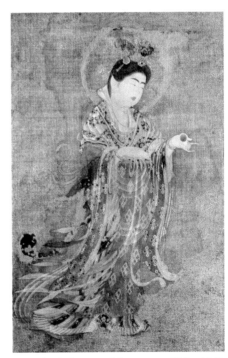

Fig. 14: *Kichijōten*, 8th century, Yakushi-ji, Nara

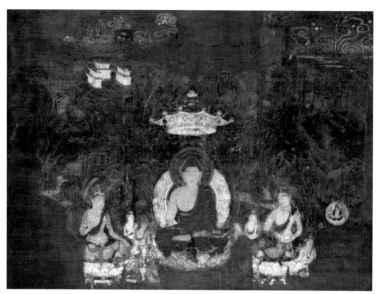

Fig. 15: *Sakyamuni's Sermon under the Trees on Vulture Peak*, 8th century, Museum of Fine Arts, Boston. Photograph © 2018 Museum of Fine Arts, Boston.

(Museum of Fine Arts, Boston) [Fig. 15], also known as the *Fundamental Mandala of the Lotus Hall*, is thought to exhibit techniques adopted from Tang Buddhist paintings of the second half of the eighth century. However, in this case, the faces have fuller brows and clear and serene expressions, while the bodies are soft and voluminous in an uninhibited fashion, which is unlike the Tang-influenced Kichijōten painting. The representation of the mountains in the background shows an aspect of Tang landscape painting derived from Daoist concepts of immortality.

The *Illustrated Scripture of Cause and Effect* [Fig. 16], which is based on the *Scripture of Past and Present Causes and Effects*, portrays the relation between the deeds of Sakyamuni in his past lives and his act of renouncing the world and becoming a monk in this life, as well as his attainment of Buddhahood. A number of eight-volume sets of the illustrated sutra were created. Single scrolls from these sets are found at Daigo-ji and Jōbon Rendai-ji temples, as well as in the Tokyo University of the Arts and other collections. Such sets of the illustrated sutra were again produced during the Kamakura period. The scrolls are divided into two registers: the upper half contains illustrations of the narrative, and the lower half contains the text of the sutra. The pictorial technique is archaic, like that found on the murals of Early Tang burial mounds, while the calligraphy is in the

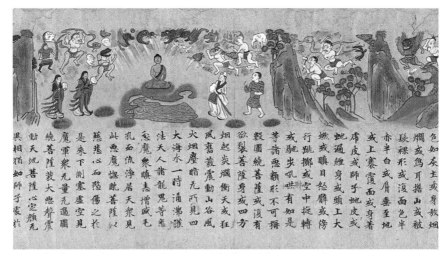

Fig. 16: *Illustrated Scripture of Cause and Effect*, 8th century, Daigo-ji, Nara

High Tang style. A mid-eighth-century artist was thus familiar with both new and old Chinese models when creating this set, the ancestor of the pictorial handscroll genre (*emaki*).

7. Treasures of the Shōsō-in Repository

Emperor Shōmu died at the age of fifty-six in 756, the year after the completion of the Great Buddha. The bereaved Empress Dowager Kōmyō donated over six hundred of the late emperor's personal belongings to Tōdai-ji following the traditional memorial service on the forty-ninth day after his passing. The Shōsō-in is a storehouse in the temple compound built to preserve these treasures. The raised-floor building is an imposing structure, measuring 14.5 meters in height, built in the split-log style (*azekura*). It has inner wooden walls that separate and seal the northern and southern repositories from the central repository [Fig. 17].

The treasures entrusted to the storehouse by the dowager empress are listed in the *Record of the State's Rare Treasures* (756–58). Among these items are many weapons and varieties of armor, which made up the majority of the collection. Most of the military items were removed during the revolt of Fujiwara no Nakamaro in 764. Fortunately, a large number of the objects beloved by the late emperor survive and are housed in the northern repository. These form the core of the treasures of the Shōsō-in. The central repository accommodates over 750 Buddhist implements and

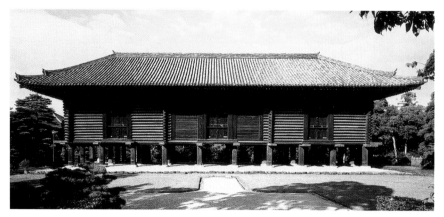

Fig. 17: Shōsō-in Repository, mid-8th century, Tōdai-ji, Nara

treasured objects used in the eye-opening ceremony to dedicate the Great Buddha, while the southern repository holds most of the metal crafts, including mirrors and works in silver.

The treasures total 902 objects, including those donated to the Great Buddha, and range from medicines, Buddhist implements, stationery, musical instruments, costumes and props for dance and other performances, leisure goods, clothing, jewels or precious stones, practical objects (folding screens, mirrors, etc.), small ritual objects for court ceremonies, work tools, and documents (calligraphy, sutras, etc.). Most were contemporary objects, produced in the eighth century; however, some had been preserved from much earlier and may date to as early as the fifth or sixth century. The survival of these various objects used in the daily lives of the denizens of the court during the eighth century or even earlier—not as burial goods but as objects preserved in a storehouse above ground—is unique in the world.

The treasures of the Shōsō-in were chiefly produced in Tang China or in Japan after Tang models, although objects of Korean origin as well as West, Central, and Southeast Asian origin are also present. The items made in Japan were produced with advanced techniques and refined aesthetics indistinguishable from those of the continent and reflect the exquisite nature and international character of the courtly arts of Tang China, then the center of world culture. Protected as national treasures, these precious textiles, woodwork, and other objects fashioned out of organic materials remain in an excellent state of preservation. The high level of preservation is in large part thanks to skillful conservation and restoration by craftsmen

during the Meiji era (1868–1912). The Meiji craftsmen's skill and dedication in this work was no doubt informed by the spiritual power with which these objects are thought to be imbued.

If pressed to arbitrarily highlight only ten or so objects from the Shōsō-in, I would first choose two lutes from among the beautiful musical instruments decorated with mother of pearl inlay (*raden*). In the northern repository are an exceptional five-stringed rosewood lute (*biwa*) with mother of pearl inlay [Fig. 18] and a round rose wood ruan lute (*genkan*) with mother of pearl inlay. The floral motifs (*hōsōge-mon*) decorating the back of the lutes have the power to mesmerize the viewer into thinking they give off a rich flowery fragrance. The ornamental jewelry that appears to undulate as it hangs from the mouths of the two mirroring parrots on the back of the round lute twinkles like stars and reminds viewers of the "oil-spot" (*yōhen* and *yuteki tenmoku*) effect seen on Chinese ceramics of the Song period (960–1279).

Such lutes generally have a surface guard made of either leather or tortoiseshell to protect that part of the instrument's face that would otherwise be scratched by the plectrum. The surface guard of the five-stringed lute has an inlaid design of a camel-mounted Persian, suggesting the taste for things foreign found in Tang art. A similar taste for things foreign can be seen on the surface guard of another lute kept in the southern repository; the maple lute dyed with sappanwood and decorated with mother of pearl inlay with a design of musicians on an elephant [Fig. 19]. Painted in the foreground are four musicians who play flutes and dance while riding on the back of an elephant; behind them, a deep gorge stretches to the horizon, where the evening sun is setting. Although small in size, this minutely rendered image is an important and rare example of Tang landscape painting that has been preserved to this day. It is also an invaluable key to understanding the origin of the Japanese-style (*Yamato-e*) landscapes seen in such works as the twelfth-century *Illustrated Scrolls of the Legends of Shigisan* from the twelfth century (see Chapter 5). The question of whether the artist who displayed such technical mastery in this image on the lute was Chinese or Japanese is hard to answer.

The ancient Chinese technique called *pingtuo* (*heidatsu*, later called *hyōmon* in Japan), in which thin sheets of gold and silver are applied to a lacquered surface, was popular in the first half of the Tang period. The octagonal mirror with gold and silver embedded in lacquer in the northern

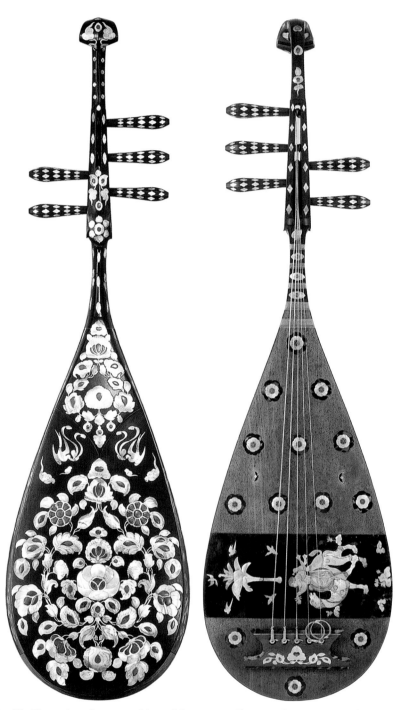

Fig. 18: Five-stringed rosewood lute, 8th century, Shōsō-in Repository, Tōdai-ji, Nara

repository is thought to have been produced in China. It is replete with fine details and a symmetrically depicted bird motif. Stolen and damaged in the thirteenth century, the mirror was later recovered, and then repaired in the Meiji era. Although many of the treasures in the Shōsō-in are rare objects that have been preserved for centuries, most would not have retained their original spectacular beauty had they not been painstakingly restored by skilled Meiji craftsmen.

The Tang-style sword mounting with gilded silver fittings and inlay in the northern repository is the only sword remaining from among those mentioned in the *Record of the State's Rare Treasures*. The scabbard depicts birds and animals with cloud-like arabesques [Fig. 20]. The technique became commonly known as burnished *maki-e* lacquer (*togidashi maki-e*). This sword is an important resource for the study of the origin of *maki-e* (literally, "sprinkled pictures") employed on lacquerware.

As noted earlier, the ancient type of oil painting known as *mitsuda-e*, or litharge painting, was used on the Tamamushi Shrine (Chapter 3, Figs. 19 and 20). Examples of *mitsuda-e* can also be found in the Shōsō-in. The litharge painted box [Fig. 21] is one such example. Oil paint was applied over images of phoenixes, mythical sea creatures, lotuses, and Japanese honeysuckle, depicted in red and ochre on the black lacquer surface. The patterns on the side panels were painted using swift brushstrokes to form motifs of waves and swirls. The

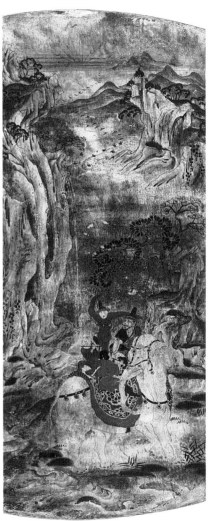

Fig. 19: Musicians Riding an Elephant, sappanwood plectrum guard of a maple lute, 8th century, Shōsō-in Repository, Tōdai-ji, Nara

Fig. 20: Tang-style sword mounting, 8th century, Shōsō-in Repository, Tōdai-ji, Nara

Fig. 21: Litharge painted box, 8th century, Shōsō-in Repository, Tōdai-ji, Nara

phoenixes on the surface spin vigorously around the lid's central axis. The patterns used on the Shōsō-in treasures were, even within the restrictions dictated by a system of symmetry, capable of eliciting a dizzying sense of movement.

The lacquered and gold painted incense burner pedestal [Fig. 22] found in the southern repository is a multicolored tray shaped like a lotus-flower dais and was used to burn incense in front of a Buddhist icon. The gold leaf, ultramarine, and vermilion ground on the underside of the four-tiered lotus petals is painted with decorations so complex as to assault the eyes. Floral arabesque patterns are shaded in such colors as crimson and gamboge yellow applied as gradient coloring (*ungen-zaishiki*), and birds, lions, and *karyōbinga* (a mythical bird with a human face) are depicted in

Fig. 22: Lacquered and gold painted incense burner pedestal, 8th century, Shōsō-in Repository, Tōdai-ji, Nara

minute detail. Its vivid coloring is a living sample of the Tang aesthetic, which prized the highly decorative. The origins of the Japanese sense of wondrous adornment (*kazari*), which was to develop domestically along its own lines, can be seen in this tray and the litharge painted box.

Although the *Record of the State's Rare Treasures* records one hundred folding screens, only one illustrated screen survives: *Standing Women Decorated with Bird Feathers* [Fig. 23], a six-panel folding screen. The wild bird feathers and the color pigments on this Japanese-made screen have long since been abraded and fallen away. Only the outlines of the faces and hands remain of the six voluptuous Tang-style beauties depicted either standing or seated next to trees. The now-white hair and robes, as well as the trees and rocks, were surely adorned with colorful feathers in the past.

Other treasures in the Shōsō-in collection are too numerous to

Fig. 23: Detail of *Standing Women Decorated with Bird Feathers*, third panel, 8th century, Shōsō-in Repository, Tōdai-ji, Nara

allow for elaborate description, but some that are particularly noteworthy are 1) a landscape painting on hemp and 2) a Bodhisattva on hemp, both rendered in ink; and 3) a white cut-glass bowl thought to be of Sassanid origin and to have been paired with a similar bowl excavated from the early sixth-century burial mound of Emperor Ankan. Exquisite textiles are abundant and include 4) a white-chestnut brocade tablecloth, which has the motif of a tree and a lion handler; 5) wax-resist dyed folding screens, which were created with a dyeing technique that produced symmetrical patterns; and 6) a seven-panel robe of woven brocade resulting in an irregular design that pleases the modern eye. Other items include 7) the Gigaku mask of the Drunken Barbarian King [Fig. 24], which was worn during the eye-opening ceremony and surely elicited laughter from the crowd; and 8) the calligraphy of the *Yueyi Lun* (Treatise on Yue Yi), which had been copied by master calligrapher Wang Xizhi (303–361) and recopied by Empress Kōmyō. The number of treasures in the Shōsō-in seems inexhaustible, but I must mention in conclusion 9) a tricolor *tsuzumi* drum modeled after Tang three-colored glazed pottery; and 10) a two-colored glazed bowl, marked by an appealing simplicity.

Through these objects, we can learn more about the highly decorative world of Chinese Tang art, which was meant to beautify both this and the next world with sacred ornament (*shōgon*), and also understand how it embellished the Tenpyō court, coloring daily life with the pleasures of adornment. There was no distinction between fine art and craft; instead, all the arts served as the starting point for the launch of the culture of wondrous adornment (*kazari*) that would overflow with bold and dynamic designs and color sensibilities that were to flourish in Japan.

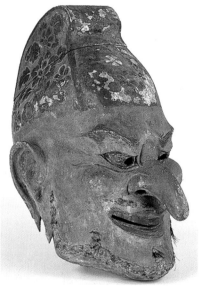

Fig. 24: The Gigaku mask of the Drunken Barbarian King, Shōsō-in Repository, Tōdai-ji, Nara

Heian:
Jōgan, Fujiwara, and Insei Art

Heian: Jōgan, Fujiwara, and Insei Art

The Heian period lasted approximately four hundred years, from the transfer of the capital to Heian-kyō (present-day Kyoto) in 794 to the appointment of Minamoto no Yoritomo to the post of shogun (an abbreviation of Sei'i Taishōgun, "barbarian-quelling general") in 1192. Art historians generally divide this lengthy period into early and late Heian, with the cessation of official missions to Tang China in 894 taken as the dividing line between the two periods. In contrast, the art historian Ariga Yoshitaka (b. 1940) divides the period into the Early Heian, which runs from 794 to 969, when the Fujiwara clan expanded their political power in the An'na Incident; the Middle Heian, which stretches from the consolidation of Fujiwara power in 969 to the establishment of the rule of cloistered, or retired, emperors (Insei), starting with Retired Emperor Shirakawa in 1086; and finally, the Late Heian, which corresponds to the rule of retired emperors from 1086 to 1192. This book adopts Ariga's three-stage chronology with one modification: the transitional first half of the tenth century is included within the Middle Heian period along with Fujiwara art. According to this chronology, the Early Heian period (794–894) is the period of Jōgan art, the Middle Heian period (894–1086) that of Fujiwara art, and the Late Heian period (1086–1192) is that of Insei art. The first of the three periods corresponds roughly to the ninth century, the second to the tenth and eleventh centuries, and the third to the twelfth century.

Heian art thus includes three subdivisions—early, middle, and late—that together spanned four hundred years, from the late eighth to late twelfth centuries. The early period witnessed Buddhist monks such as Kūkai bring back to Japan the teachings of Esoteric Buddhism (Mikkyō), the most advanced stage of Buddhism, from Tang China. Esoteric Buddhism's many enigmatic icons transformed the appearance of painting and sculpture in Japan. During the Middle Heian, such imports ceased as a result of the breakdown in relations with the continent, and a tendency toward a more Japanese style (*wayō*) in the lives of the Fujiwara nobility accelerated. The Late Heian

Early Heian	794–894
Middle Heian	894–1086
Late Heian	1086–1192

Table 1: Three stages of the Heian period

saw an even greater maturing and elaboration of the Japanese style, which engendered expressions of emotion that reflected a period of revolutionary change in social conditions.

I. Esoteric Buddhist Art

1. The Arrival of Esoteric Buddhist Art

The third year of the Enryaku era (784) was the first year in the sixty-year cycle of the Chinese calendar,[1] considered to be an auspicious time for undertaking new ventures. Bolstered by this belief, Emperor Kanmu ordered the transfer of the capital from Heijō-kyō (Nara) to Nagaoka-kyō. The impetus behind the move was to create an imperial line descended from Emperor Tenji, replacing the declining lineage of Emperor Tenmu, and to remove the court from Nara, the stronghold of the old regime, and away from the influence of powerful temples and shrines. The new capital, however, was abandoned after only ten years for reasons that are not entirely clear. In 794, a new capital, Heian-kyō (present-day Kyoto), was established not far away. Over the course of the next century, Japanese envoys were once again sent to China, and they brought back both tangible and intangible items, such as written works and knowledge from the Middle and Late Tang, the most important of which related to Esoteric Buddhism, which posed a threat to the authority of the established Nara Buddhist schools.

Before moving forward, first let me provide a brief history of Esoteric Buddhism, from its origins in India and its passage through China to its arrival in Japan. Among all the traditions within Buddhism, Esoteric Buddhism places particular significance on secret teachings. As it appeared during the final stage of Mahayana Buddhist development, it emphasizes mysticism, incantations, and symbolism. Having profound links with the ancient Indian spiritual culture called Tantrism, Esoteric Buddhism shares the same roots as Hinduism.

Although esoteric practices such as the use of incantations were forbidden in the early stages of Buddhism, esotericism filtered into the faith bit by bit as a method of casting spells. The many-faced and multi-armed icons such as those of Eleven-Headed Kannon, Kannon of the Unerring

Lasso, Thousand-Armed Kannon, and the like, which had been popular during the Nara period (710–94), were all based on incantatory scriptures and iconography brought to Japan via China. However, as the motivation behind the making of these images was to gain benefit in this life, and the practice had not yet reached the advanced stage of esotericism, which sought freeing oneself from attachments and attaining enlightenment as the ultimate goal, this practical form of the faith was classified as Zōmitsu, miscellaneous esotericism. In contrast, a more systematic version with comprehensive teachings called Junmitsu or "pure esotericism" arrived in Japan in the ninth century.

Esotericism in India developed as an unsystematized form of Zōmitsu during its initial phase (fourth–sixth century). This was followed by a middle phase (seventh–eighth century) during which Junmitsu thrived, and the late phase (ninth–eleventh century) when esotericism's momentum tapered off. When Muslims conquered the Pala empire in 1203, Esoteric Buddhist temples and their monks were eradicated, drawing the final curtain on its great legacy in India.

The two main scriptures of pure esotericism are the mid-seventh-century *Mahāvairocana sūtra* (J: *Dainichi-kyō*) and the late-seventh-century *Vajraśekhara sūtra* (J: *Kongōchō-kyō*). Both teachings were brought to China by the Indian monk Śubhakarasiṃha. He traveled overland to the Chinese capital of Chang'an in 716 at the age of eighty and translated the *Mahāvairocana sūtra* into Chinese. Similarly, the monk Varjabodhi traveled from South India to Chang'an by sea in 720, and produced a translation of the *Vajraśekhara sūtra*. The monk Amogha, who had traveled together with Varjabodhi, later journeyed from Guangzhou to Sri Lanka in 742. He returned to Tang China in 746 with 1,200 scrolls of scripture in Sanskrit. The Chinese monk Huiguo, a disciple of Amogha, is thought to have consolidated the teachings of both sutras and promulgated Junmitsu esotericism. Huiguo is also said to have transmitted these systematized esoteric teachings to Kūkai (774–835), a Japanese monk who traveled to Chang'an in 804. Kūkai returned to Japan in 806 laden with scriptures, mandalas, and Buddhist ritual implements. After his return, he used Takaosan-ji temple (later Jingo-ji temple) in Kyoto as a base to establish Esoteric Buddhist temple complexes at Kongōbu-ji on Mt. Kōya and at Tō-ji (formally Kyōō Gokoku-ji) in Kyoto. He is thus considered the patriarch of the Shingon sect of Esoteric Buddhism in Japan.

In the meantime, the Japanese monk Saichō (767–822), the founder of the Enryaku-ji temple complex on Mt. Hiei, was also sent as an envoy to Tang China. After arriving in China in 804, he journeyed to Mt. Tiantai, where he learned the doctrine of the Tiantai (Tendai) school of Buddhism. He returned to Japan in 805 with the highly eclectic Tiantai teachings, including esotericism, and founded the Tendai sect based at Enryaku-ji. He realized, however, that he lacked complete esoteric knowledge and sought instruction from Kūkai. However, Tendai Esoteric Buddhism was perfected only later with the aid of the monks Ennin and Enchin. Ennin and Enchin followed the example of Kūkai and Saichō in journeying to Tang China, together with another six scholar-monks of the Tendai and Shingon schools. They are collectively known as the Nittō Hakke, the Eight Masters Who Journeyed to Tang.[2] Soon after the death of Huiguo in 805, Esoteric Buddhism declined in China owing to the suppression of Buddhism ordered by Tang Emperor Wuzong in 844 and to other events. In the early stages of the Northern Song attempts to resurrect the Buddhist faith were undertaken, including importing sutras produced during the last stage of esotericism in India, but this had little effect on the decline. Subsequently, Chinese Buddhism merged with Tibetan Buddhism, transforming it and leading it to evolve along a path differing from that in Japan. The doctrines and art of Esoteric Buddhism thrived in Japan while dying out in India and China. Japan thus became a precious treasury, preserving the legacy of the art from the early and middle stages of Esoteric Buddhism.

2. The Rituals and Art of Esoteric Buddhism

In his *Catalogue of Imported Works*, which Kūkai presented to the court upon his return in 806, many paintings are listed in addition to a vast collection of sutras, mandalas, and portraits of the patriarchs. Kūkai claimed that Shingon scripture was so mysterious and enigmatic that its true meaning could not be transmitted without visual images. Kūkai's introduction of the "pure esotericism" of Junmitsu was the turning point after which painting began to play an equal role with sculpture, which had previously occupied the center of the world of Buddhist art. Unfortunately, repeated fires and the wear and tear of use have significantly damaged most images from Kūkai's time. The few ninth-century paintings that remain are the *Takao Mandala* at Jingo-ji [Figs. 1 and 2]; the *Sai-in Mandala* at Tō-ji

Fig. 1: *Takao Mandala*, 829–34, Jingo-ji, Kyoto

Fig. 2: Detail of the *Takao Mandala* (Fig. 1), Dainichi Nyorai
(Mahāvairocana)

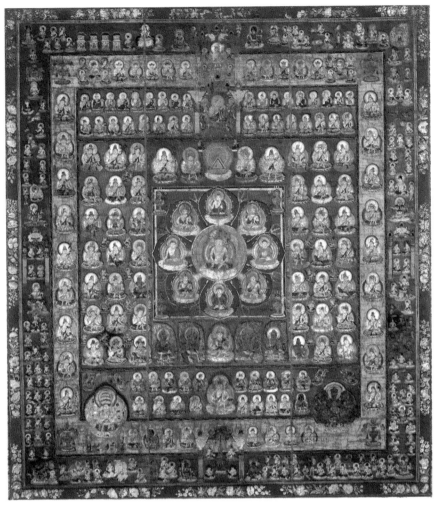

Fig. 3: *Sai-in Mandala*, second half of 9th century, Tō-ji, Kyoto

Fig. 4: "Taishakuten" (Indra), one of the *Twelve Devas*,
mid-9th century, Saidai-ji, Nara.

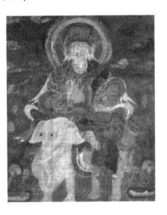

[Fig. 3], which is reputed to be the mandala from Shingon-in, the palace seminary; and the images of the *Twelve Devas* (Jūniten) at Saidai-ji temple in Nara [Fig. 4].

The court and nobility of the time welcomed the doctrine and practical rituals of pure esotericism that Kūkai presented in 806.

While they favored the ideal of protecting the state through Buddhism championed by Kūkai, in fact they most eagerly anticipated the miraculous effects that would be brought about by esoteric rituals.

The Gosai-e was an elaborate court ceremony held annually during the New Year's season. It was a Buddhist ceremony based not on esoteric teachings but on Exoteric Buddhist teachings that had been practiced since the Nara period. The purpose of the Gosai-e was to pray for political stability and good grain harvests. Kūkai, however, considered the ritual's efficacy to be insufficient and proposed a large-scale esoteric ritual be conducted simultaneously. As a direct result, the Rite of the Latter Seven Days was instituted in 835. A Shingon seminary (Shingon-in) was built within the imperial palace compound for the rite. On the walls of the new structure were hung large paintings of the Mandalas of the Two Worlds (Ryōkai Mandara), the fundamental mandalas of Shingon esotericism, namely the Womb World Mandala (Taizōkai Mandara) and the Diamond World Mandala (Kongōkai Mandara) as the principal objects of worship. Images of the Five Great Wisdom Kings (Godai Myō-ō or Godaison) and Twelve Devas were also included.[3] The arrangement of the paintings in the chapel can be discerned from an image in the twelfth-century *Illustrated Scroll of Annual Events* [Fig. 5]. Another ritual practiced around the same time, but at a different location within the palace compound, was the Rite of the Great Commander, which had been brought back from Tang by Kūkai's disciple Jōgyō. The principal object of worship for the rite was an enormous painting of the eerie-looking Great Commander Wise King (Taigensui Myō-ō; Sk: Āṭavaka).[4]

During esoteric rites, the practitioners—not limited to the monks performing it but including all those involved in the rite—would face the principal deity of the fire-ritual (*goma*) portion of the larger rite. They would use their hands to form mudras (the "secret practice of the body": *shinmitsu*), use their mouths to chant mantras (the "secret practice of the mouth": *kumitsu*), and use their minds to contemplate the principal Buddhist deity (the "secret practice of the mind": *imitsu*). It was said that the deity would appear before the eyes of experienced practitioners, and as sentient beings they would receive the deity in their presence. They would immediately attain enlightenment in this body, not after death or years of austerities.

As seen in the case of the mandalas that contain systematically organized representations of all esoteric deities, the principal objects of esoteric

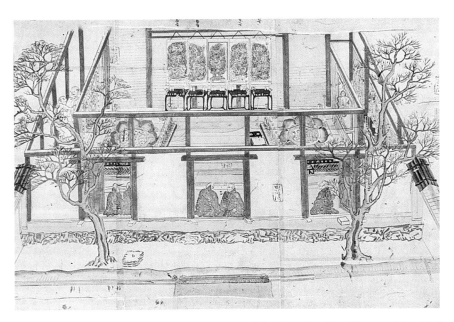

Fig. 5: "Imperial Rite of the Latter Seven Days of the New Year" in *Illustrated Scroll of Annual Events* (12th century), 1626 copy by Sumiyoshi Jokei and Gukei, Tanaka Family

rites were chiefly large-scale paintings displayed in the hanging-scroll format. Paintings were easier to transport than statues. In the case of the Rite of the Latter Seven Days in the imperial palace Shingon-in seminary, the principal objects of worship, the mandalas, would be brought from and returned to Tō-ji on each occasion. In this manner, rites required concentration of the mind and contemplation (*kansō*) of paintings of deities whose iconography was unfamiliar. This necessitated visual aids for understanding the complex imagery and hence new varieties of Buddhist painting developed. Most representative of this pictorial trend were the Mandalas of the Two Worlds.

3. The Mandalas of the Two Worlds

One etymology of the origin of the word *mandala* is that it derives from the words *manda*, meaning "essence," and *la*, meaning "to attain." The word was applied to an orderly arrangement of clay Buddhist figures positioned on a round outdoor altar made from earth. These configurations were used as visual aids to guide meditation. They began to appear from the fifth to sixth century and developed further into more systematic forms. Mandalas

are no longer found in India because they were deliberately destroyed after a ritual was completed.

As mentioned previously, the Mandalas of the Two Worlds, composed of the Womb World Mandala and the Diamond World Mandala, developed separately in India, but were paired and systematized in China. Esoteric Buddhist doctrine was visually represented by arranging various Buddhist deities around Dainichi Nyorai (Sk: Mahāvairocana) at the center of each mandala.

In the center of the Womb World Mandala is a lotus-flower-shaped area in which are painted eight buddhas or bodhisattvas encircling Dainichi Nyorai. This section of the mandala, called the Central Dias of the Eight Petal Court [Fig. 6] is said to represent a mother's womb. (For the entire mandala, see Fig. 3.) The two worlds have been described in the following terms: "The Womb World is an expression of the emotional, feminine principle that clarifies the principle of creation, while the Diamond World is an expression of rational, masculine knowledge that explains the law of spiritual existence."[5] What Kūkai learned from Huiguo was the non-duality of the principle that unites these two worlds. The doctrine behind

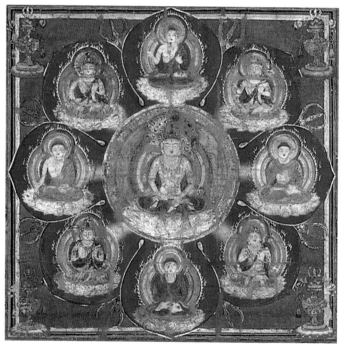

Fig. 6: Central Dias of the Eight Petal Court in the center of the *Sai-in Mandala* (Fig. 3)

the Mandalas of the Two Worlds is usually explained in this way, but their truth is ultimately considered secret. A mandala's meaning can only be deciphered by those who have performed the rituals repeatedly and have entered into the profoundest level of their mysteries. To the layperson, a mandala resembles a certain kind of graph or schematic diagram more than it does a painting. Nonetheless, mandalas are works of art in their own right, as seen in the excellent draftsmanship of those from the ninth century and the abundance of colors used in the *Sai-in Mandala*.

4. The Imagery of the Mandalas

Mandalas were hung and displayed in the ritual space created for each esoteric rite. Because of their large size, when these mandalas were repeatedly used, the silk backing would tear and pigments flake off. Furthermore, the soot from the burning wood in the fire rites would darken the surface. Consequently, almost all of the ancient mandalas that survive were made in the tenth century or later.

The mandala that Kūkai brought back from Tang China was called *Genzu Mandala* (a mandala with "currently practiced" iconography). Huiguo had commissioned Li Zhen (active 780–804) and other painters to produce this massive and colorful mandala especially for Kūkai; the final product measured 5 meters in height and 4 meters in length. However, within twenty years after his return to Japan, the mandala was seriously damaged from continuous use, and records indicate that Kūkai had a replacement made. The *Takao Mandala* [Fig. 1] at Jingo-ji appears to have been created for rituals held at the Initiation Hall during Kūkai's lifetime, sometime during the years 829 to 834. The *Takao Mandala* is the oldest extant reproduction of the original mandala brought back by Kūkai. The vivid colors of the original were replaced in the reproduction with gold and silver painted on a purplish-red woven twill ground. The silk background was significantly damaged through use, but the line work used to depict the central Dainichi Nyorai and the Fudō Myō-ō (Sk: Acala or Acalanātha) is superb, allowing us to imagine the beauty of the original mandala.

A recent theory suggests that the *Sai-in Mandala* [Fig. 3] comes from a different pictorial lineage than Kūkai's original mandala from China. These later mandalas are thought to have been created by the monk Shūei at the request of Emperor Seiwa and to have been modeled on the Mandalas of the Two Worlds introduced by Enchin. At only 185 centimeters in height,

they are rather small; the coloring shows Indian and Central Asian influences. The bodies of the Buddhist deities have round faces depicted in red outline and shading, and project a sensuous beauty.

Unlike the Mandalas of the Two Worlds, a *besson* mandala (literally a mandala of an individual deity) is one in which the most appropriate deity for a particular esoteric rite is pictorially represented at the center of the mandala and surrounded by lesser deities. There are over twenty mandalas of this type extant, such as those featuring Great Buddha's Crown, One-Letter Golden Wheel, *Humane King Sutra* (*Ninnō-kyō*), Treasure Tower, *Peacock Sutra* (*Kujaku-kyō*), and the Big Dipper. The only surviving mandala of this type dating prior to the tenth century is what is thought to be a *Taishakuten Mandala* (Indra mandala) painted on the back of the wooden wall panels behind the Yakushi Nyorai (Sk: Bhaiṣajyaguru, known as the Medicine Buddha) at Murō-ji temple in Nara prefecture.

Hakubyō, literally "white drawing," were images produced using ink to outline figures without the aid of shading. The technique was used to depict esoteric deities, mudras, and implements for ritual offering services in manuals for Buddhist rites, sculpture, paintings, and ritual implements. The *Essential Meditations on the Five Families of the Mind* in Onjō-ji temple (Ōtsu, Shiga prefecture) imported by Enchin from Tang China in the ninth century and the *Illustrations of the Mudras for the Susiddhi Ritual Procedure* in Tō-ji imported by Shūei, also from Tang China and dating to the ninth century, are some of the most famous illustrated manuals brought to Japan by the Eight Masters Who Journeyed to Tang.

The *Tantra for Wondrous Achievement in All Things* was a ninth-century addition to the Junmitsu canon in Japan, joining the other two major esoteric scriptures: *Mahavairocana sūtra* and *Vajrasekhara sūtra*. The strange appearance of the angry deities with blazing-flame mandorlas at their backs and bright red, blue, or yellow skin, as well as fangs and glaring eyes, is characteristic of Esoteric Buddhism. The Myō-ō (Wisdom Kings, Sk: Vidyaraja) were originally popular Indian gods who were later incorporated into the Buddhist pantheon; their role is to follow the orders of Dainichi Nyorai and vanquish the evil and passions lurking in the human mind. The Five Angry Deities, also known as the Five Great Wisdom Kings, are the principal deities of the *Humane King Sutra* (see note 3). The best known of these kings is Fudō Myō-ō. The ninth-century *Yellow Fudō*, which is kept as a secret devotional image (*hibutsu*) at Onjō-ji, was said to have been miraculously obtained by Enchin during his spiritual training.

The Twelve Devas were deifications of natural phenomena such as earth, water, fire, wind, sun, and moon that were worshipped in India as gods of nature. They were later positioned on mandalas as guardians of various directions. The Twelve Devas at Saidai-ji are mid-ninth-century paintings. (See Fig. 4: Taishakuten, one of the *Twelve Devas*.) Their pigments have since flaked away and the content of the images is difficult to make out. Despite the damage, one can sense from the entire image the generous, openhearted spirit of a painting that comes from an age with firm ties with Tang China. The vivid lines of the underdrawings can still be seen on the flanking deities.

In addition to paintings of Buddhist deities, Kūkai brought back portraits of the five Shingon patriarchs in the hanging-scroll format. These five portraits—of Kongōchi (Sk: Vajrabodhi), Zenmui (Sk: Śubhakarasiṃha), Fukū Kongō (Sk: Amogha or Amoghavajra, C: Bukong Jin'gang), Keika (C: Huiguo), and Ichigyō (C: Yixing)—had all been painted by famous Chinese court painters such as Li Zhen or other masters. In Japan, two additional patriarchs were added—Ryūmyō (Sk: Nāgārjuna) and Ryūchi (Sk: Nāgabodhi)—and together they formed the seven Shingon patriarchs preserved at Tō-ji. Perhaps because they were often hung together at rituals, wear and tear has caused substantial damage to each of the images. Among them, however, the painting of Amogha is in relatively good condition, and the acute depiction of his character demonstrates Li Zhen's mastery of the brush.

5. The Unique Character of Jōgan Sculpture

The impact of Esoteric Buddhism in China brought new pictorial themes to Chinese Buddhist painting, such as the Mandalas of the Two Worlds, the Twelve Devas, and Acala (Fudō Myō-ō). Their subsequent popularity in ninth-century Japan was covered in the previous section. Unfortunately, few paintings from that time survive. However, when we shift our focus to sculpture, we see that two critical changes took place between the late eighth century and the ninth century. The first was the growing popularity of carved wood sculpture, which supplanted Nara-period clay and drylacquer sculpture (*sozō* and *kanshitsuzō*). In these statues the wood surface was left untreated to reveal the beauty of the medium itself. The second was a stylistic change marked by emotive expression that was truly extraordinary.

The extant statues from this period are often called "Buddhist icons of the Kōnin era (810–24)" or "Buddhist icons from the Jōgan era (859–77),"

but I will refer to them collectively as Jōgan Buddhist icons. While generally in line with classical styles of Tenpyō sculptures, they are endowed with a powerful expressive character that contrasts with the older tradition. What triggered the innovative features typified by the standing Yakushi Nyorai [Fig. 8] in Jingo-ji? We marvel at the sense of volume evoked by the imposing torso with its thick chest, the enigmatic facial features, and the dynamic carving of the folds of the robe. The alternating rippling-wave pattern (*honpa* style) is a distinctive characteristic of the treatment of the folds of the robe.[6] The entire statue projects a spellbinding, incantatory aura.

Many specialists have drawn attention to the group of wooden sculptures at Tōshōdai-ji temple, Nara, mentioned in the previous chapter (Chapter 4, Figs. 12 and 13). Inspired by the arrival of Ganjin Wajō (C: Jianzhen) in 754, the group of sculptures in unfinished wood appears to have been created using new techniques from Tang China. These sculptures exude qualities unseen in earlier Tenpyō sculpture. Their mysterious facial expressions, the modeling that imparts an intensity to their bodies, and the carving of the folds of the garments are all the results of refreshing innovation.

While the unique character of the carving of patterns in the robes has been linked to Tang stone sculpture, as noted previously, there has also been speculation that this characteristic may reflect techniques used in statues carved from aromatic woods (*danzō*) then popular in Tang China.[7] The headless torso of the Standing Buddha (see Chapter 4, Fig. 13) is renowned for the beauty of the ripple pattern of the robes. The rope-like pattern of the robes is particularly significant as it captures the moment when the alternating rippling-wave pattern shifted to that of the later *honpa* style.

Another important aspect that has recently gained much attention is the emergence during this period of artistic forms grounded in the worship by common people of sacred mountains. This phenomenon has been obscured by the more conspicuous act of building official government temples. The nature of the standing Yakushi Nyorai at Jingo-ji and similar works is now being reassessed in terms of this new perspective.

A chief characteristic of unpainted Jōgan sculpture carved from a single block of wood (*ichiboku-zukuri*) was the close relationship to the spread of aromatic wood sculptures imported from China. The seated Yakushi Nyorai statue is the principal deity at Shin Yakushi-ji temple (Nara) [Fig. 7]. The impressive late eighth-century statue is considered to be the earliest large-scale Jōgan Buddhist sculpture that has survived to the present day. A

block of wood from a Japanese nutmeg-yew (*kaya*) was used for the main vertical section from which the entire work, including the legs, was carved. The broad shoulders, the imposing sense of volume, and the massive round face with sharp watchful gaze are striking. The wood of the nutmeg-yew tree provided an alternative to sandalwood.

The varying theories regarding the dating of the standing Yakushi Nyorai at Jingo-ji have not been resolved, but it is estimated to be sometime around the end of the eighth century to the beginning of the ninth century. The statue is usually said to have originally been the principal deity of Jingan-ji temple commissioned by Wake no Kiyomaro in an attempt to quash the ambitions of the power-seeking monk Dōkyō; it was subsequently moved to Jingo-ji.[8] Nagaoka Ryūsaku (b. 1960) cast doubt on this generally accepted theory and instead claimed that the statue was the principal deity of Takaosan-ji, the predecessor of Jingo-ji. More recently, Sarai Mai presented an analysis, which confirmed the theory that the icon was formerly the principal deity of Jingan-ji.[9]

In either case, the single-block nutmeg yew statue with its striking impact is one of the most enigmatic masterworks of Japanese sculpture, rivaled only by the Guze Kannon from the Asuka period (538–645) [Chapter 3, Figs. 8 and 9]. Behind such qualities as the deeply incised carving, the sense of volume, and the inexplicable energy radiating from the body and face was the worship of sacred trees by mountain-dwelling spiritual practitioners of Shugendō. The statue is covered in ochre-colored pigment in a deliberate effect employed to mimic the appearance of actual sandalwood. How can we explain the similarities and differences between this work and the group of wooden statues in Tōshōdai-ji? The art historian Uehara Shōichi (1927–2010) saw it as "a problem of the individual spirit of artistic creation, which cannot be fully explained and is inherent in all works that display

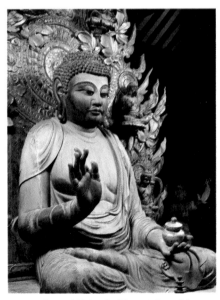

Fig. 7: Seated Yakushi Nyorai, late 8th century, Shin Yakushi-ji, Nara

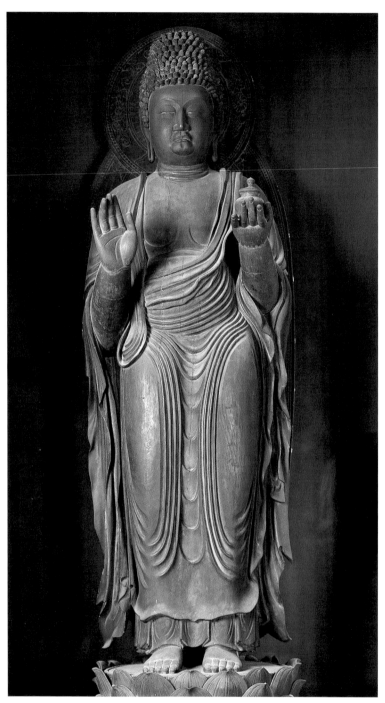

Fig. 8: Standing Yakushi Nyorai, early 9th century, Jingo-ji, Kyoto

the seminal spirit of art."[10] The Yakushi Nyorai statue predates Kūkai's introduction of systematized esoteric Buddhism to Japan. The image helps us remember that both Kūkai and Saichō trained as monks in the depth of mountains before embarking on their missions to Tang China. Furthermore, the origins of the ascetic practices of mountain worship (Shugendō) undoubtedly stretch far into the distant past of prehistoric Jōmon culture (see Chapter 1). Perhaps the astounding "seminal" artistic quality of the Yakushi Nyorai of Jingo-ji inspired the Buddhist sculptors of the period with the energy of the faith in sacred trees and awakened a residual Jōmon spirit.

Be that as it may, the sense of volume conveyed by the bodies of Jōgan Buddhist sculptures materialized in the Yakushi Nyorai of Jingo-ji is overwhelming. This statue stands in stark opposition to the generally accepted view that Japanese art is characterized by flatness. Can this statue simply be an exception?

The Yakushi Nyorai at Gangō-ji temple in Nara, thought to date to the early ninth century, represents the same deity as the statue at Jingo-ji and demonstrates a shift to a softer and more balanced form. The weighty body similarly exhibits an imposing air. On the other hand, the statues of the standing Four Guardian Kings (Shitennō) made in 791 and installed in the Hokuen-dō, a hall at Kōfuku-ji temple (Nara), and the early ninth-century Four Guardian Kings in the Eastern Kondō (Golden Hall) of the same temple have stylistic features different from those of the Nara period. They have Baroque-like elements—an exaggerated sense of volume, oversized gestures, and dynamic forms. The characteristics that emerged in wooden sculptures from the late eighth to early ninth century reflect the principles attributed to Kūkai that were based on the doctrines of pure Esoteric Buddhism. This in turn fed into the development of more diversified sculptural forms during the Jōgan period.

It is thought that mandalas were originally earthen altars on which three-dimensional figures were positioned in a prescribed configuration. These early three-dimensional mandalas were called karmic mandalas (*katsuma mandara*), and Kūkai created images based on these visual maps. During the period 819–24 he made iconographic representations of the Seven Revered Ones from the Diamond World Mandala for the lecture hall of Kongōbu-ji on Mt. Kōya. The icons were lost to fire in 1925 and only survive only in photographs. They are thought to represent a more sensuous expressionism that began to coexist alongside the wood-core dry-lacquer

tradition. Kūkai planned the statues of the twenty-one deities in the lecture hall of Tō-ji, although the eye-opening ceremony was held in 839 after his death. The statues that are carved from wood or a combination of carved wood and dry lacquer are based on the *Humane King Sutra* and the *Vajrashekhara sūtra*, but are thought to have been based on Kūkai's own design. Some contain signs of later efforts at restorations, but together they create an expansive cosmos, abounding with a powerful dynamism and displaying the essence of Esoteric Buddhism. Particularly impressive are the Five Great Wisdom Kings and the Four Guardian Kings [Fig. 9]. The passionate and dynamic expression far exceeds that of the standing

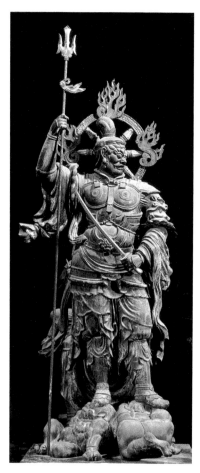

Four Guardian Kings at Kōfuku-ji, mentioned earlier. The deities in the lecture hall of Tō-ji were to later have an impact on the sculpture of Unkei (d. 1223; see Chapter 6).

The seated Five Great Sky Store Bodhisattvas (J: Godai Kokūzō Bosatsu, Sk: Ākāsagarbha) in the Hōtō-in cloister of Jingo-ji created in the first half of the ninth century [Fig. 10] are based

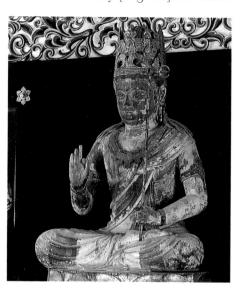

Fig. 9: Zōchōten (Virudhaka), one of the Four Guardian Kings, 839, lecture hall, Tō-ji, Kyoto

Fig. 10: Hokkai Kokūzō, one of the Five Great Sky Store Bodhisattvas, first half of the 9th century, Hōtō-in, Jingo-ji, Kyoto

on the *Sutra of the Pavilion of Vajra Peak and All Its Yogas and Yogins* that was introduced by Kūkai. These deities were also part of Kūkai's conception of a three-dimensional mandala in the halls of the temple complex. As sculpture, the bodies of the five similarly shaped deities are endowed with a firm sense of mass and perfect stability.

Another characteristic of Jōgan Buddhist sculpture is the voluptuous, sensual quality derived from Indian Esoteric art as seen in the *Sai-in Mandara*. The statue of Bonten (Sk: Brahmā) in the group of sculptures in the lecture hall at Tō-ji is an earlier example that captures this same quality. The seated Nyoirin Kannon (Wheel of the Wish-Granting Jewel Avalokiteśvara) at Kanshin-ji temple (Osaka prefecture) that was created in the mid-ninth century is a classic example of this sensuous beauty [Fig. 11]. This statue was, like the seated Five Great Sky Store Bodhisattvas at Jingo-ji, created by one of Kūkai's disciples. Based on the image in the Womb World Mandala, the icon was carved by a sculptor of superior artistic skill who imparted on the statue an engaging spatial quality. The torso with its voluptuous three-dimensionality is captivating. The standing Eleven-Headed Kannon from the mid-ninth century at Kōgen-ji temple in Kyoto [Fig. 12] is anomalous. Based on the Tendai tradition, this work was a departure from the numerous standing Eleven-Headed Kannon (Jūichimen Kannon) statues from the ninth century. The representation of the eleven heads above the crown is not seen in any other statue. The slightly twisted torso, the full hips, and the elegantly handsome face convey the sensuousness of Indian sculpture while revealing a delicate Japanese sensibility.

The double-chinned, chubby face of the standing Eleven-Headed Kannon created in the first half of the ninth century at Hokke-ji temple (Nara) was inspired by the image of a high-ranking woman, as was the Kanshin-ji statue, but here the gaze is more direct and forceful [Fig. 13]. Using the wood of the nutmeg yew tree in place of sandalwood, this unpainted figure evokes a mysterious spiritual aura that goes beyond mere sensuality. The strangely elongated arms are said to symbolize the bodhisattva's role in saving sentient beings. One scholar suggested in the 1920s that the pose captured the moment a striding figure came to a full stop. Exploring this idea further, the art historian Inoue Tadashi (1929–2014) saw the pose as an "expression of the movement of the wind," representing the miraculous transformation miracles of Kannon. Furthermore, he interpreted it as corresponding to the expression of energy (*ki*) said to reside in the works of the Tang painter Wu Daozi (680–740). Inoue's perspective of examining

Buddhist sculpture in terms of a theory of representation is stimulating. With its complexly intertwined celestial garments, the bodhisattva seated in the half-lotus position at Hōbodai-in, Gantoku-ji temple (Kyoto), represents a style rather unlike other Jōgan Buddhist sculptures [Fig. 14]. The sculpture is thought to have been made in the late eighth century, but here, too, Inoue discerns the representation of energy or *ki*.[11] Inoue also focuses on the fact that the many unusual single-block wood sculptures made in various regions of Japan were all attributed to the celebrated monk Gyōki (668–749).

Inoue suggested that the folk beliefs that formed the foundation of faith in Gyōki were reflected in the seemingly unfinished hatchet-carved sculptures whose eyes were deliberately carved unopened. He argued that these are the physical forms of the spirits

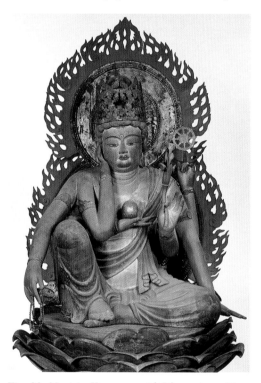

Fig. 11: Nyoirin Kannon, mid-9th century, Kan-shin-ji, Osaka

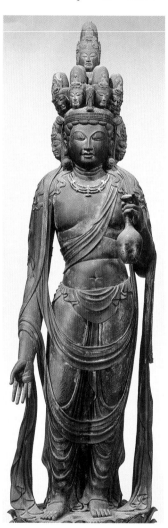

Fig. 12: Eleven-Headed Kannon, mid-9th century, Kōgen-ji, Kyoto

of the trees. Inoue felt that they represent the process of a Buddhist deity physically emerging from within a sacred tree. He concluded that many of these statues actually date as far back as the Nara period, when Gyōki was active, and not to the tenth and eleventh centuries as generally assumed. Although issues remain, Inoue's theories propose that these unusual sculptures be seen not as naive products but as deliberate representations of the manifestation of spiritual power.

There are a number of excellent examples of Jōgan Buddhist sculpture in Tōhoku, the northeastern region of the main island. Noteworthy works include the seated Yakushi Nyorai (dating to the first half of ninth century) at Shōjō-ji temple in Aizu (present-day Fukushima prefecture) and the seated Yakushi Nyorai (862) at Kokuseki-ji temple in Iwate prefecture. These simple works evoke a spellbinding, incantatory power rather than acting as objects of sheer beauty. They can be thought of as inheriting certain Jōmon characteristics that once thrived in the Tōhoku region.

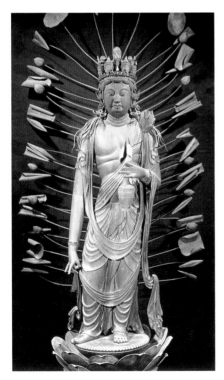

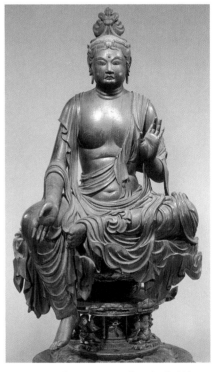

Fig. 13: Eleven-Headed Kannon, first half of the 9th century, Hokke-ji, Nara

Fig. 14: Bodhisattva seated in the half-lotus position, late 8th century, Hōbodai-in, Gantoku-ji, Kyoto

6. The Influence of Buddhism on Shinto Deities in Sculpture

When Buddhist icons were first brought to Japan in the sixth century, many people considered them the equivalent of Japanese *kami* (spirits), having the same character but simply of a different origin. Japanese previously had never represented *kami* in human form, and the brilliant appearance of the Buddhist statues must have been awe-inspiring. By the eighth century, Buddhist sculptures had spread through the land. As a result, various tales proliferated illustrating *kami* embarking on a Buddhist path such as that from Kehi Jingū-ji temple in Echizen province (a region in present-day Fukui prefecture).[12] Inoue Tadashi has explained that the mountain ascetics (*yamabushi*) who were associated with the cult of Gyōki, and who shared an animistic faith in sacred trees, practiced the ritual of carving a living tree into a Buddhist image. This marked the initial stage of the fusion of Buddhism and Shinto practices.

Depicting the *kami* as Buddhist deities or monks had already begun by the eighth century. The link with Esoteric Buddhism, centered on Mt. Hiei and Mt. Kōya, was a natural progression as it was originally a form of Buddhism associated with mountains and faith in sacred trees. Furthermore, this accelerated the fusion of Buddhism and Shinto beliefs.

In the ninth century, painted wood statues of male and female *kami* dressed in courtiers' robes were created. The fierce look of the seated male

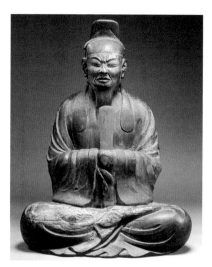 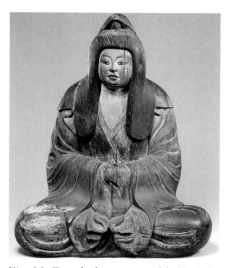

Fig. 15: Male *kami*, second half of the 9th century, Matsuo grand shrine, Kyoto Fig. 16: Female *kami,* second half of the 9th century, Matsuo grand shrine, Kyoto

kami from the second half of the ninth century in Matsuo grand shrine (Matsuo-taisha) [Fig. 15] is an expression of the "agony of a *kami* being a *kami*," according to the art historian Tanabe Saburōsuke (b. 1923).[13] In contrast, the carving of the seated female *kami* [Fig. 16] is characterized by voluminous garments and long hair. Both works project a stately and dignified manner, characteristic of Jōgan Buddhist sculpture. In the *kami* triad in Yakushi-ji temple, Nara, the expressions of the faces and the forms are more relaxed, with a human quality. The sculptures are a set of three, one male *kami* flanked by two female *kami*, one of which represents Empress Jingū. The writer Hashimoto Osamu (b. 1948) observes that in comparing the two female deities of this triad, Empress Jingū appears to be exceptionally voluminous on account of her large sleeves, which were signifiers of social status at the time. He sees these statues as the origin of Japanese dolls that prioritize the depiction of garments over the body itself.[14]

7. Secular Painting

Let us once more return to painting. In the ninth century, in addition to Buddhist paintings, secular paintings (*sezoku-ga*) with scenes from the everyday lives of the nobility came into fashion. This style of painting reflected Tang influence, as seen in the lute plectrum guard in the Shōsō-in Repository at Tōdai-ji (see Chapter 4, Fig. 19). We know from contemporary poetry written in Chinese (*kanshi*) that in 811 a tranquil landscape mural of mountain scenery was painted on the walls of the Emperor's residence (Seiryōden). Infrared examination of the six-legged "Chinese-style" chest originally in Tō-ji and currently in the MOA Museum of Art in Shizuoka prefecture, reveals images of various performers sketched in playful strokes.

Two famed painters were active during this period, Kudara no Kawanari (782–853) and Kose no Kanaoka (active in second half of the ninth century). The legend of Kawanari's masterful skill is found in tales of his unequaled technique and contests of painting prowess. One tale tells how a horse painted by Kanaoka on a wall galloped off in the middle of the night. There are also records of Kanaoka's work for the court. The renowned courtier Sugawara no Michizane ordered Kanaoka to paint a realistic image of the Shinsen-en imperial garden. That commission is said to have initiated a new fashion in painting. Unfortunately, neither of these paintings survive.

8. Calligraphy, Ritual Implements, and Lacquerware

Both Kūkai and Saichō had an unparalleled impact on the history of Japanese calligraphy. The style of calligraphy used in Kūkai's *Discourse on the Three Faiths* in Kongōbu-ji, his letter to Saichō in Tō-ji [Fig. 17], and a record of those who received esoteric initiation in Jingo-ji, as well as Saichō's letter to Kūkai in the Nara National Museum [Fig. 18], are all influenced by the calligraphy of the fourth-century Wang Xizhi (303–361) of the Eastern Jin (317–420), widely considered the Sage of Calligraphy. Wang Xizhi's brushwork was taken as the standard by Tenpyō-period (710–94)

Fig. 17: Kūkai, letter to Saichō (*Fūshin-jō*), first half of 810s, Tō-ji, Kyoto

Fig. 18: Saichō, letter to Kūkai (*Kyūkaku-jō*), 813, Nara National Museum

aristocrats. Kūkai wielded a spirited brush, creating an animated style, while Saichō's calligraphy demonstrates a calm elegance. Kūkai's calligraphy in Jingo-ji written in his later years, however, is reminiscent of the immediate and vibrant style begun by Yan Zhenqing (709–785). This demonstrates that Kūkai in later life moved on from the elegant style of writing established by Wang Xizhi. However, a calligraphy by Emperor Saga (786–842) of a transcription of the precepts received by the monk Kōjō dating to 823 in Enryaku-ji still adheres to the earlier elegant style of Wang Xizhi.

Among the many objects Kūkai brought back from Tang China were gilded-bronze Esoteric Buddhist ritual implements, such as vajras, vajra bells, and vajra trays. In China these types of implements exist only as excavated artifacts. Esoteric implements are symbolic of the spiritual power to crush evil and were often adapted from the forms of ancient Indian weapons. As indispensable tools of sacred ornament for Esoteric rituals and ceremonies, vast numbers were produced in Japan from the Fujiwara through the Kamakura period (894–1333), contributing to advances in metalworking [Fig. 19].

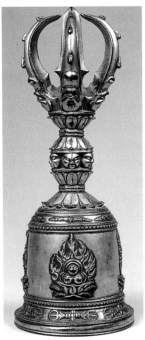

Maki-e, literally "sprinkled pictures," is a decorative technique applied to lacquerware. It involves sprinkling powdered gold and silver onto a damp lacquered surface, allowing the precious metals to adhere, and then polishing the surface to bring out a lustrous and smooth finish. The oldest reference to the *maki-e* technique can be found in *Taketori Monogatari* (*The Tale of the Bamboo Cutter*) thought to date to the early Heian period, and is Japan's oldest extant work of fiction. However, the technique is thought to have developed earlier during the Nara period. The Chinese-style sword with gold and silver inlay in the Shōsō-in Repository has a design created with the technique of burnished (*togidashi*) *maki-e* [Chapter 4, Fig. 20]. There are some dry-lacquer boxes with gold and silver decorations created using burnished *maki-e* from the late ninth to the early tenth century that survive to the present day. The *maki-e* lacquer document case with

Fig. 19: Five-pronged vajra, 11th–12th century, Kōki-ji, Kyoto

floral and mythical bird motif in Ninna-ji temple (Kyoto), dated to 919, was designed to hold thirty booklets containing ritual manuals and Buddhist scriptures introduced by Kūkai. Made around the same time was a box with a maritime motif in *maki-e* lacquer in Tō-ji [Fig. 20] used to store Buddhist robes (*kesa*) brought by Kūkai. While these designs on the boxes clearly retain links to those seen on the Shōsō-in treasures, they display a new delicate aesthetic sense more aligned to the next age of Fujiwara art.

Fig. 20: Box for Buddhist surplices, 10th century, Tō-ji, Kyoto

II. Fujiwara Art: A Period of Naturalization

1. The Formation of the Japanese-style in Art

Since the arrival of Buddhism in Japan from the sixth to the end of the eighth century, artistic expression was intimately linked to the arts of China from that same period. The same tendency is true with the arts of the Korean peninsula. Superficially, Japan seemed to fit comfortably within the East Asian artistic sphere centered on China. As we have seen though, exceptional cases that appear distinctly different from continental sensibilities do exist. They include the enigmatic Guze Kannon and the preference for naive, childlike expressions of Hakuhō and Tenpyō Buddhist sculptures.

By the ninth century, Jōgan art begins to take on a different complexion. On the one hand, the introduction of Esoteric Buddhism from Tang China led to the direct importation of foreign iconography, as in the Mandalas of the Two Worlds and the angry deities with fierce and formidable glares. On the other hand, Jōgan Buddhist sculptures, with their thick and broad chests and solemn facial features, projected an enigmatic individuality, unlike earlier Japanese statues that also differ from their contemporary Chinese counterparts. By the tenth century the *kana* syllabary, a writing

system representing the sounds of the Japanese language, was developed, allowing for the flowering of Japanese verse (*waka*). With this development an initial current of what can be identified as a Japanese culture came to the fore, and a *wayō* (Japanese style) began to emerge in the arts.

Southern Song Period	1127–1279
Yuan Period	1271–1368
Ming Period	1368–1644

Table 1: Chinese Periodization

The once-glorious Tang period of rule entered the road to decline from the second half of the eighth century, and collapsed in 907. Although Japan had by then already ceased sending official envoys to China, the news from the continent was surely a great shock. When the Song rules (960–1279), which had supplanted the Tang, signaled a desire to resume bilateral relations with Japan, the Japanese court refused to respond. The cultural relations with Song China were limited to those associated with commercial trade until the end of the eleventh century. Although there were cases such as that of the monk Chōnen who traveled to Song aboard a Chinese merchant ship in 983 and returned four years later with sculptures of Sixteen Arhats (Rakan) and a standing Sakyamuni (Shakamuni or Shaka) such ventures were exceptional. The birth and development of the "Japanese manner" (*wafū*) in art seen from tenth century onwards occurred amid these changes in Sino-Japanese relations.

It is worth noting here that the term *wafū* is not simply, nor necessarily synonymous with "Japanese-ness." The Japanese manner was limited to an aesthetic sense that was fostered within the daily environment of Kyoto-based aristocratic culture. The fact that the Japanese manner included surprisingly large elements of the Song style has recently been pointed out. And yet, this Japanese manner would hereafter become the keynote of Japanese art.

2. Esoteric Art of the Fujiwara Period

In contrast to the ninth century, when emperors continued to exert unchallenged authority, the tenth and eleventh centuries saw the aristocrats increasingly assert their prerogatives. They eventually supplanted the emperor's court and became the dominant force in government. In 969 (the An'na Incident), the Fujiwara clan was successful in banishing their rivals such as Minamoto no Taka'akira and implementing a form of politics

by regent in which they, as the regents, operated as they saw fit. It would be no exaggeration to say that the culture and art of the tenth and eleventh centuries were the creation of this aristocratic society headed by the Fujiwara clan. For this reason, I employ the term Fujiwara art. We will begin here with Esoteric Buddhist art after the ninth century.

As mentioned previously, Jōgan art of the ninth century was closely related to Esoteric Buddhist rites. Esoteric Buddhism maintained a powerful influence on aristocratic society during the Fujiwara period as well. Nevertheless, subtle shifts in the arts began to arise from around the end of the ninth century.

Murō-ji is known as the "Women's Mt. Kōya" because, unlike its namesake, women were allowed to enter its precincts. It is the only ninth-century esoteric mountain temple complex that survives intact. The temple continues to attract worshippers as it is tucked quietly away in the depth of a mountain far from urban centers. The main hall (Kondō), with its cypress-shingled roof, and the elegant five-story pagoda are both thought to have been built in the second half of the ninth century. Arranged within the Kondō are statues of five deities with colored wood-panel mandorlas. The body of the central deity, a standing Yakushi Nyorai [Fig. 21], is today fashioned from cloth saturated with black lacquer, but this is thought to be the result of later repairs. Because this statue shares numerous similarities with the seated Miroku Bosatsu (Sk: Maitreya, also known as the Buddha of the Future) at the Jison-in temple in Wakayama prefecture (made in 892), it is thought to date from the late ninth century. The intricately carved lines of the ripplet pattern in the folds of the robe are a stylistic refinement of the *honpa* style with its

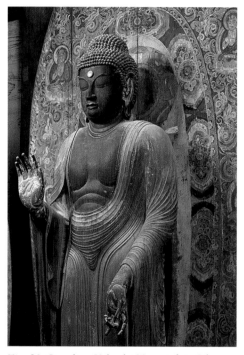

Fig. 21: Standing Yakushi Nyorai, late 9th century, Kondō, Murō-ji, Nara

alternating rippling-wave pattern seen on Jōgan-period sculptures. The character of the ripplet pattern combined the trend toward the intricate and a shallow flatness with the formalized and orderly Jōgan style. This seems to suggest that naturalization, or "Japanization," of single-block wood Jōgan Buddhist sculpture had in fact already begun as early as the late ninth century. The use of wood shingles rather than roof tiles on the Murō-ji Kondō and the delicate shape of the pagoda are related to this trend. The remarkable standing Eleven-Headed Kannon, sporting a plump feminine face, appears to have been produced in the same period as the central deity.

If we examine the Mandalas of the Two Worlds from this period, the *Kojima Mandalas* (first half of the eleventh century), kept at Kojima-dera temple in Nara, were created with techniques similar to those used for the *Takao Mandala*; gold and silver paint were applied on an indigo ground. In addition, their state of preservation is far superior to that of the *Takao Mandala*, and it is prized as a rare example of a large-scale work mounted in a hanging-scroll format. However, the *Kojima Mandalas* rely on neat and careful brushwork and display none of the uninhibited brushstrokes used to illustrate the deities in the *Takao Mandala*.

Three of the paintings of the *Five Mighty Bodhisattvas* [Fig. 22] survive from the set of five that was later transferred from Tō-ji to Mt. Kōya by order of pre-eminent daimyo Toyotomi Hideyoshi (1536–1598). These paintings were employed in the Humane King Assembly (Ninnō-e), a ritual assembly that used the *Humane King Sutra* in prayers for the stability of the state. Each painting measures over 3 meters in height and depicts an angry deity with an extraordinary appearance. Backed by roaring-flame mandorla painted on a silk ground, they radiate an awful and overwhelming aura. These five bodhisattvas originally served as the main deities of an earlier version of the Humane King Assembly, a New Year's event held along with Gosai-e (the Buddhist service to pray for the stability of the state and abundance). These rituals had been performed in the palace compound since the Nara period. As a result of Esoteric Buddhism's influence, the bodhisattvas were transformed into these rather fierce images. Their sheer scale and dynamism are sufficient evidence to presume that they are ninth-century creations, but their two-dimensionality and colors have led some scholars to suggest a tenth-century date.

The five-story pagoda of Daigo-ji temple (Kyoto) [Fig. 23] was completed in 951 and is one of few remaining examples of a multi-story pagoda from this period. Figures from the Mandalas of the Two Worlds and images

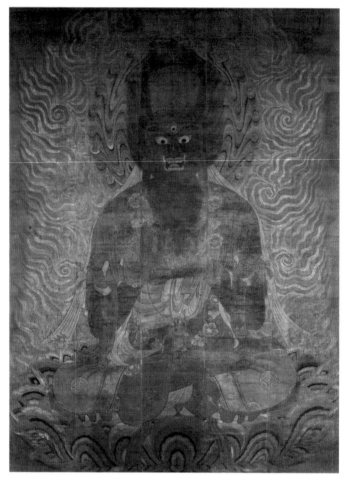

Fig. 22: "Kongōku Bosatsu," one of the *Five Mighty Bodhisattvas*, 10th century, Mt. Kōya

of the eight Shingon patriarchs are painted on the covering panels of the central pillar, side columns, and the horizontal panels between them on the ground floor. In concert with gradient-color designs, these figures vividly ornament the interior space. The images of deities painted directly on the surfaces of the panels are relatively well preserved. The gentle lines, the forms of the many deities, and color combinations signal that the elegant characteristics of Fujiwara art were already becoming apparent.

The paintings of the *Five Great Wisdom Kings* [Fig. 24] at Kiburi-ji temple in Gifu prefecture have inscriptions with dates equivalent to 1088 and 1090. As only a handful of Esoteric Buddhist paintings remain from

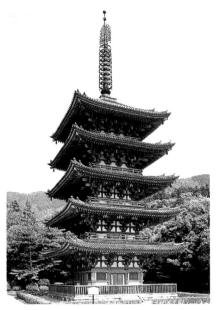

Fig. 23: Five-story pagoda, 951, Daigo-ji, Kyoto

this period, these are precious examples for understanding the style of the late eleventh century. These rather small-scale paintings of Fudō Myō-ō and the other five angry deities measure about 140 centimeters in height. Lacking the cut gold leaf (*kirikane*) typical of twelfth-century Buddhist paintings, they display an archaic ninth-century Buddhist painting style. The imagery as a whole is restrained and rather eerie. Characteristic of these paintings is the depiction of the flaming mandorlas, which appear to be enlarged versions of the small mandorlas behind the four angry deities illustrated in the Jimyō-in court of the Womb World in the *Sai-in Mandala*. Another key characteristic is the use of *teriguma*, a graduated highlighting or shading technique by which areas of the body and garments were highlighted in white to give the impression of reflecting light, a feature of twelfth-century Buddhist paintings.

Among the Five Great Wisdom Kings, Fudō Myō-ō was considered to be a manifestation of Dainichi Nyorai. Fudō was the most revered and popular deity among the angry deities of Esoteric Buddhism. The earliest images of Fudō often depicted the deity seated with both eyes open, such as the Fudō in the lecture hall of Tō-ji. But after the Tendai scholar-monks such as Annen expounded on the "Nineteen Appearances of Fudō for Contemplation," Annen's version became more prevalent. In this iconography, Fudō sits with his left eye half closed in a penetrating squint and his upper and lower fangs bite into his lips; he is flanked by his two youthful acolytes, the earnest Kongara Dōji (Sk: Kimkara) and the mischievous Seitaka Dōji (Sk: Cetaka). The painting *Blue Fudō and Two Boy Attendants* (*Fudō Myō-ō Ni Dōji*), often called the *Ao Fudō* (Blue Acala), at Shōren-in temple in Kyoto [Fig. 25] is the oldest version of this iconographic type painted in color, and it is thought to date to the eleventh century. The depiction of the well-proportioned body, the designs, and the painstakingly created

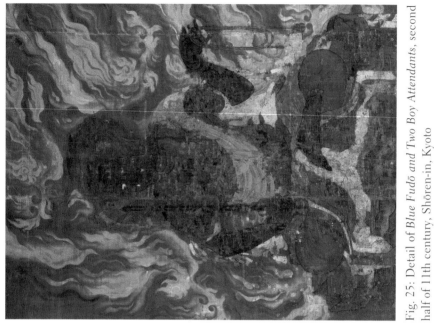

Fig. 25: Detail of *Blue Fudō and Two Boy Attendants*, second half of 11th century, Shōren-in, Kyoto

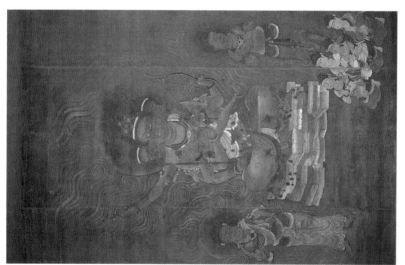

Fig. 24: "Gōzanze Myō-ō," one of the *Five Great Wisdom Kings*, 1088, Kiburi-ji, Gifu prefecture

details as well as the beautiful flaming mandorlas in carefully distinguished hues of vermilion and crimson all suggest this painting came from the hand of a master. The *Aka Fudō* (Red Acala) at Myō-ō-in temple on Mt. Kōya is also based on the "Nineteen Appearances of Fudō for Contemplation," but the style suggests that it was produced in either the twelfth or thirteenth century.

From the tenth century onwards, Esoteric Buddhist rituals, both public and private, employed pictorial forms of deities found in the esoteric scriptures that had been brought to Japan by the Eight Masters Who Journeyed to Tang. It became popular to worship these deities depicted in the basic mandalas as the central object of worship in esoteric rites either as an individual or in a group. Behind this shift was the loss of Kūkai's grand vision of a unified esoteric world. His world was now being split into distinct units comprised of protective deities that might bring this-worldly benefit or the avoidance of calamities to an individual person or family. Faith and worship of Fudō Myō-ō was part of this phenomenon. The fact that statues gradually became smaller in size, and the appearances less menacing, is likely related to this change in devotional practice.

3. Seeking Rebirth in the Pure Land

The Conception of the Rebirth in the Pure Land

The most significant event to occur during the tenth and eleventh centuries in terms of popular thought was the dissemination of the Tendai conception of the Pure Land in aristocratic society. The Tendai school competed with the Shingon school in importing a pure form of esoteric teachings to Japan from Tang China. It was able at the same time to successfully promote the idea of rebirth in the Pure Land presided over by Amida Nyorai (Sk: Amitabha). This belief was nothing new. As discussed in Chapter 3, the hope of rebirth in Amida's Pure Land can already be observed in the seventh and eighth centuries, as attested by Lady Tachibana's private devotional shrine. This desire was no longer simply something uttered at memorial services in prayers for the rebirth of the deceased. Some scholars have recently posited that the motivation likely included a desire for one's own rebirth. However, from the standpoint of the strength of the faith on the part of an individual believer, the post-tenth-century idea of rebirth in the Pure Land differed from earlier views. The Fujiwara clan was no

exception. They had faith in Amida's Pure Land but combined it with pre-vailing Esoteric Buddhist teachings. Belief in Esoteric Buddhism offered escape from suffering in this life, while Pure Land faith promised comfort in the next. The biggest influence on the spread of belief in the Pure Land in aristocratic society was the *Essentials of Rebirth* (*Ōjō Yōshū*, 985), a book written by the Tendai monk Genshin (942–1017).

Reverberations from the *Essentials of Rebirth*

Genshin wrote his treatise the *Essentials of Rebirth* in 985 while living as a recluse at Yokawa within Enryaku-ji on Mt. Hiei. The first chapter, dedicated to the concept of abandoning this polluted world, describes the six realms of transmigration and emphasizes the ultimately disappointing nature of reality. The 136 large and small subdivisions in the realm of hells are described in lavish detail. The human realm is characterized by the putrid filth of decomposing bodies. The second chapter, dedicated to joy in seeking the Pure Land, depicts paradise and describes the happiness of being reborn in the Pure Land.

The four ensuing chapters are elaborations of the teachings on the aspiration for enlightenment and methods of contemplation. Furthermore, the treatise concisely introduces about a thousand passages taken from over 160 Buddhist and other texts, including the *Great Cessation and Contemplation* (*Mohe zhiguan*, lectures by Zhiyi, 594), which clearly demonstrates Genshin's vast knowledge and powers of imagination. Soon after its completion, the text was sent to China, where by the following year it was being read by over five hundred monks at Guoxing Si temple on Mt. Tiantai.

4. Ornamenting Paradise of Pure Land Teachings

The teachings of the *Essentials of Rebirth* emphasized chanting the name of Amida, in a practice usually called reciting the *nenbutsu* in English. In addition, the visualization of lifelike scenes of the paradise where Amida resides, and thus viewing the Buddha in a practice known as *kansō nenbutsu*, contemplation and recitation was also emphasized. These ideas and practices attracted for the first time genuine interest in the afterlife that was independent from esoteric faith in incantations and spells. The politically powerful Fujiwara clan with its concern for the stability of the family in this world had at first been unable to abandon their reliance on spells, but

they were equally unable to resist the teachings found in the *Essentials of Rebirth*. An important causal factor in bringing about this change was the idea that the world had entered the final stage of the Buddhist dharma (*mappō*) in the year 1052. The Fujiwaras depleted their wealth in a competitive fervor to build extravagant halls dedicated to Amida (Amida-dō) and other buildings that emulated the magnificence of the Pure Land paradise of Amida.

Hosshō-ji temple (925), built in Kyoto by Fujiwara no Tadahira, who is said to have done the "utmost for good and the utmost for beauty," was the first of such ambitious projects. In 1020, Fujiwara no Michinaga (966–1028), the most powerful of the Fujiwara regents, built an Amida Hall enshrining nine large *jōroku*-sized Amida images (see Chapter 3, note 9), also in Kyoto. The hall was called Muryōju-in. Soon afterwards Michinaga added a Hall of Five Great Wisdom Kings, a Kondō (the main Golden Hall), a Yakushi-dō (Hall of the Medicine Buddha) and a Shaka-dō (Hall of Sakyamuni). Collectively the structures formed a temple complex called Hōjō-ji. The complex symbolized the glory of the Fujiwara clan. Michinaga died in the Amida Hall holding five-color strings attached to the hands of the nine Amida statues, and surrounded by monks chanting "Namu Amida-butsu" (We take refuge in Amitabha Buddha). The temple complex was destroyed by fire in 1058, thirty-one years after Michinaga's death.

In 1053, Michinaga's son Yorimichi built an Amida Hall at the Byōdō-in temple in Uji south of Kyoto. He donated his villa to create the temple. This hall was later to become known as the Hōō-dō (Phoenix Hall). In the following years the Byōdō-in saw the addition of several buildings, including a pagoda, Lotus Meditation Hall, and a Hall of the Five Wisdom Kings, thus insuring that it rivaled Michinaga's Hōjō-ji in magnificence. Fires, many related to warfare, destroyed most of the halls and pagodas by the end of the medieval period, and today only the Phoenix Hall remains. The Phoenix Hall is the sole structure built by the Fujiwara clan that documents the architectural legacy of Pure Land beliefs.

The Phoenix Hall [Fig. 26] gets its name from the shape of the building. Its two-story corridors connect the central hall to the wings, which together resemble the mythical bird. As the interior was intended to recreate the Pure Land, sculptures and their mandorlas and canopies were covered in gold leaf radiating a golden glow. Circular mirrors embedded in the vividly colored coffered ceiling would have shone with light reflected off the front-garden pond. The sculpture and paintings in this temple embody

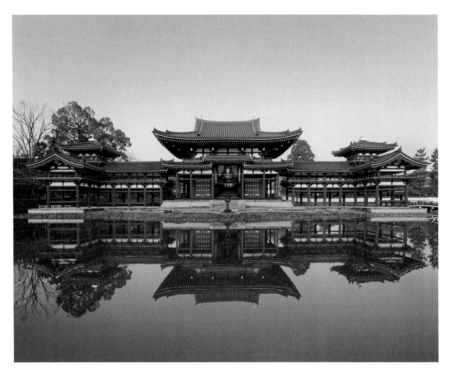

Fig. 26: Phoenix Hall, 1053, Byōdō-in, Uji, Kyoto prefecture

the essence of Fujiwara art: the main deity, the seated Amida Nyorai, carved by the master sculptor Jōchō (d. 1057); the small-scale statues of Fifty-Two Celestials, known as Bodhisattvas Making Offerings in the Clouds, also produced by Jōchō's studio; the two gilt-bronze phoenix at either end of the top-rafter ridge; and the door panels painted with images of the nine levels of rebirth in the Pure Land (see Fig. 30).

5. The Development of Aristocratic Residential Architecture

It is said that the architecture of the Asuka and Nara periods (592–794), as epitomized in the style of the East Pagoda of Yakushi-ji (see Chapter 4, Fig. 1), favored and retained the simplicity seen in early Tang buildings. This is not to say that Japanese architecture simply mimicked Chinese styles. Japan had experienced substantial development in architectural engineering since the Kofun period (late third to beginning of the eighth century) and it was on this foundation that it selected and improved on imported styles. For example, cypress-bark roofs and wooden-plank floors

had been used in temples from the Nara period. The process of domestication of imported elements had already begun at that time. During the Heian period, Japanese climate, environment, and aesthetics combined to accelerate the development of a Japanese style (*wayō*). Changes in the construction of roofs and eaves are one of the main characteristics of the trend. The Phoenix Hall with its deep eaves and detailed embellishment of its bracketry and floor spaces can be considered the epitome of Japanese style elements found in temple architecture.

It was, however, in the residential architecture of the Heian aristocracy that Japanese style took an even clearer form. The prime example is the type of residential architecture known as *shinden-zukuri* [Fig. 27]. Although original buildings in this style no longer survive, we can still learn a great deal from documents and excavations. Centered on a south-facing main residence, annexes would extend to the east and west, linked by covered passageways. A pond would be dug to the south of the main residence, where a fishing pavilion would also be built. This could be accessed from a corridor from either the east or west annex. Fujiwara no Michinaga's Tsuchimikado-dono residence was designed in this symmetrical fashion but also included a north annex in addition to the east and west annexes. The roof of the main residence was laid with cypress bark, and the garden offered a green sanctuary beyond the eaves-covered outer corridors. Besides the occasional solid plaster wall demarcating storage areas, there were no internal barriers. To partition living space and to prevent drafts, bamboo blinds (*sudare*) and various types of screens and curtains were used. The Seiryōden, the hall within the inner palace compound that served as the emperor's residence, was also constructed in the *shinden* style. The *Illustrated Scrolls of the Tale of Genji* from the twelfth century provides a glimpse of the beautifully decorated interiors of these residences [Figs. 50 and 51]. The asymmetrical residences of Michinaga and Yorimichi marked a shift from the original symmetrical design of the *shinden-zukuri* mansions and led to a later residential style called *shoin-zukuri* (study style).

6. Naturalization of Buddhist Sculptures and the Sculptor Jochō

The Buddhist sculpture made from the tenth through the eleventh centuries displays new characteristics that differ from those of the solemn icons made in the ninth century. Let us explore this point by examining several sculptures that can be dated with certainty.

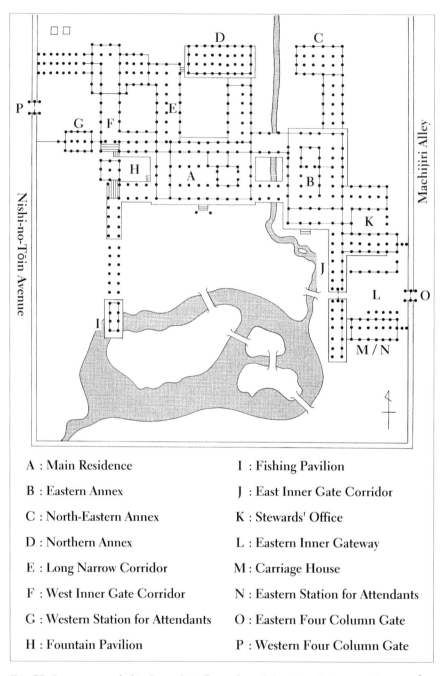

Fig. 27: Reconstructed *shinden-zukuri* floor plan of the Higashi Sanjō Palace by Ōta Seiroku, 1941; from Chino Kaori, *10–13 seiki no bijutsu, ōchō-bi no sekai* (The Beautiful World of Court Culture: Art of the 10th–13th Century), 1993.

The monk Eri was a disciple of the Shingon monk Shōbō, who trained at Tōdai-ji and eventually opened Daigo-ji. Eri oversaw the production of Daigo-ji's principal icon, the Yakushi Triad installed in the Kami-Daigo Yakushi-dō, the hall dedicated to Yakushi Nyorai. The sculptures were completed in 913. The faces retain the stern expressions typical of Jōgan sculpture, while the overall shape and the softness of the robes point to a new artistic direction. The face of the seated Amida Nyorai (946) at Kyoto's Gansen-ji temple also conveys the tension seen in Jōgan sculpture, but the facial features are softer with a more feminine cast.

The Eleven-Headed Kannon (951) of Rokuharamitsu-ji temple in Kyoto was originally the central deity at Rokuharamitsu-ji's precursor Saikō-ji temple, built by Kūya. Kūya was a monk known as a holy man who promoted the practice of calling on Amida as a means of salvation (*nenbutsu*). The body of this statue also evokes a sense of volume in the Jōgan fashion, while the plump cheeks and the folds of the garment have a much gentler appearance. These statues embody both a serene sensibility and harmonious expressions indicating the transition from Jōgan to Fujiwara style a movement toward "naturalization." The celebrated Fujiwara-period monk sculptor Jōchō built his reputation during such changing times.

The Buddhist sculptor Kōshō (dates unknown) was Jōchō's master and, some argue, his father. He had a particularly strong connection with the Tendai school centered on Mt. Hiei and created Buddhist sculptures under the direction of Genshin, leading to patronage by the Fujiwara clan. It is said that Kōshō and Jōchō worked in collaboration to create the Nine Figures of Amida for Michinaga's Muryōju-in (1020) in Kyoto. The fact that the two were pioneers in the Japanese style of Buddhist sculpture is evident from a single glance at the Fudō Myō-ō statue made in celebration of Michinaga's fortieth year. This statue is thought to have originally been the central deity in the Hall of the Five Wisdom Kings at Hosshō-ji; it is currently housed in Dōju-in, Tōfuku-ji temple (Kyoto). It is an imposing *jōroku*-sized statue, but lacks the oppressive quality usually associated with ninth-century Fudō Myō-ō statues and instead emphasizes balance and elegance. The graceful expression of the trailing hair along the left chest is a remarkable example of his artistic achievement.

In 1020, a ceremony was held to dedicate the newly completed *jōroku*-sized Nine Figures of Amida at Hōjō-ji, the new name given to the temple formerly called Muryōju-in. Fujiwara no Tadazane, the regent at the time, wrote about this event in *Chūgaishō*, his record of matters from 1137 to

1154 he had heard from his predecessors. He described a monk of about twenty who worked diligently under the guidance of the master sculptor Kōshō to adjust the image with a chisel and hammer in hand. He was carving the golden face of the Buddha when Michinaga asked who he was. The reply came back from Kōshō, "He is Jōchō, a disciple of Kōshō." This episode conjures up the image of Jōchō as a youthful prodigy.

Two years after this event, Jōchō carved a Dainichi Nyorai and various other deities for the Kondō of Hōjō-ji, as well as the Five Great (Godai) Wisdom Kings for the Godai-dō. He was granted the title "Bridge of the Law" (hokkyō) for these works, which made him the first monk sculptor to receive such a title. Later, he would be promoted to "Eye of the Law" (hōgen).[15]

The seated Amida Nyōrai [Fig. 28] in the Phoenix Hall dated to 1053 is the only extant statue confirmed as a genuine work by Jōchō. It stands at the pinnacle of Fujiwara-period sculpture, representing the perfection of the classical style (hon'yō) of Japanese sculpture. It is considered classical through a combination of the orderliness of well-balanced and proportioned body parts, the gentle drape of the garment, the serenity of the facial expression, and the power of the narrow eyes to draw the viewer in. The fact that the main deity of Pure Land Buddhism is depicted with an Esoteric Buddhist hand gesture (Sk: mudra) demonstrates the fluidity between the two schools in this period. Fujiwara no Sukefusa, the author of a diary known as the Shunki (existing entries from 1026 to 1054), evaluated one of Jōchō's Amida statues from this period, saying "the icon was like the full moon" in its perfection. The influence of Esoteric Buddhist iconography was also suggested in recent scholarship on the Fifty-Two Celestials, which hang on the tie beams of the hall. Whatever the case, the bodhisattvas would have been painted in vivid colors, without doubt enhancing the ethereal beauty of the interior that was created as an earthly version of the Pure Land.

The statue of Amida in the Phoenix Hall used the new sculptural technique of assembled-wood construction (yosegi-zukuri). This technique involved combining two or more blocks of wood to create the main parts of the statue such as the head and the torso. Compared with Jōgan single-wood-block sculptures, statues created with the new method were easily hollowed, more resistant to cracking, and lighter weight. Assembled-wood construction also allowed for the use of smaller trees. Furthermore, the technique led to several other advantages such as division of labor, better project management, and production in large numbers. While the

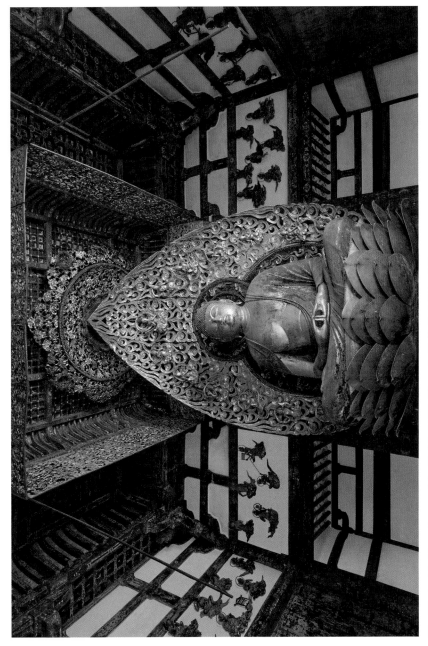

Fig. 28: Amida Nyorai, carved by Jōchō, 1053, Phoenix Hall, Byōdō-in, Uji

technique was hailed as a revolution in wood carving, it led to formalization of the finished products.

The statue of the seated Archbishop Rōben at Tōdai-ji is a masterpiece of eleventh-century portrait sculpture. The carving of the proud Rōben (689–773), the founder of Tōdai-ji, sitting erect in all his glory, is representative of portrait sculpture of the Fujiwara period. Its date of production is thought to be 1019, but some argue for a ninth-century date.

7. Sculptures after Jōchō: Hatchet-Carved Sculptures

According to an entry from 1134 in the diary of Minamoto no Morotoki, *Chōshūki* (existing entries from 1105 to 1136), there was a statue of a seated Amida, considered to be Jōchō's masterpiece, installed in a hall then known as the Hall of Kunitsune. The statue was described as "the classical form of the Buddha among all those under heaven," and it was widely copied. It is said that Morotoki took careful measurements of even the finest details with the help of the monk-sculptor Inchō (dates unknown).

In the second half of the eleventh century, Jōchō's disciple Chōsei (1019–1091), who followed his master as the leading sculptor of the period, was granted the title Seal of Law (*hōin*). He also founded the En school of Buddhist sculptors. Chōsei's work—including statues of the bodhisattvas of sunlight and moonlight (Nikkō and Gakkō Bosatsu) and the Twelve Guardian Generals (1064) at Kōryū-ji, along with the seated Amida Buddha at Hōkai-ji (both temples are in Kyoto)—is faithful to Jōchō's "classical form" but projects a somewhat flatter style.

While I have already addressed the provocative viewpoint of Inoue Tadashi regarding single-wood-block sculptures with round hatchet marks (*natame*), it is now widely recognized that these hatchet-carved statues were being made as early as the ninth century. The hatchet marks were transformed into a decorative element on statues that began to appear in eastern Japan in the tenth and eleventh centuries, such as the Yakushi Triad of Hōjōbō temple in Kanagawa prefecture and the Eleven-Headed Kannon at Gumyō-ji temple, also in Kanagawa prefecture.

8. Fujiwara Buddhist Paintings

According to the art historian Izumi Takeo (b. 1954), Buddhist statues and Buddhist paintings used in ceremonies were both simply called buddha

(*hotoke* or *butsu*) in the records of the day. When it was necessary to spec-ify that the work was a painting and not sculpture, the terms *ebutsu* and *hotoke no ezō*—both of which mean a picture of a Buddhist deity—were regularly employed. Unlike today when we make a firm distinction between a Buddhist painting (*butsuga*) and a Buddhist sculpture (*butsuzō*), there was apparently little need to distinguish these two as long as they functioned to convey the image of the deity. Both sculptural and pictorial forms of the Buddha were inseparably bound by three common threads: "ceremony," "sacred ornament," and "the image of a Buddha." With this idea in mind, let us examine Buddhist paintings.

The Mandala in Esoteric Buddhist Iconography

We have seen the strong links between Esoteric Buddhism and Fujiwara art in sculpture. In addition, I have explored the trend toward naturaliza-tion, as seen in the decoration of the interior of the ground level of the five-story pagoda of Daigo-ji, the *Kojima Mandalas* at Kojima-dera, and the *Five Mighty Bodhisattvas* on Mt. Kōya. Another important example is the incised image of *Zaō Gongen*, the principal deity of Shugendō (1001) [Fig. 29], originally presented to Mt. Kinpusen, a sacred site for Shugendō practitioners. This incised image on bronze, which reflects the fusion of angry Esoteric Buddhist deities with the mountain worship tradition, is particularly valuable as Buddhist paintings from the age of Michinaga, the zenith of Fujiwara art, have not survived. The period's pursuit of "the exquisite" can be seen in the finely incised lines that depict this extraordi-nary-looking deity.

Paintings of Pure Land Teachings

The Hall of Constant Practice (Jōgyō-dō, referring to a form of walking meditation) on Mt. Hiei was founded by the priest Ennin (see note 2). Its walls were painted with scenes of Amida, accompanied by bodhisattvas, descending to the human world to welcome the deceased to the Pure Land (*raigō-zu*). Similar scenes were painted on the walls of the Amida Hall at Michinaga's Hōjō-ji. Although these examples are no longer extant, the paintings on the door panels of the Phoenix Hall have survived. They have suffered serious damage from graffiti and peeling paint, but they are the only extant eleventh-century polychrome murals. The *Collection of Written*

Fig. 29: *Zaō Gongen*, 1001, Nishiarai-daishi, Sōji-ji, Tokyo

and Spoken Tales from the Present and the Past (*Kokon Chomonjū*), a compendium of brief anecdotes from the thirteenth century, attributes the work to Takuma Tamenari (dates unknown), a court painter. The *Nine Grades of Rebirth in the Pure Land* portrays Amida radiating light, and the left, right, and front panels are primed in thick white pigment to represent this radiance. The center-front door panel is an Edo-period (1615–1867) restoration, but the panels to its left and right and both door panels are preserved in relatively good condition. A recent discovery revealed that under each of the panel frames there is an inscription with specific grades of rebirth.

The nine grades of rebirth in the Western Paradise are prescribed in scripture as being dependent on the balance of good and bad deeds in this life. In the paintings, however, all are received in the same fashion in paradise. The welcome of Amida in the "Lower Grade of Rebirth, High Level" [Fig. 30] is a relatively well-preserved image. Amida, who is descending before the home of the soon-to-be-reborn believer, the two bodhisattvas who serve as guides, and the bodhisattvas who follow playing musical instruments are all depicted in willowy curved lines. The skirt-like garments sway like curtains of undulating seaweed, and the faces of the deities are all gentle.

The background of the descent of Amida and his retinue is reminiscent of the landscape around Uji, where the temple is located. The gently rolling green hills overlap one another, there are pines and other trees, and a river runs through the scene into which small images of natural features appropriate to the four seasons have been added. The clouds carrying Amida and his attendants approach, hovering low as they traverse the gaps between the hills. Deities in the foreground are large while those in the distance are minuscule. This is a magnificent example of eleventh-century perspective.

The paintings feature seasonal changes in nature. The north door depicts early to mid-spring. Beginning with the snow-dusted spit of land and dried reeds, it moves to the arrival of spring warmth suggested by a thatched farm house, a farm woman poling a boat, a roaming horse, and finally some mountain cherry blossoms and budding young greens. The south door panel shows autumn. It illustrates a wicker fish trap, deer frolicking in the mountains, and autumnal foliage. The two side panels on the east

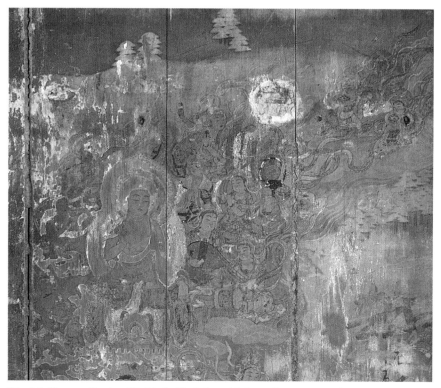

Fig. 30: "Lower Grade of Rebirth, High Level," from the *Nine Grades of Rebirth in the Pure Land*, 1053, Phoenix Hall, Byōdō-in, Uji

show summer with willows by the waterside, a mountain temple, grass huts, valleys, waterfalls, flying birds, and rows of mountain peaks. These images are based on Tang precedent, but also depart from those models. One sees in these images the painters' intent to create a new manner of painting that would fit Japanese scenery and aesthetics. The images from the *Nine Grades of Rebirth in the Pure Land* in the Phoenix Hall function as both Buddhist paintings and the first indication of the arrival of the *Yamato-e* of Japanese style, which will be discussed further in coming sections.

Depicting Sakyamuni

In 1052, the Heian aristocracy manifested a renewed adoration of Sakyamuni with the Buddhist belief in the coming of the end of the world with the final stage of the Buddhist law *mappō*. Nirvana assemblies, memorializing Sakyamuni's entry into nirvana (*parinirvana*) in the second month, were becoming increasingly popular in temples throughout the land, and the ceremony was performed even in the imperial palace. Large nirvana paintings (*nehan-zu*) would be hung during these religious services. *Buddha's Nirvana* (1086) [Fig. 31], a painting preserved at Kongōbu-ji on Mt. Kōya, is one such stunning example. Each of the many bodhisattvas surrounding the body of Sakyamuni, as well as his mother, Lady Maya, in the sky above, is a uniquely individual figure filled with dignity. The facial expressions and poses of the grieving arhats and kings amid the assembled mourners heighten the drama of the scene. Dominating the composition as a whole is a serene sense of calm, and the optimistic feel of the composition is reminiscent of early Renaissance religious painting.

Sakyamuni Emerging from the Golden Coffin [Fig. 32] is another masterpiece of Heian Buddhist painting, rivaling *Buddha's Nirvana*. The painting depicts the dramatic scene of Sakyamuni emerging from a golden coffin in response to the pleas of his mother to preach the Dharma (Buddhist law). In the center of the painting is the miraculously arisen Buddha. He is surrounded by bodhisattvas, their retinues, the masses, and animals with their gazes fixed on the center, creating a scene that captures an instant of tension and excitement. Like *Buddha's Nirvana*, it evokes a sense of calm in the depiction of figures such as the plump Lady Maya. In contrast, the lines of varying thickness used to depict Sakyamuni's robe and the cloth wrapping his begging bowl and the caricature-like treatment of faces in the bewildered gathering can be seen as precursors to techniques deployed in

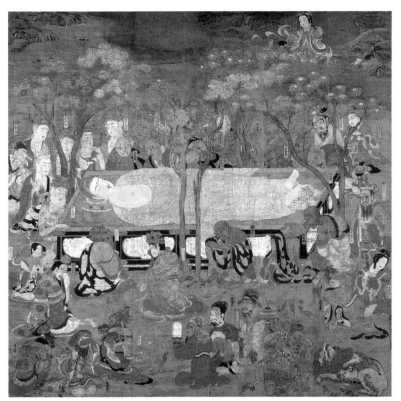

Fig. 31: *Buddha's Nirvana*, 1086, Kongōbu-ji, Mt. Kōya

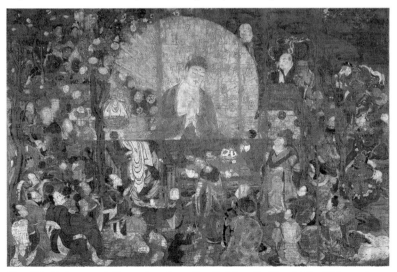

Fig. 32: *Sakyamuni Emerging from the Golden Coffin*, 11th–12th century, Kyoto National Museum

twelfth-century picture scrolls (*emaki*). The work was probably completed around the year 1100, shortly after *Buddha's Nirvana*. The murals of *Nine Grades of Rebirth* on the walls of the Taishi-dō, a hall dedicated to Prince Shōtoku, at Kakurin-ji temple in Hyogo prefecture (1112) are almost impossible to see with the naked eye. Only by using infrared rays can one see the scenes on the upper portion of the wall. Interestingly, the lower half shows scenes of devastation, such as the destruction of temples, killing, illicit relations between men and women, and visitors from hell.

Portraits of Patriarchs and Arhats

A group of ten hanging scrolls from the Fujiwara period kept at Ichijō-ji temple in Hyogo prefecture was produced after the Jōgan-period portraits of the seven Shingon patriarchs. Known collectively as *Prince Shōtoku and the High-Ranking Monks of the Tendai Sect*, the set includes a portrait of the great Indian sage Nagarjuna (Ryūmyō), founder of Mahayana Buddhism, as well as the Tendai patriarchs and Prince Shōtoku, who was a great advocate of the *Lotus Sutra*, an important Buddhist text. The images filling the closely cropped silk background are extremely varied. The large-headed Zenmui (Sk: Śubhakarasiṃha), a monk from southern India who brought Esoteric Buddhist practices to China, gazes off to one side. He seems familiar, and is easily identified with. A well-preserved example such as the image of Nagarjuna [Fig.33], which uses red as the keynote color in combination with softer greens and blues, shows that the emphasis was placed on color rather than design. The vermilion shading of the flesh and the highlights added to the folds of the robes are techniques linked to the emphasis on color of twelfth-century Buddhist paintings. Cut gold leaf (*kirikane*), also characteristic of later paintings, was not used; instead, the detailed colorful designs

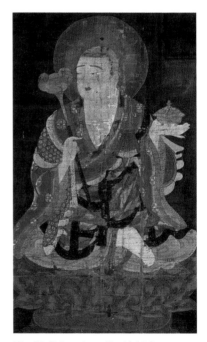

Fig. 33: "Nagarjuna," mid-11th century, Ichijō-ji, Hyogo prefecture

were painted. Nagarjuna is depicted as a handsome monk in this portrait. The portrait of Great Master Cien at Yakushi-ji depicts this patriarch of the Hossō school and disciple of the priest Xuanzang, who was a Central Asian nearly 2 meters tall. His brows are somewhat heavy, but this portrait too is that of a handsome man. Sei Shōnagon (c. 966–c. 1025), a court presence and renowned author, wrote in section 30 of *The Pillow Book* (*Makura no Sōshi*, late tenth to early eleventh century): "It is better if the preacher of the Law is handsome. If one continues to look deeply into his eyes, one will eventually appreciate the glory of his teaching."

9. Buddhist Decorative Arts and Calligraphy

As mentioned in Chapter 3, Buddhist art can be likened to a symphony combining architecture, sculpture, painting, and decorative arts into a harmonious whole that promotes the Buddhist world. The Buddhist art of the Fujiwara and the following period, which underwent a more profound naturalization, was also a comprehensive system. Extant examples from this period are extremely rare, however, limited chiefly to the Phoenix Hall in Uji and the Golden Hall at Hiraizumi in Iwate prefecture, both within registered UNESCO World Heritage sites. We need to use our imagination to piece together records in historical documents, such as *A Tale of Flowering Fortunes* (*Eiga Monogatari*, eleventh century) with surviving fragments of art works.

As is the case with eleventh-century paintings and sculptures, only a handful of decorative objects remain from this period. One of the rare surviving works is the magnificent sutra box with the Merits of the Buddha illustrated in *maki-e* [Fig. 34]. On the surface of the deep overlapping lid is a dreamlike world where musical instruments and peacocks dance in the air and lotus petals are scattered across the surface. Scenes from tales in the *Lotus Sutra* (*Hoke-kyō* or *Hokke-kyō*) are depicted in gold and silver *maki-e* lacquer on the eight sides of the box and lid in a pictorial style similar to that on actual frontispieces of the *Lotus Sutra* scrolls. It appears at first glance that each of the images is thematically independent. However, they are actually a single narrative linked by images that move from the lid to the body of the box. As one explores the images, the pictures reveal an amazing world rich in narrative, as though one were viewing an illustrated handscroll. It is appropriate that the word *e* (*picture*) is included in the term *maki-e*, though strictly speaking the word defines a technique involving the

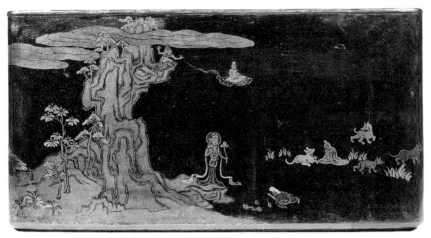

Fig. 34: Scene depicting Kannon from the *Lotus Sutra* on a sutra box, 11th century, Fujita Museum of Art, Osaka

sprinkling of powdered metal as described previously. Its pictorial possibilities are keenly felt here.

Three great calligraphers were active from the tenth to the beginning of the eleventh century. Ono no Michikaze (894–966) displays his mastery of Wang Xizhi's calligraphic style in the *Gyokusen-jō* [Fig. 35]. Here, however, he has deliberately deformed the calligraphy, using large bold characters together with thin wispy ones to create a rhythmic, unrestrained style. This marks the birth of Japanese-style calligraphy. Fujiwara no Sukemasa (944–998), who came to prominence half a century after Michikaze, further enhanced this trend, producing animated and playful calligraphy that almost seems alive, as in the *Onna Guruma-jō* (982; Shogei Bunka-in, Tokyo) [Fig. 36] and *Riraku-jō* (991; Hatakeyama Memorial Museum of Fine Art). Incidentally, these two samples of Sukemasa's calligraphy are taken from letters apologizing for his failings; even so, he maintained his fresh and playful brush style. The calligraphy of Fujiwara no Yukinari (971–1027) in the *Hakushi Shikan* displays the classical elegance preferred by the Fujiwara aristocracy and corresponds favorably with the *kana* (phonetic) calligraphy of the period.

The Japanese script *hiragana* was created between the ninth and tenth centuries by abbreviating an older style of writing known as *man'yōgana*, in which Chinese characters were used to represent the sounds of the Japanese language rather than their original meanings. At first, each *kana* or phonetic symbol was written separately, but a cursive style soon developed

Fig. 35: Detail from the *Gyokusen-jō*, calligraphy by Ono no Michikaze, 10th century, Museum of the Imperial Collections (Sannomaru Shōzōkan), Tokyo

Fig. 36: Detail from the *Onna Gurumajō*, calligraphy by Fujiwara no Sukemasa, 982, Shogei Bunka-in, Tokyo

Fig. 37: *Kōya gire Kokinshū*, attributed to Ki no Tsurayuki, mid-11th century, Gotoh Museum, Tokyo

that linked individual characters with the rhythmic repetition of delicately curved lines. The beauty of swirling *kana* calligraphy on specially prepared paper with ornate designs occupies a unique place within the calligraphic traditions of the world. Many of the works written in *kana* calligraphy were originally mounted as handscrolls and albums but were later cut or unbound for use as objects of appreciation in tea gatherings or preserved as individual excellent examples (*kohitsu-gire*). Among these, a fragment containing a poem from the *Kokin Wakashū* (or *Kokinshū*; *Collection of Japanese Poems of the Past and Present*, 905), called the *Kōya-gire*, is considered the finest example of eleventh-century *kana* [Fig. 37]. The calligraphy of the *Anthology of Thirty-Six Poets* (*Sanjūrokunin Kashū*), belonging to Nishi Hongan-ji temple (Kyoto), and that of the text of the *Genji Monogatari Emaki* (*Illustrated Scrolls of the Tale of Genji*) are examples of twelfth-century *kana* calligraphy by master calligraphers.[16]

10. The Court Painters

The names of the artists responsible for creating the best examples of Jōgan and Fujiwara painting are almost completely unknown. There are no surviving examples of the work of master painters, unlike sculpture where we find works by masters such as Jōchō. According to historic documents, however, the previously mentioned famous painter Kudara no Kawanari, who was active in the first half of the ninth century, was highly regarded by the court. There was also a family of painters who went by the name Kose, whose lineage began in the early ninth century and continued on until the end of the Heian period. The founder, Kose no Kanaoka, who was active in the second half of the ninth century, was also known for his talent as a garden designer. *The Tale of Genji* (*Genji Monogatari*; 1000s–1010s) attributes the painting of the *Taketori Monogatari Emaki* (*Illustrated Scrolls of the Bamboo Cutter*) to the painter Ōmi (mid-Heian period) from the Kose lineage. Kose no Hirotaka (mid-Heian period) was another prominent painter active in the studio associated with Fujiwara no Michinaga's projects. Kose painters occupied a central place among the master Buddhist painters of the southern capital of Nara, where their line boasted a lengthy history during the medieval period. In addition, the court painter Asukabe no Tsunenori was active in the mid-tenth century, during the reign of Emperor Murakami (reign 946–967). Tsunenori is recognized as a major contributor to the rise of the *Yamato-e* painting style.

11. The Birth of Japanese-Style Painting

Some scholars have classified paintings as religious or secular based on the presence or lack of religious themes in the imagery. Using this classification scheme, *Yamato-e* or Japanese-style painting would belong in the secular category. There are cases, however, of religious paintings borrowing elements normally considered secular. The images on the door panels in the Phoenix Hall and the later *Scrolls of Hungry Ghosts* are two such examples. The boundaries between the two painting genres are ambiguous. This is an important point to consider before discussing the beginnings of *Yamato-e* paintings.

At about the time Esoteric Buddhism was brought to the Japanese court, Chinese poetry (*kanshi*) thrived in aristocratic circles. Poems composed on murals and folding screens that are included in anthologies of Chinese poetry from the time neatly correspond to images described in Tang poems of dark valleys deep in the mountains where immortals and sages reside and phoenixes fly around. The poem "On the Landscape Mural in the Seiryōden" in the *Keikokushū* anthology of poetry (827) is a good example. Murals painted in the halls of the imperial palace precisely fit the definition of Tang-style landscape.

As Japanese poetry (*waka*) began to flourish in the second half of the ninth century, the situation changed dramatically. A poem on screens found in the *Kokin Wakashū* reveals that Japanese scenery was becoming a chosen topic for paintings.[17]

The earliest example of a poem of this type is one composed by the monk Sosei between 869 and 876 and titled, "When the Nijō Consort was Known as the Companion of the Crown Prince." The headnote to the poem gives the topic "Crimson leaves floating in the Tatsuta River, painted on a palace folding screen." The poem reads:

> Unheard of in the age of gods
> So awesome
> Red runs the water
> 'Neath the leaves
> Over Tatsutagawa

In the imperial anthology *Collection of Gleanings of Japanese Verses* (*Shūi Wakashū*, c. 1005), there is a poem composed during the Nin'na

era (885–89), on the topic "A place where a woman is bathing in a river on the seventh day of the seventh month." Thereafter, the number of screen-poems referring to Japanese pictorial topics gradually increased. This demonstrates that domestic pictorial themes for paintings on folding screens (*byōbu-e*), shoji (*shōji-e*), and fusuma (*fusuma-e*) grew increasingly popular. Paintings of this type were eventually categorized as four-seasons painting (*shiki-e*), paintings depicting monthly events (*tsukinami-e*), and paintings of famous places, which depicted celebrated spots in each province (*meisho-e*), often with a reference to a specific season that the place was renowned for. These paintings dealt with identical pictorial topics. For instance, images of famous places focused more on seasonal order than on geographic accuracy. These genres are collectively called *keibutsu-ga*, paintings of scenic views with seasonal references. *Keibutsu-ga* as a genre is a modern concept, however, *keibutsu* is a term used in this period of Japan, as well as in China (C: *jingwu*).[18]

Accompanying the establishment of these Japanese pictorial topics was the appearance in the late tenth century of the term *Yamato-e* for paintings of Japanese scenery. In parallel, the term *Kara-e*, Chinese paintings, was also created. These are mentioned in a passage from Sei Shōnagon's *Pillow Book* that lists "Wonderful things: *Kara-e* on folding screens and sliding doors." According to the art historian Akiyama Terukazu (1918–2009), the terms *Yamato-e* and *Kara-e* were originally used to distinguish wall or screen paintings that drew on either Japanese or Chinese imagery. However, as new styles of *Yamato-e* paintings of *keibutsu* grew popular, the styles of Chinese *Kara-e* were absorbed into them. From the thirteenth century onwards the term *Kara-e* came to refer to the monochrome Southern Song and Yuan-period paintings from China, which had just been introduced in Japan. We will return to this topic in Chapter 7. The term *Yamato-e* was then applied to all paintings treating secular themes that employed traditional Japanese techniques.

Incidentally, the term *Yamato-e* that appeared at this time has an important place in the history of painting as it came to represent Japanese painting in general. *Yamato-e* images were primarily painted on everyday household furnishings such as folding screens, room separators, and sliding-door panels, and consequently none of them have survived. One can only search for an understanding of early stylistic trends by reading the historical record for examples such as the screen-poems.

The pictorial topics of *Kara-e* that we know from references in litera-ture include those for sliding-door panels that depicted rough seas, a pond constructed by Emperor Wu of the Han, horses, and sages. In contrast, *Yamato-e* dealt with themes using motifs drawn from the four seasons. Spring was suggested by New Year's morning snow, plum blossoms, and warblers. Summer scenes included the Kamo (or Aoi) festival in Kyoto, rice planting, cormorant trainers, waterfalls, and summer evenings. Autumn included the Star festival (Tanabata), moon, autumnal grasses, and deer. Winter was illustrated by snow, mountain villages, and the *tsuina* ritual for dispelling demons. The landscape backgrounds of the Phoenix Hall door panels mentioned earlier are seasonal images of the Uji area. The Yuki and Suki screens for the Emperor's enthronement ceremony (Daijō-e) were folding screens commissioned specifically for the accession ceremony conducted for a new emperor. Two provinces, one for each screen, were selected by divination, and scenes of famous places in the provinces were painted on the screens. These scenes combined both views of the famous places and the four seasons. Topics included scenes from distant provinces such as "bush clovers of Miyagino" and "the Musashino plain in winter," and thus painters in the capital would have to rely on their imagination to create these scenes. Also depicted were various scenes of daily life, includ-ing sensuous ones between men and women; they predate those seen in seventeenth-century genre paintings and Edo period ukiyo-e paintings.

The motifs employed in these *keibutsu-ga* paintings can be identified from poems that were painted on various types of screens, sliding-door panels, and other room partitions. Collectively paintings in these formats are referred to as *shōheki-ga* or *shōhei-ga* (both terms mean paintings on screens or walls). However, the term *shōheki-ga* excludes paintings on fold-ing screens, while *shōhei-ga* is more inclusive, referring to painted surfaces that include folding screens.

Shōhei-ga were practical items that were painted on furnishings kept in interior spaces; when damaged, old, or out of fashion, they were readily replaced. For this reason, it is extremely rare to find *keibutsu-ga* paintings from the Heian period today. The survival of the Phoenix Hall door panels is an exception. They remain because they were elements of temple architec-ture designed as sacred ornament. Several landscape folding screens (*senzui byōbu*) are extant because they were used to ornament the ritual space used for Esoteric Buddhist consecrations. The landscape folding screen from the

second half of the eleventh century [Fig. 38] at Tō-ji is the only surviving example from the Heian period of this type. Near the center of the painting an old recluse wearing Chinese garb seems to be pondering a poem [Fig. 39]. Visitors can also be seen. In the background, stretching nearly to the top edge of the screen, a gentle panorama spreads with cherry blossoms, willows, wisteria, and other flowering plants representing a peaceful day

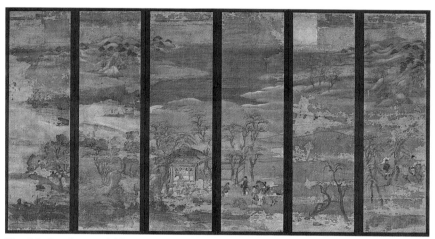

Fig. 38: Landscape folding screen, second half of the 11th century, Kyoto National Museum (formerly at Tō-ji)

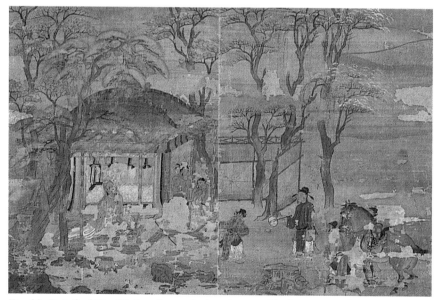

Fig. 39: Detail of Fig. 38, fourth panel picturing an elderly man in Chinese garb

in spring. The elderly Chinese-looking man is said to be a visual stand-in (*mitate*) representing the master Tang poet Bai Juyi (772–846) and to that extent this painting is an example of *Kara-e*. However, the manner in which the natural scenery surrounding the aged recluse is depicted does not differ to any great degree from techniques used on Phoenix Hall panels or the early thirteenth-century landscape screen from Jingo-ji, discussed below.

The painting of the *Sixteen Arhats* (Jūroku Rakan) once belonging to Shōjuraikō-ji temple (Ōtsu, Shiga prefecture) and now in the Tokyo National Museum collection appears to have been painted in the second half of the eleventh century, on the basis of stylistic features. It is considered the oldest depiction of the sixteen arhats made in Japan. The archaic expressions of the arhats familiar from Tang and Five Dynasties paintings have been transformed, given a Japanese *Yamato-e* interpretation.

The landscape folding screen [Figs. 40 and 41] at Jingo-ji is likely the autumn screen from what was originally a set of four-season screens.[19] Natural objects revealing the seasons stud the landscape of rolling hills dotted within *shinden*-style residences and mountain villas. The seasons would have unfolded in a temporal progression from late summer to early winter, according to the arrangement of the screens based on a hypothetical reconstruction. From the right is a bathing scene followed by women from the court admiring lotuses flowering in a pond. The screen goes on to show an autumn rice field, autumnal grasses, such as bush clover, and men with horse-drawn carts carrying tribute to the capital. Migrating birds and wild ducks playing near the water's edge indicate the arrival of winter. There is no discernable focal point to the composition. Buildings are enveloped in the natural scenery and people going about their ordinary lives are minutely depicted. This is a classic example of *Yamato-e keibutsu-ga*. This screen is somewhat later than the screen at Tō-ji; it probably dates to shortly after the start of the Kamakura period (1192–1333) in the twelfth century.

12. Additional Eleventh-Century Paintings

As I have noted, works that have survived from the tenth and eleventh centuries are extremely rare and many are so badly damaged that discerning the content of the images is virtually impossible. The situation is particularly unfortunate as this was the seminal period for *Yamato-e*. The folding screens known as the *Illustrated Biography of Prince Shōtoku* (Tokyo National Museum) were once painted on the walls of the Picture Pavilion

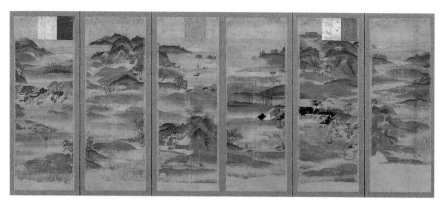

Fig. 40: Landscape folding screen, late 12th century or early 13th century, Jingo-ji, Kyoto

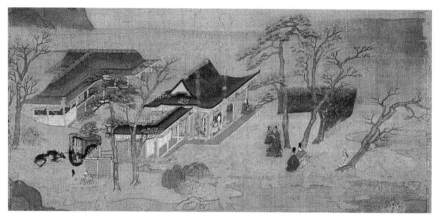

Fig. 41: Detail of Fig. 40, sixth panel picturing *shinden*-style residence

(*eden*) of Hōryū-ji and used as aids for preaching with pictures (*etoki*). Rare for this period, we know with certainty the name of the painter (Hata no Chitei) and the year they were painted (1069). The images are severely worn and additional brushwork from later restorations is prominent, leaving the original image drastically altered. Despite the damage, the paintings contain many scenes covering events in the prince's former lives, up through his death. These scenes fill the broad pictorial space, marking this as an important Buddhist narrative painting. The *Illustrated Biography of Prince Shōtoku* screens are also an important resource in understanding the influence from Chinese Buddhist narrative paintings of the seventh and eighth centuries, such as the *Transformation Tableaux of the Lotus Sutra* (C: *Fahua jing bianxiang tu*) in the Mogao caves at Dunhuang.

13. Pure Land Gardens and the *Record of Garden Making*

Blessed with flowing waters and surrounding mountainsides, artfully shaped stones and river rocks, Kyoto is the perfect setting for the creation of a garden. It was customary for aristocrats using the full extent of their property to build ponds as part of a garden on the south side of the main *shinden*-style residence. Ponds would generally come complete with a small island and a bridge. A so-called Fishing Pavilion would be built at the edge of the pond, where it could be used for moon viewing or respite from the summer heat. The *Record of Garden Making* (*Sakuteiki*) said to be by Tachibana no Toshitsuna (1028–1094), a son of the regent Fujiwara no Yorimichi, offers instruction on the contemporary practice and theory of garden design. It gives specific advice, for example, on how to place rocks to express a seascape and counsels one to "obey the wishes of the rocks" when setting them together. It also explains methods of stone placement that would bring to mind such images as "a pack of crouching dogs," "a calf nestling with its mother," and "children at play." Intriguingly, it provides information on the various taboos required to avoid the curses of the rocks, revealing the Heian belief in animistic nature.

In another example, Michinaga's garden at Hōjō-ji is described with some poetic license in *A Tale of Flowering Fortunes* (*Eiga Monogatari*). It records that the Buddha appeared on a man-made lotus placed in the garden pond and that trees of the four seasons cloaked in netting were strung with jewels, and precious metals grew around the periphery. In this fashion, Heian aristocrats attempted to recreate in their residences scenes of the Pure Land.[20]

III. Insei Art:
The Utmost for Good and the Utmost for Beauty

1. Aesthetics at the "End of the World"

The year 1086 marked both the institution of Insei (the rule of retired emperors) by Emperor Shirakawa (1053–1129) and the creation of the painting *Buddha's Nirvana* mentioned in the previous section [Fig. 31].

The Insei period spans three generations of rule by powerful monarchs, the retired emperors Shirakawa, Toba (1103–1156), and Go-Shirakawa (1127–1192). With the establishment of the military government in Kamakura by Minamoto no Yoritomo (1147–1199) and the death of Retired Emperor Go-Shirakawa in 1192, the Insei period drew to a close. The roughly hundred-year period can be divided into two: the first half, dominated by retired emperors Shirakawa and Toba, ending with the pivotal Hōgen Disturbance of 1156, and the second under Go-Shirakawa's sway.

The original impetus for Insei rule was regulation of the estates (*shōen*) controlled by the Regent's house (the northern branch of the Fujiwara clan), a policy that the monarchy vigorously supported. As a result, the monarchy, led by the retired emperor, became the largest landholder of estates in Japan. In addition, the wealth of the emerging class of custodial governors, who were closely associated with the retired emperors, increased substantially. Consequently, the monarchy monopolized wealth and lived extravagantly, but, at the same time, this led to internal disputes and conflict between retired and reigning emperors. It must not be overlooked that in this process abdicated emperors employed bands of warriors to operate their estates. The armed conflicts known as the Hōgen and Heiji disturbances broke out under just these circumstances.[21]

Retired Emperor Shirakawa—who was responsible for creating the circumstances that led to the uprisings of the Hōgen and Heiji eras, which some see as watershed events dividing the ancient from the medieval period—was also a fervent Buddhist. He built Hosshō-ji in 1077 in the Shirakawa area of Kyoto east of the Kamogawa River. According to the *Fusō Ryakki* (Abbreviated Records of Japan), a late-twelfth century chronicle of Japanese history, the temple's main hall was a tiled, rectangular structure seven bays in length, enshrining a golden Birushana (or Rushana, Sk: Vairocana), three-*jō* and two-*shaku* (approximately 9 meters) tall. The Amida Hall was a rectangular tiled hall eleven bays in length and housing nine golden statues of Amida Nyōrai, each of *jōroku* size (4.8 meters). There were also two 7.6-meter statues of the guardian Kongō Rikishi, Vajravira deities, guarding the temple from the Great South Gate (Nandaimon).

Hosshō-ji also had an imposing octagonal nine-story pagoda approximately 102.6 meters tall that was built in 1081. The cultural historian Hayashiya Tatsusaburō (1914–1998) argued that the temple, which was laid out in the style of the former Shitennō-ji temple complex with the

various halls arrayed along a single axis (see Chapter 3, Fig. 3), was based on "a powerful display of stately power." He places Hōsshō-ji at the top of the list in a lineage of eccentric architecture built by powerful rulers, such as the Sanjūsangen-dō (Hall of Thirty-Three Bays), the pagoda of Shōkoku-ji temple built by Ashikaga Yoshimitsu (1358–1408), both in Kyoto, and Azuchi Castle (Shiga prefecture) built by Oda Nobunaga (1534–1582). Retired Emperor Shirakawa built other temples as well, including Shō Kongō-in (1101) at Toba Imperial Villa and Rengezō-in (1114) in the Shirakawa area. In his lifetime he commissioned an astonishing 5,470 statues, of which over 600 were of *jōroku* size (4.8 meters).

Retired Emperor Go-Shirakawa was an equally devout Buddhist. He is said to have made thirty-four pilgrimages to Kumano during his lifetime, and each round-trip took well over a month. He was also an enthusiastic proponent of the popular songs (*imayō*) of the day, which often had Buddhist themes, and compiled an anthology of them called the *Secret Selections of Songs to Make Dust on the Rafters Dance* (*Ryōjin Hishō*, 1169). Known for his insatiable curiosity, Go-Shirakawa is recorded to have made a sudden impromptu visit to a lacquer artisan's studio in the town, which naturally caused quite a stir. He also traveled to Fukuhara (in the present-day Kobe area) at the invitation of Taira no Kiyomori (1118–1181) to meet visitors from Song China. The treasury of his Rengeō-in temple, today's Sanjūsangen-dō, was a repository for the treasures the retired emperor had amassed. The holdings included approximately sixty *Illustrated Scrolls of Annual Events* as well as *Paintings of the Six Realms.*

As is symbolized by the individualistic and uninhibited behavior of the retired emperors, the culture of the Insei period demonstrated a wealth of extraordinary developments appropriate for a time of transition from the ancient to the medieval period. Four major characteristics of the age are apparent. First, it was an age of the increasing popularity of "the idea of reclusion" in despair over the immanent approach of the end of the world. This concept can be seen in *Hōjōki* (*Record of a Hut*, 1212) by Kamo no Chōmei (c. 1155–1216). Secondly, it was an age of play and adornment (*kazari*). A prime example can be seen in the reaction of the custodial governor Ōe no Masafusa to the costumes of the participants in "the Great Ritual and Dance Performance (*Dai dengaku*) of the Eichō era" (1096). Masafusa praised them, saying, "As for the clothing, they have done the utmost for good and the upmost for beauty, it is as if they had festooned

and polished themselves; they have made clothing out of gold embroidery and decorated it using silver and gold." Third, it was an age of beauty, an age in pursuit of the "beautiful form." Buddhist icons needed to be attractive, and having a "beautiful form" was even a prerequisite for becoming a police commissioner. The fourth characteristic, which grew out of the unease created by the rapidly changing transitional period, was the birth of realism. This was best represented in the *Paintings of the Six Realms*, which reveal a concern with the ugliness that lurked behind the beauty. Realism here reflects a fundamental move away from idealized beauty.

The historian Ishimoda Shō (1912–1986) judged the period as a time of "unbridled dissipation of wealth," of "an excess of temple building and amusements," and as a time when "evil and corruption dominated the ruling strata to an extent unprecedented in the history of the ancient state."[22] If we set aside this type of moralistic viewpoint and focus instead on the arts, we begin to see that Insei-period culture was indeed committed to the pursuit of beauty but, at the same time, looked unflinchingly at an ugly and grotesque world full of hungry ghosts and illness. We recognize in this duality a profundity that resulted in an abundance of creative energy.

Insei-period art can be roughly divided into early and late stages. The earlier stage can be characterized as an age of further refinement and aestheticization of Fujiwara art. Famous works from the period include the *Illustrated Scrolls of the Tale of Genji*, the *Sutras Dedicated by the Taira Family*, and the *Anthology of Thirty-Six Poets*. In the second half, images produced with a rougher touch appear, such as the *Illustrated Scrolls of the Legends of Shigisan* and the *Illustrated Scrolls of the Courtier Ban Dainagon*. The works of the sculptor Unkei (Chapter 6) may even be included in this second category. As can be seen in the actions of Go-Shirakawa, interest in things abnormal and eccentric are visible in the *Paintings of the Six Realms* and the *Scroll of Afflictions*. An interest in popular affairs can also be detected in these images. During this period as Buddhist monk-painters became more like official court painters, their powers of artistic expression had a lasting impact on the art of the court. The period also witnessed the first appearance of art imported from Song China.

The varied use of cut gold leaf (*kirikane*) and the application of color pigment on the reverse side of a painting were techniques of adornment (*kazari*) that came to be used in the Buddhist paintings of this period. Various designs used in the Tenpyō period, which had come from Tang

China, were transformed during the Jōgan and Fujiwara periods to suit the elegant taste preferred by the court. Eventually fixed and formalized as *yūsoku* patterns, these included circular designs, such as floating twill, facing butterflies, and eight wisteria blossoms; various lozenge-shaped designs; and other traditional motifs such as slanted-cross patterns, tortoise-shell pattern, billowing clouds, overlapped hoops, nested-petal pattern, hail pattern, floral patterns, arabesque or scrolling grasses, broken-branch (sprig), and scattered flowers. Many of these patterns were considered auspicious.

2. Paintings: The Impulse toward Total Aestheticism

Painting flourished during the Insei period. Paintings can be roughly divided into three genres: Buddhist paintings, decorative sutras, and illustrated handscrolls. While Buddhist paintings and sutra scrolls are noted for their beautifully ornate character, other works stressed narrative development aided by vivid images full of movement, such as the *Illustrated Scrolls of the Legends of Shigisan*. Pictorial expression in the Insei period was varied and multilayered.

Buddhist Paintings

The large number of Buddhist paintings that survive from this period reflects the increase in privately sponsored Buddhist gatherings and esoteric rituals in addition to the public ceremonies that continued to flourish. They all demonstrate an attempt to further refine the trend toward aestheticism of the Fujiwara period. The *Twelve Devas* (1127), paintings formerly kept at Tō-ji, were used in the Rite of the Latter Seven Days. The originals were painted in 1040 but were destroyed by fire in 1127. New paintings produced in 1127 are those that survive today [Fig. 42]. The first set of paintings was based on ones brought back from Tang China by Kūkai. However, according to contemporary records, Retired Emperor Toba ordered them repainted because they were "crude and coarse." As though to substantiate this fact, the robes in the twelve paintings are depicted with shading in beautiful neutral colors over which exquisite designs were added in cut gold leaf (*kirikane*) and painted with additional colors. These, in combination with the feminine elegance of the faces and bodies of the deities, mark these paintings as the ultimate expression of the aestheticism of the period.

A similar aestheticism and decorative sense is shared by such works as the paintings of the *Sky-Store Bodhisattva* (Kokūzō Bosatsu, Tokyo National Museum), with its intricately detailed patterns, and the *Life-Extending Fugen* (Fugen Enmei, Sk. Vajramoghasamayasatlva) in Matsuo-dera temple (Kyoto prefecture), with its depiction of a sensuous body reminiscent of a *ukiyo-e* beauty and a round childlike face. Another example is the *Shaka Nyorai* known as *Red Shaka* in Jingo-ji [Fig. 43], clad in a red robe whose designs glisten with finely cut gold leaf. Both the *Eleven-Headed Kannon* (Nara National Museum) whose pink skin with white highlighting evokes a strong sensuality, and the *Peacock Wisdom King* (Kujaku Myō-ō) (Tokyo National Museum), which has an exquisite finish giving the entire image the impression of well-crafted perfection rather than a painting, were hung as individual deities that served as the primary object of worship in a Buddhist service. In each case, the mandorlas featured lavish cut gold leaf, insuring that they would emerge from the dark background like a lustrous dream.

There are many other outstanding paintings from the period, and

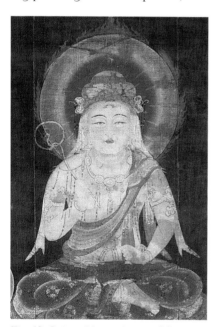

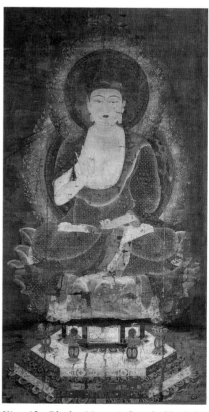

Fig. 42: *Suiten* (*Varuna*), one of the *Twelve Devas*, 1127, Kyoto National Museum

Fig. 43: *Shaka Nyorai*, first half of the 12th century, Jingo-ji, Kyoto

among them, the ethereal allure and sacred beauty of *Fugen Bosatsu* (Sk: Samantabhadra) [Fig. 44] surpass those qualities in other works. It can be counted as one of the most representative of all Japanese religious paintings. Another is *The Descent of Amida* [Fig. 45], a painting preserved on Mt. Kōya and reputed to be from the first half of the twelfth century, though some believe it to be from the second half. Among all *raigō-zu* paintings, this is the largest, almost cinema-like in size. Amida is captured dramatically as he descends with a heavenly retinue playing musical instruments. The background landscape is of natural scenery typical of Japan. In the bottom left are trees with autumnal foliage and pines that appear to be in prayer. The *Amida Triad with Banner-Bearing Youths* at Hokke-ji, in which lotus petals flutter down from the sky, appears to have been a portion of an equally large-scale painting of Amida's welcoming descent (*raigō*). It is thought that this painting dates slightly later, to the early Kamakura period. The influence of Song Buddhist painting can be seen in the use of diluted ink to draw the bodies of the deities and animals in soft lines, and the pale shades of the colors and simplified patterns on the paintings of *Enmaten* (Sk: Yama-deva) and *Kariteimo* (Sk: Hārītī) in Daigo-ji.

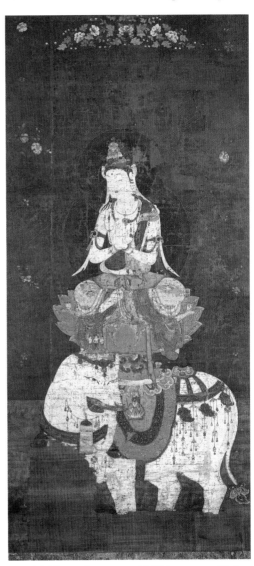

Fig. 44: *Fugen Bosatsu*, mid-12th century, Tokyo National Museum

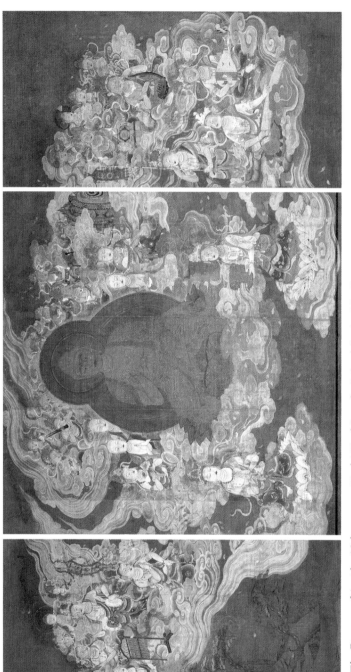

Fig. 45: *The Descent of Amida*, 12th century, Yūshi Hachimankō Jūhachika-in, Mt. Kōya

Decorative Sutras

The copying and donating of the *Lotus Sutra* and other sutras to temples was a fashionable practice among the aristocracy. Made with beautifully decorated paper and exquisite frontispieces in gold and silver, these scrolls reflected the wish to be saved from misfortunes in this life by doing "the utmost for good and the utmost for beauty." Even officials who might rail against ostentatious displays of wealth had no choice but to permit such extravagance as a religious act.

The set of scrolls known as *Heike Nōkyō* [Fig. 46], the sutras dedicated by the Taira family, donated by Taira no Kiyomori in 1164 to Itsukushima shrine (Itsukushima-jinja) in Hiroshima prefecture, is an outstanding example of decorative sutras in the handscroll format. The thirty-three scrolls of the set contain one scroll for each of the twenty-eight chapters of the *Lotus Sutra* in addition to other sutras copied by Kiyomori, Shigemori, and other members of the Taira family. A female presence is particularly obvious in the frontispieces, such as that of the "Devadatta Chapter," which depicts the rebirth of the Dragon King's daughter in paradise; the "Medicine King Chapter," which portrays a woman praying for rebirth in Amida's paradise; and the "King Wonderfully Adorned Chapter," which shows noblewomen dressed in twelve-layered robes (*jūnihitoe*) with rosaries in their hands praying for rebirth in paradise. The creation of this beautiful work demonstrates women's faith in the *Lotus Sutra*, which expounded female salvation. Silver was used more abundantly than gold in decorating the scrolls, the shimmering light of the well-preserved silver conveying the religious exultation of the donors. The craftsmanship is superb: flakes of gold and silver were affixed and gold and silver dust sprinkled on colored papers that were also painted; in addition, cut gold leaf was employed for the margin lines of the sutra text. Reed picture (*ashide-e*), a technique used on some frontispieces, marries glyphs and images in rebus-like fashion, creating a pictorialized text, which is another characteristic of *Yamato-e* Japanese-style painting.

The *Lotus Sutra* found in the set of decorative sutras known as the *Sutras of Kunō-ji Temple* (1141; Mutō family, Hyogo prefecture), is another well-known example of Japanese-style painting. The frontispiece of "The Parable of the Medicinal Herbs Chapter" pictures a nobleman bracing himself against the rain. Fan-shaped albums were also used for decorative sutras, such as the *Lotus Sutra* at Shitennō-ji and other collections [Fig. 47]. The text of the sutra has been written on sheets of fan-shaped paper that

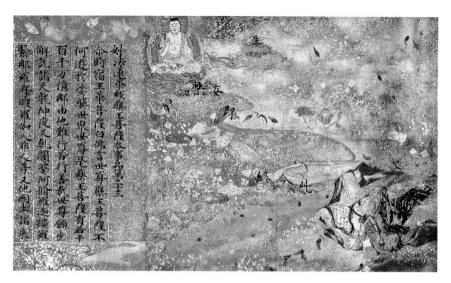

Fig. 46: Frontispiece, *Heike Nōkyō*, 1164, Itsukushima shrine, Hiroshima prefecture

have been bound in book format, and the papers are sprinkled with mica flakes. Background scenes of daily life and customs convey in a simple and straightforward but vivid fashion the lives of both aristocrats and commoners. In addition, the *Contemplation of Samantabhadra Sutra in Booklet Form (Kan Fugenkyō Sasshi)* shows people gathered around a charcoal brazier seeking warmth. These scenes give us a fascinating peek into the daily lives and customs of the Insei period.

Dazzling Waka Poem Booklets and Fan Paintings

In addition to the magnificently decorated sutras, bound booklets of splendid decorative paper containing collections of Japanese poetry, such as the *Anthology of Thirty-Six Poets (Sanjūrokunin Kashū)* [Fig. 48] in Nishi Hongan-ji, were also produced. These booklets are thought to have served as gifts presented at the celebration in 1112 to mark the sixtieth year of tonsured Retired Emperor Shirakawa. Their ostentatious beauty marks them as classical expressions of Late Heian court aesthetics. Seasonal flowers and grasses in sprig (*orieda*) motifs (literally, "broken branch" patterns) and natural scenery were painted on various types of specially prepared papers, including Chinese paper (*Kara-kami*) and those with wavy cloud-pattern borders, dyed or ink-washed (*sumi-nagashi*). Perhaps the most striking

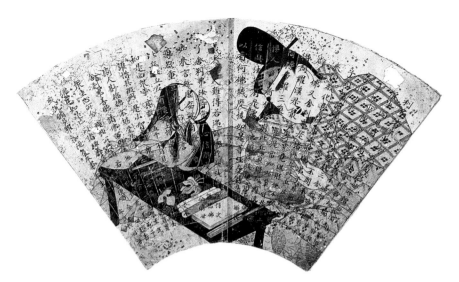

Fig. 47: "Courtier and girl reading a text," scroll 1, fan 9, from a fan-shaped album of the *Lotus Sutra*, mid-12th century, Shitennō-ji, Osaka

feature is the ways different papers were joined. Types of paper joining (*tsugi-gami*) included cut-joining (in which paper cut with a sharp object in a straight or curved line is joined), torn-joining (in which hand-torn paper with irregular edges is joined) and overlap-joining (in which five sheets of different colored papers are layered to expose a fraction of the colors of the lower sheet set on a white base sheet). These asymmetrical designs of papers that had been lovingly joined with little concern for uneven surfaces resonate with the rhythm of *kana* calligraphy, giving the viewer the sense of listening to refined music. As such, these booklets are the material realization of the spirit of elegant pursuits (*furyū*) and the wondrous expression of *kazari* (adornment) in Japan. There is no sense in trying to distinguish the art of painting from the decorative arts here.

The distinctive layered *kasane tsugi* decorative technique used to join paper in the *Anthology of Thirty-Six Poets* likely takes its inspiration from the *kasane*, the twelve-layered robes (*jūnihitoe*) worn by ladies-in-waiting, a style perfected during the period of rule by the Fujiwara regents. According to the textile historian Ogasawara Sae (b. 1942), ladies-in-waiting were skilled in sewing and embroidery and also had knowledge regarding dyeing techniques. The unique design of these anthologies was a product of the new relationship between the Bureau of the Palace Workshop, which managed the furnishings of the court, and these ladies-in-waiting themselves.

Fig. 48: Volume dedicated to Kiyoharu no Mosuke, *Anthology of the Thirty-Six Poets*, 1112, Nishi Hongan-ji, Kyoto

Folding fans are one of a small number of Japan's locally generated products. At the beginning of the Heian period, folding fans (*hiōgi*) were first made using extremely thin strips of cypress laced together, replacing the round or oval fan (*uchiwa* or *dansen*). Later, paper-covered folding fans, of the type used today, were made. These fans were decorated with beautiful *Yamato-e* images of Japanese scenery painted in rich colors and gold and silver. These Japanese fans were treated as prized commodities in China. Only a few twelfth-century folding fans survive, including the painted folding fan [Fig. 49] at Itsukushima shrine. Fans were used in daily life to bring relief from the heat, but they were also used in casting spells and in ceremonies.

Illustrated Handscrolls: Illustrated Scrolls of Short Tales and Longer Narratives

The originality of Japanese art is best displayed in the illustrated handscrolls made during the Insei period spanning the twelfth century. Despite the claim of originality, in this case as in others one can detect influences from two Chinese precursors: transformation texts (C: *bianwen*) and transformation tableaux (C: *bianxiang*). Transformation texts refer to Chinese

Fig. 49: Painted folding fan, second half of the 12th century, Itsukushima shrine, Hiroshima prefecture

manuscripts of popular lectures, which were performed to explain the difficult content of Buddhist scriptures in simple language. Ennin's diary records his having seen such performances while in Tang China. Transformation tableaux resulted from adding images to the transformation texts. Examples of transformation tableaux include the *Scenes of the Conquest of Māra* (Musée du Louvre), which tells of a test of supernatural powers between Raudraksa (Rōdosha) and Sariputra (Sharihotsu). The sense of movement in the lines of the brushwork and depiction of vibrant scenes in this scroll are recognizable in twelfth-century Japanese illustrated handscrolls known as *otoko-e* (men's paintings). The Tang popular lecture was also brought to Japan, forming the foundation for short folk narratives found in collections such as the *Collection of Tales from Times Now Past* (*Konjaku Monogatari Shū*).

The origins of illustrated handscrolls (*emaki*) can be traced back to illustrated tales, which had developed along with the popularization of stories written in Japanese script. The earliest record of an illustrated tale is from 907 and is described as "painting an image from the tale of Otomezuka." From the eleventh century onwards, the number of written records indicating the existence of illustrated tales increases, with reference to the *Illustrated Tale of Sumiyoshi* and the *Illustrated Tale of Utsubo*, of which

there was also an accompanying text or *e-kotoba* (literally, illustrated words or text). Whether these painted tales were in handscroll or booklet form is unclear. Except for the *Illustrated Scripture of Cause and Effect* (see Chapter 4, Fig. 16), all illustrated scrolls that survive were created in the twelfth century or later. The celebrated *Illustrated Scrolls of the Tale of Genji* (first half of the twelfth century) [Figs. 50 and 51] covered the entire fifty-four chapters of the *Tale of Genji* in ten scrolls. Today only the contents of four scrolls containing twenty chapters are extant. One of the scrolls is found in the Gotoh Museum collection in Tokyo while the remaining three are housed in the Tokugawa Art Museum in Nagoya. Each chapter would have contained from one to three illustrations of key scenes. The term *onna-e* (women's painting), which appears in written sources from the same period, can be understood as referring to the style of painting seen in these images. This style is also called *tsukuri-e*, or "produced paintings." They feature techniques described as *hikime kagibana* (slit for eyes, hook for nose) for faces and *fukinuki yatai* (blown-away roof view of buildings) for interiors.[23] These scrolls, in which each scene stands separate from the others, resemble picture albums spread horizontally. As such, they lack the progressive narrative quality found in *otoko-e*, which makes more effective use of the handscroll format. However, the wealth of color and the depth of lyrical sensitivity are appropriate for illustrating the world's oldest novel.

The date of the creation of the *Illustrated Scrolls of the Legends of Shigisan* (*Shigisan Engi Emaki*) [Figs. 52 and 53] at Chōgosonshi-ji temple (Nara prefecture) is thought to be the second half of the twelfth century. The miraculous deeds of the monk Myōren living on Mt. Shigi are pictured in the first scroll, titled the "The Wealthy Man of Yamazaki," which is also known as the "Scroll of the Flying Storehouse"; the second scroll, "The Rite of Spiritual Empowerment for the Engi-era Emperor," depicts the healing of Emperor Daigo by a youth known as the Protector of the Dharma (Gohō Dōji); and the third and final scroll is called the "Scroll of the Nun." Dynamic brushstrokes give the images a style that has both continuity and variation. The open, liberated feel and sense of humor in the depictions of the flying rice barrels and the youthful Protector of the Dharma are attributes of a painter of great technical genius. Unfortunately the name of the artist is unknown.

The three-scroll *Illustrated Scrolls of the Courtier Ban Dainagon* (*Ban Dainagon Ekotoba*) [Fig. 54] is attributed to Tokiwa Mitsunaga (active second half of the twelfth century), an official court painter who enjoyed

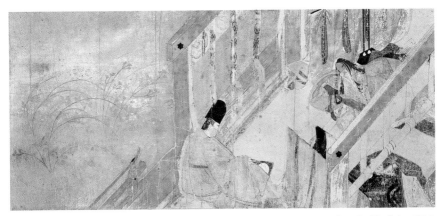

Fig. 50: "The Law" from *Illustrated Scrolls of the Tale of Genji*, first half of the 12th century, Gotoh Museum, Tokyo

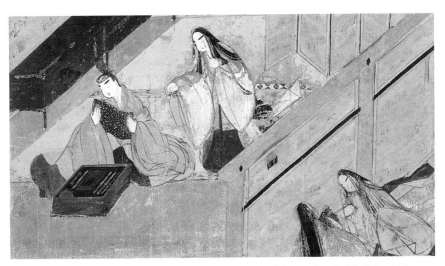

Fig. 51: "Yūgiri" from *Illustrated Scrolls of the Tale of Genji*, first half of the 12th century, Gotoh Museum, Tokyo

the patronage of Retired Emperor Go-Shirakawa. The scrolls depict events of a conspiracy led by the courtier Ban Dainagon, also known as Tomo no Yoshio, who set fire to the Ōtenmon gate in 866 in an attempt to rid himself of a political rival, Minister of the Left Minamoto no Makoto. In the end, the conspirator was banished when his ill deeds were exposed. The illustrations here, like those in the *Illustrated Scrolls of the Legends of Shigisan*, effectively show narrative progression by conveying a sense of continuity while also providing variation. Characteristics such as witty,

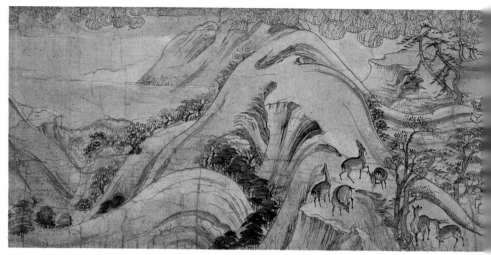

Fig. 52: "The Wealthy Man of Yamazaki" from *Illustrated Scrolls of the Legends of Shigisan*, first half of the 12th century, Chōgosonshi-ji temple, Nara prefecture

Fig. 53: "The Rite of Spiritual Empowerment for the Engi-era Emperor" from *Illustrated Scrolls of the Legends of Shigisan*, first half of the 12th century, Chōgosonshi-ji temple, Nara prefecture

keen-eyed human observation, the powerful impact of the depiction of the fire scenes, the theatrical effect of the scenes of grief on the part of the families of Minamoto no Makoto and Ban Dainagon, the sense of speed produced by the technique of "different times in one image" (*iji dōzu*) employed in the scene of the quarrel—all these are evident in the *Illustrated Scrolls of the Courtier Ban Dainagon*, revealing that the techniques used in the *Illustrated Scrolls of the Legend of Shigisan* had advanced to a new level.

The illustrations in monochrome ink in the four-scroll set *Scrolls of Frolicking Animals* (*Chōjū Jinbutsu Giga*, also known as *Chōjū Giga*)

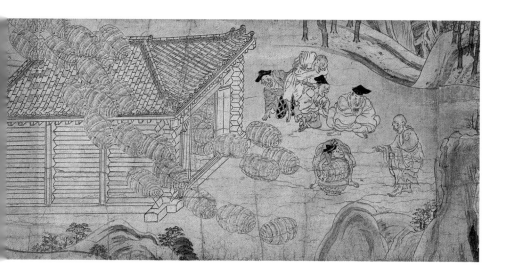

[Fig. 55], preserved at Kōzan-ji temple in Kyoto, were drawn in quick brush-strokes. Scrolls one and two are thought to have been produced in the mid-twelfth century, while scrolls three and four are considered to be slightly later, dating to the Kamakura period. The exact storyline of the first scroll —in which monkeys, deer, hares, foxes, and frogs are frolicking—is unclear. Earlier examples of these types of images can be found in a seventh-century unglazed dish excavated from the site of the former residence of Prince Nagaya in Nara and eighth-century depictions of animals found on the pedestal of the Bonten statue at Tōshōdai-ji. This older pictorial tradition was rejuvenated by the new modes of expression used in the illustrated handscrolls developed in the twelfth century, and this stimulus gave rise to the theatrical expressions of the Kōzan-ji scrolls.

The four works mentioned above are the best examples of Japanese illustrated scroll painting. Even though we must recognize that extant examples of the genre are quite limited, it is worth noting that every one of these masterpieces appeared at the earliest stage of the history of illustrated handscrolls. The techniques of using the actions of characters and changes of scene to create dynamic narrative development are suited to the act of unrolling the scrolls themselves. It has been pointed out that these techniques are shared by the *Illustrated Scrolls of the Legends of Shigisan* and the *Illustrated Scrolls of the Courtier Ban Dainagon* and that they form the basic elements of contemporary Japanese animation (anime).

Fig. 54: (This page and opposite) "The Burning of the Ōtenmon" from *Illustrated Scrolls of the Courtier Ban Dainagon*, 12th century, Idemitsu Museum of Art, Tokyo

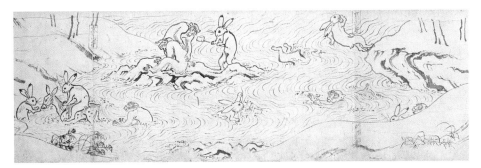

Fig. 55: "Rabbits and Monkeys Playing in the Water" from *Scrolls of Frolicking Animals*, mid-12th century, Kōzan-ji, Kyoto

Other noteworthy twelfth-century illustrated handscrolls include *Sudhana's Pilgrimage* (also known as the *Kegon Gojūgokasho Emaki* or the *Illustrated Scrolls of Visits to the Fifty-Five Kegon Masters*), preserved at Tōdai-ji and in other collections and dating to the latter half of the twelfth century. These scrolls illustrate the visits of the pilgrim Zenzai Dōji (Sk: Sudhana) to the spiritual masters described in the *Flower Garland Sutra* (*Kegon-kyō*). After visiting the bodhisattva Manjusri (Monju), Sudhana is sent on a journey through the stages of enlightenment, meeting fifty-three teachers on his way. Those who lead him to enlightenment range from a bodhisattva, to secular beings, and even a prostitute. The endearing facial expressions in the scrolls display a Japanese sensibility. The *Illustrated Scroll of the Legends of Kokawa Temple* in Kokawa-dera temple, Wakayama prefecture, which dates to the second half of the twelfth century, pictures the history and miraculous powers of the temple's principal deity, the

Thousand-Armed Kannon. The images are rendered from a fixed distance throughout in a simple and monotonous manner, resulting in an archaic style, but the childlike face of Kannon reflects the preference for prepubescent bodily and facial expressions also seen in the scrolls featuring Sudhana. The *Illustrated Scrolls of Minister Kibi's Journey to Tang* in the Museum of Fine Arts, Boston, which date to the second half of the twelfth century, portrays in caricature-like fashion the successful adventures of the Japanese envoy Kibi no Makibi in Tang China.

Paintings of the Six Buddhist Realms

Paintings illustrating the six Buddhist realms (*rokudō*) of existence—hells (*jigoku*), hungry ghosts (*gaki*), beasts (*chikushō*), fighting warriors (*ashura*), humans (*hito*), and celestials (*ten*)—became popular from the end of the Insei period through the early Kamakura. Paintings of the six Buddhist realms (*Rokudō-e*) were frequently produced during this period of political transition. The six realms are articulated in the *Essentials of Rebirth* (*Ōjō Yoshū*), which served as a guide to the six realms as described in the *Sutra of the Arising of Worlds* (*Kise-kyō*) and the *Sutra on the Right Mindfulness of Dharma* (Sk. *Saddharma-smṛty-upasthāna sūtra*, J: *Shōhōnensho-kyō*). Some theorize that these scrolls, together with *Scroll of Afflictions*, formed part of a greater project of illustrated scrolls of the six realms conceived by retired emperor and Buddhist priest Go-Shirakawa.

 Hells Scroll (*Jigoku Zōshi*) in the Nara National Museum illustrate the various types of hells deemed appropriate for the types of crimes committed

by the deceased during the person's lifetime. These include the Place of Corpses and Excrement, where the guilty fall into a pit full of feces and are devoured by maggots; the Place of Measures, where one is forced to hold a wooden measuring box of flaming hot iron; the Place of the Iron Mortar, where one is ground to bits in an iron mortar; the Hell of Cockerels, where one is seared by the flames spouting from a giant birdlike creature; the Place of Black Clouds of Sand, where burning sand rains down on one's head; the Place of Pus and Blood, where one drowns in a pool of pus and is stung by giant bees [Fig. 56]; and the Place of the Bronze Cauldron (in the Museum of Fine Arts, Boston), where one is boiled in a large bronze vat. The dark gray backgrounds intensify the sense of horror in each scene.

The fire-breathing cockerel is majestic and terrifying, while the facial expressions of the weird-looking prison guards and insects invite laughter with their black humor. The *Hells Scroll* at the Tokyo National Museum also features hells such as the Place of Flaming Hair, Place of Fire and Worms, Place of Clouds of Fiery Mist, and the Place of Raining Flames and Fiery Stones, reserved for punishments for murder, stealing, and adultery. The sinners who have fallen into these hells are starkly illustrated with heads cracked open, flesh bitten and ripped apart, writhing in bloody anguish. The great tongues of flame in the Place of Clouds of Fiery Mist, which might be called flowers of evil, have an enigmatic beauty. The seven remaining images from the *Scroll of Hell for Monks* (*Shamon Jigoku Zōshi*), formerly owned by the Masuda family (presently in the Gotoh Museum in Tokyo and in other collections), depict monks and nuns who violated Buddhist precepts (such as the prohibition against killing sentient beings) undergoing harsh punishment in similar hells separated according to gender. They contain scenes from the Hell of Skinning Flesh, where those guilty of skinning animals are themselves flayed, and an image of a nun being butchered for her sin of killing and dismembering animals during her life in the human realm. She is diced on the cutting board while still alive. The hell guard then chants a spell that restores the sinner to her original state so her dissection can be repeated again and again. The raw details of these sadistic scenes leave a deep impression.

The *Paintings of Warding off Evil* (*Hekija-e*, Nara National Museum) were once a single handscroll that has been separated into five hanging scrolls. As made clear by the art historian Kobayashi Taichirō (1901–1963), the main theme of the images is not Buddhist hells, but the warding off of evil. They relate to the various gods who subdue "plague demons" and

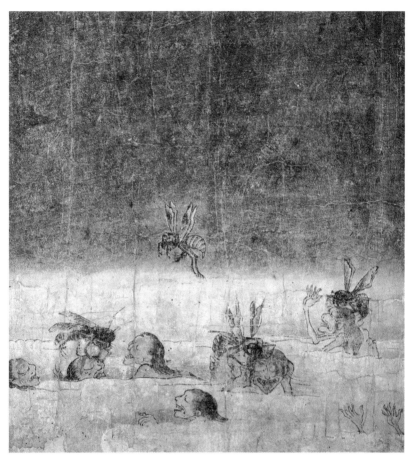

Fig. 56: "Hell of Pus and Blood" from *Hells Scroll*, 12th century, Nara National Museum

were traditionally held in awe in Chinese folk religion. The scroll featured images of Tianxingxing, who pickles and later eats demons including a bull-headed demon; Qiantapo (Sk. Gandharva), who skewers the heads of fifteen demons who harm infants and young children; Shenchong, who is a transformation of a silkworm, feasting on demons; and Zhongkui (Shōki), who plucks out demons' eyes. The coolly executed images of such cruel acts probably reflect the style found in the Chinese models.

Human bodies with string-like necks and limbs and abnormally distended stomachs must have been a common sight during periodic famines. There are two types of *Scroll of Hungry Ghosts* (*Gaki Zōshi*) that depict the dead who have fallen into the realm of hungry ghosts in such an emaciated state. Both scrolls would have required their authors to exercise

their imagination to portray hungry ghosts that could not in fact be seen. One version of the *Scroll of Hungry Ghosts* that was formerly owned by the Kōmoto family of Okayama prefecture (presently in Tokyo National Museum) [Fig. 57] depicts hungry ghosts as they appear in scenes of banqueting, giving birth, defecation in a toilet, and a graveyard. The images of the gravesite and of defecation deliberately thrust to the fore the unsanitary and filthy side of human life usually avoided in illustrated scrolls. These are scenes of this world in all its impurity that one is taught to abhor in Buddhism, as typified by the phrase "despise the polluted earth." The second version of the *Scroll of Hungry Ghosts* (Kyoto National Museum) is a single scroll that chiefly depicts scenes of hungry ghosts being saved so the gruesome elements are not emphasized. The accomplished depiction of genre scenes, particularly in the second section on ceremonial offerings made to hungry ghosts, likely indicates that both the painter and the person who commissioned the paintings had great interest in reflecting the reality of social customs.

The images from the *Scroll of Afflictions* (*Yamai no Sōshi*, in the collections of the Agency of Cultural Affairs, Kyoto National Museum and others) [Fig. 58] have been excised from the original scroll and dispersed as individual works. The paintings show various ailments that afflict human beings. There is a man with a blackened nose, a woman suffering insomnia, and a man coming down with a cold and shivering. There are those who are androgynous, visually impaired, or have an eye ailment, decaying teeth, anal fistulas, or lice. One suffers from an excessively long nose, while another lacks an anus, and one woman has bad breath. Another woman suffers from heat stroke, while a man is condemned to life as a hunchback. A midget, a woman with a blemished face, an obese woman, and an albino are also featured. A monk whose neck is so stiff that he can't raise his head, a man who has narcolepsy, another suffering from hallucinations, and others with various afflictions parade through the scroll, making it a compendium of human illnesses. The stylistic features resemble those found in the hell and hungry ghost scrolls, leading to the convincing suggestion that this scroll was conceived as part of a set of paintings of the six realms that highlighted sufferings in the human realm. Ridiculed by others, sufferers are shown in a stark, unsympathetic light, as in the scrolls of hell. Perhaps the intention was to warn the viewers of the shallowness of human existence. However, the painter's curiosity aroused by the symptoms of disease far overshadows any religious message in the scrolls.

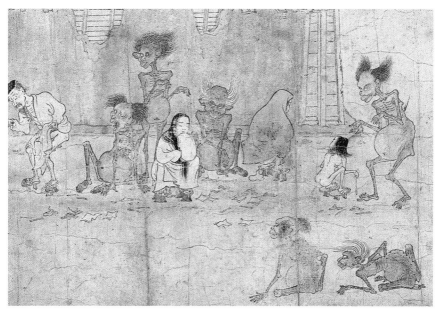

Fig. 57: "Scene of Defecators" from *Scroll of Hungry Ghosts*, 12th century, Tokyo National Museum

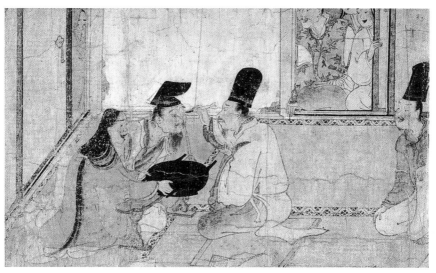

Fig. 58: "Scene of a Man with an Eye Ailment" from *Scroll of Afflictions*, 12th century, Kyoto National Museum

The Introduction of Chinese Song Art and Its Influence

Between the tenth and the eleventh century, exchanges with China were restricted to private trade. Despite this fact, expensive imported Chinese objects (*karamono*) were essentials in the daily lives of luxury-seeking Heian aristocrats, whose lifestyle was dubbed "ostentatiously refined." Objects imported during the period were primarily Chinese textiles and high-level craft items, but there were also examples of fine painting and sculpture. The unique style of the sandalwood (*sendan*) statue of Sakyamuni brought from China to Kyoto's Seiryō-ji temple in 987 by the monk Chōnen became known as the Seiryō-ji style. This variety of Shaka iconography was widely copied during the Kamakura period. The images of the sixteen Arhats were also brought to Japan during this time. Ninna-ji, famous for conducting the Rite of the *Peacock Sutra*, had a painting of the *Peacock Wisdom King* that had been imported during Michinaga's time from the Northern Song. Although the original was destroyed by fire, another Northern Song painting of the *Peacock Wisdom King* is held by the temple and is considered a masterpiece of Chinese Buddhist painting.

In the late eleventh century, during Retired Emperor Shirakawa's rule, trade between China was revived, and Chinese goods were imported in great quantities. The fall of the Northern Song in 1126 was followed by the rise of the Southern Song. The *Thousand-Armed Avalokitesvara* in Eihō-ji temple in Tajimi, Gifu prefecture, and the *Amida Triad* painted by Fuetsu (C: Pu Yue, dates unknown) in Shōjōke-in temple, Kyoto, are masterpieces of Southern Song Buddhist painting brought to Japan in the twelfth century. Together with the *Peacock Wisdom King* painting at Ninna-ji, these three paintings share intricately painted details captured in finely brushed lines with a dispassionate realism, unlike Japanese Buddhist paintings of the same period. By the mid-twelfth century, however, Song influence began to be felt, and a new style emerged in Japanese painting. The painting of the Dragon King (Zennyo Ryū-ō; Kongōbu-ji, Mt. Kōya) is identified by an inscription, originally on the reverse of the painting, as a work of Jōchi (active mid-twelfth century) dating from 1145. The painting shows the influence from Song Buddhist painting in the fine brushstrokes used for the robe and the white-based cool tones of the cloud-riding king who wears an elaborate crown and Chinese dress. The *Kariteimo* (Sk: Hārītī) and the *Enmaten* (Sk: Yama-deva) at Daigo-ji also use white as a keynote

and pale colors, making the soft lines of the underdrawing visible through the pigments.

Secular paintings from the twelfth century showing the influence of Song paintings are extremely rare, but to compensate for this absence, I deal with *maki-e* lacquer, which was clearly influenced by Song painting, in the next section.

3. Sculpture, Decorative Arts and Architecture

Architecture and Buddhist Statues

Zaō Hall at Mitoku-san Sanbutsu-ji temple in Tottori prefecture, known as Oku-no-in Zaō-dō or Nageire-dō [Fig. 59], is a particularly unusual example of architecture dating from the Insei period. The building is the oldest hall used for mountain ascetic practice (Shugendō). A technique called hanging construction (*kaketsukuri*) was used to build the perilously lodged structure. The name Nageire-dō, literally the "throw-in hall," derives from the appearance of the building, which looks as if it had been thrown into the cavity of the craggy cliff face. Tree-ring dating shows the building was constructed in the early 1100s. Documents were found inside the body of the principal deity, a statue of Zaō Gongen (Avatar Zaō), which are dated 1168. This structure is characterized by simplicity and austerity of form, reflecting the hardships and challenges that had to be overcome to construct it. The product of Shugendō practitioners, who were nature-worshipping ascetics, it stands in stark contrast to the extravagant architecture and sculpture favored by the aristocracy.

The construction of the magnificent halls dedicated to Amida, or Amida-dō, by regent families and the building and operation of temples by the tonsured, retired

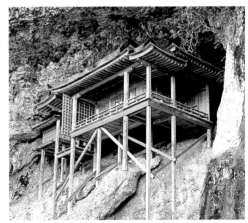

Fig. 59: Inner Sanctuary Zaō Hall, early 12th century, National Treasure, Mitoku-san Sanbutsu-ji temple, Tottori prefecture

emperors Shirakawa and Go-Shirakawa in the following period had great influence on the three generations of the Fujiwara family that ruled in Tōhoku. The Northern Fujiwara attempted to build temple and shrine complexes equally grand as those in the capital. The head of the Fujiwara family built a Nine Amida Hall (Kutai Amida-dō), in the Chūson-ji temple complex (Hiraizumi, Iwate prefecture) in 1107. The main deities measured just over 9 meters in height, and the attendant figures were *jōroku* size (nearly 5 meters).

Chūson-ji's Golden Hall (Konjiki-dō) [Fig. 60], completed in 1124 by Kiyohira, is a hall with a single-bayed façade with three bays on each side. It functions as an Amida Hall and contains three altars that hold the remains of the family patriarchs: the first for Kiyohira (built c. 1124, in the center), the second for Motohira (built c. 1157, southwest), and the third for Hide-hira and Yasuhira (built c. 1187, northwest). Eleven statues—an Amida triad, six Jizō Bosatsu (Sk: Kṣitigarbha) and two celestials (Sk: *deva*)—are arrayed on each altar. The pillars marking the boundaries of the inner

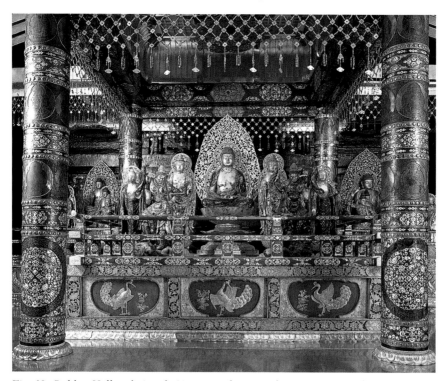

Fig. 60: Golden Hall with Amida Nyorai as the central icon, c. 1124, Chūson-ji, Iwate prefecture

sanctuary and the inner sanctuary itself are decorated in mother-of-pearl inlay (*raden*), and the entire surface of the outer corridors is finished with gold leaf affixed with lacquer. The wood-panel coverings of the altars are embellished with gilt-bronze phoenixes and peonies. The outfitting of the hall in dazzling gold certainly fits its name. Although the statues are small, they are in a style reflecting the work of monk-sculptors from the capital.

The neighboring Mōtsū-ji was an enormous temple complex built by Kiyohira as his own version of Hosshō-ji, built by Retired Emperor Shira-kawa. The temple was destroyed by fire after Kiyohira's death, and today only the pond and the curving stream that fed it remain as legacies of the temple's garden. Kanjizaiō-in, a cloister built by Motohira's wife, and the Muryōkō-in, built by Hidehira to rival the Phoenix Hall in Uji, also no longer exist. Records mention that scenes from events and places around Kyoto were painted on the four walls of the Amida Hall of Kanjizaiō-in. These included images of a Buddhist ceremony at which animals were set free, at Iwashimizu Hachiman-gū shrine in the capital. Also illustrated were festivals famous in the capital, such as the Kamo (or Aoi) festival, and famous places such as Uji's Phoenix Hall, Saga, and Kiyomizu-dera temple. These pictorial themes are of interest in considering the formation of the later genre of scenes in and around the capital.

Although the Golden Hall is all that remains of complexes built by three generations of the northern Fujiwara family at Hiraizumi, contemporary temple buildings in the same region—the Shiramizu Amida Hall (1160) of Ganjō-ji in Fukushima prefecture, and the Amida Hall (1177) of Kōzō-ji in Miyagi prefecture—today convey the flavor of these lost buildings.

Given the many buildings and statues mentioned in written documents from the Insei period, the number that have survived in Kyoto is surpris-ingly small. One noteworthy example is the Seated Nine Figures of Amida Nyorai [Fig. 61], the principal deities in the main hall of Jōruri-ji temple. Records indicate that the original hall, which was built in 1107, was later moved to its present location in 1157. Theories of the dating of the nine statues of Amida, which are very much in keeping with Jōchō's style, vary widely. This is the only surviving example of the many long halls that were built to house nine statues of Amida following the initial example of the one built at Michinaga's Muryōju-in.

The central icon of the Amida Triad (1148) in the main hall of Sanzen-in temple (Kyoto) forms the welcoming mudra and is accompanied by Kan-non, who offers a lotus pedestal, and Seishi (Sk: Mahāsthāmaprāpta),

with hands in prayer, as they descend together to welcome the deceased in *gōshō* style.[24] A special characteristic of the Sanzen-in main hall is the "boat-bottom" curvature of the ceiling of the main building. In the case of the Amida Hall at Hōkai-ji and its principal deity, a seated Amida Buddha statue, we find that although the main structure was built in the Late Heian, or possibly early Kamakura period, the principal deity was created slightly earlier, in the late eleventh century. The style is in keeping with Jōchō's *jōroku*-sized statues of Amida, but compared to that in the Phoenix Hall, the face is more innocent and childlike, perhaps reflecting the preferences of the period. The childlike innocence of the facial expression is similar to those seen in small private devotional statues. Examples of these can be seen in the seated Yakushi Nyorai (1103) statue at Ninna-ji, which was carved from aromatic wood by Ensei (d. 1135), a disciple of the sculptor Chōsei, in collaboration with Ensei's son Chōen (d. 1150), and the seated Thousand-Armed Kannon at Bujō-ji temple (1154) [Fig. 62], which was likewise carved from aromatic wood. Although there are many extant images of Fugen Bosatsu riding on an elephant with hands clasped in prayer, the statue of Fugen on an elephant currently housed at the Okura

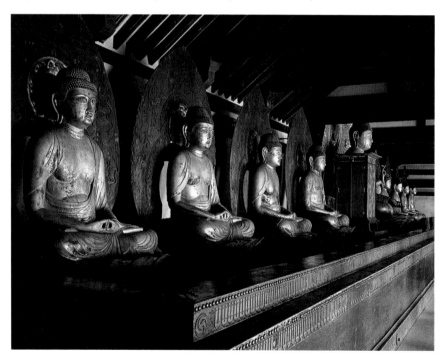

Fig. 61: Seated Nine Figures of Amida Nyorai, early 12th century, Jōruri-ji, Kyoto

Museum of Art in Tokyo is the ultimate masterpiece of twelfth-century sculpture of Fugen.

In the second half of the twelfth century, Buddhist sculptors in Kyoto clung to Jōchō's classical style and showed signs of increasing stagnation. In contrast, some Buddhist sculptors in Nara broke away from the Jōchō tradition and turned instead to the classical sculpture of the Tenpyō period. They also received stimulus from the new styles of Song sculpture as they took their first steps on a new creative path. The earliest example of this trend is the Amida Triad (1151) [Fig. 63] at Chōgaku-ji temple in Tenri, Nara prefecture. This is the earliest example of the use of crystal inset eyes, and such elements as the tautly rendered three-dimensionality of the body, the deeply carved robes of the central deity and the half-lotus postures of the flanking attendants foretell the emergence of a new style that would soon supplant that of Jōchō.

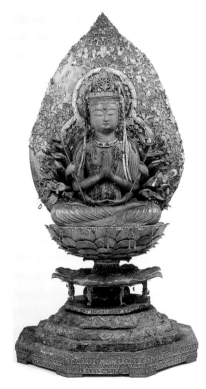 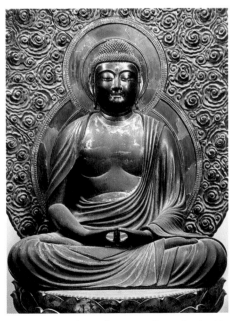

Fig. 62: Seated Thousand-Armed Kannon, 1154, Bujō-ji, Kyoto

Fig. 63: Seated Amida Nyorai from the Amida Triad, 1151, Chōgaku-ji, Tenri, Nara prefecture

Japanese Design Sense: *Maki-e*, Mother-of-Pearl, Mirrors, Ceramics, Flower Containers, and Hanging Amulets

The designs of Insei-period decorative arts demonstrated the greatest development in this period and marked the final flowering of aristocratic culture. The *maki-e* technique, which had been imported from Tang China in the Tenpyō period, began to develop independently from the ninth century onwards. Patterns became increasingly pictorial in concert with Japanese *Yamato-e* style. This in turn led to the perfection of Japanese-style design. The small Chinese-style chest with a design of plovers in a marsh in *maki-e* and mother of pearl in Kongōbu-ji [Fig. 64] is thought to have been produced in first half of the twelfth century. It depicts in burnished (*togidashi*) *maki-e* a flock of plovers playing at the water's edge where irises and three-leaf arrowhead flowers bloom. Gold and gold-alloy powders with silver were lightly sprinkled to create the gradual shading of the mounded banks (*doha*)

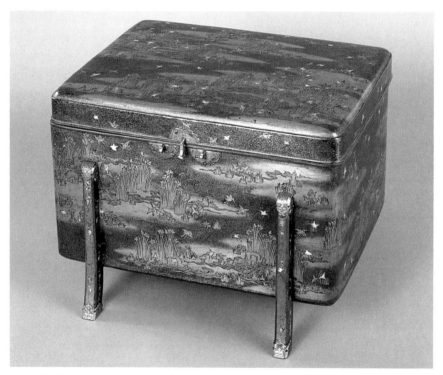

Fig. 64: Chinese-style chest with a design of plovers, first half of the 12th century, Kongōbu-ji, Mt. Kōya

in the scene.[25] The mother-of-pearl inlays (*raden*) give the plovers and some of the flowers a white glow. The scene is elegant and dreamlike. The scattered pattern of flowers, butterflies, and birds on the underside of the lid is a design unique to the *maki-e* medium.

The use of mother-of-pearl inlay is an effective way of enhancing the decorative nature of *maki-e* work. The box with the "carriage wheels in water" design in *maki-e* and mother-of-pearl [Fig. 65] transforms an ordinary scene—of immersing carriage wheels in the Kamogawa River to prevent them drying out—into a stylized design. Although I would like to praise the ingenuity behind the invention of a refined design based on a mundane scene from everyday life, the art historian Etō Shun (1930–1997) has offered another plausible explanation. Etō reasons that the box was meant to hold sutras and that the design echoes a passage in the scriptures describing Amida's Pure Land and mentioning "lotus flowers in the pond, large as carriage wheels." Indeed, the iridescent glow of the mother-of-pearl inlay on the wheels does seem to reflect scenes of paradise. The concept of visual allusion (*mitate*), which would flourish in the Edo period, can be detected in this sutra box.

The *maki-e* design of another small Chinese-style chest with cranes with sprigs of pine in their beaks (1183) preserved at Itsukushima shrine shows cranes flying with small pine branches in their beaks. It is an example of a naturalized version of the design of "Chinese flowers and a bird with a ribbon in its beak" on some of the furnishings found in the Shōsō-in Repository.

On the basis of references in written records, it would appear that examples of the pictorial theme of birds and flowers were rare in Heian-period painting, but patterns of birds and flowers, as in the bird with pine sprigs in its beak, are legion. Among them is the small box with a design in *maki-e* of a vibrant and realistic depiction of sparrows playing in a field (Kongō-ji temple, Osaka) [Fig. 66]. The anomalous *maki-e* technique for a lacquerware piece of the twelfth century has attracted scholarly attention as it shows the influence of bird-and-flower paintings of the Northern Song. The scabbard of the *kenuki*-style large sword with mother-of-pearl on an *ikakeji* lacquer ground (c. 1131) in Kasuga grand shrine (Kasuga-taisha) in Nara, has a design of bamboo and a cat ready to pounce on a sparrow. The design is rendered in the *ikakeji* lacquer technique, involving sprinkling a heavy layer of gold powder to form the ground, and using mother-of-pearl inlay to create

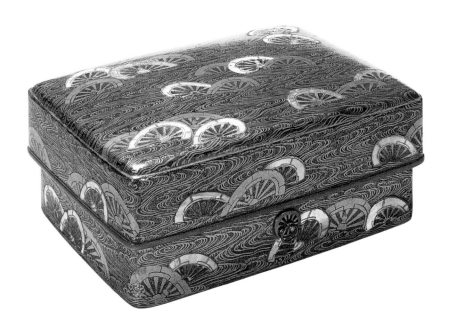

Fig. 65: Small box with "carriage wheels in water" design, 12th century, Tokyo National Museum

Fig. 66: Small box with a design of sparrows in a field, 12th century, Kongō-ji, Osaka

the image. This design is also thought to be traceable to Northern Song bird-and-flower paintings. The burnished (*togidashi*) *maki-e* design of marbling ink runs the length of the zither-like *sō*, a musical instrument that is an ancestor of the modern *koto*, also kept at Kasuga grand shrine. It ingeniously depicts a landscape by imitating the technique of *sumi-nagashi*, literally "flowing ink," but here using lacquer and *maki-e*. The design becomes a cliff and then a watery landscape inhabited by birds, plants, and insects.

Mother-of-pearl inlay techniques originated in China. But mother-of-pearl inlay *maki-e* designs advanced significantly in Japan, surpassing those of the continent during the Fujiwara and Insei periods. Inlayed *maki-e* wares were exported to China and surprised people there who were convinced that the inlay technique was a Japanese specialty. The beauty of *ikakeji* inlay work on pillars, altars, canopies, and beams in the Golden Hall of Chūson-ji, together with their glistening gold-leafed surfaces, recount the ambition of three generations of the Fujiwara family to recreate the Pure Land paradise in this world.

Design patterns on mirrors became similarly diversified, and bird-and-flower motifs in the Japanese fashion became increasingly popular. The design of cranes holding sprigs of pine in their beaks was frequently employed as an auspicious motif. The mirror originally from Nishi Hongan-ji [Fig. 67] is decorated with a strongly pictorial representation of wild cranes, some with pine branches in their beaks, among autumn grasses growing in profusion. Both the rectangular and circular mirrors in Kongōshō-ji temple in Mie prefecture were excavated from the sutra mound

on Mt. Asama in around 1159.[26] The approximately six hundred mirrors excavated from the site of the pond at Dewa shrine (Dewa-jinja) on Mt. Haguro in Yamagata prefecture in the 1920–30s are known as Haguro mirrors and are currently housed in various collections, including the Dewa shrine and the Hosomi Art Museum (Kyoto). The precise dates of their production are unknown, though they are generally thought to be from the twelfth century. In addition to pine-holding cranes, familiar images from daily life

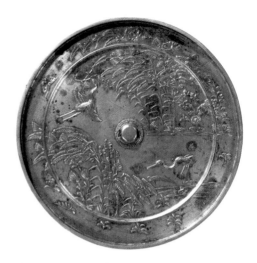

Fig. 67: Mirror with a design of autumn grasses and cranes with sprigs of pine in their beaks, 12th century, Agency for Cultural Affairs, Japan

such as birds, butterflies, flowers, and plants of the four seasons are prevalent. These are represented in a vibrant, painterly fashion in asymmetrical designs. The outstanding quality of Insei-period Japanese mirrors was unparalleled in the rest of East Asia, and they were exported as luxury wares to China and Korea.

Keko, literally a flower basket, refers to a container used in the flower-scattering portion of Buddhist offering services. Artificial paper petals to be strewn before the principal deity in the ceremony were carried in such containers. The gold- and silver-plated flower basket with scrolling floral design in openwork at Jinshō-ji temple in Shiga prefecture was made from a bronze sheet that was hammered into the shape of a dish using a repoussé technique and then decorated with a scrolling floral arabesque-like pattern in openwork. It was then thinly plated in gold and further embellished with silver plating to accentuate parts of the flowers and leaves. The excellent craftsmanship is evident in the use of metal to convincingly represent the softness and pliancy of plants.

The Shitennō-ji houses a small amulet that a woman would have worn around her neck when traveling. Various types of twill brocade are pasted on a wooden base to which decorative metal fittings such as that of a pine-holding crane have been fastened. The beautiful color combinations of the brocades recount the elegance of court aesthetics.

The Emergence of Japanese-Style Ceramics

In contrast to the high level of achievement in the decorative arts of the Insei period, it had been thought that ceramics (*yakimono*) alone stagnated at the level of ancient Sue ware, making little progress in terms of technique or design. However, scholarly attention has begun to focus on new trends that took place at domestic kilns such as the Sanage, a kiln in Aichi prefecture.

The Sanage kiln is one of the many kilns that had produced Sue ware for generations, but in the early ninth century, it sought to trade on the popularity of imported Chinese ceramics by manufacturing green ash-glazed wares that mimicked Chinese celadon wares.[27] When the number of imported Chinese high-fired wares declined in the tenth century, the kilns made replacements using glaze selectively on wares or just employing natural ash glaze. Abandoning luxury wares, the kilns instead produced large quantities of daily-use ceramics, such as jugs and pots, and became more economically viable. In the twelfth century when Chinese ceramic imports grew rapidly, the Sanage kiln practices were adopted by the Tokoname and Atsumi kilns (in present-day Aichi prefecture), after which the pace of domestic production quickened. The Japanese-style design seen on the Atsumi ware jar with autumn grass motif [Fig. 68], excavated in Kanagawa prefecture, was a product of such trends. The deeply satisfying imagery of an autumnal field complete with dragonflies, butterflies, miscanthus, and gourds, is incised in thick, simple lines on the surface of the pot.

With the increasing development and spread of markets in this period, Tokoname and Atsumi wares became available in far-flung places such as Tōhoku

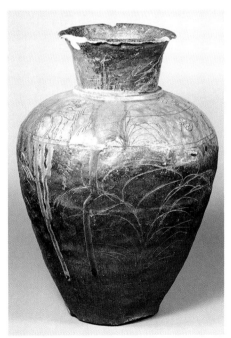

Fig. 68: Jar with autumn grass motif, 11th–12th century, Atsumi ware, Keio University, Tokyo

in the northeast and the southern island of Kyushu. The ceramic historian Yabe Yoshiaki (b. 1943) asserted that this was an important period in ceramic history, as it signaled the rise of regional kilns in place of the potters in the capital who produced wares modeled on foreign styles. Belated though it might be, this also meant the birth of Japanese-style designs in ceramics.

4. Refinement and "Produced Objects"

The concepts of refinement (*furyū*) and a "produced" object (*tsukurimono*) are strongly linked not only to the aesthetic lifestyle of Heian aristocrats but to art itself. The breadth of the meaning of the word *furyū*, which goes back to the Tang-period Chinese word *fengliu*, changed over time. But to the aristocratic society of Heian and Kamakura times *furyū* was defined in terms of decorative elegance (*kazaru furyū*), which equates to our contemporary concept of "clever design." There were two types of *furyū*: one involved taking a practical object used in daily life and adding decoration, such as painting a fan in gold and silver; the other was characterized by *kushi furyū* (literally, comb elegance),[28] which is seen in *The Record of the Clear Moon* (*Meigetsuki*, 1180–1235) diary of the late Heian-Kamakura poet and courtier Fujiwara no Sadaie (Teika, 1162–1241). The second type of *furyū* referred to creating a replica of a natural scene (*keibutsu*) or practical implement and decorating it in an eccentrically beautiful fashion.

Tsukurimono refers to replicas produced in the latter definition of *furyū*. Replicas might be of familiar objects such as desks, cabinets, wooden braziers, lunch boxes, and even toys like a spinning top. These were decorated using extravagant materials such as gold, silver, and imported Chinese textiles to produce visual representations of ordinary things. These *tsukurimono* were used to decorate celebratory spaces like drinking parties and ceremonies at which the attendees and dancers would don fanciful costumes. Such ostentatious displays were met with charges of excess and became the object of regulation as extravagances "exceeding proper bounds." Undeterred, extravagance continued, and the word *kasa* (excess) became a form of praise. The high esteem for the decorative as seen in Buddhist and domestic *Yamato-e* paintings of the Insei period and the high esteem for *furyū* and *tsukurimono* seen in the lives of aristocrats can be characterized as two sides of the same coin.

CHAPTER
6

Kamakura Period:
Aristocratic Aesthetics in Flux

Kamakura Period: Aristocratic Aesthetics in Flux

For close to four hundred years during the Heian period (794–1192), the imperial court aristocracy in Kyoto cultivated the arts of Japan within a sheltered, rarefied environment of poetry, religion, and ritualized etiquette. All this changed, however, when Taira no Kiyomori (1118–1181), the powerful leader of the Taira clan (Heike), carried out a coup d'état in 1179 and ended the cloister government of Retired Emperor Go-Shirakawa (1127–1192). The new puppet regime of the Taira clan further elicited anti-Heike sentiment and led to a revolt by Prince Mochihito, the third son of Go-Shirakawa. His command to challenge the Taira forces spread over the provinces and led to the raising of an army by Minamoto no Yoritomo (1147–1199). Yoritomo first conquered the eastern part of the country, and in 1183, his forces banished the Taira clan from Kyoto. The battle between the Minamoto (Genji) and the Taira clans, known as the Genpei War (1181–85), ended with the downfall of the Taira. Yoritomo went on to establish a new samurai government known as the *bakufu* in Kamakura (1192), far from the Kyoto court. While this centralized system was officially sanctioned by the emperor, regional governors were appointed by and made accountable to Yoritomo, who now ruled as shogun (an abbreviation of Sei'i Taishōgun, "barbarian-quelling general"), a title that became hereditary. Over the next century and a half, the Kamakura *bakufu* would suffer its own vicissitudes. It became characterized by child-shoguns governing in name only under the control of uncle-regents, who generally declined to step down when the young shogun attained maturity, and thus often succumbed to assassination at the hands of a brother, cousin, or "loyal" minister. The ritual suicide of the last Kamakura regent, Hōjō Takatoki, in 1333 brought to an end one of the more tumultuous but culturally vigorous periods in Japanese history.

1. Developments in Art with a View to Reality

While aspects of Late Heian court culture lingered on into the Kamakura period, a new set of ideas began to drive the arts, with the realities of human suffering as a central theme. Buddhism played a leading role in

addressing these realities, which included war and rapid social change —not the Buddhism of the court, but that of a new crop of religious leaders. With an approach that was controversial at the time, they went outside the religious establishment and appealed directly to a much wider set of believers seeking reassurance in a chaotic age. On the one hand there was the Pure Land (Jōdo) Buddhism espoused by Hōnen (1133–1212), Shinran (1173–1263), Ippen (1234–1289), and others, in which salvation was believed possible simply through sincere recitation of the phrase *Namu Amida-butsu* (we take refuge in Amitabha Buddha). This phrase, known as the *nenbutsu*, refers to Amida, the merciful ruler of the Pure Land in the West. Jōdo and the *nenbutsu* soon won adherents among the established clergy, including Shunjōbō Chōgen (1121–1206), a monk who first studied Esoteric Buddhism at Daigo-ji temple in Kyoto but then took an interest in Jōdo teachings, eventually even adopting the Buddhist name Namuamidabutsu. In contrast to the religious emphasis on *tariki* (relying on the strength of the other; i.e., of Amida), the Zen Buddhist school emphasizing *jiriki* (self-reliance) also arose during this period. Both Rinzai Zen, founded by Eisai (or Yōsai; 1141–1215), and Sōtō Zen, founded by Dōgen (1200–1253), found adherents among Japan's samurai elite. Other important reformers of Buddhism included Myōe (1173–1232), reviver of the Kegon sect, and Nichiren (1222–1282), a fisherman's son, who sought to relieve the suffering of commoners and eventually gained influence over government policy.

The volatile social and religious conditions of the day led to new approaches in the arts. For example, the reconstruction of Tōdai-ji and Kōfuku-ji temples in Nara, destroyed by the Taira clan in 1181, proved an opportunity to experiment with the latest architecture and sculpture in the Chinese Song style (960–1279), which became accessible owing to renewed trade with the continent. After the Nara period (710–94; see Chapter 4), the Kamakura period may in fact be considered the second major period of engagement with Chinese art, due to broad fascination with the latest *karamono*, or Chinese products and art objects such as paintings, ceramics, and other decorative arts imported from China. The China connection was strengthened by the rise of Zen Buddhism around the mid-1200s, as the comings and goings of Chinese missionaries and Japanese Zen monks trained in China ensured a steady stream of imported objects of all kinds; these in turn influenced domestic artists in a variety of ways.

2. The New Wave of Chinese Song Architecture: The Great Buddha Style

Appalling as it was, the destruction of Tōdai-ji by the Taira only improved the temple's standing in the eyes of the people, due both to its long history and its close ties with the imperial family. Inspired by his religious faith and devotion to the imperial court, the monk Chōgen made it his life's mission to restore Tōdai-ji to its former glory, and headed the fundraising effort for the rebuilding project. Chōgen crisscrossed Japan over a period of twenty years, founding temples and raising money and materials in pursuit of his goal. In effect he dedicated his life to reviving the spiritual energy of the Nara-period monk Gyōki (668–749), who had organized the funding and labor for the construction of the first Great Buddha at the original temple, and to building on the achievements of Tenpyō Buddhism. By 1199 Chōgen had not only achieved his goal, but also introduced a new mode of architecture called the Great Buddha style (Daibutsu-yō). Incorporating architectural elements native to the Jiangnan area of southeastern China, the style is represented by Tōdai-ji's Great South Gate (Nandaimon, 1199) [Fig. 1]. Characteristic features include the use of long crossbeams running through pillars in a manner reminiscent of modern steel construction,

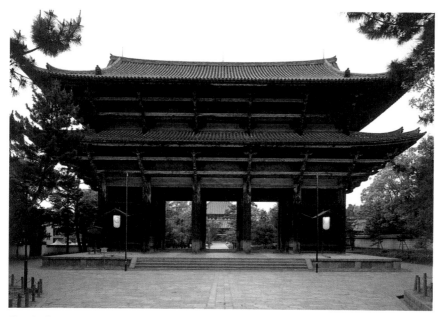

Fig. 1: Great South Gate, 1199, Tōdai-ji, Nara

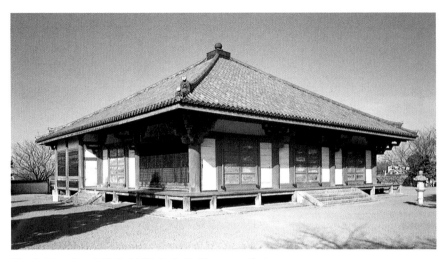

Fig. 2: Pure Land Hall, 1192, Jōdo-ji, Hyogo prefecture

bracket arms inserted directly into the supporting pillars, a high ceiling and vast interior space, and tiered beams supporting the eaves. These innovations have strongly influenced even modern architects, including Isozaki Arata (b. 1931; discussed in Chapter 10), who singled out the Great South Gate as Japan's key architectural monument.

The Great Buddha style recurs in other extant buildings associated with Chōgen. The Pure Land (Jōdo) Hall of Jōdo-ji temple (1192, in Hyogo prefecture) offers a straightforward example [Fig. 2]. The roof's exterior cuts a clean profile, while its underside is fully exposed to view, endowing the hall with a structural beauty different from its more conventional counterparts. The temple's main icon is a 5-meter statue of Amida flanked by two attendants (1195), sculpted by Kaikei (dates unknown) [Fig. 3]. Late on summer afternoons, when the shutters behind the statues are open, the long rays of the setting sun illuminate the statues and the interior of the building. As Isozaki has commented:

> Because the light approaches from behind, one might imagine that the backlit effigies would be reduced to silhouettes, but such is not the case. The sun's rays reflecting off the red lacquered ceiling, beams, and pillars bounce in all directions to saturate the room with light and illuminate the statues from the front. The effect is as if an otherworldly being has descended to take over the entire hall with its presence—a truly divine manifestation.[1]

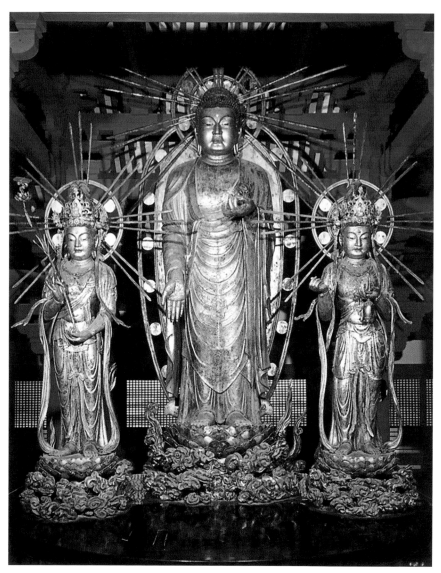

Fig. 3: Amida Triad, carved by Kaikei, 1195, Pure Land Hall, Jōdo-ji, Hyogo prefecture

Chōgen also restored Tōdai-ji's Great Buddha Hall (Daibutsuden; 1190) in the Great Buddha style, but this second incarnation of the building was lost to fire in 1567. As at Jōdo-ji, the underside of the roof was fully exposed and would have encompassed an area three times that of the present Great Buddha Hall at Tōdai-ji, which was completed in 1709 and remains the largest extant wooden building in Japan.

The Great Buddha style fell out of use for some time after Chōgen's death, replaced by the new Japanese style (Shin Wayō), which combined elements of Great Buddha style and traditional Japanese Wayō, or by Zen-shū-yō (Zen style), or Karayō (Chinese style). The stiff quality of regional Chinese architecture seems not to have held lasting appeal, however, as it was Chōgen's Great Buddha Hall at Tōdai-ji that eventually became a reference point for later large-scale temple construction projects, such as the Triple Gate (Sanmon) of Tōfuku-ji (1425) and the Great Buddha Hall of Hōkō-ji temple (1588), both in Kyoto.

3. A Renaissance in Buddhist Sculpture

The Appearance of Unkei, a Sculptural Genius

During the first half of the twelfth century, Buddhist sculptors imitated the classic style of Jōchō (d. 1057), which for almost a hundred years worshippers had considered the standard expression of the Buddha's "true form" (see Chapter 5, Fig. 28). Sculptural activity was concentrated in sophisticated, urban Kyoto, home of the imperial court. During the second half of the century, however, a new movement among Buddhist sculptors in Nara was gathering momentum. An early example is the Amida Triad (1151) in Chōgaku-ji temple, Nara (discussed in Chapter 5). This is among the first Japanese Buddhist sculptures known to have used reverse-painted crystal inset eyes, which glint in a highly realistic manner in candlelight. Here also the deep grooves of Amida's garment signal a revival of styles favored three to four hundred years earlier, particularly those associated with Buddhist sculptures of the Tenpyō period (710–49; see Chapter 4) and the Jōgan period (794–894; see Chapter 5). Pioneered by the Nara sculptor Kōkei (active 1175–1200), guided by Kōkei's son Unkei (d. 1223), and sustained by their pupils in what became known as the Kei school, this movement reached full force in conjunction with the rebuilding of Tōdai-ji and Kōfuku-ji over the period from 1186 to 1208.

Kōkei's Tenpyō- and Jōgan-revival sculptures are infused with an energetic and vigorous Kamakura sensibility. For example, the taut expression of his seated Fukūkenjaku Kannon (Kannon of the Unerring Lasso, Sk: Amoghapāśa) (1189) in the Nan'en-dō, Kōfuku-ji, projects an intense sense of life, as do his realistic portraits of the Six Patriarchs of the Hossō sect [Fig. 4]. Unkei's earliest known work is the seated Dainichi Nyorai (Sk:

Mahāvairocana) at Enjō-ji temple in Nara (1176) [Fig. 5]. Signed with a flourish, "Unkei, the true apprentice of master sculptor Kōkei," the sculpture captures the soft fleshiness of the deity's body and the clean youthfulness of his face, hinting at the young prodigy's skill. Unkei then traveled to the Kantō region (eastern Japan), where in 1186 he produced a seated statue of Amida Nyorai, the main icon of Ganjōju-in temple in Izu (Shizuoka prefecture) [Fig. 6]. The sculpture's fierce and overpowering presence seems an expression of the Kantō warrior temperament. During his time in Kantō, Unkei also produced statues of Fudō Myō-ō (Sk: Acala or

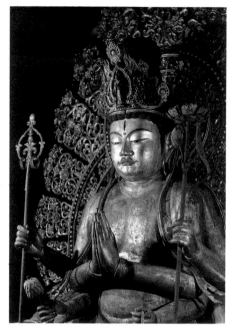

Fig. 4: Seated Fukūkenjaku Kannon, carved by Kōkei, 1189, Nan'en-dō, Kōfuku-ji, Nara

Acalanātha, the "Unmovable One") and Bishamonten (Sk: Vaiśravaṇa) (also in Ganjōju-in), and the Amida Triad (1191) of Jōraku-ji temple (in Kanagawa prefecture), commissioned by the military commander Wada Yoshimori.

Historical documents indicate that, after returning to Kansai (western Japan), Unkei worked with other sculptors of the Kei school such as Kōkei, Kaikei, and Jōkaku to produce a series of colossal wooden religious sculptures in rapid succession. These included a pair of 7-meter-tall heavenly guardians Bishamonten and Jikokuten (Sk: Dhṛtarāṣṭra) for the Middle Gate (Chūmon) at Tōdai-ji, along with a set of 9-meter-tall flanking attendants and 9.5-meter-tall Four Guardian Kings (Shitennō) for the Great Buddha Hall. These particular works no longer survive, but the remaining six of eight child-attendant deity (*dōji*) figures (1191) in the Fudō Hall of Kongōbu-ji temple, Mt. Kōya, demonstrate Unkei's remarkable skill and depth of experience. Then in 1203, over a period of only sixty-nine days, Unkei, Kaikei, and others sculpted the two Kongō Rikishi (Ni-ō, Sk: Vajradhara) guardian figures for the Great South Gate of Tōdai-ji [Figs. 7–9]. Each of these towering 8.4-meter, four-ton sculptures consists of

some 3,000 pieces of wood carefully pinned together in the assembled wood (*yosegi-zukuri*) technique. One guardian, the "Ah" figure (Agyō), stands with his mouth open as though haranguing the worshipper. The other guardian, known as the "Un" figure (Ungyō), greets the worshipper with an angry scowl. The sounds "ah" and "un" together produce the Japanese equivalent for the Sanskrit "ohm."

It was once thought that Kaikei had directed production of Agyō and Unkei that of Ungyō. However, during a four-year conservation project (June 1989–November 1993), conservators discovered within the Agyō statue an authenticating inscription reading, "Master sculptors Hōgen Unkei and Kaikei, with thirteen apprentice sculptors," while the Ungyō statue contained sutras and an inscription stating, "Master sculptors Jōkaku and Tankei, with twelve apprentice sculptors." Also inscribed in Ungyō was the name of the monk Chōgen (who would have been eighty-three at the time). Jōkaku, said to have been Unkei's younger brother, was an experienced carver of large-scale sculptures in his own right. For example, he is thought to have produced the flanking attendants of the

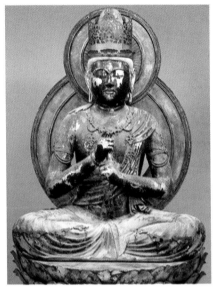

Fig. 5: Seated Dainichi Nyorai, carved by Unkei, 1176, Enjō-ji, Nara

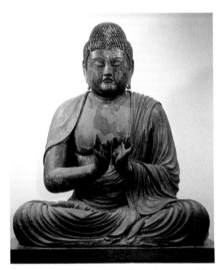

Fig. 6: Seated Amida Nyorai, carved by Unkei, 1186, Ganjōju-in, Izu, Shizuoka prefecture

Great Buddha and the Four Guardian Kings—both in Tōdai-ji—and the Jikokuten in the Middle Gate, although none of these sculptures survives. His role in the development of Kamakura sculpture deserves further study.

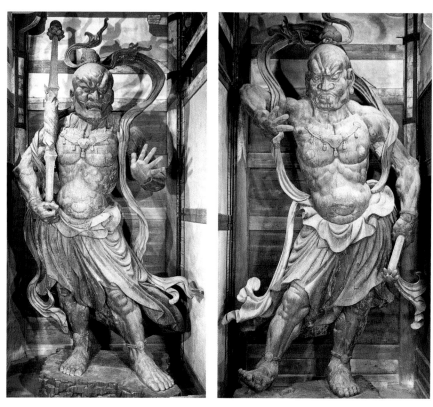

Fig. 7: Standing Kongō Rikishi (Agyō and Ungyō), carved by Unkei and Kaikei, 1203, Great South Gate, Tōdai-ji, Nara

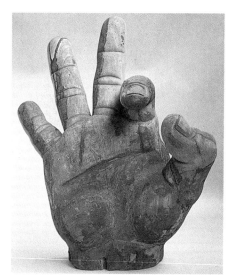

Fig. 8: Right hand of Ungyō during restoration (Fig. 7)

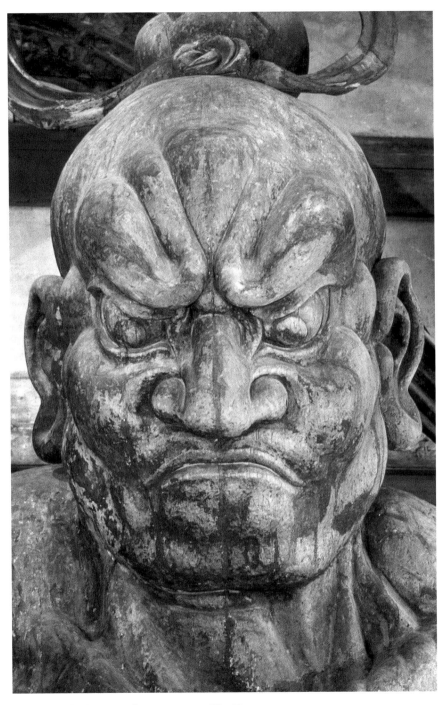

Fig. 9: Head of Ungyō after restoration (Fig. 7)

Even so, it seems evident that the virile form of the Ungyō statue would not have been possible without Unkei's close supervision.

Unkei was also most likely the sculptor of the renowned figure of Chōgen enshrined in Shunjō Hall at Tōdai-ji [Fig. 10]. The figure, which depicts the monk reciting the *nenbutsu* and facing west toward Amida's

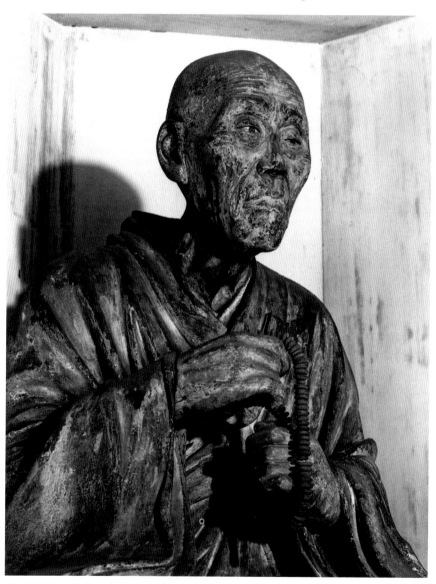

Fig. 10: Seated Shunjō Shōnin (Holy Priest Chōgen), attributed to Unkei, first half of 13th century, Shunjō-dō, Tōdai-ji, Nara (Photo: Domon Ken)

Pure Land, captures not only every sign of age in unstinting detail, but also the sitter's austere personality and religious fervor. The Buddhist sculptural historian Mizuno Keizaburō (b. 1932) credits Unkei with transforming "the aged monk's stooped back and the way his fingers count the rosary beads into a powerful sculpture with a strong sense of volume," and notes that the carving technique employed on the garment corresponds to other examples of Unkei's work.[2] As many have suggested, the figure seems in part to reflect the influence of naturalistic Song Chinese portrait sculptures (appropriately so, since Chōgen claimed to have visited China three times), but its dynamism elevates it to the status of a major work of Kamakura realism.

After the completion of Tōdai-ji, Unkei spent his last years leading ten younger sculptors in creating sculptures of the seated Miroku Bosatsu (the bodhisattva Maitreya, also known as the Buddha of the Future), Asanga (Mujaku), and Vasubandhu (Seshin) (1212) for Hokuen-dō at Kōfuku-ji [Figs. 11 and 12]. The brothers Asanga and Vasubandhu, scholarly monks in India during the fourth to fifth centuries, helped propagate the *vijnapti-matrata* ("consciousness-only") philosophy, which holds that all existence is subjective and nothing exists outside of the mind. The Hossō sect temples Kōfuku-ji and Gangō-ji in Nara were founded on this principle. In depicting

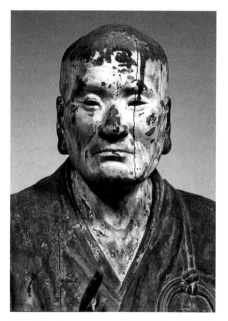

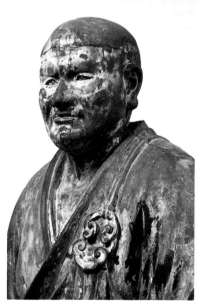

Fig. 11: Asanga, carved by Unkei, 1212, Hokuen-dō, Kōfuku-ji, Nara

Fig. 12: Vasubandhu, carved by Unkei, 1212, Hokuen-dō, Kōfuku-ji, Nara

the two brothers, Unkei seems to have transposed the image of the venerable Indian monk onto that of a more familiar Japanese monk, thereby creating two commanding portraits that rival the finest works of Western Renaissance sculpture. Within the history of Japanese sculpture, these two works are unparalleled.

Kaikei's Artistic Achievements

Unkei's equal in terms of talent, Kaikei trained under Kōkei; he later took the Buddhist name An'amidabutsu to signal his allegiance to Chōgen. His style, labeled the An'ami style, combines well-balanced elegance with a sense of compassion, and in this respect offers a stark contrast to the bold, austere manner of Unkei. All thirty of Kaikei's known sculptures bear the signature, "Skilled workman An'amidabutsu Kaikei," suggesting an awareness of his status as an artist. A superb example of the An'ami style is a sculpture of Miroku Bosatsu (1189; Museum of Fine Arts, Boston) [Fig. 13]. Other recognized examples include the deity Hachiman in the form of a seated monk (1201; Tōdai-ji), a standing figure of Miroku Bosatsu (Sanbō-in, Daigo-ji), and an

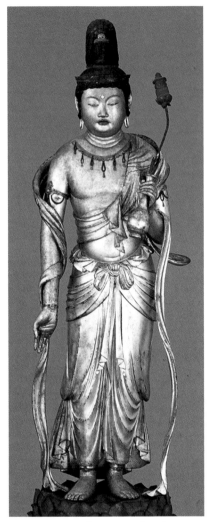

Fig. 13: Standing Miroku Bosatsu, carved by Kaikei, 1189, formerly at Kōfuku-ji, Museum of Fine Arts, Boston. Photograph © 2018 Museum of Fine Arts, Boston

Amida Triad (1195; Pure Land Hall, Jōdo-ji) depicting Amida descending on a cloud flanked by his attendants Kannon (Sk: Avalokiteśvara) and Seishi (Sk: Mahāsthāmaprāpta). This iconography derives most directly from Chinese Song Buddhist paintings.

Unkei's successors: Jōkei, Tankei, Kōben, and Kōshō

Later Kei sculptors preserved and developed the style of the school. Unkei's sons were instrumental in advancing the Kei style. Tankei (1173–1256) was a prolific Buddhist sculptor who succeeded his father as head of the school; in 1213 he received the honorary Buddhist title *hōin* (Seal of the Law) for his commitment to sculpting. Buddhist sculptors working under Tankei produced the main Thousand-Armed Kannon (Senju Kannon) and a large proportion of the flanking smaller Kannon figures at the Sanjūsangen-dō (Hall of Thirty-Three Bays) in Kyoto in 1254. Tankei worked on a smaller scale than his father, but perhaps for that reason honed his technical skills to a remarkably high degree. He endowed his figures with characteristically lighthearted expressions, as seen in his sculptures of Bishamonten and flanking attendants Kichijōten (Sk: Śrī-mahādevī) and Zennishi Dōji at Sekkei-ji temple, Kōchi [Fig. 14]. The feeling of tenderness in his works, as seen in the puppy and deer statues at Kōzan-ji temple, Kyoto, mark him as one of the most talented monk-sculptors.

Unkei's third son Kōben (dates unknown) produced a number of serene and also humorous works, such as the statues of demons Tentōki and Ryūtōki with lanterns (1215) [Fig. 15] in Kōfuku-ji. Unkei's fourth son Kōshō (dates unknown) created the celebrated standing figure of the tenth-century Pure Land priest Kūya (early thirteenth century; Rokuhara-mitsu-ji temple, Kyoto). The syllables of the *nenbutsu* recited by Kūya in a moment of religious ecstasy are represented by six small Amida figures that appear to be issuing from the priest's mouth. The attempt to visualize religious experience in this way represents one element of Kamakura realism.

The late Kei-school style is seen in a pair of guardian figures (Ni-ō) at Kōfuku-ji (c. 1300). Measuring only 1.5 meters, they are relatively small compared to the guardians flanking the Great South Gate, but their musculature seems based on a more natural observation of human anatomy, and their fierce expressions are also more human. These sculptures have been attributed to Jōkei, an apprentice of Kōkei active at Kōfuku-ji around 1200. However, they were most likely produced one generation later. There is another Buddhist sculptor also named Jōkei, known as Higo Bettō Jōkei (dates unknown), who came from the Higo province (present-day Kumamoto area in Kyushu). This sculptor's works are characterized by an enigmatic sensibility that goes beyond Song-influenced sculptural forms, as seen

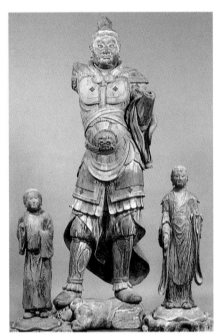
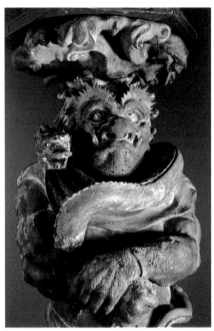

Fig. 14: Bishamonten with Attendants, carved by Tankei, first half of 13th century, Sekkei-ji, Kochi prefecture

Fig. 15: Demon Ryūtōki with Lantern, carved by Kōben, 1215, Kōfuku-ji, Nara

in his slender statue of standing Shō Kannon Bosatsu (1226; Kurama-dera temple, Kyoto).

Other Buddhist Sculptors in the Kyoto and Kamakura Areas

While Kei-school sculptors took center stage during the Kamakura period, in and around Kyoto the conservative En and In schools founded by the disciples of Jōchō continued to be important. In fact, a number of sculptors from these schools contributed to Kei-school projects, such as the Thousand-Armed Kannon figures at the Sanjūsangen-dō. An offshoot of the Kei school was the Zen school, so called because its sculptors' names begin with the character *zen* (meaning good). One of them, Zen'en (1197–1258; also known as Zenkei), established a workshop at Saidai-ji temple in Nara, where he produced work alongside his son Zenshun (active in the late thirteenth century). Perhaps because of their eagerness to extend and elaborate on the innovations of Kōkei and Unkei, these later sculptors produced

little work that might be considered remarkable. A notable exception is the seated figure of the Shinto goddess Tamayori-hime no mikoto (1251), the main deity of Yoshino Mikumari shrine (Mikumari-jinja) in Nara. With its thickly painted brows, blackened teeth, and dimples, this sculpture is almost a portrait. The work was commissioned by Sen'yōmon-in, a daughter of Emperor Go-Shirakawa. During the second half of the thirteenth century, many temples and shrines relied on the patronage of the court aristocracy and individual warrior clans, and the struggles of secular life seem to have motivated these patrons to commission new types of Shinto sculpture.

Far to the east, in Kamakura, new local varieties of Buddhist sculpture emerged independently, combining stylistic elements of Unkei and Song Chinese works. Two important examples are the Great Buddha at Kamakura (1252; officially called the Amida Statue at Kōtoku-in temple) and the seated figure of Shokō-ō (King of the First River) (1251) at Ennō-ji temple. The latter, inscribed "Made by Kōyū" (*Kōyū saku*), shows the direct influence of Chinese Song sculpture.

The practice of venerating secular and religious figures through portrait sculpture also developed during the latter half of the Kamakura period. A major example is the seated figure of warrior Uesugi Shigefusa, progenitor of the Uesugi clan, at Meigetsu-in temple [Fig. 16]. Shigefusa moved

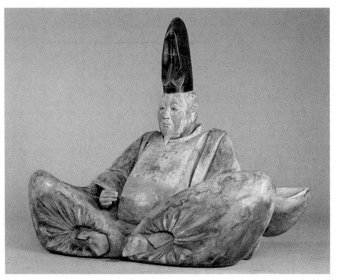

Fig. 16: Portrait of Seated Uesugi Shigefusa, second half of 13th century, Meigetsu-in, Kamakura

to Kamakura sometime after 1252 during his service under Prince Munetaka. Another example is the portrait of the warrior Hōjō Tokiyori at Kenchō-ji temple. We have seen an earlier example of religious portrait sculpture in the figure of Chōgen, but the practice extended further as the mid-Kamakura nobility and warrior clans encouraged highly respected Ch'an monks from Song and Yuan China to visit and preach in Japan. These figures, too, inspired portraits, called in the Zen context *chinzō* (literally, "appearance of the head"), their purpose being to capture the essence of a high-ranking monk in the midst of preaching. Two successful thirteenth-century examples depict the Chinese priests

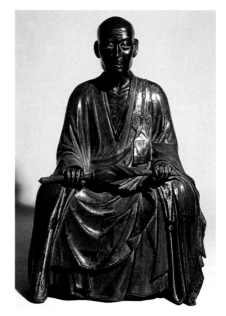

Fig. 17: Portrait of Dajue Zen Master Lanxi Daolong, 13th century, Kenchō-ji, Kamakura

Lanxi Daolong (Rankei Dōryū, also called Daikaku [C: Dajue] Zenji; 1213–1278 in Kenchō-ji) [Fig. 17], and Wuxue Zuyuan (J: Mugaku Sōgen, also called Bukkō Kokushi; 1226–1286 in Engaku-ji temple, Kamakura). Later *chinzō* sculptures tended toward the formulaic.

4. New Movements in Buddhist Painting

The Influence of Chinese Song Buddhist Painting

The Song influence on Japanese Buddhist painting was felt most strongly from the late twelfth century onward. For example, in a painting of the deity Butsugen Butsumo (Sk: Buddhalocanā) dated to 1186 (Kōzan-ji), the eyes of the deity are rendered with a distinctly human form [Fig. 18]. Song influence is also evident in the treatment of the nostrils, the clean use of *gofun* shell-white, and the application of colored pigments to the reverse side of the painting surface. A hanging scroll depicting Monju Bosatsu (Bodhisattva Manjusri) crossing the ocean on the back of a lion to reach Mt. Wutai in China (Daigo-ji) also displays a new compositional method

related to Song Buddhist painting. The painting of Butsugen Butsumo is interesting in that the priest Myōe used it for personal devotion. An inscription in his writing identifies the deity as "the mother of the earless priest," a reminder that Myōe, who lost both his parents at a young age, associated images of Sakyamuni with his father and images of Butsugen Butsumo with his mother. The inscription also refers to the fact that, in an act of religious devotion, Myōe cut off his ear in front of this painting (the surface still carries traces of his blood).

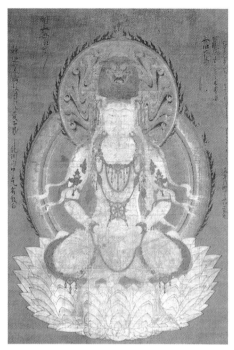

Fig. 18: *Butsugen Butsumo*, second half of 12th century, Kōzan-ji, Kyoto

A number of painters around this time seem to have combined traditional Japanese styles with Song styles, but the Takuma school of Buddhist painters, founded by Takuma Tametō (active mid-twelfth century), excelled in the style. Tametō's son Shōga (dates unknown) is distinguished for his use of thick and thin ink lines and pastel colors, as observed in a set of paintings depicting twelve flying heavenly beings (1191; Tō-ji temple). Shōga's younger brother Tamehisa (dates unknown) expanded the school's base of operations to Kamakura, while his brothers Ryōga, Chōga, and Eiga, and a next-generation pupil, Shunga, kept the school active in Kyoto through the mid-fourteenth century. It has been speculated that a Takuma-school painter produced Myōe's *Butsugen Butsumo* painting.

Buddhist Narrative Painting

The term "Buddhist narrative painting" (*bukkyō setsuwa-ga*) refers to handscrolls, hanging scrolls and other paintings illustrating the corpus of Buddhist teachings, including miraculous tales, interpretations of the sutras. No extant example predates the thirteenth century, but one can readily

imagine these subjects appearing in paintings of late 1100s in response to the anxieties of the times. Song influence, however, lends Buddhist narrative paintings of the thirteenth century a striking sense of reality.

Pure Land teachings provided a major subject for thirteenth-century Buddhist narrative paintings, particularly Genshin's *Essentials of Rebirth* (*Ōjō Yōshū*) (discussed in Chapter 5). Among a set of fifteen Buddhist scrolls now preserved at Shōjuraikō-ji temple (Ōtsu, Shiga prefecture), twelve depict scenes related to the Six Realms of Existence (Rokudō), which Genshin described in terrifying detail. The set was originally kept at Ryōsen-in, a temple established by Genshin, in the Yokawa area of the Enryaku-ji temple. One painting from the set depicting the suffering of the human realm shows the corpse of a beautiful woman as it lies abandoned in a field undergoing various stages of decay [Fig. 19]. Maggots can be seen in her body, and one scene shows stray dogs ravaging the corpse, while at the end nothing recognizable remains but scattered bones. The other paintings in this set depict the agonies of hell, separation from loved ones, and people abusing animals. The set skillfully interweaves Song techniques with the Japanese *Yamato-e* tradition.

The *White Path between the Two Rivers* hanging scroll (Kōsetsu Museum of Art, Kobe) presents a condensed version of a parable from the annotation of the *Sutra of Immeasurable Life* (*Kanmuryōju-kyō sho*) written by the Chinese priest Shandao (613–668), founder of Pure Land Buddhism and popularized by Hōnen and Shinran in Japan [Fig. 20]. According to Shandao, a river of water and a river of fire spring from a single point and flow out in opposite directions, right and left. The river of water symbolizes greed and obsession, while the river of fire symbolizes anger and hatred. Only a thin white path (symbolizing the Buddha's teachings) leads safely from this world across the rivers to Amida's Pure Land. In this world, a traveler beset by thieves and wild animals (representing the passions) hears Sakyamuni saying, "Walk on," while from the opposite side Amida calls, "Proceed this way." Paintings of the subject show the Pure Land bathed in golden light—a stark contrast to the grim world of ordinary existence—inviting devotees to make the crossing. The priest Ippen evidently used similar paintings to teach this parable to his own followers (as seen in scroll 1 of the *Ippen Hijiri-e*; discussed below). The beautification of paradise occurs in other Buddhist works, such as the pair of two-panel *Hell and Paradise* folding screens in Konkai Kōmyō-ji temple, Kyoto.

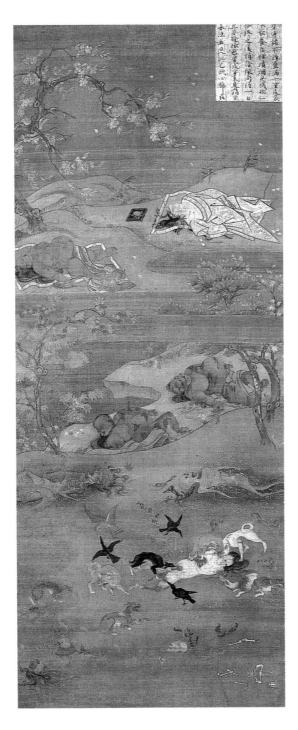

Fig. 19: "Aspects of the Unclean Human Path," from *The Six Realms of Existence*, 13th century, Shōjuraikō-ji, Ōtsu, Shiga prefecture

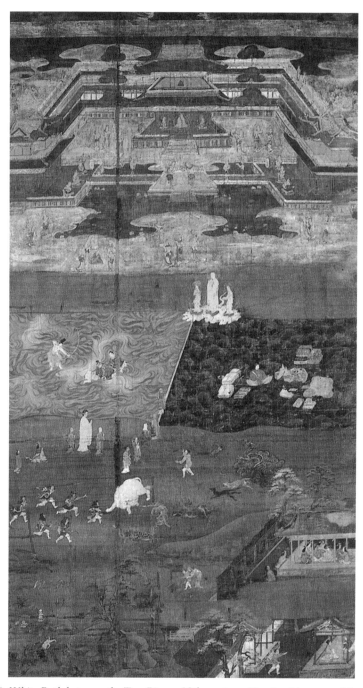

Fig. 20: *White Path between the Two Rivers*, 13th century, Kōsetsu Museum of Art, Kobe

Many Buddhist paintings of this period used "virtual reality" to suggest a connection with the contemporary world. For example the painting *Fugen* (Sk: Samantabhadra) *and Ten Rasetsunyo* (Sk: Rākshasis) (Rosan-ji temple, Kyoto) depicts the deities who guard devotees of the *Lotus Sutra*, as described in the "Dharani Chapter" (Chapter 26) of that sutra. Several figures in this painting wear Chinese garb, suggesting that the work was based on a Chinese original. By contrast, the women (*Rasetsunyo*) in paintings of the same subject in the Nara National Museum and the Masuda Family Collection dated to the later thirteenth century are dressed in the type of robes worn by Japanese court ladies. Both examples reflect the fact that the Lotus Sutra offered the possibility of salvation to women, and that court ladies who promoted the sutra were rewarded by being represented in paintings as deities who safeguard the sutra's devotees.

New Styles of *Raigō-zu*

Enhanced realism occurs also in Kamakura-period Pure Land paintings of Amida descending to welcome the soul of a dying worshipper into paradise (*raigō-zu*; also discussed in Chapter 5). In these examples, Amida is shown standing tall, enhancing the impression of an accelerated descent. One such example is the *Amida and Twenty-Five Bosatsu* in Chion-in temple in Kyoto, informally known as the *haya-raigō* or "speedy welcome." Here Amida and his attendants make their descent in a steep diagonal from top left to bottom right, where the devoted deceased awaits them [Fig. 21]. Amida raises his hands in a welcoming gesture (*raigō* mudra), as wispy clouds trail behind him, vanishing to nothing and contributing to the dramatic overall sweep of miraculous beings. The Amida group is painted in golden pigments that serve to highlight them in otherwise dark surroundings. The background, which includes waterfalls cascading from cliffs and cherry blossoms in full bloom, confers an impression of natural paradise.

Another type of Kamakura-period *raigō* iconography is "Amida coming over the mountain" (*yamagoe raigō*). In this case, Amida is depicted towering from the chest up over a line of rounded hills, his hands raised in the "expounding the teachings of the Buddha" gesture (*tenpōrin* mudra). Sometimes—as in the *yamagoe raigō* triptych in Zenrin-ji temple, Kyoto— he appears flanked by Fugen and Monju. The *raigō* painting in Konkai

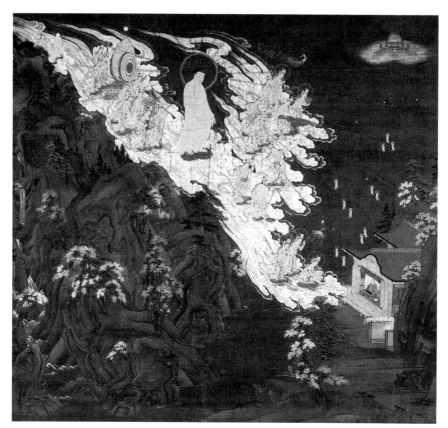

Fig. 21: *Welcoming Approach of Amida and Twenty-Five Bosatsu*, 13th century, Chion-in, Kyoto

Kōmyō-ji once had colored silk threads attached to Amida's hands, so that a dying believer could hold the other end and establish a physical link between him/herself and the deity [Fig. 22]. At his death in 1028, the mighty Fujiwara no Michinaga (discussed in Chapter 5) performed this very practice, as described in A *Tale of Flowering Fortunes* (*Eiga mono-gatari*). Dated somewhat later, the *yamagoe raigō* in the Kyoto National Museum shows Amida as though he is about to cross a mountain ridge [Fig. 23]. Gray clouds filtering through chasms in the landscape appear to rise toward the viewer like living creatures set loose. This hyper-realistic painting also bears traces of an area where colored silk threads were once attached. Powerful images such as these were intended to offer reassurance of rebirth in Amida's Western Paradise.

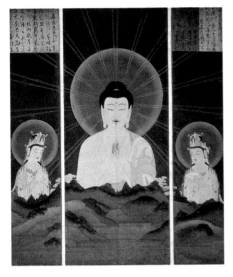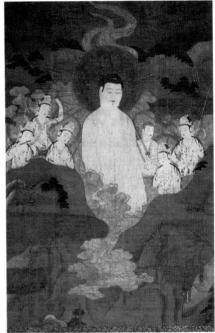

Fig. 22: *Amida Coming over the Mountain*, 13th century, Konkai Kōmyō-ji, Kyoto

Fig. 23: *Amida Coming over the Mountain*, 13th century, Kyoto National Museum

Of course, *raigō-zu* were not invented in the Kamakura period. Painted on the sliding doors of the Phoenix Hall of Byōdō-in temple in Uji, Kyoto (eleventh century) is a depiction of Amida already having crossed the mountains to stand directly before the viewer. This painting creates a sense of continuous three-dimensional space extending from the deity back through to the landscape. In Kamakura-period versions of the subject, however, the mountain ridge serves as a dramatic boundary separating the world of mortals from that of the divine, the profane land from the Pure Land. In this regard, Kamakura *raigō* paintings are decidedly more theatrical than those of other periods.

It should be noted that Amida's welcoming descent also became a subject for religious festival processions. Still performed today is a welcoming ceremony (*mukaekō*) held annually in May at Taima-dera temple (Nara prefecture). This version of religious theatre incorporates various aspects of Pure Land art and belief, and represents perhaps the quintessential enactment of *raigō* iconography.

Paintings Based on the Theory of Buddhist and Shinto Unity and Manifestations of These Deities

Late ninth-century Japanese theorists of Esoteric Buddhism (see Chapter 5) aimed to synthesize their imported religion with native Japanese beliefs. They did so by defining Buddhist divinities as the "originating sites" (*honji*) of Shinto deities, which they called "traces" (*suijaku*). *Honji-suijaku* theory soon gave rise to a host of composite Shinto-Buddhist deities known as "provisional manifestations" or avatars (*gongen*), a term that implies shared power. Avatars or *gongen* are central to the theory of a "union between *kami* and Buddhas" (*shinbutsu shūgō*; Chapter 5). In this way, for example, the deity Hachiman came to be known as both Hachiman the Great Bodhisattva and Hachiman the Avatar. Followers of Shugendō mountain worship treated the Japanese landscape in similar terms, as they understood ancient, *kami*-infused wild places such as Mt. Kōya and Mt. Kinpusen in Yoshino, Nara, to have been visited by Miroku. Likewise, they saw Kumano, Wakayama prefecture, to be a manifestation of Mt. Potalaka, the Pure Land of Kannon as described in the *Flower Garland Sutra* (Sk: *Avataṃsaka sūtra*; J: *Kegon-kyō*). Meanwhile, the non-duality of the principle represented in the Mandalas of the Two Worlds was incorporated in the *suijaku* theory to explain the inseparable nature of the *kami* and Buddhas.

Suijaku paintings (paintings based in the theory of Buddhist and Shinto unity) reflect the Kamakura-period interest in lending concrete form and specific visualization to abstract ideas. One category of *suijaku* painting, for example, is the "shrine mandala" (*miya mandala* or *shaji mandala*) which depicts a shrine as being inhabited by a protective Buddhist divinity (*honji-butsu*). Important in this category were Kasuga shrine mandalas, although it should be noted that this subject was not new. According to historical records, a Kasuga shrine mandala was painted on the sliding doors of Hōjō-ji temple (1017) in Kyoto, built by Fujiwara no Michinaga. Here, hovering above the peak of Mt. Mikasa (the location of Kasuga grand shrine) was the *kami*'s true identity, the shrine's protective Buddha.

The earliest extant Kasuga shrine mandala is a Kamakura-period painting depicting Kasuga's four shrines, each with a gold medallion above it inscribed with a Sanskrit letter representing that sub-shrine's principal Buddhist deity: Fukūkenjaku Kannon, Yakushi Nyorai (Sk: Bhaiṣajyaguru, also known as the Medicine Buddha), Jizō Bosatsu (Sk: Kṣitigarbha) and

Eleven-Headed Kannon (Jūichimen Kannon) (Nezu Museum, Tokyo). This format evolved into a second type of Kasuga shrine mandala providing an overall bird's-eye view of the shrine compound (Museum of Fine Arts, Boston). Later, a third type developed in which the divine spirits occupy the area between the shrine's first and second torii gates is added as well as an image of Monju as the Wakamiya-sha shrine's original Buddhist identity. This is seen in an example dated to 1300, which was commissioned by Fujiwara no Munechika, painted by Kanshun (late Kamakura period), and is now in the collection of Yuki Museum of Art in Osaka [Fig. 24]. The enigmatic supernatural world of this shrine mandala, rendered in superbly controlled pigments, carries echoes of Pure Land images. It features flowering cherry trees to complete the picture of a sacred realm. This is the most prevalent type of Kasuga shrine mandala in Kamakura and Nanbokuchō (1336–92) art. Another example is in the Metropolitan Museum of Art, New York (formerly in the Burke Collection).

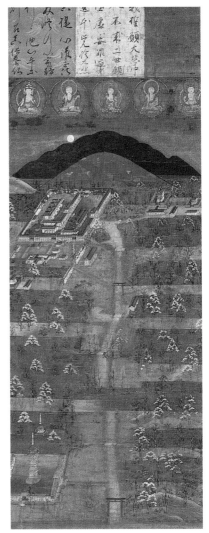

Fig. 24: *Kasuga Shrine Mandala*, 1300, Yuki Museum of Art, Osaka

Both Kasuga grand shrine and Kōfuku-ji had close ties with the Fujiwara family who, together with Kōfuku-ji, sought to integrate the two establishments as a way of extending their influence. This political circumstance was a strong undercurrent in the development of the theory of *honji suijaku* (synthesis of imported Buddhist religion with native Japanese beliefs). An art-historical byproduct of this maneuvering was the emergence of a counterpart to the Kasuga

grand shrine mandala; namely, the Kasuga shrine-temple mandala. These depicted the temples and Buddhist statues of Kōfuku-ji in combination with the view of Kasuga grand shrine. One of such examples is the *Kōfuku-ji Mandala* in the collection of Kyoto National Museum (early thirteenth-century) which pays tribute to the temple by depicting its subtemples and sculptures in great detail, while treating Kasuga grand shrine almost as an auxiliary element. These mandalas provide insight into the later practical workings of the *honji suijaku* system and its theological balance of power.

The Kasuga deer mandala is a variant of the Kasuga shrine mandala. In place of the shrine we find a deer —the messenger of Kasuga deity— with willow branches mounted on its body. One highly accomplished example presents a deer charged with a supernatural aura (Yōmei Bunko, Kyoto) [Fig. 25]. Other Kasuga deer mandalas depict the animal bearing a golden mirror containing the Buddhist avatar of the Kasuga deity; the mirror also doubles as a rising full moon. Scrolls of this type are in the

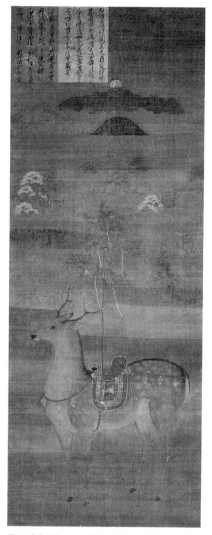

Fig. 25: *Kasuga Deer Mandala*, end of 13th century, Yōmei Bunko, Kyoto

Tokyo National Museum, Seikadō Bunko Art Museum in Tokyo, and the Minneapolis Institute of Arts (formerly in the Burke Collection). A magnificent sculptural example of the subject can be seen in the Hosomi Art Museum, Kyoto.

Regarded as sacred by Shugendō practitioners and thought to be itself the Pure Land of Kannon, the landscape of Kumano and its many enshrined deities were also themes for *suijaku* painting. The focus was

Kumano's three shrines—the main shrine (*hongū*); the new shrine (*shingū*) or Hayatama grand shrine; and Nachi grand shrine—and their respective Buddhist identities: Amida, Yakushi Nyorai, and Thousand-Armed Kannon. A rare example of the Kumano shrine mandala, formerly held at Chōgaku-ji temple, Tenri, and now in the Cleveland Museum of Art, shows the three shrines in a single painting, with the main shrine at the bottom, then the new shrine, and finally Nachi grand shrine at the top. The clarity and delicacy of execution recall the *Illustrated Scrolls of the Miracles of the Kasuga Deity* (*Kasuga Gongen Kenki Emaki*, 1309; Museum of the Imperial Collections, Tokyo), suggesting an early fourteenth-century date. Notable are not only the accurate rendering of the shrines and the presence of many associated Buddhist deities floating in roundels, but also—quite unlike the Kasuga shrine mandalas—the presence of pilgrims, which places this work early in the development of pilgrimage mandalas (*sankei mandara*). Interest in these would rise almost to the level of a craze over the course of medieval and premodern times.

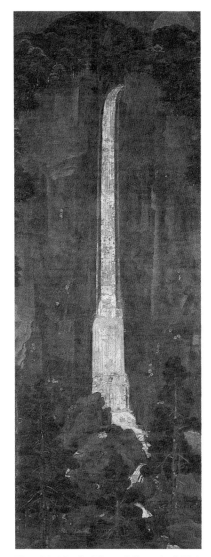

Fig. 26: *Nachi Waterfall*, end of 13th century, Nezu Museum, Tokyo

The nearly audible torrent of water depicted in the *Nachi Waterfall* (Nezu Museum) hints at the presence of an almighty power and corresponds to the Japanese reverence for nature [Fig. 26]. Toward the bottom of the image is the roof of Hirō shrine (Hirō-jinja), suggesting that the painting served for worshipping the waterfall as a manifestation of the *kami*. Nearby is the large wooden stele erected when Emperor Kameyama made a pilgrimage to the site in 1281, making

it possible to date the scroll to around the late thirteenth century. Above and just behind the mountain is the shadowy form of the moon—perhaps the original Buddhist site of Hirō Gongen; as the art historian Miyajima Shin'ichi (b. 1946) rightly stated, this painting "captures the actual location where the *kami* manifests itself."[3] The painting throughout shows the influence of Song landscapes, particularly in the axe-cut strokes used to depict the craggy rock surface.

Another type of Kamakura manifestation image is the *yōgō-zu*, or manifestation of the Buddhist and Shinto deities, which portrays scenes from a dream or a dreamlike episode. The *Dreamlike Manifestation of Kumano Gongen* (Dannō Hōrin-ji temple, Kyoto), for example, depicts Amida appearing before an old woman who has completed forty-eight pilgrimages to the Kumano shrines [Fig. 27]. In this case the illustration depicts a vivid but dreamlike experience; the exaggerated hyperrealism of Amida's

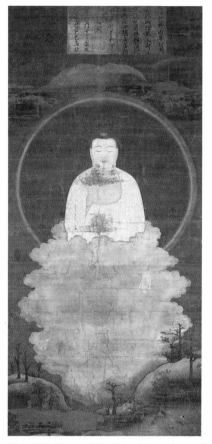

Fig. 27: *Dreamlike Manifestation of Kumano Gongen*, first half of 14th century, Dannō Hōrin-ji, Kyoto

gigantic size, in contrast to that of the bewildered worshippers, recalls paintings of Amida crossing the mountains (discussed above). This work bears an inscription dated 1329. Another example is the *Dreamlike Manifestation of Kasuga Myōjin* (before 1327; Fujita Museum of Art, Osaka) by the court painter Takashina Takakane (active during the first half of the fourteenth century). This work bears an inscription by Chief Councillor Takatsukasa Fuyuhira explaining that it illustrates the occasion when the deity appeared in the garden of Fuyuhira's mansion holding a calligraphed scroll. The Kasuga deity wears an official form of court robes, but his face is lightly shrouded in mist, while original Buddhist deities of the five sub-shrines

of Kasuga surround him. *Hachiman Manifesting in the Form of a Monk* (second half of the thirteenth century; Ninna-ji temple, Kyoto) presents an enormous silhouette of the deity Hachiman floating up against the wall, enhancing the impression of a mystical experience.

Such efforts at mystical realism in early to mid-Kamakura Buddhist and Shinto paintings reflect a visual interest in the world shaped in part by Song realism. That said, however, Chinese Song influence at this point was still indirect. Song techniques would be heavily employed, particularly from the mid-Kamakura period onward, in the area of ink paintings, under the influence of Zen monks.

5. New Styles in *Yamato-e*

Portraits and Likenesses

Portraits of secular personages were uncommon for most of the Heian period. The few portraits remaining from that time depict saints or high-ranking monks. It has been argued that the scarcity of Heian secular portraiture reflects a fear that a portrait, whether painted or sculpted, could serve as a vehicle for exercising black magic against the subject. Whatever the case, secular portraits gradually increased in importance during the century associated with cloistered imperial rule (Insei period; 1086–1192). The reasons for this development are uncertain, but they cannot be entirely unrelated to a strengthening of interest in the human condition over the same period.

As suggested, formal portraits, particularly representations of emperors, were not unknown prior to the Kamakura period. A passage in *A Tale of Flowering Fortunes* (*Eiga monogatari*) associated with the year 1088, for example, describes a posthumous portrait of Emperor Go-Ichijō stating, "Although it did not resemble him, it was profoundly moving." And *Kikki* (existing entries are from 1173–88), the diary of courtier Yoshida Tsunefusa, notes that a portrait of retired Emperor Toba was painted at the time of his death in 1156. However, the oldest surviving formal portrait of an emperor is that of Go-Shirakawa (early thirteenth century; Myōhō-in, Kyoto) [Fig. 28]. Breaking protocol for this type of work, the face (now flaked) and the large figure (now barely visible) exude an unyielding authority and strong personality, as though to confirm Minamoto no Yoritomo's description

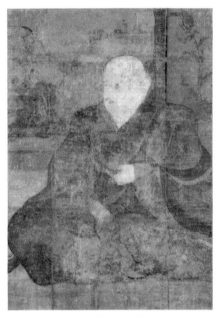

Fig. 28: *Portrait of Retired Emperor Go-Shirakawa*, attributed to Fujiwara no Takanobu, beginning of 13th century, Myōhō-in, Kyoto

of the subject of the painting as "Japan's greatest goblin [*tengu*]."

A *Short History of Jingo-ji Temple* (fourteenth century) has provided the traditional identification for three other famous Kamakura portraits, all in the collection of Sentō-in (a subtemple of Jingo-ji founded 1188 in Kyoto). One is said to be of Minamoto no Yoritomo [Fig. 29]; another of Taira no Shigemori [Fig. 30]; and a third, Fujiwara no Mitsuyoshi. The *Short History* reports that these, along with a portrait of Taira no Narifusa, were painted by Fujiwara no Takanobu (d. 1204 or 1205), a leading figure in the history of Japanese portraiture. Yonekura Michio (b. 1945) has suggested, however,

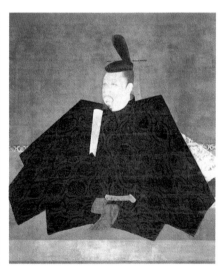

Fig. 29: Portrait traditionally identified as Minamoto no Yoritomo, attributed to Fujiwara no Takanobu, 13th century, Jingo-ji, Kyoto

Fig. 30: Portrait traditionally identified as Taira no Shigemori, attributed to Fujiwara no Takanobu, 13th century, Jingo-ji, Kyoto

that these portraits were produced in the mid-fourteenth century, and that the first one actually depicts Ashikaga Tadayoshi, younger brother of Ashikaga Takauji (see Chapter 7). The issue is not yet settled; younger scholars accept this theory while those of an older generation seek further evidence. In my view, taking stylistic factors into account, the "Yoritomo" portrait was produced later than that of Go-Shirakawa, but it was made prior to the fourteenth century.

It is perhaps not surprising that Takanobu would receive credit for having painted the Jingo-ji portraits, for by the early fourteenth century his fame was well established. An entry for the year 1173 in *Gyokuyō*, the diary of Kujō Kanezane (exisiting entries are from 1164–1202), states:

> On the sliding door panels of the halls at Saishōkō-in temple [in Kyoto], Fujiwara no Takanobu depicted scenes from the imperial visit of Go-Shirakawa and Kenshunmon-in [retired Emperor Go-Shirakawa's favorite consort] to Hirano, Hiyoshi, and Kōya. The paintings were by Tokiwa Mitsunaga, and Takanobu was in charge of [painting] the faces. Although described as "unsurpassed treasures," they were rarely displayed, and even then only in a discreet manner. When Kenshunmon-in heard of this, she ordered the paintings to be opened to view immediately. It was a great blessing that I had not accompanied the group on the trip and so was not depicted.

This passage suggests that Takanobu made a specialty of portraits, and that while his images were much discussed, they were not casually displayed. For viewers of the time, the focus of contention seems to have been his rendering of people's faces.

Takanobu's skills passed to his son Fujiwara no Nobuzane (1176?–1266?), who became one of the Kamakura period's most celebrated portrait painters. Nobuzane was a half-brother of the poet Fujiwara no Sadaie (Teika; 1162–1241), so his work is well recorded. Extant paintings include *A Gathering at the Central Palace* (fourteenth-century copy of 1218 original; Kitamura Museum, Kyoto), which depicts thirty-one court nobles at a moon-viewing party in the palace; and a portrait of Retired Emperor Go-Toba at the time of his banishment in 1221 (Minase Jingū shrine, Osaka prefecture). Nobuzane's important *nise-e* (likeness pictures) include images in the *Illustrated Scroll of the Imperial Guard Cavalry* (c. 1247; Okura

Museum of Art, Tokyo) [Fig. 31]. Except for the last two, all the figures in this scroll are said to be Nobuzane's work. The poetry anthology *New Gleanings of Japanese Poetry* (*Shin Shūi Wakashū*; 1364) notes the existence of a self-portrait as well. Nobuzane's last recorded painting is a Zen portrait (*chinzō*) of the monk Gokū Keinen, produced in 1266 when Keinen returned from Zen training in China; Nobuzane would have been ninety years of age.

Unlike the term for portraiture (*shōzō-ga*), which is a modern word, the term *nise-e* first emerges in historical documents dating to the mid-twelfth century. The term's meaning in those early contexts has been a subject of debate, however. For our purposes, *nise-e* may be character-

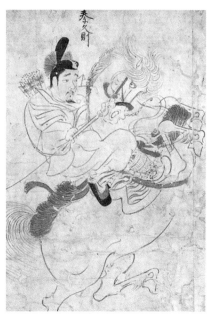

Fig. 31: *Illustrated Scroll of the Imperial Guard Cavalry*, attributed to Fujiwara no Nobuzane, c. 1247, Okura Museum of Art, Tokyo

ized as: 1) *Yamato-e*, excluding images of religious patriarchs and *chinzō* (discussed below); 2) secular sketches of living persons featuring multiple outlines to define the contours of the face, excluding portraits used for religious worship; 3) small-scale paintings rendered on paper; 4) depictions of a single person or a group; 5) somewhat exaggerated depictions, reminiscent of caricature (the Meiji-era edition of the *Documents of Old Paintings* [*Corrected and Amended Kōko Gafu*, vol. 9, 1910] described *shōzō* as respectful and *nise-e* as playful); 6) depictions of horses and cows; 7) works possibly influenced by Song Chinese concepts of verisimilitude (*xiezhen*; J: *shashin*) and "sketching from life" (*xiesheng*; J: *shasei*), as well as Song depictions of people and animals—for example, depictions in handscroll format of tribal peoples offering tribute to the Chinese emperor (see *Emperor Yuan of Liang Receiving Foreign Visitors* [*Liang Yuan-di Fankeruchao-tu*], National Palace Museum, Taipei) and images such as *Five Horses* by Li Gonglin (or Li Longmian, 1049–1106).

While *nise-e* are an important component of Kamakura realism, *Documents of Old Paintings* correctly identified in them an element of

playfulness. In fact, they are good examples of what might be termed the "play of imitation," an important theme in Japanese art. One thus finds striking similarities in method and the playful mode of caricature making between the *nise-e* rendition of the horsemen in the *Illustrated Scroll of Imperial Guard Cavalry* and the half-length portraits of actors by Tōshūsai Sharaku (active 1794–1795; discussed in Chapter 9).

It is worth noting that secular *nise-e* techniques occasionally influenced the portrayal of high-ranking Buddhist monks. A prime example is the portrait of Priest Myōe attributed to Enichibō Jōnin (active thirteenth century), one of Myōe's close disciples [Fig. 32]. Jōnin wonderfully captured the stillness of the priest in quiet seated meditation between the two parted branches of a pine tree, rendering his features in *nise-e* style brushwork that conveys the painter's familiarity with — and profound respect for — his subject. A portrait

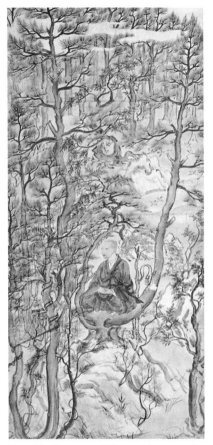

Fig. 32: *Portrait of Priest Myōe*, attributed to Enichibō Jōnin, 13th century, Kōzan-ji, Kyoto

of Priest Ippen chanting the *nenbutsu* and distributing *nenbutsu* amulets (Fujita Museum of Art) likewise captures the eccentric nature of this old monk who devoted himself to the life of an itinerant priest with complete disregard for such basic necessities as clothing, food, and shelter.

Developments in Illustrated Scrolls

As discussed in Chapter 5, twelfth-century illustrated handscrolls often seem like lengths of film combining an abundance of small episodes that, when viewed in succession, create the impression of motion and live action. Illustrated handscrolls of the thirteenth and fourteenth centuries exhibit

three new features. First, the illustrations tend to focus on self-contained episodes isolated one from another by notable temporal gaps.[4] Practical narrative reasons may explain this change, but the result is a reduced sense of dynamism and flowing time. Second, the handscrolls of this period show the influence of the landscapes depicted in Chinese Song-period handscrolls and narrative paintings: background scenery becomes more prominent, with a quality of realistic three-dimensional space. Third, illustrated handscrolls were being produced in greater numbers for a wider, popular audience. Of these, less formal scrolls intended for personal enjoyment rather than formal situations proved particularly successful, with demand coming from commoners and aristocrats alike. Below we will consider the major illustrated handscrolls of the period classified according to the following themes or genres: illustrated tales (*monogatari-e*); poetry contests (*uta awase-e*); war tales (*kassen-e*); popular narratives (*setsuwa-e*); the legendary origins and histories of shrines and temples (*shaji engi-e*); pictorial biographies of eminent Buddhist priests and patriarchs (*kōsōden-e*); and paintings of great poets (*kasen-e*).

Illustrated tales (*monogatari-e*) or handscrolls depicting popular tales are the successors to picture scrolls of fictional tales (*tsukuri monogatari*) such as the twelfth-century *Tale of Genji* scrolls (Chapter 5), a genre that in the past was occasionally called "women's pictures" (*onna-e*). Examples include the handscrolls of *Wakefulness at Night* (late twelfth century; Museum Yamato Bunkakan, Nara), the *Diary of Murasaki Shikibu* (second half of the thirteenth century; Fujita Museum of Art and other collections), and the *Tales of Ise* (early fourteenth century; Kubosō Memorial Museum of Arts, Osaka prefecture). All employ the established techniques for handscroll illustration encountered in the *Tale of Genji* scrolls—areas of colored pigment reinforced with ink outlines (*tsukuri-e*), faces with "slits for eyes and hooks for noses" (*hikime kagibana*), and "blown-away roofs" (*fukinuki-yatai*)—although with improved articulation of architectural plans and more precise and recognizable physical gestures. The *Illustrated Scroll of Tales of Ise* (*Ise monogatari*) handscroll is particularly known for these techniques, as well as for its abundant use of gold and silver foil.

The delicate beauty of line drawing inspired a separate genre of narrative paintings in monochrome ink. Known as *hakubyō* or *shira-e* ("white pictures"), these have precedents in Chinese *baihua* (J: *hakuga*, "white images"). An early example is the so-called *Eyeless Sutra* or *Menashi-kyō* (late twelfth century; Tokyo National Museum, the Gotoh Museum and

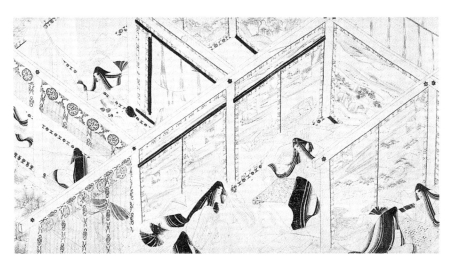

Fig. 33: *Illustrated Scroll of Toyo no Akari*, beginning of 14th century, Maeda Ikutokukai Foundation, Tokyo

other collections). Transcribed onto writing paper, this sutra has *hakubyō* under-drawings in which the faces lack eyes and noses. Also well known is the *Romantic Story of Lord Takafusa* (second half of the thirteenth century; National Museum of Japanese History, Chiba prefecture), telling of Fujiwara no Takafusa's unrequited love for Lady Kogō. In the case of the *Illustrated Scroll of Toyo no Akari* (early fourteenth century; Maeda Ikutokukai Foundation, Tokyo) [Fig. 33]—relating the story of a young aristocrat who takes the tonsure upon the death of his wife—the text and illustrations are both thought to be the work of Go-Fukakusa-in Nijō (1258–1307), a consort of Emperor Go-Fukakusa known for *An Unsolicited Tale* (*Towazu-gatari*, soon after 1306). The limpid aesthetics of *hakubyō* scrolls suggest a feminine sensibility that may be linked to certain types of modern-day girls' manga (see Chapter 10, Fig. 78).

Depictions of poetry contests (*uta awase-e*) show two teams of poets competing for supremacy in the composition of *waka*, or thirty-one-syllable classical Japanese poems. The scrolls may also illustrate the places that the poems reference. Historical documents suggest that *uta awase-e* were produced as early as the Insei period, but the oldest extant example is the *Picture Contest of Poems on the New Famous Places in Ise* (c. 1295; Jingū Chōkokan Museum, Ise). The lyrical paintings here aptly reflect the accompanying verses in capturing the rich poetical quality of Ise's famous sites (the artist is thought to have also painted the *Illustrated Scroll of the Tale of*

Obusuma Saburō, discussed below). A subcategory of poetry-contest scrolls that became important from the second half of the Kamakura period are depictions of fictional contests between teams of craftsmen and laborers (*shokunin zukushi uta awase*). The poems in these scrolls were composed by members of the courtly elite, suggesting a curiosity on the part of this social rank regarding the lives of commoners. The earliest known example is the *Tōhoku-in Poetry Contest among Persons of Various Occupations* (first half of the fourteenth century, Tokyo National Museum) [Fig. 34].

Fig. 34: "The Gambler" from *Tōhoku-in Poetry Contest among Persons of Various Occupations*, first half of 14th century, Tokyo National Museum

In this case, the different workmen who have arrived at Lady Tōhoku-in's palace to compose on the themes of the moon and love are rendered in agile brushstrokes that create a lively sense of movement. Two later examples are the *Poetry Contest among Persons of Various Occupations on the Occasion of a Hōjō Ritual at Tsurugaoka Hachiman-gū shrine* and *Poetry Contest among Persons of Various Occupations in Thirty-Two Rounds*, both dated to around the mid-fourteenth century.

The first illustrated war tale (*kassen-e*) mentioned in historical documents is the *Illustrated Scrolls of Latter Three Years' War* commissioned by Retired Emperor Go-Shirakawa in 1171, near the end of the Insei period. The earliest surviving example is the *Illustrated Scrolls of the Tale of the Heiji* (early fourteenth century), now dispersed in various sections, including the "Night Attack on Sanjō Palace" (Museum of Fine Arts, Boston), the "Tale of Shinzei" (Seikadō Bunko Art Museum), "Removal of the Imperial Family to Rokuhara" (Tokyo National Museum), and the "Battle of Rokuhara" (Metropolitan Museum of Art, formerly in the Burke Collection). The ravaging flames of the Sanjō Palace scene point to superior powers of observation and draftsmanship in the artist, although the flames in the *Illustrated Scrolls of the Courtier Ban Dainagon* scroll may be said to have a greater visual impact [Chapter 5, Fig. 54]. In this latter connection, Umezu Jirō (1906–1988), an important scholar of Japanese handscrolls, suggested

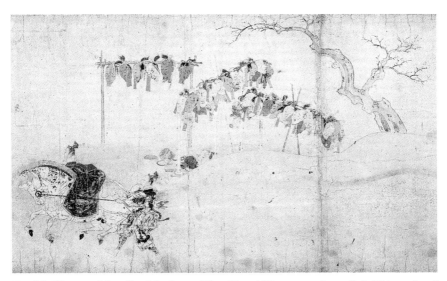

Fig. 35: *Illustrated Scrolls of the Latter Three Years' War*, scene 4, scroll 3, Hida no kami Korehisa, 1347, Tokyo National Museum

that the Sanjō Palace section must be a later copy and that the original might exist elsewhere. Another major *kassen-e* depicts the Mongol invasions of 1274 and 1281, which the Japanese survived due to a combination of military prowess and a driving storm known as the "divine wind" (*kamikaze*). This work, known as the *Illustrated Scrolls of the Mongol Invasion* (*Mōko shūrai emaki*; 1293; Museum of the Imperial Collections) was commissioned by the warrior Takezaki Suenaga (1246–1314) to document his own valor during the invasion. An *emaki* known for its dispassionate depiction of violence is the *Illustrated Scroll of the Latter Three Years' War* by Hida no kami Korehisa (1347; Tokyo National Museum) [Fig. 35]. Scenes with images such as a prisoner of war having his tongue ripped out seem reminiscent of *rokudō-e* hell paintings, and may have had a similar didactic purpose.

Pictures of popular narratives (*setsuwa-e*) depict tales derived from familiar stories. Topics range from Buddhist spiritual experiences to incidents from the lives of ordinary commoners. These works are connected with the illustrated scrolls of popular tales (*otogi zōshi*) that would emerge in later centuries (see Chapter 7). Typical of the genre is the *Illustrated Scroll of the Tale of Obusuma Saburō* (late thirteenth century), which tells of a man and his brothers who all had unattractive wives and Yoshimi Saburō, a warrior from Musashi who had a beautiful wife. The interests and methods of popular folklore emerge in the depiction of Obusuma Saburō's

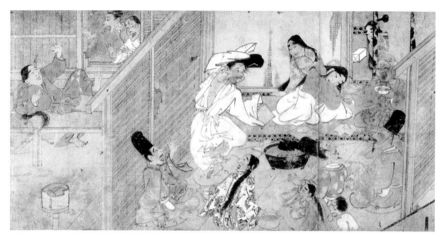

Fig. 36: *Tale of the Hapless Painter*, scene 1, first half of 14th century, Museum of the Imperial Collections (Sannomaru Shōzōkan), Tokyo

daughter, with her distinctly unappealing features such as a dark-colored nose and the curly hair inherited from her mother. This rather new approach to depicting the human figure contrasts with the artist's classical rendering of the Japanese landscape, which recalls the method of the *Picture Contest of Poems on the New Famous Places in Ise*. The fusion of old and new elements is an interesting feature of this work. The *Scroll of Lord Haseo* (mid-fourteenth century; Eisei-Bunko Museum, Tokyo) tells of a man who bests a demon in a game of dice, and as a reward receives a woman of unrivaled beauty to be his wife—on the condition that he not consummate the marriage for one hundred days. Unfortunately he fails to keep his promise, and so can only stand by and watch as his new wife turns into a puddle of water. The handscroll format effectively keeps the reader in suspense as the story develops. Though amusing, *setsuwa-e* were at the same time often formulated as indirect expressions of social discontent. For example, according to the scholar Gomi Fumihiko (b. 1946), the *Tale of the Hapless Painter* (first half of the fourteenth century; Museum of the Imperial Collections) was intended to reveal to the *bakufu* authorities the plight faced by painters [Fig. 36]. Even so, the various characters' comical gestures are a strong indication that one of the main functions of the illustrated handscroll was providing the viewer with appealing entertainment.

The rise of illustrated narratives of the origins of temples and shrines (*shaji engi-e*) followed from a sea change in funding practices which required temples and shrines to promote themselves in order to secure new patrons.

Fig. 37: *Illustrated Legends of the Kitano Tenjin Shrine* (Jōkyū-era version), scene 4, scroll 5, 1219, Kitano Tenman-gū, Kyoto

Illustrated handscrolls conveniently served in the retelling of miraculous foundation tales, and could be distributed to generous donors, as well as to branch temples and shrines, in order to help spread the home institution's fame. Kitano Tenman-gū shrine in Kyoto seems to have made an early start in this direction: the *Illustrated Legends of the Kitano Tenjin Shrine* (*Kitano tenjin engi emaki*; 1219) handscrolls are among the first in the genre [Fig. 37]. The narrative explains how in 901 the statesman and poet Sugawara no Michizane (845–903) endured undeserved banishment to Dazaifu in Kyushu, where he ended his days in lonely exile. Shortly afterward, a series of plagues and natural disasters befell Kyoto and the Seiryōden hall of the imperial palace. The cause was determined to be Michizane's angry spirit, so in a gesture of appeasement and supplication the emperor ordered the construction of the shrine where Michizane would be enshrined as Tenjin (literally, Spirit of Heaven). While other Kamakura-period illustrated handscrolls depicting the story are known, such as the Kōan-era version (1278) and the *Illustrated Scrolls of the Origins of Matsuzaki Tenjin Shrine* (1311), the Jōkyū-era version (1219) at Kitano Tenman-gū is the earliest example extant and is truly worthy of being considered the original version of the tale. With an uninhibited brush, the painter filled a series of 52-centimeter-high scrolls with scenes of dynamic imagery. Dramatic and unrivalled in their grandeur are the scenes of Michizane's banishment in the fourth scroll, the relentless lightning strikes on the Seiryōden hall in the fifth scroll, and, in the eighth scroll, the images of hell as the monk

Nichizō journeys through the Six Realms. Two other major works in this category are the *Illustrated Scrolls of the Legend of the Taima Mandala* (mid-thirteenth century; Kōmyō-ji temple, Kamakura), telling of Princess Chūjō and her role in the overnight weaving of the famous Pure Land mandala at Taima-dera; and the *Illustrated Scrolls of the Miracles of the Kasuga Deity* (1309; Museum of the Imperial Collections) by the chief court painter Takashina Takakane (discussed earlier).

Pictorial biographies of eminent Buddhist monks and patriarchs (*kōsōden-e*) were produced in great numbers during the second half of the Kamakura period, both to help propagate the faith in general and to increase the renown of key figures in the history of individual sects. An early example is the *Illustrated Biographies of the Kegon Patriarchs* (first half of the thirteenth century; Kōzan-ji, Kyoto), completed under the direction of Priest Myōe, who as previously noted, revitalized the once-stagnant Kegon (Flower Garland) sect of Buddhism in Japan. The biographies comprise four scrolls on the life of Uisang (Gishō) and two on the life of Wonhyo (Gangyō), Korean monks who transmitted the Flower Garland teachings from China to the Silla kingdom in Korea. The sets are by two different painters. A central episode in Uisang's biography reports that while he was in Tang China, a beautiful woman named Shanmiao (Zenmyō) fell hopelessly in love with him, but with Uisang's guidance she learned to transform the passions of love and lust into compassion. Wonhyo's biography tells how he headed for China with Uisang but eventually went his own way and returned home to Silla, where through writing he succeeded in spreading the teachings of the *Flower Garland Sutra* (Sk: *Avataṃsaka sūtra*) and converting the Korean king. The most impressive scene in the scrolls is in the biography of Uisang, when the lovestruck Shanmiao throws herself into the sea and transforms into an enormous guardian dragon who ensures that Uisang and his ship return safely to Korea [Fig. 38]. With a fine sense of dramatic tension, the artist depicted the dragon in close-up detail, fighting its way through a turbulent sea. Interestingly, these scrolls are the first known with dialogue inscribed directly onto the images.

Another of the major pictorial biographies of eminent Buddhist monks and patriarchs of the Kamakura period is the *Illustrated Biography of the Saintly Ippen* (*Ippen Hijiri-e*).[5] While several versions of the biography are known, the set of twelve handscrolls painted by the monk En'i (active in the late thirteenth century) with text by Ippen's disciple Shōkai is considered the first (1299; Shōjōkō-ji temple, Kanagawa prefecture and Kankikō-ji,

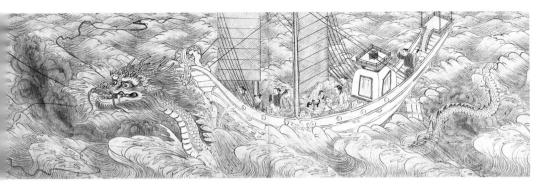

Fig. 38: "Tale of Uisang" from *Illustrated Biographies of the Kegon Patriarchs*, scroll 4, first half of 13th century, Kōzan-ji, Kyoto

Kyoto; the original of scroll 7 is in the Tokyo National Museum) [Fig. 39]. Completed a decade after Ippen's death, the set (which includes a colophon explaining its history) provides an important basis for understanding the legends associated with Ippen. Throughout, En'i depicts Ippen and his traveling mission in natural landscapes that seem to advance back in layered space from plains to hills to mountains, an indication of familiarity with Song-style landscape painting. The scrolls, however, remain within the Japanese-style *Yamato-e* tradition in the temporal progression through the four seasons, and in the lyricism that serves to evoke an awareness of the pathos of travel. Shrine and temple buildings are also vividly presented from above using the technique of isometric projection, perhaps derived from shrine and temple mandalas. En'i's sympathetic coverage of life in the country and city even includes details of the habits of beggars, a tribute to the common people who were the focus of Ippen's teachings. Particularly lively, however, are the *odori nenbutsu* gatherings, which evidently attracted members of all classes, from aristocrats to commoners, who chanted, danced, and beat drums together.

Other significant illustrated hagiographies include the *Tale of Saigyō* (thirteenth century; Agency for Cultural Affairs, Tokugawa Art Museum in Nagoya and other collections); the *Illustrated History of the Eastern Expedition* (1298; Tōshōdai-ji temple, Nara), describing the perilous journey of Priest Ganjin (C: Jianzhen; Chapter 4) to Japan; the *Illustrated Biography of Priest Hōnen* (first half of the fourteenth century; Chion-in, Kyoto) in forty-eight scrolls; *Secret Teachings of the Hossō Sect* (late Kamakura; Fujita Museum of Art), attributed to Takashina Takakane, based on legends associated with the Chinese priest Xuanzang (Genjō Sanzō; 602–664) and the

Boki-e scrolls depicting the life of Kakunyo, third abbot of the Jōdo Shinshū temple Hongan-ji (1351; Nishi Hongan-ji temple, Kyoto).

Depictions of great poets (*kasen-e*) first appeared in handscrolls during the Kamakura period. Fujiwara no Kintō's (966–1041) famous selection of thirty-six poets had already inspired "Thirty-Six Poets" poetry anthologies in handscroll format, such as the Insei-period example now in the

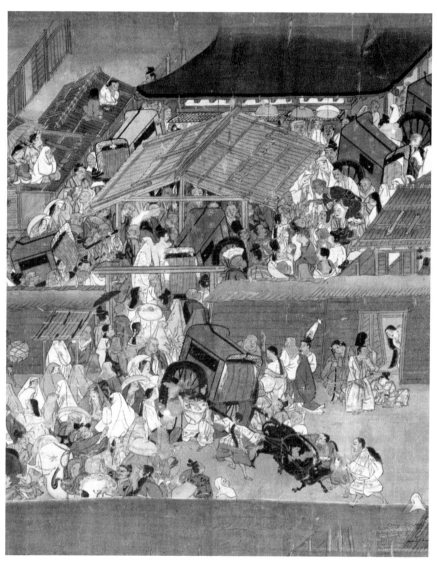

Fig. 39: *Illustrated Biography of the Saintly Ippen*, scene 3, scroll 7, painted by En'i, 1299, Tokyo National Museum

collection at Nishi Hongan-ji. But during the Kamakura period, when new versions of the anthology were produced, the verses were matched with imagined portraits or *nise-e* of the poets themselves, a genre called "Thirty-Six Poets handscrolls" (*sanjūrokkasen emaki*). One of the most important is the Satake scroll (mid-thirteenth century), originally in the collection of the Satake family but since 1919 dispersed in different collections. Another is the Agedatami scroll, so named because the poets are shown seated on raised tatami mats (*agedatami*). This scroll was cut into sections and dispersed during the Edo period (1615–1867). In the Gotoba-in scroll (Senshū-ji temple, Mie prefecture), the textile patterns and hairstyles worn by the female poets such as Ise (c. 877–c. 939), Kodai (dates unknown), and Nakatsukasa (mid-Heian period) display a humorous eccentricity. Such casual portraits, also witnessed in the Narikane scroll, might seem inappropriate for eminent figures, but could be explained by *kasen-e*'s proximity to playful *nise-e* likenesses.

Reading Medieval Lifeways from Illustrated Handscrolls

For many decades, illustrated handscrolls were the subject primarily of stylistic analysis by art historians, who tended to concentrate on iconography, artists, and schools, and on identifying the lineages of different illustrated versions of a subject. Then historians of medieval and early modern Japan began following the example of researchers in folklore studies, anthropology, and archaeology, drawing on a range of visual sources—illustrated handscrolls, folding screens depicting scenes in and around the capital (*rakuchū rakugai zu*; Chapters 7 and 8), shrine and temple mandalas, and pictorial maps of landed estates (*shōen ezu*)—to supplement documentary materials. An early example of this method was the five-volume series *Pictorial Index of the Lives of Japanese Commoners as Depicted in Illustrated Scrolls* (*Emakimono ni yoru Nihon jōmin seikatsu ebiki*; Kadokawa Shoten, 1964–68). This work provided a starting point for advances made in the 1980s and 1990s by social historians such as Kuroda Hideo (b. 1943) and Gomi Fumihiko. These developments have opened new lines of research for art historians, and have provided opportunities for scholarly collaboration and symposia bridging academic disciplines. For example, they gave rise to the intellectual historian Matsuo Kōichi's (b. 1963) proposal that the medieval bathhouse functioned both as a place of entertainment and as a local government meeting hall, a theory that may offer new perspectives

on *kazari* (adornment) and the related concept of *furyū* (elegance). Where methodological caveats have been respected, such approaches have served to enrich and diversify knowledge.

6. Court Painters and Buddhist Painters

The social position of court painters and Buddhist painters changed considerably over the period from the eighth through the fourteenth centuries. In the eighth century, the government formed an official painting bureau (*edakumi no tsukasa*, literally "bureau of picture craftsmen"), in which four "painting masters" (*eshi*) supervised artists collectively known as the "painting division" (*ekakibe*). Not long afterward the bureau was scaled down, but in the ninth century an official court painting studio (*edokoro*) was established within the precincts of the imperial palace. Over time these various official studios produced such famous names in painting history as Kudara no Kawanari (782–853), Kose no Kanaoka (active ninth century), and Asukabe no Tsunenori (active c. tenth century). Buddhist sculptors and painters were meanwhile jointly identified as Buddhist masters (*busshi*) until around the twelfth century, when officials began to differentiate sculptors—"Buddhist masters of wood" (*kibusshi*)—from painters, or "Buddhist masters of pictures" (*ebusshi*). The status of these artists improved over time, as seen in the case of a Buddhist painter named Chijun who in 1154 was awarded the honorific title *hōin* (Seal of the Law). Buddhist painters belonged to associations or studios based at powerful temples and shrines. Occasionally a school of secular painters would relocate from the palace *edokoro* to an "organized studio" *edokoro-za* based at a temple. One such example was the Kose school of painters that moved from the court painting studio to *edokoro-za* at Daijō-in and Ichijō-in at Kōfuku-ji, and together with the Takuma school, which started in the twelfth century, became leading Buddhist painter groups in the medieval period.

7. New Art Associated with Zen Buddhism

According to Buddhist tradition, the Indian monk Bodhidharma (Daruma) introduced the practice of concentrated meditation (*dhyāna*) to China during the sixth century. His Chinese disciples further developed the practice and associated teachings through the time of the religion's sixth patriarch Huineng (638–713), author of the influential *Platform Sutra of*

the Sixth Patriarch. From that point Ch'an (Zen) branched into two main regional divisions: the Northern and Southern schools. The Southern school was particularly successful, eventually spawning five religious houses plus two sub-branches, collectively called the "five houses, seven sects." Prominent among them was the Linji (J: Rinzai) sect founded by Linji Yixuan (d. 866). Addressed primarily to the aristocracy, Linji's teachings spread across the country and brought Ch'an to the height of its prosperity. Another prominent master was Linji's contemporary Dongshan Liangjie (807–869), founder of the Caodong (J: Sōtō) sect.

The man who carved out a permanent place for Rinzai Zen practice in Japan was Eisai, a Tendai-trained monk who in 1167 traveled to Song China over fifty days with a group that reportedly included Chōgen. Twenty years later he journeyed there again, this time remaining for four years, during which time he absorbed the teachings of Linji. Upon returning to Japan in 1191, Eisai became head abbot of three temples—Jufuku-ji in Hakata (Fukuoka prefecture in Kyushu), Jufuku-ji in Kamakura, and Kennin-ji in Kyoto—and founded a training hall (*dōjō*) that combined Esoteric and Zen Buddhist teachings. Credited with introducing tea seeds to Japan, Eisai also composed Japan's first tea treatise, *Healthy Living through Drinking Tea* (*Kissa yōjō ki*, 1211), in which he preached the benefits of tea and laid the foundations for tea gatherings. The tea plant in Priest Myōe's garden reportedly grew from seeds that Eisai had carried from China.

Eisai's eclectic approach to Buddhism was common to other monks who broke ground for Zen in Japan. For example, the scholar-monk Shunjō led a revival of Buddhist precepts while at the same time absorbing the teachings of Zen and other sects. Following in Eisai's footsteps, he traveled to China in 1199 and remained there until 1211, engaging with Chinese versions of the precepts. Upon returning to Japan, he took over the leadership of Sen'yū-ji temple in Kyoto, altered the characters in the temple's name from "Temple Where the Immortals Wander" to "Temple of the Gushing Spring," and reformed the temple as place of training for Tendai, Shingon, Zen, and the Buddhist precepts.

The notable exception to this trend is Dōgen, who made it his life's work to examine every aspect of Zen and strip the practice of meditation down to its essence. He had originally trained in Tendai Buddhism but discovered Zen during a visit in 1217 to Kennin-ji to see Eisai. In 1223 he traveled to China, where he remained for five years training under the Caodong monk Tiandong Rujing, known for criticizing Linji Ch'an's slide

into secularization. Dōgen returned to Japan and spent the next twenty years formulating his ideas before finally heading to a remote area of Fukui, where in 1243 he founded Eihei-ji temple, which remains today the head-quarters of Sōtō Zen. Dōgen's profound insights and observations are collected in the voluminous *Treasury of the True Dharma Eye* (1231–53). Unlike Rinzai, Sōtō Zen steered clear of secularization and Kyoto culture, but also as a consequence produced little in the way of art or poetry.

During this early period of Japanese Zen, the teachings arrived in small doses, as a handful of Japanese monks made the long journey to China, spent years there training, and then returned. The situation changed dramatically in the mid to late thirteenth century, however, as the Mongols began sweeping down across China, driving out Song culture as they went. Chinese Ch'an monks, many of them high-ranking abbots, fled en masse to Japan, where they were eagerly welcomed and offered an opportunity to share their wisdom. These individuals greatly expanded the world of Japanese Zen and gave the teachings a more concrete, unified, and personal form.

A pioneer in the religious migration was Lanxi Daolong (Rankei Dōryū or Daikaku Zenshi), who reached Japan in 1246 and after several years of teaching founded Kenchō-ji (1253) in Kamakura upon the invitation of Hōjō Tokiyori [Fig. 40]. Six years later he succeeded Enni (also called Shōichi Kokushi) as the eleventh head abbot of Kennin-ji in Kyoto. From these commanding positions, Lanxi studied the world of Japanese Zen, recognizing that it constituted a loose medley of teachings and practices. At Kenchō-ji he therefore made a point of introducing a strict Chinese style of Zen distilled to a single teaching. Another important reformer was Wuxue Zuyuan, who came to Japan in 1279 (the year the Mongols finally conquered China) upon the invitation of Hōjō Tokimune (1251–1284), regent and de facto head of the Kamakura government. Three years later, Wuxue received permission to found Engaku-ji in Kamakura.

Occasionally, however, an arriving Chinese monk did not receive the hearty welcome that he might have expected. For example, Yishan Yining (Issan Ichinei) reached Japan in 1299 as a religious ambassador for the Mongol Yuan government and was immediately imprisoned. However, his erudition and scholarly achievements so impressed the ruling shogun Hōjō Sadatoki that Sadatoki invited the monk to take up a position at Kenchō-ji. A talented poet whose verses appear inscribed on many extant paintings,

Yishan is considered the founder of Japanese Zen literary culture, known as the Literature of the Five Mountains (*Gozan bungaku*) after the five head temples (Gozan) in Kamakura where the culture initially flourished. One of Yishan's poems appears on the oldest extant Japanese ink landscape painting, *Wild Geese Descending on a Sandbank* by Shikan (active early thirteenth century).

Qingzhuo Zhengcheng (Seisetsu Shōchō, also called Daikan Zenji; 1274–1339) was a popular Yuan monk who came to Japan in 1326 upon the invitation of Sadatoki's son Takatoki, the last ruler of the Kamakura shogunate. Qingzhuo served in Kamakura as head abbot of Kenchō-ji, Jōchi-ji, and Engaku-ji, as well as Kennin-ji and Nanzen-ji temples in Kyoto.

Even as Chinese monks streamed toward Japan, Japanese monks continued to make the crossing to China —around ninety departed during the Song period and another two hundred during the Yuan period. Among them

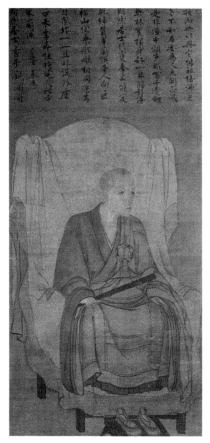

Fig. 40: *Portrait of Dajue Zen Master Lanxi Daolong*, 13th century, Kenchō-ji, Kamakura

was Enni, who had a dream in which Sugawara no Michizane personally directed him to study Zen in China. For six years (1235–41) Enni trained under the great Linji master Wuzhun Shifan (1178–1249). Upon returning, he traveled to Kyoto in order to take up a position as the first head abbot of Tōfuku-ji, a Zen temple founded in 1236 by Kujō Michiie. In 1258 the *bakufu* in Kamakura named Enni tenth abbot of Kennin-ji and assigned him responsibility for rebuilding the temple, which had been damaged by fire. The ongoing legacy of China is further seen in the case of Shūhō Myōchō (also called Daitō Kokushi; 1282–1337), a disciple of the Rinzai monk Nanpo Jōmin, who in turn had received the dharma transmission

in China from Xutang Zhiyu (J: Kidō Chigu; 1185–1269). Shūhō is well known as the founder of Daitoku-ji temple (1324) in Kyoto, and a portrait of him at the temple emanates the gravitas appropriate for a founding monk of his distinguished religious lineage.

The Traces of High-Ranking Zen Priests: Portraiture and Calligraphy

Upon completing a course of Zen training, a disciple would receive his master's portrait, a *chinzō*, as a certificate of enlightenment (*inka*)—in effect, a form of diploma. The detailed and realistic image would typically show the master seated on a Chinese-style chair (*kyokuroku*) holding the flat wooden stick (*kyōsaku*) used to strike and reawaken a meditating monk succumbing to drowsiness. The master would often inscribe an aphorism, statement, or other encouraging words above the portrait. The term *chinzō* originally referred to paintings, but in modern times it has come to include sculptural portraits. A few of these sculptures remained secret temple treasures for centuries, and have only become available for exhibition in recent years. Among these is the sculpture of Lanxi Daolong [Fig. 17]. Though somewhat less severe than the painting, this figure still communicates a tense energy, as though capable of admonishing a hall full of disciples. The *chinzō* sculptural portrait of Wuxue Zuyuan, founder of Engaku-ji, mentioned earlier expertly reveals the severe personality that lay behind the priest's mild exterior. Another excellent painting in the genre is the portrait of Wuzhun Shifan commissioned by Enni during his training and completed with an inscription by the Chinese master himself (1238; Tōfuku-ji).

The term *bokuseki* (literally, "ink traces") refers to calligraphic inscriptions brushed by Zen priests. For example, at Wuzhun Shifan's request, the master Zen calligrapher Zhang Jizhi (1186–1266) produced two powerful and now-famous inscriptions—one reading *fang zhang* (J: *hōjō*; meaning unit of area 10 feet square, abbot's chamber, or Buddhist abbot); the other *Shujing* (*Classic of History*, the title of one of the five classics of Chinese literature)—which Wuzhun Shifan sent as a gift to Enni (both at Tōfuku-ji). Wuxue Zuyuan's *bokuseki*, show that he was an accomplished calligrapher in his own right. The characters in his rendering of the phrase *Shaka hōden* (Treasure House of Sakyamuni) are carefully positioned, yet possess amplitude and elegance (Tokyo National Museum). Also impressive is the deceptively simple two-character phrase *getsurin* ("moon-grove"; Chōfuku-ji temple, Kyoto) by Gulin Gingmao (Kurin Seimu; 1262–1329) [Fig. 42].

Shūhō Myōchō (Daitō Kokushi) was a vigorous Japanese practitioner of the art as well [Fig. 41]. In a special category of *bokuseki* are the deathbed poems of high priests (*yuige*), which exemplify the Zen monks' dynamic energy. Among them are magnificent *yuige* by Qingzhuo Zhengcheng (Tokiwayama Bunko Foundation, Tokyo) and by Enni's disciple Chigotsu Daie (1229–1312) (Ganjō-ji temple, Kyoto). While the former is more famous, the latter is especially moving for its dramatic feel.

Fig. 41: Calligraphy by Shūhō Myōchō, 1329, Myōshin-ji, Kyoto

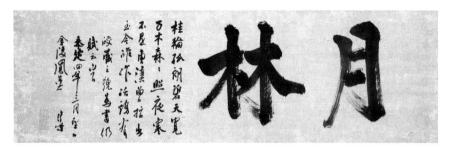

Fig. 42: Calligraphy by Gulin Gingmao, 1327, Chōfuku-ji, Kyoto

Architecture of Zen Temples

The principles of Zen-style architecture (Zenshū-yō) reached Japanese shores in the wake of continental visitors such as Lanxi Daolong. A 1333 diagram of Kenchō-ji (founded 1253) suggests that at this time, a Zen temple's main buildings ranged along a single axis leading from the front gate through the main gate and on to the main worship hall and lecture hall, ending with the abbot's quarters. Training and residential halls stood to the left and right of the main buildings. Since none of the original Kenchō-ji temple buildings survive, stylistic details remain unknown. The earliest extant Zen temple buildings date to the fourteenth century. A good example of the style is Engaku-ji's current relic hall, which originally stood at Taihei-ji temple (founded early 1280s), one of Kamakura's five leading Zen nunneries [Fig. 43]. Constructed perhaps during the first half of the

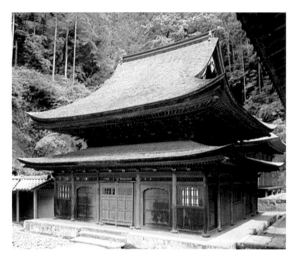

Fig. 43: Relic Hall, first half of 15th century, Engaku-ji, Kamakura

fifteenth century and relocated to Engaku-ji during the sixteenth century, the structure displays many foreign elements, including a steeply angled roof, fan rafters, window frames with curvilinear upper sections, paneled entrance doors, and rainbow-form tie beams (*ebi-kōryō*), whose Japanese name derives from their resemblance to a curled shrimp or lobster (*ebi*).

8. *Kōgei*: Bold and Robust in the Decorative Arts

Having wrested political control from the imperial court, Kamakura warriors paused to look admiringly at Heian courtly crafts and adopted them as a model of good taste. On this account some scholars have tended to dismiss Kamakura-period crafts as merely conservative imitations. Kamakura craft as whole, however, reveals important technological advances and reflects not courtly tastes but warrior aesthetics. As the art historian Nakano Masaki (1929–2010) has described it, Kamakura taste tended to favor things that were heavy rather than light, thick rather than thin, high rather than low, stout rather than slight. In essence, Kamakura decorative arts must be understood as boldly three-dimensional.

The technical advances of Kamakura craft are evident first in the metalwork of the period. Bronze mirrors of the time show how improved casting techniques gave rise to increasingly prominent designs. Chasing techniques also developed, leading to the production of elegant pierced Buddhist reliquaries, such as the important example in the main hall of Saidai-ji. Also at this time, warriors abandoned the continental-style "scale

armor" (*kake-yoroi*) popular during the Heian period and adopted the box-like six-part "great armor" (*ōyoroi*), a formal armor made for cavalry battles, combining plate and lacquer-reinforced scales laced together. Excellent *ōyoroi* from the period include the *odoshi-yoroi* (braided armor) with red threads (Mitake shrine [Mitake-jinja], Ōme, Tokyo), the *kaeshi odoshi-yoroi* with cherry blossoms (Itsukushima shrine, Hiroshima prefecture), and the *odoshi-yoroi* with deep blue threads (Ōyamatsumi shrine [Ōyamatsumi-jinja], Ehime prefecture). The evolution of armor design is seen in another *odoshi-yoroi* with red threads (Kasuga grand shrine, Nara), which features tall hoe-shaped ornaments (*ōkuwagata*, "great stag beetle") jutting from the helmet [Fig. 44]; another example is at Kushibiki Hachiman-gū, Hachi-nohe, Aomori prefecture. The production of armor, like that of other objects during the period, became closely intertwined with *kazari* (adornment).

Lacquerware (*urushi*) also advanced at this time, with the perfection of mother-of-pearl shell inlay (*raden*) and pictures in sprinkled gold (*maki-e*) —the latter made possible by the manufacture of more refined metallic powders. Testing the aesthetic limits of both techniques is the saddle with a design of autumn rain (*shigure*) (late thirteenth to early fourteenth century; Eisei-Bunko Museum) [Fig. 45]. The design is based on a poem by the eminent prelate Jien found in the *New Collection of Japanese Poems of Ancient and Modern Times* (*Shin Kokin Wakashū*; 1205): "My love pours down / to no effect, like autumn rain / on the pine. / It howls like the wind / across the fields of *makuzu* (arrowroot)." Words from the poem intermingle with pictorial elements such as pine trees and arrowroot leaves, a design method known as "reed-style" (*ashide*) incorporating calligraphy in the image. For its elaborate workmanship alone this saddle commands a leading position in the history of the aesthetics of *furyū* (elegance). Decorated saddles such as this one and ornate armor were

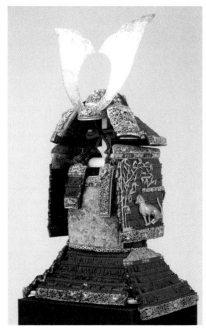

Fig. 44: Red-braided armor, 14th century, Kasuga grand shrine, Nara

commissioned as offerings to shrines. The Japanese custom of donating not only clothing and objects from daily life, but also military gear, when seeking the protection of the *kami* (deities) has played a crucial role in the transmission of artistic knowledge down the centuries.

Other *maki-e* lacquerware from the period displays a more robust taste, one example being a gold lacquer box inlaid with mother-of-pearl chrysanthemums (c. first half of eleventh century; Tsurugaoka Hachiman-gū shrine, Kamakura). This box features the technique of gold *ikakeji*, in which the ground is prepared first with a heavy sprinkling of gold. Other examples of this technique include a cosmetic box with a *maki-e* plum blossom pattern (c. thirteenth century; Mishima grand shrine [Mishima taisha], Shizuoka prefecture) and a cosmetic box with *fusenryō* (stylized floral pattern) design in mother-of-pearl inlay and *maki-e* (thirteenth century; Suntory Museum of Art, Tokyo). Another technique called *hyōmon* (surface design; called

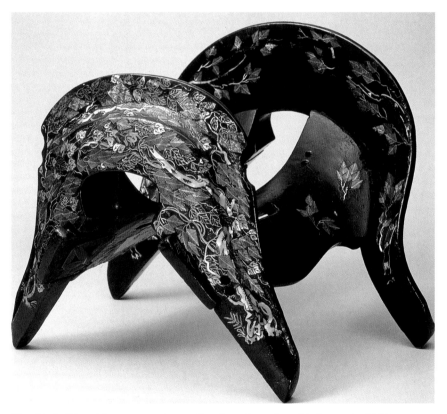

Fig. 45: Saddle with autumn rain motif and mother-of-pearl inlay, end of 13th century to beginning of 14th century, Eisei-Bunko Museum, Tokyo

heidatsu in the Nara period) was employed in a lacquer box with butterflies and inlaid mother-of-pearl, now in the Hatakeyama Memorial Museum of Fine Art in Tokyo. In this method, thin sheets of gold and silver foil are inlaid to create part of the design. The mid-Kamakura period additionally saw the invention of raised sprinkled lacquer (*takamaki-e*), which lends the design a more realistic appearance, one example being the lacquer cosmetic box with plum blossom pattern at Mishima grand shrine mentioned above. Perhaps the essential feature of Kamakura-period lacquerware is the synthesis of old and new techniques, which resulted in new directions in decoration. In the case of the well-known writing box with a design of autumn fields in the Nezu Museum, if one leaves aside the uncertainties in relative scale among the bush clover, birds, and deer, it becomes evident that the work's pictorial rhythms are particular to Kamakura lacquerware. Apart from those just mentioned, another popular motif of the period was scattered fans, as seen in a lacquer cosmetic box at the Okura Museum of Art in Tokyo. An intriguing comparative example from the late Heian period is an writing box with a sandy beach and cormorant motif and mother-of-pearl inlay; the shape of the beach-island recalls that of a formal table used to display miniature landscapes (also called a *suhama*) [Fig. 46].

In Heian lacquerware, natural motifs tended to be schematic and symbolic, whereas in the Kamakura period they became increasingly pictorial and intellectualized. A similar trend occurred in the design of "scattered motifs" or repeating patterns: those from the Kamakura period suggest a conscious awareness of overall layout and demonstrate a preference for crisp outlines. Characteristic are the lacquer box with butterflies and inlaid mother-of-pearl mentioned above, and a cosmetic box with a repeating design of round crests formed of three opened cypress fans at the Tokyo National Museum.

In regard to ceramics, the popularity of Tokoname and Atsumi wares, two characteristically Japanese ceramic styles that emerged during the Insei period, stimulated ceramic production in many other regions, particularly from the late twelfth century onward. The parade of

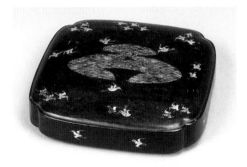

Fig. 46: Writing box with cormorant and sand beach motif, c. 12th century, private collection

styles included Suzu ware from Noto peninsula, Hizen ware from Fukui prefecture, Shigaraki ware from Shiga prefecture, Tanba ware from Hyogo prefecture, and Bizen ware from Okayama prefecture. The Sanage kilns (see Chapter 5), too, were reborn during the Kamakura period as the Seto kilns, famous for their creative reinterpretations of Chinese ceramics, which remained popular into the Muromachi period (1392–1573; see Chapter 7). All these wares were called *yakimono* (ceramics), a term that at the time applied to earthenware, stoneware, and porcelain. In addition, the unglazed *yakishime* wares used as daily crockery were simple but pleasing. *Yakishime* was high-fired at 1200°C in tunnel-shaped *anagama* kilns, a form of kiln introduced from Korea as far back as around the fifth century. These unassuming wares would later capture the imagination and interest of sixteenth-century tea masters.

Nanbokuchō and Muromachi:
Zen Buddhism and Chinese Art

Nanbokuchō and Muromachi: Zen Buddhism and Chinese Art

After the Kamakura *bakufu* collapsed in 1333, Ashikaga Takauji (1305–1358) entered Kyoto and was granted the title of Sei'i Taishōgun (shogun) by Emperor Kōmyō of the Northern court in 1338. Under the new government he established, called the Muromachi or Ashikaga *bakufu*, a new culture flourished that would influence Japanese art and thought into the modern era. Like the Minamoto shoguns in Kamakura, Takauji and his descendants embraced Zen Buddhism, but they used Zen as a means to stake out a cultural position vis-à-vis the aristocratic culture of the imperial court. They created a system of Zen temples to oversee cultural activities, and in this way Zen Buddhism came to play a major role in shaping the art of the period.

Under Ashikaga rule Japanese culture developed along two major but diverging paths: courtier culture, steeped in the elegance of *kazari* (adornment); and warrior culture, centered on Zen and "things Chinese" (*karamono*), especially works of art produced in China during the Southern Song (1127–1279), Yuan (1271–1368), and Ming (1368–1644) periods. The dichotomy between them is reflected in efforts to combine traditional Japanese (*wa*) art with the newly imported Chinese (*kan*) art. These efforts would eventually result first in a convergence and then in a Sino-Japanese synthesis. Warrior culture versus court culture, opposition and intermixing: this represents the overriding dynamic of cultural activities over the centuries from 1333 to 1573. The process would filter down through the social strata to the cultural activities of commoners.

The Nanbokuchō period (1333–92) represents the formative years of Japan's medieval artistic traditions, with the term Nanbokuchō referring to

Nanbokuchō	1333–92
Early Muromachi	1392–1467 (Kitayama culture)
Late Muromachi	1467–1573 (Higashiyama culture and Warring States period)

Table 1: Nanbokuchō and Muromachi periods

two rival imperial lines, the Southern and Northern courts, which in 1392 the Ashikaga united, giving the clan's dominion over the realm. The first half of the Muromachi period, from the unification of the Southern and Northern courts to the start of the devastating Ōnin War (1392–1467), represents an artistic golden age known as Kitayama culture. The second half of the Muromachi period, from the end of the Ōnin War to the fall of the Muromachi *bakufu* (1467–1573), marks a transitional period comprising Higashiyama culture and Japan's Warring States period.

I. Chinese Art in Japan: Nanbokuchō Culture

In Japanese political history, the Nanbokuchō period is usually considered as either marking the very end of the Kamakura (1192–1333) or signaling the beginning of the Muromachi period. Here, the period is taken as transitional, a time in which Zen Buddhism served as the main vehicle for introducing Chinese art into Japan. The cultural seeds of this period would take root and spread as a sort of internalized Chinese style leading to the development of Kitayama culture.

1. Buddhist Sculpture and Painting, and the Development of Japanese Art in Song, Yuan, and Ming styles

During this time new movements in thought and society brought an end to the Kamakura renaissance in Buddhist art. A combination of factors precipitated the break, which occurred as Buddhism itself continued to spread among the general populace. First there was a decline in official patronage. The Buddhist clergy lost interest in the visual arts, concentrating instead on inscribing the names of Buddhist deities (*myōgō*) and sacred chants (*daimoku*) on strips of paper. Well known among these is the sacred chant of the Nichiren school, "Praise the wondrous law of the *Lotus Sutra*" (*Namu Myōhō Renge-kyō*). Later, although the Ashikaga supported Zen, they did not make Buddhist art a priority. Other factors include the challenge of new teachings from the continent, such as the Buddhist-Daoist blend that became popular in Song-period China (960–1279), as well as Confucian and Ch'an (Zen) philosophies. Third, the renaissance itself seems to have run out of steam, with Japanese Buddhist art based on ancient models

growing standardized and devoid of creativity. On the one hand, Buddhist sculptors and painters became concerned with preserving their status and privilege through a hereditary system of succession, raising a barrier to innovation. On the other hand, the potential Daoist influence underlying many imported Yuan-period sculptures seems to have given these icons an unfamiliarity that hindered broad adoption of the style. One example is the *Amida Triptych* (1309) in the collection of Uesugi shrine (Uesugi-jinja, Yamagata prefecture), a set of hanging scrolls that the art historian Ide Seinosuke (b. 1959) has described as having "a raw, almost human streak never seen before. It possesses a mysterious sense of belonging to both our world and the realm of the afterlife."[1]

Buddhist sculpture, however, did not die out entirely, as the descendants of the Kei, In, and En schools of Kyoto and Nara continued to flourish and produce important work for regional temples. Their modified, Japanese-style "Song sculpture" displays calm warmth and increasingly the use of motifs and designs found in paintings and decorative arts. Additional sculptures of this type may come to light in future, as art historical study of sculpture of this period broadens its range.

Noh and Kyōgen masks are included in the canon of Japanese sculpture. These are as important as the masks used in the earlier dance forms of Sarugaku and Dengaku. Noh plays and their manner of performance, as well as their masks, costumes, and other accoutrements were perfected under the enthusiastic patronage of the Ashikaga shoguns [Figs. 1 and 2]. Worn by actors on stage, Noh masks represent a range of types of men and women, old and young, courtier and warrior, whose life experience usually tended toward the poetic, tragic, and noble. The masks have a poignant beauty that reflects the essence of the highly symbolic fantasies created by the playwrights, most famously Zeami Motokiyo (1363–1443). In contrast, the curious and comical Kyōgen masks often reflect the taste of commoners, and relate to the demons and monsters that appeared in illustrated popular tales (*otogi zōshi*), such as the *Night Procession of One Hundred Demons* (*Hyakki Yagyō*; discussed later in this chapter).

In architecture, the Zen style (see Chapter 6) spread to temples throughout the country. For example, the Triple Gate (Sanmon) of Tōfuku-ji temple in Kyoto (1425), a rare surviving example of large-scale Muromachi Zen architecture, overlays a Zen style onto the Great Buddha style (*Daibutsu-yō*) [Fig. 3]. Other traditional Japanese buildings incorporated both the Zen and Great Buddha styles, giving rise to such eclectic structures as the Golden

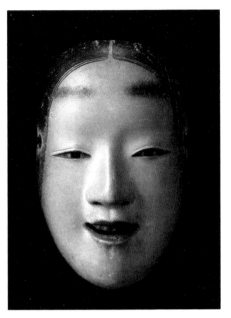

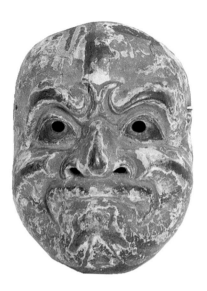

Fig. 1: Noh mask Magojirō, inscribed "Omo-kage," attributed to Kongō Ukyō Hisatsugu (Magojirō), 15th–16th century, Mitsui Memorial Museum, Tokyo.

Fig. 2: Noh mask of *beshimi* (demon), 1413, Naratsuhiko shrine, Nara

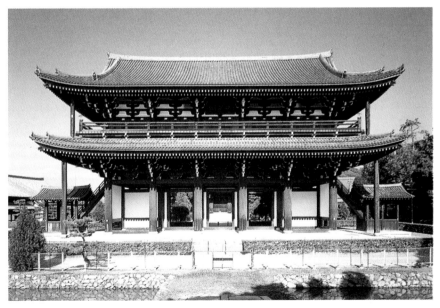

Fig. 3: Sanmon Gate, 1425, Tōfuku-ji, Kyoto

Hall (Kondō) of Kanshin-ji temple (1439; Osaka prefecture) and the Main Hall of Kakurin-ji temple (1397; Hyogo prefecture). But the Japanese style proved hard to discard altogether. One splendid example is the abbot's quarters at Ryōgin-an, a sub-temple of Tōfuku-ji (late fourteenth century). The oldest surviving Zen abbot's quarters, this building is truly fascinating, in that a pure Japanese style was used for the living quarters of a Zen monk.

2. Influx of Song, Yuan, and Ming Period Chinese Art and *Furyū*

Older, established styles of Japanese Buddhist sculpture and painting were overwhelmed by a new wave of Chinese art from the Song, Yuan, and Ming period art, including not just ink paintings, but also other types of *karamono* ("Chinese" objects), such as decorative arts, items related to calligraphy, and objects for daily use. Disrupted since the Insei period (1086–1192, see Chapter 5), trade with China accelerated under Ashikaga rule. Objects that had earlier arrived on Song Chinese trade ships were now joined by goods transported from Ming China by returning Japanese warriors, envoys, and Zen monks. These works were highly prized by the Ashikaga. Political developments that one might expect to have hindered passage between the two countries, notably the defeat of the Song and the invasion of the Yuan, actually did little to impede trade. The business of importing art thrived, allowing some spectacular objects to enter Japan.

The *Catalogue of the Property of Butsunichi-an* (begun 1319, completed 1363), an inventory of *karamono* in the collection of Butsunichi-an, a sub-temple of Engaku-ji temple in Kamakura, documents a rich array of superb objects imported from China during the late Kamakura period, including Song and Yuan calligraphy and furnishings such as ceramics, lacquerware, and other implements. The technical quality, delicacy, and exotic beauty of these works fueled a kind of *karamono* worship. Room decor (*zashiki kazari*) planned around Chinese objects as the preferred form of room adornment (*shitsurai*) gave rise to the new verb, *shitsuraeru*, meaning "to set up." This new standard in interior decoration all but supplanted the earlier tradition of *furyū* (elegance) so cherished by Heian (794–1192) aristocrats.

The trend is evident in the way Sasaki Dōyo prepared for an invading army. When in 1361 Kyoto was seized by Kusunoki Masanori, leader of the enemy armies behind the Southern court, Dōyo, an eminent general himself, assumed that many of the renowned generals of the day would soon

be entering his residence as they took Kyoto. Known as a daimyo (lord of a domain) of ostentatious taste (*basara daimyo*), he arranged his mansion in a way suited to receive visitors of similar high rank even in his defeat. According to Chapter 37 of the *Chronicle of the Grand Pacification (Taiheiki*; fourteenth century), he covered his six-bay meeting room with tatami mats and displayed three hanging scrolls with his family's patron deity in the center. Also decorating the room were a *karamono* vase, incense burner, and bronze teakettle and tray. In the *shoin* study he displayed an example of calligraphy by renowned Chinese calligrapher Wang Xizhi (303–360), and an anthology of writings by Chinese Confucian scholar Han Yu (768–824). He outfitted his sleeping quarters with pillows, damask sleeping gowns, and other items suited to the rank of the invaders. And he had the twelve-*ma*2 guest quarters prepared with live birds and sake, along with two monks as attendants. These hasty preparations (completed before Dōyo evacuated the premises) anticipated the *zashiki kazari* that flourished under Kitayama and Higashiyama culture. The types of calligraphy were more limited than those present in room decor at the height of the Muromachi period, but otherwise each room was decorated according to use, and even the term "semi-recluse" (*tonseisha*) made an appearance here, long before its application to such connoisseurs as Nōami and his grandson Sōami, discussed below.

Demand for Chinese objects among the warrior class stimulated the manufacture of Japanese copies. Their quality, however, was no match for the originals, and in room decoration of this period it was actually uncommon to combine domestic wares with *karamono*. More successful was a new genre of domestically produced paintings, especially ink paintings, termed *Kara-e* (Chinese pictures). Below we will consider this important new development in detail.

3. Introduction and Development of Ink Painting in Japan

In Chapter 4, we saw how continental Chinese painting, sculpture, and decorative art vied for space in the decadent world of *kazari*, a world almost obsessed with what might be termed "international ornamentalism." Into this opulent world now stepped monochrome ink painting. A variety of explanations might be offered for the rise of ink painting in China, but key to this development was the influence of government officials and other literati who were well versed in calligraphy and who maintained an

aesthetic preference for monochrome over polychrome. The ancient Chinese painting technique of *baimiao* (J: *hakubyō*; literally "white drawing"), in which the artist created a design using only ink outlines, was also an influence, as was a type of shading through graded colors (*ungen-zaishiki*) that had originated in western China during the Tang period (618–907). Combined with methods of applying ink using varied pressure and the tip of the brush, these techniques gave pictorial subjects in ink an understated sense of weight and three-dimensionality.

Some of the most expressive and technically outstanding Chinese ink landscape paintings were produced during the Five Dynasties (907–960) and Northern Song (960–1127) in China. By this time, ink painting had matured to the point where artists such as Li Cheng (919–967), Fan Kuan (c. 960–c. 1030), Guo Xi (c. 1020–c. 1090), Dong Yuan (c. 934–c. 962), and Ju Ran (tenth century) could capture with convincing realism the "essence of the universe" and the profound splendor of the Chinese landscape. Interestingly, however, Northern Song landscape painting had little impact in Japan. Art historian Yonezawa Yoshiho (1906–1993) has suggested that, being based on the vast geography of the Chinese continent, expansive Northern Song landscape paintings did not resonate with the Japanese, who tended to focus on the intimate and the immediate. It seems unlikely, however, that Heian aristocrats, who were fervent worshippers of fierce Esoteric Buddhist deities, would not have taken an interest in Northern Song landscapes. Rather than citing psychological constraints, it may be more useful to consider the practical constraints of the tenth and eleventh centuries, a time when monumental Chinese landscape painting had reached a peak, but Sino-Japanese relations had reached a low, limiting many forms of cultural appreciation and exchange.

Southern Song, Yuan, and Ming Chinese paintings were brought to Japan in and after the thirteenth century, coinciding with the influx of Zen Buddhist teachings. Collectors included members of the court and samurai nobility, guided by Zen monks who served as brokers in the China trade. Stylistic transitions in imported works match historical transitions in painting on the continent, Southern Song predominating in the thirteenth century, Yuan in the first half of the fourteenth century, and Ming in the late fourteenth to fifteenth centuries. Overall, then, the dates of production and import coincided, although Southern Song and Yuan paintings proved especially popular, and continued to be sought after during the Ming period.

Southern Song painters combined the Northern Song concept of "principle" (*ri*) with a poetic mood to produce images extremely refined in both technique and sentiment. Whereas artists of the Northern Song aimed for grand realism, those of Southern Song depicted landscapes as artfully rendered, scaled-down microcosms. Particularly well received in Japan were compositions by Ma Yuan (d. 1225) and Xia Gui (active in the early thirteenth century), in which the elements of a landscape are presented in detail but placed far to one side or down in a corner, the remainder of the composition comprising a vast area of poetically open space. Poetry was another element integrally related into Chinese painting that was deeply appreciated in Japan.

The art of Ch'an monk Muqi Fachang (1210?–1269?) also figured prominently during this period. Said to have trained under leading Ch'an priest Wuzhun Shifan (1178–1249), Muqi was the abbot of Liutong temple, located on West Lake in Zhejian province. His affiliation with Wuzhun seems to have caught the attention of educated Japanese Zen monks who affectionately called him *oshō* (high priest), and had his works brought over to Japan. Muqi's monumental triptych, *Guanyin, Gibbons, and Crane* (Daitoku-ji temple, Kyoto) [Fig. 4] is among the crown jewels of Chinese art in Japan. These three paintings are outstanding not only for their scale and rich ink tonality, but also for their symbolism and tenderness of expression, particularly in the relationship between the mother monkey and her

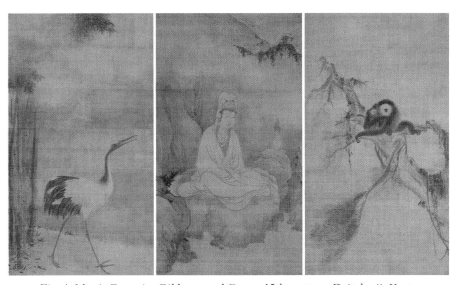

Fig. 4: Muqi, *Guanyin, Gibbons, and Crane*, 13th century, Daitoku-ji, Kyoto

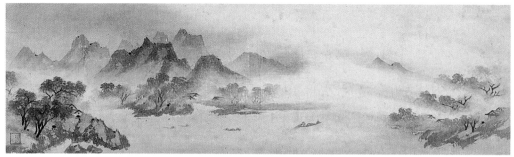

Fig. 5: Attributed to Muqi, "Sunset Glow on a Fishing Village," from *Eight Views of the Xiao and Xiang Rivers*, 13th century, Nezu Museum, Tokyo

young. In Japan the triptych has had a distinguished provenance: the image of Guanyin (Kannon) bears the seal "Dōyū," while the crane painting and the painting of the gibbons both bear the seal "Tenzan," indicating that the set was formerly in the collection of third shogun Ashikaga Yoshimitsu (1358–1408; discussed below).

Other key Chinese paintings evidently impressed the Japanese of this period, for they served as core models of technique and composition over many generations. One of the central themes of the period was the *Eight Views of the Xiao and Xiang Rivers*, eight contemplative landscape motifs that included "Sunset Glow on a Fishing Village" [Fig. 5]. The hanging scrolls by Muqi bear Yoshimitsu's collection seals (Nezu Museum, Tokyo, Hatakeyama Memorial Museum of Fine Arts and other collections). Originally a handscroll whose format was altered by painting connoisseur Sōami for the purposes of display, this set was considered a collector's item, and ownership of it a symbol of daimyo status. Equally prized was a set of *Eight Views* made into hanging scrolls (also formerly a handscroll) by monk-painter Yujian (active thirteenth century). The main technique here is "splashed ink" (C: *po'mo*; J: *hatsuboku*), in which the artist splashes, spills, or lightly pours ink onto the painting surface to create barely defined mountains and rock forms that are almost antithetical to the carefully delineated motifs found in standard ink painting. The technique first became popular during the late eighth to ninth century among artists working in southern China, particularly the Jiangnan region in Nanning province. Muqi and Yujian's vast, allusive pictorial spaces proved highly influential in Japan.

The work of official Chinese painters, those who produced commissions for the imperial court, also made their way to Japan and into shogunal collections. Interest centered on the landscapes of Ma Yuan, Xia Gui, and

Li T'ang (c. 1050–1130), and on the bird-and-flower and animal paintings of Li Anzhong (active early twelfth century), Mao Song (active early twelfth century), and Li Di (second half of the twelfth century). Paintings in the latter category feature astonishingly precise brushwork and a convincingly tactile rendering of feathers and fur, as seen in Li Anzhong's *Quails* (Nezu Museum), which bears the *Zakkashitsu* collector's seal of sixth shogun Ashikaga Yoshinori, and in Mao Song's *Monkeys* (Tokyo National Museum). Other important paintings collected in Japan at this time include *Dove on a Peach Branch* by Emperor Huizong (1082–1135) [Fig. 6], *Li Bai Composing a Poem, Snowy Landscape*, and *Sakyamuni Descending from the Mountain* (all in the Tokyo National Museum) by Liang Kai (c. 1140–c. 1210), an eccentric who styled himself "Liang, Son of the Wind." Huizong's *Dove on a Peach Branch* bears Yoshimitsu's "Tenzan" seal, and we can imagine Yoshimitsu's delight as he gazed at this work. Also influential was a pair of mysterious hanging scrolls by Yan Hui (active late thirteenth century), *Liu Hai* (or Haichan, J: Gama) and *Li Tieguai* (J: Tekkai), depicting two Chinese immortals (Chion-ji temple, Kyoto) [Fig. 7]. Yan Hui was the leading Daoist-Buddhist painter of the Song period.

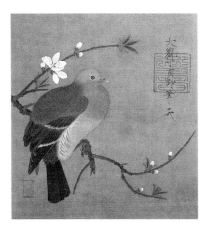

Fig. 6: Emperor Huizong, *Dove on a Peach Branch*, 1107, private collection

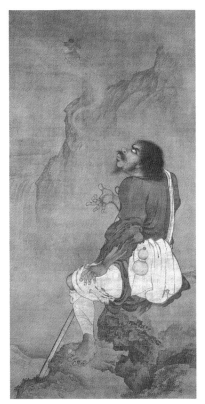

Fig. 7: Yan Hui, "Liu Hai" from the diptych *Liu Hai and Li Tieguai*, 13th–14th century, Chion-ji, Kyoto

It is not known precisely when these works first reached Japan. Some scholars have suggested that it would

have been sometime from 1401, when Ashikaga Yoshimitsu resumed trade with Ming China, through the first half of fifteenth century. However, the mid-fourteenth century *Catalogue of the Property of Butsunichi-an* already lists four paintings by Muqi, along with works by Emperor Huizong and Li Di. This suggests that high-ranking Japanese began to collect Song and Yuan paintings during the Kamakura period. Further evidence is found in the catalogues compiled by curators to the Ashikaga shoguns (who were called *dōbōshū*) such as Nōami and Sōami. The *Record of Decorations for the Imperial Visit to the Muromachi Palace* (1437) lists items belonging to Ashikaga Yoshimitsu and Yoshinori. Collections created during the time of eighth shogun Ashikaga Yoshimasa (1435–1490) are recorded in the *Catalogue of Princely* Treasures (*Kundaikan Sōchōki*) and the *Catalogue of Objects and Paintings in the Royal Collection* (*Gomotsu On-e Mokuroku*). These catalogues include a number of the Chinese paintings mentioned earlier.

4. Early Japanese Ink Landscape Painters

A disproportionate number of the imported Song and Yuan paintings by Ch'an (Zen) monks and imperial academy masters are much smaller in size than the impressively large examples found in China, probably due to a combination of Japanese preference and the limited space for display. Still, as discussed, they were of unparalleled quality. In the twelfth and thirteenth centuries, Japanese artists did polish their skills enough to come within a hair's-breadth distance of the Chinese bird-and-flower paintings brought to Japan at that time, as seen for example in the small lacquer box with a design of sparrows in a field (see Chapter 5, Fig. 66), the peonies painted on the sliding door panels behind the portrait sculpture of retired emperor Go-Shirakawa (late twelfth century), and the *Lotus Pond* painted on the wall of Higashi-in Shariden (Relic Hall) at Hōryū-ji temple (Nara). Domestic artists of the fourteenth and fifteenth centuries, however, found themselves entirely outdone by the technical skill encountered in the Song academic models of this genre. Much easier to mimic were ink paintings, particularly those in the genre known as "ink play" (*giboku*), which appeared much like improvisations. Japanese paintings of this type were produced mainly in Zen temples and despite their Japanese provenance were called "Chinese pictures" (*Kara-e*). Later, during the Edo period (1615–1867), Japanese paintings in Song, Yuan, or Ming style would be identified by

the slight variant, "Chinese paintings" (*Kanga*), while actual Song, Yuan, and Ming paintings produced in China would be called "Song-Yuan paintings" (*Sōgen-ga*).

As noted in Chapter 6, artists in Japan produced ink paintings as early as the Kamakura period. Examples include the sliding door panels in the former mansion of Saionji Kintsune; the *Bodhidharma* (Daruma) at Kōgaku-ji temple (1271; Yamanashi prefecture) [Fig. 8], which is painted entirely in ink apart from the red robe; and the *Wild Geese Descending on a Sandbank* (before 1318, see page 235) by Shikan, as well as two or three other smaller ink paintings. However, what might be called a first generation of Japanese ink painters emerged during the late Kamakura and Nanbokuchō periods,

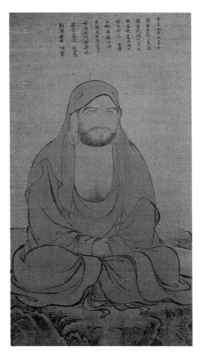

Fig. 8: *Daruma*, 1271, Kōgaku-ji, Yamanashi prefecture

from two main schools: the Takuma and the Zen. The Takuma was a school of monk-painters who became pioneers in adopting ink as their medium. The school is represented by Takuma Eiga (active mid-fourteenth century) who employed ink to depict subjects like the deities Hotei (C: Budai) and Bodhisattva Fugen (Sk: Samantabhadra). Ryōzen (mid-fourteenth century) who painted the hanging scroll *White Heron*, is also likely to have been a monk-painter. He is known for the impressive *Death of the Buddha* at Hongaku-ji temple (1328; Fukui prefecture).

The Zen school of painters is represented by Mokuan (died around 1345 in China) who made the crossing to Yuan China and was known to the monks of Muqi's Liutong temple as "the reincarnation of Muqi." Other painters of this generation include Kaō (active in the first half of the fourteenth century), a witty interpreter of Muqi's style, and Tesshū Tokusai (d. 1366), a specialist in depicting orchids in ink. Tesshū was a disciple of Musō Soseki (1275–1351), the high-ranking priest and adviser to court and *bakufu* who, at Tenryū-ji temple and Kōinzan in Saihō-ji temple (both Kyoto), also brought a fresh Zen approach to the Heian garden tradition.

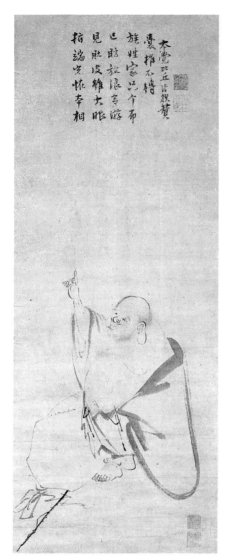

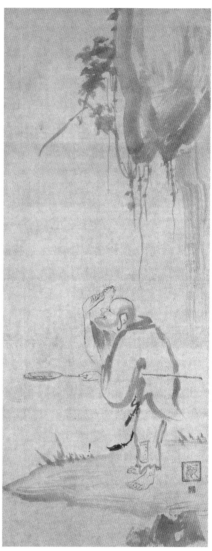

Fig. 9: Mokuan, *Hōtei*, first half of 14th century, MOA Museum of Art, Atami

Fig. 10: Kaō, *Priest Xianzi*, first half of 14th century, Tokyo National Museum

First-generation Japanese ink paintings often depict figures associated with Zen lore, for example Mokuan's *Hotei* [Fig. 9], or Kaō's portrait of Priest Xianzi (Kensu Oshō) (Tokyo National Museum) [Fig. 10], an eccentric Zen monk who ate crayfish despite the Buddhist ban on eating meat. Other extant paintings are lively Muqi-style "ink-play" works. But one should remember that early Japanese ink painters were not limited

in style or subject. Mutō Shūi (active in the mid-fourteenth century), for example, produced not only a famous portrait of Musō Soseki (c. 1351), but also paintings depicting the moment of Zen enlightenment (*Zenki-zu*), *Arhats* (*Rakan*), and *Carp* on the walls of Saihō-ji, a temple revived by Musō Soseki. The painter Kissan Minchō (discussed below) is a successor of this line of monk-painters dedicated to painting as a profession and who possessed a wide repertoire.

5. New Trends in *Yamato-e* and Pictures Illustrating the Origins of Temples and Shrines

The warrior emphasis on things Chinese and the waning political fortunes of the imperial court might seem to imply that during this period the Japanese *Yamato-e* tradition went into decline. However, that impression is due merely to the limited number of surviving large-scale works, such as sliding door paintings and folding screens. We learn from depictions in fourteenth-century handscrolls such as the *Illustrated Biography of Priest Hōnen* (Chion-in temple, Kyoto), *Illustrated Origins of Ishiyama Temple* (Ishiyama-dera temple, Shiga prefecture), *Illustrated Life of Priest Shinran* (Shōgan-ji temple, Chiba prefecture) and the narrative handscroll *Boki-e* (Nishi Hongan-ji temple, Kyoto), that whereas previously the panels of screens had to be individually framed, now a single frame could enclose two panels, a change made possible by the development of hinges. Then in the first half of the fourteenth century, further changes in the technical aspects of hinging obviated the need for frames, resulting in the now-familiar six-panel format that allows for continuous, unified compositions.

Illustrated handscrolls are also of interest in themselves. They began reaching a much wider audience than during the Kamakura period, and as a consequence often suffered a decline in quality due to production in large numbers. On the other hand, they tended to be accessible, and offered an opportunity for stylistic invention, as seen in the *Tale of the Hapless Painter* [Chapter 6, Fig. 36] and the *Illustrated Bibliography of the Saintly Ippen* [Chapter 6, Fig. 39]. These handscrolls led to the later development of illustrated popular stories (*otogi zōshi*).

Another important subject for *Yamato-e* at this time was the origins of temples and shrines (*engi-e*). The *Origins of Shido Temple* (fourteenth century; Shido-ji temple, Kagawa prefecture), a 170-centimeter high six large hanging scrolls, demonstrates the central role of images in making

temple and shrine narratives accessible to believers during an age of war. One scroll records the voyage of a sacred tree that drifted down river after river for more than a hundred years before reaching the Seto Inland Sea and floating across to Shido Bay on Shikoku, where it was finally carved into the temple's main icon, an Eleven-Headed Kannon (Jūichimen Kannon). Formerly employed during illustrated narrative sermons (*etoki*), this painting now also provides an example of sacred tree worship in Japan.

II. Kitayama Culture:
The Golden Age of the Muromachi Shogunate

The title of shogun was handed down successively from Ashikaga Yoshimitsu, who unified the Northern and Southern courts, to his son Yoshimochi, briefly to Yoshimochi's son Yoshikazu, and then to Yoshinori, another of Yoshimitsu's sons. During this period of Ashikaga rule, and with the backing of their financial resources, a new aristocratic culture blossomed in Kyoto and eventually replaced the earlier court culture that had lingered since the Heian period. This is often called "Kitayama culture," after the area of Kyoto where Yoshimitsu built his villa (the complex was renamed after his death and is known today as Rokuon-ji temple, or, more informally, Kinkaku-ji temple [Temple of the Golden Pavilion]).

1. Room Decor and Illustrated Popular Narratives

Perhaps the most famous structure at Rokuon-ji is the Relic Hall or Golden Pavilion (Kinkaku; 1397), an unprecedented three-tiered building that presents a different style of architecture on each floor: *shinden*-style residential architecture on the first floor, a combination of traditional-Japanese and Buddhist-hall styles on the second floor, and Zen-style (Zenshū-yō) Buddhist architecture on the upper floor [Fig. 11]. Attached to the main residential building with a corridor, there was an independent two-story meeting hall (*kaisho*), which functioned as a guest quarters and as a gallery space where Chinese works of art from the shogun's collection were displayed. The previously mentioned *Record of Decorations for the Imperial Visit to the Muromachi Palace* describes the works laid out in twenty-six rooms of two

Fig. 11: Golden Pavilion, 1398 (rebuilt 1955), Rokuon-ji, Kyoto

meeting halls at Shogun Yoshinori's palace for Emperor Go-Hanazono's visit in 1437, including paintings by Muqi, Liang Kai, Li Di, Huizong, Yujian, and Qian Xuan (active in the late-thirteenth–early fourteenth century), and exemplary Chinese decorative objects. Court nobles of the time competed with equal intensity in their own personal displays. For example, Prince Fushiminomiya Sadafusa noted in his *Diary of Things Seen and Heard* (*Kanmon Gyoki*, 1416–48) that the celebrations associated with the annual midsummer Tanabata festival provided the imperial household and court nobles with an occasion to fill their guest quarters with flower arrangements, Chinese wares, Japanese folding screens, and ink paintings.

Sadafusa's diary also usefully records the types of illustrated popular tales (*otogi zōshi emaki*), and shows that they were in vogue even among the court nobility. They include the *Tale of Wealth and Prosperity* (*Fukutomi Sōshi*; Shunpo-in temple, Kyoto), *Legends of Urashima Myōjin* (Ura shrine, Kyoto prefecture), *Tale of Ame-no-Wakahiko* (attributed to Tosa Hirochika [active mid-late fifteenth century]; Museum of Asian Art, Berlin), and the *Origins of Dōjō-ji Temple* (Dōjō-ji, Wakayama prefecture). Another popular illustrated narrative was the eccentric *Night Procession of One Hundred Demons* (*Hyakki Yagyō*), one example being in the collection of Shinju-an, Daitoku-ji (first half of the sixteenth century) [Fig. 12]. The scroll depicts a parade of daily household objects and Buddhist implements that a century after first being used have transformed into nightly frolicking demons. Joining this supernatural procession are women engaged in a joyful dance, their

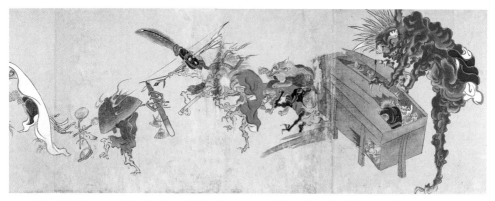

Fig. 12: *Illustrated Scroll of the Night Procession of One Hundred Demons*, 16th century, Shinju-an, Daitoku-ji, Kyoto

faces humorously fixed as though they have entered a trance. The riotous atmosphere matches that of the late Muromachi period, a time of rapid power shifts and overthrow of superiors by their subordinates (*gekokujō*).

2. The Chinese-style Ink Painting of Kissan Minchō

Kissan (or Kichizan) Minchō (1352–1431) spent his entire career at Tōfuku-ji, one of the five leading Zen temples in Kyoto. He nominally held the position of *densu*, a monk responsible for arranging the Buddhist ceremonial implements hence his nickname, "Chō-densu," but his actual remit was producing paintings, both the formal Buddhist religious icons (*butsu-ga*) seen in earlier centuries, and paintings of Daoist-tinged narrative subjects, which had become part of Zen lore, a genre called Daoist-Buddhist paintings (*dōshakuga*). Minchō possessed great facility in a variety of brush techniques, from rough to fine, and from color to ink, and often worked on a grand scale. For example, his *Death of the Buddha* (1408) measures 8.8 meters tall and 5.3 meters wide, *White-Robed Kannon* is 6 by 4 meters [Fig. 13]; and each scroll in his *Bodhidharma, Liu Hai*, and *Li Tieguai* triptych is 2.4 by 1.5 meters (all at Tōfuku-ji). He brought a feisty new energy to Japanese ink painting, perhaps inspired by the rather coarse brushwork found in earlier Chinese Daoist-Buddhist paintings (a close comparison is the Yuan-period *Sixteen Arhats* paintings at Daitoku-ji). Minchō's works are large in size, but almost appear to have been painted in a single session, with energetic brushstrokes filling the pictorial space. This type of brushwork would inspire later artists such as Kanō Eitoku (1543–1590),

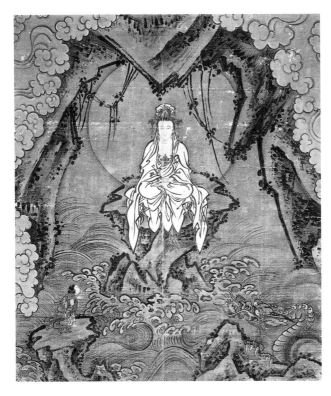

Fig. 13: Kissan Minchō, *White-Robed Kannon*, beginning of 15th century, Tōfuku-ji, Kyoto

whose *Chinese Lions* folding screen (Museum of the Imperial Collections [Sannomaru Shōzōkan], Tokyo; see Chapter 8, Fig. 3) has a similar character. On the other hand, Minchō's fifty-scroll set, *Five Hundred Arhats* is meticulously executed using fine color pigments (forty-five scrolls are at Tōfuku-ji, and two are at the Nezu Museum). And the *White-Robed Kannon* (c. 1430; Tokyo National Museum), a lovely small work completed in his last years, has an almost freely improvisational manner.

3. Poetry–Picture Scrolls, and the Art of Josetsu and Shūbun

The term "poetry-picture scroll" (*shiga-jiku*) refers to Muromachi-period hanging scrolls and handscrolls that feature one or more inscribed poems and an image. Originating in the Zen community during the Ōei era (1394–1427), the time of Ashikaga Yoshimitsu and Yoshimochi, the genre grew out of elite gatherings to compose Chinese-style poetry, sessions to which the shoguns themselves sometimes contributed. The landscape is positioned toward the bottom of the composition, with the majority of space

devoted to poems and comments inscribed by Zen priests, sometimes as many as twenty. Themes popular with Ch'an priests in Song China and later with Zen literati in Japan seem to have predominated. They include the study (*shosai*), an occasion to express one's thoughts about retreating from secular life; parting, an occasion to lament the departure of a close friend; and "poetic meaning," an occasion to reminisce about a friend. The oldest surviving poetry-picture scroll is *New Moon over a Brushwood Gate* (1405; Fujita Museum of Art, Osaka), inscribed with a verse by the Chinese poet Du Fu (712–770) on the subject of parting [Fig. 14]. The earliest "study" painting is *Small Hut in Valley Shade* (1412; Konchi-in, Nanzen-ji temple, Kyoto). In this case eight poets contributed inscriptions, among them Taihaku Shingen (1357–1415), a Zen monk at Kennin-ji temple in Kyoto who called the painted scene "a painting of the mind." The Chinese literati idea of "leaving one's body to the bustle of city life, and allowing one's mind to roam freely in quiet mountain peace" clearly resonated with Japanese Zen priests of this time. The painting is unsigned but tentatively attributed to Minchō.

Following Minchō, two other monk-painters came in prominence: Josetsu and Shūbun. Through their affiliation with Shōkoku-ji, a temple founded by Yoshimitsu and closely associated with the Ashikaga family, they served as official artists to the shogun. Shōkoku-ji ranked second among the so-called Five Mountains of Kyoto (Kyoto Gozan), five leading Zen temples that included first Tenryū-ji, then Shōkoku-ji, Kennin-ji, Tōfuku-ji, and Manju-ji. The Kyoto Gozan and the previously established Kamakura Gozan together constituted the "Five Mountains and Ten Temples system," which brought the activity of the priestly community under the authority of Nanzen-ji temple in Kyoto, and ultimately under central *bakufu* control.

Josetsu's (active c. 1394–c. 1428) leading painting is *Catching a Catfish with a Gourd* (*Byōnen-zu*, before 1415; Taizō-in, Myōshin-ji temple, Kyoto) [Fig. 16]. The work illustrates a theme set by shogun Yoshimochi, whose interest in Zen led him to pose the *kōan* (paradoxical remark), "How can one catch a catfish with a gourd?" perhaps a metaphor for unenlightened attempts to pin down the mind. Josetsu's response was to show a peasant brandishing a slippery gourd at a wriggling catfish. Now mounted as a hanging scroll, the painting originally appeared on one side of a screen positioned beside Yoshimochi's seat. On the reverse of the screen were commentaries on the theme of the painting prepared by high-ranking Zen

Fig. 14: *New Moon over a Brush-wood Gate*, 1405, Fujita Museum of Art, Osaka

Fig. 15: Attributed to Shūbun, *Reading in a Bamboo Grove*, c. 1446, Tokyo National Museum

Fig. 16: Josetsu, *Catching a Catfish with a Gourd*, before 1451, Taizō-in, Myōshin-ji, Kyoto

monks of the time (the commentaries are now mounted above the painting). One author observed that Josetsu had painted the work in a "new style" (*shinyō*), perhaps referring to the fine brushwork and atmospheric setting reminiscent of Chinese Southern Song paintings.

Shūbun (d. mid-1450s?) was a central figure in the Zen art community. He worked in a variety of formats, including hanging scrolls, screens and sliding doors, and seems to have been prolific, although it is difficult to ascertain the authenticity of the many fifteenth-century ink paintings attributed to him. Likely works are the exemplary "study" hanging scrolls, *Hue of the Water, Light on the Peaks* (1445; Nara National Museum), and *Reading in a Bamboo Grove* (1456; Tokyo National Museum) [Fig. 15], and the pair of six-fold screens, *Landscapes in the Four Seasons* (Maeda Ikutoku-kai Foundation, Tokyo), which convey a strong sense of composition over a large format. Shūbun's many students included Sesshū (discussed below), and Oguri Sōtan (1413–1481), an artist of commoner rank who upon completing his training at Shōkoku-ji rose to become official painter (*goyō-eshi*) to the Ashikaga family.

III. Higashiyama Culture and Artistic Production during the Warring States Period

1. Room Decor in Yoshimasa's Higashiyama Mountain Villa

Between 1401 and 1543, the Ashikaga dispatched seventeen embassies to Ming China and to Korea. Their tribute cargo included specifically Japanese art works such as gold-ground *Yamato-e* folding-screens, fans, paintings depicting a variety of flora and fauna, and *maki-e* lacquerware. The ships did not return empty, but rather brought countless Chinese and Korean treasures whose impact is especially evident during the shogunate of Ashikaga Yoshimasa (1449–1473).

It was under Yoshimasa that the precarious Ashikaga hold on power suffered a rapid decline with the final blows arriving in the form of the Ōnin War (1467–77) and the Warring States period (c.1467–1568). Faced with political turbulence beyond his control, in 1482 Yoshimasa removed himself to the Higashiyama hills east of Kyoto and there built a retreat,

Fig. 17: Silver Pavilion, 1489, Jishō-ji, Kyoto

an aesthetic villa now called Jishō-ji temple or more popularly Ginkaku-ji temple (Temple of the Silver Pavilion).

Inspired by Musō Soseki's Saihō-ji, Yoshimasa took an active role in designing this villa and the private residence he hoped to occupy; unfortunately he did not live to see its completion. The Silver Pavilion itself (now the temple's Kannon Hall; 1489) [Fig. 17] combines traditional Japanese-style living quarters on the first floor with a Zen-style Buddhist hall on the second floor, similar to the Golden Pavilion. The notable absence of a separate sleeping quarters at Jishō-ji is explained by Yoshimasa's death partway through construction, as well as a move in contemporary architecture away from the *shinden* ("mansion") style to the *shoin* ("study") style. Decorating the sliding doors in Yoshimasa's private quarters were ink paintings in the style of Song and Yuan Chinese masters such as Ma Yuan, Muqi, Yujian, and Li Gonglin (Li Longmien, 1049–1106). The paintings are attributed to Kanō Masanobu (1434–1530), who took over from Oguri Sōtan. In contrast, the doors throughout the meeting hall (*kaisho*), decorated with scenes of famous places in Japan such as Saga and Ishiyama, are attributed to Tosa Mitsunobu (discussed below), an official court painter. Here beginning to gather momentum we see the practice of combining things Japanese and Chinese into a synthesized style.

Throughout the Muromachi period, the shogun's collections of Chinese and other treasures were maintained by official curators known as *dōbōshū*. Most famous among these were Nōami (1397–1471), his son

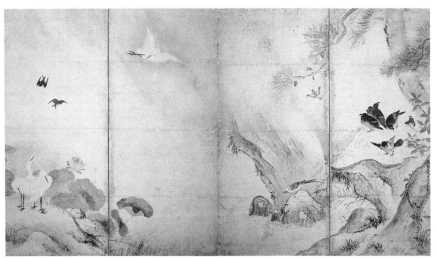

Fig. 18: Nōami, *Birds and Flowers* screens, right screen, 1469, Idemitsu Museum of Arts, Tokyo

Geiami (1431–1485), and his grandson Sōami (d. 1525)—three generations together known as the "Three Ami." One of their most significant projects was the previously mentioned *Catalogue of Princely Treasures*, Sōami's manual of room décor using Chinese lacquer, metal, and ceramic wares and paintings. In addition to evaluating paintings and calligraphy, the three Ami also painted ink landscapes and nature studies in a style inspired by Muqi but filtered through a Japanese sensibility. A model of the Ami-school style is *Birds and Flowers* (1469; Idemitsu Museum of Arts, Tokyo), a pair of four-panel folding screens by Nōami [Fig. 18]. Geiami is known by only one authenticated painting, *Viewing a Waterfall* (1480; Nezu Museum). Sōami is celebrated for his work at Daisen-in (1509–13), a sub-temple of Daitoku-ji, where he both painted the ink landscapes on the sliding doors in the guest hall. Zen'ami, one of the *dōbōshū* tasked with creating gardens, was known as a master of garden design.

The Art of the Dry Landscape

The term "dry landscape" (*karesansui*) refers to gardens in which water features such as streams or ponds are represented by strategically placed areas of sand and pebbles. The term appears as early as the *Record of Garden Making* (*Sakuteiki*) in the eleventh century, but it is associated particularly with the gardens created for Zen temples during the Nanbokuchō, Muromachi,

and Warring States periods. Their popularity at this time owes to Zen priests who travelled to China and brought the Chinese taste for such gardens back to Japan, where the local landscape inspired new interpretations of the style.

Two leading examples are the *shoin* garden at Daisen-in (first half of sixteenth century) [Fig. 19] and the famous Hōjō garden at Ryōan-ji temple (c. sixteenth century). In the Daisen-in garden, stones and rocks brought from famous sights around Japan create the impression of streams flowing into rivers and thence into the ocean. The garden at Ryōan-ji trades motion for stillness, with fifteen rocks of varying size posi-

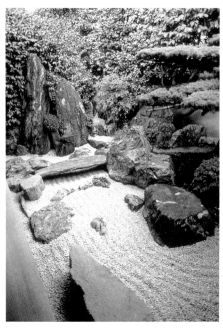

Fig. 19: Daisen-in *shoin* garden, first half of 16th century, Daitoku-ji, Kyoto

tioned on a white sand ground to form a single composition. With minimal means, the arrangement leads the eye from one rock to the next in endless variety, a rare instance in garden design of the simplicity characteristic of other types of Japanese art. The period fascination with *karesansui* gardens is evident from the daimyo mansions and Zen temples depicted in contemporary folding screens showing views of Kyoto (discussed further below).

2. New Movements in the Decorative Arts: Lacquer Work, Textiles, and Metalwork

The brilliance of imported Chinese decorative arts may have seemed unattainable, but it nevertheless inspired skilled Japanese craftsmen specializing in lacquer work (*urushi*), textile design, and metalwork to refine and improve their artistry and techniques. Lacquer artists of the period began exploring a variety of new techniques such as high relief lacquer (*takamaki-e*), latticework or textured carving (*ukibori*), and lacquer imitations of Chinese ink brushwork. The idea of combining Chinese and Japanese elements to create new designs may have derived from Yoshimasa's fresh approach

to room decor, for instead of allowing Chinese objects to dominate a space, he would at times set out only objects produced domestically, often *maki-e*. The proliferation of pictorial allusions to, and quotations from, poems in classical poetry anthologies such as the *Kokin Wakashū* (905; *Collection of Japanese Poems of the Past and Present*) points to a growing warrior admiration for court literature, a trend headed by the shogun himself. Representative lacquer objects of the period include the writing box with Shio-no-yama mountain

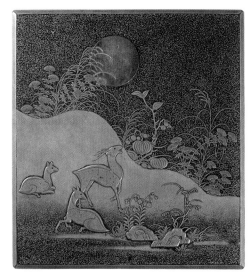

Fig. 20: Writing box with Kasuga mountain design, second half of 15th century, Nezu Museum, Tokyo

design (early fifteenth century; Kyoto National Museum) and the writing box with Kasuga mountain design (fifteenth century; Nezu Museum) [Fig. 20]. Also at this time new families of craftsmen began practicing traditional crafts and rising to prominence based on their skill. For example, Igarashi Shinsai (active fifteenth century) founded a lacquer-craft lineage that commanded a leading position in the industry through the Edo period (Chapter 9). A counterpart to this pattern in the world of painting is the rise of the Tosa and Kanō families. Another major lacquer artist was Kōami Dōchō (1410–1478), who earned the patronage of Yoshimasa.

New movements in textile design become evident from around the end of the Muromachi period, particularly the 1570s, when luxurious textiles from Ming China (gold brocade *kinran*, silk damask (*donsu*), wave-patterned fabric, gold-printed cloth) and Europe (brocade, lace, calico) became highly prized and known as "Chinese" (*kara*; i.e., foreign) textiles. Efforts to reproduce similar items domestically resulted in hybrid designs combining traditional Japanese patterns with new motifs. The garment that dominated the period is the *kosode*. It was originally worn by tradesmen as a work robe and by courtiers as an undergarment, but it emerged under warrior rule as an outer garment proper. The abrupt shift in the status of the *kosode* inspired new patterns and colors unburdened by convention, and

hence led to major revisions elsewhere in textile design, the ambitious warrior's disregard for precedent creating an environment suited to the expression of personal taste. Warrior Uesugi Kenshin (1530–1578), for example, wore a short outer jacket made from patches of exorbitantly expensive foreign textiles deliberately cut into odd shapes and stitched together to form an irregular pattern and an ostentatious display of wealth (Uesugi shrine [Uesugi-jinja]) [Fig. 21]. The groundbreaking aesthetic here reflects the warrior interpretation of elegant taste (*furyū*).

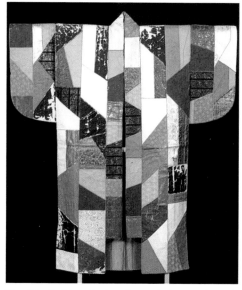

Fig. 21: Gold and silver brocaded satin damask patchwork coat, second half of 16th century, Uesugi shrine, Yamagata prefecture

Another new technique of the time was tie-dyeing in conjunction with applied decoration and embroidery (*tsujigahana-zome*), a technique redolent of Japan's medieval era.

Perhaps the finest decorative metalwork of the period came from the hand of Gotō Yūjō (1440–1512 or 23), a samurai originally in service to Yoshimasa who won renown for his high-relief sword decoration. The Gotō lineage of metal craftsmen would continue to earn the patronage of the warrior elite for generations through the Edo period.

3. Early Signs of Momoyama Style: *Yamato-e* Screens and Sliding Doors, and Architectural Decoration

Sliding doors and folding screens intended for daily use that were not donated to temples or shrines have experienced a high rate of attrition, suffering the same fate as the countless nameless buildings where they were installed. The loss is particularly acute in the case of screens and sliding doors from the Kamakura and Nambokuchō periods. However, it happens that many do survive from the last quarter of the fifteenth century. Examples include the *Landscapes of the Four Seasons* sliding doors attributed to Soga

Jasoku (active in the late fifteenth century), which is a depiction of a poetic secluded (*yūsui*) place in ink (1491; Shinju-an, Daitoku-ji) [Fig. 22], and several pairs of ink landscape folding screens attributed to Shūbun (Seikadō Bunko Art Museum in Tokyo, Museum Yamato Bunkakan in Nara, and other collections). The Seikadō Bunko examples have a particularly strong and unified composition. Japanese painters at this time began to identify the underlying principles of Chinese ink landscape painting and gradually to pursue an independent course expressive of a different sensibility.

It was once thought that by the Muromachi period Japanese style *Yamato-e* had grown insular and limited in scope, focusing on a traditional repertoire of famous places. However, art historian Yamane Yūzō's (1919–2001) discoveries of *Yamato-e* folding screens from the late fifteenth to sixteenth century demonstrate that at this time the genre portrayed not merely famous places, but rather indigenous landscapes full of immediacy: areas rich in nature (mountains, forests, waterfalls) considered to be the abode of *kami* (Japanese deities). The locations are depicted in seasonal, decorative, and almost tactile terms, as for example the *Pine Beach* screens (Satomi Family Collection), where the rolling waves are almost audible; the *Sun and Moon in the Four Seasons* screens (Tokyo National Museum); or the *Landscape with Sun and Moon* screens (Kongō-ji temple, Osaka) [Fig. 23, see pp. 272–73]. Vibrant and lyrical, these decorative worlds imparted new

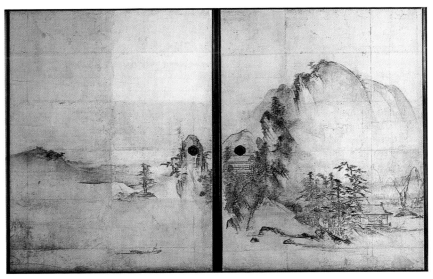

Fig. 22: Attributed to Jasoku, *Landscapes of the Four Seasons* sliding doors, c. 1491, Shinju-an, Daitoku-ji, Kyoto

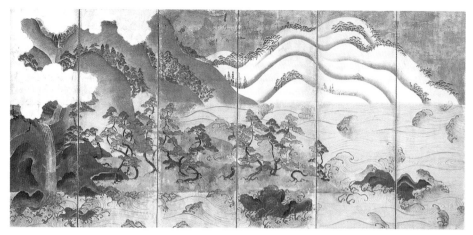

Fig. 23: *Landscape with Sun and Moon* screens, 16th century, Kongō-ji, Osaka

energy to the *Yamato-e* tradition. Their strong compositions and forceful character speak to the influence of contemporary Chinese-style ink painters such as Sesshū (discussed below).

Perhaps the central figure in the world of *Yamato-e* at the time was Tosa Mitsunobu (d. early 1520s), official painter to the imperial court (*e-dokoro azukari*). Mitsunobu and his son Mitsumochi produced exceptional work in a wide thematic range, from sets of paintings such as the *Ten Kings of Hell* (c. 1489; Jōfuku-ji temple, Kyoto), to illustrated handscrolls such as *Origins of Kiyomizu Temple* (1517; Tokyo National Museum), to albums such as the *Tale of Genji Album* (1509; Harvard Art Museums) [Fig. 24]. Mitsumochi produced outstanding paintings based on the theme of the four seasons, such as the illustrated handscroll *Origins of Kuwanomi Temple* (1532; Kuwanomi-dera temple, Shiga prefecture), and possibly the *Pine Beach* folding screens (Agency for Cultural Affairs).

A new field to emerge during the Warring States period was genre painting (*fūzoku-ga*) as an offshoot of *keibutsu-ga* paintings which combined depictions of nature in four seasons with scenes of people's everyday life. *Scenes of the Twelve Months* (first half of sixteenth century; Hoshun Yamaguchi Memorial Hall, Kanagawa prefecture) is a rare surviving example which demonstrates the *Yamato-e* painter's great skill in depicting the bustling lives of ordinary people [Fig. 25]. Another typical theme of this period is exemplified by "scenes in and around the capital" (*rakuchū rakugai zu*), which tackles the political and economic mood of Kyoto. This pictorial theme may have first appeared around the end of the fifteenth

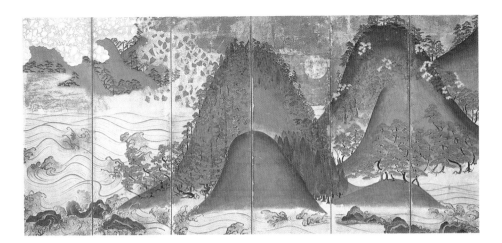

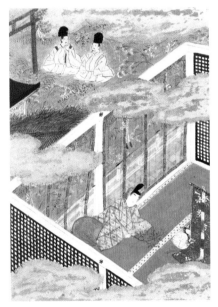

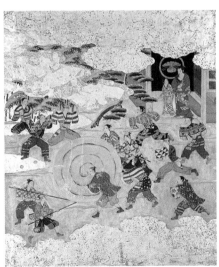

Fig. 24: Tosa Mitsunobu, "The Green Branch (*Sakaki*)" from the *Tale of Genji Album*, 1509, Arthur M. Sackler Museum, Harvard University Art Museums, Cambridge, Massachusetts. Bequest of the Hofer Collection of the Arts of Asia

Fig. 25: Attributed to Tosa Mitsuyoshi, "The Twelfth Month, Rolling Snow" from *Scenes of the Twelve Months*, first half of 16th century, Hoshun Yamaguchi Memorial Hall, Kanagawa prefecture

century, since contemporary records state that Tosa Mitsunobu painted a work titled *Scenes of Kyoto* in 1506. However, the oldest extant example is a pair of six-panel screens dated to around 1530. Formerly in the collection

Fig. 26: (This page and opposite) *Scenes in and around the Capital* (Rekihaku A version), first half of 16th century, National Museum of Japanese History, Chiba prefecture

of the Machida family, these screens are currently in the National Museum of Japanese History in Chiba prefecture, and hereafter will be referred to as the "Rekihaku A" screens [Fig. 26]. The right screen of the pair depicts south Kyoto and the city east of the Kamo river toward Higashiyama. The left screen shows north Kyoto and the city west of the river toward Kitayama and Nishiyama. According to art historian Ishida Hisatoyo (1922–2016), the view of north Kyoto was based on actual views from the impressive seven-story pagoda that once stood at Shōkoku-ji. This pagoda was first built by shogun Ashikaga Yoshimitsu at Shōkoku-ji in 1399, on the same scale as the pagoda at Tōdai-ji temple. When four years later lightning destroyed the structure, Yoshimitsu had a replacement built at his Kitayama mansion. When in 1416 this too burned down, another replacement was constructed back at Shōkoku-ji; it lasted until it was destroyed by fire in 1470. Based on Ishida's theory, the "Rekihaku A" screens would seem to depict Kyoto as it looked prior to 1470.

While the pagoda at Shōkoku-ji and other buildings indicate that Yoshimitsu had a passion for large-scale monuments, temple architecture itself seems not to have undergone significant development during this period. By contrast, shrine architecture and decoration positively flourished. Buildings such as the main hall of Kibitsu shrine [Kibitsu-jinja] in Okayama prefecture (1425) feature decorative patterns of concentric circles across their surfaces. Others are large structures with linked hip-and-gable roofs that present an ostentatious exterior. Sculptural decoration also developed

during the Warring States period. Powerful decorative designs such as the open latticework on the sliding door frames (1414) of Ōsasahara shrine (Ōsasahara-jinja, Shiga prefecture) would continue in popularity through the Momoyama period (1568–1615).

4. The Art of Sesshū Tōyō, and Paintings by Generals of the Warring States Period

The chaos of the Warring States period spurred both the political and the cultural ambitions of the military governors (*shugo daimyō*) across the country, who in the course of exercising their newfound authority became great patrons of the arts. One artist who benefitted from and successfully rode this wave of change was Sesshū Tōyō (1420–1506?). Sesshū was a monk-painter who learned the art of ink painting from Shūbun at Shōkoku-ji. In 1468, with assistance from the Ōuchi family of Suō province (present-day Yamaguchi prefecture), he fled the erupting violence in Kyoto and boarded a tribute ship headed for China, at last able to pursue a lifelong dream of visiting the continent. In China, he undertook further study at the painting academy of the imperial court, but was soon producing robustly structured work surpassing that of his masters, such as the set of hanging scrolls, *Landscapes of the Four Seasons* (Tokyo National Museum). He is also recorded as having painted a set of murals in the central hall of the Department of Rites at the Forbidden City, Beijing. Of deeper significance in

Fig. 27: Sesshū Tōyō, *Long Handscroll of Landscapes in the Four Seasons*, 1486, Mōri Museum, Yamaguchi prefecture

the development of Sesshū's already exceptional skills was the opportunity personally to see the vast landscape of China, an experience that lent his work a new gravitas. Upon returning to Japan in 1469, he resumed the life of an independent artist, travelling to different regions and producing ink landscapes in a powerful, resolute style. Examples of his post-China work include the *Autumn and Winter Landscapes* (Tokyo National Museum) and the famous *Long Handscroll of Landscapes in the Four Seasons* (1486; Mōri Art Museum, Yamaguchi prefecture) [Fig. 27].

In his later years, Sesshū began to focus on sites in the Japanese landscape, such as *Amanohashidate* (c. 1501–06; Kyoto National Museum) [Fig. 28], a natural land bridge on the north coast of central Japan, and also to apply techniques learned from Ming painters in creating a new manner of bird-and-flower paintings for folding screens, such as his *Birds and Flowers of the Four Seasons* (Kyoto National Museum). Transmitted through the work of Kanō Motonobu (discussed below) this latter subject would become central to the gold-ground sliding doors of the Momoyama period.

Muromachi-period warriors were for the most part highly educated; some like Yamada Dōan and Toki Tōbun (dates unknown for both) were also talented painters. A major artist in this line was Sesson Shūkei (1504?–1589?), son of the daimyo of the eastern province of Hitachi (in present-day Ibaraki prefecture), who took the tonsure to become a monk-painter. For a short while he was associated with a studio in Odawara, in central Japan, but was otherwise active in the northeast, the region from which he also drew inspiration. Sesson's work combines Daoist elements with an expressive use of color and a bold individualism. The dynamic topography of his landscapes, and the energy in paintings such as *Wind and Waves* (Nomura Art

Fig. 28: Sesshū Tōyō, *Amanohashidate*, c. 1501–1506, Kyoto National Museum

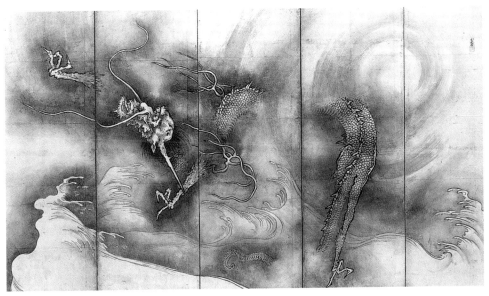

Fig. 29: Sesson Shūkei, *Tiger and Dragon* screens, right screen, second half of 16th century. © The Cleveland Museum of Art, purchase from the J. H. Wade Fund

Museum, Kyoto) and the *Tiger and Dragon* folding screens (The Cleveland Museum of Art) [Fig. 29] capture the combination of social instability and dynamism experienced in the provinces during the late medieval period.

5. From Combining to Unifying Elements of Japan and China

All the while Sesshū was active in western Japan and Sesson in the east, the Ami artists and other schools continued to produce excellent work in Kyoto. For example, *Pine Beach at Miho* (late fifteen century; Egawa Museum, Hyogo prefecture), attributed to Nōami, presents an ink-landscape vision of a celebrated site at the foot of Mt. Fuji, with barely visible shimmering washes of gold pigment lending the scene a luminous atmosphere [Fig. 30]. Sōami used subtle variations in ink tone to create landscapes filled with poetic feeling and a sense of natural light, as for example in his *Eight Views of Xiao and Xiang* sliding doors in the guest hall at Daisen-in (Daitoku-ji), works that build on his deep understanding of Muqi's painting.

Decorating the room to the west of Sōami's understated landscapes at Daisen-in we find a beautiful display of ink and color: *Birds and Flowers of the Four Seasons* by Kanō Motonobu (1476–1559) [Fig. 31]. Motonobu followed in his father Masanobu's footsteps as official court painter (*goyō eshi*) to Ashikaga Yoshimasa. He absorbed not only Sōami's style, but also by studiously examining the Chinese paintings in Yoshimasa's collection, the formal (*shin*), semi-formal (*gyō*), and cursive (*sō*) brush styles associated respectively with Ma Yuan, Muqi, and Yujian. His sliding door paintings at Reiun-in, a sub-temple of Myōshin-ji (1543), exhibit a highly refined brush technique and a clearly organized approach to composition. His strategic marriage to the daughter of Tosa Mitsunobu hints at an ambition to advance the development of large-format paintings by combining decorative *Yamato-e* with the realism and compositional strength of Chinese painting (Tosa-school painters then being the bearers of the *Yamato-e* tradition). Motonobu's *Birds and Flowers of the Four Seasons* folding screens (Hakutsuru Fine Art Museum, Kobe) is a product of this strategy. Through Motonobu, the two parallel approaches to art present in Japan since the introduction of Chinese ink painting finally merged and formed the foundation for the gold-ground screens and sliding doors of the Momoyama period.

6. The Beauty of Natural Ash–Glazed Stoneware, Domestically Produced Ceramics

Over time, from the late Heian through Kamakura period, Japanese stoneware production centers learned to use the mineral content of unglazed clay to react with the naturally changing conditions inside a kiln during

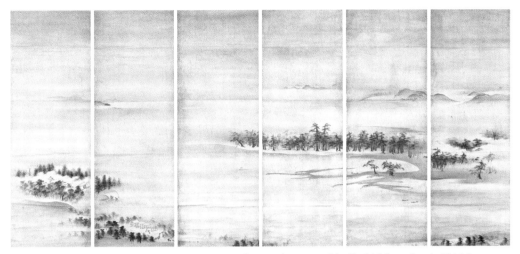

Fig. 30: Attributed to Nōami, *Pine Beach at Miho*, second half of 15th to first half 16th century, Egawa Museum of Art, Hyogo prefecture

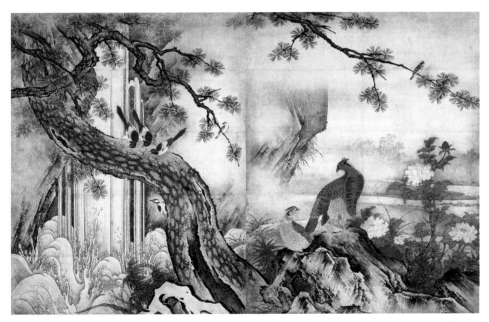

Fig. 31: Kanō Motonobu, *Birds and Flowers of the Four Seasons*, two panels, first half of 16th century, Daisen-in, Daitoku-ji, Kyoto

firing (such as heat fluctuation, placement in the kiln, and falling ash), producing natural ash glaze on the ceramic body. Regional kilns during the fourteenth through sixteenth centuries found particular success in

producing everyday wares with natural glazes in large numbers. Tokoname ware (see Chapter 5) is an early example, and it gave rise to the related but distinct and individually attractive Echizen, Tanba, and Shigaraki wares. Bizen ware later joined these three "sisters." Shigaraki clay contains a high proportion of white feldspar, which melts during kiln firing, resulting in a distinctive, pockmarked surface of unostentatious beauty. I have recently had the pleasure of working at the Miho Museum near the Shigaraki kilns and as a result had many chances to enjoy Shigaraki wares first hand. The surface treatment of the feldspar produced pockmarks filled with natural ash glaze that I found particularly compelling. The origins of these rough, almost magma-like surfaces can be traced back far beyond the rise of the contemplative *wabi*-style of tea gatherings to the Jōmon period [Figs. 32 and 33]. Late-Muromachi kilns also began producing vessels in various unusual shapes, in the hope of impressing tea masters practicing *wabi*-style tea. The production of massive storage jars peaked during the fourteenth to fifteenth centuries, but they had no connection with tea gatherings, being made for use as a functional container; they were often unsigned. For the most part, however, despite their widespread production, naturally glazed domestic

stoneware was overshadowed by imported Southern Song, Yuan, and Ming celadon, white porcelain, and brown-and-black glazed stoneware (Jian ware from the Fujian kilns generally termed *tenmoku* in Japanese)—highly sought-after prizes that could crown a collection or command respect in *zashiki kazari* (room decor). Not until the post-1945 years would the austere beauty of Japanese unglazed stoneware and natural ash-glazed wares, embodying a harmony between humanity and nature, win general acceptance.

Fig. 32: Detail of large jar, Shigaraki ware (Fig. 33)

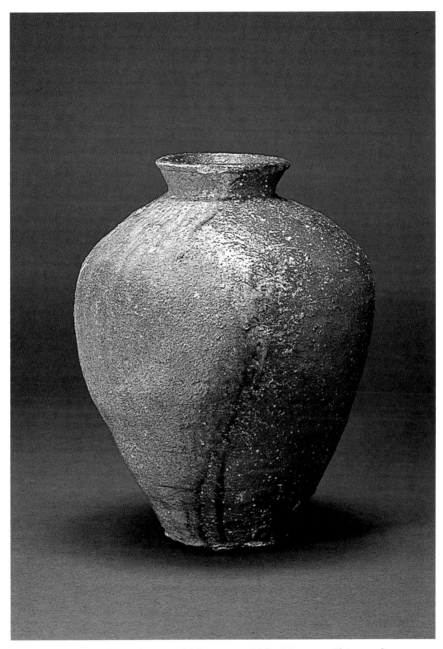

Fig. 33: Large jar, Shigaraki ware, 15th century, Miho Museum, Shiga prefecture

Azuchi–Momoyama:
The Flowering of *Kazari*

Azuchi–Momoyama: The Flowering of *Kazari*

During the brief but critical Azuchi-Momoyama period of Japanese history, three successive generals—Oda Nobunaga (1534–1582), Toyotomi Hideyoshi (1536/7–1598), and Tokugawa Ieyasu (1543–1616)—gradually lifted Japan out of the brutal chaos of the Warring States period and into an age of stability and prosperity. To students of political history, the period corresponds to the interlude of twenty-seven years from the collapse of the Muromachi shogunate (1573) to the Battle of Sekigahara (1600) during which Ieyasu rose to prominence. Culturally, however, the period extends through to 1615, the year marking the death of Toyotomi Hideyoshi's son Hideyori, the annihilation of the Toyotomi family, and the conclusive victory of Ieyasu's armies. The period as a whole can be usefully divided around Hideyoshi's death in 1598, with the first part centered on the Tenshō era (1573–92) and the second part on the Keichō era (1596–1615).

The unifying generals shared a fascination with art and design as a tool for displaying authority, which helped to create a world of *kazari* (adornment) that exuded ambition, glamour, and vitality. Driving the engines of ostentatious display was a massive gold and silver rush, Japan's first. Constant warfare and abrupt power shifts during the Warring States and Momoyama periods wrought widespread destruction, including the loss of countless art objects from temples and private collections. Even so, while much of the art produced during this short-lived period was destroyed, each surviving work shines with the energy imbued in it by its makers and owners.

1. The Flourishing of Momoyama Art: The Tenshō Era (1573–92)

Azuchi Castle and Kanō Eitoku

Momoyama marked the height of what could be termed warrior or samurai culture. Opulence was the standard not only for works of art but also for the beautiful and remarkable castles that housed them. The first of the Momoyama fortresses was Azuchi Castle (1576–79, Shiga prefecture), built by Oda Nobunaga. Azuchi Castle was built on a high, flat-topped hill with a massive keep (*tenshu*) that from the exterior appeared to have five floors but actually rose through seven. According to the *Chronicles of Lord*

Nobunaga (*Shinchōkō-ki*, c. 1600), which was compiled by Nobunaga's retainer Ōta Gyūichi for the period 1568–82, the sliding doors throughout this unprecedented building were decorated in heavy mineral pigments on gold leaf, or entirely in gold. Anticipating a visit from the emperor, Nobunaga constructed an additional mansion within his residence, and here too the sliding doors were decorated in mineral pigments and gold leaf with genre paintings of famous places (*meisho-e*). Nobunaga was so proud of this achievement that he presented the visiting Jesuit priest Alessandro Valignano with a pair of screens depicting the castle.

The master painter behind the decorative program at Azuchi Castle was Kanō Eitoku (1543–1590). With the encouragement of his grandfather, Motonobu (discussed in Chapter 7), Eitoku demonstrated great talent from a young age. In 1566, when he was twenty-three, he and his father Shōei (1519–1592) painted the sliding door panels (*fusuma*) at Jukō-in, a mortuary temple at Daitoku-ji temple dedicated to the memory of Warring States-period general Miyoshi Nagayoshi. Eitoku's ink paintings of birds and flowers exhibit a playfulness and dynamism that appealed to the warrior aesthetic of the time [Fig. 1]. Eventually, he was appointed to succeed Shōei as head of the Kanō school, and at the age of thirty-three he was placed in charge of the painting project at Azuchi Castle. Two years prior to assigning him to Azuchi, Nobunaga had commissioned Eitoku to paint a pair of folding screens depicting scenes of Kyoto. Destined as a gift for warrior Uesugi Kenshin (1530–1578) and hence called the Uesugi version, this pair shows a lively scene, visible through pockets of golden clouds, of more than 2,800 people in warrior residences, temples, shrines, and other sites within and outside Kyoto [Fig. 2]. This is one of Eitoku's masterpieces.

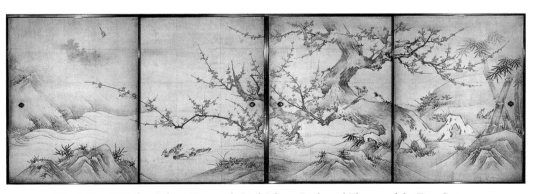

Fig. 1: Kanō Eitoku, "Plum Tree with Birds" from *Birds and Flowers of the Four Seasons* sliding doors, 1566, Jukō-in, Daitoku-ji, Kyoto

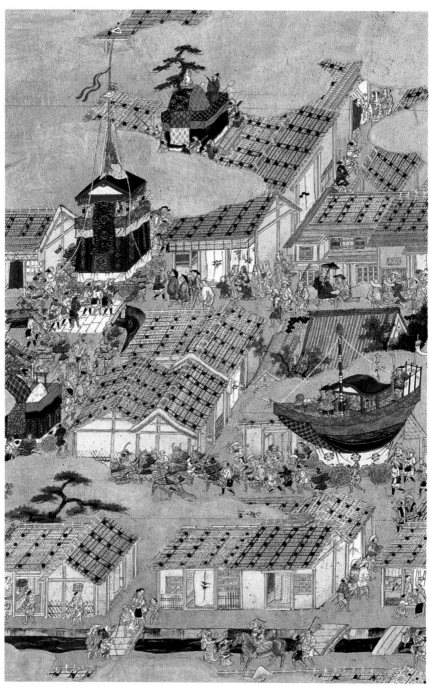

Fig. 2: Kanō Eitoku, detail from the right screen of *Scenes in and around the Capital* (Uesugi version), 1574, Yonezawa City (Uesugi Museum), Yamagata prefecture

After Nobunaga was assassinated and Azuchi Castle destroyed by fire during a raid in 1582, Hideyoshi had a host of other castles and mansions built on a much grander scale, such as the castles of Osaka (1585), Juraku-dai (1587, Kyoto), Hizen Nagoya (1591, present-day Saga prefecture), and Fushimi (1596, Kyoto). Each contained residential quarters in the *shoin* (study) style decorated with wall and screen paintings by Eitoku and his studio. The luxurious abbot's quarters at Tenzui-ji (1588), a sub-temple of Daitoku-ji that Hideyoshi built in prayer for the recovery of his mother's health, also once contained Eitoku's paintings (now lost) done in gold and mineral pigments. These commissions kept Eitoku and his team busy, but today only a few examples of their work have survived. Besides the two mentioned earlier, among those extant are the *Chinese Lions* folding screen (Museum of the Imperial Collections [Sannomaru Shōzōkan], Tokyo) [Fig. 3] and the *Cypress Trees* folding screen (Tokyo National Museum), paintings that more than adequately convey the nature of Eitoku's grand and awe-inspiring style. His cypresses, for example, have powerful trunks and mighty radiating branches that may be considered a pictorial counter-part to warrior machismo. Through these two screens we witness a "bewildering yet compelling" creative spark that shines "once every 500 years" as described by his contemporaries. Among a few examples of genre paintings by Kanō-school artists painted around Eitoku is the *Maple-Viewing at Takao* folding screen (Tokyo National Museum), by Motonobu's second son or grandson, Kanō Hideyori (active c. 1534–1569). This screen depicts

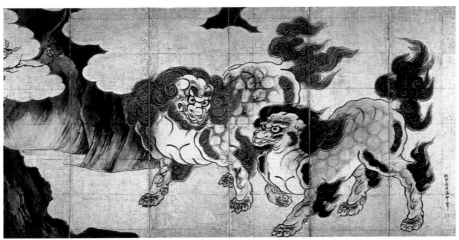

Fig. 3: Kanō Eitoku, *Chinese Lions* screen, second half of 16th century, Museum of the Imperial Collections (Sannomaru Shōzōkan), Tokyo

ordinary people embracing the momentary pleasures provided by nature, surrounded by the famous autumn scenery of Takao, northwest of Kyoto.

Designs on decorative arts during the Momoyama period grew increasingly bold, bright, and stylized. Well known are the saddle (*kura*) and stirrups (*abumi*) with a reed design decorated in lacquer and *takamaki-e* (1577; Tokyo National Museum), said to have been based on a design by Kanō Eitoku [Fig. 4]. The lines of the reeds bend gently to follow the curving form of the saddle, conveying a sense of energy and prosperity characteristic of Momoyama art at its best. Textile and costume design similarly experienced a burst of invention, largely due to new developments in fashion and modes of production during the end of the Muromachi period (1392–1573). Noh costumes such as the embroidered silk *kosode* (a basic type of kimono; see Chapter 7, pp. 269–70) decorated with snow-covered willows and swallowtail butterflies (late 16th century; Seki Kasuga shrine [Seki Kasuga-jinja], Gifu prefecture) [Fig. 5], or the *kosode* with flora on a white ground (Tokyo National Museum) almost seem to be celebrating the birth of Momoyama artistry. The finest Momoyama textiles, particularly *kosode*, display a mastery of techniques and materials, such as raised designs (*uki-ori*), twill weave (*ayaori*), embroidery (*nui* and *shishū*), pasted metallic leaf (*surihaku*), and intricate tie dyeing (*tsujigahana*). Here we discover the origins of premodern *kosode* as well as modern-day kimono.

Designs for *Wabi* Tea

In contrast to the opulent world of *kazari* (adornment), which aimed to dazzle the viewer with gold and color, the world of contemplative *wabi*-style tea avoided ornament and instead sought beauty in things subdued and incomplete. The key figure in the spread of *wabi* tea during the Momoyama period was Sen no Rikyū (1522–1591). Born a townsman in the wealthy commercial seaport of Sakai (near Osaka), Rikyū studied tea with Takeno Jōō and became well versed in the teachings of Zen Buddhism. His mastery of tea was recognized early, and his reputation was such that both Nobunaga and Hideyoshi appointed him as their head tea master. He rejected the study-room tea-stand (*shoin daisu*) style of tea typical of the mid-sixteenth century, which celebrated Chinese objects and exotic rare finds, and instead reduced tea practice to absolute austerity. For example, he is credited with having designed Tai-an (1582–83), a teahouse at Myōki-an temple in Kyoto that has only two tatami mats' worth of floor space (approximately 3.3 square

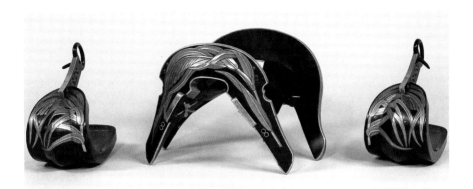

Fig. 4: Saddle and stirrups with reed design, 1577, Tokyo National Museum

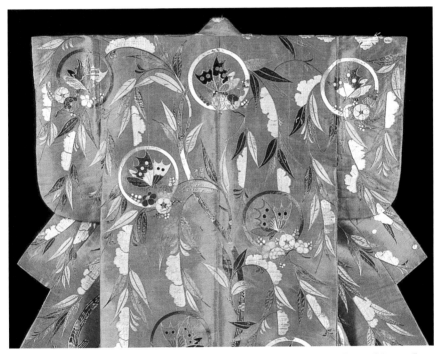

Fig. 5: Noh costume decorated with snow-covered willows and swallowtail butterflies, second half of 16th century, Seki Kasuga shrine, Gifu prefecture

meters) [Fig. 6]. Such small-scale (smaller than 7.4 square meters), austere style came to be known as *sukiya*. Rikyū's asceticism is exemplified by the *nijiri-guchi*, a small entrance to a teahouse that requires the visitor to stoop low, much like the cramped entrance to the sort of dwellings of fishermen or farmers. Rikyū's idea was to honor a guest with a display of humility

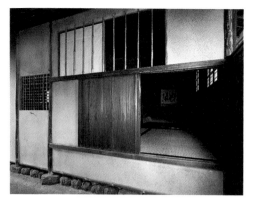

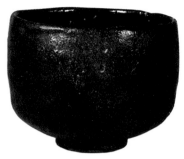

Fig. 6: Tai-an, 1582–83, Myōki-an, Kyoto prefecture

Fig. 7: Chōjirō, "Great Black" (Ōguro), Black Raku ware teabowl, second half of 16th century, private collection

rather than ostentatious wealth. Rikyū also favored the black and red Raku ceramic teabowls made by Tanaka Chōjirō I (1516–?1592). The sense of peace one derives from holding the generous forms of such Raku bowls as *Ōguro* ("Great Black") [Fig. 7], *Shunkan* (name of a twelfth-century priest and the title of a Noh play; Mitsui Memorial Museum, Tokyo), and *Muichimotsu* ("Void"; Egawa Museum of Art, Hyogo prefecture) reminds one how intimately art has been tied to function in Japan. Often described as a reaction to the warrior taste for excessive decoration, the *wabi*-style tea that Rikyū formulated during his last years was in itself extremely polished, an almost dandyish "anti-decorative decoration."

2. Development of Decorative Art: The Keichō Era (1596–1615)

Hasegawa Tōhaku, Kaihō Yūshō, and Other Artists

Momoyama art attained maturity during the 1590s to the early 1600s. Characteristic of the period's architecture is Shōun-ji (now Chishaku-in; 1593) in Kyoto, constructed by Hideyoshi as a mortuary temple honoring the memory of his son Tsurumatsu (also called Sutemaru), who died at the age of two. Despite its function, the temple also includes an extravagant guest hall overshadowing even that of Tenzui-ji. Other monuments from the period include the Chinese Gate (Karamon) of Hōgon-ji temple and the main hall of Tsukubusuma shrine (Tsukubusuma-jinja) on Chikubu

island in Lake Biwa (Shiga prefecture), both originally part of the Hōkoku mausoleum, the tomb of Hideyoshi built in 1599 in Higashiyama, Kyoto.[1] The architectural decoration here includes birds, animals, and plants—with a notable open-relief peony carving [Fig. 8]—their powerful sense of energy transmitting to us today the dynamism of the Momoyama period at its peak.

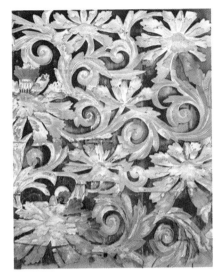

Fig. 8: Paneled door with open relief flora, 1599, Main Hall, Tsukubusuma shrine

A similar praise to the wonders of nature occurs in the door panels by lacquer artist Kōami Chōan (1569–1610) in the Otamaya Hall, the mortuary chapel of Hideyoshi and his wife Nene at Kōdai-ji temple, Kyoto, in the beautiful lacquerware with design of autumn grasses favored by the couple. Lacquer of this type, known as *Kōdai-ji maki-e*, brings an added visual liveliness to designs worked in the relatively simple technique of flat sprinkled-gold lacquer (*hiramaki-e*).

A principal figure in the realm of art was Hasegawa Tōhaku (1539–1610), every bit Eitoku's equal as a giant of the Momoyama period. Originally from the Noto Peninsula (Ishikawa prefecture), he started off as a local Buddhist painter under the name Shinshun, but around 1570 moved to Kyoto in order to study the ink-painting techniques of the thirteenth-century Chinese painter Muqi and the mid-Muromachi period (1392–1573) painter Shūbun, among others. Having absorbed these and the new techniques of Eitoku, he created his own independent style. The golden sliding doors with gigantic maples, cherry blossoms, pines and other flowers and plants by Tohaku and his disciples represent not just a feast of beautiful color, but a fantastic union of Pure Land Buddhist religious themes with the decorative tendencies of Momoyama culture (Chishaku-in, Kyoto) [Fig. 9]. His son Kyūzō (1568–1593) and other pupils closely followed this aspect of his style. Tōhaku also produced the superb *Pine Forest* folding screens (Tokyo National Museum), which adhere to the traditions of Muromachi ink painting while expressing the heightened spirit of his day [Fig. 10]. Contemporary with Tōhaku, Eitoku's son Mitsunobu (1565?–1608) painted scenes

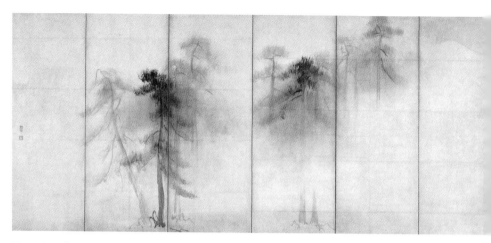

Fig. 10: (This page and opposite) Hasegawa Tōhaku, *Pine Forest* screens, second half of 16th century, Tokyo National Museum

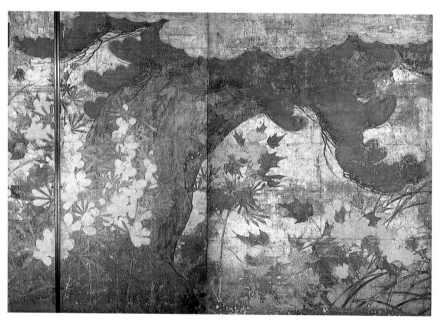

Fig. 9: Hasegawa Tōhaku and his studio, detail from *Sunset Hibiscus in Pines* (affixed in alcove), c. 1592, Chishaku-in, Kyoto.

of nature in different seasons filled with elegant lyricism on gold-ground sliding doors, including *Flowering Trees of the Four Seasons* (Kangaku-in reception hall, Onjō-ji temple, Ōtsu, Shiga prefecture) [Fig. 11].

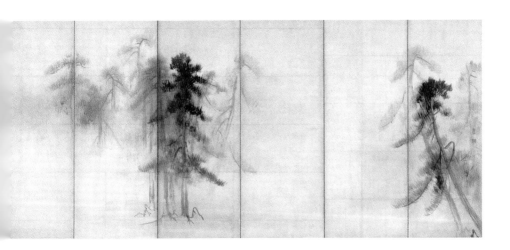

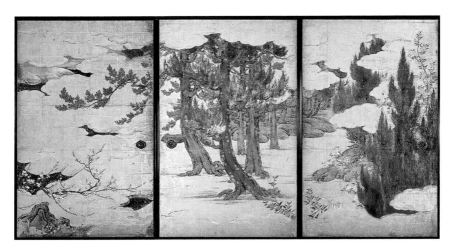

Fig. 11: Kanō Mitsunobu, detail from *Flowering Trees of the Four Seasons*, 1600, Kan-gaku-in, Onjō-ji, Shiga prefecture

Kaihō Yūshō (1533–1615), a son of the warrior Azai Nagamasa's important vassal, learned the art of painting while training as a Zen monk at Tōfuku-ji temple in Nara. He eventually developed a distinctive free-spirited style. For example, the dragon in his *Dragons in Clouds* folding screens wears a recalcitrant expression that may reflect the painter's own personality [Fig. 12]. In the *Landscape with Temples* folding screens (MOA Museum of Art, Shizuoka prefecture), he employed a modified form of

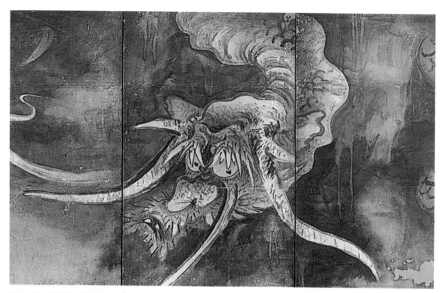

Fig. 12: Kaihō Yūshō, detail from *Dragons in Clouds* screens, right screen, beginning of 17th century, Kitano Tenman-gū, Kyoto

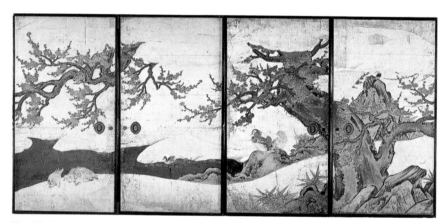

Fig. 13: Kanō Sanraku, *Red Plum Trees* sliding doors, first half of 17th century, Daikaku-ji, Kyoto

the splashed-ink (*hatsuboku*) technique to create an intentionally unde-fined, evocative pictorial space reminiscent of the work of the late Song-period Chinese painter Yujian. In common with much other painting done after Eitoku's time, however, his folding screen depicting flowering plants (Myōshin-ji temple, Kyoto) suggests a revived interest in the elegant deco-rative techniques of Japanese-style *Yamato-e* painting. Elsewhere in Kyoto,

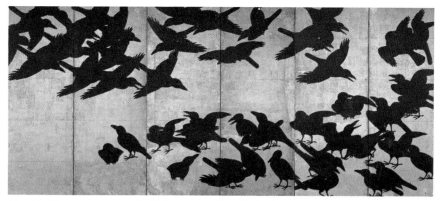

Fig. 14: *Crows* screens, early 17th century, Seattle Art Museum, Eugene Fuller Memorial Collection. (Photo: Seiji Shirono, National Research Institute for Cultural Properties, Tokyo)

Eitoku's student Kanō Sanraku (1559–1635) took over the Kanō school and created such striking works as *Red Plum Trees* sliding doors [Fig. 13], while far to the west in Suō province (present-day Yamaguchi prefecture), Unkoku Tōgan (1547–1618) recreated Sesshū's style with all the zest of the Momoyama spirit.

Gold and various metal pigments played an increasingly important role in decoration over the course of the Momoyama period, leading to work such as Sanraku's sliding-door paintings of peonies (Daikaku-ji temple, Kyoto). There were also bold experiments in decoration, such as the *Crows* screens (Seattle Art Museum), which is painted entirely in gold and black [Fig. 14]. It is largely on the basis of such work that the *Things Seen and Heard during the Keichō Era* (1605–15) and other literary sources described Momoyama as a golden age of prosperity, as though Miroku (Maitreya), the Buddha of the Future, had finally arrived.

The Pinnacle of Castle Keep Design

Castle keeps were a prominent feature of Momoyama architecture. Those at Azuchi Castle, Osaka Castle, Jurakudai Palace, and Fushimi Castle are now lost, but a small number remain. Ōtsu Castle (1586, Shiga prefecture), a lowland structure built by Hideyoshi's ally Asano Nagamasa, had a four-story keep now found as a three-story keep (c. 1607) at Hikone Castle (completed 1622, Shiga prefecture) [Fig. 15]. The way the various types of gables combine to emphasize the weight of the roofs represents a true

design achievement. Himeji Castle (1609, Hyogo prefecture) consists of a main keep linked to three smaller keeps by fireproof mud- and white-plaster-coated walls; these structures, together with the linear and curved contours of the eaves and gables, inspired the castle's nickname, "White Heron." The keep at Nagoya Castle (completed 1614, lost to fire 1945, reconstructed 1959), which moves from a single viewing-tower design to a multilevel structure, represents the last phase of castle keep architecture.

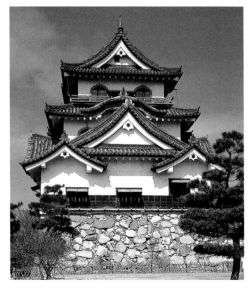

Fig. 15: Keep of Hikone Castle, keep completed c. 1607, Shiga prefecture

Genre Painting and *Nanban* Art

Genre scenes, a subject of painting since the late Muromachi period, gained in popularity among late-Momoyama-period warriors, as people anticipating an end to more than a century of turbulence and warrior rulers developed a new interest in the lives of the commoners over whom they held power. Mainly the province of the Kanō school, genre scenes reveal a fundamental change in social outlook, from seeing the world as a place of constant suffering to seeing it as a place for fleeting lives to be enjoyed. Examples include the *Hōkoku Festival* screens (c. 1606; Hōkoku shrine [Hōkoku-jinja], Kyoto) by Kanō Naizen (1570–1616) [Fig. 16], and the *Merrymaking under the Cherry Blossoms* screens (first half of 17th century; Tokyo National Museum) by Kanō Naganobu (1577–1654) [Fig. 17].

During the Momoyama period, the term *Nanban* referred to anything strange or foreign, but principally described people and imports from Europe. The ships bearing these goods were both Portuguese and Chinese, but they arrived at the port of Nagasaki in Kyushu having sailed up from China's southern coast, hence the term *Nanban* (literally "Southern Barbarian"). Portuguese ships sailed into port and unloaded cargo so

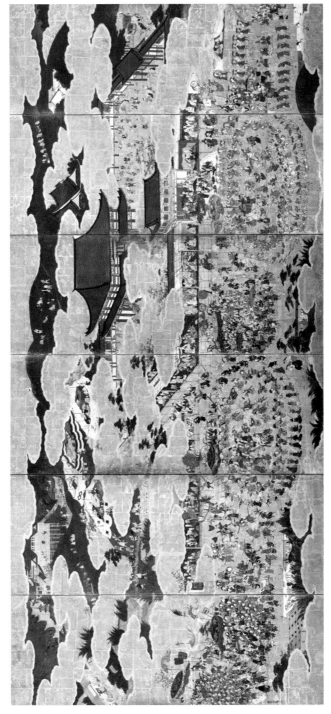

Fig. 16: Kanō Naizen, *Hōkoku Festival* screens, left screen, first half of 17th century, Toyokuni shrine, Kyoto

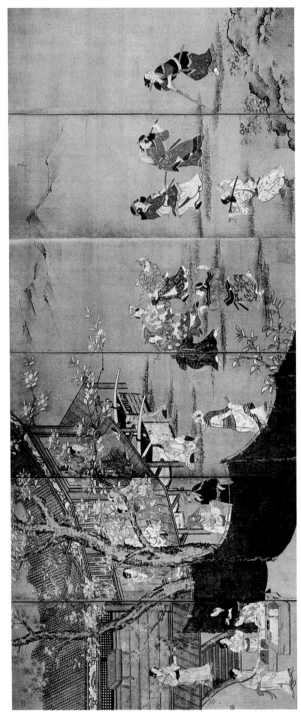

Fig. 17: Kanō Naganobu, *Merrymaking under the Cherry Blossoms* screens, left screen, first half of 17th century, Tokyo National Museum

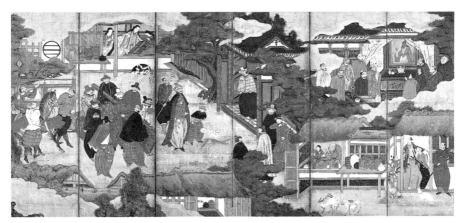

Fig. 18: *Southern Barbarians' Arrival* screens, right screen, beginning of 17th century, Museum of the Imperial Collections (Sannomaru Shōzōkan), Tokyo

regularly during this period that they became a popular genre subject for so-called *Nanban* folding screens, which feature scenes reflecting Japanese curiosity about the unusual faces and clothing of Westerners [Fig. 18]. The oldest screens of this type are pictures of Chinese ships, which, as bearers of treasure from foreign lands, may have appeared like the treasure ships (*takarabune*) of myth and lore bringing good fortune and treasure. Images of foreigners can also be found on horse trappings, candle holders, and even folding chairs used in Buddhist monks' gatherings, decorated with *makie-e* lacquer, and on ceramics from the period.

Also at this time, Japanese converts to Christianity studied techniques of Western painting in church-supported seminaries, and produced religious images for worship and catechism such as the *Fifteen Scenes from the Life of Mary* hanging scroll (Kyoto University Museum) [Fig. 19]. Most overtly religious works were later destroyed during the violent anti-Christian campaigns of the late 1630s, but missionaries also occasionally used secular images as a teaching tool when proselytizing to daimyo lords, and many of these have survived, including the *Westerners Playing Musical Instruments* folding screens (MOA Museum of Art) [Fig. 20] and the *Western Kings on Horseback* folding screens (Kobe City Museum and Suntory Museum of Art, Tokyo). These first generation of Western-style paintings (*yōfū-ga*) born from a combination of traditional Japanese painting methods and Western painting techniques have a curious appeal. Also at this time, *maki-e* lacquer and mother-of-pearl inlaid Christian ritual implements and objects for daily use were custom-made in Japan for export to the Christian world.

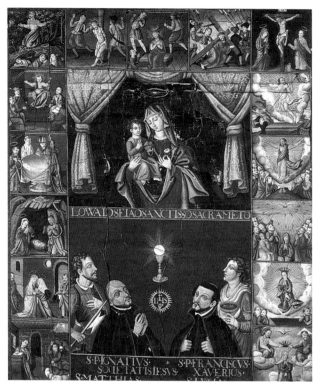

Fig. 19: *Fifteen Scenes from the Life of Mary*, first half of 17th century, Kyoto University Museum

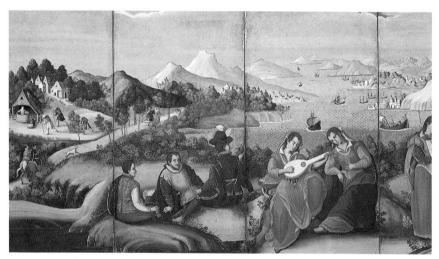

Fig. 20: Detail from *Westerners Playing Musical Instruments* screens, left screen, end of 16th century, MOA Museum of Art, Shizuoka prefecture

Kabuku or "Unconventional" Spirit: From Rikyū to Oribe

Tea masters in Rikyū's line preferred understated ceramics of Japanese manufacture, such as Bizen stoneware made in western Japan, and Mino stoneware. Production of Mino wares began in the Tenshō era (1573–92) alongside Seto ceramics, in what is today Gifu prefecture. Masters of *wabi*-style tea also prized the warm, tactile qualities of the Shino feldspathic white glaze, introduced around the early 1600s. Korean ceramics had a considerable impact on the ceramic styles of the period. Korean potters were brought over to Japan during Hideyoshi's invasions of the Korean Peninsula in the 1590s and began to work at ceramic-producing areas such as Karatsu in northwestern Kyushu. Iga ware, fired in kilns not far from Shigaraki (modern-day Shiga prefecture), was also popular with practitioners of tea during the early Momoyama period. Each Iga ware vase and water container from this period is fiercely individual in character and a work of art in its own right.

Following Rikyū's ritual suicide in 1591 (the consequence of a dispute with Hideyoshi), the tradition of *wabi* tea passed to the daimyo Furuta Oribe (1544–1615), in whose hands it became firmly established as a new dimension of Japanese aesthetics and decorative sensibilities. The tradition, however, did not pass on entirely unchanged. Under the influence of Oribe and Oda Nagamasu (also known as Oda Urakusai; 1547–1621), another warrior practitioner of tea, tea gatherings changed in character from Rikyū's sober *wabi* style to the daimyo style. Tea rooms, previously no larger than huts, now were designed on a larger scale with better lighting and sense of openness, and with increasingly decorative architectural details. A good example is the Oribe-style teahouse Ennan (Yabunouchi School of Tea, Kyoto), with its distinctive sloping thatched roof and shoji-covered windows of various shapes [Fig. 21].

Tea ceramics produced according to Oribe's instructions were known during the period as "playful wares" (*hyōgemono*). They were produced in Mino in efficient linked-chamber climbing kilns (*noborigama*) introduced from Korea. Some of these tea utensils have curious shapes, such as vessels in the form of vine baskets from Southeast Asia. Overall the designs appear improvisational and free flowing. Oribe also favored the Iga ware piece named *Karatachi* (Hatakeyama Memorial Museum of Fine Art, Tokyo), with its cracked surfaces and clumped ash glaze areas. These features occurred naturally in the course of firing, but also became an

effective vehicle for artistic expression. Like the well-known *Broken Pouch* (*Yabure-bukuro*; Gotoh Art Museum, Tokyo), they are bold, prehistoric "Jōmon"-like objects, in which the spirit of medieval *wabi* tea has been transformed by the premodern, *kabuki* unconventional (*kabuku*, to cut a dash; literally meaning "to tilt") aesthetic into objects striking in their own right [Fig. 22].

The age is also known for its spirit of playfulness (*yuge*), apparent in the outrageous appliqué designs on the woolen campaign coats (*jinbaori*) [Fig. 23] worn by elite warriors such as Kobayakawa Hideaki, Date Masamune, and Tokugawa Ieyasu, and in the extraordinary shapes and surprising designs of unusual helmets (*kawari kabuto*) [Fig. 24]. A similar spirit runs through the calligraphy of the Kyoto courtier Konoe Nobutada (1565–1614). While it is difficult for us now to imagine how freely warfare and play intermixed during this period, it is important nevertheless to recognize how the open-minded spirit of the unconventional *kabuku* aesthetic converted medieval art into premodern art and remained a vital force throughout much of the seventeenth century.

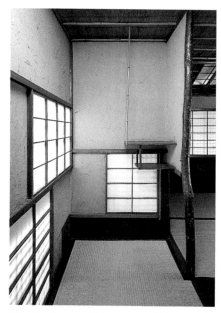

Fig. 21: Ennan, 19th century, Yabunouchi School of Tea, Kyoto

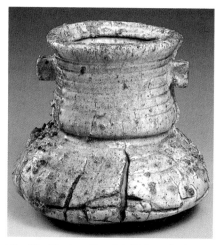

Fig. 22: "Broken Pouch" (Yabure-bukuro), beginning of 17th century, water jar with handles, Iga ware, Gotoh Art Museum, Tokyo

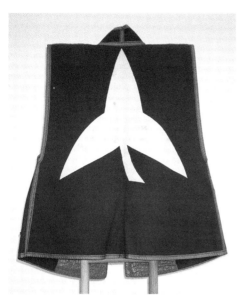 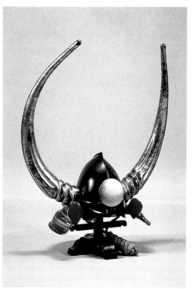

Fig. 23: Campaign coat with three leaf arrow-head design, second half of 16th–first half of 17th century, Nakatsu Castle (Okudaira Family), Oita prefecture

Fig. 24: Peach-shaped helmet with applied black lacquer and water buffalo horn fittings, c. 1600, Fukuoka City Museum

Edo:
Townspeople and the Rise of Urban Culture

Edo: Townspeople and the Rise of Urban Culture

In Japanese art and cultural history, the Edo period refers to the years from the fall of the Toyotomi family in 1615 to the return of political authority to the emperor in 1867. During those two and a half centuries, the Tokugawa shogunate, a newly established government, brought peace and prosperity to society by instituting new systems of law, commerce, and education that largely isolated Japan from the outside world, but also created an environment in which the arts could flourish.

The development of art in the Edo period can be seen as a process by which the realism and secularism of Momoyama art was inherited and amplified in the popular arena. In earlier times, the main producers of art had been members of the ruling elite (aristocrats and warriors), but now townspeople took the lead, drawing on their daily lives for creative inspiration and successfully popularizing their work in a range of urban settings. This is the distinguishing feature of Edo-period art. In no other culture of the same period do we find a situation in which members of a stratum of society without any political power, banned from traveling abroad, nurtured the arts to such a high standard on their own terms.

Tokugawa policy restricted contact with foreigners and foreign culture; as has often been noted, this policy ended up assisting the development of particularly Japanese cultural styles: townspeople's version of the cultural styles developed by aristocrats of the late Heian period. Conversely, the restrictions stimulated great interest in the outside world. It is difficult to overestimate the influence of the materials and goods of Chinese (Ming and Qing) origin and Western art that entered Japan via Nagasaki, the only port open to Chinese or Dutch trade from around 1636 until 1859. Even in fragmentary form, information about foreign art was received with enthusiasm and ultimately exerted a major impact on various areas of art and culture.

Edo-period art developed in two main phases that can be demarcated by the Kyōhō era (1716–36). During the first phase, the *kazari* (adornment) trend of the Momoyama period evolved into a more refined and settled artistic style associated with the townspeople. Below we will consider how this phase progressed from a transitional stage in the Kan'ei era (1624–44) into a fully formed stage in the Genroku era (1688–1704); the former was

represented by Tawaraya Sōtatsu, who channeled the vigor of Momoyama art into ever-bolder designs, and the latter by Ogata Kōrin, who added further intellectual refinement to Sōtatsu's achievement and perfected the character of Japanese decorative art.

The second phase featured what Japanese literature scholar Fujioka Sakutarō (1870–1910) called "the reformation of old customs," inspired by contact with Chinese literati painting and the introduction of Western books (these became available after the Kyōhō reforms of 1720 authorized importation of foreign publications). Most striking in the early part of this phase (1750s–80s) is the activity of the Kyoto painters Maruyama Ōkyo, Ike no Taiga, Itō Jakuchū, and Soga Shōhaku, and Edo woodblock-print artists Suzuki Harunobu and Torii Kiyonaga. During the latter part of this phase, increasing numbers of wealthy townspeople and farmers took an interest in the art world, which consequently took on the character of popular art. This is the environment that gave rise to the individualism of the painter and woodblock-print designer Katsushika Hokusai. By the nineteenth century the center of the art world had decisively shifted from Kyoto to Edo. In sum, Edo art reflected the maturity and decline of urban culture, but it also increasingly inclined toward empiricism and rationalism, leading to the art of the modern period.

Kan'ei art	First half of the 17th century
Genroku art	Second half of the 17th century to early 18th century
Kyōhō and Bunka-Bunsei art	Early 18th century to early 19th century

Table 1: Edo Period

I. Art of the Kan'ei Era:
The End and Transformation of Momoyama Art

1. Large-Scale Architectural Projects

The early decades of the seventeenth century represent the grand summation of Momoyama-period art and the transition to Edo-period art. It was a time when the Tokugawa government (*bakufu*) spent its abundant

financial resources on constructing castles and mausoleums as symbols of its authority.

Ninomaru Palace, the second bailey of Nijō Castle in Kyoto (1624–26), with its grand plan encompassing guard rooms (*tōzamurai*), banquet rooms (*ōhiroma*), and studies (including the *kuro-shoin* "black study" and *shiro-shoin* "white study"), is representative of this construction activity. The outer residence of Nijō Castle is among the most important extant examples of Momoyama-style *shoin*-style palace architecture. Nagoya Castle would have been another, but it was destroyed during World War II. The interior of Nijō Castle is adorned with gorgeous gold-ground wall images of giant spreading pines painted by Kanō Tan'yū (1602–1674) [Fig. 1]. Its magnificent architecture epitomizes the palace ideal that the lords of individual domains had pursued since the construction of Azuchi Castle (discussed in Chapter 8).

Another important project was the Tōshō-gū shrine dedicated to Tokugawa Ieyasu (1543–1616). Originally his mausoleum was erected on Mt. Kunō in Shizuoka prefecture, but another shrine was later built in Nikkō (north of Tokyo in present-day Tochigi prefecture). Between 1634 and 1636, Nikkō was completely refurbished by Ieyasu's grandson Iemitsu (1604–1651). In design, these grand architectural projects lack the vitality

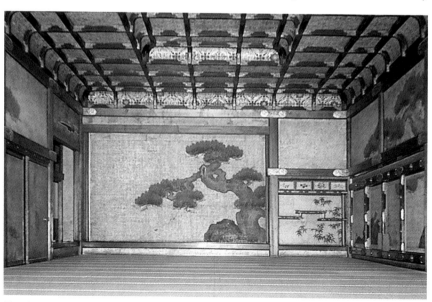

Fig. 1: Upper chamber in the grand audience hall of the Ninomaru Palace, 1624–26, Nijō Castle, Kyoto

of Momoyama-period art, substituting instead a ceremonious sublimity. The same can be said of the room with Chinese phoenix decorations in the meeting hall of Nishi Hongan-ji temple in Kyoto (1632), which is assumed to have been built to receive Tokugawa Iemitsu.

The Nikkō Tōshō-gū shrine complex in particular deserves high standing within the "culture of adornment." The complex of temples, shrines, and graves presents a variety of architectural styles, but its main feature is the splendid decoration applied to the exterior of the buildings in a style known as *gongen-zukuri*, a syncretic blend of Buddhist and Shinto motifs, as seen for example on the Yōmeimon gate [Fig. 2]. The surfaces are replete with gold and enamel fittings, brightly colored three-dimensional openwork decoration (*sukashi-bori*), and carved figures, animals, plants, and geometric patterns. The dazzling decorative effects stand at the extravagant extreme end of Momoyama art. This form of decoration was further refined at the Taiyū-in mausoleum (1653; Rinnō-ji temple) also at Nikkō, which was built for Iemitsu. Magnificent though they are, these monuments at the same time give one the impression that excessive decoration was driving architecture into decline.

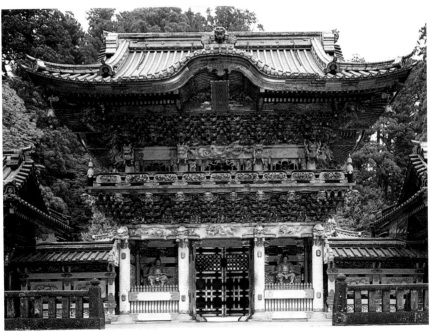

Fig. 2: Yōmeimon gate, 1636, Nikkō Tōshō-gū Mausoleum, Tochigi prefecture

In its first year, the Tokugawa shogunate issued a decree restricting dai-myo (domain lords) to one castle per domain and prohibiting any form of architectural renovation, thus obstructing the development of castle archi-tecture. Only the Tokugawa *bakufu* itself was permitted to erect and repair castles; these included Edo Castle and Osaka Castle (1626); the latter was built over the remains of the original edifice constructed by Toyotomi Hide-yoshi (1536/7–1598). After major refurbishment completed in 1637, Edo Castle boasted the highest and grandest castle keep in Japan (over 50 meters tall). The palace in the main bailey was equally grand, covering more than 3 hectares. The surrounding daimyo residences vied with the splendor of the Chinese-style gates built at the entrance to their compounds, adopting a style that recalled the Yōmeimon gate at Nikkō Tōshō-gū shrine, as seen in the *View of Edo* screens (*Edo-zu Byōbu*) held in the National Museum of Japanese History in Sakura (Chiba prefecture). The Momoyama war-rior taste for splendor evidently still carried influence, although one may question whether the result was as richly inventive as it had been in that earlier period.

2. Kanō Tan'yū, Kanō Sanraku, and Kanō Sansetsu

Kanō Tan'yū, the grandson of Eitoku (1543–1590; see Chapter 8), served starting at the age of seventeen as painter-in-attendance (*goyō-eshi*) to the Tokugawa *bakufu*; he went on to lead a well-organized academy whose important masters included his brothers Naonobu (1607–1650) and Yasu-nobu (1613–1685). Tan'yū worked both in Edo and Kyoto, and directed the production of wall paintings for many castles and temples, including Nijō, Osaka, and Nagoya castles and Daitoku-ji temple (Kyoto), as well as the Imperial Palace in Kyoto. Over the course of these projects, he moved from the exaggerated grand manner of Eitoku to the plain and refined style seen in the sliding-door painting *Plum Tree, Bamboo, and Birds in the Snow* produced for the Jōrakuden hall at Nagoya Castle (1634) [Fig. 3].

Unlike Momoyama-period painting, which Langdon Warner described as "continuing to paint in the air, as it were, beyond boundaries,"[1] Tan'yū's art seems to rest within the framed composition and to emphasize the allusive character of empty space. This approach marked a return to the qualities of Muromachi-period (1392–1573) ink painting, but also drew on the *Yamato-e* tradition, evident in his *Pine Trees in the Four Seasons* (Daitoku-ji). Perhaps for these reasons, Tan'yū's contemporaries classified

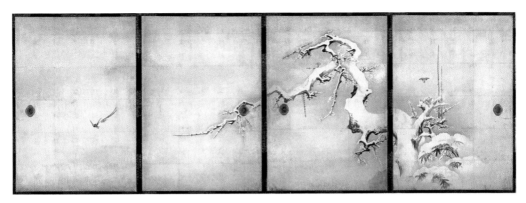

Fig. 3: Kanō Tanyū, *Plum Tree, Bamboo, and Birds in the Snow* sliding doors, 1634, north wall of the third chamber, Jōrakuden hall, Nagoya Castle, Nagoya

his work as *Waga* (Japanese-style painting) rather than *Kanga* (Chinese-style painting). He also experimented with sketching animals, plants, and landscapes from life, and in this way prefigured the "Japanese-style painting" (Nihonga) that emerged at the beginning of the Meiji era (1868–1912). Erasing the boundaries between *Yamato-e* and *Kanga*, his new style had a major influence on the direction of later Edo painting. In fact, he has been considered the "Tokugawa Ieyasu of the painting world."

Kanō Sanraku (1559–1635) was the last major painter of the Momoyama period. He allied himself with the Toyotomi family, and as a consequence suffered great hardship when the Tokugawa came to power. After being pardoned, he returned to painting and supported Tan'yū in the production of major works. The *Birds amid Plum Trees* sliding doors (1631; Tenkyū-in, Myōshin-ji temple, Kyoto), for example, are considered a joint work by Sanraku and his adopted son Sansetsu (1590–1651) [Fig. 4]. Their somber tone and eccentrically shaped trees, unique to Sansetsu, remind us that the Momoyama period was coming to a rapid close, and rising to the fore was a new type of individualistic artist, sensitive to contemporary trends in Chinese literati painting.

After Sanraku's death, Sansetsu's style became increasingly mannered, as demonstrated by the *Sea Birds along a Snowy Shore* screens (on loan to Kyoto National Museum) [Fig. 5]. The scene seems almost to recreate the world of the classical anthology *New Collection of Japanese Poems of Ancient and Modern Times* (*Shin Kokin Wakashū*) dating from 1205, with a serene and minute decorative style that suggests a moonlit shore in winter. Sansetsu's followers in Kyoto continued this "Kyoto Kanō" (Kyō-Kanō) style.

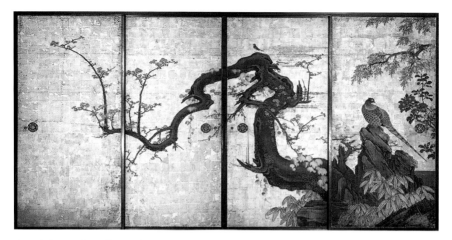

Fig. 4: Kanō Sanraku and Sansetsu, *Birds amid Plum Trees* sliding doors, four panels from a group of eighteen, 1631, Tenkyū-in, Myōshin-ji, Kyoto

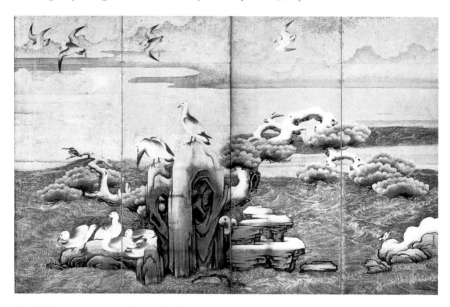

Fig. 5: Kanō Sansetsu, *Sea Birds along a Snowy Shore* screens, detail from right screen, first half of 17th century, private collection

Sansetsu's expertly crafted screens recall the Hatsune Dowry (1637; Tokugawa Museum), a large set of *maki-e* lacquer objects produced by the Kōami family of master lacquer artists for Shogun Iemitsu's daughter Chiyohime (Tokugawa Art Museum, Nagoya) [Fig. 6]. The Kōami family also produced *Kōdai-ji maki-e* lacquer, but the Hatsune Dowry contrasts

with *Kōdai-ji maki-e* lacquer in the extensive use of earlier Muromachi-type high relief (*takamaki-e*) to create delicate and elaborate designs. Also new in the early transitional years of the Edo period were textiles called Keichō *kosode* (Keichō robes), named for the Keichō era (1596–1615) in which they first appeared. They are characterized by detailed patterns with an understated beauty articulated in black that are quite different in style from those used in the Momoyama period.

3. Nostalgia for Court Culture

Pure, Elegant Simplicity and the Katsura Imperial Villa

The Japanese word *konomi* is now understood as denoting "taste," but in the premodern context it can be understood to have meant "design." Chapter 8 explored how students of Sen no Rikyū (1522–1591), notably Furuta Oribe (1544–1615), transformed the master's rustic tea style into a new mode featuring freer decoration. This mode further developed into the "pure, elegant simplicity" (*kirei sabi*) of Oribe's student Kobori Enshū (1579–1647), handsomely combining the simplicity of *wabi* with the splendor of *kazari* (adornment). Two tearooms designed by Enshū, named Mittan and Bōsen at Daitoku-ji's subtemples Ryōkō-in and Kohōan respectively reflect this style in their eclectic combination of traditional *shoin* elements in the manner of thatched huts. They also demonstrate how, as an instructor of tea for daimyo and as the supervisor of architecture and garden design for the *bakufu*, Enshū prioritized aesthetic harmony over things unconventional or exceptional.

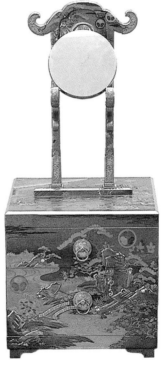

Fig. 6: Kōami Chōjū, Hatsune Dowry, 1637, Tokugawa Art Museum, Nagoya (detail)

 Prioritizing harmony, a characteristic also of Kanō Tan'yū's style, emerged as a trend as the warrior class attempted to fit in to the new Tokugawa order. However, the creative energies of the Momoyama period

were alive outside the centers of power in a freer environment. While receiving the generous protection of the *bakufu*, the court became, as if in resistance to the government controls, the center of a kind of classic revival, which inspired a number of wealthy townspeople to follow suit.

Katsura Imperial Villa (1615–62), built by Prince Hachijō-no-miya Toshihito and his son Prince Toshitada, consists of three *sukiya*-style pavilions famous for their structural design details (colored walls, some posts with the bark intact, exquisitely crafted furnishings and fixtures such as staggered shelves, nailhead covers, and door handles) [Fig. 7]. The combination of the *shoin* style with *sōan* or *wabi*-style tearooms (see Chapter 8) resonates with Enshū's ideal of *kirei sabi*. However, even more strongly in evidence here is a longing for the gracious refinement of the ancient imperial court of the Heian period (794–1192), for on this site once stood a country villa where Fujiwara no Michinaga (966–1027) had enjoyed the changing seasons. According to *Nigiwaigusa*, a collection of miscellaneous writings by Haiya Shōeki (1607–1691), a wealthy Kyoto merchant and close friend of Toshitada, the landscape in the stroll garden east of the villa recreated a garden described in the *Tale of Genji*, as per the prince's instructions. Here, in an environment of rustically elegant teahouses interspersed with

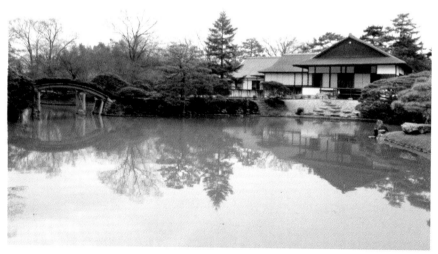

Fig. 7: *Shoin* (study), Katsura Imperial Villa, 1615–62, Kyoto

twenty-four stone garden lanterns in different shapes and sizes, we find the basis for premodern and modern Japanese architecture.

Shugakuin Villa, at the foot of Mt. Hiei, is another example of the imperial family's creative enthusiasm for courtly culture. Completed c. 1659 under the direction of retired emperor Go-Mizuno'o, Shugakuin is a large garden villa that gracefully incorporates nature into the inhabited space by emphasizing the garden over the villa. For example, a large pond for boating was created by constructing a retaining wall in the middle of the mountain; an arbor with a fine view was then built on an "island" in the pond (the island is actually part of the mountain ridge rising out of the water).

Kōetsu and Sōtatsu: Forerunners of Popular Design

The cultural interests of wealthy Kyoto townspeople gave rise to two highly original artists—Hon'ami Kōetsu (1558–1637) and Tawaraya Sōtatsu (active early seventeenth century)—who revived the art of the ancient court in terms of the magnanimous spirit of the Momoyama period. Kōetsu came from a merchant family that since the Muromachi period had specialized in the connoisseurship and care of swords. He was a versatile artist, equally skilled in the fields of *maki-e* lacquer ware, tea ceramics and calligraphy. His *maki-e* lacquer writing box with pontoon bridge (*funabashi*) design (Tokyo National Museum) has an unconventional design inspired by a poem in the *Later Collection of Japanese Poems* (*Gosen Wakashū*, tenth century). The arched form of the lid shows Kōetsu's strong interest in overall design. In ceramics, Kōetsu replaced the solemnity of the Raku earthenware favored by Rikyū with witty lightness. Excellent examples are his teabowls called "Rainclouds" (Amagumo) [Fig. 8], "Otogoze" (Otome-gozen), "Late-Autumn Shower" (Shigure), and "Mt. Fuji" (Fuji-san). In calligraphy, Kōetsu created an original style with varied thick and thin brush strokes, following the Japanese style practiced

Fig. 8: Hon'ami Kōetsu, "Rainclouds" (Amagumo), Black Raku ware teabowl, first half of 17th century, Mitsui Memorial Museum, Tokyo

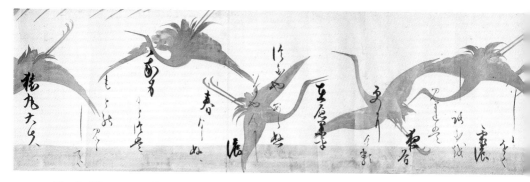

Fig. 9: (This page and opposite) Tawaraya Sōtatsu and Hon'ami Kōetsu, *Anthology of the Thirty-Six Poets with Crane Design*, first half of 17th century, Kyoto National Museum

by the Heian masters Kūkai (774–835) and Ono no Michikaze (894–964). One of Kōetsu's contemporaries was tea master Shōkadō Shōjō (1584–1639), another multitalented man of culture with particular skill in calligraphy and painting.

It was, however, Tawaraya Sōtatsu who, with Kōetsu's support, revolutionized decorative design in the *Yamato-e* tradition. Sōtatsu is thought to have operated an independent painting studio (*eya*) in Kyoto. Using silver and gold ink, he elegantly decorated writing papers in handscrolls and *shikishi* (square-format) albums, which Kōetsu then inscribed with classical Japanese poems. These collaborative works represent the perfect union of courtly elegance and Momoyama-period playfulness. They can be found today in the collections of the Hatakeyama Memorial Museum of Art, Tokyo, the Museum of East Asian Art, Berlin, the Kyoto National Museum and others [Fig. 9]. Sōtatsu's originality is evident also in his fan paintings. For example in *Farm House in Early Spring* (Daigo-ji), he used the the special "dripping in" (*tarashikomi*) technique, in which ink or pigment is applied to painted areas that are still wet, resulting in a blurred, mottled, or pooling effect. The technique is emblematic of his style and that of his followers.

From around the first quarter of the seventeenth century, Sōtatsu began working on large-scale paintings, including the *Cedar Doors with Elephants* in Yōgen-in, a small temple rebuilt in 1621 at the request of Sūgen-in, the wife of the second Tokugawa shogun, Hidetada. Here, late in his career, and in a series of other works such as the *Wind God and Thunder God* screens (Kennin-ji temple, Kyoto) [Fig. 10], the *Sekiya and Miotsukushi* screens (1631; Seikadō Bunko Art Museum, Tokyo) depicting scenes from the *Tale*

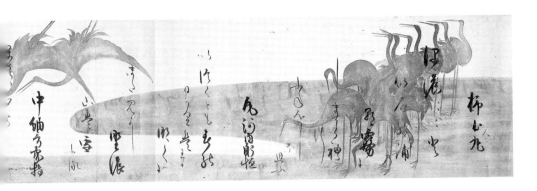

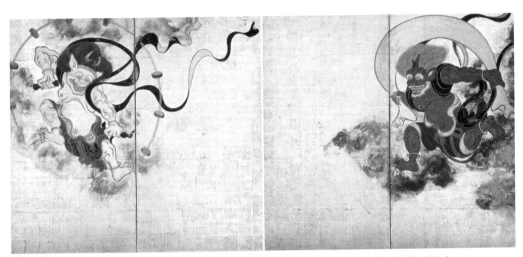

Fig. 10: Tawaraya Sōtatsu, *Wind God and Thunder God* screens, first half of 17th century, Kennin-ji, Kyoto

of Genji, the *Waves at Matsushima* screens (early seventeenth century; Freer Gallery of Art, Smithsonian Institution) [Fig. 11], and the *Bugaku* screens (Daigo-ji temple), Sōtatsu created a new tradition in the *Yamato-e* style. His art displays his awareness of the autonomy of form, and the best of it lies in the skill with which he used form and color like a musical score to create a playful and celestial vision of the world.

4. Pleasures of the Floating World: Trends in Genre Painting

The roots of Edo-period genre pictures reach back to the tradition of screens depicting aerial views of Kyoto, known generally as "scenes in and around the capital" (*rakuchū rakugai zu*; introduced in Chapter 7). These paintings

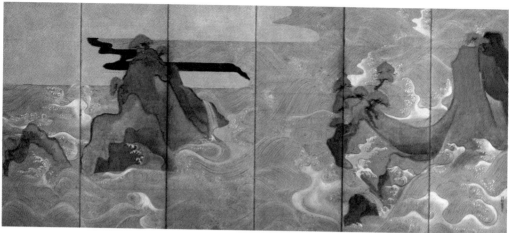

Fig. 11: Tawaraya Sōtatsu, *Waves at Matsushima* screens, right screen, early 17th century, Freer Gallery of Art and Arthur M. Sackler Gallery, Smithsonian Institution, Washington, D.C.: gift of Charles Lang Freer, F.1906.231–232

developed in two main formats. An example of the first is the Warring States-period (1467–1573) Rekihaku A screens (see Chapter 7, Fig. 26), where Kyoto is divided into two regions, north and south, with each screen of the pair depicting one region. Kanō Eitoku's *Scenes in and around the Capital* is another example of this type (see Chapter 8, Fig. 2). During the early seventeenth century, a second format appeared with the city was divided east and west, again with one side depicted on each screen, but featuring Nijō Castle, built by the Tokugawa family, as the centerpiece of the city. A separate, unique composition developed around 1614 is that of the Funaki screens (Tokyo National Museum) [Fig. 12]: one screen is centered on Toyotomi Hideyoshi's Great Buddha Hall at Hōkō-ji temple on the east, and the other screen features the Tokugawa family's Nijō Castle on the west; the Kamo River runs through both. In a sense the Funaki screens' composition satirizes the political standoff of the 1610s between the Toyotomi and Tokugawa families. The focus on the theater district and pleasure quarters tells us that attention was shifting towards a coarser and more popular view of worldly pleasure. This notable screen was painted by Iwasa Matabei Katsumochi (1578–1650) (discussed further below).

The vast number of extant early Edo genre paintings attests to their popularity. Most of these genre paintings were produced by independent painters who, in response to increasing demand for decorative screens, began competing with the Kanō and Tosa schools for commissions. The preferred

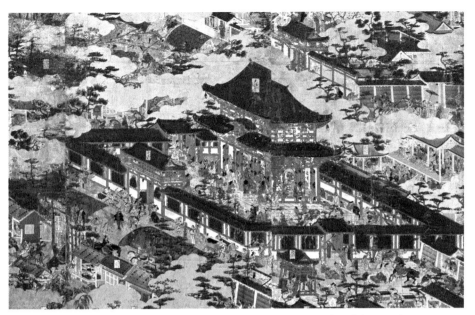

Fig. 12: *Scenes in and around the Capital* (Funaki version), detail from right screen, first half of 17th century, Tokyo National Museum

subject was the world of pleasure and entertainment, usually called the "floating world" (*ukiyo*), centering on the brothel and theater districts.

Unofficial paintings by painters with official positions are also found in this category, such as the *Hikone* screen (Hikone Castle Museum, Shiga prefecture), said to represent one of the precedents for ukiyo-e [Fig. 13]. Independent artists also produced unique works like *Women of a Public Bathhouse* (MOA Museum of Art, Shizuoka prefecture), which captures the free-spirited life of lower-class prostitutes [Fig. 14]. The unique mixture of vitality and decadence in Kan'ei genre painting perhaps reflects the outlook of the warrior class, whose members could no longer hope for promotion through military exploits.

Iwasa Matabei deserves attention at this point. An orphan of the warlord Araki Murashige, "Ukiyo Matabei" (Floating-World Matabei), as he was sometimes called, brought a new and distinctive style to genre painting; the Funaki screens (discussed above) are considered an early work by him. His paintings include the richly colored *Handscroll of the Tale of Lady Tokiwa in the Mountains* (*Yamanaka Tokiwa Monogatari Emaki*) [Fig. 15] and the *Handscroll of the Tale of Jōruri* (both at MOA Museum of Art), painted for the Echizen Matsudaira family, one of the *gokamon*

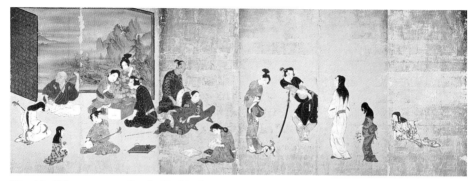

Fig. 13: *Hikone* screen, first half of 17th century, Hikone Castle Museum, Shiga prefecture

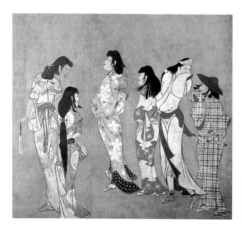

Fig. 14: *Women of a Public Bathhouse*, mid-17th century, MOA Museum of Art, Shizuoka prefecture

families descended from the sons of Ieyasu. These scrolls depicting stories from *ko-jōruri* (seventeenth-century puppet dramas) are receiving increased attention for their strong decorative qualities and unconventional modes of painterly expression. In particular, the tragically beautiful scene in which a thief murders Lady Tokiwa may reflect Matabei's feelings about the execution of his own mother when he was a child.

II. Genroku Art: Art for Townspeople

If the Gen'na and Kan'ei eras (1615–44) represent the sudden end and transformation of Momoyama art, the following span from Keian to Kanbun (1648–73) and from Genroku to Kyōhō (1688–1736) can be understood as

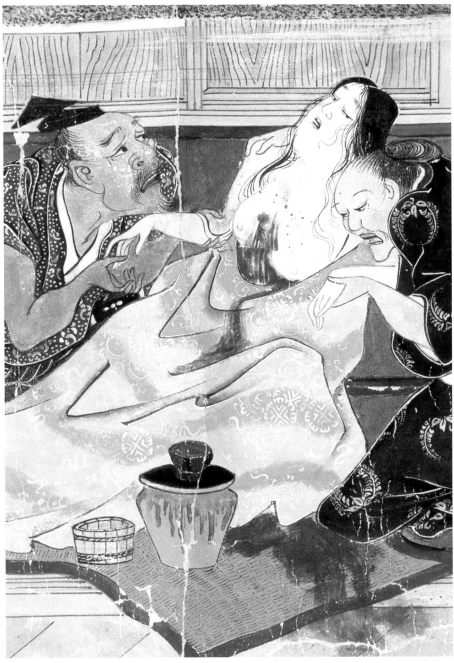

Fig. 15: Iwasa Matabei, *Handscroll of the Tale of Lady Tokiwa in the Mountains*, detail from the fifth scroll, first half of 17th century, MOA Museum of Art, Shizuoka prefecture

a time when Edo-period art became more settled in character, though with traces of the Momoyama period still in evidence. It was also a time when townspeople took over from the ruling class as the main producers of art. Under their influence, the arts—once generally bold and daring—began catering to individual tastes and interests.

1. The End of Momoyama-Style Architecture

In 1657 the Great Meireki Fire destroyed central Edo, including the magnificent keep of Edo Castle and the grand daimyo mansions that surrounded it. The main residential areas of the castle were later reconstructed, but the keep was thought redundant in a time of peace and never rebuilt. The surrounding daimyo residences were also simplified; thus the Meireki Fire marks the end of Momoyama architecture. The Tokugawa *bakufu*, moreover, had to spend enormous sums aiding refugees and reconstructing the city, leading eventually to serious financial difficulties. In the meantime, the merchant class grew continually wealthier and, owing to loopholes in the repeated bans issued by the government, began to build *sukiya*-style houses, characterized by tastefully decorated—sometimes extravagant—furnishings and interior appointments. Sumiya House, for example, once a house of entertainment in Kyoto's Shimabara pleasure quarter, contains an array of inventively designed floors, ceilings, partition panels, and beams. The *sukiya* style spread to town houses and farmhouses, and eventually became so widely established that today it is considered one of the main architectural styles of Japan.

2. The Merits and Challenges of the Kanō School: The Kanō School after Tan'yū

Having served as official painters to successive generations of shoguns, including Ashikaga Yoshimasa (1436–1490), Oda Nobunaga (1534–1582), and Toyotomi Hideyoshi, the Kanō school consolidated its position and authority under the Tokugawa, particularly through the efforts of Kanō Tan'yū (see above). During the Edo period, the Kanō controlled a network of schools and affiliates across the country, extending from the "inner court painters" (*oku-eshi*) who worked directly for the shogun, to the "outer court painters" (*omote-eshi*) who supported the *oku-eshi*, and to the official

painter-in-attendance (*goyō-eshi*) employed by local domains, ending with the "townsmen Kanō" (*machi-ganō*) who worked for the townspeople. Kanō-school training centered on copying the style of the masters such as Tan'yū, a useful practice for beginners. Enthusiastic painters, however, could not remain satisfied for long. Itō Jakuchū and Kitagawa Utamaro (both discussed below), for example, studied under the Kanō school but later pursued their own styles. Still, the Kanō school did play an important role in training beginners from all walks of Edo-period society.

The Kanō school, though, also had its rebels. Prominent among them were Kusumi Morikage (active mid-seventeenth century), who was expelled for disobedience; and Hanabusa Itchō (1652–1724), exiled to a remote island for bad behavior. Morikage's screen *Enjoying the Evening Cool under the Moonflower Trellis* (Tokyo National Museum) expresses a samurai's longing for the life of the farmer unbound by the strictures of prescribed manners and etiquette [Fig. 16]. And Itchō drew on the world of ukiyo-e for his *Leading a Horse at Dawn* (Seikadō Bunko Art Museum) in which the surface of the water catches an impressionistic shadow of the boy and horse cast by the morning light [Fig. 17].

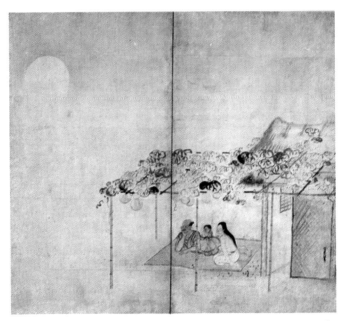

Fig. 16: Kusumi Morikage, *Enjoying the Evening Cool under the Moonflower Trellis* screen, second half of 17th century, Tokyo National Museum

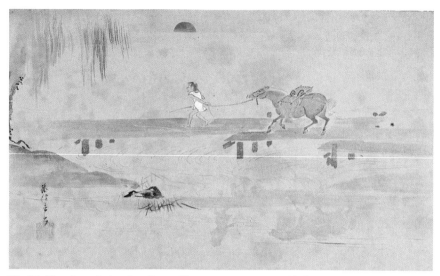

Fig.17: Hanabusa Itchō, *Leading a Horse at Dawn*, second half of 17th century, Seikadō Bunko Art Museum, Tokyo

3. Porcelain with Polychrome Enamel Designs: The Formation of a Japanese Style

Fine craft underwent remarkable development from around the beginning of the Kanbun era (1661–73), notably the discovery in Hizen province (present-day Saga prefecture) of the overglaze polychrome enamel technique for decorating porcelain. The development of this technique in Japan was certainly inspired by the large number of imported Chinese porcelains. Sakaida Kakiemon (1615–1653) is thought to have been responsible for the development of the overglaze technique called *aka-e* (literally, "painting with red") in 1647.

After the initial discovery of overglaze polychrome enamel decoration, a range of superior polychrome enamel styles as well as underglaze cobalt-blue-decorated porcelain emerged from the Arita kilns and from the Nabeshima domain kilns in Ōkawachiyama (Imari) in Hizen. The late seventeenth century represented a high point in the history of Japanese ceramic production. One contemporary term for these ceramics was "karamono" ("Chinese-style" objects), which reflects the strong influence of Chinese porcelains on their technique and style. In fact, large quantities of Chinese-style ceramics produced in Arita—also known then as Imari ware after the port from which they were exported—were transported to

Europe as substitutes for Chinese porcelains in the late seventeenth century, during the period of Chinese maritime restrictions that occurred with the transition from Ming to Qing rule. The word *karamono* was also used in a broader sense for exotic or foreign things.

The best-quality Kakiemon-style porcelain from 1670 to 1700 had brilliantly colored overglaze enamel designs painted on a milky-white body called *nigoshide* [Fig. 18]. Another high-end porcelain produced in the nearby official domain kiln at Okawachiyama was Nabeshima ware, which featured Japanese-style motifs, specific shapes, and a highly elevated sense of refinement. These wares were never for sale during the Edo period; they were used instead by the domain for gifts (*kenjōhin*) to be presented to the shogun and his family and counselors or for other lords [Fig. 19].

Kokutani-style overglaze enamel porcelain perhaps best represents the Kanbun-era aesthetic with its bold, distinctive designs. Produced only between 1640 and the 1660s, Kokutani-style wares were made in Arita-area kilns such as Yanbeta and decorated with dynamically arranged pictorial motifs and geometric patterns in overglaze polychrome enamels inspired by imported porcelain and other current styles [Fig. 20]. The three styles —Kakiemon, Nabeshima, and Kokutani—are all different in appearance but represent the reformulation of imported styles in a Japanese idiom.

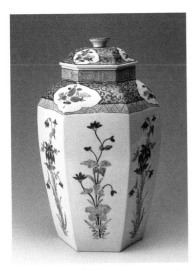

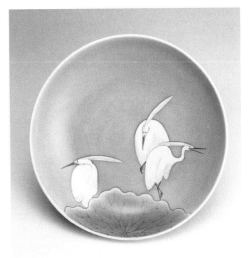

Fig. 18: Lidded jar, Kakiemon style, Hizen ware, Arita kilns, 1670–1700, British Museum © Trustees of the British Museum

Fig. 19: Tripod dish with underglaze cobalt blue design of herons and lotus leaf, Nabeshima ware, Ōkawachi kilns, 1690–1710. The Kyushu Ceramic Museum, Saga prefecture

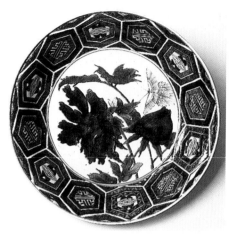

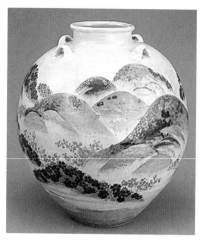

Fig. 20: Dish with butterfly, peony, and tortoiseshell design in overglaze polychrome enamels, Kokutani style, Hizen ware, Arita kilns, 1640–60

Fig. 21: Nonomura Ninsei, tea jar with polychrome overglaze enamel design of Yoshino mountains, second half of 17th century, Fukuoka City Museum (Matsunaga Collection)

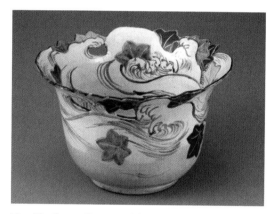

Fig. 22: Ogata Kenzan, foliate bowl with overglaze polychrome enamel design of maple leaves in the Tatsuta river, 18th century, Idemitsu Museum of Arts, Tokyo

Nonomura Ninsei (active mid-seventeenth century) also produced remarkable polychrome overglaze-enamel-decorated wares but followed a different tradition. His stoneware ceramics occasionally leave Chinese taste behind, turning to a more Japanese world of "refined elegance" (*miyabi*), a style strongly influenced by the teachings of tea master Kanamori Sōwa

(1584–1656, also called Hime Sōwa), who promoted a classical courtly style of tea practice among members of the court aristocracy. It was through Sōwa that Ninsei established a kiln and produced Omuro ware, first mentioned in *Kakumeiki* (1635–68), the diary of Hōrin Shōshō, the head priest at Rokuon-ji temple in Kyoto, in an entry for the new year of 1648. Ninsei's ceramics feature pictorial motifs transferred from decorative screens of the early Edo period, and they include (among other famous examples) the tea jar painted with a design of the Yoshino mountains (Fukuoka City Museum) [Fig. 21], and the tea jar with a design of wisteria in polychrome enamels (MOA Museum of Art). Ninsei found a successor in Ogata Kenzan (1663–1743), who further developed the polychrome enamel style in a diversified and fashionable range of ceramics [Fig. 22].

4. Afterglow of Momoyama Art: Kanbun Robes

As their name suggests, Kanbun robes (Kanbun *kosode*) enjoyed a vogue during the Kanbun era (1661–73). They are distinguished by large designs that stretch across the entire back of the robe, from the shoulder downward, much like large paintings. They reflect the style and preferences of male dandies (*kabukimono*) and courtesans, as depicted in early Edo-period genre painting. The designs feature motifs not previously seen in textiles, such as Japanese chess (*shōgi*) pieces, illustrating their popular character.

The bold patterns on Kanbun *kosode* were suited to production in quantity, but they also suggest a desire to revive the dynamic designs of Momoyama-period textiles. The lively patterns recall those found on Arita porcelain of the same period. Their visual playfulness forms one summit in the history of Japanese textile design, as seen for example in the robe with mandarin ducks on a black figured satin ground (Tokyo National Museum) [Fig. 23]. Following the enactment of further sumptuary laws in the 1680s, simpler and more cost-effective dyed patterns began to replace previously popular techniques such as stitching and tie-dyeing.

Many paintings of the Kanbun era depict courtesans from the Yoshiwara pleasure district and others dressed in beautiful Kanbun *kosode* and wearing the raised chignon known as the "Hyogo hairstyle." The figures in these paintings, called Kanbun beauties (Kanbun *bijin*), generally seem less animated than those in Kan'ei genre painting, suggesting that the earlier genre painting had reached an endpoint. However, the theme would soon revive in the woodblock-printed book illustrations of Hishikawa Moronobu.

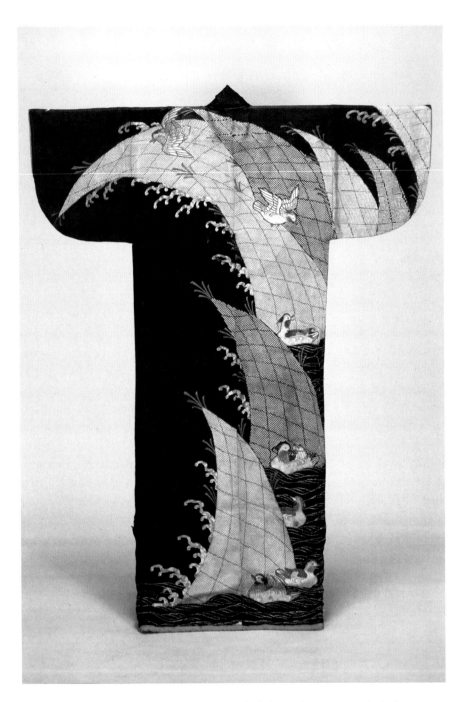

Fig. 23: *Kosode* with mandarin ducks on a black figured satin ground, 17th century, Tokyo National Museum

5. Art for Farmers and Fishermen, Enkū, and Hatchet-Carved Religious Art

The story of Japanese art history thus far suggests that the production of paintings and decorative arts occurred mainly in Kyoto and central Japan (the Kinki area). Religious sculpture is an exception to this rule: from around the eighth or ninth century, outstanding works were produced in outlying parts of the country, such as the northeast (Tōhoku). During the Edo period the production of regional religious sculpture became associated particularly with Shugendō, a syncretic Buddhist-Shinto sect connected with mountain worship. Shugendō ascetics traveled throughout the provinces, using chisels and hatchets to carve religious images for local farmers and fishermen. These ascetics were known as "Buddha-making holy men" (*sakubutsu hijiri*). One such holy man was Tanzei (1551–1613), whose disciples are thought to have carved the stone image of Buddha known as the "Stone Buddha of the Manji era" on the riverbank behind the Harumiya, a sub-shrine of Suwa grand shrine (Suwa-taisha) in Nagano prefecture. Bearing an inscription dated to 1660 (Manji 3), the image reflects the activities of the monk Enkū's predecessors.

Enkū (1632–1695) came from Mino province (now Gifu prefecture). In 1666, upon completing Shugendō training at Mt. Ibuki (Gifu and Shiga prefectures), he set off on a pilgrimage around the country that extended as far as Hokkaido and the Tōhoku region. He spent the rest of his life traveling throughout the Kanto (eastern part of Honshū) and Kinki regions, using a hatchet to carve as many as 100,000 statues. His sculptures are rough and unfinished, but they also feature a warm smile that seems to represent the good humor of the common people [Figs. 24 and 25]. His sculptures combine worship of sacred trees with a keen visual sense that appeals to the modern eye. Through his strikingly creative works Enkū established a new type of religious art not just made for commoners but generated by commoners (farmers and fishermen) in the countryside, rather than by townspeople.

6. Stars of Genroku Art: Hishikawa Moronobu and Ogata Kōrin

Perhaps as a result of new generations within the art world, the latter half of the seventeenth century and the first half of the eighteenth century produced fewer major painters than the preceding and succeeding eras, but

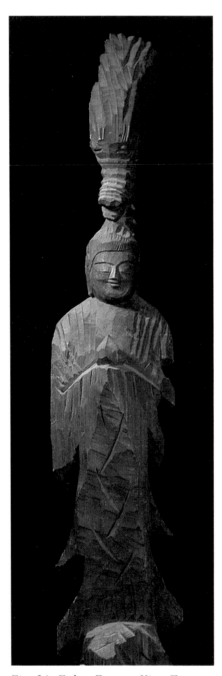

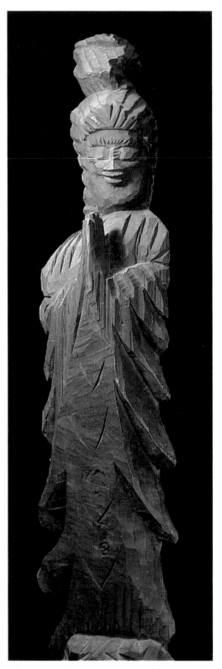

Fig. 24: Enkū, Dragon King Zennyo, 1690, Seihō-ji, Gifu prefecture

Fig. 25: Enkū, Zenzai Dōji (Sudhana), 1690, Seihō-ji, Gifu prefecture

two names nevertheless stand out: Hishikawa Moronobu and Ogata Kōrin. Both left a lasting mark on the art of their own day (the Genroku era) and on that of subsequent eras.

During the earlier Kanbun era, the center of genre painting gradually shifted from Kyoto to Edo, a city of newly affluent and increasingly cultured townspeople. Hishikawa Moronobu (1618–1694) was a major force behind this shift. He was born in Awa province (now Chiba prefecture), the son of a family specializing in textile decoration, particularly embroidery and metallic leaf decoration, but he made a name for himself as a designer of book illustrations in Edo, showing exceptional talent in the area of genre scenes of beauties. By 1683 Moronobu had established a distinctive figural type, as referenced in the haiku (*haikai*) poetry collection *Minashiguri* (1683), which mentions "an Eastern lady in Hishikawa style."

Moronobu was the first to call himself an "ukiyo-e artist" (*ukiyo-eshi*), and is thought of as the founder of the genre. In this and other respects, he stands as a defining figure in the field of ukiyo-e [Fig. 26]. It was in Moronobu's day that technical advances in the quality of woodblock printing finally allowed for the production of single-sheet prints whose subjects

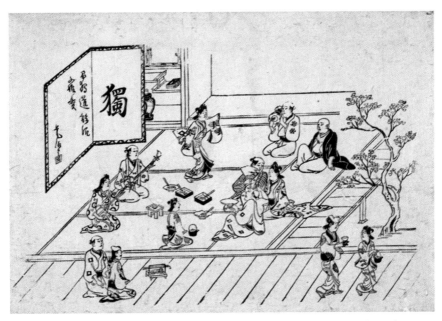

Fig. 26: Hishikawa Moronobu, "Entertainers in a House of Assignation" from the series *Aspects of the Yoshiwara*, 1681–84, Tokyo National Museum

and designs reflected those depicted in contemporary popular wood-block-printed books. In other words, we should remember that the ukiyo-e woodblock print grew out of book illustration, and further that ukiyo-e artists played a fundamental role in illustrating books throughout the Edo period. The production of woodblock prints was a collaborative work, requiring what Tijs Volker (1892–1979) famously described as the "ukiyo-e quartet": the publisher (*hanmoto*), designer (*eshi/gakō*), woodblock cutter (*horishi*), and printer (*surishi*). This was basically the same for illustrated books; however, when artwork accompanied text, the author of course played a significant role in the production, along with the copyist (*hikkō*), who specialized in producing the clean copy of manuscripts to be carved on the blocks.

Whereas Moronobu came from a merchant family based in a fishing village, Ogata Kōrin (1658–1716) came from a merchant family that owned and operated an old and distinguished textile shop in Kyoto, the Kariganeya. Kōrin inherited the artistic tradition of the Kyoto elite, and gave Sōtatsu's ornamental style a more intellectual form. His painted screens, including *Red and White Plum Blossoms* (MOA Museum of Art) [Fig. 27] and *Irises* (Nezu Museum, Tokyo) [Fig. 28], are the most refined expression of the *kazari* tradition, encompassing both painting and design. Kōrin also showed versatility in designing *maki-e* lacquer ware, as for example his writing box with an eightfold bridge design (Tokyo National Museum), in decorating *kosode* such as his *kosode* with a design of winter trees (Tokyo National Museum), and in brushing designs onto his brother Kenzan's ceramics.

Even as a new group of townspeople gained prominence, an older, privileged class of merchants who had benefitted from the patronage of aristocrats and warriors found itself in decline. Thus when the Kariganeya, Kōrin's family business, went bankrupt due to being unable to recover leans to domain lords, Kōrin was forced to become a painter, but as we have seen, this crisis led him on to cultural immortality. In addition to his other work, Kōrin produced a number of *kosode* design books called "Kōrin pattern books" (Kōrin *hiinagata*) rivaling those of Miyazaki Yūzen (1654?–1736?), a fan painter and contemporary who is thought to have devised the *yūzen* dyeing technique. Thanks to the wide circulation of these pattern books, the Kōrin brand remained popular for decades after his death. In sum, the so-called Rinpa line of artists from Sōtatsu to Kōrin and Kenzan to Sakai Hōitsu (discussed below) revived the tradition of courtly decorative art by incorporating into it elements of popular taste.

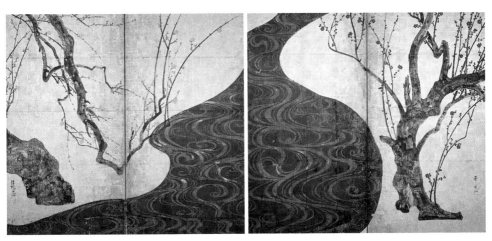

Fig. 27: Ogata Kōrin, *Red and White Plum Blossoms* screens, first half of 18th century, MOA Museum of Art, Shizuoka prefecture

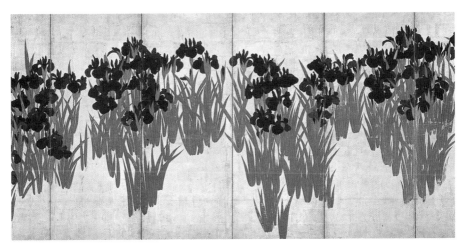

Fig. 28: Ogata Kōrin, *Irises* screens, detail from right screen, first half of 18th century, Nezu Museum, Tokyo

7. Ōbaku Art and Imported Ming Art

The port town of Nagasaki served as temporary home to a large community of Chinese traders who, hoping to recreate something of their homeland in a foreign country, requested and received permission to invite carpenters and priests from the continent to build and manage Buddhist temples in authentic Chinese style. One of the earliest was Sōfuku-ji (1629), whose

main gate is a recognized National Treasure. The year 1654 then saw the arrival of the Chinese Ōbaku (C: Huangbo) priest Yinyuan Longqi (Ingen, 1592–1673) and his followers, who were met with an enthusiastic reception. Ōbaku was a contemporary Chinese style of Zen practice, and this may partly account for the warm reception Yinyuan received.

With Tokugawa approval and patronage, Yinyuan oversaw construction of Manpuku-ji temple in Uji near Kyoto (1661), which became the Ōbaku sect's base in Japan. In plan and style, Manpuku-ji closely replicates Yinyuan's home temple, Wanfu Si temple in Fujian province. The buildings employ a few traditional Japanese architectural motifs, but otherwise have a strongly exotic character, as suggested in a poem by Tagami Kikusha in 1790: "Exiting the gate, we are back in Japan, and we hear a song accompanying the gathering of tea leaves." (Uji has long been famous for its tea cultivation.)

Manpuku-ji was a conduit for the transmission of late Chinese Ming art to Japan. In particular, the temple's novel sculptures, including that of the deity Skanda (Idaten) carved by Chinese sculptor Fan Daosheng (1635–1670), exerted a strong influence on Japanese Buddhist sculptural types. For example, Shōun Genkei's (1648–1710) sculptures for Gohyaku Rakan-ji (the Temple of Five Hundred Arhats; c. 1688–95) in Edo combine traditional and new styles [Fig. 29]. And in 1699 Enkū produced the Twelve Devas (Jūniten) for Nata Yakushi-dō (also known as Iōdō temple) restored for the Owari domain (present-day Aichi prefecture) by Zhang Zhenfu, a Ming doctor and refugee. The unique pattern of Enkū's carving drew on elements of Ming decorative art.

Ōbaku influence may be seen in other areas as well. First, realistic portraits (*chinzō*) of venerable Ōbaku priests were painted in great quantity over the second half of the seventeenth century, using late Ming and early Qing painting techniques influenced by Western realism. These portraits represent

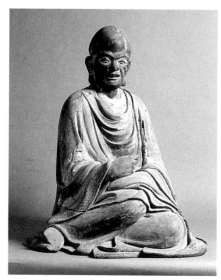

Fig. 29: Shōun Genkei, Seated Arhat, c. 1695, Gohyaku Rakan-ji, Tokyo

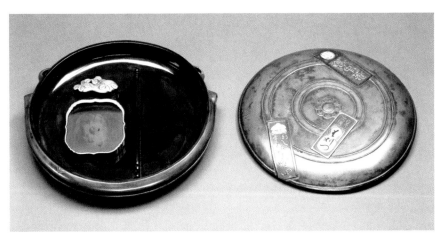

Fig. 30: Ogawa Haritsu, writing box, 1746. © Victoria & Albert Museum, London

yōfū-ga, the first stage of Western-style painting during the Edo period.[2] Around the same time, Kawamura Jakushi (1629–1707), Watanabe Shūseki (1634–1707), and other artists working in Nagasaki copied the style of late Ming and early Qing bird-and-flower paintings. It was around this time that Confucian scholar Kitajima Setsuzan (1636–1697) and others studied the calligraphy of visiting Ōbaku priests and intellectuals, and established a new "Chinese style" (*karayō*) of calligraphy.

Chinese merchant ships additionally brought Ming decorative arts to Japan. The versatile lacquer artist Ogawa Haritsu (1663–1747) is well known for lacquer works called *gisaku* (imitations), which skillfully imitate objects made of other materials. He inlaid lacquer ware with pieces of shell, ivory, ceramic, and metal, a technique now generally called "Haritsu work" (*Haritsu zaiku*). This unconventional process was actually derived from Chinese *baibaoqian* work, popular in China since the Ming period [Fig. 30]. In addition, Hiki Ikkan (1576–1657), who came from Ming China and was eventually naturalized in Japan, created the *ikkanbari* technique of lacquer papier-mâché, which is related to Haritsu's work.

8. Vernacular Architecture

Broadly understood, the term *minka* (private dwelling) refers to a commoner's residence, but in the context of folklore studies and architectural history, it more particularly indicates a residence constructed using local materials and techniques. *Minka* in this sense fall roughly into two

categories: townhouses and farmhouses. Today more farmhouses remain than townhouses. Recent excavations and research indicate that until about the second half of the eighteenth century, farmhouses were constructed on pillars sunk into the ground (*hottate* style), eliminating the need to lay a foundation. In fact, the same construction method was used during the Jōmon period (13,500–500 BCE; see Chapter 1). Excavations also indicate that in the case of some *minka* in the northern Tōhoku and Hokuriku regions (the area encompassing Niigata, Toyama, Ishikawa, and Fukui prefectures), straw mats were placed directly on earthen floors. One should therefore bear in mind that it was not just commoners, but commoners of high status who built the *minka* that stand today.

Existing *minka* have gone through multiple renovations, and so their original plans are not preserved, but careful research has recovered the details of these changes. The oldest remaining *minka* are called *sennen-ya* (thousand-year houses), of which three examples remain, all constructed during the second half of the Muromachi period (perhaps the fifteenth century). They were built using a developed form of the *hottate* method, rather than the *shoin* style. These include the Hakogi House in Kobe, Hyogo prefecture [Fig. 31].

Examples of seventeenth-century *minka* are the Yoshimura House in Osaka prefecture (around 1615) and the Imanishi House in Nara prefecture (1650), both built by wealthy farmers or townspeople. The simple

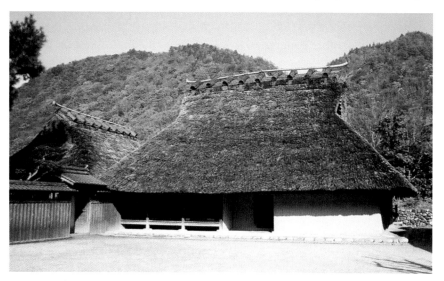

Fig. 31: Hakogi House, second half of Muromachi period, Kobe

pitched-roof construction of the Yoshimura House places it in the category of *yamatomune-zukuri*, a gable-roofed style of *minka* that incorporates elements of the *shoin* style. *Minka* of this kind were built primarily around Kawachi (eastern Osaka) and Iga (in present-day Mie prefecture). The Imanishi House has a more complicated hip-and-gable roof construction similar to that of castle keeps. Both houses have powerful exterior and interior designs. Such *minka*, which exhibit the massive and sturdy air of the Momoyama period, eventually disappeared when the Tokugawa *bakufu* instituted sumptuary laws restricting the materials and techniques that could be used to build dwellings.

During the second half of the Edo period, *minka* in rural towns and farming villages developed distinctive local characteristics. For example, *minka* of the "praying-hands style" (*gasshō-zukuri*) have steeply pitched thatched roofs, a style associated with the village of Shirakawa in Gifu prefecture. By contrast, in Nagano prefecture another style of *minka*, *honmune-zukuri*, has a notably broad roof with a shallow pitch. There are also the L-shaped (*magari-ya*) *minka* associated with Iwate prefecture in northern Japan. Each type has a unique grace rooted in the local climate and culture.

III. Arts of the Townspeople:
Maturity and Decline in the Kyōhō and Bunka–Bunsei Eras

1. New Forms of Artistic Expression Imported from China and the West

The Tokugawa *bakufu* imposed severe restrictions on the importation of books and goods from Western countries but was lenient with regard to those from China. As discussed earlier, the Ōbaku sect of Zen Buddhism flourished under Tokugawa *bakufu* patronage; the *bakufu* also approved trade with Ming and Qing China and authorized the importation of paintings and other materials that revealed, however fragmentarily, new artistic developments on the continent.

Kanō Tan'yū, for example, had the opportunity to copy paintings by Chinese artists of the literati (C: *wenren*; J: *bunjin*) or Southern (C: *Nanhua*; J: *Nanga*) school, such as Shen Zhou (1427–1509), Wen Zhenming

(1470–1559), Tang Yin (1470–1524), Lu Zhi (1496–1576), Wen Jia (1501–1583), and Mo Shilong (1537–1587). The works were likely imported during the early Edo period, along with examples of these artists' seal impressions. Serious study of these imported materials would have to wait, however, until the first half of the eighteenth century, when new sources of artistic inspiration—painting manuals such as the *Mustard-Seed Garden Manual of Painting* (C: *Jieziyuan Huazhuan*, J: *Kaishien Gaden*; part 1, 1679; parts 2 and 3, 1701); amateur paintings by Ōbaku priests like Itsunen (1601–1668) and Taihō (1691–1774); and the teachings of professional Chinese artists such as Shen Quan (Shin Nanpin; c. 1682–1760), who reached Nagasaki at the end of 1731 and remained for over a year; Yi Fujiu (1698–1747?), who arrived in 1720; and Song Ziyan, who arrived 1758—resulted in a new Ming and Qing manner of "Chinese-style painting" (*Kara-e*).

This environment of cultural exchange led to an easing of the prohibitions against Western goods, or at least those unrelated to Christianity. Thus after the embargo on Western books was lifted in 1720, knowledge of new modes of both Chinese and European painting began to enter the country, influencing developments in a range of artistic circles. Unlike the first part of the Edo period, when the production of art depended largely on government patronage, in the latter half of the period private commissions increased. The new trend emerged particularly in Kyoto around the first half of the eighteenth century, marking a renaissance in that city's art world led by the literati artists Ike no Taiga and Yosa Buson; by Maruyama Ōkyo, who advocated sketching from nature; and by the individualistic, less readily classifiable "unconventional painters" whom I often collectively refer to as "the eccentrics" (*kisō-ha*): Hakuin Ekaku, Itō Jakuchū, Soga Shōhaku, and Nagasawa Rosetsu.

2. Art of the Literati: A New Mode of "Chinese Painting"

Nanga or literati painting (*bunjin-ga*) was among the most popular imports of the Edo period, echoing the fashion for literati culture in contemporary China. Japanese Nanga artists modeled their work on Chinese Southern school landscapes (C: *nanzhoghua*, J: *nanshū-ga*), and themselves on their image of the unworldly Chinese literati, and in this way found favor among intellectuals in general, but especially among samurai of relatively low rank.

Just as Vincent van Gogh (1853–1890) imagined Japan to be an ideal land of art based solely on his exposure to popular woodblock prints

(ukiyo-e), so Edo-period literati thinkers and artists idealized China and the life of the Chinese *wenren* (literati), both of which were beyond their direct observation. On the one hand, Japanese Nanga painters had (and could have) only a remote understanding of Chinese Nanga techniques, so that their interpretations represent a blend of miscellaneous Ming and Qing modes. These same painters were, on the other hand, free from the burden of slavishly copying Chinese Nanga, and it was precisely their creative "misunderstandings" that resulted in a unique art form with a value of its own.

The first generation of Japanese artists to explore this new mode included Gion Nankai (1677–1751), Sakaki Hyakusen (1698–1752), and Yanagisawa Kien (1703–1758). The second generation of artists, notably Ike no Taiga (1723–1776) and Yosa Buson (1716–1783), freely reinterpreted Southern School techniques to create a new and fresh Japanese painting style. In China, literati painting had been closely associated with the ruling class and the scholarly elite; in Japan, however, it accompanied an idealized view of society liberated from social distinctions. Taiga's grandfather is said to have been a farmer in a remote village far outside Kyoto, and Buson came from a village in Settsu (now Osaka prefecture), although further details of their childhoods are not known. Environments of this type can be understood as egalitarian artistic spaces separated from social restrictions. They contributed to making Taiga and Buson important masters of the Japanese literati tradition. In this sense Edo-period Nanga was the product of integration of warriors and commoners.

Embracing the Chinese literati ideal of "visiting and observing mountains and lakes, so as to obtain a true view of creation," Taiga traveled far and wide in Japan, climbing Mt. Fuji, Mt. Haku, Mt. Tate, and Mt. Asama. The resources available to him regarding literati art were limited, the most significant being imported books, such as the *Mustard-Seed Garden Manual* mentioned earlier, and the *Manual of Eight Categories of Painting* (C: *Bazhong Huapu*; J: *Hasshu Gafu*). Taiga, however, learned a great deal from these limited resources, as well as from Muromachi-period ink painting and the work of Ogata Kōrin. Rising to prominence at an early age, he achieved a distinctive style characterized by a clear harmony between black ink and pale colors, a rhythm of free and easy brushwork, a natural way of rendering ambient light, and innocent figures delighting in nature. These characteristics are seen in major works such as the *Gathering at Longshan/Winding Stream at Lanting* screens (1763; Shizuoka

Prefectural Musuem of Art) [Fig. 32], the *Red Cliff at Lake Dongting* handscroll (1771; New Otani Art Museum, Tokyo), the sliding door paintings at Manpuku-ji including *Five Hundred Arhats* (c. 1756), the *Eight Views of Xiao and Xiang* screen (1760s; private collection), and the *Blue-and-Green Landscape Album* (1763; Suntory Museum of Art, Tokyo).

Buson was a haiku poet with a talent for painting. Around the age of twenty, he travelled to Edo in order to train in composing haiku (also called *haikai*), then spent time wandering through northern Kantō, where he began to paint. Upon returning to Kyoto, he came under the influence of the Chinese painter Shen Quan's exotic bird-and-flower scrolls,

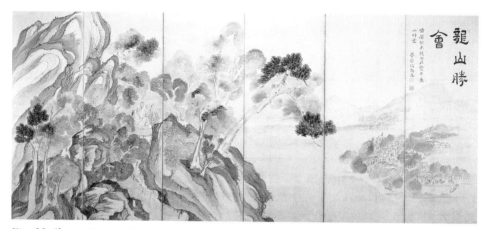

Fig. 32: Ike no Taiga, "Gathering at Longshan" from a pair of screens *Gathering at Longshan, Winding Streams at Lanting*, 1763, Shizuoka Prefectural Museum of Art

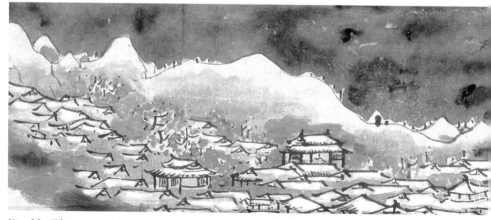

Fig. 33: (This page and opposite) Yosa Buson, *Snow-Clad Houses in the Night*, second half of 18th century, private collection

eagerly absorbed the various styles of Ming and Qing painting, studied Muromachi-period ink brushwork, but found it hard to settle on a single style. He achieved a mature style only late in his sixties. His masterpieces from this period include *Snow-Clad Houses in the Night*, portraying the poetic scene of houses on a cold, snowy evening [Fig. 33], and the *Crows and Kite* pair of hanging scrolls (Kitamura Museum, Kyoto), in which the birds, perched stoically on the trunks of trees in inclement weather, seem to convey an aspect of human experience. These are masterpieces where the worlds of haiku and painting overlap. Together Buson and Taiga may be said to have perfected the Nanga style in Japan.

3. Maruyama Ōkyo and Rational Naturalism

Whereas Taiga and Buson pursued an art of subjective expression, Maruyama Ōkyo (1733–1795) took a path of objectivity, studying techniques of European realism and one-point perspective so as to represent the fullness of objects in the present world. He discovered a way to blend this method with Chinese realism and Japanese decorative techniques, and achieved a strikingly realistic style. His distinctive skills are demonstrated in a number of works that place him among the leading figures of Edo-period painting, including *Screens with Snow-Covered Pines* [Fig. 34], *Sliding Doors with Pines and Peacocks* (1773; Daijō-ji temple, Hyogo prefecture), *Screens with Wisteria* (1775; Nezu Museum) and *Screens with Bamboo in Rain and Wind* (1776; Enkō-ji temple, Kyoto). With encouragement from the

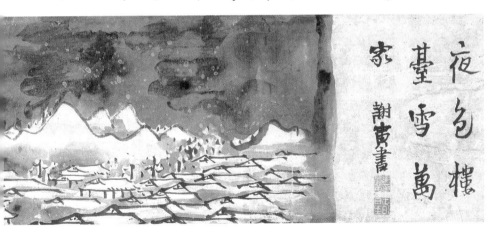

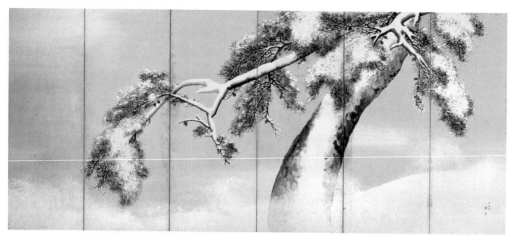

Fig. 34: Maruyama Ōkyo, *Screens with Snow-Covered Pines*, right screen, second half of 18th century, Mitsui Memorial Museum, Tokyo

Fig. 35: Maruyama Ōkyo, detail from *Album of Sketches: Insects*, 1776, Tokyo National Museum

head abbot of Enman-in temple (Ōtsu, Shiga prefecture), an expert in herbal medicines, Ōkyo also produced sketches of insects and plants that are encyclopedic in their detail [Fig. 35]. He additionally mastered a range of other techniques, including the "boneless" (*mokkotsu*) technique of creating shapes using only fields of color without outlines, an example being his *Screens of Fuji at Miho* (1779; Chiba City Museum of Art).

Ōkyo's art was highly popular in Kyoto, particularly with townspeople, and perhaps on that account students flocked to work under him. Ten students proved exceptional; outstanding among these was Matsumura Goshun (1752–1811), who studied first with Buson, later with Ōkyo, and successfully combined the styles of both masters to develop a style of his own. A representative work is his *Herons in Willows* screens (Kyoto National Museum).

4. "Unconventional Painters": The Sunset Glow of the Kyoto Art World

The artists just discussed—Taiga, Buson, and Ōkyo—cleared the Kyoto painting world of many long-accumulated stylistic conventions, but even these artists seem moderate compared to the avant-garde, radical stylists Itō Jakuchū, Soga Shōhaku, and Nagasawa Rosetsu. Before turning to them, however, let us first consider the work of Zen priest Hakuin Ekaku (1685–1768), who influenced both Shōhaku and Rosetsu.

Born in Suruga province (modern Shizuoka prefecture), Hakuin traveled around Japan practicing Zen asceticism at various temples before eventually returning to his hometown at the age of thirty-two. From that point until his death at the age of eighty-four, he served as head abbot of the local Zen temple, Shōin-ji. With a gift for writing and lecturing, Hakuin soon attracted numerous devoted followers, as well as talented monks eager to hear his teachings. His style of Zen eventually captured the attention of his sect's head temple, Myōshin-ji in Kyoto. Hakuin was also prolific with the brush. His calligraphy, produced mostly after the age of sixty, has a bold and carefree manner that transcends mere technical skill and directly touches the heart of the viewer.

Hakuin's paintings at first seem almost clumsy, but as with his unique portraits of Zen patriarch Daruma (Bodhidharma), what at first appears unsteady soon begins to overwhelm the viewer with a mysterious power [Fig. 36]. Other examples of Daruma by Hakuin are at Shōjū-ji temple

in Toyohashi (1751), and Manju-ji temple in Oita (c. 1767). To convey his teachings, Hakuin additionally improvised humorous sketches, and it was precisely such unconventional forms of self-expression that attracted young artists seeking inspiration outside the traditional Kanō-school program of copying the master's models (*funpon*). Taiga visited Hakuin to inquire about his teachings, Shōhaku incorporated Hakuin's expressive mode into his own artwork, and Rosetsu studied with one of Hakuin's disciples.

Among the unconventional painters of eighteenth-century Kyoto, Itō Jakuchū (1716–1800) has attracted and deserves special notice. His family operated a wholesale vegetable business in Kyoto's Nishiki-kōji area, but Jakuchū devoted himself instead to painting. Dissatisfied with the Kanō school training, he copied imported Ming and Qing bird-and-flower paintings, including those by Shen Quan, and kept hens and cockerels in his garden for direct study.

Fig. 36: Hakuin, *Daruma*, mid-18th century, Eisei-Bunko Museum, Tokyo

Gradually Jakuchū formulated a unique painting style. He spent his forties completing a set of thirty hanging scrolls, the *Colorful Realm of Living Beings*, which he subsequently donated to Shōkoku-ji temple in Kyoto [Fig. 37].[3] Painted in richly colored pigments and minute detail, this varied set constitutes a marvelous world of realism and decoration, fantasy and animism. His sliding-door paintings, *Roosters and Cactus* (1790; Saifuku-ji temple, Osaka), include a fascinating section with roosters and cactus on a gold ground borrowed from Ogata Kōrin. In his ink painting *Vegetable Parinirvana* (Kyoto National Museum), Jakuchū combined worship and humor to depict the death of the Buddha (*Parinirvana*) as enacted by various vegetables, with a giant radish representing the great teacher reclining at the moment of death. The bold color divisions in his *Birds*,

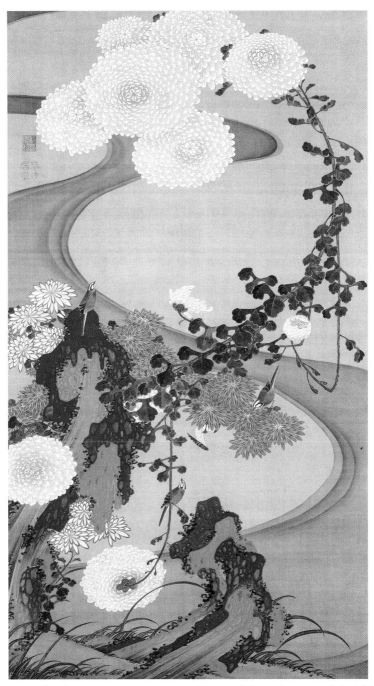

Fig. 37: Itō Jakuchū, "Chrysanthemums and Stream" from the series *Colorful Realm of Living Beings*, c.1766, Museum of the Imperial Collections (Sannomaru Shōzōkan)

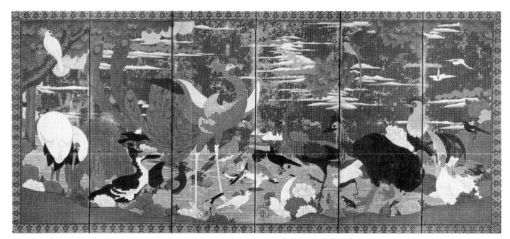

Fig. 38: (This page and opposite) Itō Jakuchū, *Birds, Animals, Flowers, and Plants* screens, second half of 18th century, Etsuko and Joe Price Collection

Animals, Flowers, and Plants screens seem to anticipate certain trends in modern avant-garde art [Fig. 38].

Soga Shōhaku (1730–1781) was also born into a Kyoto merchant family, but perhaps because of the decline of the family business, he chose to become a painter. He styled himself the successor to the Soga school, a lineage of painters formerly active during the Momoyama period. He blended the techniques of the previous Muromachi and Momoyama-period ink painting traditions with an individualistic, late-Ming literati manner found, for example, in the work of the Chinese artist Chen Hongshou (1598–1652). Combining elements from these different sources, Shōhaku created a strange and grotesque but also humorous pictorial world. Representative are his *Sliding Screens of Dragon and Clouds* (1763; Museum of Fine Arts, Boston) and *Screens with Immortals* (1764; Agency for Cultural Affairs, Japan) and the painting *Chinese Lions* (c. 1765; Chōden-ji temple, Mie prefecture) [Fig. 39]. The *Four Sages of Mount Shang* screens (c. 1768; Museum of Fine Arts, Boston) [Fig. 40] depict wizened sages residing deep in the mountains to escape a troubled world. Influenced by Hakuin and reviving elements of Momoyama painting, Shōhaku, fully aware of his anachronistic attitude, turned it into a most radical style of his own. His expressive style has a popular appeal that seems to resonate with modern manga. Kyoto culture had matured to a level that the individual "unconventionality" of popular painters such as Jakuchū and Shōhaku was acceptable.

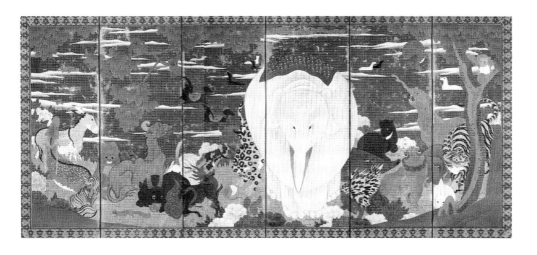

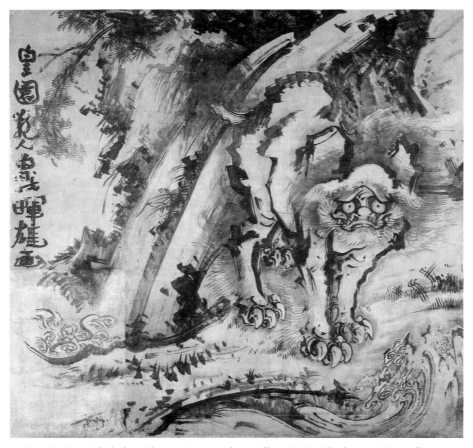

Fig. 39: Soga Shōhaku, *Chinese Lions*, right scroll, c. 1765, Chōden-ji, Mie prefecture

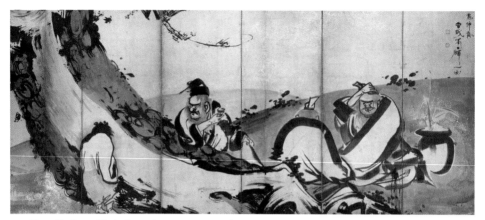

Fig. 40: Soga Shōhaku, *The Four Sages of Mount Shang*, right screen, c. 1768, Museum of Fine Arts, Boston. Photograph © 2018 Museum of Fine Arts, Boston

Another talented Kyoto painter generally included in this "unconventional" circle is Nagasawa Rosetsu (1754–1799), who achieved a dynamic mode that almost seems to parody the style of his teacher Ōkyo. In *Sliding Doors with Tiger* (Muryō-ji temple, Wakayama prefecture), one of his most memorable works, he offers a close-up view of a tiger about to pounce like a ferocious cat [Fig. 41].

5. Ukiyo-e after Moronobu: The Golden Age of Woodblock Prints

Returning now to the city of Edo, let us explore how ukiyo-e developed after the death of Hishikawa Moronobu in 1694. An important artist who imparted new energy to the genre in this period was Torii Kiyonobu I (1664–1729). Born the son of a kabuki actor in Osaka, Kiyonobu traveled to Edo, where he painted signboards for plays featuring scenes of "rough-style performances" with exaggerated and dynamic actions (*aragoto*), and soon won fame for his energetic and unique method of drawing "legs like gourds, and lines like worms." He also produced monochrome-ink woodblock prints of standing courtesans in the extra-large (*ō-ōban*) format (approximately 30 by 55 centimeters). The courtesans are rendered in a slightly modified form of Moronobu's style. Kiyonobu's brother (or perhaps son), Torii Kiyomasu I (active early eighteenth century), was another talented artist who specialized in scenes from *aragoto kabuki* and standing courtesans in charming *ō-ōban* prints hand-colored with orange-red (*tan*), green, and yellow

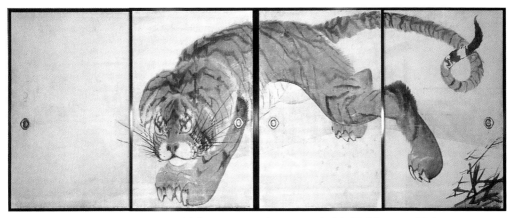

Fig. 41: Nagasawa Rosetsu, *Sliding Doors with Tiger*, c. 1786–87, Muryō-ji, Wakayama prefecture

pigments, a genre known as *tan-e* [Fig. 42]. The principal subjects of ukiyo-e—beauties and actors—were established in Kiyonobu and Kiyomasu's time.

Kaigetsudō Ando (active early eighteenth century) created a new, stylized version of the courtesan type originally developed by Kiyonobu and Kiyomasu, and mobilized an entire studio of apprentices, including Anchi and Dohan (both active c. Kyōhō era, 1711–36), to produce courtesan paintings and *ō-ōban* woodblock prints in large numbers. In 1714, he was caught up in the "Ejima Scandal," which centered on a noblewoman attendant to shogun Tokugawa Ietsuna's mother. Officials discovered Ejima having an improperly good time at the Yamamura Theater, and the ensuing scandal led to closure of

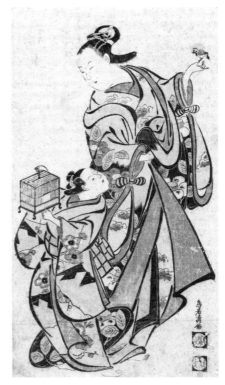

Fig. 42: Torii Kiyomasu, *Courtesan with a Bird and an Attendant Holding a Cage*, 18th century, Tokyo National Museum

the theater and punishment of nearly 1,500 persons, including exile for the theater's proprietor, the leading actor, and also Ando, the details of whose involvement remain uncertain. The genre of beauty painting was eventually taken over by Miyagawa Chōshun (1682–1752).

In the early and middle decades of the eighteenth century, ukiyo-e also advanced from monochrome-ink into full-color prints. Indications of how to produce color prints may have been obtained through careful study of color-printed Chinese illustrated books, such as the *Mustard-Seed Garden Manual of Painting*. As mentioned, color was first applied to Japanese prints by hand, one example being Kiyomasu's *tan-e*. Follow-up developments included the "lacquer pictures" (*urushi-e*) of Okumura Masanobu (1718–1764), in which ink was mixed with animal glue and brushed on to give the effect of polished black lacquer, useful for indicating kimono sashes and glossy black hair. This technique was often supplemented with sprinkled brass powder. The earliest true color prints, called *benizuri-e*, used only two or three colors, predominantly *beni*, a red pigment derived from safflower; these were popular from the 1740s to the 1760s. Finally, in 1765 Suzuki Harunobu (1725?–1770) devised the first full-color prints (*nishiki-e*, "brocade pictures").

The birth of the *nishiki-e* genre came about when in 1765 a circle of wealthy rice merchants and *hatamoto* (direct retainers of the shogun) began privately commissioning or producing their own picture-calendars (*egoyomi*) and exchanging them at parties. *Egoyomi* were not literal calendars but picture-puzzles that hid information about the long months (thirty days) and short months (twenty-nine days) of the year within their designs. Harunobu was the circle's artist of choice, and he brought their suggested designs to life in prints produced to the highest standards—detailed carving of the woodblocks and layering of multiple finely printed colors. The prints are characteristic of the refined taste and elegance (*furyū*) that prevailed during the second half of the eighteenth century. Ukiyo-e publishers produced *nishiki-e* as popular versions of these picture calendars, the term *nishiki-e* being derived from *shujiangjin* (J: *shokkōkin*; Shujiang brocade), which was a beautiful red-patterned brocade introduced from China during the Asuka period (538–645).

Harunobu's *nishiki-e* enhanced the artistic quality of ukiyo-e and enlarged the range of subjects available to the genre, particularly with his allusions to the elegant world of *Yamato-e* even in depictions of the daily life of Edo citizens. Thereafter, from the late eighteenth through early

nineteenth centuries, ukiyo-e entered a golden age sustained by the genius of Katsukawa Shunshō, Torii Kiyonaga, Kitagawa Utamaro, Tōshūsai Sharaku, and Chōbunsai Eishi.

Harunobu designed *nishiki-e* mainly in the medium-size paper format (*chūban*; about 28 by 20 centimeters). Many of his prints are inscribed with classical poems taken from familiar anthologies such as the *Thirty-Six Poets (Sanjūrokkasen)* and *One Hundred Poems by One Hundred Poets (Hyakunin Isshu)*, but they portray these poetic subjects in a contemporary manner, and in this way demonstrate the townspeople's appreciation for courtly culture [Fig. 43]. Several decades earlier, the Kyoto ukiyo-e artist Nishikawa Sukenobu (1671–1750) had taken a similar approach in his illustrated books, but it was Harunobu who transported the method to Edo. The works follow the concept of *yatsushi* ("disguise"), presenting ancient culture in modern form. Later on, "floating world" artists would tend to follow an inverse concept known as *mitate*, in which aspects of modern life are patterned on aspects of classical culture.

Harunobu also created color harmonies using warm and neutral tones suggestive of *Yamato-e*. The compositions are often organized along the diagonal, a technique familiar from Heian-period handscrolls. Harunobu's *nishiki-e* give us an idea why the early ukiyo-e artists Moronobu and Kiyonobu would call themselves "*Yamato-e* painters." Small as dolls, Harunobu's women feature not-quite-mature bodies that emanate a wraith-like eroticism, while his men have ambiguous faces and bodies free of definite masculinity. In these various ways, Harunobu's *nishiki-e* depicted an idealized version of the daily lives of Edo's townspeople.

Unlike Harunobu's dreamlike prints of young beauties, Katsukawa Shunshō's (1726?–1792) actor prints capture the realistic features and characteristic poses of kabuki actors on stage. The prints' portrait-like qualities, a revival of the portrait painting (*nise-e*) tradition of the Kamakura period (1192–1333), helped viewers to identify the actors and their roles, and made the prints highly popular. Shunshō's series of large-size paper format (*ōban*; about 39 by 26.5 centimeters) *nishiki-e* titled *Fans of the East* (*Azuma Ōgi*; late 1770s) present bust portraits of actors as though painted on fans, a simple concept that also proved popular, and eventually served as the prototype for the half-length "large-head" portraits (*ōkubi-e*) of the 1790s.

Harunobu's sweet young girls seem rarely to venture outdoors, preferring the protection of interiors or occasionally the veranda. A radical change occurred, however, in the work of Torii Kiyonaga (1752–1815)

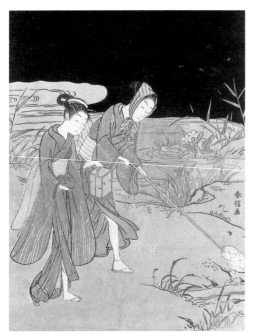

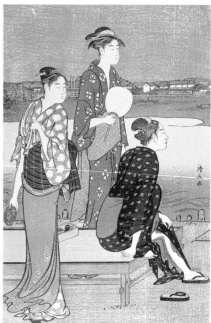

Fig. 43: Suzuki Harunobu, *Firefly Hunting*, mid-18th century, Hiraki Ukiyo-e Foundation, Tokyo

Fig. 44: Torii Kiyonaga, *Evening Cool on the Banks of the Sumida River*, left print of a diptych, second half of 18th century, Hiraki Ukiyo-e Foundation, Tokyo

who around the mid-1780s designed a series of prints depicting tall, robust young women (the American art historian Ernest Fenollosa (1835–1908) likened them to Greek caryatids) taking full advantage of Edo's pleasures [Fig. 44]. Kiyonaga's diptychs and triptychs in particular have an expanded horizontality inspired by the copperplate prints that Shiba Kōkan (1747–1818, discussed further below) issued around the same time.

Renowned as a master of the "beauties" or *bijin-ga* genre, Kitagawa Utamaro (d. 1806) gained early fame with his illustrations for anthologies of comic poems (*kyōka-bon*) written and compiled by the members of amateur poetry circles formed mainly of *hatamoto* samurai and wealthy merchants. Utamaro's two best-known *kyōka* anthologies are *Picture Book: Selected Insects* (*Ehon Mushi Erami*) [Fig. 45] and *Gift of the Ebb Tide* (*Shiohi no Tsuto*), both published in 1788 by influential publisher Tsutaya Jūzaburō (1750–1797), who was among the first to recognize Utamaro's talent. The illustrations in these books have a poetic beauty that stands out even in

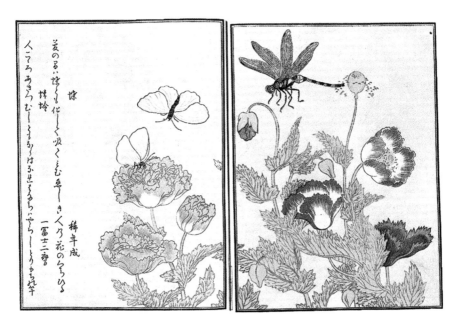

Fig. 45: Kitagawa Utamaro, *Picture Book: Selected Insects*, 1788. British Museum © Trustees of the British Museum

comparison with numerous other contemporary illustrated encyclopedias of fauna and flora published in the world. They even achieved international status when Edmond de Goncourt (1822–1896), a French novelist, ukiyo-e collector, and author of biographies of Utamaro and Hokusai, ranked them first among picture albums depicting the natural world.

From 1791 and continuing for several years, Tsutaya published Utamaro's celebrated half-length portraits of beautiful women in the two series *Ten Types in the Physiognomic Study of Women* (*Fujin Sōgaku Jittai*) and *Anthology of Poems: The Love Section* (*Kasen Koi no Bu*). Issued soon after (and almost certainly inspired by) a number of half-length actor portraits by Shunshō's students Katsukawa Shunchō (active 1780s–1790s) and Shun'ei (1762–1819), these series feature a sensuous type of beauty that contrasts with the trim beauty portrayed by Kiyonaga. With these prints Utamaro introduced into the limited genre of *bijin-ga* a new sense of the character of the model and subtle glimpses of feeling [Fig. 46]. His successes, however, were nearly matched by some difficulties, particularly later in his career. In 1803, Utamaro published a triptych titled *The Retired Regent and His Five Wives Viewing Cherry Blossoms East of the Capital*, which depicted

Toyotomi Hideyoshi on an excursion, but identified the Momoyama-period general by his historical name, rather than using a pseudonym, as was customary. For this Utamaro was sentenced the following year to fifty days in handcuffs. It is uncertain whether Utamaro then merely tired of fighting the *bakufu*'s repeated crackdowns on popular culture, or whether he gave in to the rapid popularization of culture then underway. Whatever the case, a certain vulgar realism and decadence crept into his later work, evident for example in the series *A Parent's Moralizing Spectacles* (c. 1801–03).

Tōshūsai Sharaku (active 1794–1795) is the mystery genius of ukiyo-e [Fig. 47]. Nothing of his life is known except that he worked in Edo for ten months from 1794–95, and in that time produced about 140 actor prints and a small number of sumo prints, with a few sketches also remaining. In attempting to solve the puzzle of his identity, scholars have claimed that he was actually (among others) Ōkyo, Hokusai, Tsutaya Jūzaburō, kabuki actor Nakamura Konozō, writer and ukiyo-e artist Santō Kyōden (1761–1816), other ukiyo-e artists such as Utagawa Toyokuni I and Eishōsai Chōki (active 1786–1808). The most convincing proposal is that Sharaku was Saitō Jūrobei (1763–1820), a Noh actor in service to Lord Awa in Hatchōbori, Edo.

Whereas by definition *bijin-ga* were limited to depicting varieties of beauty, actor prints are not so restricted. Sharaku took advantage of this leeway to depict the individual characteristics of actors with a keen insight. For example, he revealed actors performing female roles (*onnagata*) to be middle-aged men in disguise. As a result, his actor prints were criticized for being "too honest and faithfully realistic, so much so that they did not last long and disappeared after a year or two."[4] Their extraordinary expressionist qualities, foreign to Western portraiture, were introduced to Europe by Julius Kurth (1870–1949) and provided a direction for the famous montage theory of Russian film director Sergei Eisenstein (1898–1948).

Chōbunsai Eishi (1756–1829) was the scion of the Hosoda clan, samurai of the high-ranking *hatamoto* class, but instead of succeeding as head of the family, he transferred the position to his son and devoted himself to producing first-rate prints and paintings of beautiful women. At a time when warriors despised the production of ukiyo-e as an occupation suitable only for commoners, Eishi's example suggests how during the Edo period the production of art began crossing the boundaries of rank and class.

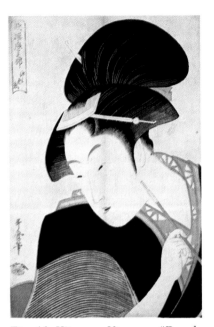 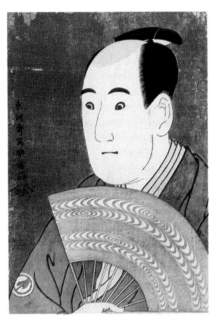

Fig. 46: Kitagawa Utamaro, "Deeply Hidden Love" from the series *Anthology of Poems: The Love Section*, first half of 1790s, Tokyo National Museum

Fig. 47: Tōshūsai Sharaku, *Sawamura Sōjūrō III as Ōgishi Kurando*, 1794, British Museum © Trustees of the British Museum

6. Publishing Culture: Illustrated Books (*Ehon*)

So far, we have considered ukiyo-e painters and print designers to be artists, but it is doubtful whether they thought of themselves as such. Ukiyo-e were not produced merely as "art objects," intended solely for viewing. Rather, as recent research has shown, these pictures made available to a broad audience various types of information, particularly concerning kabuki actors and Yoshiwara courtesans—the day's urban heroes and sources of fashion. The successive generations of ukiyo-e artists following Moronobu put great effort into designing book illustrations, treating them as an opportunity to demonstrate their skill. They contributed illustrations to a range of published works, including short comic novels (*kibyōshi*), long multipart narratives (*yomihon*), travel guides, design books (*hiinagata bon*), encyclopedias of animals and plants, picture calendars, talismans, and general reference books (*chōhōki*). Many are unexamined treasures waiting to teach us more about the quality and variety of life during the Edo period. Sexually

explicit books (*shunpon*, more commonly referred to as *ehon* or *enpon* in the period) and sexually explicit pictures (*shunga*, more commonly referred to as *makura-e* or *warai-e* in the period) also enjoyed a wide, if clandestine, popularity, reflecting the large proportion of men in Edo's population.

7. The Popularization of Literati Painting

During the late eighteenth to early nineteenth centuries, literati painting became a nationwide interest shared through friendships and cultural exchange between different scholarly communities. In Kyoto and western Japan (Kansai), the participants in literati culture were notably diverse. For example, Okada Beisanjin (1744–1820) operated a rice brokerage in Osaka before turning to artistic pursuits. An eccentric intellectual, he had a notably free style compared to that of other Nanga artists. Urakami Gyokudō (1745–1820) was born to a retainer of the Ikeda clan in what is now Okayama prefecture, but his dedication to calligraphy and music (particularly the *qin*, or Chinese zither) led him to retire for the life of a traveler. His expressive landscapes feature scenery that reflects the inner world of the artist and is charged with poetic atmosphere, seen, for example, in *Snow Sifted through Frozen Clouds* (Kawabata Yasunari Foundation, Kamakura) [Fig. 48]. Mokubei (1767–1833) was both a painter and a designer of utensils for the tea ceremony, as

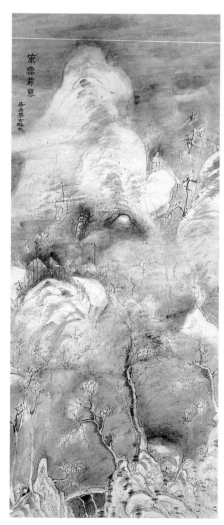

Fig. 48: Urakami Gyokudō, *Snow Sifted through Frozen Clouds*, beginning of the 19th century, Kawabata Yasunari Foundation, Kamakura

discussed further below. Finally, Tanomura Chikuden (1777–1835) was born the son of a doctor in Bungo province (now Oita prefecture), but chose the reclusive life of a literatus as a gesture of a political protest. He adopted a delicate, poetic style, and in true literati manner, exchanged paintings with other literati in the Kyoto and Osaka region.

At the same time, samurai intellectuals in Edo and eastern Japan (Kantō) developed a new Chinese-style of painting known as "Kantō Nanga." This version of Nanga tended to be more eclectic than that from Kansai, incorporating assorted elements of Ming and Qing painting. Tani Bunchō (1763–1840), the father of Kantō Nanga, blended brush techniques from the Chinese Ming academic (Zhe school) and literati (Wu school) traditions. He was also interested in Western realism, and left sketches that capture particular moments, as in his *Landscapes Painted during a Break in Public Service* handscroll (1793; Tokyo National Museum), and his portrait of Osaka collector and intellectual Kimura Kenkadō (1736–1802) (1802; Osaka Prefectural Board of Education).

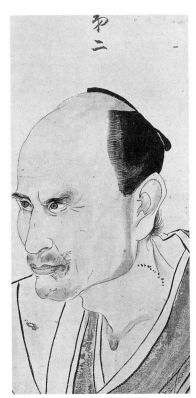

Fig. 49: Watanabe Kazan, Study No. 2 for *Portrait of Satō Issai*, c. 1818–21, private collection

Watanabe Kazan (1893–1841), one of Bunchō's many students, adopted his master's realism, producing sketches such as *True Views of the Four Provinces* during his travels in 1825, as well as incisive portraits featuring Western-style shading. The drafts of the portraits, including those of scholar Tachihara Suiken and influential teacher Satō Issai, more successfully capture the inner life of the subject than the finished paintings, revealing Kazan's keen observation of human nature [Fig. 49]. Kazan was a sharp critic of the *bakufu*, and a run-in with the government led to his suicide shortly thereafter. His work and that of other artists such as Hayashi Jikkō (1777–1813) from Mito and his student Tachihara Kyōsho (1785–1840) tell us that artists of the time were moving in the direction of a modern sensibility.

8. Western-Style Painting in Akita Province and Shiba Kōkan

The latter half of the Edo period saw rising enthusiasm for what at the time was called Dutch Studies (Rangaku), initially exploration of European approaches to the natural sciences. The Edo residences of domain lords and their retainers provided the main venue to gather and exchange information derived from newly imported Dutch books on subjects such as human anatomy. These books required painstaking translation efforts to decipher. The spread of Rangaku accompanied a growing interest in Western painting techniques, such as perspective and shading, and Western pictorial technologies such as copperplate engraving and oil paint.

Leaders in the study of Western painting were Satake Shozan (1748–1785), lord of the Akita domain, and his retainer Odano Naotake (1749–1780), under the instruction of Hiraga Gennai (1728–1780) [Fig. 50]. These pioneers, however, did not employ oils; their painting style, "Akita Western-style painting" (Akita Ranga), represents a peculiar blend of Eastern and Western painting techniques. Shiba Kōkan (1747–1818) successfully mastered for himself the technology of copperplate engraving in 1783 [Fig. 51], and brought

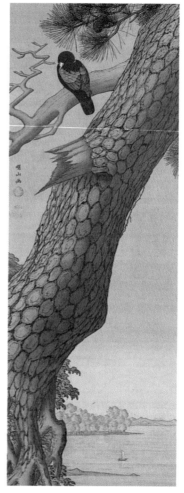

Fig. 50: Satake Shozan, *Exotic Bird in a Pine*, 1770s, private collection

other new possibilities to Japanese landscape painting, such as landscapes painted in oil on votive tablets (*Shichirigahama Beach, Kamakura, Sagami Province*, 1796, at Kobe City Museum is now mounted as a screen). Aōdō Denzen (1748–1822) further developed the subjects of copperplate prints by depicting famous places in Edo. In the hands of Yasuda Raishū (active mid-nineteenth century), a student of Katsushika Hokusai, the subjects expanded to the fifty-three stations of the Tōkaidō (c. 1844).

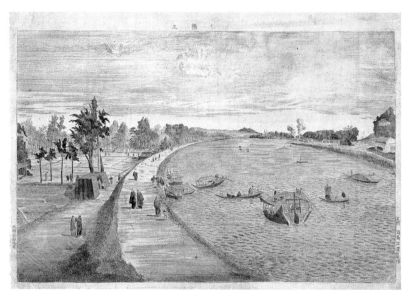

Fig. 51: Shiba Kōkan, *A View of Mimeguri Shrine from the Sumida River*, 1783, Kobe City Museum

9. Art in the City of Edo: Later Developments

Sakai Hōitsu and Katsushika Hokusai: Rinpa and Ukiyo-e at the End of the Edo Period

The city of Edo steadily overtook Kyoto as a center for all kinds of cultural activity, art being no exception. The culture of the townspeople centering on the city of Edo during the Bunka-Bunsei eras (1804–30) is known as the Kasei culture. The tradition of Rinpa begun by Sōtatsu and Kōrin (discussed earlier) reached Edo through the efforts of Sakai Hōitsu (1761–1828). Second son of the wealthy daimyo of Himeji domain (Hyogo prefecture), Hōitsu lived a privileged life in Edo where he created Rinpa-style masterpieces incorporating naturalistic elements suggestive of nature studies, one example being his *Screens with Summer and Autumn Grasses* (c. 1821–22; Tokyo National Museum) [Fig. 52]. Hōitsu's followers included Suzuki Kiitsu (1796–1858), who possessed a distinctive artistic sensibility and outlook that bridged the later Edo period to the modern era.

Ukiyo-e, too, changed in character during and after the Bunka-Bunsei eras, in line with the increasing popularization of culture and the shifting temperament of a city that sustained the Yoshiwara pleasure district and

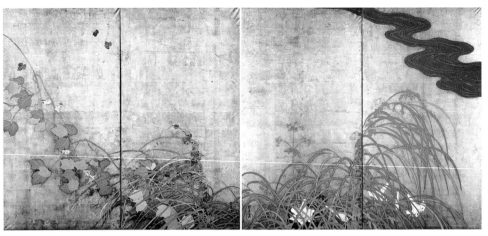

Fig. 52: Sakai Hōitsu, *Screens with Summer and Autumn Grasses*, c. 1821–22, Tokyo National Museum

kabuki. Utagawa Toyokuni I (1769–1825) set the standard by depicting actors and beautiful women in a new manner adopted by numerous artists, including Utagawa Kunisada (Toyokuni III) (1786–1864) and Keisai Eisen (1790–1848). A taste for the grotesque is also evident in late ukiyo-e during the last phase of the Edo period (*bakumatsu*), perhaps reflecting the social decadence of the time.

In this complicated environment, one artist stands out for his achievements: Katsushika Hokusai (1760–1849). Raised the son of an artisan in a neighborhood of Edo, Hokusai began his career as an apprentice to Katsukawa Shunshō, using the name Shunrō. A dispute around 1793 led to his leaving Shunshō's studio, after which he spent many years designing prints and trying to establish himself as an artist. Around 1800 he changed his artistic name to Hokusai and began experimenting with a new style of woodblock prints inspired by Western copperplate landscapes. Also at this time, author Kyokutei Bakin (1767–1848) began writing a new kind of multipart novel (*yomihon*) filled with mystery and romance: *Strange Tales of the Crescent Moon* (*Chinsetsu Yumiharizuki*; 1807–11). Hokusai took up the challenge of illustrating Bakin's novel, providing designs in a powerful mode that rivaled Toyokuni's in popularity. The first volume of his famous collections of miscellaneous sketches titled *Hokusai Manga* was published in 1814; the tenth volume, planned as the last in the series, was released five years later, although due to popular demand an additional five volumes would eventually be produced [Fig. 53].

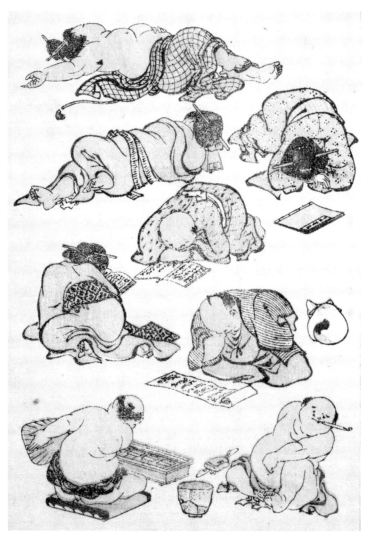

Fig. 53: Katsushika Hokusai, "Plump Men and Women" from *Hokusai Manga*, 1817, Hagi Uragami Museum, Yamaguchi prefecture

Hokusai secured his standing as an artist with the celebrated series *Thirty-Six Views of Mt. Fuji*. Begun around 1831, the series depicts the everyday life of ordinary people from unconventional angles, contrasted with views of the sacred mountain. During his long ninety years, Hokusai frequently changed residences and artistic names, each time in the hope of being reborn as an artist. His intense, omnivorous curiosity, as well as his wit, humor, animistic vision, and approach to Western painting technique

all blended in a way unique not only in Japan but also in world art history. Already during his lifetime, *Hokusai Manga* had captured the attention of collectors in Europe, and later the originality of "Under the Wave off Kanagawa" from *Thirty-Six Views of Mt. Fuji* would make its influence felt on the French Impressionists [Fig. 54]. Hokusai was not simply a designer of ukiyo-e, but an artist of world standing.

Utagawa Hiroshige (1797–1858) may be said to have taken over the landscape print genre pioneered by Hokusai, but he did so in keeping with his much gentler temperament, itself probably the product of his upbringing as the son of a low-ranking Tokugawa government official. The character of Hiroshige's world is seen in such series as *Fifty-Three Stations of the Tōkaidō* (mid-1830s) [Fig. 55] and *One Hundred Famous Views of Edo* (late 1850s). In these series, it is as though landscape has been converted from Hokusai's fantastic world full of movement to a lyrical world of "rustic simplicity," almost a conversion from the prehistoric "Jōmon-esque" to the more settled "Yayoi-esque." Hiroshige's vision of landscape achieved a vast popularity in his own day, to the same degree as Hokusai's, and has also won many fans in Europe and America.

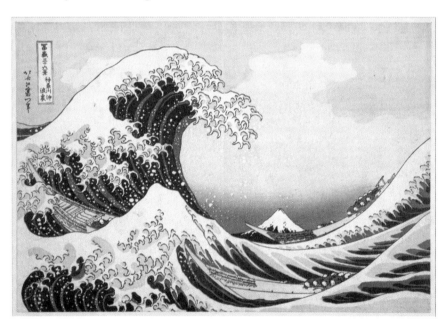

Fig. 54: Katsushika Hokusai, "Under the Wave off Kanagawa" from the series *Thirty-Six Views of Mount Fuji*, c. 1830–32, Metropolitan Museum of Art. Image copyright © The Metropolitan Museum of Art. Image: Art Resource, NY.

Utagawa Kuniyoshi (1797–1861) built on Hokusai's creative achievement by carrying it further in the direction of popular appeal. Strangely compelling scenes and lively humor were his real forte. The former is evident in his triptych *The Spirit of Retired Emperor Sanuki Sends Allies to Rescue Tametomo* (late 1840s) [Fig. 56]. The latter is seen in the series *Graffiti on the Storehouse Wall* (mid-1840s), featuring caricatured depictions of kabuki actors drawn with a lively sense of humor reminiscent of modern manga.

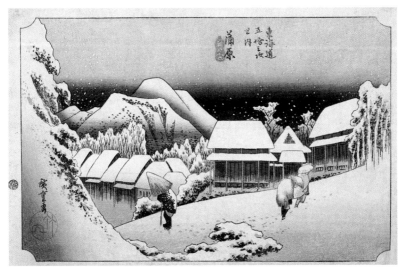

Fig. 55: Utagawa Hiroshige, "Evening Snow at Kanbara" from *Fifty-Three Stations of the Tōkaidō*, c. 1833–34, Chiba City Museum of Art

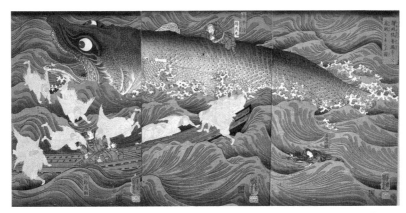

Fig. 56: Utagawa Kuniyoshi, *The Spirit of Retired Emperor Sanuki Sends Allies to Rescue Tametomo*, c. 1850, Kanagawa Prefectural Museum of Cultural History

10. Review of Late Edo-Period Decorative Arts

Riding a general tide of popularization, decorative art in the late Edo period displays as much diversity as painting does. Areas of particular significance include ceramics, textiles, and items for personal adornment.

Late Edo ceramics were influenced by the taste of the literati, who preferred the Ming- and Qing-period Chinese style of tea drinking known as *sencha*, or steeped tea. Thus, the potter Okuda Eisen (1753–1811) introduced into the Kyoto ware ceramic tradition a multicolored palette of glazes and overglaze enamels based on Chinese prototypes. He was especially inspired by ceramics from Zhangzhou (Swatow) in Fujian province, China, and their use of red overglaze enamel. His pupils included Nin'ami Dōhachi (1784–1855), who derived new inspiration from the Japanese-style motifs of earlier Edo-period potters such as Nonomura Ninsei and Ogata Kenzan, and also of Mokubei, whom we encountered earlier as a Nanga painter but who was also a skilled designer of Chinese-style *sencha* wares.

In the field of textiles, improved dyeing techniques such as Kyoto *yūzen* spurred a fashion for pictorial motifs in multiple colors. Meanwhile, stencil dyeing supported the development of textiles with small-motif patterns (*komon*) and medium-scale patterns (*chūgata*), both of which were suited to production in large numbers, although examples of inconspicuous (or hidden) luxury are known to have been produced using dozens of paper stencils (*katagami*).

Urban samurai and townspeople competed with each other in the elegant and detailed design of their personal adornments, which ranged from sword fittings to *inrō* (portable medicine cases worn suspended from a sash around the waist) [Fig. 57] and netsuke (toggles used to secure *inrō* and other portable containers such as tobacco pouches with a silk cord to kimono sashes). Reflecting the taste and aesthetics of a peaceful age, these objects frequently

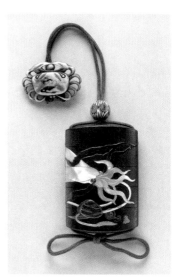

Fig. 57: Hara Yōyūsai, *inrō* with design of squid, shells, and seaweed, early 19th century, Metropolitan Museum of Art. Image copyright © The Metropolitan Museum of Art. Image source: Art Resource, NY

combine techniques from diverse areas of craft production, as well as different materials including metal, wood, bamboo, ivory, animal horn, lacquer, and ceramics. Artists were influenced by both the traditional metalwork techniques that had been applied to domestic sword decoration for centuries and the minute craftsmanship of Chinese Qing-period imports. It should be noted that the blending of Japanese and Chinese motifs and designs expresses a characteristically Japanese wit and design sense. Netsuke were collected abroad from an early stage, and as is the case with ukiyo-e prints, European and American netsuke collections are superior to those in Japan in terms of both quality and quantity. As an additional source of income, swordsmiths also produced articulated metalwork sculptures called *jizai* (literally, "freely, at will"), usually animals and insects whose bodies could be moved and positioned in lifelike ways.

In the same way that the Kyoto *yūzen* dyeing technique for textiles was introduced to Kaga domain (Ishikawa prefecture) and became Kaga *yūzen*, decorative arts and crafts spread throughout the country, and where transplanted grew into local products. Crafts in the latter half of the Edo period were closely tied to the promotion of local industry in each domain. The thinker Yanagi Muneyoshi (also known as Yanagi Sōetsu; 1889–1961) proposed a view of folk craft (*mingei*) that prioritizes objects made for daily use by "unknown craftsmen," who were unburdened by the need to create something "beautiful" or "artistic." Craft in this sense is integral to the lives of ordinary people, and the idea may also capture the significance of crafts in the second half of the Edo period. Extant *minka* (private dwellings of commoners; discussed earlier in this chapter) from the late Edo period convey a similar appreciation for the character of local craft. Yanagi also saw beauty in the folk arts of the Ainu people of the far northeast and the Ryūkyū people of far southwest Japan (Okinawa); in particular, the colorfully decorated Ryūkyū-produced *bingata* dyed textiles are highly appreciated today.

11. Architecture and Garden Design in the Late Edo Period

The Popularization of Temples and Shrines: A Tendency toward Over-Decoration

The Tokugawa *bakufu* never quite recovered its financial footing after the Great Meireki Fire destroyed much of Edo in 1657. The various domains

likewise had to manage on reduced budgets. So in 1688, when Priest Kōkei (1648–1705) suggested to the fifth shogun Tokugawa Tsunayoshi (1646–1709) that the Great Buddha Hall of Tōdai-ji temple in Nara should be rebuilt, the project had to be supported by public fundraising efforts and popular subscription. Finally completed in 1705, the hall is the world's largest extant wooden building, and also the last of the great Edo temple projects. From this time onward, particularly during the second half of the Edo period, temple and shrine construction and maintenance would be possible only through fundraising by the temples and shrines themselves. Temples had an advantage in that they were able to organize special public viewings of their main icons in Edo, and these events drew in paying crowds.

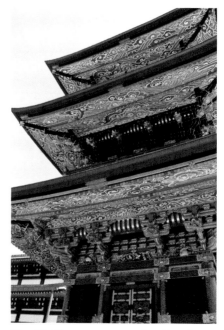

Fig. 58: Three-story pagoda, Shinshō-ji, 1712, Narita, Chiba prefecture

In order to capture the attention of worshippers, shrines and temples began adopting ever more dazzling styles of architecture, a process that might be considered the popularization of the decorative program (*kazari* or adornment), as seen at Nikkō Tōshō-gū, the Tokugawa mausoleum in Tochigi prefecture. One of the earliest examples is the three-story pagoda (1712) at the Narita-san Shinshō-ji temple in Chiba prefecture. This temple was a favorite place of worship for kabuki actors, beginning with Ichikawa Danjūrō I (1660–1704). The pagoda's pillars and transoms are covered with shallowly carved geometric designs (*jimonbori*), and the reverse side of the eaves is carved and painted with flowing patterns reminiscent of clouds and waves [Fig. 58].

The Shōden-dō hall of the Kangi-in temple (mid-eighteenth century), in Menuma, Saitama prefecture, more explicitly follows the Nikkō Tōshō-gū in its ornamentation and use of the syncretic *gongen-zukuri* style discussed at the beginning of this chapter [Fig. 59]. Produced by local

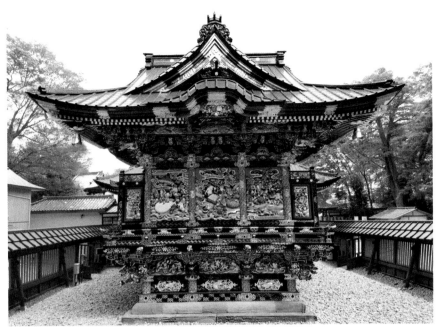

Fig. 59: Inner Palace (Okuden) of the Shōden Hall, mid-18th century, Kangi-in, Saitama prefecture

carpenters and carvers rather than by master craftsmen under the direction of the warrior elite, the building reflects a dedicated effort to construct a hall of worship for a popular congregation. Even more so than Tōshō-gū, richly colored carvings cover every surface. The geometric *jimonbori* patterns, which were applied sparingly at Nikkō Tōshō-gū, here appear even on banisters and the base of the building. This suggests a movement toward extreme ornamentation beyond that found at Shinshō-ji. In this light it is interesting to consider that Yoshiwara courtesans were regular worshippers at the Kangi'in Shōden Hall.

Shrine architecture followed a similar line of development. For example, the main hall of Myōgi shrine (Myōgi-jinja) in Gunma prefecture (1756) is rich in decoration, but the use of colored carvings is more limited and these are set against black-lacquered backgrounds. A later generation would abolish this kind of decorative scheme and replace it with plain wood buildings (*shiraki-zukuri*), but the use of Chinese-style gables (*kara-hafu*) and a tendency to fill every surface with carvings would continue. At Ōtaki shrine (Ōtaki-jinja) in Fukui prefecture, dedicated to worship of Mt.

Haku, both the main hall and the worshippers' hall (1843) offer a splendid sight, with their Chinese-style gables and spreading "plover-wing gables" (*chidori hafu*) suggesting a series of waves approaching shore. As the architectural historian Ōkawa Naomi (1929–2015) has noted, the inclination toward such an eccentric appearance is characteristic of the latter half of the Edo period.

Turbo-Shell Halls

Among the distinctive building types to appear during the latter half of the Edo period are the multistory structures with spiral staircases popularly called *sazae-dō* or "turbo-shell halls." In these buildings, which were associated with Buddhist temples, visitors would ascend a spiral stairway to obtain a continuous view of sculptures representing all five hundred arhats. The earliest example was constructed at Gohyaku Rakan-ji temple (1780), east of Edo. A famous extant example is Entsū Sansō-dō (1796) at the former Shōsō-ji temple in Aizu Wakamatsu, Fukushima prefecture

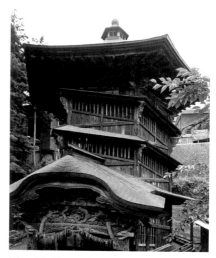

Fig. 60: Entsū Sansō-dō, 1796, former Shōsō-ji, Fukushima prefecture

[Fig. 60]. Constructed under the direction of priest Ikudō, this building houses the only premodern Japanese dual-spiral staircase—one for ascending and the other for descending—perhaps inspired by similar staircases found in imported Western prints or Akita Ranga painting. Another contributing factor may have been the Japanese arithmetic system developed by the Tokugawa official Seki Kazutaka (1642–1708). Whatever its source, this Guggenheim Museum-like structure vividly evokes the spirit of intellectual adventure during the period.

Daimyo Garden Design

Following the model of the elegant imperial gardens at Katsura Imperial Villa and Shugakuin Imperial Villa, daimyo lords commissioned large

gardens for their domain estates and for their mansions in Edo. Surviving in Tokyo today is Koishikawa Kōrakuen (second half of seventeenth century), built for the powerful daimyo Tokugawa Mitsukuni (1626–1700) of Mito domain in accordance with the Chinese style preferred by his advisor, Ming refugee and scholar Zhu Zhiyu (Shu Shunsui). Rikugien, in Komagome, Tokyo, designed at the beginning of the eighteenth century for high-ranking samurai and shogunal advisor Yanagisawa Yoshiyasu (1658–1714), is a grand and airy strolling garden that recreates the famous scenery of Waka no Ura (in present-day Wakayama prefecture) featured in classical poems using fine garden rocks gathered from around the country. Like other areas of cultural pursuit, garden culture became popularized in the second half of the eighteenth century; gardens created by townspeople, such as the Hyakkaen (Hundred Flowers Garden) in Mukōjima (Sumida ward of Tokyo), as well as daimyo gardens like Kairakuen in Mito (Ibaraki prefecture), were opened for public viewing. Daimyo gardens were dismissed by critics for a while during the modern period, but more recently their relaxed style has met with greater appreciation.

12. Late Developments in Buddhist Art: Mokujiki, Sengai, and Ryōkan

A broad trend toward secularization notwithstanding, Buddhist art continued to develop during the second half of the Edo period. For example, late in his life Mokujiki Myōman (1718–1810) traveled around the country and produced wooden sculptures in Enkū's hatchet-carved style. Buddhist sculptures by specialists had become standardized, but Mokujiki's work seems fresh, infused with religious fervor [Fig. 61].

Then far to the west in Hakata, on the island of Kyushu in present-day Fukuoka prefecture, Zen priest Sengai (1750–1837) adopted and expanded Hakuin's spontaneous manner, painting light and humorous pictures in a playful, childlike style much admired by the populace [Fig. 62]. The unworldly character of calligraphy by such priests as Hakuin, Jiun (1718–1804), and Ryōkan (1758–1831) today enjoys a higher reputation than the Chinese-style calligraphy of Edo Confucian scholars like Nukina Kaioku (1778–1863) and Ichikawa Beian (1749–1820). Ryōkan's refreshing calligraphy in particular deserves closer attention [Fig. 63]. Ike no Taiga's calligraphy, too, is appreciated for having transcended the Chinese style. These examples show that, even late in the period, the production of art

remained closely tied to religious experience and conviction, and the reclusive proclivities of the literati.

To conclude, what distinguishes the art of the Edo period is that, despite having been created in a small country and in a relatively closed social environment, it boasts extraordinary diversity and superb quality. It was a time when the cultural seeds nurtured by court aristocrats and high-ranking warriors were transferred to the broader populace, under whose care they grew, blossomed, and bore abundant fruit. It was also during this period that art was integrated into daily life. Soon, however, the image of Japan as a "country of the arts," a place whose bright image rode through Europe on a wave of Japonisme, would be threatened by a returning wave of modernization from Europe and America.

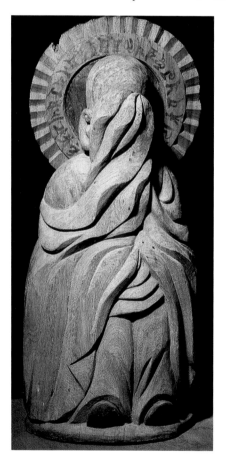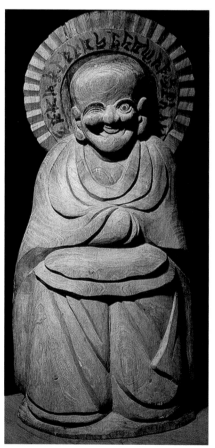

Fig. 61: Mokujiki Myōman, Subhinda (right) and Nakula (left) from Sixteen Arhats, 1806, Seigen-ji, Kyōto

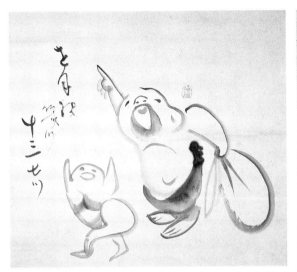

Fig. 62: Sengai, *Hotei Pointing at the Moon*, first half of 19th century, Idemitsu Museum of Arts, Tokyo

Fig. 63: Ryōkan, *Iroha Poem*, 1826–31, private collection

CHAPTER
10

Meiji to Heisei:
Modern and Contemporary Art

Meiji to Heisei: Modern and Contemporary Art

The history of Japanese art includes times of slow growth and explosive change, domestic invention and international discovery. The arts of modern (*kindai*) and contemporary (*gendai*) Japan encompass all these, along with a diversity of responses to the weight of tradition. The challenge is to understand how art has developed over the four official eras that constitute this complex time: Meiji (1868–1912), Taishō (1912–1926), Shōwa (1926–1989), and Heisei (1989–2019). Artistic movements, however, are not confined to official periodization, so the discussion that follows is more usefully organized into five sections: early Meiji (1868–early 1880s); mid-Meiji (1880s–90s); late Meiji and early Taishō (1890s–1910s); Taishō through early Shōwa (1910s–1945); and mid-Shōwa through Heisei (1945–2019).

I. New Encounters with Western Art:
Early Meiji (1868–Early 1880s)

In July 1853, Commodore Matthew Perry (1794–1858) and a squadron of four black American warships steamed into Uraga Bay, Kanagawa prefecture, and requested permission for United States trade with Japan. Tokugawa officials negotiated a year's delay to consider the matter. After much internal debate they decided to abandon the longstanding "seclusion policy" observed by the *bakufu*. Disregarding the opponents of change, in 1854 they signed an agreement with Perry that effectively opened Japan's doors to the West. Within four years, similar agreements had been negotiated with England, France, Russia, and the Netherlands, and by 1859 the new port of Yokohama was open for business.

The Tokugawa regime had been tottering for some time, and these events may have hastened its end. In 1867, after nearly a decade of unrest, the *bakufu* gave the political authority back to the emperor (*taisei hōkan*) and a new government was established in the following year (Meiji Restoration or Meiji Ishin), officially centered on Emperor Meiji (1852–1912).

To mark the break from the past, the emperor relocated from Kyoto to Edo; that city was designated the new capital and renamed Tokyo (Eastern Capital). Although generally successful, the new Meiji government contained an inherent contradiction in that it sought to revive an ancient imperial system while at the same time remaking Japan in the mold of the modern European state. Japanese artists found themselves similarly caught between centuries of tradition and the influence of Western art, which they were encountering in a genuine and lasting way for the first time. This encounter, perhaps the most important in the history of Japanese art since the arrival of Buddhism in the sixth century, led to developments that we will consider in the following section: the early Western-style painting of Takahashi Yuichi; the advent of world expositions; the impact of Western artists and ideas on Japanese art; the emergence of Western-style painting as a formal movement; responses to this age of "civilization and enlightenment"; and finally sculpture, architecture, and crafts.

1. Takahashi Yuichi and the Development of Oil Painting

As a result of its contact with Perry, in 1856 the Tokugawa *bakufu* established the Institute for Dutch Studies (Bansho Shirabesho; literally, Institute for Research into Barbarian Texts). Six years later, as awareness of and interest in the West as a region encompassing Europe and America grew, the office was relocated and renamed the Institute for Western Studies (Yōsho Shirabesho). Takahashi Yuichi (1828–1894) was a thirty-four-year-old retainer of Sano domain (now Tochigi prefecture) when he was admitted to the Institute's department of painting to train under Kawakami Tōgai (1827–1881), a specialist in Western-style and literati painting. Takahashi (or Yuichi, as he is well known) had been determined to learn the techniques of Western-style painting since his twenties, when he first saw a lithograph whose astonishing realism prompted him to declare, "Real taste lies in being true to nature." In 1866 he had an even better opportunity to study oil painting when English artist Charles Wirgman (1832–1891) in Yokohama agreed to take him on as a student. Wirgman had been sent to Japan around 1861 as a society reporter for the *Illustrated London News*; during this period he also founded the monthly satirical magazine *Japan Punch* (published 1862–87). Within a year, Yuichi is thought to have produced an early oil painting, *Self-Portrait with Topknot* (1866–67; Kasama

Nichido Museum of Art, Ibaraki prefecture), which depicts him with a strong sense of determination when still at the Institute (some have suggested, however, that the artist in this case may have been Wirgman; others see Wirgman's involvement as not more than a possible touch-up). Apart from this, the earliest oil painting by Yuichi is *Courtesan* (*Oiran*) (c. 1872; University Art Museum, Tokyo University of the Arts) [Fig. 1]. The model, a high-ranking Yoshiwara courtesan, was reportedly quite distressed when she saw the finished work, exclaiming, "I don't look like this at all." The painting is impressive for its ingenuity and realism, distancing itself from

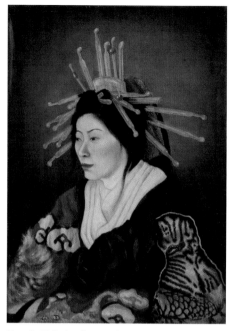

Fig. 1: Takahashi Yuichi, *Courtesan*, c. 1872, University Art Museum, Tokyo University of the Arts

both traditional Japanese and Western standards of beauty. Yuichi often painted subjects from daily life, but his obsession with "copying" form and volume was infused with a belief that "painting is a product of spirit"; this is evident in works such as *Yomihon and Sōshi* (*Books*) (1874–75), *Tofu* (1876–77) [Fig. 2], *Rolls of Cloth* (1873–76), and *Half-Dried Bonito* (1877), all in the collection of Kotohira-gū shrine, Kagawa prefecture, as well as *Dried Salmon* (1877; University Art Museum, Tokyo University of the Arts). With works such as these, Yuichi placed himself at the forefront of modern Western-style painting in Japan.

2. Sideshows, the Foundation of Modern Exhibitions

Takahashi Yuichi's art was just one of the unexpected results of the encounter between Western and traditional Japanese culture during the late Edo period (1615–1867). Another was Japan's participation in international world expositions. Organized exhibitions were not in themselves new to Japan: as mentioned in Chapter 9, temples held fundraising

Fig. 2: Takahashi Yuichi, *Tofu*, 1877, Kotohira-gū, Kagawa prefecture

displays of their treasures (*kaichō*), and early seventeenth-century genre paintings include depictions of sideshow entertainments (*misemono*), such as rare animals and acrobatic performers, along the riverbank at Shijō in Kyoto. Ukiyo-e of the late Edo period (*bakumatsu*) show comparable scenes of bustling crowds enjoying *misemono* displays at the foot of Ryōgoku Bridge and in the precincts behind Sensō-ji temple in Edo. In fact, the Okuyama district was where one of the most popular *misemono* of the period, the lifelike "living dolls" (*iki ningyō*) of Matsumoto Kisaburō (1825–1891), were to be found. A native of Kumamoto in far western Japan (Kyushu), Kisaburō enjoyed early success in 1854 with his first exhibition of *iki ningyō* in Nanba Shinchi in Osaka. His *iki ningyō* proved to be equally popular in Edo when he showed them in the Okuyama district in the year 1855–56. The leading Meiji sculptor Takamura Kōun (discussed below) reported having frequently visited an 1857 show of Kisaburō's works entitled "Record of Spiritual Experiences along the Thirty-Three Kannon Temples in Western Japan," and finding his *iki ningyō* a source of inspiration. These dolls demonstrate an obsession with verisimilitude similar to that observed in Yuichi's paintings. The art historian Kinoshita Naoyuki (b. 1954) places these and other *misemono* at the foundations of

modern exhibitions in Japan, noting that Yuichi, photographer Shimooka Renjō (1823–1914), oil painter Goseda Hōryū (1827–1892), and Hōryū's son Yoshimatsu (1855–1915) all held oil-painting shows in the Okuyama district of Asakusa. Kisaburō would later exhibit at the Vienna International Exposition (1873) and produce models of the human body for Tokyo Medical School (now the Medical Department of Tokyo University). Kisaburō's *iki ningyō* represent the rebirth of the *tsukurimono* ("produced objects") tradition in the new context of early modern exhibitions (see Chapter 5).

Even so, Europe's international expositions had a substantially different character and operated on a different scale. Beginning in 1851 with the Great Exhibition at Crystal Palace, London, international expositions provided an opportunity for participating nations to display their latest technological advances, as well as their individual cultures, customs, and arts. The Tokugawa government, along with Saga and Satsuma domains (today's Saga and Kagoshima prefectures), exhibited works of art at the Paris International Exposition (1867) and received highly favorable reviews. In 1873 the newly established Meiji government sent a larger collection to Vienna, fanning the flames of Japonisme in Europe. The necessity of translating the concepts and rules of universal expositions as a participating country led to the coinage of the Japanese term *bijutsu* as a translation for the German *Schönen Künste* (fine art). From this time onward, the Japanese government specifically encouraged the production of high-level crafts for display in international settings.

These international expositions made the Meiji government keenly aware of the gap between Japan's industrial and technological development and that of countries in the West. As a result, Meiji officials planned a series of domestic industrial expositions (*naikoku kangyō hakurankai*) to promote business, industry, and the arts. The Ministry of Education organized a preliminary version in 1872 at the Yushima Seidō, a Confucian temple in Tokyo, and while the eclectic mix of items on display was closer to a *misemono* show, this exhibit did establish the foundation for what would become the Tokyo National Museum. The first true domestic exposition took place in 1877 in Ueno Park, Tokyo, and featured a display of as many as 84,000 objects [Fig. 3]. This was followed by expositions in 1881, 1890, 1895, and 1903. Machinery was the primary focus, but in keeping with the format of the international expositions, painting and crafts also appeared, as well as displays of oil paintings by Takahashi Yuichi and *iki ningyō* by Matsumoto Kisaburō.

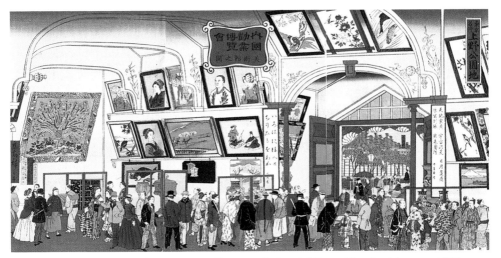

Fig. 3: Utagawa Hiroshige III, *First Domestic Industrial Exposition Art Museum*, 1877, Kobe City Museum

3. Antonio Fontanesi and the Technical Art School

In 1871 the Meiji government founded the School of Engineering (Kōgaku-ryō; renamed in 1877 the Imperial College of Engineering or Kōbu Dai-gakkō) with the aim of introducing Western technology in Japan. An affiliated institution, the Technical Art School (Kōbu Bijutsu Gakkō), was founded in 1876 and staffed specifically with professors of painting, sculpture, and architecture invited from Italy. The choice of teaching staff reflected the decision to encourage the systematic and formal study of Western realism, a shift away from the traditional art of Japan and China and toward the art of the West.

One of the school's first professors was Antonio Fontanesi (1818–1882), a Barbizon-school painter who arrived to teach sketching and linear perspective. According to modern art historian Takashina Shūji (b. 1932), "Fontanesi conveyed the realism of physical space in his [landscape] paintings, just as Takahashi Yuichi conveyed the realism of physical objects, through his close observation (literally, getting very close to the object) of every detail." During his brief tenure—he was forced to return to Italy in 1878 on account of deteriorating health—Fontanesi trained a number of those who would lead the generation of Western-style painters after Takahashi, including Asai Chū (1856–1907), Goseda Yoshimatsu, Yamamoto Hōsui (1850–1906), Koyama Shōtarō (1857–1916), and Matsuoka Hisashi (1862–1944). It is

also worth noting that the Technical Art School admitted female students nearly twenty years ahead of comparable schools in France; one of these, Yamashita Rin (1857–1939), traveled on her own to Russia after Fontanesi's departure and worked on icons in Russian Orthodox churches. The Technical Art School survived for only a few years without Fontanesi, closing in 1882 under pressure from a new interest in traditionalism encouraged by visiting American scholar Ernest Fenollosa (discussed below).

Having lost their mentor, Japan's aspiring young Western-style painters sought further training abroad. For many years while still in Japan, Asai Chū focused on painting rural subjects, including *Farmers Returning Home* (1887; Hiroshima Museum of Art), *Vegetable Garden in Spring* (1889; Tokyo National Museum), and *Harvest* (1890; University Art Museum, Tokyo University of the Arts). In 1900 he traveled to France and over the next two years produced excellent watercolor landscapes with a distinctive gray tone. There he also had an opportunity to witness the vogue for Japonisme and the decorative art movement Art Nouveau, which brought home to him the importance of *kazari*, the Japanese concept of adornment. Upon returning to Japan, he took up a position as professor of decorative design at the newly founded Kyoto Advanced School of Industry (Kyoto Kōtō Kōbu Gakkō); to promote Western-style panting in the Kansai (western Honshu) area he also helped found the Shōgo-in Institute for Western Studies (Shōgo-in Yōgaku Kenkyūjo) and the Kansai Art Institute (Kansai Bijutsuin). Asai had a profound influence on those who studied under him, including Yasui Sōtarō and Umehara Ryūzaburō, both of whom later attempted to nativize Western-style oil painting, albeit in different ways.

Having studied oil painting and watercolor with Wirgman in his youth, Goseda Yoshimatsu already possessed excellent technique when he entered the Technical Art School, leading to commissions from the Imperial Household Agency and the Meiji government. In 1880 Goseda traveled to France, where he produced the unfinished genre painting *Marionette* (1883; University Art Museum, Tokyo University of the Arts). He returned to Japan after a nine-year stay in Europe, but his work, mainly consisting of Japanese landscapes and portraits, gradually lost its brilliance. French writer Joris-Karl Huysmans (1848–1907), looking at Goseda's watercolors, lamented: "[O]h, what an unfortunate fellow! He lost what talent he might have had, or he stopped pretending to have such talent."[1] This comment reflects the alarm felt in France, where Japonisme was at its height, over the erosion of Japan's aesthetics due to the influence of Western art.

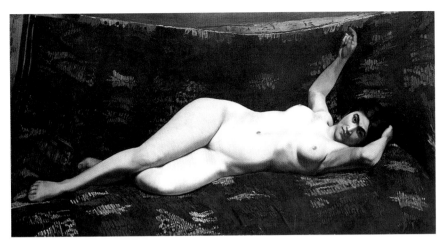

Fig. 4: Hyakutake Kaneyuki, *Reclining Nude*, c. 1881, Bridgestone Museum of Art, Ishibashi Foundation, Tokyo

Yamamoto Hōsui went to France in 1878 and there painted *Nude* (1880; Museum of Fine Arts, Gifu), one of the earliest female nudes by a Japanese artist. The work is almost contemporary with *Reclining Nude* (c. 1881; Bridgestone Museum of Art, Tokyo) by Hyakutake Kaneyuki (1842–1884), who was studying oil painting in Europe around the same time [Fig. 4]. Both paintings stand up well beside other examples of late-nineteenth-century European academism, but their true worth is not likely to have been fully appreciated in Japan at the time, where the idea of the nude as a painting genre had not yet been established and where nude images elicited strong reactions.[2]

4. Ernest Fenollosa and Kanō Hōgai

In 1878, the year Fontanesi left Japan, a young American educator named Ernest Fenollosa (1853–1908) arrived to teach political economy and philosophy at Tokyo Imperial University (now the University of Tokyo). He had a strong interest in culture, and soon began studying the connoisseurship of Japanese painting under Kanō Eitoku (1815–1891). From 1880 he also began traveling regularly to Kyoto and Nara, and gradually formulated a set of views on Japanese art and culture. In 1882 Fenollosa gave a lecture at a semi-governmental art association called Ryūchi-kai (Dragon Pond Society), titled "A True Theory of Art" (Bijutsu shinsetsu). Criticizing what he considered the rough, expressionistic manner of the literati painting, he

advocated a revival of the brushwork associated with traditional Japanese painting, in particular that of the then-declining Kanō school, seeing it as better suited to the expression of ideals. The lecture proved highly influential, forcing a major shift in official opinion, which up to that point had placed a high value on Western realism. When Fenollosa visited Hōryū-ji temple in Nara with his student Okakura Kakuzō (better known by his adopted moniker Okakura Tenshin; 1863–1913) in 1884, he managed to view the Guze Kannon (World-Saving Avalokitesvara), which had been kept hidden in Yumedono Hall for centuries (see Chapter 3, Figs. 8–9). The experience led him to petition the Japanese government to enact a law that had been stalled since the beginning of the Meiji era that would require Japanese antiquities to be documented and protected. Fenollosa officially left Japan in 1890 to take up a position as curator of the department of Oriental art in the Museum of Fine Arts, Boston. But he continued working with Okakura on a nationwide survey of Japanese art in Japan, which between 1888 and 1896 recorded more than 200,000 objects considered to be of historical or artistic interest. Based on their work, in June 1897 the Japanese government finally enacted the Ancient Temples and Shrines Preservation Law.

Fenollosa's advocacy of the Kanō school brought sudden attention to Kanō Hōgai (1828–1888), an officially trained Kanō painter who, after the upheavals of the Meiji Restoration, had lost his sources of patronage and fallen into poverty. He and Fenollosa met for the first time in 1882, and it was perhaps under Fenollosa's influence that Hōgai produced the first version of *Merciful Mother Kannon* (*Hibo Kannon*) (1883; Freer Gallery of Art) [Fig. 5]. This painting was featured at the second Paris exhibition of Japanese paintings by living artists in 1884 and then purchased by Fenollosa, who in turn sold it to American industrialist and collector Charles Lang Freer (1854–1919). Hōgai painted another version of the painting which he was working on until just several days before his death (University Art Museum, Tokyo University of the Arts). Interestingly, this final work has been considered a masterpiece in Japan, but it has also been described as almost "too perfect" and has met with an uneven reception abroad.

Hōgai's novel adaptation of Chinese painting with a unique sense of fantasy, as seen in such paintings as *Landscape: Scenes along the River* (c. 1885; Museum of Fine Arts, Boston) and *Two Dragons* (1885; Philadelphia Museum of Art), seems to have a more universal appeal. His work also has

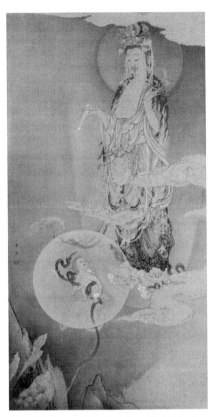

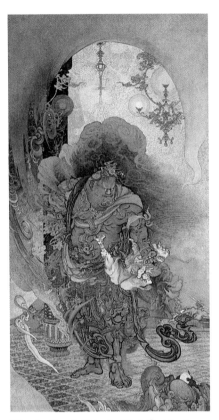

Fig. 5: Kanō Hōgai, *Merciful Mother Kannon*, 1883, Freer Gallery of Art and Arthur M. Sackler Gallery, Smithsonian Institution, Washington, D.C.: gift of Charles Lang Freer, F1902.225

Fig. 6: Kanō Hōgai, *Ni-ō Capturing a Demon*, 1886, National Museum of Modern Art, Tokyo

a humorous aspect, which comes through in *Ni-ō (Vajrapāni) Capturing a Demon* (1886; National Museum of Modern Art, Tokyo) [Fig. 6], and *Fudō Myō-ō (Acala)* (1887; University Art Museum, Tokyo University of the Arts). Fenollosa supplied Hōgai with Western pigments for *Ni-ō Capturing a Demon*, and in this and other respects the painting represents Fenollosa's ideals of modernizing and reviving traditional Japanese art. Fenollosa's Painting Viewing Society (Kanga-kai) awarded the *Ni-ō* first prize. The almost comical, manga-like quality of this painting is strikingly similar to the much later six-fold screens *Chinese Lions* (1926; Museum of the Imperial Collections, Tokyo) painted by Maeda Seison to celebrate the

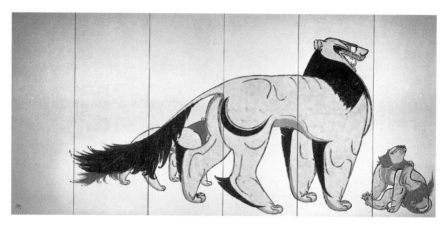

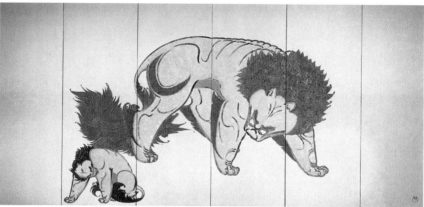

Fig. 7: Maeda Seison, *Chinese Lions* screens, 1935, Museum of the Imperial Collections (Sannomaru Shōzōkan), Tokyo

coronation of the Emperor Shōwa [Fig. 7], in that both works emphasize the pictorial surface and so demonstrate the concept of "super flat" introduced by the contemporary avant-garde artist Murakami Takashi (b. 1962; discussed in Section V) [Fig. 85].

The new manner inaugurated by Hōgai and supported by Fenollosa in the early 1880s is usefully associated with the term "Nihonga" (Japanese-style painting), a category introduced around the 1870s–80s (not long after the term *bijutsu*) to indicate paintings that give a modern reinterpretation to traditional Japanese artistic practices. Nihonga thus identifies modern paintings associated with the art of Japan, in contrast to the category of Yōga, or Western-style oil painting, which emerged as its counterpart. The Nihonga style would come into its own during the 1890s.

5. Western-Style Painting: Difficulty and Consolidation

Perhaps building on the lessons of Fenollosa's lecture, the Meiji government in 1882 launched the first National Painting Exhibition (Naikoku Kaiga Kyōshin-kai), which despite its inclusive-sounding name offered no place for Western-style painting. The second exhibition two years later followed the same policy. By 1889, having grown impatient with official rejection, Asai Chū and Fontanesi's other students, along with Kawamura Kiyoo (1852–1934), and Harada Naojirō (1863–1899), who had just returned from study in Europe, founded Japan's first Western painting association, the independent Meiji Art Society (Meiji Bijutsu-kai). Their aim was to make oil painting more widely familiar in Japan by depicting Japanese landscapes, customs, religious festivals, and well-known stories and legends. The result of this experiment can be seen in Harada's *Kannon Riding a Dragon* (1890; Gokoku-ji temple, Tokyo), and Yamamoto Hōsui's *Urashima* (1893–95; Museum of Fine Arts, Gifu) [Fig. 8] and *Chinese Horoscope* (1892; Mitsubishi Heavy Industries, Nagasaki Shipyard and Machinery Works).

In the opinion of Toyama Masakazu (1848–1900), an educator who held the position of chancellor of Tokyo Imperial University and Minister of Education, Harada's *Kannon Riding a Dragon* failed to convey any significant ideas (which was, in Toyama's view, the primary aim of painting), while Yamamoto's *Urashima* was "like a circus." But these judgments seem to miss the challenge that these painters faced, for both works finally succeeded in transplanting the animated feeling of Edo-period popular painting into the rather difficult and imposing manner of European painting. *Urashima*, moreover, possesses a sense of fantasy similar to that found in children's story illustrations, and as the art historian Takashina Erika (b. 1964) has noted, the playful spirit of Edo runs through the composition and concept of Yamamoto's *Chinese Horoscope*.

Kawamura Kiyoo studied in Italy from 1871 to 1881, but after returning home favored Japanese subject matter in his art. For example, in memory of his guardian and patron Katsu Kaishū (1823–1899), the Japanese statesman and naval engineer who helped negotiate the transition from Tokugawa to Meiji rule, Kawamura painted *Ceremonial Robes Preserved as Keepsakes (Airing of Robes)* (after 1899; Tokyo National Museum) [Fig. 9]. At center of the painting a young woman sits wrapped in the white ceremonial robe that Kawamura wore at Katsu's funeral. Her outstretched hand directs the viewer toward a small sarcophagus, on top of which rests

Fig. 8: Yamamoto Hōsui, *Urashima*, 1893–95, Museum of Fine Arts, Gifu

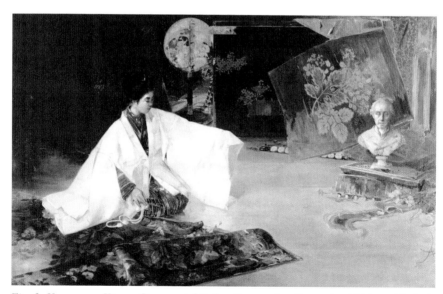

Fig. 9: Kawamura Kiyoo, *Ceremonial Robes Preserved as Keepsakes* (*Airing of Robes*), after 1899, Tokyo National Museum

a stone bust portrait of Katsu. She is surrounded by objects formerly in Katsu's possession. The allegorical iconography suggests that the ideal of European academism had at last found proper representation in Japan. Like Goseda, after returning to Japan, Kawamura seems to have gone back to working with Japanese subject matter and style. *Airing of Robes* is a rare example that exemplifies what Kawamura had absorbed from his study of Italian academism.

Japan's encounter with Western-style oil painting in the late nineteenth century produced serious efforts to master the technique. However, the road to success was long and hard. The artists' experiences in Europe did not necessarily show in the quality of their work. Takahashi Yuichi's paintings are appealing more for the artist's sincerity and passion in exploring ways of representing reality than for the excellence of his technique. What would become of Western influence on Japanese artists who had been steeped in Chinese influence for a very long time?

6. The Age of "Civilization and Enlightenment": Adversaries and Advocates

Kawanabe Kyōsai and Kobayashi Kiyochika

As previously mentioned, the early Meiji-era Japanese government promoted intense study of the West as a way of remaking Japan into a modern nation — or, as a slogan of the period phrased it, a country of "civilization and enlightenment" (*bunmei kaika*). The various educational and social experiments undertaken at the time echoed in the world of art, for while Takahashi Yuichi, Asai Chū, and others worked to master Western oil painting, and while Kanō Hōgai struggled to establish a new Japanese style, other artists freely took up the brush to cater to the taste of contemporary townspeople. The two leaders in this area were Kawanabe Kyōsai (1831–1889) and Kobayashi Kiyochika (1847–1915).

Kyōsai trained first in the studio of Utagawa Kuniyoshi (see Chapter 9), where he developed a rambunctious sense of humor; and then in the Kanō school, where he acquired a repertoire of energetic brush strokes. He also studied the work of Katsushika Hokusai (see Chapter 9), and these disparate influences led to an unrestrained, lively, and humorous style that appealed equally to Japanese and to Westerners [Fig. 10, jacket cover of

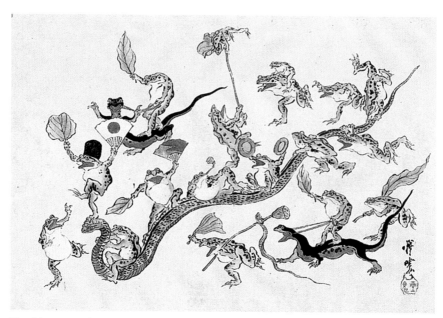

Fig. 10: Kawanabe Kyōsai, *Frogs Triumphing over a Snake and Lizards*, c. 1879, British Museum © Trustees of the British Museum

this book]: British architect Josiah Conder (1852–1920) became his pupil, and his work is in fact found in collections throughout Europe and the United States. In this respect Kyōsai is like the prolific painter and lacquer artist Shibata Zeshin (1807–1891), whose hanging scrolls, handscrolls, drawings, and finely crafted, imaginatively designed decorative objects are well known both inside and outside Japan.

Kiyochika studied Western-style painting in Yokohama, and over time found ways to represent both natural and artificial light in pictures. His work in this area, described by his publisher as "light-ray pictures" (*kōsen-ga*), is perhaps best represented by a series of woodblock prints featuring famous places in Tokyo that was published between 1875 and 1881. One print from the series, "View of Takanawa Ushimachi under a Shrouded Moon," demonstrates Kiyochika's great skill in differentiating between various sources of light: flames rising from a smokestack, lanterns behind windows, the glow of a sunset, light from the moon illuminating clouds and the railway track-bed, and moonlight reflecting off the surface of the sea [Fig. 11]. Kiyochika seems to have based the idea for this print on an American lithograph he had purchased in Yokohama, but he may also have had in mind the work of Hiroshige, who had explored the effects

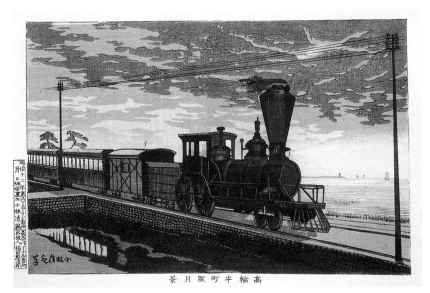

Fig. 11: Kobayashi Kiyochika, "View of Takanawa Ushimachi under a Shrouded Moon" from the series *Famous Places of Tokyo*, 1879, Shizuoka Prefectural Museum of Art

of natural light in his popular woodblock prints decades earlier. Given that the first Impressionist exhibition took place in Paris only in 1874, Kiyochika may be considered an early exponent of the Impressionist school in Japan.

The political turmoil of *bakumatsu* (the last years of Tokugawa rule by the *bakufu*) and the struggle to achieve "civilization and enlightenment" found expression elsewhere in popular culture, particularly the many bloody and macabre plays offered in the kabuki theater over the same period. A similar spirit runs through the woodblock prints of Tsukioka Yoshitoshi (1839–1892), and also the paintings of Hirose Kinzō (1812–1876). Kinzō —more familiarly called Ekin—left his position as painter-in-attendance to the Tosa domain and headed for Edo, where he studied in a Kanō school. After returning to Tosa, he produced large-scale folding screens depicting subjects from kabuki. Kikuchi Yōsai (1788–1878) explored provocative themes in Chinese historical subjects.

7. Vincenzo Ragusa and the Introduction of Western-Style Sculpture

Like "art" (*bijutsu*), "craft" (*kōgei*), "architecture" (*kenchiku*), and other art-related terms now commonly used in Japan, the modern term for "sculpture"

(*chōkoku*) was part of a set of words newly coined in the early Meiji era to facilitate the introduction of Western culture. It was first used at the Technical Art School under the tenure of Vincenzo Ragusa (1841–1927), who arrived in 1876 with Fontanesi and the School's other Italian teaching staff to train young Japanese in the tradition of Western academic sculpture [Fig. 12]. Through the young painter Kiyohara Tama (1861–1939), who modeled for him and whom he later married, Ragusa also became interested in the Japanese lacquer tradition as practiced by Tama's older brother Einosuke (1852–1916). When he returned to his native Palermo in 1882, Ragusa brought along Tama, Einosuke, and Einosuke's wife, and provided Einosuke with a teaching post at a school Ragusa personally funded.

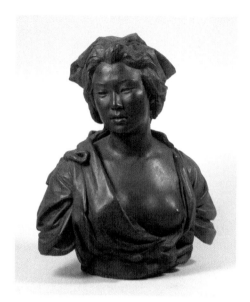

Fig. 12: Vincenzo Ragusa, *Japanese Woman*, c. 1891, University Art Museum, Tokyo University of the Arts

In the years after Ragusa's departure, two Japanese sculptors came to prominence. First was Ōkuma Ujihiro (1856–1934), one of his students who went to Europe in 1888 to train in the manufacture of bronze sculpture and after returning produced Japan's first Western-style bronze commemorative portrait, a standing figure of the "father of the modern Japanese Army" Ōmura Masujirō (1824–1869) (designed 1883, completed 1893; Yasukuni shrine [Yasukuni-jinja]). Elsewhere in Tokyo, the traditionally trained wood-carver Takamura Kōun (1852–1934) recognized the declining demand for wooden Buddhist statues and forged a new path in the field of realistic animal and bird sculptures. One of his best-known works is *Old Monkey* (1893; Tokyo National Museum), which he exhibited at the Chicago World's Columbian Exposition in 1893. He also carved the original wood model for the bronze statue of General Saigō Takamori (1826–1877) in Ueno Park (1898). The familiarity of this popular statue of "Saigō-san" (Mr. Saigō) might come from the impression of a tiny wood-carved netsuke (toggle) transformed into an enormous bronze statue.

8. Architecture in the Late Nineteenth Century: Western Style and Pseudo-Western Style

Western-Style Architecture in Foreign Residential Areas and Elsewhere

Only forty-five non-Japanese lived in the new treaty port of Yokohama when it first opened in 1859, but within a decade the number had jumped to a thousand. Soon Western-style buildings constructed with a unique mixture of European and Japanese elements lined the foreign residential quarter. Exotic buildings of this type appear regularly, albeit in a exaggerated manner, in the popular prints known as "Yokohama pictures" (*Yokohama-e*). Only a handful of the actual buildings of that time survive, however; notably those constructed before 1868 in the foreign residential area of Nagasaki. The oldest extant example is the former Glover residence, completed in 1863 in the British colonial style [Fig. 13]. The building combines such Western details as stone-tiled verandas, latticed arches, and French windows with elements of Japanese construction in the form of traditional roof supports and roof tiles. Standard colonial architecture with verandas initially spread far and wide, but being unsuitable to the Japanese climate, steadily declined in popularity. Another example of foreign architecture in Nagasaki is the Gothic-style wood Ōura Catholic Church (1864), designed by a French missionary; its interior is almost perfectly preserved.

Fig. 13: Former Glover residence, 1863, Nagasaki

Japanese master carpenters constructed pseudo-Western-style buildings in many parts of the country. An early proponent of the style was Shimizu Kisuke II (1815–1881), who traveled to Yokohama soon after the port opened in order to study with the American architect Raphael P. Bridgens (1819–1891). Shimizu went on to build, among other structures, the Mitsui House (later the First National Bank) (1872; demolished 1898) at Kaiun Bridge in Tokyo. He became a leading architect of pseudo-Western-style buildings, but only a few examples of his work remain today. Extant examples of pseudo-Western-style architecture from the early Meiji era include the gate to Oyama shrine (Oyama-jinja) in Kanazawa, Ishikawa prefecture (1875); Saiseikan Hospital in Yamagata (1879); and former Kaichi School in Matsumoto, Nagano prefecture (1876). The gate of Oyama shrine, built as a symbol of unity among clansmen of the Kaga domain, takes the form of an arched structure supporting an Ōbaku Zen temple gate, making it unique in shrine architecture. The former Saiseikan Hospital has a main building in the form of a polygonal ring with a fanciful tower attached to the front [Fig. 14]. Former Kaichi School represents a type of pseudo-Western-style architecture that became fashionable for schools all over Japan after the emperor proclaimed the Rescript on Education in 1872, instituting a newly formed educational system [Fig. 15]. The building's Chinese-style gable and two angels supporting the sign over the carriage porch were borrowed from a design in a contemporary newspaper.

Fig. 14: Former Saiseikan Hospital building, 1879, Yamagata

Elements such as the clouds applied to the veranda, the carved decoration on the railing, and the raised ridge tiles may strike us today as a form of Meiji "kitsch," but they actually represented the hopes of the people of the time, who saw a new future in "civilization and enlightenment" [Fig. 16].

Fig. 15: Former Kaichi School, 1876, designed by Tateishi Seijū, Matsumoto, Nagano prefecture

Inviting Professional Architects from Abroad

The Meiji government recognized that Western-style and pseudo-Western-style buildings were being constructed by engineers and carpenters, rather than by trained architects, and so decided to invite professional architects from abroad in a teaching capacity similar to that of the professors at the Technical Art School. Among the earliest of these professionals was the British architect Josiah Conder (1852–1920), who was appointed professor of architecture at the Imperial College of

Fig. 16: Entrance porch of former Kaichi School (detail of Fig. 15)

Engineering in 1877. A scholar and admired personality, Conder trained twenty-one students at the College, many of whom came to lead their field

in subsequent years, making Conder in this respect the "father of modern Japanese architecture." Conder, who had a deep respect for traditional Japanese culture, also studied painting with Kawanabe Kyōsai (see above).

Many of Conder's buildings are now lost—for example, his Ueno Museum (1881) and the famous banqueting house known as the Deer Cry Pavilion (Rokumeikan; 1883)—but others remain, including the Holy Resurrection Cathedral in Tokyo (informally called Nikolai-dō; 1891) and the Mitsui Club in Tsunamachi, Tokyo (1913). In 1884, Conder handed over his professorship to one of his leading students, Tatsuno Kingo (1854–1919), opening the way for a new generation of Japanese architects. After his retirement he designed a number of private residences, including one commissioned in 1896 by the industrialist Iwasaki Hisaya (1865–1955) [Fig. 17]. The design in this case combined Japanese and Western-style living spaces, an approach made possible by Condor's personal experience of living in Japan.

Conder's students gravitated toward three different schools of Western architecture: British, German, and French. Tatsuno took an interest in the British school. After returning from study in Britain, he designed the headquarters for the Bank of Japan (1896) [Fig. 18] and Tokyo Station (1914). The classical style of the Bank of Japan won him success and a

Fig. 17: Former residence of Iwasaki Hisaya, 1896, designed by Josiah Conder, Tokyo

Fig. 18: Headquarters for the Bank of Japan, 1896, designed by Tatsuno Kingo, Tokyo

position as the leading architect of the Meiji era. The German school was led by Tsumaki Yorinaka (1859–1916), who designed the Yokohama Specie Bank (1904) and the Tokyo Chamber of Commerce and Industry Building (1899). Katayama Tōkuma (1854–1917) followed the style of the French school in designing the Kyoto Imperial Museum (1895) and the state guest-house of Akasaka Palace (1909), which took ten years to complete. Japanese architects could now design and construct large-scale Western-style build-ings in their own right, based on careful study of the historical styles of the past. This historicist approach, which was shared by Western architects of Conder's period, tended to emphasize beauty over practicality.

9. Promoting Industrial Arts and Fine Art Crafts

When the modern Japanese word for *kōgei* first appeared in 1871, it included the sense of "industrial manufacturing" (*kōgyō*), but by around 1888 the term had moved closer to "craft," as it is used today. The early Meiji government regarded all types of craft as primary export goods, and so among the first of the technically trained foreigners they invited to Japan was the German scientist Gottfried Wagener (1831–1892), who arrived in 1868 and successfully increased craft exports by supervising the

Fig. 19: Nagasawa Naganobu I, white vase decorated with basket-weave effect and birds and flowers in high relief, c. 1877, National Museum of Modern Art, Tokyo

Japanese exhibits at the Vienna International Exposition in 1873. Two leading craft companies were established soon after: Kiryū Kōshō Kaisha, founded in Asakusa Kuramae, Tokyo, in 1875; and Eishinsha, founded by retainers of the former Izushi domain in Hyogo prefecture. Kiryū Kōshō Kaisha commissioned leading craft artists to design and produce work for both national and international expositions, and the company's products were always praised. Eishinsha produced porcelains for the export market.

The wares of these companies, like those of other makers and manufacturers during this period, are notable for their realistic designs and trompe-l'oeil effects. For example, Kiryū Kōshō Kaisha commissioned Nagasawa Eishin I (1861–1919) to produce a cast-bronze vase with a bird-and-flower design inlaid in gold and silver, while Eishinsha commissioned a white porcelain jar in the shape of a basket with applied birds and flowers, made to look like a birdcage [Fig. 19].

The excellent quality of the *Twelve Hawks* by metal artist Suzuki Chōkichi (1848–1919), exhibited at the World's Columbian Exposition, came as a surprise to Western critics, accustomed to making a clear distinction between sculpture and craft. [Fig. 20]. Craftsmen of the Myōchin metalworking studio, who during the peaceful Edo period had lost most of their

Fig. 20: Suzuki Chōkichi, one of the Twelve Hawks, 1893, National Museum of Modern Art, Tokyo

main business of manufacturing armor, amazed Western viewers with their lifelike articulated iron figures (*jizai*) of insects, lobsters, dragons, and other creatures (see Chapter 9). Works such as bowl in brown glaze with applied crabs by Miyagawa (or Makuzu) Kōzan I (1842–1916), exhibited at the first Domestic Industrial Exhibition of 1881 [Fig. 21], and *Persimmons* (1920) by ivory artist Andō Rokuzan (1885–1955) are once again attracting attention today for their resonance with the hyper-realism

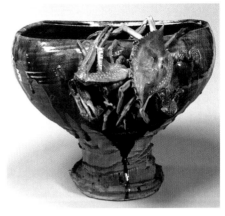

Fig. 21: Miyagawa Kōzan, bowl in brown glaze with applied crabs, 1881, Tokyo National Museum

in contemporary art [Fig. 22]. Namikawa Sōsuke (1847–1910) won international acclaim for creating beautiful pictures using the technique of cloisonné wireless enamels (*musen shippō*). Only a few examples of his work can be found in Japan today, as most are in European and North American collections.

These various crafts were produced with Western taste in mind and may unavoidably seem like hybrid works of art. At the same time, they communicate the enthusiasm of the highly skilled craftspeople who produced them, artists who were conscious of addressing an international

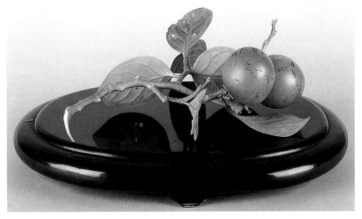

Fig. 22: Andō Rokuzan, *Persimmons*, 1920, Museum of the Imperial Collections (Sannomaru Shōzōkan), Tokyo

audience. Derived from the crafts of the late Edo period, their sublime techniques appealed to Western taste and quickly became the talk of international expositions. Even as work of this type began to lose its appeal in the West toward the end of the Meiji era, following the decline of Japonisme, two ceramicists in particular maintained the tradition at a high standard: Itaya Hazan (1872–1963) and Kusube Yaichi (1897–1984). Hazan emerged as a leader of government-organized art exhibitions with his new glazes that he created from his study of Chinese porcelain and use of Art Nouveau motifs, and elegant vessel shapes grounded in his historical knowledge about Chinese porcelain [Fig. 23].

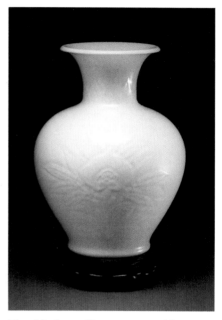

Fig. 23: Itaya Hazan, vase with auspicious flowers and peach sprays, c. 1925, British Museum © Trustees of the British Museum, acquisition supported by the Brooke Sewell Bequest and the Art Fund

II. Advancing toward Modern Art:
Mid-Meiji (1880s–90s)

As the Meiji government consolidated power following the successful repression of a rebellion and the founding of a national bank (both 1877), and then secured broad support from the general populace with the rhetoric of democracy and a rescript ensuring national standards of education (1890), Japanese artists felt emboldened to seek firsthand experience of the world of Western art by going abroad. Alternatively, they could delve deeper into the strengths of their own tradition. This section explores how changes in mid-Meiji society affected the second generation of Western-style artists, including Kuroda Seiki, Fujishima Takeji, and Aoki Shigeru; as well as a generation of artists and thinkers like Okakura Kakuzō, who were looking

anew at traditional Japanese art; and those engaged in the emerging profession of architectural design.

1. Kuroda Seiki and the New Yōga (Western-Style Painting)

The history of Japanese Western-style painting took a new turn with the emergence of Kuroda Seiki (1866–1924). Born as a son of a retainer of the Shimazu clan from present-day Kagoshima prefecture, Kuroda was adopted in 1866 by his uncle, Kuroda Kiyotsuna, who received the title of viscount for having played an important role in the events leading up to and following the Meiji Restoration. In 1884 at the age of eighteen Kuroda was sent to France to study law, but two years later embarked on a career as a painter under the tutelage of the French academic painter Raphaël Collin (1850–1916).

Radical change was overtaking European art at this time. A decade earlier the Impressionists had started a revolution that would reach its climax in the 1890s with Claude Monet's celebrated *Haystacks* and *Rouen Cathedral* series. Artists of the French Academy could hardly ignore what was happening around them, and some—Collin among them—began to adopt the Impressionist way of interpreting and depicting natural light. As the son of a viscount, Kuroda received favorable treatment in France. He gained solid training from Collin in a new eclectic style, as seen in his *Reading* (1891; Tokyo National Museum) and *Woman (The Kitchen)* (1892; the University Art Museum, Tokyo University of the Arts). When he exhibited at the Paris Salon, his career as a painter was confirmed. Kuroda returned to Japan in 1893 with his artist colleague Kume Keiichirō (1866–1934), initially feeling some trepidation over his future in his home country. Soon after, he began to paint Japanese subjects in oil, but using the bright airy palette he had learned in France, as seen for example in his portrayal of an apprentice geisha, *Maiko* (1893; Tokyo National Museum) [Fig. 24]. The style that Kuroda and Kume introduced was variously called the "new school" (Shinpa), "purple school" (Murasaki-ha), and the "school of natural light" (pleinairism, Gaikō-ha), as opposed to the style of artists who had received their training at the former Technical Art School, now called the "old school" (Kyū-ha) or "resin school" (Yani-ha). When, in 1896, the Tokyo School of Fine Arts (Tokyo Bijutsu Gakkō; founded in 1888 by Okakura Kakuzō) finally established a department of Western-style painting, Kuroda was appointed one of their first instructors. The same year, he

and Kume were also central to the founding of the White Horse Society (Hakuba-kai), which split from the Meiji Art Society and the artists of the "old school" who supported it.

Kuroda has gained a reputation as the "father of modern Yōga," thanks to his work training younger artists at Tenshin Dōjō in Tokyo, a private French-style painting academy—where his students included Wada Sanzō (1883–1967) and Okada Saburō-suke (1869–1939)—as well as to his positions as professor at the Tokyo School of Fine Arts and as president of the White Horse Society.

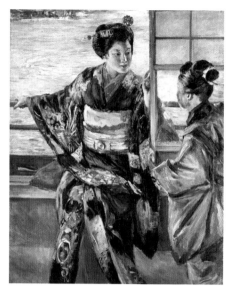

Fig. 24: Kuroda Seiki, *Maiko*, 1893, Tokyo National Museum

His style, though, is not in itself as novel as might be expected, being simply a mixture of the old and the new. *Lakeside* (1897; Tokyo National Museum), a portrait of his wife seated beside Lake Ashi in Hakone, is often cited as one of his most important works [Fig. 25]. However, its lack of freshness in comparison to Edo-period color woodblock prints by Hiroshige or Kunisada on the similar theme of enjoying the evening cool beside the Sumida River suggests that oil is not a suitable medium for this subject. Kuroda himself did not consider the work much more than a study. He made a great effort to import the European idea of "composition" in its literal sense. The art historian Takashina Shūji has coined the term *kōsō-ga* (well-composed painting) to explain Kuroda's ideas. The painter, choosing the subject from mythological or historical sources or abstract concepts, would then work on the composition over and over again, making numerous sketches to conceive an overall idea to finally realize it on a large canvas. As if in evidence of his struggle, many of Kuroda's *kōsō-ga* were never completed; while *Wisdom, Impression, Sentiment* (1899; Tokyo National Museum) is one of the rare examples that he finished. It was displayed at the International Exposition in Paris in 1900, where it received a silver medal [Fig. 26]. The work depicts three ideally proportioned Japanese female nudes standing against a gold background, almost like a Buddha triad.

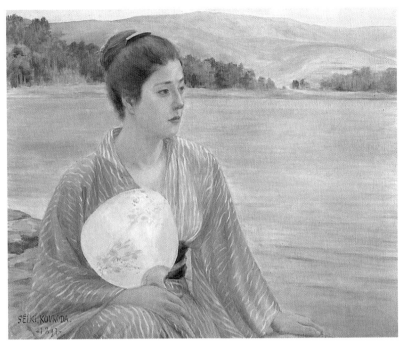

Fig. 25: Kuroda Seiki, *Lakeside*, 1897, National Research Institute for Cultural Properties, Tokyo

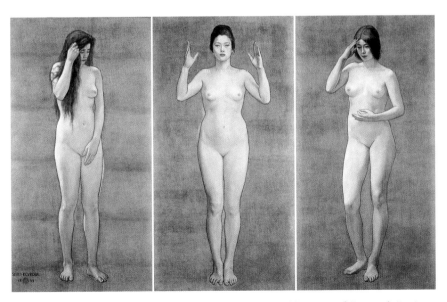

Fig. 26: Kuroda Seiki, *Wisdom, Impression, Sentiment*, 1899, National Research Institute for Cultural Properties, Tokyo

When this work was shown at a more recent exhibition held at the Tokyo National Museum together with other contemporary works seen at universal expositions of the period, its thinly painted surface and shallow spatial qualities stood out positively beside the heavier work of oil paintings by Western painters displayed nearby. The painting can be understood as Kuroda's response to Western academism. Another *kōsō-ga* painting Kuroda worked on for many years and finally completed was *Talk on Ancient Romance* (1898); however, the finished painting is now lost and only studies and a draft in oil survives (*Composition Study II*, 1896; Tokyo National Institute for Cultural Properties). It depicts an itinerant storyteller and his small audience of passersby, a subject that probably carried nostalgic overtones for viewers of Kuroda's day. Later in his career, Kuroda moved away from large canvases to focus on sketches, which include many fine works—such as *Sifting Red Beans* (1918)—that reflect his study of the lives of farmers.

2. Divisions among Western-style Artists, Romanticism, and Affinity for the Decorative

When Kuroda and Kume split from the Meiji Art Society to form the White Horse Society in 1896, they were joined by a number of other artists then teaching at the Tokyo School of Fine Arts, including Fujishima Takeji (1867–1943) and Wada Eisaku (1874–1959), both from Kuroda's hometown of Kagoshima; and Okada Saburōsuke from Saga prefecture. The Meiji Art Society disbanded five years later, whereupon a group of affiliated artists trained in Western technique—including Yoshida Hiroshi (1876–1950), Mitsutani Kunishirō (1874–1936), Ōshita Tōjirō (1870–1911), Maruyama Banka (1867–1942), and Nakagawa Hachirō (1877–1922)—formed a new group, the Pacific Painting Society (Taihei Yōga-kai). They were later joined by Nakamura Fusetsu (1866–1943) and Kanokogi Takeshirō (1867–1942) upon their return from France, where they had studied under the academic painter Jean-Paul Laurens (1838–1921) at the Académie Julian. Both the White Horse and Pacific Painting Societies specialized in Western-style painting, but represented different backgrounds and artistic approaches: the former represented the official government-supported school of eclectic academism; the latter, an independent group of painters focusing on authentic academism and traditional techniques. The latter, the artists of the Pacific Painting Society, represented a strong tradition of watercolor painting passed down from Goseda Yoshimatsu and

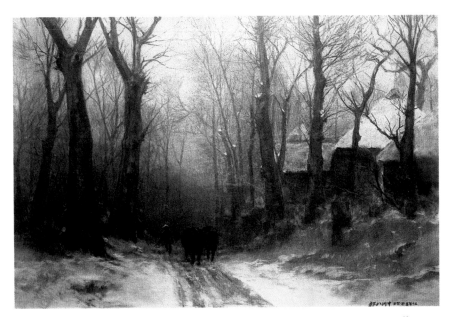

Fig. 27: Nakagawa Hachirō, *Farmers Returning in Snowy Woods*, 1897, private collection

Asai Chū and were well received in the United States. Yoshida Hiroshi's fine technique also earned him a following in Britain. Nakagawa Hachirō's (1877–1922) *Farmers Returning in Snowy Woods* (1897) is an excellent example of the ink-painting tradition revived in a modern watercolor [Fig. 27]. This style was passed on to watercolor painting by Ishii Hakutei (1882–1958).

Around this time Tokyo's intelligentsia developed a passion for things romantic, forming a movement in both literature and the visual arts known as the Meiji Romantic School. Participating artists engaged with European Art Nouveau and the fin de siècle styles practiced by Gustave Moreau (1826–1898) in France and Aubrey Beardsley (1872–1898) in England, among others. Romanticism runs through two paintings freighted with dark impressions of poverty: Wada Eisaku's *Evening at the Harbor* (1897) and *Night Train* (1901) by Akamatsu Rinsaku (1878–1953), shown at the White Horse Society exhibition of 1902 (both works are now at the University Art Museum, Tokyo University of the Arts). Kuroda encouraged the production of these genre paintings.

It was, furthermore, on Kuroda's recommendation that Fujishima Takeji (1867–1943) won an appointment as assistant professor of Western-style painting at the Tokyo School of Fine Arts in 1896. Fujishima steadily

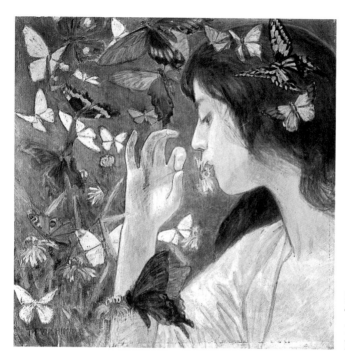

Fig. 28: Fujishima
Takeji, *Butterflies*,
1904, private col-
lection

developed an independent style, leading to such decorative Romantic works as *Reminiscence of the Tenpyō Era* (1902; Bridgestone Museum of Art) and *Butterflies* (1904) [Fig. 28], both shown at exhibitions of the White Horse Society. He also produced Art Nouveau-style illustrations for the cover of the monthly literary magazine *Bright Star* (*Myōjō*; 1900–08) and for *Tangled Hair* (1901), the Romantic poet Yosano Akiko's (1878–1942) first published book of Japanese-style verse (*tanka*). In 1905 he went to study in France and Italy, where he spent five years absorbing the lessons of academism and the works of the European modernists Vincent van Gogh (1853–1890) and Paul Gauguin (1848–1903). While abroad he produced paintings that display bold and expressive brushwork and a cheerful decorative flair, including *Black Fan* (1908–09; Bridgestone Museum of Art), and *Cypress* (*Villa Falconieri, Frascati*) (c. 1908–09; Pola Museum of Art, Kanagawa prefecture). After returning to Japan in 1910, he tried to unite the technique of oil painting with the traditional Japanese interest in deco-ration. His ambition is embodied in such sublime late landscapes as *Rough Seas at Daiōzaki* (1930; Mie Prefectural Art Museum) and *Rising Sun Illu-minating the Universe* (1937; Museum of Imperial Collections). Fujishima's

interest in the Japanese inclination for the decorative was passed on to the next generation of painters, in particular Kojima Zenzaburō (1893–1962).

The career of Aoki Shigeru (1882–1911) began almost explosively when, although he was only twenty-one and still a student at the Tokyo School of Fine Arts, the White Horse Society awarded him a prize for some ten of his sketches portraying mythological subjects displayed in its 1903 exhibition. These included *Escape from the Land of the Dead* (*Yomotsu-hirasaka*, 1903; University Art Museum, Tokyo University of the Arts), an impressionistic vision of the deity Izanagi, troubled, leaving the world of the dead where he had gone to retrieve his deceased wife. The following year he produced *Fruits of the Sea* (1904; Bridgestone Museum of Art), based on his own observations of life along the shore of Mera, Chiba prefecture. In this work he depicted a line of nude fishermen marching home carrying the day's catch of sharks [Fig. 29]. The powerful aura of these men of the sea reflects the romantic passions of the young, incredibly gifted artist, but the painting's lively energy is also closely tied to its unfinished state.

As the Italian art critic Giovanni Morelli (1816–1891) observed, "The spontaneous sketch retained in its freshness what the labors of execution tended to stale"; the French art historian Henri Focillon (1881–1943) also noted, "The rough draft always gives vitality to the masterpiece."[3] In a similar way, we may recall that the sketches of Watanabe Kazan (see Chapter 9, Fig. 49) are far livelier than his finished paintings. Aoki's *Tenpyō Era* (1904, Bridgestone Museum of Art), a hazy portrayal of nude and seminude women entranced by the music of a single flute, also owes much of its charm to being unfinished. Vermilion lines of under-drawing create a fine decorative effect, suggesting that Aoki may have known the virtue of an unfinished painting. Continuing his interest in ancient and mythological subjects, Aoki then painted *Paradise under the Sea* (1907; Bridgestone Museum of Art), based on an ancient Japanese myth in which a mountain deity descends into the ocean and encounters the beautiful daughter of a sea creature. Not long after completing this major work, Aoki decided to separate from his girlfriend Fukuda Tane; he returned to Kyushu where, four years later, he succumbed to tuberculosis at the age of twenty-nine. The art historian Yashiro Yukio (1890–1975) placed Aoki's artistic gifts at a higher rank than those of Eugène Delacroix (1798–1863) and suggested Japan was not ready to appreciate and nurture an artist of such talent during Aoki's lifetime.

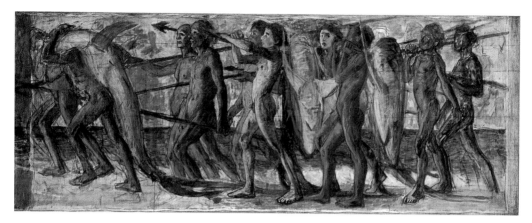

Fig. 29: Aoki Shigeru, *Fruits of the Sea*, 1904, Bridgestone Museum of Art, Ishibashi Foundation, Tokyo

3. Okakura Kakuzō and the Japan Art Institute: Yokoyama Taikan and Hishida Shunsō

Among those who felt the impact of Fenollosa's seminal lecture of 1882 was Okakura Kakuzō (Tenshin). Okakura came from a samurai family affiliated with the Fukui domain, but his father made a living as a trader in Yokohama. He was born in that port town and gained fluency in English while attending a school there operated by a Christian missionary. Although Okakura had initially shown interest in politics and literature, Fenollosa turned his attention to Japanese art, leading him on an art tour through Europe and North America in 1886. Two years later Okakura returned to Japan and founded the Tokyo School of Fine Arts, also becoming the school's first president. Kanō Hōgai was appointed first head of the painting department, but died before he could take up the post, so his close friend Hashimoto Gahō (1835–1908) received the appointment instead. Gahō was not Hōgai's equal in terms of technique, but like many other painters of his day, he possessed dynamic energy and a sense of ambition, as reflected in his pair of *Screens with Tiger and Dragon* (1895; Seikadō Bunko Art Museum, Tokyo).

Over the next few years, Okakura pursued a number of pioneering projects. (Meanwhile, Fenollosa left Japan in 1890 to take up a curatorial post at Museum of Fine Arts, Boston.) For example, in 1889 he and Takahashi Kenzō (1855–1898), then head of the Cabinet Gazette Bureau, published the first issue of the arts magazine *Kokka* (*Flower of the Nation*; still in

publication), which despite its nationalistic name introduced readers to the broader world of Asian art. Over the 1891–92 school year, Okakura also delivered Japan's first series of general lectures on the history of Japanese art.

Okakura appeared to be enjoying success as a dynamic leader, but his unilateral decision-making ways stirred antipathy, and he was forced out of the Tokyo School of Fine Arts in 1898. In the same year he founded the Japan Art Institute (Nihon Bijutsuin), with his former students and then colleagues who were sympathetic to his views such as Yokoyama Taikan (1858–1958), Hishida Shunsō (1874–1911), and Shimomura Kanzan (1873–1930), as well as Hashimoto Gahō, who all had resigned in in support of Okakura. Shunsō was not unfamiliar with social politics, having undertaken for his graduation project a painting titled *Widow and Orphan* (1895; University Art Museum, Tokyo University of the Arts), an appeal on behalf of the victims of the Russo-Japanese War (1894–95). The new institute's first endeavor was the Inten (Institute Exhibition), which aimed to foster the modern form of Japanese painting known as Nihonga. Taikan took to heart Okakura's advice to paint Nihonga on the same grand scale as Yōga, and to the first Inten exhibition in 1898 submitted *Qu Yuan* (*Kutsugen*, 1898; Itsukushima shrine [Itsukushima-jinja]), a depiction of the eponymous Chinese poet and minister (343–278 BCE) who was forced into exile after being slandered at court. Taikan endowed the work with a sense of pain and sadness, and there is speculation that his model was Okakura.

In the early years of the Inten, with Okakura's encouragement, Taikan and Shunsō also experimented with an ambitious new style that emphasized atmosphere, color, and light over outline. They ran into trouble, however, when critics dismissed their approach as both an imitation of Western methods and the "hazy style" (*mōrō-tai*). The Inten gradually lost momentum and closed in 1903. In 1906, Okakura opened a studio in Izura, Ibaraki prefecture, where for a few years Taikan, Shunsō, Kanzan, and Kimura Buzan (1876–1942) lived and worked together. Over subsequent decades Taikan would emerge as the leader of the Nihonga movement.

Aware of the looming divisions between Nihonga and Yōga, and perhaps hoping to bring order to the contemporary art world, the Japanese government's Ministry of Education in 1907 founded the Art Exhibition of the Ministry of Education (Monbushō Bijutsu Tenran-kai, usually abbreviated as Bunten). This was the first Japanese art exhibition convened directly under government auspices, and it is often identified as the beginning of modern Japanese academism. Occasionally the target of antigovernment

disapproval, the Bunten in fact introduced a number of paintings now celebrated as landmarks. For the first Bunten, Shimomura Kanzan submitted *Autumn through the Trees* (1907; National Museum of Modern Art, Tokyo), an original work blending the decorative style of Rinpa with the approach to natural light usually found in Western painting. Wada Sanzō contributed *Southerly Wind* (1907; National Museum of Modern Art, Tokyo), which shows a lively depiction of the ocean, although the heroically posed central figure appears rather static, as if posing in a studio. For the third Bunten, Shunsō submitted *Fallen Leaves* (1909; Eisei-Bunko Museum, Tokyo), a beautiful piece of work with its delicately painted bark and leaves, airy perspectival space, and overall tranquil atmosphere reminiscent of Chinese Southern Song-style painting as well as the lyricism found in quiet *wabi* simplicity [Fig. 30].

4. Painting in Kyoto and Tomioka Tessai

In contrast to Tokyo, Kyoto's art circles accepted modernization in a spirit of relative calm. For almost a century, the mainstream of Kyoto painting had been the Maruyama-Shijō tradition of realism, which provided grounds for absorbing further developments in Western-style realism, although artists in Kyoto were also receptive to newer movements. This balanced appreciation is evident in the 1880 founding of the Kyoto Prefectural Painting Academy (now Kyoto City University of the Arts) a full eight years before the Tokyo School of Fine Arts. The school offered courses in both Nihonga

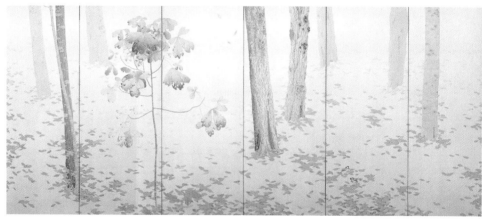

Fig. 30: (This page and opposite) Hishida Shunsō, *Fallen Leaves*, 1909, Eisei-Bunko Museum, Tokyo

and Yōga (called "Seishū," Western school), unlike the Tokyo School of Fine Arts where it took seven years to create a department for Western-style painting; and the professors there included the Maruyama-Shijō painter Kōno Bairei (1844–1895) as well as the literati artist Tanomura Chokunyū (1814–1907), who had trained under Tanomura Chikuden (see Chapter 9), an indication that Fenollosa's harsh criticism of literati painting had not dimmed the style's popularity in Kyoto.

Despite the rapid changes associated with modernization, however, one artist remained happily absorbed in the mythological world of the ancient Daoist immortals: Tomioka Tessai (1836–1924). Tessai was born in Kyoto into a merchant family that sold priests' robes. He received formal training in the Chinese Wang Yangming branch of neo-Confucian philosophy and the study of Japanese and Chinese classical poetry and literature, but also taught himself painting, not only in the *bunjin-ga* (literati painting) style but also in the *Yamato-e* style including Rinpa. While serving as a Shinto priest at various shrines, he devoted himself to reading and calligraphy as well as traveling. His reputation as a literati artist was established by the time he reached his forties, but when he reached his sixties, particularly more so in the eighties, his style became endowed with exquisite charm. One can hardly believe that he produced *Two Divinities Dancing* (1924; Tokyo National Museum) [Fig. 31], a vivid and sensual depiction of the deities Sarutahiko and Ame-no-uzume dancing in a mountainous land-scape, just before his death at the age of eighty-nine. The widely accepted view is that Japanese literati painting ended with Tessai's death. However,

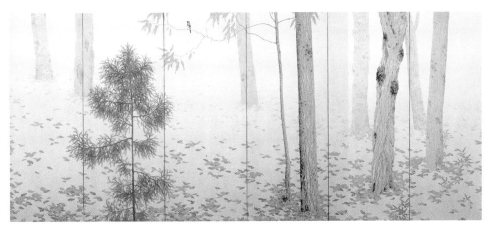

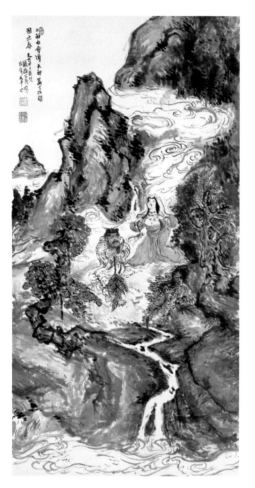

it is possible to see later artists such as Ogawa Usen (1868–1938), Kumagai Morikazu (1880–1977), Kosugi Hōan (1881–1964), Yorozu Tetsugorō (1885–1927), Umehara Ryūzaburō (1888–1986), and Nakagawa Kazumasa (1893–1991) reinterpreting and keeping the tradition alive in various ways.

Takeuchi Seihō (1864–1942) first studied Maruyama-Shijō realism under Kōno Bairei, but after hearing Fenollosa lecture in Kyoto he began to pursue a closer study of earlier masters. He then traveled through Europe from 1900 to 1901, and upon his return delivered a lecture in which he

Fig. 31: Tomioka Tessai, *Two Divinities Dancing*, 1924, Tokyo National Museum

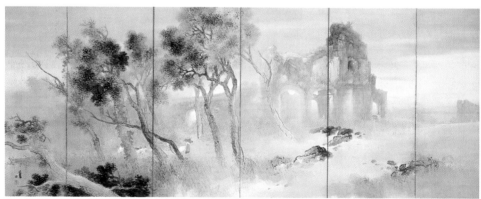

Fig. 32: (This page and opposite) Takeuchi Seihō, *Historic Spots of Rome*, 1903, Umi-Mori Art Museum, Hiroshima prefecture

reported discovering that modern Western painting not only represented a realistic vision of reality, but also possessed an expressionistic quality. This view lies behind his romanticized portrayal of a ruined Roman viaduct in the pair of six-fold screens *Historic Spots of Rome* (1903; Umi-Mori Art Museum, Hiroshima prefecture) [Fig. 32]. Seihō successfully reinterpreted the traditions of Japanese and Chinese painting through his own experience of Western art, an approach that galvanized the modernization of Kyoto Nihonga and earned him many followers.

5. Architecture and the Expression of Tradition

Itō Chūta and His Work

A student of Tatsuno Kingo, Itō Chūta (1867–1954) graduated from the Imperial College of Engineering in 1892, with a dissertation titled "A Philosophy of Architecture," in which, like Conder, he argued that the essence of architecture rests in its beauty rather than its function; he also suggested that beauty could be discovered in the styles of the past. His approach recalls the historicism popular in the contemporary Western countries as mentioned earlier, as well as the theories being proposed by Okakura Kakuzō around the same time. The following year Itō presented a famous paper, "Report on the Architecture of Hōryū-ji Temple" (published 1898), in which he claimed that the swelling midsection (entasis) of the columns of Hōryū-ji's Middle Gate (Chūmon) was inspired by the columns of the Parthenon in Athens.

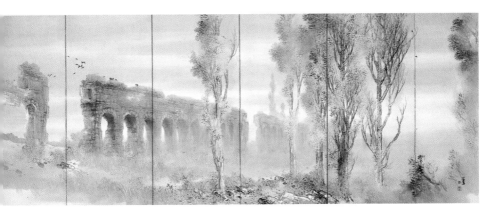

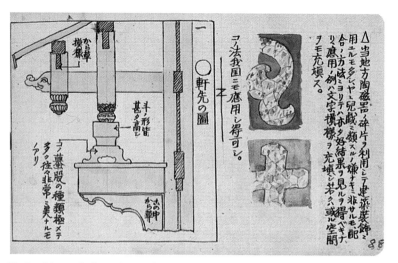

Fig. 33: Itō Chūta, "Chengdu, Sichuan Province" (November 8, 1902) from *Itō Chūta kenbun yachō: Shin koku III* (*Itō Chūta's Field Notes: Qing, Vol. III*), Architectural Institute of Japan, Tokyo

Itō later spent three years (1902–05) traveling through China, India, Turkey, and Greece to gather proof for his theory, and during this period also led the first expedition (1903) to study the Yungang grottos in northeast China [Fig. 33]. Pioneering in his methods as well as his research, Itō advocated that Japan move away from construction in traditional wood to building with inflammable stone. His later works, constructed in Tokyo, include the Okura Museum of Art (1927), Yushima Seido (1934), and Tsukiji Hongan-ji temple (1934), built in the style of an Indian Buddhist temple. A similar respect for ancient traditions and skillful blending of Japanese and Western architectural elements and materials can be seen in Nagano Uheiji's Nara Prefectural Office (1902). Takeda Goichi's (1872–1938) "Teahouse Architecture" (1899) was the first research report on teahouse design prepared by a trained architect.

Influences from Art Nouveau and Historicism

Art Nouveau influenced Japanese architecture as well as its painting. Beginning with the architectural designs prepared in 1901 by Takeda Goichi during his visit in Europe, Art Nouveau residential houses remained popular in Japan into the 1910s. However, it was not Art Nouveau but historicism reinforced by the American Beaux-Arts style which formed

the mainstream of modern Japanese architecture well into the 1930s. Beaux-Arts was a Greek- and Roman-inspired classicizing style favored by American architects who studied in Paris, and it dominated American architecture from the end of the nineteenth century into the 1920s. Examples in Japan include the Osaka Prefectural Library (1904) by Noguchi Magoichi (1869–1915), the Tokyo Stock Exchange Building (1927) by Yokogawa Tamisuke (1864–1945), and the Nihon Kangyō Bank (1929) by Watanabe Setsu (1884–1967). And a masterpiece of British-style historicism, as advocated by Conder and Tatsuno, is Keiō University's Old Library (Kyū-toshokan; 1912), designed by Chūjō Seiichirō (1868–1936).

III. In Search of Free Expression:
Art of the Late Meiji and Taishō Eras (1900s–10s)

Through most of the Meiji era, Japanese artists had taken European academism as their standard, but then Impressionism, Post-Impressionism, Fauvism and other art movements began inexorably calling that standard into question. In sculpture, Auguste Rodin (1840–1917) started work on the *Gates of Hell* as early as 1880. The influential fin de siècle proto-Expressionist artist Edvard Munch (1863–1944) painted his *Scream* in 1893. Fauvism emerged in France during the early 1900s, in conjunction with expanding interest in van Gogh and Gauguin, and simultaneously with German Expressionism. Cubism was born around 1907–08, following in the footsteps of Cézanne; in 1909 the Italian poet Filippo Tommaso Marinetti (1876–1944) published the Futurist manifesto, while in 1911 Wassily Kandinsky (1866–1944) and other artists formed the Blaue Reiter (1911–14), with the participation of Paul Klee (1879–1940). Academicism fell completely out of fashion, to be replaced by free artistic self-expression.

The trend reached Japan quite quickly. For example, in a now-famous essay titled "A Green Sun" (Midori iro no taiyō; 1910), published in the literary magazine *Subaru* (meaning "the Pleiades," 1909–13), the sculptor and author Takamura Kōtarō (1883–1956) declared, "If someone were to paint the sun green, I would not say that he is wrong." In the same year, the founding of the literature and arts journal *White Birch* (*Shirakaba*, 1910–23) brought modern European artistic developments to the attention

of a younger generation of Japanese artists. The journal published color plates of images discussed in the text, offering a first glimpse of the art being produced in Europe at that time. The journal's groundbreaking special issue on Vincent van Gogh (1912) ran to ninety pages. Also in 1912, Ishii Hakutei (1882–1958) returned from France and reported in the journal *Waseda Literature* (*Waseda Bungaku*, 1891 onwards), "A major change is taking place in art circles in the West." The same shift occurred in Japan. The next section will address the new mode of self-expression that emerged in Japanese art at this time; new expressionistic painting, the modern history of the woodblock print; developments in modernist sculpture; and modernism in architecture.

1. Self-Awareness and Self-Expression

Inspired and motivated by the ongoing ferment in the art world, Yorozu Tetsugorō (1885–1927) astonished his professors and colleagues at the

Tokyo University of the Arts with his graduation painting, *Nude Beauty* (1912; National Museum of Modern Art, Tokyo) [Fig. 34]. As he later commented, this unconventional work, which depicts a seminude woman reclining on the grass and looking contemptuously downward, in a sense symbolized Yorozu's contempt for his seniors, who were still making an over-serious effort to come to grips with Yōga. Originally from Iwate prefecture in the northern part of Japan, Yorozu used the raw energy of his regionalism to produce a breakthrough painting in the history of the Japanese avant-garde. Areas far from urban centers continued to hold his interest, as seen in such works as *Woman with a Boa* (1912; Iwate Prefectural Art Museum), *Nude with a Parasol* (1913; Museum of Modern

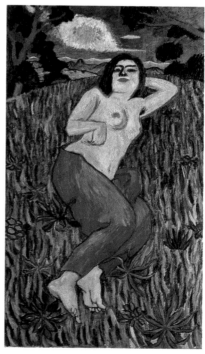

Fig. 34: Yorozu Tetsugorō, *Nude Beauty*, 1912, National Museum of Modern Art, Tokyo

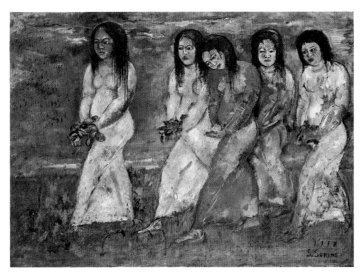

Fig. 35: Sekine Shōji, *Sorrow of Faith*, 1918, Ohara Museum of Art, Okayama prefecture

Art, Kamakura and Hayama), *Female Nude: Resting Her Chin on Her Hand* (1926; Tokyo Metropolitan Art Museum), and *Bathing Costume* (1926; Iwate Prefectural Museum). In these years Yorozu also painted the Cubist near-parody *Leaning Woman* (1917; National Museum of Modern Art, Tokyo). Possessing great knowledge of Nanga (literati painting)—he even published a study of Tani Bunchō (1763–1840; see Chapter 9)—Yorozu developed a version of free expression closely tied to Nanga; a lineage of what may be called "Nanga Expressionism" links him to Tomioka Tessai.

Younger artists after Yorozu also took up the challenge of painting in a direct and personally expressive manner. When he was only nineteen, for example, Sekine Shōji (1899–1919) produced *Sorrow of Faith* (1918; Ohara Museum of Art, Okayama prefecture), a work suffused with both despair and reverence [Fig. 35]. Like Sekine, the artist and poet Murayama Kaita (1896–1919) who painted *Woman beside a Lake* (1917; Pola Museum of Art) also suffered an early death. Murayama conveyed emotions of exultation in his paintings and poems.

The system of organized painting circles and official exhibitions soon felt the effects of this artistic turmoil. Inspired by the directness of the Post-Impressionists, a group of artists, including Takamura Kōtarō and Kishida Ryūsei (discussed below), in 1912 formed the Fuzankai (Charcoal Sketching Society; from the French word *fusain*, or charcoal), aiming to advance the cause of expressionism in Japan. In 1914, Tsuda Seifū

(1880–1978), Yamashita Shintarō (1881–1966), Arishima Ikuma (1882–1974) and other Yōga painters organized the inaugural Second Division Society (Nika-kai) show, an independent exhibition organized protesting the selection process behind the Ministry of Education's Bunten. Nika-kai artists labeled the Bunten and the White Horse Society, including Kuroda Seiki, as "old school." That same year, Yokoyama Taikan revived the Japan Art Institute exhibition both to honor the memory of Okakura Kakuzō (who had died the year before) and to critique the standards of the Bunten.

In 1916, several established artists associated with the Nihonga style quit the Bunten and, spurred on by the success of the Nika-kai, formed the Kinrei-sha (Gold Bell Society), hoping (as the name of their organization suggests) to set a pure tone ringing through the contemporary art world. Two years later a number of artists based in Kyoto also split from the Bunten to form the Association for the Creation of a National Painting (Kokuga Sōsaku Kyōkai). At last, to prevent further criticism and revolt, the Bunten in 1919 reorganized and took on the new name of Imperial Academy of Art (Teikoku Bijutsuin), accompanied by a new exhibition known as the Teiten (Academy of Fine Arts Exhibition). In subsequent years the conflicts in the art world resulting in the formation and dissolution of multiple painting circles would be a consistent theme.

While Yorozu and Sekine sought to express their artistic vision through unique styles influenced by the most recent European innovations, other artists sought inspiration in the type of traditional realism achieved by Takahashi Yuichi, an artist who aimed to recreate objects in paint. One of the leading figures in this development was Kishida Ryūsei (1891–1929). Kishida had been a member of the White Horse Society, but he came into his own only after the journal *White Birch* introduced him to reproductions of post-Impressionist works. Subsequently he began to study the work of Albrecht Dürer (1471–1528), Anthony van Dyck (1599–1641), and other masters of the Northern European Renaissance. Between 1915 and 1916, at the Sōdosha (Plants and Soil Society) exhibition that he himself convened, Kishida showed a series of landscapes meticulously worked to an almost super-realistic degree. The paintings include *Road Cut through a Hill* (1915; National Museum of Modern Art, Tokyo), and *Dry Road in Winter* (*Sketched in the Vicinity of Harajuku, Sun on Red Soil and Grass*) (1916; Niigata Prefectural Museum of Modern Art) [Fig. 36]. Kishida's obsession in recreating every detail in his painting gave the landscape a life of its own; the swell of the earth has a super-naturalistic appearance

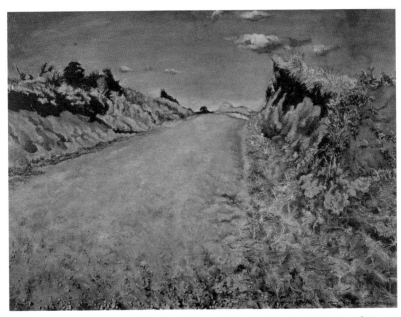

Fig. 36: Kishida Ryūsei, *Dry Road in Winter (Sketched in the Vicinity of Harajuku, Sun on Red Soil and Grass)*, 1916, Niigata Prefectural Museum of Modern Art/Niigata Bandaijima Art Museum

that one could almost describe as "monsters depicted in soil."

Kishida's visual style was quite unique for his time, especially when one considers that Andre Breton's (1896–1966) Manifesto of Surrealism (1924) was only a few years away. Kishida took a similar approach in his famous series of portraits of his young daughter Reiko, although these seem infused with an interest in Asian art, since his daughter's smiling expression often recalls traditional representations of the ancient Chinese monk Hanshan [Fig. 37]. Kishida was also interested in the art of the Edo period

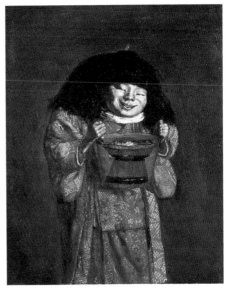

Fig. 37: Kishida Ryūsei, *Natural Girl (Yadōjo)*, 1922, entrusted to the Museum of Modern Art, Kamakura and Hayama

(Chapter 9). In his book *Early Ukiyo-e Painting* (Iwanami Shoten, 1926) he confesses that the charm of decadent Kan'ei-era beauties provided some solace when he experienced frustration in his artistic activities. He planned to break through such frustrations further with a trip to Europe, but died at the age of thirty-eight before having the chance.

For the sake of the art he managed to produce, it was perhaps fortunate that Kishida never came face to face with the majestic tradition of European painting and the thriving modernist movement that countered it. The same may be said also of other artists who never traveled abroad, such as Aoki Shigeru, Yorozu Tetsugorō, Sekine Shōji, and Nakamura Tsune (1887–1924). Nakamura had to express his passion for the unseen Europe, his devotion to Renoir and Rembrandt, through works he exhibited at the Bunten and Teiten. His portrait of the blind Russian Esperantist, writer and educator Vasili Eroshenko (1890–1952) (1920; National Museum of Modern Art, Tokyo) is filled with a humanist pathos that vividly projects its subject [Fig. 38].

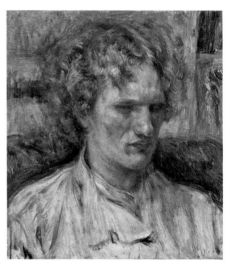

Fig. 38: Nakamura Tsune, *Portrait of Vasilii Yaroshenko*, 1920, National Museum of Modern Art, Tokyo

2. The Later Woodblock-Print Tradition: New Prints and Creative Prints

The great tradition of Edo color woodblock prints suffered greatly later in the Meiji era due to the high cost of producing prints using woodblocks compared to such cheap new technologies as lithograph and photogravure. Skilled woodblock cutters and printers were forced out of business, leaving Kobayashi Kiyochika (discussed above) and his colleagues the last generation of artists whose work was reproduced through woodblock printing on a broadly popular scale. However, the tradition did not entirely disappear. Observing the general decline of the genre, the publisher Watanabe Shōzaburō (1885–1945) saw an opportunity to produce what he called "new

prints" (*shin hanga*) to the highest standards of Edo ukiyo-e, using the most refined woodblock techniques to print the work of top artists. He embarked on this experiment in 1915 with Hashiguchi Goyō (1880–1921), and soon found willing partners in Kawase Hasui (1883–1957) for landscapes and Itō Shinsui (1898–1972) for pictures of beautiful women. Hasui, who learned his art from Kaburaki Kiyokata (1887–1972) like Shinsui, was perhaps Watanabe's most loyal artist.

In the popular realm, one artist did manage to keep the spirit of Edo ukiyo-e alive, and in so doing became a superstar of the Taishō era: Takehisa Yumeji (1884–1934). Yumeji was a self-taught artist from western Japan who arrived in Tokyo with the goal of becoming a painter. A man of popular sympathies and Socialist interests, he contributed illustrations and poems to a wide variety of newspapers and journals. The lyrics to the famous song "Yoimachigusa" (Evening Primrose) are also by him. His "Yumeji-style beauties" capture the essence of the ukiyo-e tradition going back to Suzuki

Harunobu (1725?–1770), and are generally regarded as the epitome of Taishō-era Romanticism [Fig. 39]. His posters also made an influential contribution to the world of commercial design. In addition to these activities, Yumeji explored the world of "creative prints" (*sōsaku hanga*) through his friendship with Onchi Kōshirō (discussed below).

When the Expressionist woodblock prints of Edvard Munch and the Symbolist copperplate etchings of Odilon Redon (1840–1916) began appearing in such Japanese art journals as *White Birch* and *Art News* (*Bijutsu Shinpō*) during the late nineteenth and early twentieth century, they created a sensation among Japanese artists. Soon print artists such as Yamamoto Kanae (1882–1946) were advocating the

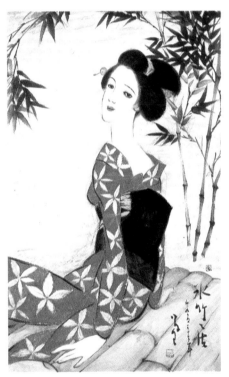

Fig. 39: Takehisa Yumeji, *Suichikukyo* (Dwelling amidst Water and Bamboo), 1933, Takehisa Yumeji Museum, Tokyo

importance of the artist's personal involvement in producing the printing medium—carving the blocks or preparing the etching plate—with the aim of producing "creative prints" (*sōsaku hanga*) that truly reflected the artist's intention.[4] Yamamoto's *Fisherman*, his first exercise in the area of "creative prints," was published in 1904 in the journal *Bright Star* (*Myōjō*). He gave a more detailed presentation of his ideas in the art and literary journal *An Inch Square* (*Hōsun*, 1907–11), which he co-founded with Ishii Hakutei in 1907. Yamamoto later produced a fine series of prints related to Brittany (1920) following a period of study in France during the mid-1910s.

Many artists built on Yamamoto's initiatives, but the figure who eventually emerged as the leader of the *sōsaku hanga* movement was Onchi Kōshirō (1891–1955), whose early work appeared in *Moonglow* (*Tsukuhae*), the poetry and print journal that he helped to found. Based on this early work, Onchi has sometimes been acclaimed as the forerunner of Japanese abstract painting, but he also created highly lyrical prints influenced by the Symbolists, using multiple woodblocks that he had carved and prepared himself in combination with other materials. Over the course of his long career Onchi produced only seven portraits, but among these is one of his most important works, *Portrait of the Author of "Hyōtō"* (*Hagiwara Sakutarō*) (1943), in which he skillfully used transparent layers of color to suggest the complexity and sensitivity of this thoughtful poet's mind [Fig. 40].

German Expressionism and French Symbolism inspired numerous other Japanese artists to devise their own modes of personal expression; among these were Tanaka Kyōkichi (1892–1915), Fujimaki Yoshio (1911–1935?), and Taninaka Yasunori (1897–1946). Having lived the last two years of his short life with tuberculosis, Tanaka's works are filled with angst and yearning. Fujimaki's main subject was the solitude and anxiety associated

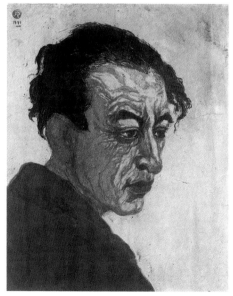

Fig. 40: Onchi Kōshirō, *Portrait of the Author of "Hyōtō"* (*Hagiwara Sakutarō*), 1943, National Museum of Modern Art, Tokyo

with urban life, while Taninaka tended more to depictions of fantasy. Another important artist of this period, Kawakami Sumio (1895–1972), in 1916 created *Early Summer Breeze* (Kanuma Municipal Art Museum of Kawakami Sumio, Tochigi prefecture), a print whose intimacy and modernity inspired the young Munakata Shikō (discussed below) to embark on a career as a print artist.

3. Sculpture, an Expression of Life

In the decades after Vincenzo Ragusa introduced the practices of Western-style sculpture to Japan, numerous Japanese artists adopted the medium as a vehicle of self-expression, particularly from the early 1900s onward. Auguste Rodin was perhaps the most influential figure at this time, even attracting Japanese apprentices such as Fujikawa Yūzō (1883–1935). Fujikawa learned from Rodin the importance of remaining true to his own nature in his art, as reflected in his calm and gentle work titled *Blonde* (1913; National Museum of Modern Art, Tokyo). Rodin's *The Thinker* had a great impact on Ogiwara Morie (Rokuzan) (1879–1910) when he saw it in Paris in 1903, and eventually led to his decision to become a sculptor. By an interesting coincidence, in the same year that Ogiwara completed his important work, *Woman* (1910; National Museum of Modern Art, Tokyo), the journal *White Birch* published a special issue on Rodin. The problem of existence was an important subject for many younger artists at the turn of the century, as is evident in the twisting form of *Woman*, which conveys an impression of life as an experience of conflict.[Fig. 41]. Ogiwara's close friend Takamura Kōtarō also admired Rodin, as shown in his sculpture *Hand* (1918; Kure Municipal Museum of Art, Hiroshima prefecture), which combines a Rodin-esque vitality with Buddhist symbology [Fig. 42]. Sculptures by other contemporary artists such as Tobari Kogan (1882–1927) and Nakahara Teijirō (1888–1921) emanate a similar vital energy.

4. Modernism in Architecture

Like Takamura Kōtarō in his essay, "A Green Sun," and Yorozu Tetsugorō in his graduation painting of 1912 and other work, Japanese architects of this time pursued the ideal of self-expression through art. The Osaka architect Yasui Takeo (1884–1955) was a leader in this area, standing out even at the time of his graduation in 1907, when for his final project he

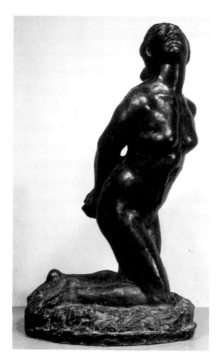

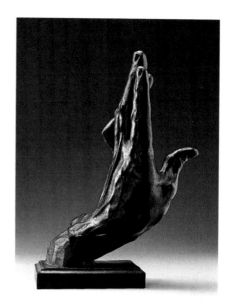

Fig. 42: Takamura Kōtarō, *Hand*, 1918, Kure Municipal Museum of Art, Hiroshima prefecture

Fig. 41: Ogiwara Morie, *Woman*, 1910, National Museum of Modern Art, Tokyo

submitted plans for a traditional Japanese *sukiya*-style house instead of the Western-style building tacitly expected by his tutors and fellow students. In his individualistic work, Yasui was also early to incorporate aspects of Art Nouveau, a style then overtaking historicism as an approach to design. Yasui later designed buildings in what architect and architectural historian Fujimori Terunobu (b. 1946) has called an "extremely personal manner" undefined by nationalities or any particular culture. Among these is the Osaka Club (1924), which almost seems to poke fun at existing architecture designed in the manner of historicism.

Although Art Nouveau was a primary feature of modernism in Europe and the United States, modernist architects there soon took issue with its focus on surface ornament and headed in the direction of almost pure non-ornamentation, resulting in what Fujimori in 1993 evocatively called "box-like buildings with smooth, flat surfaces, like blocks of tofu."[5] In Japan, however, modernist architecture combined aspects of the anti-traditionalist Expressionism that emerged as a trend in German architecture during the 1910s with elements of the Art Deco movement, which during the 1920s

and '30s replaced the curvilinearity of Art Nouveau with functional straight lines and geometry.

An important proto-Expressionist architect in Japan was Gotō Keiji (1883–1919), known particularly for designing Toyotama Prison (completed in 1915). Only the main gate of this Taishō-era masterpiece survives, but photographs sufficiently convey its ample volume and freely expressive individuality. A short-lived genius, Gotō believed that architectural design should respond to the ways of the universe and nature; this idea inspired younger architects and led to the formation of the Japan Secessionist movement, which had close affinities with Expressionism. The Japanese Secessionists aimed to design buildings that countered the architect Noda Toshihiko's (1891–1929) 1915 idea of the "Theory of Inartistic Architecture." They took encouragement from the work of American architect Frank Lloyd Wright (1867–1959), who around this period visited Japan and designed the partially Maya-inspired style Imperial Hotel (completed in 1923; partly preserved at the Museum Meiji-mura in Aichi prefecture). Representative of the Secessionists' approach, and a high point of Japanese Expressionism, is the thatch-roofed residence Shiensō (Purple Smoke) (1926; now demolished) built by Horiguchi Sutemi (1895–1984) in Warabi, Saitama prefecture [Fig. 43]. When Expressionism came to an end around the late 1920s to early 1930s, Japanese architects began to push modern design in new directions. For example, Yoshida Isoya (1894–1974) formulated a synthesis of modernism and traditional *sukiya* Japanese architecture (see Chapter 8) that came to be called the "new *sukiya* style."

Meanwhile, the Art Deco movement particularly caught the imagination of Prince and Princess Asaka. Upon returning to Japan after a trip

Fig. 43: Horiguchi Sutemi, Shiensō, 1926, formerly in Warabi, Saitama prefecture (no longer extant)

through Europe and the United States, during which they visited the 1925 Exposition Internationale des Arts Décoratifs et Industriels Modernes in Paris, the imperial couple ordered construction of an entirely new Art Deco mansion (completed in 1933; now the Tokyo Metropolitan Teien Art Museum).

IV. Maturity and Setbacks for Modern Art:
Taishō through Early Shōwa Eras (1910s–1945)

Although the terms "Taishō Romanticism" and "Taishō Democracy" were formulated long after the period they describe (1912–26), they capture the generally buoyant mood of the era, and particularly the attitude of the emerging middle class, whose constituents strove to break away from older traditions. The art world, freed from the government-controlled exhibition system of the early 1910s, also experienced changes and developments. Many of these originated in the decisive economic upturn and subsequent boom that followed Japan's victory over Russia in the Russo-Japanese War (1904–05), a period of prosperity that continued through World War I (1914–18). However, the shadows of economic difficulty and political conflict lengthened again in the form of the postwar depression, the Great Kantō Earthquake (1923), and mounting political and civil restrictions, including the Peace Preservation Law (1925) forbidding changes in the political system and outright suppression of the Japanese Communist Party (1928)—all compounded by the Great Depression (1929 onward) worldwide.

In 1931 the Japanese army staged a minor explosion near a rail line in Manchuria, claiming it to be the act of a Chinese dissident. The army used this event, known as the Manchurian (or Mukden) Incident, as a pretext for invading northeast China, and engineered the assassination of Prime Minister Inukai Tsuyoshi (1855–1932) in the following year (which is the year the author of this book was born). These assaults on democratic politics by the army were surpassed in severity only by the attempted coup d'état of February 26, 1936 and the outbreak of the Second Sino-Japanese War (1937–1945). How did the world of art fare under these conditions? The next section will consider the maturation of Yōga; the modernization

of Nihonga; the emergence of a true avant-garde; Japanese Surrealism; painting in wartime; and architecture after the Great Kantō Earthquake.

1. Western–Style Painting Reaches Maturity

For Japanese at the beginning of the Meiji era, the gateway to the world of Western art was Italy, the birthplace of the Renaissance, but by the end of the nineteenth century young Japanese artists recognized that the center of the art world had moved decisively to France, and especially Paris. Accordingly, Paris became the goal for those aspiring to master the styles and techniques of the time. We have already encountered the examples of Asai Chū and Kuroda Seiki, as well as Kanokogi Takeshirō and his colleague Nakamura Fusetsu, who like numerous other Japanese students trained under the French academic painter Jean-Paul Laurens at the Académie Julian.

Another of Laurens' students was Yasui Sōtarō (1888–1955), a native of Kyoto who had studied with Asai Chū before traveling to Paris in 1907 and entering the Académie, where he soon began winning top awards in sketching competitions. Yasui remained in Paris until he was forced to return home upon the outbreak of World War I. Back in Japan, in 1915 he debuted at the second Nika-kai exhibition with a number of works he had painted while in France, including *Woman Washing Her Feet* (1913; Museum of Modern Art, Gunma), a portrait of a woman seated in a simple wooden chair washing her feet in a wooden tub. These works demonstrated his stylistic shifts from academism to that of Cézanne, and consequently drew positive reviews. However, like many of his repatriate colleagues, Yasui had to go through a fifteen-year-period of searching. Eventually he established a unique style, as seen in his *Landscape at Sotobō* (1931; Ohara Museum of Art), and from that time produced landscapes and portraits using an unexpected combination of transparent colors and viscous, almost clay-like forms [Fig. 44]. His dedication to Cézanne's method of deforming pictorial motifs often resulted in unnaturally formed motifs in his own paintings, but otherwise his work offered a solution to a difficult problem that many Western-style painters in Japan had to face: how to be creative, Japanese, and modern.

Umehara Ryūzaburō (1888–1986) was born into a merchant family in Kyoto where, like Yasui, he studied painting under Asai Chū before enrolling in the Académie Julian in 1908. A 1909 visit with Pierre-Auguste

Fig. 44: Yasui Sōtarō, *Landscape at Sotobō*, 1931, Ohara Museum of Art, Okayama prefecture

Renoir (1841–1919) in southern France, however, fixed in Umehara's mind the determination to become a master colorist. After returning to Japan in 1913, he introduced a new approach to Japanese oil painting in the form of a rich and varied palette demonstrating his natural talent as a colorist, almost as though Rinpa-style ornamentation had been liberated by the expressive manner of Tomioka Tessai, for whom he had great respect. In contrast to Yasui's intellectual approach to painting, Umehara was more intuitive in his pursuit of Japanese-style oil painting. Umehara's technical experiments included blending traditional mineral pigments not with animal glue (as is standard in East Asian painting) but with oil. He is best represented by a series of landscapes of Beijing, in particular *Autumn Sky over Beijing* (1942; National Museum of Modern Art, Tokyo) [Fig. 45].

In 1913, three years after graduating from the Tokyo School of Fine Arts, Foujita Tsuguharu (also known as Foujita Tsuguji or Léonard Foujita,

Fig. 45: Umehara Ryōzaburō, *Autumn Sky over Beijing*, 1942, National Museum of Modern Art, Tokyo

1886–1968) went to Paris seeking further training. There he expended considerable effort developing a unique style consisting of thin, delicate lines painted over a milky white ground; this technique lent his female nudes and other portraits of women an exotic sensuality and earned him great success [Fig. 46]. A popular figure at the École de Paris during the 1920s —indeed, no other modern Japanese painter was as well liked in France— in 1931 Foujita flew with his third wife to Brazil to travel throughout Latin America, where his exhibitions were enthusiastically attended. By 1933 he had returned to Japan; from around 1938 and throughout the Pacific War (1941–45) he produced propaganda paintings as an official war artist.

During the brief period of economic prosperity that followed the end of World War I, perhaps as many as five hundred young Japanese artists traveled to Europe and the United States. Among them was Koide Narashige (1887–1931), who debuted as a painter at the 1919 Nika-kai exhibition with *Family of N* (Ohara Museum of Art), a dark-toned portrait of the artist with his wife and young son seated behind a Western-style still life. A trip to Europe in 1921–22 affected Koide's style profoundly. This is perhaps best seen in his new approach to the female nude, which he now depicted in a compact and almost tactile manner, one example being *Female Nude on*

Chinese Bed (Female Nude A) (1930; Ohara Museum of Art) [Fig. 47]. Western-style artists had been producing oil paintings that were somewhat halting and heavy in feeling; from Fujishima Takeji's generation to Koide's, however, artists began to learn a better way to handle the pigments in a way more suited to their culture.

Sakamoto Hanjirō (1882–1969) came to Tokyo with Aoki Shigeru, who was from the same town in Kyushu, but studied at the Pacific Painting Society in Tokyo. One of his early paintings, *Fading Sunlight* (1912), exhibited at the

Fig. 46: Foujita Tsuguharu, *Spanish Beauty*, 1949, Toyota Municipal Museum of Art © Fondation Foujita/ADAGP, Paris & JASPAR, Tokyo, 2018 E3000

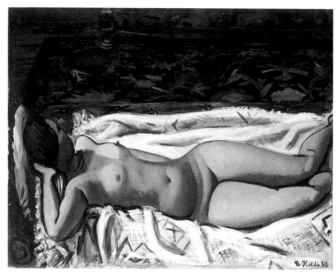

Fig. 47: Koide Narashige, *Female Nude on Chinese Bed* (*Female Nude* A), 1930, Ohara Museum of Art, Okayama prefecture

Bunten in 1912, depicts a docile black-and-white bull standing on the shore near the sea. The overall use of silver-gray tones to represent natural light lends the painting and its principal subject an air of tranquility; when the author Natsume Sōseki (1867–1916) saw it at the Bunten, he was moved to remark, "The bull in this picture is thinking." Sakamoto developed a new soft-toned palette while studying in France from 1921 to 1924, as seen in *Woman with a Hat* (1923; Bridgestone Museum of Art). After returning to Japan, he worked alone in his hometown of Yame, Fukuoka prefecture, taking his subjects from his neighborhood and producing bucolic landscapes and scenes of horses in fields and on the shores. His coloration grew ever softer and paler, rendering his works more and more symbolic, until in his late work he was able to suggest an almost indefinable world of subtlety and profundity, as seen in his *Noh Mask* series (Pola Museum of Art).

Like Foujita before him, Saeki Yūzō (1898–1928) graduated from the Tokyo School of Fine Arts and shortly afterward, in 1924, headed to France for further training. There he met Maurice de Vlaminck (1876–1958), who promptly criticized his style as being too academic. Saeki thereupon adopted Vlaminck and Maurice Utrillo (1883–1955) as his new models, and devoted himself to sketching sights around Paris. Unfortunately, he fell ill with tuberculosis and was forced to return to Japan in 1926; once home, he seems not to have been able to assimilate himself into his native

Fig. 48: Saeki Yūzō, *Gas Street Lamp and Advertisements*, 1927, National Museum of Modern Art, Tokyo

landscape. A year later, after winning recognition at the thirteenth Nika-kai exhibition, he returned to Paris, but due to overwork his health deteriorated once again, and he suffered a nervous breakdown resulting in further complications that led to his early death at the age of thirty-one.

Blending expressive and poetic elements inherited from Vlaminck and Utrillo respectively, Saeki established a sensitive style conveying a new artistic point of view through his keen insights. For example, in his *Gas Street Lamp and Advertisements* (1927; National Museum of Modern Art, Tokyo), the shop signs and wall posters create a tense pictorial atmosphere [Fig. 48]. The prominence of writing in this work shows affinities with the role of calligraphy in the Japanese literati tradition. Saeki added an Eastern visual grammar to his Western-style paintings.

2. Modernization of Nihonga

In Tokyo, the Revival of the Inten (Japan Art Institute Exhibition)

During the 1910s and '20s a healthy rivalry between Nihonga painting circles in eastern and western Japan inspired a number of talented artists to put their best skills forward in the creation of many paintings now considered masterpieces of the style. Activity in the east centered on Tokyo, where

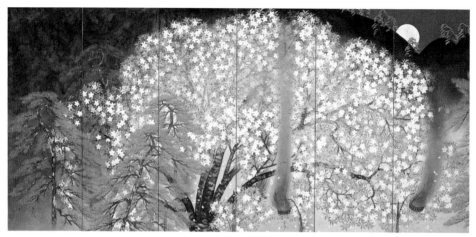

Fig. 49: Yokoyama Taikan, *Cherry Blossoms at Night*, left screen, 1929, Okura Museum of Art, Tokyo

Yokoyama Taikan orchestrated the revival of the Inten exhibition in 1914. His contributions to later Inten exhibitions included such major works as *Lively Perpetual Motion* (*Seisei ruten*, 1923; National Museum of Modern Art, Tokyo), a long landscape handscroll with ever-changing scenes suffused with soft mist; and *Cherry Blossoms at Night* (1929; Okura Museum of Art, Tokyo), a pair of six-fold screens in which the cherry blossoms appear to be glowing in the light of a full moon [Fig. 49].

A younger generation of Tokyo Nihonga artists—including Yasuda Yukihiko (1884–1978), Kobayashi Kokei (1883–1957), and Maeda Seison (1885–1977)—began making regular and important contributions to the art world even before the Inten's return to prominence. Yasuda and Kobayashi both developed original styles well suited to depicting romanticized versions of historical subjects. Relatively early in his career, for example, Yasuda produced *Yumedono Pavilion* (1912; Tokyo National Museum), a representation of Prince Shōtoku (574–622) seated in meditation. His later work, *Prayer at Time of Childbirth* (1914; Tokyo National Museum), was an imaginary visualization of the ceremony conducted in 1008 to ensure that Fujiwara no Akiko (or Shōshi) (988–1074) would safely deliver a child, the first event recorded in the diary of Murasaki Shikibu (c. 933–c. 1014), the author of the *Tale of Genji*. Around this time, Kobayashi painted *Heresy* (1914; Tokyo National Museum), showing three Japanese women of the Momoyama period (1573–1600) praying to an image of Jesus on the cross. Seison, meanwhile, mastered the use of shaded ink and colors without

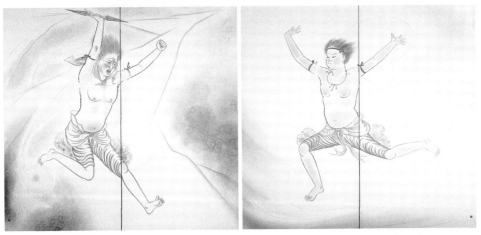

Fig. 50: Yasuda Yukihiko, *God of Wind and God of Thunder* screens, 1929, Tōyama Memorial Museum, Saitama prefecture

outlines (*mokkotsu-hō*), and with his superior descriptive skills produced work such as the *Healing Springs* triptych (1914; Tokyo National Museum) and the *Eight Famous Views of Kyoto* set of eight hanging scrolls (1916; Tokyo National Museum).

In 1923, Maeda Seison and Kobayashi Kokei accompanied the art historian Fukui Rikichirō (1886–1972) on a study trip to London, where they visited the British Museum and prepared a detailed copy of the museum's renowned *Admonitions Scroll* (c. fifth to eighth century CE), one of the earliest known Chinese handscrolls (the copy is now in the collection of the Tōhoku University Library). Studying the work of their Chinese predecessor opened the two artists' eyes to the art of lines in the East-Asian tradition. This included "iron wire drawing" (*tessenbyō*) technique, which had originally begun in Khotan during the late seventh to early eighth century. News of their encounter with this ancient art of lines seems to have reached Yasuda, for soon afterward he began combining extensive use of fluent lines with the *mōrō*-style subtle color gradations that had been a characteristic of his works, as seen in his *Solar Eclipse* (1925; National Museum of Modern Art, Tokyo). The painting depicts a group of officials in ancient China terrified by an inauspicious eclipse (an allusion to the history of King Yu in the *Classic of History*, c. 300 BCE). In his *Wind God and Thunder God* screens (1929; Tōyama Kinenkan), Yasuda took a step further in his employment of line, and used thin, hard iron wire line drawing reminiscent of Buddhist paintings [Fig. 50]. Kobayashi similarly employed

the technique to outline the figure of a partially nude young woman having her hair combed in his painting *Hair* (1931; Eisei-Bunko Museum) [Fig. 51]. The art critic Sakazaki Otsurō (1928–1985) once described these inorganic lines as being "inert and impossible for the eye to scan," and "unusually abstract line expression in Japanese-style painting." However, the use of these lines in Nihonga appear to be a late revival of the long-held East Asian tradition of line drawing. Maeda, in the meantime, was sufficiently impressed by the large-scale paintings and sculptures he saw in Europe and Egypt to produce his own large-scale works, including the powerful *Yoritomo in the Cave* (1929; Okura Museum of Art).

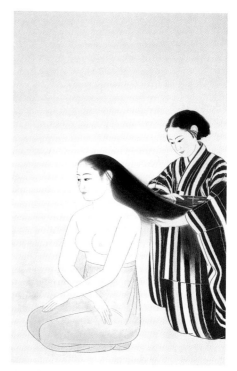

Fig. 51: Kobayashi Kokei, *Hair*, 1931, Eisei-Bunko Museum, Tokyo

Hayami Gyoshū (1894–1935), another Nihonga painter of this period, followed a somewhat different path. Influenced by the light-filled palette and theories of Nihonga reform in the work of Imamura Shikō (1880–1916)—both given practical application in Imamura's *Tropical Lands* handscroll (1914, Tokyo National Museum)—Gyoshū adopted a similarly luminous palette in a way that also demonstrated his awareness of European modernism. His style, however, underwent a significant, if temporary, change after a tram accident in 1919 cost him his left leg at the age of twenty-six. Over the next few years his work showed a tendency toward the fin-de-siècle symbolism shadowed by the presence of death. Works of this period include *Kyoto Dancing Girl* (1920; Tokyo National Museum), in which the subject is not shown performing, but quietly seated and dressed in a blue robe. The same dark tone recurs even in minutely painted, vividly colored flowers reminiscent of paintings by Dürer, such as folding screen with chrysanthemums (1921; private collection); and in his painting of sunflowers (1922; Reiyūkai Myōichi Collection, Tokyo). Also representative

of these years is the graceful and poetic but faintly morbid *Dancing in the Flames* (1925; Yamatane Museum of Art, Tokyo), which depicts butterflies and moths drawn to the light of a bonfire [Fig. 52]; as well as the dense, twisting form of *Tree* (1925; Reiyūkai Myōichi Collection). By the end of the 1920s, though, Gyoshū had returned to a brighter and more decorative manner, as seen in the *Scattering Camellia Blossoms* screens (1929; Yamatane Museum of Art).

Another important figure in Tokyo Nihonga was Kawabata Ryūshi (1885–1966), who advocated a healthy and dynamic form of "art for the exhibition hall," the idea being to move art out of the close, intimate environment of the private display alcove in order to make a bold statement in the public sphere. Kawabata resigned from the Inten in 1928, founding the Blue Dragon Society (Seiryūsha) in Tokyo the following year.

Taishō Decadence and the Association for the Creation of National Painting in Kyoto

During these same years, Nihonga also flourished independently in Kyoto. Central to the movement in that city was Tsuchida Bakusen (1887–1936), a student of Takeuchi Seihō (discussed above), who for a time showed his work at the Bunten in Tokyo. Bakusen's decorative and eclectic style incorporating elements of Post-Impressionism, particularly Gauguin, was not well received, however, so in 1918 he and several other Kyoto artists including Murakami Kagaku (1888–1939) formed the Association for the Creation of National Painting (Kokuga Sōsaku Kyōkai). The society's exhibitions proved more successful for Bakusen, whose works included the well-known *Bathhouse Attendant* (1918; National Museum of Modern Art, Tokyo), *Maiko in a Garden* (1924; National Museum of Modern Art, Tokyo), the fresh and charming *Female Divers* (*Ama*, 1913; National Museum of Modern Art, Kyoto), and the decorative *Springtime* (1920; Kodansha Noma Memorial Museum, Tokyo).

Kagaku worked mostly in isolation away from the activities of the Association, due to his severe asthma. Whereas Bakusen tended to the decorative, Kagaku's work was often deeply symbolic, pursuing an inner essence lacking in other Nihonga paintings. This is particularly true of his landscapes [Fig. 53], but even his female nudes suggest a kind of physical spirituality that may have been influenced by Buddhist sculpture. Still, perhaps the most characteristic of early-Taishō Nihonga painters in Kyoto were

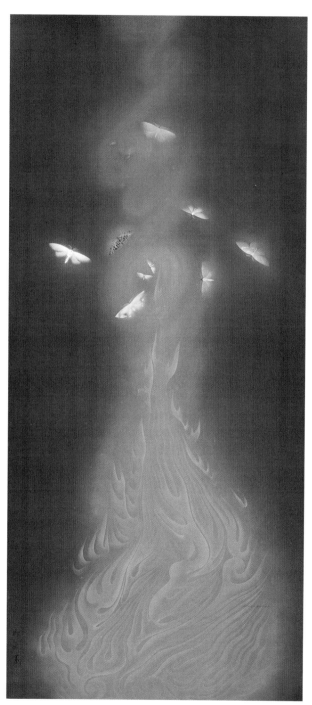

Fig. 52: Hayami Gyoshū, *Dancing in the Flames*, 1925, Yamatane Museum of Art, Tokyo

Fig. 53: Murakami Kagaku, *Calm Winter Mountain*, 1934, National Museum of Modern Art, Kyoto

three individualistic and spirited talents: Kainoshō Tadaoto (1894–1978), Okamoto Shinsō (1894–1933), and Hata Teruo (1887–1945). Combining Kyoto traditionalism with the fin-de-siècle mentality of Edvard Munch and Gustav Klimt (1862–1918), these painters created images of women that were briefly fashionable for a few years after World War I. They expressed the dark side of urban culture at the height of Taishō democracy.

Return to Classicism and the Embrace of Modernism

After an unsettled period of reactions and adjustments to the changing circumstances in Western-style painting, by the mid-Taishō era, Nihonga had evolved into a relatively consistent and harmonious style that the art historian Uchiyama Takeo (1940–2014) dubbed "New Classicism," effectively meaning a new conservatism aligned with middle- and upper-class taste. The work of Uemura Shōen (1875–1949) is representative of this trend. Shōen was a talented student of Takeuchi Seihō who followed in the footsteps of such leading female Japanese artists as Ema Saikō (1787–1861), Katsushika Ōi (Hokusai's daughter, active mid-nineteenth century), and Okuhara Seiko (1837–1913).

Throughout her career Shōen primarily depicted young women in domestic settings, but these women, whatever their particular circumstances,

always seem to possess an air of what may be called "resolute elegance." *Flame* (1918; Tokyo National Museum), for example, portrays a distraught young woman inspired by the main character in the classic Noh drama *Lady Aoi* (*Aoi no ue*), a retelling of an episode from the *Tale of Genji* in which Aoi no Ue, Genji's first wife, is possessed by the malevolent spirit of a lady whom Genji has rejected. Shōen's choice of subject reflected the period interest in romanticism, but in her hands even this intense theme conveys a sense of refinement and nobility worthy of the lead character and the drama. Shōen followed a similar approach in such late works as *Noh Dance Prelude* (*Jo no mai*) (1936; University Art Museum, Tokyo University of the Arts) [Fig. 54], and *Evening* (1941; Ōki High School, Kyoto), the latter depicting a graceful and industrious young woman who is threading a needle by the last light of day.

Shōen's immaculate world, inhabited by women too flawless to be true, finds parallels in the work of other Nihonga artists adhering to the New Classicism of the late 1910s to '30s. Kaburaki Kiyokata (1878–1972), for example, endowed the life and people of downtown Tokyo with noble refinement, as sensed in the tall slender woman out for a neighborhood stroll in *Tsukiji Akashi-chō* (1927; private collection), or in *Ichiyō* (1940; University Art Museum, Tokyo University of the Arts) [Fig.55], a commemorative portrait of the Meiji author Higuchi Ichiyō (1872–1896), whose face currently adorns the 5,000-yen note in Japan. However, as these examples indicate, while Kiyokata's paintings are idealized, they are unlike Shōen's in that they portray people who conceivably, and often actually, inhabited the real world, a quality that lends a feeling of nostalgia to much of his work. This element may have carried over from Kiyokata's early experience as an illustrator of serialized novels published in newspapers. A similar combination of the real and ideal is found in the subtle ink landscapes of Kawai Gyokudō (1873–1957), who depicted Japanese rural life and plausible mountain views in works like *Evening in the Mountains* (1935) [Fig. 56].

Not all Nihonga artists, however, were captivated by lofty classicism. Some, like Fukuda Heihachirō (1892–1974), instead embraced the styles associated with Modernism. Heihachirō's early works, such as *Carp* (1921; Museum of Imperial Collections) and *Peonies* (1924; Yamatane Museum of Art), demonstrate an obsession with realism, but he later changed his style dramatically and moved Nihonga in a new direction. In *Ripples* (1932; Osaka City Museum of Modern Art), for example, he focused on a detail from nature, but rendered the subject as a nearly abstract pattern

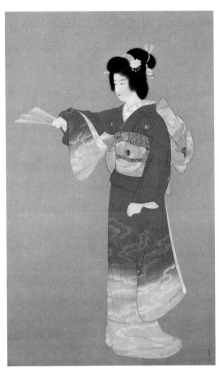

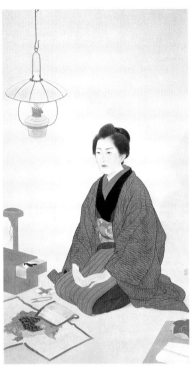

Fig. 54: Uemura Shōen, *Noh Dance Pre-lude*, 1936, University Art Museum, Tokyo University of the Arts

Fig. 55: Kaburaki Kiyokata, *Ichiyō*, 1940, University Art Museum, Tokyo University of the Arts

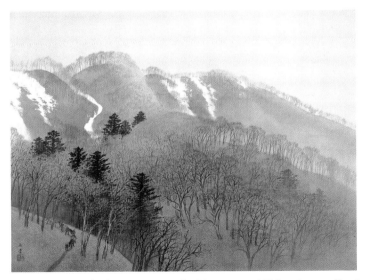

Fig. 56: Kawai Gyokudō, *Evening in the Mountains*, 1935, private collection

in blue and white. He developed the approach further, as seen in *Rain* (1953; National Museum of Modern Art, Tokyo), by concentrating on closely cropped and enlarged motifs, such as roof tiles dotted with marks of raindrops or persimmon leaves changing color [Fig. 57]. Even shadows appear as patterns in his work, and his bright palette otherwise exhibits no hint of darkness. Through his work, Heihachirō negates the analysis of the traditional Japanese aesthetic of shadows articulated by Tanizaki Jun'ichirō (1881–1965) in his essay "In Praise of Shadows" (1939).

Fig. 57: Fukuda Heihachirō, *Rain*, 1953, National Museum of Modern Art, Tokyo

3. The Emergence of Avant-Garde Art

The term "avant-garde" originally referred to a small, elite corps of soldiers who would advance against the enemy ahead of the main army. The art world adopted this military term to identify a group of artists with advanced ideas who were attempting to break through stereotypes and open up new possibilities in visual expression. From the 1910s to the 1930s, a series of key movements constituted the avant-garde in the West: Fauvism, German Expressionism, Cubism, Futurism, Surrealism, and Dada.

In line with their manifesto of 1909, for example, the Futurists praised the dynamism of machinery, rejected the use of one-point perspective, and invented new methods of conveying speed and motion. Futurism took hold in Japan somewhat later, in 1920, with the founding of the Association of Futurist Artists. By fortunate coincidence, that same year, the Ukrainian Futurist David Burliuk (1882–1967) fled the upheavals of the Russian Revolution and arrived in Japan, where he remained to paint, exhibit, and lend his support to the Association. Burliuk, who had been a close friend of Wassily Kandinsky, possessed a good all-around knowledge of the European avant-garde. His encouraging presence inspired many budding Japanese Futurists, including Kanbara Tai (1898–1997), who formed the

group Action in 1922 with several other artists. Tai's representative work, *On Scriabin's "Poem of Ecstasy"* (1922; National Museum of Modern Art, Tokyo), is an abstract picture that recalls Kandinsky in its treatment of music and painting as occupying the same artistic plane. Kanbara was a pioneering figure in the history of Japanese Abstract Expressionism.

Around this same period Murayama Tomoyoshi (1901–1977) returned from a year in turbulent Weimar Germany. With his experiments in collage using pieces of wood, photographs, and lengths of cord, he quickly emerged as a leading figure in the avant-garde of his day. His *Construction* (1925; National Museum of Modern Art, Tokyo) [Fig. 58] combines elements of antisocial Dadaism with egalitarian Russian Constructivism—the latter being a movement in Russia during the 1910s and 1920s that rejected ordinary painting and sculpture as art of the bourgeoisie and instead promoted the use of raw materials, such as iron and glass, that were close to the lives of ordinary working people.[6] Murayama was central to the formation of the art collective MAVO in 1923, but this organization attracted limited public interest; it disbanded two years later, having mounted several exhibitions and produced seven issues of an eponymous journal (1924–25). A few members of MAVO then created the Association for Plastic Artists (Zōkei Bijutsuka Kyōkai), originally pursuing avant-garde ideals in art, then

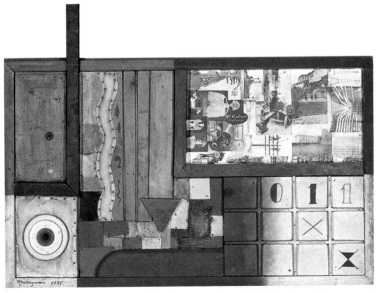

Fig. 58: Murayama Tomoyoshi, *Construction*, 1925, National Museum of Modern Art, Tokyo

eventually shifting its focus onto its social and political aspects. Several years later, in 1929, Yabe Tomoe (1892–1981) and Okamoto Tōki (1903–1986) organized the Proletarian Artists' League of Japan, but this group was actively suppressed by the Japanese government.

4. Fantasy, Surrealism, and the Approach of War

Surrealism explores the fantastic world of dreams, the subconscious world of thoughts and feelings beyond the control of reason. An offshoot of Dadaism, it shifted into a formal movement when the French writer and poet André Breton published his first *Surrealist Manifesto* (*Manifeste de Surréalisme*; 1924), and by 1926 counted among its members such artists as Salvador Dali (1904–1989). While Surrealism would reach its fullest expression in Japan during the 1930s with writers such as Nishiwaki Junzaburō (1894–1982) and Takiguchi Shūzō (1903–1979) and artists such as Fukuzawa Ichirō (1898–1992), the movement had its forerunners in the form of two short-lived but influential artists: Koga Harue (1895–1933) and Migishi Kōtarō (1903–1934). Koga's early work has a fairy-tale quality influenced by Paul Klee—as seen, for example, in the dimly lit, collage-like *Smoke* (1927; Mie Prefectural Museum of Art)—but he went on to produce more fully Surrealist paintings such as *Sea* (1929; National Museum of Modern Art, Tokyo) [Fig. 59]. Based on images from photography magazines and science magazines, this depiction of a female bather wearing high-heeled

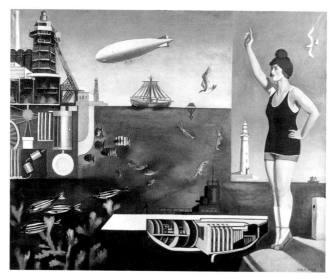

Fig. 59: Koga Harue, *Sea*, 1929, National Museum of Modern Art, Tokyo

shoes and surveying an industrialized seascape with an exposed structure of a submarine reflects the serious approach to fantasy advocated by the "new perceptionists" (Shinkanku-ha), a literary group that included Kawabata Yasunari (1899–1972), who would, after the war, win a Nobel Prize. Koga concluded his brief but creative artistic life with *Scene from the Circus* (1933; Museum of Modern Art, Kamakura and Hayama), in which the animals appear to be suspended in mid-air.

Migishi Kōtarō, who died at the age of thirty-one, considered aspects of the sea in a series of late paintings depicting seashells, for example *Sea and Sunshine* (1934; Fukuoka Art Museum), which shows a nude woman reclining on a beach of pink sand strewn with shells, her face and legs covered by towels, with a bright blue sky overhead. This series is both dreamlike and brightly youthful, and transcends the influences of Klee and Georgio de Chirico (1888–1978) to achieve an original vision. In combining aspects of poetry and painting, Migishi's work (and that of other artists in that generation) may be considered a late flowering of Taishō Romanticism.

Fukuzawa Ichirō, however, is considered Japan's first true Surrealist painter. He traveled to Paris in 1924 to become a sculptor, but by 1926 had turned his focus to painting, and inspired by Max Ernst (1891–1976) joined the Surrealists. Between 1930 and 1931 Fukuzawa sent numerous works from France to the newly established Independent Art Association (Dokuritsu Bijutsu Kyōkai). These works were displayed at the Society's first exhibition in 1931 and had a great impact on younger Japanese artists at the time. They include: *Widow and Temptation* (1930; Tomioka City Museum / Fukuzawa Ichiro Memorial Gallery, Gunma prefecture), based on illustrations in the French scientific journal *La Nature*; and *A Good Cook* (1930; Museum of Modern Art, Kamakura and Hayama), combining an advertising image with illustrations from a children's science book.

The full scope of Dali's vision was introduced to Japan in 1936, and from that time until the start of the Pacific War in 1941, young artists explored Surrealism in many forms. One example is Kitawaki Noboru (1901–1951), whose *Airport* (1937; National Museum of Modern Art, Tokyo) includes mushroom forms and crane-like maple seeds. Among the most impressive examples of Japanese Surrealism, however, is *Industrial Zone, Kōtō Ward* (1936; Chino City Museum of Art, Nagano prefecture) [Fig. 60] by Yasaki Hironobu (1914–1944). Here a factory on the banks of the Nakagawa river spews human bodies white as death from its chimney, while another figure on the riverbank appears upside-down, and a crowd

in the river, with one figure facing the horizon and waving for assistance (a possible reference to Théodore Géricault's [1791–1824] *Raft of the Medusa* [1818–19]). Even the clouds appear to be reaching out for help. This painting has been interpreted as a nightmarish response to the harsh realities endured by contemporary factory workers and to the crackdown on proletarian art. It also seems like a premonition of the tragic loss of life suffered by the neighborhood of Kōtō in the air raids of 1945, and even of the artist's own death while fighting in the Pacific.[7]

Representing Japan among the European Surrealists during the 1930s was Okamoto Tarō (1911–1996), who contributed *Wounded Arm* (originally painted in 1936, lost to fire in the war, repainted by the artist in 1949; Okamoto Tarō Museum, Kanagawa prefecture) to the International Surrealist Exhibition in Paris in 1938 [Fig. 61]. This painting similarly conveys a dark, bleak sense of foreboding. Okamoto returned to Japan in 1940 and after the war became a leader of the avant-garde art movement.

5. Painting in Wartime

The Japanese government's military operations during the civil conflicts of the early Meiji era quickly became a subject for popular woodblock prints. Not until the victories of the First Sino-Japanese War (1894–95), however, was painting recognized as a medium suited to commemorating modern battle. Asai Chū and Mitsutani Kunishirō were among the first artists to engage with the subject. Their precedent paved the way for the production of war paintings in great numbers from the start of the Second Sino-Japanese War (1937–1945) throughout the Pacific War. These paintings served both to record events on the battlefield and to rouse the fighting spirit of the troops. One of the earliest examples is Foujita Tsuguharu's, *Battle on the Bank of the Haiha, Nomonhan* (begun 1939, completed 1941; National Museum of Modern Art, Tokyo). This Western-style depiction of Japanese soldiers mounting a stricken Soviet tank refers to the decisive conflict in the Battles of Khalkhin Gol (1939), when, against the orders of central command, Japan's Sixth Army attempted to invade Mongolia from Manchuria, a territory then under Japanese control. Roundly defeated in this effort, Japan afterward turned its attention to territories south of China, and eventually to the western Pacific and Southeast Asia. Foujita's heroic depiction seems to have been influenced by input from one of the army's commanding generals, who commissioned the painting. In following years,

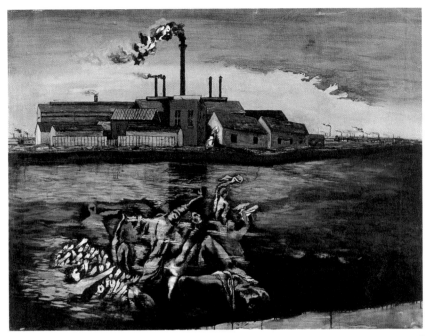

Fig. 60: Yasaki Hironobu, *Industrial Zone, Kōtō Ward*, 1936, Chino City Museum of Art, Nagano prefecture

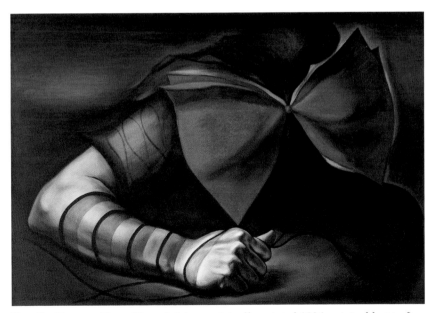

Fig. 61: Okamoto Tarō, *Wounded Arm*, originally painted 1936, original lost to fire, repainted by the artist in 1949, Taro Okamoto Museum of Art, Kanagawa prefecture

Foujita would travel to Southeast Asia on commission from the army and led the production of war paintings.

From 1939 to 1944 the army also organized special touring exhibitions consisting entirely of war paintings. The US authorities confiscated these works after the war, but returned them to Japan in 1970 on indefinite loan. They are hardly ever displayed, except occasionally at the National Museum of Modern Art, Tokyo. While most are plainly mediocre, a few of the day's leading Western-style painters, including Foujita, Nakamura Ken'ichi (1895–1967), Koiso Ryōhei (1903–1988), and Miyamoto Saburō (1905–1974), produced what may be considered some of their best work in this genre, leaving aside the issue of participation in and responsibility for the war. With little other opportunity to engage in their calling, these artists seem to have found some fulfillment in serving their country and applying their skills to a new and challenging subject. The works did change notably as the war situation deteriorated; for example, Foujita's *Shattered Jewels of Attu Island* (1943; National Museum of Modern Art, Tokyo) depicts Japanese troops making a desperate last-ditch attack on US forces on Attu, a strategic island in the Aleutian archipelago [Fig. 62]. Every Japanese soldier was killed in the charge. The term "shattered jewels" (*gyokusai*) was a wartime euphemism used to describe total defeat with no survivors, but Foujita's picture is less a paean than a gruesome scene from hell. This and Foujita's other late wartime paintings display what has been called a "strange 'enthusiasm'" not found elsewhere in his career or in the work of his contemporaries.[8]

The severity of the circumstances and the difficulties in procuring even such basic materials as paint notwithstanding, a few Japanese artists did manage to preserve and express a personal vision during the war years. For example, Aimitsu's (also known as Aikawa Mitsurō, born Ishimura Nichirō; 1907–1946) *Landscape with an Eye* (1938; National Museum of Modern Art, Tokyo) communicates a sense of looming destruction [Fig. 63]. Shown at an exhibition of the Independent Art Association, this unfinished work combines a gunsight-like hole and a large eye staring from what look like the roots of a giant plant. This powerful image, being unfinished, recalls Aoki Shigeru's *Fruits of the Sea*, but there is an important difference in that Aimitsu left his work in its incomplete state not because he thought it unnecessary to proceed further, but because, in his words, after two months he could "only look on it helplessly." Aimitsu's *Bird* (1940; Miyagi Museum of Art) represents a mysterious confluence of Surrealism with the artist's

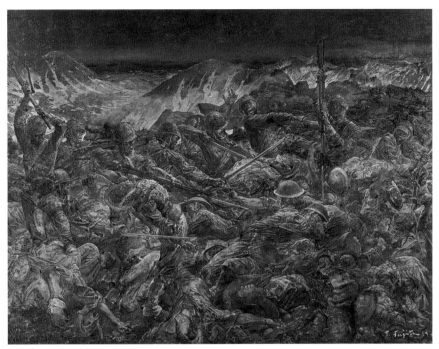

Fig. 62: Foujita Tsuguharu, *Shattered Jewels of Attu Island*, 1943, on indefinite loan to the National Museum of Modern Art, Tokyo © Fondation Foujita/ADAGP, Paris & JASPAR, Tokyo, 2018 E3000

Fig. 63: Aimitsu, *Landscape with an Eye*, 1938, National Museum of Modern Art, Tokyo

Fig. 64: Matsumoto Shunsuke, *Bridge in Town* Y, 1943, National Museum of Modern Art, Tokyo

interest in Chinese Song- and Yuan-period bird-and-flower painting. In 1944, at the height of the war, Aimitsu was conscripted into the army; he survived until the end of the war but died of illness before returning to Japan. Shortly after being called up, however, he produced a self-portrait that communicates a quiet resolve to preserve his identity as an artist faced with no hopeful vision of future. Another independent artist, the Tokyo-born Matsumoto Shunsuke (1912–1948), escaped conscription owing to his deafness. Sketches of Tokyo streets along the Yamanote train line prior to an air raid served as the basis for his vacant and still *Bridge in Town* Y (1943; National Museum of Modern Art, Tokyo) [Fig. 64]. Like Aimitsu, he painted a self-portrait that suggests a firm commitment to a personal artistic vision.

6. Architecture after the Great Kantō Earthquake

Beyond the enormous physical destruction and loss of life that it caused, the Great Kantō Earthquake that struck eastern Japan on September 1, 1923 had at least two significant political and social consequences. First, it opened the way for a central government controlled by the military; second, it left the construction industry in a state of shock. The event prompted a widespread reassessment of building materials, with renewed emphasis on durable materials designed to withstand both earthquake and fire. Within a few years, the urban landscape in Tokyo and elsewhere had been

transformed, as construction companies steadily worked to cover the exterior of almost every traditional wooden building with metal, copper, mortar, and tile. The resulting flat square façades were characterized as "signboard architecture" (*kanban kenchiku*).

"Architecture Is Not Built for Beauty"

Even before the earthquake, leading architects such as Sano Toshitaka (1880–1956) and Uchida Yoshikazu (1885–1972) had prioritized strong engineering and resistance to earthquakes over beautiful design. One of Sano and Uchida's leading students, Noda Toshihiko (1891–1929) summarized the approach in his 1915 essay "Theory of Inartistic Architecture" (Kenchiku hi-geijutsu ron), where he asserted, "Architecture can be purely functional. The pursuit of aesthetics and artistic expression is unnecessary in architecture." Noda's theory stirred much debate in Japanese architectural circles, which until then had accepted Josiah Conder's idea that the essence of architecture is beauty. Uchida built his own practical approach deep into the structure of Tokyo Imperial University, which is known for the stalwart Yasuda Lecture Theater (1925) and Central Library (1928), as well as for the system of earthquake-resistant (aseismatic) iron grates that underlie the campus's stone paths. Since attention throughout is given to structure rather than ornament, the exterior of the buildings is rather austere. This tension between function and beauty may seem a difficulty particular to the history of modern and postmodern architecture, but it finds a parallel in the disagreement between Koyama Shōtarō and Okakura Kakuzō over whether calligraphy is an art form. The issue deserves fuller treatment within the larger scheme of art history; it is mentioned here simply to demonstrate the importance of reviewing the history of art from a perspective that is not restricted to "pure art," but also examines function.

Elsewhere the ecclesiastical style combining historicism with modernism survived as the architectural norm through the 1920s and '30s, as seen in Okada Shin'ichirō's (1883–1932) plan for the Meiji Seimeikan (completed 1934) in Tokyo. Also characteristic of this period is the so-called "Imperial Crown" (*teikan*) style, in which a Western-style building is capped with a Japanese-style tiled roof. Shimoda Kikutarō (1866–1931) had introduced the idea in a plan submitted to the 1919 competition for the design of the new National Diet Building. Although rejected at that time, the Imperial Crown style was widely adopted during the 1920s and

1930s, one important example being the Aichi Prefecture Government Office (1938) in Nagoya with a Japanese castle-style roof on top of a wide square Western-style building.

MAVO and Other Modernist Projects

Though different in certain respects, the engineers and designers discussed above were equally motivated to clear the ground and rebuild as quickly as possible in the wake of the earthquake. For the avant-garde group MAVO, however, it was precisely the residual effects of the earthquake—structural fragments and rubble—that seemed of greatest interest. MAVO's projects, led by Murayama Tomoyoshi, frequently took the form of performances —featuring performers who might be acrobatic or nude—staged in earthquake-damaged buildings using confrontational assemblages of discarded materials. Constructed amid Tokyo's burned-out ruins and largely cut off from mainstream society, MAVO's extraordinary designs are usefully understood as "manifestations of Dada heretofore unseen in any part of the world."[9]

Another influential figure in the field of architecture at this time was Kon Wajirō (1888–1973), who developed a branch of sociology known as *kōgengaku* ("modernology"), which examines how modernization alters cityscapes, specifically that of Tokyo throughout its history. In 1923, Kon founded the Barracks Ornamentation Society (Barakku sōshoku-sha), which intervened in the existing urban environment as MAVO did, though the aim in this case was to beautify the city by painting murals on the façades of "signboard-architecture" (*kanban kenchiku*) buildings. As was the case with MAVO, the society's extreme Expressionism was in itself short-lived, but Kon and his theories had a longer-term positive effect. For example, during his training as an architect, Murano Tōgo (1891–1984) took in Kon's often radically expressionist ideas, and subsequently came into contact with state-of-the-art modernist architecture and its designers during a study trip to Europe in 1920. In his mature work he drew on elements of traditional *sukiya* architecture in order to balance the demands of modernism and conservatism. Murano considered his finest work to be Watanabe-ō Memorial Hall (1937) in the city of Ube, in Yamaguchi prefecture [Fig. 65]. This building, one of several that he designed for the city that year, grew out of Taishō-era liberal humanism; it demonstrates that Japanese modernism had reached its maturity by the 1930s. Two other architects with firsthand

Fig. 65: Ube City Watanabe-ō Memorial Hall, 1937, designed by Murano Tōgo, Yamaguchi prefecture

exposure to European modernism were Maekawa Kunio (1905–1986) and Sakakura Junzō (1901–1969), both of whom studied with Le Corbusier (1887–1965) in France and became leading modernists in Japan during the 1930s.

The Nationalist Trend in Architecture and Modernist Resistance

Like the painters of this period, Japanese architects in the 1930s found themselves caught between conformity and resistance to the nationalist militarism overtaking the country, particularly in the wake of the Manchurian Incident in 1931. For example, in 1931 Watanabe Hitoshi (1887–1923) won the competition for the design of the Tokyo Imperial Museum (now the Tokyo National Museum) with a plan for a concrete main building topped by a roof recalling that of a traditional Japanese Buddhist temple —in effect treating the museum as a hall of sacred cultural patrimony. To the same competition, on the other hand, Maekawa Kunio submitted a design that had no roof at all. While he knew that this sort of radical modernism would lose him the commission, he wanted to demonstrate that what it meant to be truly Japanese was to create a form best suited to the construction material. Another architect who asserted his independence within the profession was Sakakura Junzō, whose Japanese Pavilion won the grand prize at the 1936 Paris International Exposition. Architectural historian Inoue Shōichi (b. 1955) contends that, with this building, Sakakura tried

to create a new postmodernist architecture simply through a fusion of Japanese and modernist elements. But there may have been something more deliberate in the way that Sakakura's interpretation omitted a number of the "Japanese" features specified for inclusion by Japan's exposition committee.

Japanese-style architectural elements, such as the *teikan* roof, would continue to replace the Western motifs that had prevailed in historicist architecture but were falling into decline. By the end of the 1930s, Japan would march headlong into war, proving the futility of modernist resistance. From that point, while painters churned out war paintings, architects pumped out war monuments and installations that were intended to fire nationalist sentiment. One of the first comprehensive architectural initiatives along these lines was the Ministry of the Interior's mandate, issued in January 1939, authorizing every city, town, and village to honor the war dead with a Monument to Loyal Souls (Chūreitō).

A few years later, Tange Kenzō (1913–2005), a younger classmate of Maekawa and Sakakura at Tokyo Imperial University, won first prize in a national competition with his "Plan for a Monument Commemorating the Foundation of Greater East Asia" (1942), a tribute to the Japanese empire. Tange's design centered on an enormous parabolic arch whose overall form recalled the roof of a ceramic *haniwa* in the shape of a house from the fifth or sixth century (Chapter 2).[10] In focusing on this particular motif, Tange may have been alluding to what is believed to be the earliest historical period associated with the consolidation of a Japanese state. On the negative side, these wartime monuments bear a certain responsibility for the intensity of the war effort; yet, as Inoue Shōichi has also noted, they stimulated Japanese architects to work out ways of finally "moving beyond modernism," an effort that would eventually lead to the emergence of postwar Japanese modernist architectural design.

V. Art of the Postwar Period:
Mid-Shōwa through Heisei (1945–2019)

Decades since the end of World War II have generated such a variety of events and incidents that in many respects the period is still too fresh to allow for proper historical assessment. Even so, we have here an opportunity

to make at least an initial attempt to grasp the rich and diverse movements that constitute postwar Japanese art. To highlight the complex interactions between the global and the local that inform much of the art of this period, this section will concentrate on four topics: the struggles of Japanese artists and art institutions in the early postwar years; the later history of Japanese modernist architecture; changing approaches to the concept of art; and the place of cultural heritage in Japanese art history.

1. The Early Postwar Years (1945–60)

Coming to Terms with the War Experience

The destruction of Japan's major cities and the loss of over two million lives in the Pacific War left deep scars on the national psyche. For some artists, the situation demanded a visceral response. *Heavy Hand* (1949; Museum of Contemporary Art, Tokyo) by Tsuruoka Masao (1907–1979), for example, is a nightmarish image that draws on the artist's war years as filtered through the sight of homeless refugees filling the underground passages of the Ueno train station [Fig. 66]. Hamada Chimei (b. 1917) similarly turned his time as a soldier on the China front into a set of surrealist etchings titled *Requiem for a New Recruit* (1952), a painful valediction to the artist's own lost youth. Kazuki Yasuo (1911–1974) worked on his Siberia series over twenty-seven years until the end of his life, creating fifty-seven paintings in total. Dramatic changes in style testify to the artist's endeavor to find ways to truly convey what he and his comrades went through in the labor camp.

Fig. 66: Tsuruoka Masao, *Heavy Hand*, 1949, Museum of Contemporary Art, Tokyo

If *Burial* (1948) is a more distanced tone of melancholic elegy, commemorating the artist's comrades who had died while in the camp, *Black Sun* (1961) [Fig. 67] is an intense expression of the hardships they faced (both works are at the Yamaguchi Prefectural Art Museum). Personal experience almost certainly informs the emaciated figures in Abe Nobuya's (1913–1971) *Starvation* (1949; Museum of Modern Art, Kamakura and Hayama), and Inoue Chōzaburō's (1906–1995) earlier *Death Ship* (1943), a brooding portrayal of a crowded lifeboat lost in an empty ocean. War's internal and external scars often take many years to heal, and for the artist Miyazaki Shin (b. 1922), who survived three years of war and four years in a

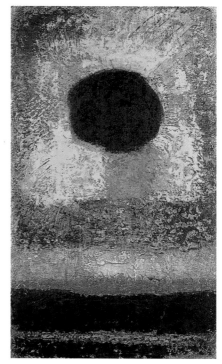

Fig. 67: Kazuki Yasuo, *Black Sun*, 1961, Yamaguchi Prefectural Art Museum

labor camp in Siberia, the main subject to this day is the war, rendered in powerful images that are an ensemble of requiem to honor those who died in battle and paean to life [Fig. 68]. The husband-and-wife artists Maruki Iri (1901–1995) and Maruki Toshi (1912–2000), meanwhile, grappled with the war from a purely humanist perspective. After a time working to aid survivors of the atomic bombing of Hiroshima, they began to produce the *Hiroshima Panels* (1950–82; Maruki Gallery for the Hiroshima Panels), a series of fifteen large murals that show the bomb's victims as ghostly figures wandering through scenes from hell. In the view of several survivors, however, even these paintings are "too nicely presented" to capture the terror and grief of a massacre beyond description.

Nitten and Independent Exhibitions

In 1946, just one year after the war's end, the Ministry of Education convened the first Japan Fine Arts Exhibition (Nihon Bijutsu Tenrankai

or Nitten), which soon rose to prominence and retained its position of authority even after being privatized in 1958. Contributors included major artists from the prewar period—such as the Yōga painters Umehara Ryūzaburō and Yasui Sōtarō, and the Nihonga painters Ono Chikkyō (1889–1979), Fukuda Heihachirō, Dōmoto Inshō (1891–1975), Nakamura Gakuryō (1890–1969), Itō Shinsui, and Sugiyama Yasushi (1909–1993)—and relative newcomers such as Higashiyama Kaii (1908–1999). In paintings like *Afterglow* (1947; National Museum of Modern Art, Tokyo), exhibited at the third Nitten, and *Road* (1950; National Museum of Modern Art, Tokyo), exhibited at the sixth Nitten, Kaii in particular introduced a clear and understated style that brought relief to both the eyes and the minds of the devastated people in the postwar period [Fig. 69]. The year 1946 likewise marked the revival of many nongovernmental art shows, including the Second Division Society Exhibition (Nikaten), the Japan Art Institute Exhibition (Inten), and the New Production Association Exhibition (Shin Seisaku-ha Kyōkai-ten).

Another group of artists independently founded the Japan Art Society (Nihon Bijutsu-kai) in 1946, which, counter to Nitten, welcomed artists espousing liberal

Fig. 68: Miyazaki Shin, *Landscape of the Drifting Heart*, 1994, Yokohama Museum of Art

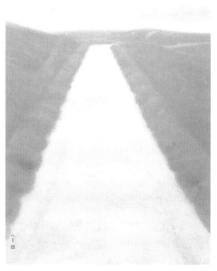

Fig. 69: Higashiyama Kaii, *Road*, 1950, National Museum of Modern Art, Tokyo

and socialist ideals. The following year, this society inaugurated the Japan Independent Exhibition (Nihon Andepandan-ten), a democratic forum for all types of art, whether by professionals or amateurs. Early participants included the above-mentioned Inoue Chōzaburō, Maruki Iri, and Tsuruoka Masao. Still active, the exhibition has been run in close relationship with the Japanese Communist Party. The success of the Japan Independent Exhibition inspired the Yomiuri Newspaper Company to launch the annual Yomiuri Independent Exhibition in 1949, which likewise dispensed with judges and awards to present an open stage for all types of artists, eventually becoming a showcase for the avant-garde. It was discontinued in 1963 following an altercation with the exhibition's regular venue, the Tokyo Metropolitan Art Museum, over the issue of public morals. In 1954, the Mainichi Newspaper Company started the Contemporary Japanese Art Exhibition (Gendai Nihon Bijutsu-ten), which alternated annually with the Japan International Art Exhibition (Nihon Kokusai Bijutsu-ten) at the Tokyo Metropolitan Art Museum. Over the years, although the Mainichi exhibition attracted a number of leading artists—Tada Minami (1924–2014), Yamaguchi Katsuhiro (b. 1928), Takamatsu Jirō (1936–1998), Arakawa Shūsaku (1936–2010), Lee Ufan (b. 1936), Shingū Susumu (b. 1937), Usami Keiji (1940–2012), Sekine Nobuo (b. 1942), and Suga Kishio (b. 1944) among them—it did not enjoy major success and was finally discontinued in the year 2000 after its 29th exhibition.

Displays of modern European art had been few and far between during the prewar years, but that changed almost overnight with the opening, in February 1951 at the Takashimaya department store in Tokyo, of the Salon de Mai exhibition focusing on French postwar art. Heavily eclectic, only moderately adventurous, and, as Okamoto Tarō said, "pseudo avant-garde" in character, this show nevertheless had Japanese visitors mesmerized. It was followed by an exhibition of Henri Matisse (1869–1954) in March at the Hyōkei Gallery, Tokyo National Museum (the exhibition travelled to the Osaka City Museum of Fine Arts and the Ohara Museum of Art in Kurashiki, Okayama prefecture), and another exhibition of Pablo Picasso (1881–1973) in August at the Takashimaya department store in Tokyo, subsequently touring to the Osaka City Museum of Fine Arts. The ground staff at Haneda Airport are said to have wept with joy as they unloaded the Matisse exhibition. When the show traveled to rural Kurashiki, a special Matisse train had to be organized in order to accommodate the crowds. Following this, the Tokyo National Museum held exhibitions of Georges

Braque (1882–1963) in 1952 and Georges Rouault (1871–1958) in 1953, and the National Museum of Modern Art, Tokyo, held a memorable retrospective of the Japanese-American artist and printmaker Yasuo Kuniyoshi (1893–1953). A fine selection of work by Vincent van Gogh, almost impossible to put together today, also reached Japan in 1958. The postwar interest in Western art was almost palpable, with paintings by inspired Japanese artists, echoing the style of the Salon de Mai, Picasso, Matisse, Braque, and Rouault, filling art galleries and other exhibition venues.

It should be noted, however, that while some members of the museum-going public hurried to see Matisse, many others headed to the main gallery of the Tokyo National Museum to see a Rinpa exhibition featuring works by Tawaraya Sōtatsu (d. 1643), Ogata Kōrin (1658–1716), and other artists of this style. In fact, a review of the time praised Sōtatsu and Kōrin as being more modern than Matisse.

Japanese Art on the International Stage, and the Domestic Activities of the Gutai Art Association

Even as Western art traveled east, Japanese art and artists were traveling west, particularly those who continued Japan's premodern tradition of color-woodblock and copperplate printmaking. One of the earliest to achieve success in the immediate postwar period was the dynamic Munakata Shikō (1903–1975). In 1951 Munakata won first prize in the print section at the São Paulo International Biennale, and in 1956, the year in which Japan joined the United Nations, he won the Grand Prix in the print section of the Venice Biennale with the large monochrome woodblock print set *Two Bodhisattvas and Sakyamuni's Ten Great Disciples* (originally made in 1939, the Two bodhisattvas were recarved in 1948 as the original woodblocks for the two prints were lost to fire). Munakata transformed the natural vigor and powerful animism of his native Tōhoku into a modern and expressionist form of art [Fig. 70]. Brazil seems to have favored Japanese artists, for in 1955 the Sao Paulo print award went to Saitō Kiyoshi (1907–1997) and in 1957 to Hamaguchi Yōzō (1909–2000). Other print artists who achieved international acclaim around this time included Komai Tetsurō (1920–1976), Kanō Mitsuo (b. 1933), and Ikeda Masuo (1934–1997).

As well as the works by contemporary Japanese artists, many important classical arts also traveled to be shown in the world. In 1953, the Exhibition of Japanese Painting and Sculpture toured the United States for a year,

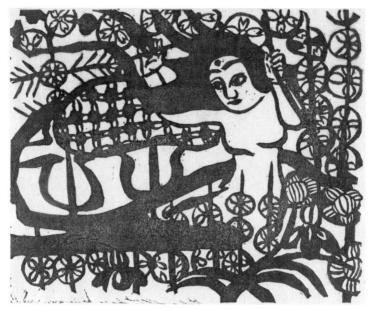

Fig. 70: Munakata Shikō, "Joshin" (Goddess) from the series *Kegonpu* (Record of the Kegon Sutra), 1937, British Museum © Trustees of the British Museum

stopping at five venues: the National Gallery of Art in Washington, D.C., the Metropolitan Museum of Art in New York, the Seattle Art Museum, the Art Institute of Chicago, and the Museum of Fine Arts in Boston. This Japanese government-sponsored touring exhibition included sixty-nine national treasures and important cultural properties among the total of ninety-one exhibits. In 1958, another major exhibition of important Japanese art objects was organized by the government and traveled to the National Museum of Modern Art in Paris, the Victoria and Albert Museum in London, the Gemeentemuseum Den Haag (Municipal Museum of Haag), and Palazzo delle Esposizioni (Palace of Exhibitions) in Rome. These exhibitions were part of an effort to restore and improve the relationships between Japan and other countries after the war. Art works became ambassadors of peace in the postwar period.

Innovations in postwar Western art became available to Japanese artists almost as soon as they emerged, with many Japanese traveling to the United States and Europe to experience the developments at first hand. For example, in 1948 Ogisu Takanori (1901–1986), who had spent more than ten years in Paris before the war, became the first Japanese artist to visit France again. He was followed four years later by Imai Toshimitsu

(1928–2002), who traveled to explore *art informel* (literally, "formless art"), also called *tachisme*, the European counterpart to abstract expressionism. Okada Kenzō (1902–1982) moved permanently to New York in 1950, and Inokuma Gen'ichirō (1902–1993) made a tour of the United States in 1952. The internationalism and cross-cultural experiments of the time went on display at the innovative *Art of Today* exhibition (Kyō no Bijutsu-ten) held in 1956 at the Takashimaya department store in Tokyo.

Meanwhile, in Kansai (western Japan), the leading Nika-kai artist Yoshi-hara Jirō (1905–1972) and his younger colleagues Motonaga Sadamasa (1922–2011), Shiraga Kazuo (1924–2008), Murakami Saburō (1925–1996), and Tanaka Atsuko (1932–2005) in 1954 formed the Gutai Art Association (Gutai Bijutsu Kyōkai), causing a sensation with a series of radical and unique projects that included outdoor exhibitions in Kobe's Ashiya Park, staged happenings, and an exhibition in the sky using advertisement balloons (large floating balloons with a banner for ads). The group treated art not as a private creation intended for solitary viewing, but as an inclusive social action, a performance involving the audience. As Yoshihara stated in the first issue of the association's eponymous journal, *Gutai* (January 1955), "We hope to make friends with artists working in a broad range of visual arts, for example calligraphy, flower arrangement, crafts, and architecture . . . We would like to work closely also with practitioners of such contemporary arts as children's art, literature, music, dance, film, and performance." When the French art critic Michel Tapié (1909–1987) — originator of the phrase "art informel" and an advocate of experimental art in Europe — learned about Gutai during a visit to Japan in 1957, he recognized their importance and brought the group to the attention of an international audience. Their activities continue today.

Gutai is the first evidence that new cutting-edge movements in contemporary art started to happen independently in Japan even without direct influence from the West. By the end of the 1960s the group had moved from forceful action to a more sedate but still intelligent and sensitive type of picture-making, an example being Kanno Seiko's (1933–1988) abstract *World of Levi-Strauss I* (1971; National Museum of Modern Art, Tokyo). The group's renown, however, should not be taken to mean that contemporary avant-garde art dominated the Japanese postwar art scene. On the contrary, the postwar general public responded less enthusiastically to the avant-garde than to the Nitten and other established art exhibitions. No matter how well organized or supported by art critics, exhibitions of

contemporary art remained outside the purview of most people, not least because such installations and performances bewilderingly dissolved the standard categories of "art object" (sculpture, painting, craft). For example, in preparation for an exhibition at a rural museum, a work was installed in a city park ready for the opening on the following day. The next morning the work was nowhere to be seen; the caretakers, it turned out, thought someone had just left something unidentifiable there for disposal. This circumstance underlies the broadly stoic and pompous character of many artists at the time, and the situation has not appreciably altered, as contemporary art remains rather estranged from society at large.

The Journal *Aesthetics of Ink*

Kansai was the birthplace of yet another development in the avant-garde: the journal *Bokubi* (*Aesthetics of Ink*). Inaugurated in 1951 by the calligrapher Morita Shiryū (1912–1998) as the voice of the Society for the People of Ink (Bokujin-kai), which Morita founded in the same year, *Bokubi* promoted the view that Eastern calligraphy ranks equally to abstract painting in terms of its power, invention, and interest. Articles introduced Western artists whose work showed the influence of Eastern calligraphy, such as Franz Kline (1910–1962) and Gérard Ernest Schneider (1896–1986), as well as famous calligraphers in the Japanese and Chinese traditions like Zen masters Sengai (1750–1837), Hakuin (1685–1768), and Jiun (1718–1804), and also modern Japanese calligraphers, including Inoue Yūichi (1916–1985), whose achievement is now beginning to be recognized in China and Korea as well as Europe [Fig.71]. Morita's belief in calligraphy went far beyond the academic discussion between Koyama Shōtarō and Oka-kura Kakuzō mentioned earlier. When the postwar Nitten decided to bar avant-garde calligraphy from its displays, Morita confronted the exclusion head-on by organizing a

Fig. 71: Inoue Yūichi, *Foolishly Adamant* (*Gutetsu*), 1956, National Museum of Art, Osaka

European tour of work by the members of Bokujin-kai (1955). Convinced that modern Japanese calligraphy deserved fuller attention not just as a kind of avant-garde art, but as an art equal to painting, Morita devoted constant attention to *Bokubi*, which reached an international audience and continued through 301 issues, the last being published in 1981.

Calligraphy Today

Other recent calligraphers have taken a more traditional and scholarly approach by enlarging upon Edo and Meiji precedents in connection with a close study of the Chinese and Japanese classics. Even so, whether their métier has been Chinese characters or the Japanese syllabary (*kana*), these masters, like Inoue Yūichi, have sought to introduce a contemporary element into their work. The literary scholar Nishikawa Yasushi (1902–1989), for example, possessed a thorough knowledge of both classical Chinese literature and the history of Chinese calligraphy and added to them modern interpretations in his own work. His contributions to the Nitten became the standard by which new submissions were judged. Another important contributor to the Nitten was Ueda Sōkyū (1899–1968), who adhered to the rules of classical calligraphy until the avant-garde took him in new directions and caused him to quit the Nitten. Teshima Yūkei (1901–1987) also developed an innovative style that has much in common with the introspective painting of Murakami Kagaku (see Section IV above). Teshima and Inoue were both invited to exhibit at the Sao Paulo Biennale in 1957.

Notable practitioners of Japanese syllabary (*kana*) calligraphy include Andō Seikū (1893–1983) and Kuwata Sasafune (1900–1989), both leaders of the "Kobe *kana* style." Kuwata's *Sun and Moon* screens (1986; Fukuyama Museum of Calligraphy, Hiroshima prefecture) reinterpret the Rinpa tradition (see Chapter 9) with the calligrapher's own poems on the sun and moon rendered in gold and silver on paper made by Kuwata himself. The well-known *Iroha Poem* screen (1963) by Hibino Gohō (1901–1985) is informed by the calligraphy of Fujiwara no Sukemasa (944–988) and Konoe Nobutada (1565–1614) [Fig. 72]. Today brush and ink are even less a part of daily life than they were in previous decades, so leading practitioners of calligraphy, like current masters of tea (*chanoyu*) and flower arranging, face the constant challenge of how to both maintain and regenerate their tradition.

Fig. 72: Hibino Gohō, *Iroha Poem*, 1963, Tokyo National Museum

2. The Later History of Japanese Modernist Architecture

After the war, the building industry found itself in circumstances even more desperate than in the days after the Kantō earthquake. Entire cities had to be rebuilt; returning soldiers, survivors at home, and displaced persons had to be housed; businesses had to find new locations; and industry had to begin again. All this was further complicated by a shortage of materials and funds. The situation began to improve around 1950, when the Korean War (1950–53) brought new demand for modern construction.

The first architects to take the lead in these years were modernists who had been active prior to the war, including Maekawa Kunio and Sakakura Junzō. Sakakura, for example, designed the Museum of Modern Art, Kamakura (1951–2016: the building will reopen in 2019 as the Kamakura Bunkakan Tsurugaoka Museum at Tsurugaoka Hachiman-gū shrine), which situates a traditional Japanese space within a modern iron building. The modern architect who has gained perhaps the widest recognition, however, is Tange Kenzō. One of his earliest postwar works was the simple and direct Tsuda College Library (1954), which recalls Le Corbusier's prototype "Dom-Ino" building (1914) in being a multi-story structure consisting of open-plan concrete slabs supported around the perimeter by thin concrete columns, with a connecting stairway. Though a modernist, Tange was deeply aware of Japanese tradition. In the same year that he designed the Tsuda project, he adapted the restrained style of the Shōsō-in for the Hiroshima Peace Memorial Museum and the roof of a *haniwa* in the shape of a house for the Cenotaph for the Victims of the Atomic Bomb, both located in his Hiroshima Peace Memorial Park (1954). Tange's design for

the Kagawa Prefectural Government Office (completed 1958) also recalls traditional Japanese architecture in its use of eaves and a veranda. Tange has said, "The tradition of modern architecture . . . is created through the practice of architects." His words echo Okamoto Tarō's "Theory of Jōmon Pottery" (1952), an influential essay that reminded Tange, Shirai Seiichi (1905–1983), and other architects of the rough and robust style of expression in Japanese tradition. In 1964, when the Japanese economy was rapidly expanding, the Japanese Olympic Committee commissioned Tange to design the stadium and gymnasium in Yoyogi Park for the Tokyo Olympics (1964; demolished in 2015). On this occasion, Tange took advantage of recent technological developments to create a novel hanging-roof structure with a striking silhouette acclaimed by architects worldwide. More recently, Tange explored the concepts of "open spaces" and the city of the future in collaboration with architects such as Kikutake Kiyonori (1928–2011) and Kurokawa Kishō (1934–2007).

Expo '70 in Osaka provided another opportunity for architectural experimentation. New design ideas, applications of the latest technologies, and constructions using unconventional materials filled the grounds. In practical terms, though, the venue could hardly cope with the masses of visitors, and it remained, in the words of one critic, "a cartoon city built on an optimistic vision of technology." Today only Okamoto Tarō's monumental *Tower of the Sun* still stands on the site. Over the past few decades, the dream shared by modern architects and Le Corbusier of erecting new cities by combining technology, practical function, and architectural expression has gone largely unfulfilled. In the face of persistent economic realities, the younger generation of modern Japanese architects has shifted focus from large-scale urban planning to individual buildings.

3. Differentiating the Modern Japanese Terms for Art (1960s to the present)

A brief summary hardly suffices to cover the decades since the 1960s, a period in which Japanese artists have generated a rapidly changing kaleidoscope of styles and explored a complex mixture of the old and the new, with multiple forms of copying and originality. Making a distinction between *bijutsu*—which, as discussed earlier in the chapter, is the Meiji-era translation of the Western concept of "fine art," and has been firmly established in the Japanese lexicon—and the more recent notion of *aato* (a direct

transliteration of the term "art"), however, provides an initial framework for discussion. *Aato* is a product of the transformations that, commencing in the West during the 1960s and thence extending throughout the world, have accompanied both the expansion of cities and developments in computer technology. In particular, the information technology revolution, which has allowed information to freely cross national and class boundaries, has fundamentally altered not only our understanding of property and ownership, but just as importantly our idea of "making," since to create something "by hand" can now mean pressing a key. In this new age of computer art, the pictorial medium is no longer canvas or paper, but a liquid-crystal display, often incorporating sound and moving pictures that effectively erode the divisions between painting, film, and music.

Meanwhile, handcrafted art in this period (Pop Art and Kinetic Art, for example) has raised new and difficult challenges of its own. As Takashina Shūji has argued, it's no longer a question of different styles of expression, for example between Cubism or Surrealism; but it's the idea ("how to be" and "what to be") of art itself that is under discussion. Describing these young styles as *aato* highlights the fact that they belong to a multimedia universe that frequently encompasses photography, design, and performance as much as pictures and sound, and in this way calls into question many of our core ideas of what art should be. Thus, while in English the term "art" remains broadly useful—for example, when modified to indicate "fine art" or "visual art"—*bijutsu* in Japanese is best supplemented by the term *aato* which can be use to suggest added dimensions in creative activities of this period. Many of the movements that fall under this rubric may be considered descendants of Dadaism, the "anti-art" brainchild of artists like Marcel Duchamp (1887–1968), who in 1917 famously turned a urinal into a work of art simply by declaring it to be so. The various forms of Japanese *aato*—including Pop Art, Op Art and Conceptual Art—are branches of the neo-Dada movement of the 1950s.

A Society in Flux: Hi Red Center and Mono-ha

Two early hotbeds of *aato* were the Yomiuri Independent and Mainichi Contemporary Japanese Art exhibitions, venues supported by artists such as Shinohara Ushio (b. 1932), Takamatsu Jirō (1936–1998), Nakanishi Natsuyuki (1935–2016), Arakawa Shūsaku (1936–2010), Akasegawa Genpei (1937–2014), Miki Tomio (1938–1978), and Kudō Tetsumi (1935–1990).

Encouraged in part by reviews of their work at these exhibitions, Taka-matsu, Akasegawa, and Nakanishi banded together in 1963 to form the collective Hi Red Center, a name that combines the first characters of the members' family names: *taka* or hi (high); *aka* or red; and *naka* or center. More politically engaged than Gutai, Hi Red Center formulated art actions that blended art, performance, and social commentary. For example, one day in 1964 the three dressed in white lab coats and headed for central Tokyo, where they proceeded to use detergent and brushes to scrub every last bit of dirt from a busy sidewalk—a mocking tribute to the government's efforts to evacuate the homeless and otherwise "clean up" the city immedi-ately prior to the Tokyo Olympics.

Also in 1963, Akasegawa raised the issue of surface versus substantive reality with his *Model Thousand-Yen Notes*, single-sided actual-size pho-tocopies of a thousand-yen note that the artist wrapped around everyday household objects. For this idea Akasegawa was charged with "money imi-tation" and awarded a mild (suspended) sentence in a case of censorship that rose to Japan's Supreme Court and occupied the newspapers for years. Takamatsu's *Shadow Paintings* (1964–98) similarly address questions of void/emptiness versus reality/substance [Fig. 73]. When displayed, the art-ist's hazy painted shadows merge with those cast onto the painted surface by viewers or passersby, creating an intermediate space that is neither of

Fig. 73: Takamatsu Jirō, *Shadow of the Baby No. 122*, 1965, Toyota Municipal Museum of Art, Aichi prefecture

the painting nor of the gallery. An additional current of ancient animism runs through Nakanishi's *Unsettling Phenomenon* series, with hundreds of clothespins densely amassed like a swarm of beetles.

A natural spiritualism also seems to inform the art of Shingū Susumu (b. 1937), whose works move under the influence of wind or water and in this way promote the idea of coexistence with nature. Wakabayashi Isamu (1936–2003), using mainly iron, produced work that is equal parts poetic and enigmatically meditative. The works created by both of these artists are not so much sculpture as three-dimensional constructions.

In the late 1960s, amidst the violent student protests against the renewal of Japan's security treaty with the United States (the Anpo protests), a number of artists began independently to seek a more contemplative engagement with their craft, looking again at the material quality of artworks and reconsidering art's role as an intervention in the environment. The seminal work in the history of this movement, later known as Mono-ha (literally "School of Things"), is *Phase—Mother Earth* (1968) by Sekine Nobuo (b. 1942). Originally exhibited at Suma Rikyū Park (Kobe) on the occasion of the first Contemporary Sculpture Exhibition, this piece consisted of a cylindrical hole in the ground measuring 270 centimeters deep by 220 centimeters across (106 x 87 inches), and, standing beside it, a cylinder of equal dimensions formed of the earth that had been removed to create the hole. In his book *The Art of the Empty Space* (*Yohaku no geijutsu*), Lee Ufan (b. 1936), the movement's main theoretician, describes this form of *aato* as "a road leading to the convergence of interior and exterior."[11] Lee explores spatial and textural relationships in his own art, as exemplified by a work from his *Relatum* series: *Relatum: Silence* (1979/2005; Museum of Modern Art, Kamakura and Hayama) [Fig. 74]. In a sense, as Takashina Shūji has noted, the Mono-ha artists represented "the antithesis of the 'modern,' in that their approach to *aato* placed the natural qualities of the material ahead of artistic self-assertion, and the relativity of interdependent spaces ahead of artistic completeness."[12]

Postmodern Architecture

"Postmodern" is now used to identify a host of contemporary cultural phenomena, but the term originally referred to a set of trends that emerged in international architecture during the latter half of the 1960s in response to two problems of contemporary society: over-consumption of natural

Fig. 74: Lee Ufan, *Relatum: Silence*, 1979 / 2005, Museum of
Modern Art, Kamakura and Hayama

resources and the accompanying destruction of the environment. Viewing
the modernist architect's emphasis on efficiency and function as thoroughly
discredited, the postmodernist architect has sought to build on a human
scale, to reintroduce the appeal of decoration, and to create a sense of har-
mony with nature. Two world leaders of the style have been Isozaki Arata
(b. 1931) and Andō Tadao (b. 1941), both strongly individualistic talents
who have explored their beliefs in their buildings as well as their writings.
Among many other projects, Isozaki is known for the streamlined and boldly
geometric Kitakyushu Municipal Museum of Art (1972–74) and the Kita-
kyushu Central Library (1973–74), while Andō has won acclaim for such
crisply detailed structures as the two Rokkō Housing buildings in Kobe, both
of which survived the Great Hanshin (Kobe) Earthquake of 1995.

 Among other practitioners of the style is Mozuna Kikō (1941–2001),
known for his *Anti-Residential Appliance* (1972), a single-person dwelling
built for his mother in Hokkaido. Conceived as three nested boxes — an
outer wall, a central living space and a functional core — this cubical build-
ing is a domestic counterpart to the kind of Expressionism seen in the work

of Isozaki and Andō. Urabe Chintarō's (1909–1991) Kurashiki Ivy Square (1974) is a combination tourist center and hotel for which the architect created a new interior space within an existing building, an example of the postmodernist preference for restoration and regeneration over demolition and new construction. To an extent, the postmodernist interest in decoration is a decided improvement on the planar surfaces of modernist architecture, which were too reminiscent of "blocks of tofu."[13] Even so, the fact remains that while they may be camouflaged in surface elements, the high-tech high-rise buildings sprouting up here and there cause no small inconvenience for those who occupy the lower buildings around them. High-tech buildings are, after all, a continuation or extension of modernism, and so certain fundamental issues related to the place of contemporary architecture in the urban environment continue to go unresolved.

Rise of Manga and Anime

Two important branches of *aato* are not usually represented in standard art histories: manga (literally "random pictures"; Japanese narrative art, driven by the power of the drawn line) and anime (film animation). These areas of cultural production are sustained by major subcultures that operate outside the system of galleries and museums focusing on other forms of contemporary art. Japanese manga and anime may appear easily dismissed on that account, and also because they emerged relatively recently and tend to attract a younger audience. Over the past few decades, however, the popularity of manga and anime has increased exponentially both in Japan and around the world. In Japan alone, despite the overall decline in the publishing industry, manga books such as volumes of collected episodes from favorite manga series (*tankōbon*) still account for around a third of the total book market. Manga and anime not only have a limitless variety of subjects but are also highly crafted in terms of style. Together manga and anime constitute one of the major movements in *aato* and contemporary Japanese visual culture.

Although manga and anime are historically recent developments, it seems fair to say that the Japanese have always enjoyed humorous and entertaining pictures. Some of the earliest examples of graffiti have been found scribbled on Asuka- and Nara-period (538–794) repair work to ancient buildings. During the twelfth century, court aristocrats are known to have

exchanged examples of graffiti, leading (if indirectly) to the high-spirited artistry of early picture handscrolls such as the *Illustrated Scrolls of the Legends of Shigisan*, the *Illustrated Scrolls of the Courtier Ban Dainagon* (both discussed in Chapter 5, Figs. 52–54), and the *Scrolls of Frolicking Animals* (see Chapter 5, Fig. 55). Monster (*yōkai*) manga can trace their origins to the early-sixteenth-century *Night Procession of One Hundred Demons* (discussed in Chapter 7, Fig. 12), while the idea of depicting human figures and animals with comically elongated limbs arranged in impossibly splayed poses derives from eighteenth-century *toba-e* pictures. Humor permeates the art of Hakuin, Sengai, Soga Shōhaku (1730–1781), Itō Jakuchū (1716–1800), and Nagasawa Rosetsu (1754–1799), while Edo-period illustrated drawing manuals (*edehon*), multivolume novels (*yomihon* and *gōkan*), and short comic fiction (*kibyōshi*) are filled with the wit and imagination of such major ukiyo-e artists as Katsushika Hokusai (1760–1849) and Utagawa Kuniyoshi (1798–1861) (all discussed in Chapter 9).

Western-style caricature reached Japan during the *bakumatsu* (last years of Edo period) and Meiji periods, through the work of resident foreigners, notably the social satirists Charles Wirgman (mentioned early in this chapter) and Georges Bigot (1860–1927), a French artist perhaps best known for his published collection *Croquis Japonais* (Japanese Sketches; 1886). Combining their examples with the format of the American comic strip, in 1902 Kitazawa Rakuten (1876–1955) created *Jiji manga* (Current Manga), which began as a one-page newspaper supplement targeting both politics and humorous situations in daily life. Kitazawa's supplement, which was so popular that it made "manga" a household word in Japan, continued through 530 issues until the artist's retirement in 1932. Around that time, Okamoto Ippei (1886–1948) (the father of Okamoto Tarō, discussed earlier) came to the fore with comics that introduced cinematic effects to enhance the narrative. Also in these years, the leading boys' magazine *Shōnen kurabu* (Boys' Club; 1914–62), published by Kodansha, reached a readership as high as 750,000 by regularly featuring such popular manga series as *Norakuro* (stories about the adventures of an orphan dog in military service) by Tagawa Suihō (1899–1989). These pioneers laid the groundwork for the postwar manga boom.

The grand master of postwar manga was Tezuka Osamu (1928–1989), who achieved fame with such classic manga series as *New Treasure Island* (*Shin takarajima*, 1947), *Metropolis* (1949) [Fig. 75], *Jungle Emperor*

(*Janguru taitei*, 1950–54), and
the internationally beloved *Astro
Boy* (*Tetsuwan Atomu*, 1952–68).
Tezuka studied the techniques
of Disney animation and freely
experimented with close-ups
and the division of narrative pan-
els (*komawari*). His manga were
among the first to treat large
themes in an extended narrative
arc, and they frequently did so
while casting a skeptical eye on
science and the promises of sci-
entific advancement.

Shirato Sanpei (b. 1932) att-
racted new older audiences with
his grim, historically based manga
on social oppression and injustice
during the Edo period: *The Ninja
Book of Warrior Arts: The Story of
Kagemaru* (*Ninja bugei chō Kage-

Fig. 75: Tezuka Osamu, *Metropolis*, 1949.
© Tezuka Productions

maru den; 1959–62) and *Legend of Kamui* (*Kamui den*; 1964–71). Other
postwar readers were drawn to the introspective, surrealist dream worlds
that Tsuge Yoshiharu (b. 1937) conjured in *Salamander* (*Sanshōuo*; 1967)
and most famously *Screw System* (*Nejishiki*; 1968). Chiba Tetsuya (b. 1939)
[Fig. 76], with his engaging story lines and endearing characters focused
largely on human drama in sports manga, captivated Japan with Yabuki
Joe in the long-running story still popular today, *Tomorrow's Joe* (*Ashita no
Joe*, drawn by Chiba Tetsuya with script by Asao Takamori, 1968–1973).

Soon there emerged a younger generation of manga artists raised on the
work of Tezuka. One of them, Ōtomo Katsuhiro (b. 1954), specialized in
creating complex future worlds in series such as *Akira* (1982–90) [Fig. 77],
a manga which came to international attention in the form of an animated
film. Ōtomo went beyond Tezuka in the sometimes shockingly realistic
detail of his worlds; one episode, for example, showed the destruction of
an entire city. While the above-mentioned manga were intended primarily
for a male readership, perhaps unique to Japan is the parallel phenomenon
of manga aimed at girls and women. Interestingly, although geared to a

female audience, these manga often attract male readers with their highly developed technique of expressing progress in time and characters' psychology in a complex structure of panels, creating a mesmerizing pictorial narrative, as witnessed in Hagio Moto's (b. 1949) *The Poe Family* (*Pō no ichizoku*, 1972–76) [Fig. 78]. Precisely undulating black-and-white lines recall the *shira-e* technique developed during the Kamakura period (see Chapter 6, Fig. 33). Now an art form that is recognized and practiced around the world, manga has been the subject of museum exhibitions that in turn have generated thoughtful reviews, articles, essays and books.

Fig. 76: Chiba Tetsuya, *Tomorrow's Joe* (*Ashita no Jō*). © Takamori Asao/Chiba Tetsuya/Kodansha

The history of animated films dates back to *Fantasmagorie* (Phantasmagoria, 1908), an eighty-second short drawn and produced by Emile Cohl (1837–1958) in France. The first animated commercial film was made and shown in Japan in 1917. It is said to be *Dekobō shingachō: Imosuke Inoshishi-gari no maki* (Kid Deko's New Picture Book: The Story of Imosuke's Boar Hunt) by Shimokawa Hekoten (or Ōten, 1892–1973). From the 1920s onwards, Walt Disney (1901–1966) developed the technique into the type of long-form animation familiar today. In these early decades, the genre was generally known in Japanese as "manga film" (*manga eiga*), but during the 1970s the more familiar term "anime" emerged as an abbreviated form of the word "animation." The pioneer of manga films in Japan was Masaoka Kenzō (1898–1988), whose wartime short *Spider and Tulip* (1943) is recognized as both Japan's first full-cel animated film and a masterpiece rivaling the work of Disney Studios. Postwar masterpieces of long-form animation include *The Tale of the White Serpent* (*Hakuja den*; 1958), *The Little Prince and the Eight-Headed Dragon* (*Wanpaku ōji no orochi taiji*; 1962), and *The Great Adventure of Horus, Prince of the Sun* (*Taiyō no ōji Horusu no daibōken*; 1963),

Fig. 77: Ōtomo Katsuhiro, *Akira*, 1982–90. © Ōtomo Katsuhiro/Mushroom/Kodansha

Fig. 78: Hagio Moto, *The Poe Family*, 1972–76. © Hagio Moto/Shogakukan

all produced by the Tōei Motion Picture Company. In 1963, a full-length made-for-television animated version of *Astro Boy* became a popular hit in its own right. Television in fact became an important medium for showing animated films and extending the audience for the genre even further.

Miyazaki Hayao (b. 1941) and Takahata Isao (1935–2018), two of the founders of Studio Ghibli, have been celebrated for endowing long-form animation with emotional resonance and a richer play of time and space. Their work includes, among others, the films *Nausicaä of the Valley of the Wind* (*Kaze no tani no Naushika*, 1984), *Castle in the Sky* (*Tenkū no shiro Rapyuta*, 1986), *My Neighbor Totoro* (*Tonari no Totoro*, 1988), *Only Yesterday* (*Omoide poroporo*, 1991), *Pom Poko* (*Heisei tanuki gassen pon-poko*, 1994). In the course of developing *Princess Mononoke* (*Mononoke-hime*, 1997) and the Academy-award-winning *Spirited Away* (*Sen to Chihiro no kamikakushi*, 2001), Miyazaki took advantage of computer-generated graphics to create highly descriptive and skillfully directed films [Fig. 79]. In the view of Takahata Isao, as articulated in his book titled *Twelfth-Century Animation* (*Jūni-seiki no animēshon*, Tokuma Shoten, 1999), Japanese animated films can trace their roots to the motion-picture-like effects and animated spirit running through traditional Japanese narrative handscrolls. For example, in *Kiki's Delivery Service* (*Majo no takkyūbin*, 1989) the exhilarating scenes of the young heroine sailing through the air on a broom recall the depiction of Gohō Dōji sailing through the air accompanied by

Fig. 79: *Spirited Away*, 2001, directed by Miyazaki Hayao © 2001 Studio Ghibli • NDDTM

flying bales of rice in the *Illustrated Scrolls of the Legends of Shigisan* (see Chapter 5, Fig. 53). Due to the success of films such as these, anime has pulled ahead of manga as one of Japan's leading exports, and serves as an ambassador for Japanese culture abroad. In this connection we recall the adorable monsters from the television cartoon *Pocket Monsters* (*Poketto monstā*, shortened to *Pokémon*, 1997–present), which have captured the hearts of children worldwide. *Pokémon* was originally a videogame (Game Freak Inc., 1996) for Nintendo Game Boy, and continues to be successful in the gaming world with the most recent success of an augmented reality game (AR), *Pokémon Go* (the Pokémon Company and Niantic, Inc., 2016).

Bijutsu Today

Although trends in *aato* have dominated the media since the 1960s, more traditional forms of *bijutsu*, particularly Nihonga and Yōga, still maintain a strong presence in Japan, and several organizations have remained active since the Meiji era. The organizations suffer somewhat from a reputation of formalism and mannerism, and because they attract relatively few practitioners of contemporary art, they tend to remain out of the media spotlight. Nevertheless, as previously noted, they enjoy a much closer rapport with the general public than do practitioners of *aato* and the avant-garde. Nihonga painters in this later period have included Higashiyama Kaii, Ogura Yuki (1895–2000), Okuda Gensō (1912–2003), Takayama Tatsuo (1912–2007), Kudō Kōjin (1915–2011), Hieda Kazuho (b. 1920), and Hirayama Ikuo (1930–2009). Notable in the field of Western-style art have been the Yōga painters Kumagai Morikazu (1880–1977), Yamaguchi Kaoru (1907–1968), Wakita Kazu (1908–2005), Asō Saburō (1913–2000), and Nomiyama Gyōji (b. 1920), and the sculptor Satō Chūryō (1912–2011). Two other artists seem certain to remain of interest long into the future: Mukai Junkichi (1901–1995) and Satō Tetsuzō (1910–1954). Mukai produced propaganda paintings during the Pacific War, but regretted having participated in the wartime painting program, and thereafter until his death produced only pictures of thatch-roofed farmhouses that seem on the verge of vanishing into the rural landscape. Satō, who suffered an early death at the age of forty-four due to leukemia, focused on the landscape of his native Echigo Plain in Niigata prefecture. In particular, his oil painting *Sleet* (*Mizore*; 1953) impresses with its extraordinary luminosity [Fig. 80].

Fig. 80: Satō Tetsuzō, *Sleet*, 1952–53, entrusted to the Museum of Modern Art, Kamakura and Hayama

Photography and Design

Two other avenues of artistic expression have served modern Japanese artists well: photography and design. Major Japanese prewar photographers included Koishi Kiyoshi (1908–1957); Hirai Terushichi (1900–1970); Ei-Q (Ei Kyū, born Sugita Hideo, 1911–1960), whose "photo-dessins" (photosketches), photograms with a use of cut-paper he created after sketches, made a strong contribution to the surrealist movement of the 1930s; and Yasui Nakaji (1903–1942), who captured the struggles of Jewish refugees in his series *The Wandering Jew* (1941) [Fig. 81]. A documentary approach dominated photography in the immediate postwar years. Domon Ken (1909–1990), for example, used richly toned black and white to record the subtleties of Japanese Buddhist art in *Murō-ji Temple* (1954), and the tough but lively life of children at the rapidly declining Chikuhō coal mine in Fukuoka prefecture in *The Children of Chikuhō* (1960) [Fig. 82]. Preferring a warm and spontaneous style, Kimura Ihei (1901–1974) captured aspects of daily life throughout Japan. And Hamaya Hiroshi (1915–1999) photographed stoic farmers and fishermen living at the mercy of the forces of nature. The next generation of photographers, however, sought to push beyond the documentary into modes of direct personal expression. Key figures in this period were Tōmatsu Shōmei (1930–2012), Narahara Ikkō (b. 1931), Hosoe Eikō (b. 1933), and Kawada Kikuji (b. 1933), who in

Fig. 81: Yasui Nakaji, *Wandering Jew* (*Child*), 1941, private collection

Fig. 82: Domon Ken, from *The Children of Chikuhō*, 1960, Ken Domon Museum of Photography

1959 together formed the photographer's association VIVO. Other internationally renowned Japanese photographers include Moriyama Daidō (b. 1938) and Sugimoto Hiroshi (b. 1948).

Our brief glimpses into the history of Japanese design, through works of the Rinpa artists (Chapter 9), crafts, and modern decorative painting, have revealed a richly creative history. My own interest in the relationship between Japanese art and design is grounded in Nikolaus Pevsner's (1902–1983) classic, *Pioneers of Modern Design* (1936), which traces the roots of modern design to the writer and textile designer William Morris (1834–1896), an influential figure who admired medieval craftsmanship and despised modern mechanization. Pevsner's study provides an inspiring model of the way the design elements in Japanese art could be studied. A fuller treatment of the subject must await the attention of future scholars, but one well-known example from the modern period is Tanaka Ikkō (1930–2002), a graphic designer who made skillful use of Rinpa and other decorative traditions in Japan.

4. The Avant-Garde and Tradition: Creative Succession to Cultural Heritage

Two major concerns have occupied Japanese artists in the modern period: first, how to reconcile the demands of modernism and tradition; and second, how to create art that has meaning for both the artist and the art-viewing public. Whether consciously or unconsciously, many artists in the contemporary avant-garde have addressed and resolved these concerns through a seemingly paradoxical proposition: making art that is both contemporary and traditional. This aim has applied equally to painters working in Western, blended popular, or Japanese styles, and to artists working within the craft tradition.

In the area of Yōga, for example, Yoshihara Jirō (1905–1972) in the late 1960s took inspiration from the Zen circles (*ensō*) of Hakuin (discussed in Chapter 9) to create a series of works titled *White Circle*. These feature a freely painted white circle on a black ground—the photographic inverse of Hakuin's work. Viewers may also be struck by a sense of artistic lineage when comparing *Screens with Plants, Birds, and Animals* by Itō Jakuchū (see Chapter 9, Fig. 38) with Onosato Toshinobu's (1912–1986) *Partitions 1260* (1962), both of which piece together small colored squares into larger compositions. There also seems to be a formal continuity between the

stylized illusionistic snow formations in *Snow Wall* (1964; Kyoto Municipal Museum of Art) by Komatsu Hitoshi (1902–1989) [Fig. 83], known as a Nihonga painter, and voluminous forms of snow depicted in Jakuchū's *Golden Pheasant in the Snow* (*Setchū kinkei-zu*, 1761–65; Museum of Imperial Collections), both creating a fantastic scenery with unusual depiction of snow, linked by their animistic view of the world. A similar fusion of animism and adornment (*kazari*) runs through the work of Kataoka Tamako (1905–2008). And the painter Komaki Gentarō (1887–1978) found unique ways to integrate surrealism with Japanese folklore.

Fig. 83: Komatsu Hitoshi, *Snow Wall*, 1964, Kyoto Municipal Museum of Art

In regard to blended popular styles, Yokoo Tadanori (b. 1936), an artist whose sensibilities are reminiscent of Soga Shōhaku's (discussed in Chapter 9), reinvented the world of *bakumatsu* (end of the Edo period) ukiyo-e in his contemporary silkscreen poster-style art [Fig. 84]. From the 1960s onward Yokoo in fact served as an important point of contact between the avant-garde and the general public. In a similar way, Murakami Takashi (b. 1962) has won global recognition with manga- and anime-inspired paintings that feature his own invented characters [Fig. 85]. These creations tie the modern avant-garde to the decorative two-dimensionality of much traditional Japanese art through a concept that Murakami calls "superflat." Nara Yoshitomo's (b. 1955) sharp-eyed little girls and his flat application of paint (*hiranuri*) likewise recall traditional line drawings.

The goal of uniting tradition and modernism has also been central for modern Nihonga artists and skilled craftsmen. The theme particularly underlies the paintings of such Nihonga artists as Sugiyama Yasushi (1909–1993; mentioned above), Yokoyama Misao (1920–1973), and Kayama Matazō (1927–2004). In developing their work, modern craft artists have meanwhile drawn on the thinking of the founder of the *mingei* (folk craft) movement, Yanagi Sōetsu (also called Muneyoshi; 1889–1961), who saw beauty in the innocent, trained skill of anonymous craftsmen. His theory helped shape the approaches of such strongly individualistic artists as the craftspeople Kawai Kanjirō (1890–1966) and Hamada Shōji (1894–1978),

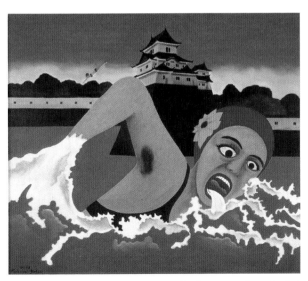

Fig. 84: Yokoo Tadanori, *Moat*, 1966, Tokushima Modern Art Museum

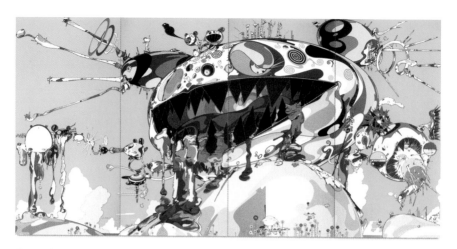

Fig. 85: Murakami Takashi, *Tan Tan Bo Puking - a.k.a. Gero Tan*, 2002, Courtesy Galerie Emmanuel Perrotin © 2002 Takashi Murakami/Kaikai Kiki Co., Ltd. All rights reserved.

and the woodblock print artist Munakata Shikō; the work of all three contains elements of the local and the international. Sculptor Yagi Kazuo (1918–1979), on the other hand, turned traditional ceramics into avant-garde objects, and thus propelled craft ahead into a new future [Fig. 86].

"The day is certain to arrive when all kinds of painting—what we now call Yōga in oil and watercolor, and Nihonga, such as I practice—will be regarded all together as Japanese painting (Nihonga)." This prediction, offered by the Nihonga artist Hishida Shunsō (discussed in section II above), has so far not come to pass, but it is nevertheless true that the border between Nihonga and Yōga is more and more blurred. There has even been a recommendation that Nihonga be identified by its prevailing technique, "glue-applied colors" (*kōsaiga*), rather than attempting to differentiate it entirely from Yōga. However, the term Nihonga (Japanese-style painting) still carries stylistic weight, and its association with a national consciousness seems to carry certain importance even more so in this international society.

We have now reached the end of our journey through the history of Japanese art, covering the great span from early Jōmon ceramics to the art of our own day. This rich tradition of art and culture continues to grow and develop; yet the majority of Japanese, now living a Westernized lifestyle dominated by urban sprawl, have all but lost contact with it. Nearly gone from view are traditional customs and household furnishings, such as the tokonoma display alcove and painted sliding doors. Deprived of its original

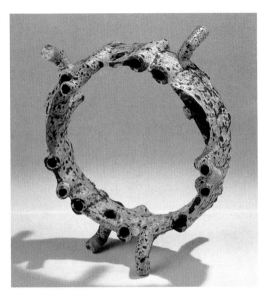

Fig. 86: Yagi Kazuo, *Mr. Samsa's Walk*, 1954, private collection

function, the once-central folding screen now serves as an object of display with other crafts in museums. Arakawa Shūsaku (1936–2010), Kawara On (1932–2014), Kusama Yayoi (b. 1929), and Murakami Takashi—these artists successfully made the world their territory of activity. Following their path, more and more artists will make their way out into the rapidly homogenized world forum. Will the trend bring a slow but certain end of the arts of Japan? Formally answering this question would require a lengthy study of changing aesthetic standards and concepts of nationhood, supplemented by predictions about not only the future of Japan, but even that of humankind, taking us well beyond our present focus. In essence, however, I believe that Japanese art will indeed continue to survive and to thrive. Whether it takes old or new forms, in its fundamentals, as Langdon Warner (1881–1955) once observed, Japanese art is "enduring."[13]

Notes

Introduction

1. Ernest Fenollosa, *Epochs of Chinese and Japanese Art* (London: W. Heinemann, 1912), 1.
2. Langdon Warner, *The Enduring Art of Japan* (Cambridge, MA: Harvard University Press, 1952), viii.

Chapter 1

1. Okamoto Tarō, "Yojigen to no taiwa: Jōmon doki ron" (Dialogue with the Fourth Dimension: A Theory of Jōmon Ceramics), *Mizue* 558 (February 1952), reprinted in *Nihon no dentō* (Traditions in Japan; Tokyo: Misuzu Shobō, 1956), 24.

Chapter 2

1. It should be noted that a new sub-period of the Yayoi, the "Initial" Yayoi, is now recognized as starting in northwest Kyushu around 900 BCE, confirmed through calibrated radiocarbon dates, when the first paddy fields were constructed and rice farming first appears in the Japanese archipelago. It took several hundred years for rice farming to spread to the area that encompasses modern Osaka, Kyoto and Nara prefectures, and even longer for it to spread to eastern Honshu.
2. In addition to the three-stage model, however there is now also the four-stage model that includes the "Initial" Yayoi referred to above.
3. A *haniwa* is an earthenware figure or cylinder that was created for ritual use in burial sites during the Kofun period. They were hollow and took various forms, from simple cylinders to elaborate renditions of dancers, horses, and even boats. It is thought they were used on the upper levels of mounded tombs, particularly in the earlier part of the Kofun period, and had some performative function.
4. See Lothar van Faulkenhausen, *Suspended Museum, Chime-bells in the Culture of Bronze Age China* (Berkeley and Los Angeles: University of California Press, 1993).
5. The archaeologist Harunari Hideji (b. 1942) has noted that deer are the most common images depicted on bells, followed by humans and herons. To the Yayoi people, deer symbolized fertile land given to the people by the *kami* (spirits), and herons the protecting deity of rice paddies and spirit of the rice. Perhaps they sealed these images into the space formed by the decorative bands and wished that the act would help yield a successful harvest.

6. Yoshikawa Itsuji, "Genshi Nihon no bijutsu" (The Art of Primitive Japan) in vol. 1 of *Genshoku Nihon no bijutsu* (Japanese Art in Color; Tokyo: Shōgakukan, 1970).

7. Himiko paid tribute to Wei in 239 CE, and in return she received a gold seal and 100 bronze mirrors. The mirrors excavated from Kurozuka burial mound in 1997 could belong to the group of mirrors Himiko received from the king of Wei. Before this discovery, similar mirrors were excavated from Tsubai Ōtsuka-yama burial mound in Kyoto prefecture, which caused a great sensation.

8. The deities of the four cardinal directions are: Blue Dragon (J: Seiryū, C: Qinglong) of the East, Vermilion Bird (J: Suzaku, C: Zhu Que) of the South, White Tiger (J: Byakko, C: Bai Hu) of the West, and Black Turtle-snake (J: Genbu, C: Xuanwu) of the North.

9. The quantity of *haniwa* does not necessarily correspond to that of the funerary goods they protect. There are many cases where a large army of *haniwa* are employed to protect a very meagre assemblage of goods and vice versa.

10. Sue ware is a blue-gray stoneware fired at 1200 degrees centigrade in kilns. Sue stoneware was revolutionary in that the potter's wheel was employed to form the shape, and it was fired in special high-temperature kilns to make it semi-vitreous. Haji earthenware (sometimes called *hajiki*) and Sue stoneware (also called *sueki*) continued to be made side by side into the late Heian period (1086–1192).

11. The *chokkomon* pattern is particular to Japan, where swirling lines are coiled around the center of diagonally positioned crosses. Especially noteworthy is the *chokkomon* decoration on the stone chamber wall of the Idera burial mound in Kumamoto prefecture.

Chapter 3

1. Recent excavations revealing the similarity in the layouts of the temple complexes of Wangheungsa temple in Baekje and Asuka-dera temple have brought renewed attention to the relation between the Buddhism of Asuka and that of Baekje.

2. The Asuka period derives its name from the location Asuka which was a capital under certain emperors and empresses from the end of the sixth century until 694.

3. Umehara Takeshi, *Kakusareta jūjika: Hōryūji ron* (The Hidden Cross: A Study of Hōryū-ji; Tokyo: Shinchōsha, 1972).

4. Takamura Kōtarō studied at the Tokyo School of Fine Arts (Tokyo Bijutsu Gakkō) and then traveled to Europe in 1906, where he became an admirer of Rodin while in Paris. After returning to Japan, Takamura was active as a poet who candidly expressed passion and suffering through his verse, while continuing to produce sculpture influenced by Rodin. (See also Chapter 10)

5. See *Takamura Kōtarō senshū* (Anthology of the selected writings of Takamura Kōtarō), vols. 5 and 6 (Tokyo: Shunjūsha, 1968, 1970).
6. Some suggest the dates 538 to 662 for Early Asuka and 663–710 for Late Asuka. They see the defeat of the allies Yamato and Baekje to the forces of Silla and Tang at the battle of Baekgang (J: Hakusukinoe, C: Baijiangkou) in 663 as the turning point in representational styles used in sculpture.
7. The ancient Indian kingdom of Gupta rose to power during the early fourth to mid-sixth centuries. The exquisite Buddhist sculptures produced in the Mathura region during the golden age around the year 400 are considered the apex of Buddhist art.
8. For further information on dry-lacquer and clay statues, see Chapter 4, note 4.
9. *Jōroku* is the standard height of a standing Buddhist statue. The word is an abbreviation derived from one *jō* and six (*roku*) *shaku* (approximately 4.8 meters). This height is traditionally attributed to a Buddha.
10. In this pictorial method, a brief series of actions or events of a character is depicted over a single static background, resembling frames of a film. Effective use of this technique can be seen in other works such as the twelfth-century handscroll *Illustrated Scrolls of the Legends of Shigisan* (*Shigisan Engi Emaki*; see Chapter 5, Figs. 52 and 53).

Chapter 4

1. Tenpyō is a designation derived from the name of a reign period associated with Emperor Shōmu (regin 724–49). It spans the years 710–94.
2. Note, however, the decorative taste in Tang arts had already developed during the Northern and Southern Dynasties period as attested by the brilliance of the Dunhuang grottos, for example.
3. *Jōroku*-sized statues are explained in Chapter 3, note 9.
4. *Sozō* are sculptures made of clay. The technique involved making a skeletal wooden structure held together with straw rope. Rough and medium-grade clay were then applied to form the general shape. Finishing clay was next layered on the figure and details were modeled. Copper wire would be implanted in finer parts, such as the arms and fingers, to fasten them securely. *Kanshitsuzō* are statues made with dry lacquer. Successive layers of hemp soaked with lacquer were applied onto a wood or clay core. There are two types of dry-lacquer statues: the hollow type (*dakkanshitsu*) and wood-core type (*mokushin kanshitsu*). The former involved slicing open the dry lacquer and removing the wood and clay core to which the lacquer had been applied. To prevent the papier-mâché-like figure from warping, a new wooden core would be placed inside the cavity and the surface of hemp that had been cut would be stitched together. It would then be sealed using a lacquer paste mixed with fine plant fibers, such as pounded or ground leaves of cedar and Japanese

cypress (*hinoki*). The paste (*kokuso urushi*) was used as a finishing coat for *kanshitsu* and wood sculptures. Once the finishing lacquer paste was applied and the surface modeled to the desired shape, black lacquer would be applied, followed by decorative materials such as gold leaf and color pigments. The wood-core variety is a later development. Layers of lacquer-soaked hemp were pasted over the wooden core and finished with a topcoat of *kokuso urushi*.

5. The eight classes of deities that act as protectors of the Buddhist law are: Ten (Sk: Deva), Ryū (Sk: Naga), Yasha (Sk: Yaksa), Kendatsuba (Sk: Gandharva), Ashura (Sk: Asura), Karura (Sk: Garuda), Kinnara (Sk: Kimnara), and Magoraka (Sk: Mahoraga).

6. The ten disciples are: Sharihotsu (Sk: Śāriputra), Daikashō (Sk: Mahākāśyapa), Mokukenren (Sk: Maudgalyāyana), Anaritsu (Sk: Aniruddha), Subodai (Sk: Subhūti), Furuna (Sk: Purna), Kasennen (Sk: Kātyāyana), Ubari (Sk: Upāli), Ragora (Sk: Rāhula) and Ananda (Sk: Ānanda).

7. Kuninaka no Muraji Kimimaro was a grandson of a Baekje immigrant from the Korean Peninsula. He was named deputy head of the Bureau for the Construction of Tōdai-ji. In 761, he was awarded the rank Junior Fourth, Lower Grade. It is thought that he was called master of the Great Buddha (*daibusshi*) because, unlike other government officials, he had technical training.

8. The nine-story pagoda of Hwangryongsa, a temple in Silla on the Korean peninsula, was made of wood and measured 68.2 meters in height, but the seven-story pagodas at Tōdai-ji stood even taller. These tall towers would not topple in an earthquake because of the functioning of the central column (*shinbashira*).

Chapter 5

1. The Chinese sexagenary system of recording time uses sixty two-character terms for recording days and years. Originating in China, it was adopted in Japan in the early seventh century.

2. The eight Japanese monks who traveled to Tang, collectively called Nittō Hakke, and the length of their stays in China are as follows: Tendai monk Saichō 804–805, Shingon monk Kūkai 804–806, Shingon monk Jōgyō 838–839, Shingon monk Engyō 838–839, Tendai monk Ennin 838–847, Shingon monk Eun 842–847, Tendai monk Enchin 853–858 and Shingon monk Shūei 862–863.

3. The Five Great Wisdom Kings (Godai Myō-ō) also known as the Five Great Honored Ones (Godaison) or the Five Angry Deities (Gofunnu) are: Fudō Myō-ō (Sk: Acala or Acalanātha), Gōzanze Myō-ō (Sk: Trailokyavijaya), Gundari Myō-ō (Sk: Kuṇḍali Vidyārāja), Daitoku Myō-ō (Sk: Yamāntaka), and Kongō Yasha Myō-ō (Sk: Vajrayakṣa). The Twelve Devas include guardian deities of the heavens and earth Bonten (Sk: Brahmā), Jiten (Sk: Pṛthivī),

of the Sun and the Moon Nitten (Sk: Sūrya) and Gatten (Sk: Candra), and of the eight directions: Taishakuten (Sk: Indra), Katen (Sk: Agni), Enmaten (Sk: Yama), Rasetsuten (Sk: Rākṣasa), Suiten (Sk: Varuṇa), Fūten (Sk: Vāyu), Bishamonten (Sk: Vaiśravaṇa) and Izanaten (Sk: Īśāna).

4. The current fourteenth-century image at Daigo-ji temple is a replacement for a painting lost to fire. The immense painting of the eighteen-faced thirty-six-armed icon stands 3.5 meters in height. The body of the deity is adorned with skulls. The original image would likely have been of a similar scale.

5. Hamada Takashi, *Mandara no sekai: Mikkyō kaiga no tenkai* (The World of Mandalas: The Development of Esoteric Buddhist Painting) (Tokyo: Bijutsu Shuppan, 1971).

6. *Honpa*-style robe design: Thick rounded folds resembling large waves alternate with sharp shallow folds resembling small waves. The technique was used as early as the Nara period in dry-lacquer (*kanshitsu*) sculptures.

7. *Danzō* refers to sculptures made using sandalwood (*byakudan* or *sendan*) native to India. To prolong the aroma of the wood, the sculpture was left untreated. First in fashion in Tang China, the style was adopted in Japan. The Nine-Headed Kannon (Kumen Kannon) at Hōryū-ji temple was brought to Japan in 719 during the High Tang. The niche-shaped portable shrine with a host of Buddhist deities at Kongōbu-ji was brought back by Kūkai in 806. In Japan, the term *byakudan-zō* was applied to statues that were made using alternative kinds of wood: Japanese nutmeg-yew (*kaya*), Chinese juniper (*byakushin*), Japanese cypress (*hinoki*), *Cercidiphyllum japonicum* (*katsura*), cherry (*sakura*) and camphor (*kusu*). The use of such alternative types of wood contributed to the development of single-block sculpture.

8. Dōkyō attempted to usurp the throne using his intimate ties to reigning Empress Shōtoku, Emperor Shōmu's first daughter. Courtiers opposing Dōkyō dispatched Wake no Kiyomaro to the Usa Hachiman-gū shrine to receive an oracle from the *kami* in 769. On the order of the *kami*, the statue at Jingan-ji in Kawachi (the present southwest Osaka area), which was constructed in the Enryaku era (782–806), was moved to Jingo-ji by Wake no Kiyomaro's sons Hiroyo and Matsuna.

9. Sarai Mai, "Jingo-ji Yakushi Nyorai no zō no shiteki kōsatsu" (Historical Consideration of the Yakushi Nyorai Image at Jingo-ji Temple) in *Bijutsu Kenkyu* 403 (2011).

10. Uehara Shōichi, "Heian shoki chōkoku no tenkai" (The Development of Early Heian Sculpture) in *Nihon bijutsu zenshū 6: Mikkyō bijutsu* (Complete Collection of Japanese Art, vol. 6: Esoteric Buddhist Art) (Tokyo: Gakushū Kenkyūsha, 1980).

11. Some scholars think that this statue was made by an immigrant Chinese sculptor.

12. According to the *Tōshikaden* (*History of the Fujiwara Family*, 706), the deity Kehi appeared in a dream to Fujiwara no Muchimaro, confessing his agony at becoming a *kami* under the law of karma and saying that he was seeking salvation in Buddhism. Upon hearing this, Muchimaro built Kehi Jingū-ji for the deity in 715.

13. Tanabe Saburōsuke, "Shinbutsu shūgō no shozō" (Various Statues that Represent the Union between *Kami* and Buddha) in *Nihon bijutsu zenshū: Mikkyō jiin to butsuzō* (*Complete Collection of Japanese Art* 5: Esoteric Buddhist Temples and Statues; Tokyo: Kōdansha, 1992).

14. Hashimoto Osamu, "Sono jū, yutakasa to iu mono, Jingū kōgō zazō" (Number Ten: On Richness, Seated Statue of Empress Jingū) in *Hiragana Nihon bijutsushi* (Japanese Art History in Hiragana) (Tokyo: Shinchōsha, 1995).

15. Hōgen ("Eye of the Law") is one of honorary Buddhist titles given to distinguished sculptors, painters, poets, doctors and other professions. There are three titles (from high to low): *hōin* ("Seal of the Law"), *hōgen* ("Eye of the Law") and *hokkyō* ("Bridge of the Law").

16. In the history of Japanese calligraphy, the Heian period was the most fruitful. Calligraphy was in fact valued more than pictorial images and hence more has survived. For a detailed explanation, see *Nihon bijutsu zenshū 8: Sanpitsu / Sanseki* (Complete Collection of Japanese Art, vol. 8: Sanpitsu and Sanseki) (Tokyo: Gakushū Kenkyūsha, 1980).

17. Screen-poems (*byōbu uta*) were collaborative efforts in which aristocrats would compose Japanese poetry (*waka*) to describe their responses to scenes that had been painted on folding screens.

18. Tracing the Chinese origins of *keibutsu-ga* genres in written sources and extant examples reveals that the origins date back to Early Tang folding screens depicting popular annual events from various seasons in China (C: *yueling tu pingfeng*; J: *getsureizu byōbu*). The pictorial theme "landscapes of four times of year" (C: *sishi shanshui*) corresponds to the Japanese "landscapes of the four seasons" (*shiki sansui*). Murals on the walls of Yong Xingling, the tomb commissioned by the Liao Empire of the Khitans in 1031, depict birds and flowers of each of the four seasons on the four walls.

19. From the medieval period onwards, two folding screens were counted as a single pair (*issō*, modern *ittsui*), though prior to that each individual screen was counted separately (*ichijō*). There were exceptions, however, as in the case of the Shōsō-in Repository records where screens were counted as one unit consisting of a pair (*ichigu ryōjō*).

20. Tsuji Nobuo, "Hana no bi, hana no ishō" (The Beauty of Flowers, Designs of Flowers), in Nakanishi Susumu and Tsuji Nobuo (ed.), *Hana no hensō: Hana to Nihon bunka* (Variation on Flowers: Flowers in Japanese Culture) (Tokyo: Perikansha, 1997).

21. The Hōgen Disturbance is attributed Emperor Shirakawa's lechery. He was reportedly infatuated with his adopted daughter Tamako (later Taikenmon-in). When he retired, Shirakawa made her empress to his grandson, Emperor Toba. Tamako bore the new emperor a son who became Emperor Sutoku. But a rumor circulated that Sutoku was in fact Shirakawa's son. Wounded by such gossip, Toba made another son, Konoe, emperor in place of Sutoku. When Konoe died in 1155, Toba ordered that Konoe's younger half-brother Go-Shirakawa be named emperor. Sutoku was unbearably angered that his son was blocked from ever ascending the throne. There was a corresponding split in aristocratic society. Fighting broke out between those who sided with Sutoku and those who sided with Go-Shirakawa. Sutoku's partisans were defeated, and the ex-emperor was exiled to Sanuki on the island of Shikoku. The victorious Go-Shirakawa retired shortly thereafter but continued to wield power. However, a rift developed between his close advisors Shinzei (Fujiwara no Michinori) and Fujiwara no Nobuyori. They were allied with different warrior clans. The Taira (Heike) sided with Shinzei while the Minamoto (Genji) aligned with Nobuyori. Their rivalry erupted in the Heiji Disturbance in 1159, the first year of the Heiji era. The Taira forces led by Taira no Kiyomori triumphed, and there followed a period of Taira ascendancy and glory.
22. Ishimoda Shō, *Nihonshi gaisetsu I* (History of Japan: A Survey I). In Iwanami Zensho (Iwanami Library). Tokyo: Iwanami Shoten, 1995.
23. *Tsukuri-e* is technique used to produce painted images on small surfaces such as an illustrated handscroll. Thick layers of color were applied over ink underdrawings. Finishing details such as faces and garment patterns were painted using ink. This technique was used by successive generations.
24. The word *gōshō* refers to the physical act of welcoming the deceased in one's arms. The term has a more direct sense than *raigō*.
25. *Doha* is a slightly elevated mound. These mounds often appear in *Yamato-e* landscape paintings.
26. A sutra mound (*kyōzuka*) was a buried repository of sutras and/or other religious paraphernalia deposited for specific religious purposes such as the belief in *mappō*, the end of the third Buddhist world in 1052.
27. Ash glaze (*kaiyū*) is produced when alkaline minerals like potassium and sodium, which are contained in ash from plant matter, and silicate compounds like feldspar and quartz are vitrified after being melted down by the firing. Ash glaze can naturally occur in the process of firing ceramics when ash from the wood settles on the pots. This is also called natural glaze. In China this method was deliberately used from the beginning of the Common Era and was also used to produce celadon wares. A green glaze can be produced by adding verdigris or similar copperized compounds to low-fired lead glaze to make it appear green. The green glaze of Sanage kilns was produced by modifying

the lead-glaze method used for producing three-color ware in the Tenpyō period. The natural glazes seen in Tokoname and Atsumi wares appear to have made conscious use of the design patterns of flowing glazes. Natural glaze was frequently used in the teabowls from the later sixteenth century onwards.

28. *Kushi furyū* referred to such actions as building a tiny hut with dried leaves from reeds, placing a papier-mâché child wearing a kimono inside it. The floor and roof would be mimicked with combs. Threads would represent flowing water of the artificial stream. Other objects might be represented by various toiletries. These were ingenious *tsukurimono*. The viewer was supposed to see the meaning of the poem "The small hut in Tsu / Where we lived, hidden / By the leaves of the reeds / Exposed / As winter has come" in the *Shūi Wakashū* anthology in the representation of this *tsukurimono*. See Tsuji Nobuo, "Furyū no kisō" (Eccentric/ Fantastic Elegance) in *Kisō no zufu* (Illustrated Catalogue of the Eccentric/Fantastic), (Tokyo: Heibonsha 1989; and Chikuma Gakugei Bunko, 2005).

Chapter 6

1. Isozaki Arata, *Kenchiku ni okeru "Nihon-teki" na mono* (Japan-ness in Architecture) (Tokyo: Shinchōsha, 2003) 245-6.

2. Mizuno Keisaburō, *Unkei to Kamakura chōkoku* (Unkei and Kamakura Sculpture), Books of Books (Tokyo: Shōgakukan, 1973).

3. Miyajima Shin'ichi, "*Nachi taki zu kaisetsu*" (On *Nachi Waterfall*), *Nihon bijutsu zenshū 9: Engi-e to nise-e* (Complete Collection of Japanese Art, vol. 9: Engi-e and Nise-e) (Tokyo: Kōdansha, 1993).

4. Around two hundred Kamakura-period illustrated handscrolls are recorded in Okudera Hideo, *Emaki-mono saiken* (A New Look at Illustrated Handscrolls) (Tokyo: Kadokawa Shoten, 1987).

5. Ippen (1239–1289) first trained in Tendai Buddhism on Mt. Hiei, but studied Pure Land (Jōdo) Buddhism with Hōnen's disciple Shōkū. His faith took yet another turn when, during a pilgrimage to Kumano, he heard an oracular voice promising "an afterlife paradise for all living beings" (*shujō ōjō*). From that point onward he traveled throughout Japan, attracting followers and leading enormous crowds in a form of ecstatic chanting known as *odori nenbutsu* (dancing *nenbutsu*). He also renounced all forms of worldly possession, earning the epithet "Renunciatory Saint" (*sute-hijiri*).

Chapter 7

1. Ide Seinosuke, "Nihon no Sō Gen butsuga" (Song and Yuan Buddhist Paintings in Japan), *Nihon no bijutsu* (Arts in Japan) 418 (Tokyo: Shibundō, 2001).

2. One bay (*ma* or *ken*) is the standardized space between two pillars in a *shinden*-style building, generally measuring a little less than two meters.

Chapter 8

1. The main hall of Tsukubusuma shrine was remodeled in 1602. The magistrate Katagiri Katsumoto of the Toyotomi family donated architecture sections, perhaps from the Hōkoku mausoleum, in the name of Toyotomi Hideyori.

Chapter 9

1. Langdon Warner, *The Enduring Art of Japan* (New York: Grove Press; London: Evergreen Books, 1952), 66–67.
2. They represent the second generation of Western-style painting in Japan, however. See Chapter 8, page 299 for the first generation of Western-style painting.
3. The set is now in the Museum of the Imperial Collections.
4. Saitō Gesshin, *Zōho Ukiyo-e Ruikō* (Augmented and Revised Account of Ukiyo-e), 1844. This compilation of biographies and notes on ukiyo-e artists identifies Sharaku as Saitō Jūrobei. Saitō Gesshin (1804–1878) was the ward representative (*nanushi*) of Kiji-chō in Kanda, Edo, where he was in charge of town's day-to-day administration, and whose responsibilities included updating registration of residents and their family members. He is the author of basic references about the city of Edo such as *Edo Meisho Zue* (Famous Places of Edo; 1834–36), *Tōto Saijiki* (Chronicle of the Year's Events in the Eastern Capital; 1838), and the *Buko Nenpyō* diary (1882).

Chapter 10

1. Quoted in Motoe Kunio, "On Fairness," in *Mō hitotsu no Meiji bijutsu* (Another Type of Meiji Art), ed. Shizuoka Prefectural Museum of Art, Fuchū Art Museum, Nagano Prefectural Shinano Art Museum and Okayama Prefectural Museum of Art, 2003.
2. In 1895, at the fourth Domestic Industrial Exposition, a female nude painting Kuroda Seiki produced during his time in France titled *Morning Toilette* (*Chōsō*, 1893; lost to fire) was exhibited. The painting caused a storm of criticism in the newspapers, which described the work as "a despicable painting that corrupts public morals."
3. Quoted in Edgar Wind, *Art and Anarchy*, (Evanston, IL: Northwestern University Press, 1985), 40. For the translation of the other quote in French, "L'esquisse fait bouger le chef-d'oeuvre," in Henri Focillon, *The Life of Forms in Art*, trans. George Kubler (New York: Zone Books, 1992), 27.
4. As noted in Chapter 9, woodblock printing in preceding periods was a work of a team described as the "ukiyo-e quartet": the publisher (*hanmoto*), the designer (*eshi/gakō*), the woodblock cutter (*horishi*) and the printer (*surishi*). However, it is important to note that even for *sōsaku hanga*, print artists did occasionally collaborate with master woodblock carvers such as Igami Bonkotsu (1875–1933) to produce their work.

5. Fujimori Terunobu has noted that modernism and historicism represent the two sides of a fundamental divide in the idea of architecture. Fujimori Terunobu, *Nihon no kindai kenchiku* (Modern Architecture in Japan), vol. 2 (Tokyo: Iwanami Shoten, 1993), 155.

6. By the late 1930s, many Russian Constructivists had moved on to Socialist Realism after being criticized for extreme leftist beliefs.

7. In 2003, the Museum of Modern Art, Tokyo, put on an exhibition titled "Dream of the Horizon: Surrealist Paintings of the 1930s and '40s" (Chihei-sen no yume: Shōwa jūnendai no gensō kaiga) that featured Surrealist works depicting the horizon on land or sea. In the catalogue, Ōtani Shōgo (b. 1969) analyzed hope and a sense of crisis for the period through the depiction of horizons.

8. Hayashi Yōko, "Tabisuru gaka Foujita Tsuguharu: Nichi-Futsu no aida no Amerika" (The Traveling Painter Foujita Tsuguharu: America in-between Japan and France), *Geijutsu kenkyū* 381 (2004).

9. Fujimori, *Nihon no kindai kenchiku*, vol. 2, 186.

10. The term *haniwa* refers to fourth- to sixth-century earthenware cylinders occasionally topped with figural or other representations of objects such as houses, as in this reference. *Haniwa* were originally placed near or on top of mounded tombs during the Kofun period (second half of third to early eighth century), possibly serving some performative or ceremonial function. See Chapter 2 for further discussion of the production of *haniwa* and their cultural setting.

11. Lee Ufan, *Yohaku no geijutsu* (The Art of the Empty Space) (Tokyo: Misuzu Shobō, 2000), 3.

12. Takashina Shūji, *19–20 seiki no bijutsu higashi to nishino deai* (Art of the 19–20 Centuries: Encounter of the East and the West). In vol. 6 of Iwanami Nihon Bijutsu no Nagare (Iwanami overview of Japanese Art series), (Tokyo: Iwanami Shoten, 1991), 134.

13. Fujimori, *Nihon no kindai kenchiku*, vol. 2, 155.

14. Langdon Warner, *The Enduring Art of Japan* (Cambridge, MA: Harvard University Press, 1952), viii.

Recommended Reading for Further Study

Surveys and Broad Studies

Addiss, Stephen. *How to Look at Japanese Art*. New York: Abrams, 1996.

Arthur M. Sackler Gallery and Smithsonian Freer Gallery of Art. *The Arts of Japan: A Teacher's Guide*. Washington, DC: Smithsonian Institution, 2005.

Cahill, James. *The Lyric Journey: Poetic Painting in China and Japan*. Cambridge, MA: Harvard University Press, 1996.

Cavaye, Ronald, Paul Griffith, and Akihiko Senda. *A Guide to the Japanese Stage: From Traditional to Cutting Edge*. Tokyo: Kodansha International, 2005.

Chino, Kaori. "Gender in Japanese Art." In *Gender and Power in the Japanese Visual Field*, edited by Joshua S. Mostow, 17–34. Honolulu: University of Hawai'i Press, 2003.

Clark, Timothy, C., Andrew Gerstle, Aki Ishigami, and Akiko Yano, eds. *Shunga: Sex and Pleasure in Japanese Art*. London: The British Museum Press, in association with Hotei, 2013.

Coaldrake, William H. *Architecture and Authority in Japan*. Nissan Institute / Routledge Japanese Studies Series. London and New York: Routledge, 1996.

——. *The Way of the Carpenter: Tools and Japanese Architecture*. New York and Tokyo: Weatherhill, 1990.

Cort, Louise Allison. *Shigaraki: Potters' Valley*. New York: Weatherhill, 2000. Originally published by Kodansha International, 1979.

Cox, Rupert A., ed. *The Culture of Copying in Japan: Critical and Historical Perspectives*. Japan Anthropology Workshop Series. London and New York: Routledge, 2007.

Croissant, Doris, ed. *Splendid Impressions: Japanese Secular Painting 1400–1900 in the Museum of East Asian Art, Cologne*. Leiden: Hotei, 2011.

Epprecht, Katharina. *Kannon: Divine Compassion: Early Buddhist Art from Japan*. Zurich: Museum Rietberg, 2007.

Frampton, Kenneth, Kunio Kudo, and Keith Vincent. *Japanese Building Practice: From Ancient Times to the Meiji Period*. New York: Van Nostrand Reinhold, 1997.

Graham, Patricia J. *Japanese Design: Art, Aesthetics, and Culture*. Rutland, VT: Tuttle, 2014.

Grotenhuis, Elizabeth ten. *Japanese Mandalas: Representations of Sacred Geography*. Honolulu: University of Hawai'i Press, 1999.

Hayakawa, Masao. *The Garden Art of Japan*. Translated by Richard L. Gage. The Heibonsha Survey of Japanese Art, vol. 28. New York and Tokyo: Weatherhill, 1973.

Hillier, Jack. *The Art of the Japanese Book*. 2 vols. London: Sotheby's, 1987.

Isozaki, Arata, and David B. Stewart. *Japan-ness in Architecture*. Translated by Sabu Kohso. Cambridge, MA: MIT Press, 2006.

Itoh, Teiji. *Traditional Domestic Architecture of Japan*. Translated by Richard L. Gage. The Heibonsha Survey of Japanese Art, vol. 21. New York and Tokyo: Weatherhill, 1972.

Jackson, Anna. *Japanese Textiles in the Victoria and Albert Museum*. London: V&A Museum, 2000.

——. ed. *Kimono: The Art and Evolution of Japanese Fashion: The Khalili Collections*. London: Thames and Hudson, 2015.

Jordan, Brenda G., and Victoria Weston, eds. *Copying the Master and Stealing His Secrets: Talent and Training in Japanese Painting*. Honolulu: University of Hawaiʻi Press, 2003.

Kageyama, Haruki. *Shinto Arts: Nature, Gods, and Man in Japan*. New York: Japan Society, 1976.

Keyes, Roger S. *Ehon: The Artist and the Book in Japan*. Seattle: University of Washington Press, 2006.

Kornicki, Peter F. *The Book in Japan: A Cultural History from the Beginnings to the Nineteenth Century*. Handbuch der Orientalistik. Fünfte Abteilung, Japan, vol. 7. Leiden: Brill, 1998.

Kuitert, Wybe. *Themes in the History of Japanese Garden Art*. Honolulu: University of Hawaiʻi Press, 2002.

Larsen, Knut Einar. *Architectural Preservation in Japan*. Paris: ICOMOS International Wood Committee; Tapir, 1994.

Levine, Gregory. *Daitokuji: The Visual Cultures of a Zen Monastery*. Seattle: University of Washington Press, 2005.

——. *Long Strange Journey: On Modern Zen, Zen Art, and Other Predicaments*. Honolulu: University of Hawaiʻi Press, 2017.

Levine, Gregory, Andrew Watsky, and Gennifer Weisenfeld, eds. *Crossing the Sea: Essays on East Asian Art in Honor of Professor Yoshiaki Shimizu*. Princeton, NJ: Princeton University Press, 2012.

Mason, Penelope E., and Donald Dinwiddie. *History of Japanese Art*. 2nd ed. Upper Saddle River, NJ: Pearson / Prentice Hall, 2005.

Mertz, Mechtild. *Wood and Traditional Woodworking in Japan*. Otsu: Kaiseisha Press, 2011.

Mikami, Tsugio. *The Art of Japanese Ceramics*. Translated by Ann Herring. The Heibonsha Survey of Japanese Art, vol. 29. New York and Tokyo: Weatherhill, 1972.

Mostow, Joshua S., Norman Bryson, and Maribeth Graybill. *Gender and Power in the Japanese Visual Field*. Honolulu: University of Hawaiʻi Press, 2003.

Nakata, Yūjirō. *The Art of Japanese Calligraphy*. Translated by Alan Woodhull in collaboration with Armins Nikovskis. The Heibonsha Survey of Japanese Art,

vol. 27. New York: Weatherhill, 1973.

Nishi, Kazuo, and Kazuo Hozumi. *What Is Japanese Architecture?* Tokyo and New York: Kodansha International, 1985.

Nitschke, Günter, and Karen Williams. *Japanese Gardens: Right Angle and Natural Form*. Cologne and New York: Taschen, 1999.

Noma, Seiroku. *Japanese Costume and Textile Arts*. Translated by Armins Nikovskis. The Heibonsha Survey of Japanese Art, vol. 16. New York and Tokyo: Weatherhill, 1974.

Parent, Mary Neighbour. *The Roof in Japanese Buddhist Architecture*. Tokyo and New York: Weatherhill/Kajima, 1983.

Rathbun, William Jay, ed. *Beyond the Tanabata Bridge: Traditional Japanese Textiles*. New York: Thames and Hudson, in association with Seattle Art Museum, 1993.

Rosenfield, John M. "Japanese Studio Practice: The Tosa Family and the Imperial Painting Office in the Seventeenth Century." In *The Artist's Workshop*, edited by Peter M. Lukehart. Washington: National Gallery of Art, 1993.

Rousmaniere, Nicole Coolidge. *Vessels of Influence: China and the Birth of Porcelain in Medieval and Early Modern Japan*. London: Bristol Classics Press / Bloomsbury Academic, 2012.

——, ed. *Kazari: Decoration and Display in Japan, 15th–19th Centuries*. New York: Japan Society; London: British Museum Press, 2002.

Ruch, Barbara, ed. *Engendering Faith: Women and Buddhism in Premodern Japan*. Michigan Monograph Series in Japanese Studies, no. 43. Ann Arbor: Center for Japanese Studies / University of Michigan, 2002.

Shimizu, Yoshiaki. *Japan: The Shaping of Daimyo Culture, 1185–1868*. New York: G. Braziller; Washington, DC: National Gallery of Art, 1988.

Shimizu Yoshiaki, and John M. Rosenfield. *Masters of Japanese Calligraphy: 8th–19th Century*. New York: Asia Society Galleries, 1984.

Shirahara, Yukiko, ed. *Japan Envisions the West: 16th–19th-Century Japanese Art from Kobe City Museum*. Seattle: Seattle Art Museum, distributed by University of Washington Press, 2007.

Shirane, Haruo. *Japan and the Culture of the Four Seasons: Nature, Literature, and the Arts*. New York: Columbia University Press, 2012.

——, ed. *Envisioning The Tale of Genji: Media, Gender, and Cultural Production*. New York: Columbia University Press, 2008.

——, ed. *Traditional Japanese Literature: An Anthology, Beginnings to 1600*. New York: Columbia University Press, 2007.

Stavros, Matthew. *Kyoto: An Urban History of Japan's Premodern Capital*. Spatial Habitus Making & Meaning in Asia's Architecture. Honolulu: University of Hawai'i Press, 2014.

Steinhaus, Werner, and Simon Kaner, eds. *An Illustrated Companion to Japanese*

Archaeology. Oxford: Archeopress, 2016.

Suzuki, Jun and Ellis Tinios. *Understanding Japanese Woodblock-Printed Illustrated Books: A Short Introduction to Their History, Bibliography and Format*. Leiden: Brill, 2013.

Tokyo National Museum, ed. *Elegant Perfection: Masterpieces of Courtly and Religious Art from the Tokyo National Museum*. Museum of Fine Arts, Houston; New Haven, CT: Yale University Press, 2011.

Totman, Conrad D. *The Green Archipelago: Forestry in Preindustrial Japan*. Ohio University Press Series in Ecology and History. Athens: Ohio University Press, 1998.

Tsuji, Nobuo. "Ornament (*Kazari*): An Approach to Japanese Culture." *Archives of Asian Art* 47 (1994): 35–45.

——. *Playfulness in Japanese Art*. Franklin D. Murphy Lectures, no. 7. Lawrence, KS: Spencer Museum of Art, 1985.

Varley, Paul H., and Kumakura Isao, eds. *Tea in Japan: Essays on the History of Chanoyu*. Honolulu: University of Hawai'i Press, 1989.

Wilson, Richard. *Inside Japanese Ceramics: Primer of Materials, Techniques and Traditions*. New York and Tokyo: Weatherhill, 1999.

Yonemura, Ann. *Twelve Centuries of Japanese Art from the Imperial Collections*. Washington, DC: Freer Gallery of Art; Arthur M. Sackler Gallery; Smithsonian Institution Press, 1997.

Yoshikawa, Itsuji. *Major Themes in Japanese Art*. Translated by Armins Nikovskis. The Heibonsha Survey of Japanese Art, vol. 1. New York and Tokyo: Weatherhill, 1976.

Young, David and Michiko. *The Art of Japanese Architecture*. Tokyo and Rutland, VT: Tuttle, 2007.

——. *The Art of the Japanese Garden*. Tokyo and Rutland, VT: Tuttle, 2005.

Chapter 1 The Jōmon Period

Egami, Namio, and John Bester. *The Beginnings of Japanese Art*. Translated by John Bester. The Heibonsha Survey of Japanese Art, vol. 2. New York and Tokyo: Weatherhill, 1973.

Habu, Junko. *Ancient Jomon of Japan*. Cambridge, UK: Cambridge University Press, 2004.

Kaner, Simon, ed. *The Power of Dogu: Ceramic Figures from Ancient Japan*. London: British Museum, 2009.

Kenrick, Douglas M. *Jomon of Japan: The World's Oldest Pottery*. London: Kegan Paul International, 1995.

Kobayashi, Tatsuo, Simon Kaner, and Oki Nakamura. *Jomon Reflections: Forager Life and Culture in the Prehistoric Japanese Archipelago*. Oxford: Oxbow Books, 2004.

Naumann, Nelly. *Japanese Prehistory: The Material and Spiritual Culture of the Jōmon Period*. Wiesbaden: Harrassowitz, 2000.

Rousmaniere, Nicole Coolidge. "The *Dogū* Phenomenon." In *Dogū Cosmos*, edited by Nobuo Tsuji, 246–62, 334–40. Tokyo: Hatori Shoten, 2012.

Chapter 2 Art of the Yayoi and Kofun Periods

Amakasu, Ken. "The Significance of the Formation and Distribution of Kofun." *Acta Asiatica* 31 (1977), 24–51.

Barnes, Gina Lee. *State Formation in Japan: Emergence of a Fourth-Century Ruling Elite*. Durham East Asia Series. London and New York: Routledge, 2007.

Farris, William Wayne. *Ancient Japan's Korean Connection*. Working Papers in Asian/Pacific Studies, 95–01. Durham, NC: Asian/Pacific Studies Institute, Duke University, 1995.

——. *Sacred Texts and Buried Treasures: Issues in the Historical Archaeology of Ancient Japan*. Honolulu: University of Hawai'i Press, 1998.

Fogel, Joshua A. *Japanese Historiography and the Gold Seal of 57 CE: Relic, Text, Object, Fake*. Brill's Japanese Studies Library, vol. 42. Boston: Brill, 2013.

Hong, Wontack. *Paekche of Korea and the Origin of Yamato Japan*. Ancient Korean-Japanese History. Seoul: Kudara International, 1994.

Kidder, J. Edward, Jr. "The Fujinoki Sarcophagus." *Monumenta Nipponica* 44:4 (1989): 415–60.

——. *Himiko and Japan's Elusive Chiefdom of Yamatai: Archeology, History, and Mythology*. Honolulu: University of Hawai'i Press, 2007.

——. "The Newly Discovered Takamatsuzaka Tomb." *Monumenta Nipponica* 27:5 (Autumn 1972): 245–51.

Mizoguchi, Koji. *The Archaeology of Japan: From the Earliest Rice Farming Villages to the Rise of the State*. Cambridge World Archaeology. Cambridge, UK: Cambridge University Press, 2013.

——. *Archaeology, Society and Identity in Modern Japan*. Cambridge Studies in Archaeology. Cambridge, UK: Cambridge University Press, 2006.

Chapter 3 The Asuka and Hakuhō Periods

Coaldrake, William H. "Ise Jingu." In *Asian Art*, edited by Rebecca M. Brown and Deborah S. Huttom. London: Blackwell, 2006.

Deal, William E. "Buddhism and the State in Early Japan." In *Buddhism in Practice*, edited by Donald S. Lopez Jr., 216–27. Princeton, NJ: Princeton University Press, 1995.

Domenig, Gaudenz. "The Valley of the Inner Ise Shrine: Ritual Structure and Cosmological Significance of a Protohistoric Territory." In *Temples in Traditional Environments*, 84–119. Traditional Dwellings and Settlements Working Paper Series, vol. 49. Berkeley: University of California, 1992.

Toshifumi, Konno. "Tōdaiji's Great Buddha: Its Foundations in Buddhist Doctrine and Its Chinese and Korean Precedents." In *Transmitting the Forms of Divinity: Early Buddhist Art from Japan and Korea*, edited by Hiromitsu Washizuka et al., 115–27. New York: Japan Society, 2003.

McCallum, Donald F. *The Four Great Temples: Buddhist Archaeology, Architecture and Icons of Seventh-Century Japan*. Honolulu: University of Hawaiʻi Press, 2008.

———. *Hakuhō Sculpture*. Seattle: University of Washington Press, 2011.

Mizuno, Seiichi. *Asuka Buddhist Art: Horyu-ji*. Translated by Richard L. Gage. The Heibonsha Survey of Japanese Art, vol. 4. New York and Tokyo: Weatherhill, 1974.

Ooms, Herman. *Imperial Politics and Symbolics in Ancient Japan: The Tenmu Dynasty, 650–800*. Honolulu: University of Hawaiʻi Press, 2009.

Pradel, María del Rosario. *Fabricating the Tenjukoku Shūchō Mandara and Prince Shōtoku's Afterlives*. Leiden: Hotei, 2016.

Walley, Akiko. *Constructing the Dharma King: The Hōryūji Shaka Triad and the Birth of the Prince Shōtoku Cult*. Leiden: Brill, 2015.

———. "Flower of Compassion: The Tamamushi shrine and the Nature of Devotion in Seventh-Century Japan." *Artibus Asiae* 72:2 (2012): 265–322.

Washizuka, Hiromitsu, et al., eds. Transmitting the Forms of Divinity: Early Buddhist Art from Korea and Japan. New York: Japan Society, 2003.

Wong, Dorothy C., and Eric M. Field. *Hōryūji Reconsidered*. Newcastle, UK: Cambridge Scholars, 2008.

Chapter 4 Art of the Nara Period

Como, Michael. "Horses, Dragons, and Disease in Nara Japan." *Japanese Journal of Religious Studies* 34:2 (2007): 393–415.

Farris, William Wayne. "Trade, Money and Merchants in Nara Japan." *Monumenta Nipponica* 53:3 (Autumn 1998): 303–34.

Goepper, Roger. "Icon and Ritual in Japanese Buddhism." In *Enlightenment Embodied: The Art of the Japanese Buddhist Sculptor (7th–14th Centuries)*, edited by Washizuka Hiromitsu and Roger Goepper, 73–77. New York: Japan Society, 1997.

Grapard, Allan G. "Shrines Registered in Ancient Japanese Law: Shinto or Not?" *Japanese Journal of Religious Studies* 29:3–4 (Fall 2002): 209–32.

Hayashi, Ryōichi. *The Silk Road and the Shoso-in*. Translated by Robert Ricketts. The Heibonsha Survey of Japanese Art, vol. 6. New York and Tokyo: Weatherhill, 1975.

Kobayashi, Takeshi. *Nara Buddhist Art: Todai-ji*. Translated by Richard L. Gage. Heibonsha Survey of Japanese Art, vol. 5. New York and Tokyo: Weatherhill, 1975.

Moran, Sherwood F. "The Gilding of Ancient Bronze Statues in Japan." *Artibus Asiae* 31:1 (1969): 55–65.

Ōoka, Minoru. *Temples of Nara and Their Art.* Translated by Dennis Lishka. The Heibonsha Survey of Japanese Art, vol. 7. New York and Tokyo: Weatherhill, 1973.

Tanaka, Hidemichi. "The Discovery of a Great Sculptor: Kimimaro of the Nara Period (710–793)." *Artibus et Historiae* 17:33 (1996): 187–220.

Tsuboi, Kiyotari, and Tanaka, Migaku. *The Historic City of Nara: An Archaeological Approach.* Translated by David W. Hughes and Gina L. Barnes. Tokyo and Paris: Centre for East Asian Cultural Studies / UNESCO, 1991.

Yiengpruksawan, Mimi Hall. "The Legacy of Buddhist Art at Nara." In *Buddhist Treasures from Nara: The Cleveland Museum of Art,* edited by Michael R. Cunningham, 1–34. New York: Hudson Hills Press, 1998.

Chapter 5 The Heian Period

Adolphson, Mikael S. *The Gates of Power: Monks, Courtiers and Warriors in Premodern Japan.* Honolulu: University of Hawai'i i Press, 2000.

Adolphson, Mikael S., Edward Kamens, and Stacie Matsumoto, eds. *Heian Japan, Centers and Peripheries.* Honolulu: University of Hawai'i Press, 2007.

Akiyama, Terukazu. "Continuity and Discontinuity in the Pictorial Composition of Handscroll Painting." *Acta Asiatica* 56 (1989): 24–45.

——. "Women Painters of the Heian Court." In *Flowering in the Shadows: Women in the History of Chinese and Japanese Painting,* edited by Marsha Weidner, 159–84. Honolulu: University of Hawai'i Press, 1990.

Andrews, Allan A. *The Teachings Essential for Rebirth: A Study of Genshin's Ōjōyō-shū.* Monumenta Nipponica Monograph. Tokyo: Sophia University, 1973.

Bargen, Doris G. *A Woman's Weapon: Spirit Possession in the Tale of Genji.* Honolulu: University of Hawai'i Press, 1997.

Blair, Heather. "Zaō Gongen: From Mountain Icon to National Treasure." *Monumenta Nipponica* 66:1 (2011): 1–47.

Boehm, Christian. *The Concept of Danzō: "Sandalwood Images" in Japanese Buddhist Sculpture of the 8th to 14th Centuries.* London: Saffron Books, 2012.

Bogel, Cynthea J. "Canonizing Kannon: The Ninth-Century Esoteric Buddhist Altar at Kanshinji." *Art Bulletin* 84:1 (2002): 30–64.

——. "A Matter of Definition: Japanese Esoteric Art and the Construction of an Esoteric Buddhist History." *Waseda Journal of Asian Studies* 18 (1996): 23–39.

——. *With a Single Glance: Buddhist Icon and Early Mikkyō Vision.* Seattle: University of Washington Press, 2009.

Brock, Karen L. "The Marking and Remarking of Miraculous Origins of Mt. Shigi." *Archives of Asian Art* 45 (1992): 42–71.

Fowler, Sherry Dianne. *Muroji: Rearranging Art and History at the Japanese*

Buddhist Temple. Honolulu: University of Hawaiʻi Press, 2005.

Fukuyama, Toshio. *Heian Temples: Byodo-in and Chuson-ji.* Translated by Ronald K. Jones. The Heibonsha Survey of Japanese Art, vol. 9. New York and Tokyo: Weatherhill, 1976.

Grapard, Allan G. "Institution, Ritual, and Ideology: The Twenty-Two Shrine-Temple Multiplexes of Heian Japan." *History of Religions* 27:2 (1987): 246–69.

Hall, John W. "Kyoto as Historical Background." In *Medieval Japan: Essays in Institutional History*, edited by John W. Hall and Jeffrey P. Mass. New Haven, CT: Yale University Press, 1988.

Hirasawa, Caroline. *Hell-Bent for Heaven in Tateyama Mandara: Painting and Religious Practice at a Japanese Mountain.* Japanese Visual Culture, vol. 6. Leiden and Boston: Brill, 2013.

Kamens, Edward. "Dragon-Girl, Maidenflower, Buddha: The Transformation of a Waka Topos, 'The Five Obstructions.'" *Harvard Journal of Asiatic Studies* 53:2 (1993): 389–442.

Kasuya, Makoto. "Pictures of Rebirth Foretold: The Gosho Mandara (Mandala of Amitabha's Welcoming Descent) of Seiryoji, Kyoto." In *Miraculous Images in Christian and Buddhist Culture "Death and Life" and Visual Culture II. Bulletin of Life and Death Studies* 6 (2010): 76–98.

Lippit, Yukio. "Figure and Facture in the Genji Scrolls: Text, Calligraphy, Paper and Painting." In *Envisioning The Tale of Genji: Media, Gender and Cultural Production*, edited by Haruo Shirane, 49–80. New York: Columbia University Press, 2007.

Matsuo, Kenji. "Explaining the 'Mystery' of Ban Dainagon ekotoba." *Japanese Journal of Religious Studies* 28:1–2 (Spring 2001): 103–31.

Morse, Anne Nishimura, and Samuel Crowell Morse. *Object as Insight: Japanese Buddhist Art and Ritual.* Katonah, NY: Katonah Museum of Art, 1995.

Morse, Samuel C. "Jōchō's Statue of Amida at the Byōdōin and Cultural Legitimization in Late Heian Japan." *RES* 23 (1993): 96–113.

———. "Space and Ritual: The Evolution of the Image Hall in Japan." In *Object as Insight: Japanese Buddhist Art and Ritual*, edited by Anne Nishimura Morse and Samuel Crowell Morse, 18–25. Katonah, NY: Katonah Museum of Art, 1995.

———. "The Standing Image of Yakushi at Jingo-ji and the Formation of the Plain-Wood Style." *Archives of Asian Art* 40 (1987): 36–55.

Mostow, Joshua S. "Mother Tongue and Father Script: The Relationship of Sei Shōnagon and Murasaki Shikibu to Their Fathers and Chinese Letters." In *The Father-Daughter Plot: Japanese Literary Women and the Law of the Father*, edited by Rebecca L. Copeland and Esperanza Ramirez-Christensen, 115–42. Honolulu: University of Hawaiʻi Press, 2001.

Pollack, David. *The Fracture of Meaning: Japan's Synthesis of China from the*

Eighth through the Eighteenth Centuries. Princeton, NJ: Princeton University Press, 1986.

Ruppert, Brian, D. *Jewel in the Ashes: Buddha Relics and Power in Early Medieval Japan*. Cambridge, MA: Harvard University Asia Center, Harvard University Press, 2000.

Sawa, Takaaki. *Art in Japanese Esoteric Buddhism*. Translated by Richard L. Gage. The Heibonsha Survey of Japanese Art, vol. 8. New York and Tokyo: Weatherhill, 1972.

Sharf, Robert H. "Visualization and Mandala in Shingon Buddhism." In *Living Images: Japanese Buddhist Icons in Context*, edited by Robert H. Sharf and Elizabeth Horton Sharf, 151–97. Palo Alto, CA: Stanford University Press, 2001.

Shimizu, Yoshiaki. "The Shigisan-engi Scrolls, c. 1175." In *Pictorial Narrative in Antiquity and the Middle Ages*, edited by Herbert L. Kessler and Marianna Shreve Simpson, 115–29. Washington, DC: National Gallery of Art, 1985.

Soper, Alexander C. "The Illustrative Method of the Tokugawa 'Genji' Pictures." *Art Bulletin* 37:1 (1955): 1–16.

——. "The Rise of Yamato-*e*." *Art Bulletin* 24:4 (1942): 351–79.

Suzuki, Yui. *Medicine Master Buddha: The Iconic Worship of Yakushi in Heian Japan*. Leiden: Brill, 2012.

Takei, Jirō, and Marc P. Keane. *Sakuteiki: Visions of the Japanese Garden: A Modern Translation of Japan's Gardening Classic*. Boston: Tuttle, 2001.

Yiengpruksawan, Mimi Hall. "Hakusan at Hiraizumi: Notes on a Sacred Geopolitics in the Eastern Provinces." *Japanese Journal of Religious Studies* 25:3–4 (1998): 259–76.

——. *Hiraizumi: Buddhist Art and Regional Politics in Twelfth-Century Japan*. Harvard East Asian Monographs 171. Cambridge, MA: Harvard University Asia Center, 1998.

——. "On the Hybrid Nature of the Amitabha Hall of Byōdōin." In *Harmony in Discord: Buddhism as a Means of Integration across Cultures*, 212–41. Beijing: Proceedings Peking University, 2006.

——. "The Phoenix Hall at Uji in Three Degrees of Replication." *Art Bulletin* 77:4 (1995): 647–72.

Yoshida, Kazuhiko. "The Enlightenment of the Dragon King's Daughter in the *Lotus Sutra*." Translated by Margaret Childs. In *Engendering Faith: Women and Buddhism in Premodern Japan*, edited by Barbara Ruch, 299–324. Michigan Monograph Series in Japanese Studies, no. 43. Ann Arbor: Center for Japanese Studies, University of Michigan, 2002.

Chapter 6 Art of the Kamakura Period

Chin, Gail. "The Gender of the Buddhist Truth: The Female Corpse in a Group of Japanese Paintings." *Japanese Journal of Religious Studies* 25:3–4 (1998):

277–317.

Conlan, Thomas. *In Little Need of Divine Intervention: Takezaki Suenaga's Scrolls of the Mongol Invasions of Japan.* Cornell East Asia Series, 113. Ithaca, NY: East Asia Program, Cornell University, 2001.

Covaci, Ive Aaslid. *Kamakura: Realism and Spirituality in the Sculpture of Japan.* New Haven, CT: Yale University Press, 2016.

Fabricand-Person, Nicole. "Demonic Female Guardians of the Faith: The Fugen Jūrasetsunyo Iconography in Japanese Buddhist Art." In *Engendering Faith: Women and Buddhism in Premodern Japan,* edited by Barbara Ruch, 343–82. Michigan Monograph Series in Japanese Studies, no. 43. Ann Arbor: Center for Japanese Studies, University of Michigan, 2002.

Faure, Bernard. *Visions of Power: Imagining Medieval Japanese Buddhism.* Princeton, NJ: Princeton University Press, 1996.

Harris, Victor, and Ken Matsushima. *Kamakura: The Renaissance of Japanese Sculpture, 1185–1333.* London: Published for the Trustees of the British Museum by British Museum Press, 1991.

Kaminishi, Ikumi. *Explaining Pictures: Buddhist Propaganda and Etoki Storytelling in Japan.* Honolulu: University of Hawai'i Press, 2006.

Kanda, Fusae. "Behind the Sensationalism: Images of a Decaying Corpse in Japanese Buddhist Art." *Art Bulletin* 87:1 (2005): 24–49.

LaFleur, William R. "Hungry Ghosts and Hungry People: Somaticity and Rationality in Medieval Japan." In *Fragments for a History of the Human Body,* vol. 1, edited by Ramona Naddaff, Nadia Tazzi, and Michel Feher. New York: Urzone, 1989.

Mack, Karen. "The Phenomenon of Invoking Fudō for Pure Land Rebirth in Image and Text." *Japanese Journal of Religious Studies* 33:2 (2006): 297–317.

Mōri, Hisashi. *Sculpture of the Kamakura Period.* Translated by Katherine Eickmann. The Heibonsha Survey of Japanese Art, vol. 11. New York and Tokyo: Weatherhill, 1974.

Rosenfield, John M. *Portraits of Chōgen: The Transformation of Buddhist Art in Early Medieval Japan.* Japanese Visual Culture, vol. 1. Leiden: Brill, 2001.

Tanaka, Ichimatsu. *Japanese Ink Painting: Shubun to Sesshu.* Translated by Bruce Darling. The Heibonsha Survey of Japanese Art, vol. 12. New York and Tokyo: Weatherhill, 1972.

Tyler, Susan C. *The Cult of Kasuga Seen through Its Art.* Michigan Monograph Series in Japanese Studies, no. 8. Ann Arbor: Center for Japanese Studies, University of Michigan, 1992.

Chapter 7 Art of the Nabokuchō and Muromachi Periods

Arichi, Meri. "Sannō Miya Mandara: The Iconography of Pure Land on This Earth." *Japanese Journal of Religious Studies* 33:2 (2006): 319–48.

Berthier, François, and Graham Parkes. *Reading Zen in the Rocks: The Japanese Dry Landscape Garden*. Chicago: University of Chicago Press, 2000.

Brinker, Helmut, and Hiroshi Kanazawa. *Zen Masters of Meditation in Images and Writings*. Zurich: Artibus Asiae, 1996.

Collcutt, Martin. *Five Mountains: The Rinzai Zen Monastic Institution in Medieval Japan*. Cambridge, MA: Council on East Asian Studies, 1981.

Covell, Jon Carter. *Under the Seal of Sesshū*. New York: De Pamphilis Press, 1941.

Fontein, Jan, and Money L. Hickman. *Zen Painting and Calligraphy: An Exhibition of Works of Art Lent by Temples, Private Collectors, and Public and Private Museums in Japan, Organized in Collaboration with the Agency for Cultural Affairs of the Japanese Government*. Boston: Museum of Fine Arts, Boston, 1971.

Gerhart, Karen M. *The Material Culture of Death in Medieval Japan*. Honolulu: University of Hawai'i Press, 2009.

Glassman, Hank. "At the Crossroads of Birth and Death: The Blood Pool Hell and Postmortem Fetal Extraction." In *Death and the Afterlife in Japanese Buddhism*, edited by Jacqueline I. Stone and Mariko Namba Walter, 175–206. Honolulu: University of Hawai'i Press, 2008.

Grapard, Allan G. "Flying Mountains and Walkers of Emptiness: Toward a Definition of Sacred Space in Japanese Religion." *History of Religions* 21:3 (1982): 195–221.

——. *The Protocol of the Gods: A Study of the Kasuga Cult in Japanese History*. Berkeley: University of California Press, 1992.

Hall, John Whitney, and Toyoda Takeshi, eds. *Japan in the Muromachi Age*. Berkeley: University of California Press, 1977.

Havlicova, Eva. "What Is in a Place? New Initiatives in Ink Landscape Painting in Eastern Japan during the Later Muromachi Period." In *Crossing the Sea: Essays on East Asian Art in Honor of Professor Yoshiaki Shimizu*, edited by Gregory P.A. Levine, Andrew M. Watsky and Gennifer Weisenfeld, 183–202. Princeton, NJ: P.Y. and Kinmay W. Tang Center for East Asian Art and the Department of Art and Archaeology, Princeton University, in association with Princeton University Press, 2012.

Johnson, Norris Brock. "Tenryū Temple and Garden: The Evolution of a Religious Landscape in Medieval Japan." In *Temples in Traditional Environments*, 1–30. Traditional Dwellings and Settlements Working Paper Series, vol. 49. Berkeley: University of California, 1992.

Keene, Donald. *Yoshimasa and the Silver Pavilion*. New York: Columbia University Press, 2003.

Kitagawa, Anne Rose. "Veiled in Shadow: Recent Discoveries and Technical Analyses of the Harvard Art Museum's Tale of Genji Album." In *Crossing the Sea: Essays on East Asian Art in Honor of Professor Yoshiaki Shimizu*, edited by

Gregory P.A. Levine, Andrew M. Watsky and Gennifer Weisenfeld, 39–54. Princeton, NJ: P.Y. and Kinmay W. Tang Center for East Asian Art and the Department of Art and Archaeology, Princeton University, in association with Princeton University Press, 2012.

Levine, Gregory, and Yukio Lippit. *Awakenings: Zen Figure Painting in Medieval Japan*. New York: Japan Society; New Haven, CT: Yale University Press, 2007.

Lillehoj, Elizabeth. "Reconsidering the Identity of Ri Shubun." *Artibus Asiae* 55:1–2 (1995): 99–124.

Lippit, Yukio. *Japanese Zen Buddhism and the Impossible Painting*. Los Angeles: Getty Research Institute, 2017.

——. "Negative Verisimilitude: The Zen Portrait in Medieval Japan." In *Asian Art History in the Twenty-First Century*, edited by Vishakha N. Desai, 64–95. Williamston, MA: Sterling and Clark Art Institute, 2007.

——. "Of Modes and Manners in Medieval Japanese Ink Painting: Sesshū's Splashed Ink Landscape of 1495." *Art Bulletin* 94:1 (2012): 50–77.

——. "Seer of Sounds: The Muqi Triptych." In *Crossing the Sea: Essays on East Asian Art in Honor of Professor Yoshiaki Shimizu*, edited by Gregory P.A. Levine, Andrew M. Watsky and Gennifer Weisenfeld, 243–66. Princeton, NJ: P.Y. and Kinmay W. Tang Center for East Asian Art and the Department of Art and Archaeology, Princeton University, in association with Princeton University Press, 2012.

Lyons, Michael, Ruth Campbell, Andre Plante, Mike Coleman, Miyuki Kamachi, and Shigeru Akamatsu. "The Noh Mask Effect: Vertical Viewpoint Dependence of Facial Expression Perception." *Proceedings of the Royal Society of London* B, no. 267 (2000): 2239–45.

McCormick, Melissa. "Genji Goes West: The 1510 'Genji Album' and the Visualization of Court and Capital." *Art Bulletin* 85:1 (2003): 54–85.

——. "Monochromatic Genji: The Hakubyō Tradition and Female Commentarial Culture." In *Envisioning the Tale of Genji: Media, Gender, and Cultural Production*, edited by Haruo Shirane, 101–28. New York: Columbia University Press, 2008.

——. *Tosa Mitsunobu and the Small Scroll in Medieval Japan*. Seattle: University of Washington Press, 2009.

Miyajima, Shin'ichi, and Satō Yasuhiro. *Japanese Ink Painting*. Los Angeles: Los Angeles County Museum of Art, 1985.

Murase, Miyeko. *Iconography of the Tale of Genji: Genji Monogatari Ekotoba*. New York and Tokyo: Weatherhill, 1983.

Parker, Joesph D. *Zen Buddhist Landscape Arts of Early Muromachi Japan (1336–1573)*. Albany: State University of New York Press, 1999.

Phillips, Quitman E. *The Practices of Painting in Japan, 1475–1500*. Palo Alto, CA: Stanford University Press, 2000.

Rousmaniere, Nicole. "Defining Tenmoku: Jian Ware Teabowls Imported into Japan." In *Hare's Fur, Tortoiseshell and Partridge Feathers: Chinese Brown and Black Glazed Ceramics, 400–1400*, edited by Robert Mowry, 43–58. Cambridge, MA: Harvard University Art Museums, 1996.

Shimizu, Yoshiaki. "Notes and a Reflection on the Freer Shūbun Painting." *Ars Orientalis* 28, 75th Anniversary of the Freer Gallery of Art (1998): 86–102.

———. "Workshop Management of the Early Kano Painters, ca. AD 1530–1600." *Archives of Asian Art* 34 (1981): 32–47.

Shimizu, Yoshiaki, and Carolyn Wheelwright. *Japanese Ink Paintings from American Collections: The Muromachi Period (An Exhibition in Honor of Shūjiro Shimada)*. Princeton, NJ: Princeton University Press, 1976.

Stanley-Baker, P. Richard. "Josetsu's Catching a Catfish with a Gourd: Cultural Agendas and the Early Fifteenth-Century Shogunal Academy." In *Bridges to Heaven: Essays on East Asian Art in Honor of Professor Wen C. Fong*, edited by Jerome Silbergeld, Dora C.Y. Ching, Judith G. Smith, and Alfreda Smith, 421–45. Princeton, NJ: P.Y. and Kinmay W. Tang Center for East Asian Art Department of Art and Archeology, Princeton University, in association with Princeton University Press, 2011.

———. "Mythic and Sacred Gardens in Medieval Japan: Sacred Meditation in the Rokuonji and Saihōji Gardens." In *Sacred Gardens and Landscapes: Ritual and Agency* edited by Michel Conan, 115–51. Dumbarton Oaks Colloquium on the History of Landscape Architecture. Washington, DC: Dumbarton Oaks Research Library and Collection, 2007.

Stavros, Matthew. "Building Warrior Legitimacy in Medieval Kyoto." *East Asian History* 31 (2007): 1–28.

———. "Locational Pedigree and Warrior Status in Medieval Kyoto: The Residences of Ashikaga Yoshimitsu." *Japanese Studies* 29:1 (2009): 3–18.

Takahashi, Yasuo, and Matthew Stavros. "Castles in Kyoto at the Close of the Age of Warring States: The Urban Fortress of the Ashikaga Shoguns Yoshiteru and Yoshiaki." In *Japanese Capitals in Historical Perspective: Place, Power and Memory in Kyoto, Edo and Tokyo*, edited by Nicolas Fiévé and Paul Waley, 41–66. London: Routledge Curzon, 2003.

Watanabe, Akiyoshi, Hiroshi Kanazawa, and Paul Varley, eds. *Of Water and Ink: Muromachi Period Paintings from Japan, 1392–1568*. Detroit: Founders Society, Detroit Institute of Arts, 1986.

Weigle, Gail Capitol. "The Reception of Chinese Painting Models in Muromachi Japan." *Monumenta Nipponica* 35:3 (1990): 257–72.

Wheelwright, Carolyn. "Late Medieval Japanese Nirvana Painting." *Archives of Asian Art* 38 (1985): 67–94.

Zainie, Carla M. "The Muromachi Dono Gyōkō Okazari Ki: A Research Note." *Monumenta Nipponica* 33:1 (1978): 113–18.

Chapter 8 Azuchi-Momoyama Art

Berry, Mary Elizabeth. *The Culture of Civil War in Kyoto*. Berkeley: University of California Press, 1994.

Brown, Kendall H. *The Politics of Reclusion: Painting and Power in Momoyama Japan*. Honolulu: University of Hawaiʻi Press, 1997.

Butler, Lee. *Emperor and Aristocracy in Japan, 1467–1680: Resilience and Renewal*. Harvard East Asian Monographs, no. 209. Cambridge, MA: Harvard University Asia Center and Harvard University Press, 2002.

Cort, Louise Allison. "Shopping for Pots in Momoyama Japan." In *The Arts of Japan: An International Symposium*, edited by Miyeko Murase and Judith G. Smith, 161–81. New York: Metropolitan Museum of Art, 2000.

Cunningham, Michael. "Sesshū's Legacy: Toward Momoyama Painting." In *The Arts of Japan: An International Symposium*, edited by Miyeko Murase and Judith G. Smith, 58–81. New York: Metropolitan Museum of Art, 2000.

Doi, Tsugiyoshi. *Momoyama Decorative Painting*. Translated by Edna B. Crawford. The Heibonsha Survey of Japanese Art, vol. 14. New York and Tokyo: Weatherhill, 1977.

Elison, George, and Bardwell L. Smith. *Warlords, Artists and Commoners: Japan in the Sixteenth Century*. Honolulu: University of Hawaiʻi Press, 1981.

Fiévé, Nicolas, and Paul Waley, eds. *Japanese Capitals in Historical Perspective: Place, Power and Memory in Kyoto, Edo and Tokyo*. London and New York: Routledge Curzon, 2003.

Fischer, Felice, Kyoko Kinoshita, Yukio Lippit, Masato Matsushima, Shunroku Okudaira, and Aya Ota. *Ink and Gold: Art of the Kano*. New Haven, CT: Yale University Press, 2015.

Gerhart, Karen M. "Tokugawa Authority and Chinese Exemplars: The Teikan Zusetsu Murals of Nagoya Castle." *Monumenta Nipponica* 52:1 (1997): 1–34.

Haga, Kōshirō. "The *Wabi* Aesthetic Through the Ages." In *Tea in Japan: Essays on the History of Chanoyu*, edited by Paul Varley and Kumakura Isao. Honolulu: University of Hawaiʻi Press, 1989.

Hashimoto, Fumio. *Architecture in the Shoin Style: Japanese Feudal Residences*. Translated by H. Mark Horton. Japanese Arts Library, vol. 10. Tokyo and New York: Kodansha International, 1981.

Hayashiya, Tatsusaburō, Masao Nakamura, and Seizo Hayashiya. *Japanese Arts and the Tea Ceremony*. Translated by Joseph P. Macadam. The Heibonsha Survey of Japanese Art, vol. 15. New York: Weatherhill, 1974.

Hirai, Kiyoshi. *Feudal Architecture of Japan*. Translated by Hiroaki Sato and Jeannine Ciliotta. The Heibonsha Survey of Japanese Art, vol. 13. New York and Tokyo: Weatherhill, 1973.

Jordan, Brenda G., and Victoria Weston, eds. *Copying the Master and Stealing His Secrets: Talent and Training in Japanese Painting*. Honolulu: University

of Hawai'i Press, 2003.

Klein, Bettina, and Carolyn Wheelwright. "Japanese Kinbyōbu: The Gold-Leafed Folding Screens of the Muromachi Period (1333–1573). Part I." *Artibus Asiae* 45:1 (1984): 5–33.

———. "Japanese Kinbyōbu: The Gold-Leafed Folding Screens of the Muromachi Period (1333–1573) Parts II–IV." *Artibus Asiae* 45:2–3 (1984): 101–73.

Lillehoj, Elizabeth. *Art and Palace Politics in Early Modern Japan, 1580s–1680s.* Leiden: Brill, 2011.

Ludwig, Theodore M. "Before Rikyū: The Aesthetic and Origin of the Tea Ceremony." *Monumenta Nipponica* 36:4 (1981): 367–90.

McKelway, Matthew P. "Autumn Moon and Lingering Snow: Kano Sansetsu's West Lake Screens." *Artibus Asiae* 62:1 (Spring 2003): 33–80.

———. *Capitalscapes: Folding Screens and Political Imagination in Late Medieval Kyoto.* Honolulu: University of Hawai'i Press, 2006.

———. "Masterworks of Kano Workshop Screen Paintings in the Larry Ellison Collection of Japanese Art." In *In the Moment: Japanese Art from the Larry Ellison Collection*, edited by Laura W. Allen, Melissa M. Rinne, and Emily J. Sano, 21–34. San Francisco: Asian Art Museum, 2013.

Mostow, Joshua S. *Courtly Visions: The Ise Stories and the Politics of Cultural Appropriation.* Leiden: Brill, 2014.

Murase, Miyeko, ed. *Turning Point: Oribe and the Arts of Sixteenth-Century Japan.* New York: Metropolitan Museum of Art, 2003.

Okamoto, Yoshitomo. *The Namban Art of Japan.* Translated by Ronald K. Jones. The Heibonsha Survey of Japanese Art, vol. 19. New York and Tokyo: Weatherhill, 1972.

Ōkawa, Naomi. *Edo Architecture: Katsura and Nikko.* Translated by Alan Woodhull and Akito Miyamoto. The Heibonsha Survey of Japanese Art, vol. 20. New York and Tokyo: Weatherhill, 1975.

Ooms, Herman. *Tokugawa Ideology: Early Constructs, 1570–1680.* Michigan Classics in Japanese Studies, no. 18. Ann Arbor: Center for Japanese Studies, University of Michigan, 1998.

Rousmaniere, Nicole Coolidge, and Tsuji Nobuo eds. *Kazari: Decoration and Display in Japan, 15th–19th Centuries.* New York: Japan Society; Abrams, 2002.

Rosenfield, John M. "Japanese Studio Practice: The Tosa Family and the Imperial Painting Office in the Seventeenth Century." In *The Artist's Workshop*, edited by Peter M. Lukehart. Washington, DC: National Gallery of Art, 1993.

Sakomura, Tomoko. *Poetry as Image: The Visual Culture of Waka in Sixteenth-Century Japan.* Leiden: Brill, 2016.

Schweizer, Anton. *Osaki Hachiman: Architecture, Materiality and Samurai Power in Seventeenth-Century Japan.* Berlin: Reimer, 2017.

Shimizu, Yoshiaki. "Workshop Management of the Early Kano Painters, ca.

1530–1600." *Archives of Asian Art* 34 (1981): 32–47.

Slusser, Dale. "The Transformation of Tea Practice in Sixteenth-Century Japan." In *Japanese Tea Culture: Art, History, and Practice*, edited by Morgan Pitelka, 39–60. London and New York: Routledge Curzon, 2003.

Takeda, Tsuneo. *Kano Eitoku*. Translated and adapted by H. Mack Horton and Catherine Kaputa. Japanese Arts Library, vol. 3, Tokyo: Kodansha International, 1977.

Varley, Paul, and Kumakura Isao, eds. *Tea and Japan: Essays on the History of Chanoyu*. Honolulu University of Hawai'i Press, 1989.

Watsky, Andrew Mark. "Commerce, Politics, and Tea: The Career of Imai Sōkyū." *Monumenta Nipponica* 50:1 (1995): 47–65.

——. *Chikubushima: Deploying the Sacred Arts in Momoyama Japan*. Seattle: University of Washington Press, 2004.

——. "Locating 'China' in the Arts of Sixteenth-Century Japan." *Art History* 29, no. 4 (2006): 600–624.

Watt, James C.Y., and Barbara Brennan Ford. *East Asian Lacquer: The Florence and Herbert Irving Collection*. New York: Abrams, 1991.

Weston, Victoria, ed. *Portugal, Jesuits, and Japan: Spiritual Beliefs and Earthly Goods*. Boston: McMullen Museum of Art, Boston College, 2013.

Wheelwright, Carolyn. "Kanō Painters of the Sixteenth Century: The Development of Motonobu's Daisen-in Style." *Archives of Asian Art* 34 (1981): 6–31.

——. "Tōhaku's Black and Gold." *Ars Orientalis* 16 (1986): 1–31.

——. "A Visualization of Eitoku's Lost Paintings at Azuchi Castle." In *Warlords, Artists and Commoners: Japan in the Sixteenth Century*, edited by George Elison and Bardwell L. Smith, 87–112. Honolulu: University of Hawai'i Press, 1981.

Yamane, Yūzō. *Momoyama Genre Painting*. Translated by John M. Shields. The Heibonsha Survey of Japanese Art, vol. 17. New York and Tokyo: Weatherhill, 1973.

Chapter 9 Art of the Edo Period

Addis, Stephen. *The Art of Zen: Paintings and Calligraphy by Japanese Monks, 1600–1925*. New York: Abrams, 1989.

——. *77 Dances: Japanese Calligraphy by Poets, Monks, and Scholars, 1568–1868*. Boston: Shambhala/Weatherhill, 2006.

——. *Tall Mountains and Flowing Waters: The Arts of Uragami Gyokudō*. Honolulu: University of Hawai'i Press, 1987.

Allen, Laura W. "Japanese Exemplars for a New Age: Genji Paintings from the Seventeenth-Century Tosa School." In *Critical Perspectives on Classicism in Japanese Painting, 1600–1700*, edited by Elizabeth Lillehoj, 99–132. Honolulu: University of Hawai'i Press, 2004.

Alphen, J. van, and Jeroen Pieter Lamers. *Enku, 1632–1695: Timeless Images from 17th-Century Japan*. Antwerp: Etnografisch Museum Antwerpen, 1999.

Asano, Shūgō. "An Overview of Surimono." *Impressions: Journal of the Ukiyo-e Society of America* 20 (1998): 17–37.

Avitabile, Gunhild. *Early Masters: Ukiyo-e Prints and Paintings from 1680–1750*. Rev. English ed. New York: Japan Society Gallery, 1991.

Ayers, John, Oliver Impey, and J.V.C. Mallet. *Porcelain for Palaces: The Fashion for Japan in Europe 1650–1750*. London: The Oriental Ceramic Society, 1990.

Baroni, Helen Josephine. *Obaku Zen: The Emergence of the Third Sect of Zen in Tokugawa, Japan*. Honolulu: University of Hawai'i Press, 2000.

Berry, Mary Elizabeth. *Japan in Print: Information and Nation in the Early Modern Period*. Asia: Local Studies / Global Themes 12. Berkeley: University of California Press, 2006.

Bogel, Cynthea J., and Israel Goldman. *Hiroshige: Birds and Flowers*. New York: G. Braziller, in association with Rhode Island School of Design, 1988.

Brock, Karen L. "Shogun's Painting Match." *Monumenta Nipponica* 50:4 (1995): 433–84.

Bruschke-Johnson, Lee. *Dismissed as Elegant Fossils: Konoe Nobutada and the Role of Aristocrats in Early Modern Japan*. Japonica Neerlandica: Monographs of the Netherlands Association for Japanese Studies, vol. 9. Amsterdam: Hotei, 2004.

Buckland, Rosina. *Kabuki: Japanese Theatre Prints*. Edinburgh: National Museums of Scotland, 2013.

Butler, Lee. "Introduction: Pre-modern Japan through the Prism of Patronage." *Early Modern Japan* 12:2 (Fall-Winter 2004): 3–10.

——. "Patronage and the Building Arts in Tokugawa Japan." *Early Modern Japan* 12:2 (2004): 39–52.

Cahill, James. *Sakaki Hyakusen and Early Nanga Painting*. Japan Research Monograph, no. 3. Berkeley: Institute of East Asian Studies, University of California, Berkeley, Center for Japanese Studies, 1983.

Calza, Gian Carlo. *Hokusai*. London and New York: Phaidon, 2003.

Carpenter, John T., ed. *Hokusai and His Age: Ukiyo-e Painting, Printmaking and Book Illustration in Late Edo Japan*. Amsterdam: Hotei, 2005.

——, ed. *Imperial Calligraphy of Premodern Japan: Scribal Conventions for Poems and Letters from the Palace*. Kyoto: Art Research Center, Ritsumeikan University, 2006.

——, ed. *Designed for Pleasure: The World of Edo Japan in Prints and Paintings, 1680–1860*. New York: Asia Society and Japanese Art Society of America, 2008.

——, ed. *Reading Surimono: The Interplay of Text and Image in Japanese Prints*. Zurich: Museum Rietberg, 2008.

Chance, Frank. "In the Studio of Painting Study: Transmission Practices of Tani Bunchō." In *Copying the Master and Stealing His Secrets: Talent and Training*

in Japanese Painting, edited by Brenda G. Jordan and Victoria Weston, 60–85. Honolulu: University of Hawaiʻi Press, 2003.

——. "Tani Bunchō's Eight Views of Xiao and Xiang: Origins, Ideas, Implications." *Bulletin of the Cleveland Museum of Art* 76:8 (1989): 266–79.

Clark, Timothy. *Kuniyoshi: From the Arthur R. Miller Collection*. London: Royal Academy of Arts, 2009.

——. *The Passionate Art of Kitagawa Utamaro*. 2 vols. London: The British Museum Press, 1995.

Clark, Timothy, et al. *The Dawn of the Floating World 1650–1765: Early Ukiyo-e Treasures from the Museum of Fine Arts, Boston*. London: Royal Academy of Arts, 2001.

Clark, Timothy, and Roger Keyes, eds. *Hokusai: Beyond the Great Wave*. London: Thames and Hudson, 2017.

Coaldrake, William H. "Edo Architecture and Tokugawa Law." *Monumenta Nipponica* 36:3 (1981): 235–84.

Cort, Louise Allison. *Seto and Mino Ceramics (Japanese Collections in the Freer Gallery of Art)*. Washington, DC: Freer Gallery of Art, 1992.

Davis, Julie Nelson. "Artistic Identity and Ukiyo-e Prints: The Representation of Kitagawa Utamaro to the Edo Public." In *The Artist as Professional in Japan*, edited by Melinda Takeuchi, 113–51. Palo Alto, CA: Stanford University Press, 2004.

——. *Partners in Print: Artistic Collaboration and the Ukiyo-e Market*. Honolulu: University of Hawaiʻi Press, 2015.

——. "Tsutaya Jūzaburō, Master Publisher." In *Designed for Pleasure: The World of Edo Japan in Prints and Paintings, 1680–1860*, 115–41. New York: Asia Society and Japanese Art Society of America, 2008.

——. *Utamaro and the Spectacle of Beauty*. London: Reaktion; Honolulu: University of Hawaiʻi Press, 2007.

Fischer, Felice, ed. *The Arts of Honʼami Kōetsu: Japanese Renaissance Master*. Philadelphia: Philadelphia Museum of Art, 2000.

Fischer, Felice, and Kyoko Kinoshita. *Ike Taiga and Tokuyama Gyokuran: Japanese Masters of the Brush*. Philadelphia: Philadelphia Museum of Art; New Haven, CT: Yale University Press, 2007.

Fister, Patricia. *Art by Buddhist Nuns: Treasures from the Imperial Convents of Japan*. New York: Institute for Medieval Japanese Studies, 2003.

——. "Creating Devotional Art with Body Fragments: The Buddhist Nun Bunchi and Her Father, Emperor Gomizuno-o." *Japanese Journal of Religious Studies* 27:3–4 (Fall 2000): 213–38.

——. "The Impact of Shugendō on the Painting of Yokoi Kinkoku." *Ars Orientalis* 18 (1988): 163–95.

——. *Japanese Women Artists, 1600–1900*. Lawrence: Spencer Museum of Art,

University of Kansas, 1988.

——. "Merōfu Kannon and Her Veneration in Zen and Imperial Circles in Seventeenth-Century Japan." *Japanese Journal of Religious Studies* 34:2 (2007): 417–42.

Forrer, Matthi, ed. *Hiroshige: Prints and Drawings*. Munich: Prestel, 2011.

——, ed. *Hokusai*. Munich: Prestel, 2010.

French, Calvin L. *Shiba Kōkan: Artist, Innovator, and Pioneer in the Westernization of Japan*. Studies of the East Asian Institute, Columbia University. New York and Tokyo: Weatherhill, 1974.

Gerhart, Karen M. *The Eyes of Power: Art and Early Tokugawa Authority*. Honolulu: University of Hawai'i Press, 1999.

——. "'Honchō Gashi' and Painting Programs: Case Studies of Nijō Castle's Ninomaru Palace and Nagoya Castle's Honmaru Palace." *Ars Orientalis* 27 (1997): 67–97.

——. "Issues of Talent and Training in the Seventeenth-Century Kano Workshop." *Ars Orientalis* 31 (2001): 103–28.

——. "Kano Tan'yū and Hōrin Jōshō: Patronage and Artistic Practice." *Monumenta Nipponica* 55:4 (Winter 2000): 483–508.

——. "Talent, Training, and Power: The Kano Painting Workshop in the Seventeenth Century." In *Copying the Master and Stealing His Secrets: Talent and Training in Japanese Painting*, edited by Brenda G. Jordan and Victoria Weston, 9–30. Honolulu: University of Hawai'i Press, 2003.

——. "Tokugawa Authority and Chinese Exemplars: The Teikan Zusetsu Murals of Nagoya Castle." *Monumenta Nipponica* 52:1 (1997): 1–34.

——. "Visions of the Dead: Kano Tan'yū's Paintings of Tokugawa Iemitsu's Dreams." *Monumenta Nipponica* 59:1 (2004): 1–34.

Gerstle, C. Andrew, ed. *18th-Century Japan: Culture and Society*. Richmond, UK: Curzon, 2000.

Gluckman, Dale Carolyn, and Sharon Sadako Takeda. *When Art Became Fashion: Kosode in Edo-Period Japan*. Los Angeles: Los Angeles County Museum of Art, 1992.

Graham, Patricia J. *Faith and Power in Japanese Buddhist Art, 1600–2005*. Honolulu: University of Hawai'i Press, 2007.

——. *Tea of the Sages: The Art of Sencha*. Honolulu: University of Hawai'i Press, 1998.

Guth, Christine. *Art of Edo Japan: The Artist and the City 1615–1868*. New York: Abrams, 1996; reprinted New Haven, CT: Yale University Press, 2010.

——. *Art, Tea, and Industry: Masuda Takashi and the Mitsui Circle*. Princeton, NJ: Princeton University Press, 1993.

——. "Hokusai's Great Waves in Nineteenth-Century Japanese Visual Culture." *Art Bulletin* 93:4 (2011): 468–85.

———. "Memorial Portraits of Kabuki Actors: Fanfare in the Floating World." *Impressions: The Journal of the Ukiyo-e Society of America* 27 (2006): 22–41.

———. *Shinzō: Hachiman Imagery and Its Development*. Cambridge, MA: Council on East Asian Studies, Harvard University, 1985.

Haft, Alfred. *Aesthetic Strategies of the Floating World, Mitate, Yatsushi and Fūryū in Early Modern Japan*. Leiden: Brill, 2012.

Hickman, Money L. et al. *The Paintings of Jakuchū*. New York: Asia Society Galleries, 1989.

Hillier, Jack Ronald. *Suzuki Harunobu: An Exhibition of His Colour Prints and Illustrated Books on the Occasion of the Bicentenary of His Death in 1770*. Philadelphia: Philadelphia Museum of Art, 1970.

Hinago, Motoo. *Japanese Castles*. Translated by William Howard Coaldrake. Japanese Arts Library, vol. 14. Tokyo and New York: Kodansha International and Shibundo, 1986.

Hockley, Allen. *The Prints of Isoda Koryūsai: Floating World Culture and Its Consumers in Eighteenth-Century Japan*. Seattle: University of Washington Press, 2003.

Hofmann, Alexander. *Performing / Painting in Tokugawa Japan: Artistic Practice and Socio-Economic Functions of Sekiga (Painting on the Spot)*. Berlin: Reimer, 2011.

Hutt, Julia. *Japanese Inro*. London: V&A Museum, 1997.

Ikegami Eiko. *The Taming of the Samurai: Honorific Individualism and the Making of Modern Japan*. Cambridge, MA: Harvard University Press, 1995.

———. *Bonds of Civility: Aesthetic Networks and the Political Origins of Japanese Culture*. Cambridge, UK: Cambridge University Press, 2005.

Imahashi, Riko. *The Akita Ranga School and the Cultural Context in Edo Japan*. Translated by Ruth S. McCreery. Tokyo: International House of Japan, 2016.

Iwakiri, Yuriko, and Amy Newland. *Kuniyoshi: Japanese Master of Imagined Worlds*. Leiden: Hotei, 2013.

Izzard, Sebastian. *Kunisada's World*. New York: Japan Society; Ukiyo-e Society of America, 1993.

Jackson, Anna. *Kimono*. London: Thames and Hudson, 2016.

Jenkins, Donald, ed. *The Floating World Revisited*. Portland Art Museum; Honolulu: University of Hawai'i Press, 1993.

Jinnai, Hidenobu. *Tokyo: A Spatial Anthropology*. Berkeley: University of California Press, 1995.

Jordan, Brenda G. "Copying from Beginning to End? Student Life in the Kano School." In *Copying the Master and Stealing His Secrets: Talent and Training in Japanese Painting*, edited by Brenda G. Jordan and Victoria Weston, 31–59. Honolulu: University of Hawai'i Press, 2003.

Jungmann, Burglind. *Painters as Envoys: Korean Inspiration in Eighteenth-Century*

Japanese Nanga. Princeton, NJ: Princeton University Press, 2004.

Kaminishi, Ikumi. *Explaining Pictures: Buddhist Propaganda and Etoki Storytelling in Japan*. Honolulu: University of Hawai'i Press, 2006.

Kern, Adam L. *Manga from the Floating World: Comicbook Culture and the Kibyō-shi of Edo Japan*. Harvard East Asian Monographs, vol. 279. Cambridge, MA: Harvard University Asia Center, 2006.

Kita, Sandy. *The Last Tosa: Iwasa Katsumochi Matabei, Bridge to Ukiyo-e*. Honolulu: University of Hawai'i Press, 1999.

Kobayashi, Fumiko. "Surimono to Publicize Poetic Authority: Yomo no Magao and His Pupils." In *Reading Surimono: The Interplay of Text and Image in Japanese Prints; With a Catalogue of the Marino Lusy Collection*, edited by John T. Carpenter, 46–53. Zurich: Museum Rietberg, in association with Hotei, 2008.

Kornicki, Peter F. "Manuscript, Not Print: Scribal Culture in the Edo Period." *Journal of Japanese Studies* 32:1 (Winter 2006): 23–52.

Lillehoj, Elizabeth. *Art and Palace Politics in Early Modern Japan, 1580s–1680s*. Leiden: Brill, 2011.

——. *Critical Perspectives on Classicism in Japanese Painting, 1600–1700*. Honolulu: University of Hawai'i Press, 2004.

——. "Tōfukumon'in: Empress, Patron, and Artist." *Woman's Art Journal* 17 (1996): 28–34.

——. "Transfiguration: Man-Made Objects as Demons in Japanese Scrolls." *Asian Folklore Studies* 54:1 (1995): 7–34.

——, ed. *Acquisition: Art and Ownership in Edo-period Japan*. Warren, CT: Floating World Editions, 2007.

Link, Howard A., ed. *The Theatrical Prints of the Torii Masters: A Selection of Seventeenth- and Eighteenth-Century Ukiyo-e*. Honolulu: Honolulu Academy of Arts, 1977.

Lippit, Yukio. *Colorful Realm: Japanese Bird-and-Flower Paintings by Itō Jakuchū*. Washington DC: National Gallery of Art, 2012.

——. *Painting of the Realm: The Kano House of Painters in 17th-Century Japan*. Seattle: University of Washington Press, 2012.

Lippit, Yukio, and James Ulak, *Sōtatsu*. Washington DC: Arthur M. Sackler Gallery, Smithsonian Institution, 2015.

Marcon, Federico. *The Knowledge of Nature and the Nature of Knowledge in Early Modern Japan*. Studies of the Weatherhead East Asian Institute. Chicago: University of Chicago Press, 2015.

Markus, Andrew L. "The Carnival of Edo: Misemono Spectacles from Contemporary Accounts." *Harvard Journal of Asiatic Studies* 45:2 (1985): 499–541.

McCausland, Shane, and Matthew McKelway. *Chinese Romance from a Japanese Brush: Kano Sansetsu's Chōgonka Scrolls in the Chester Beatty Library*. London: Scala, 2009.

McKelway, Matthew. "Screens for a Young Warrior." *Impressions* 30, Pictures and Things: Bridging Visual and Material Culture in Japan (2009): 42–51.

———. *Silver Wind: The Arts of Sakai Hōitsu (1761–1828)*. New York: Japan Society, 2012.

———. *Traditions Unbound: Groundbreaking Painters from Eighteenth-Century Kyoto*. San Francisco: Asian Art Museum, 2005.

Meech, Julia, and Jane Oliver, eds. *Designed for Pleasure: The World of Edo Japan in Prints and Paintings, 1680–1860*. New York: Asia Society and Japanese Art Society of America, 2008.

Mizuo, Hiroshi. *Edo Painting: Sotatsu and Korin*. Translated by John M. Shields. The Heibonsha Survey of Japanese Art, vol. 18. New York and Tokyo: Weatherhill, 1972.

Mueller, Laura J., ed. *Competition and Collaboration: Japanese Prints of the Utagawa School*. Leiden and Boston: Hotei, 2007.

Nakane, Chie, and Shizaburō Ōishi, eds. *Tokugawa Japan: The Social and Economic Antecedents of Modern Japan*. Tokyo: University of Tokyo Press, 1990.

Nenzi, Laura. *Excursions in Identity: Travel and the Intersection of Place, Gender, and Status in Edo Japan*. Honolulu: University of Hawai'i Press, 2008.

Newland, Amy Reigle, and Julie Nelson Davis, eds. *The Hotei Encyclopedia of Japanese Woodblock Prints*. Amsterdam: Hotei, 2005.

Phillips, Quitman E. "Honchō gashi and the Kano Myth." *Archives of Asian Art* 47 (1994): 46–57.

Pitelka, Morgan. "The Empire of Things: Tokugawa Ieyasu's Material Legacy and Cultural Profile." *Japanese Studies* 29:1 (2009): 19–32.

———. *Handmade Culture: Raku Potters, Patrons, and Tea Practitioners in Japan*. Honolulu: University of Hawai'i Press, 2005.

———. "The Price Shuten Dōji Screens: A Study of Visual Narrative." *Ars Orientalis* 26 (1996): 1–21.

———. "Tea Taste: Patronage and Collaboration among Tea Masters and Potters in Early Modern Japan." *Early Modern Japan* (Fall 2004): 26–38.

———, ed. *Japanese Tea Culture: Art, History, and Practice*. London: Routledge Curzon, 2003.

Rosenfield, John M. *The Courtly Tradition in Japanese Art and Literature: Selections from Hofer and Hyde Collections*. Cambridge, MA: Fogg Art Museum, Harvard University, 1973.

———. *Extraordinary Persons: Works by Eccentric, Nonconformist Japanese Artists of the Early Modern Era (1580–1868) in the Collection of Kimiko and John Powers*. Cambridge, MA: Harvard University Art Museums, 1999.

———. "Japanese Studio Practice: The Tosa Family and the Imperial Painting Office in the Seventeenth Century." In *The Artist's Workshop*, edited by Peter Lukehart. Washington DC: Center for Advanced Study in the Visual Arts,

1993.

———. *Mynah Birds and Flying Rocks: Word and Image in the Art of Yosa Buson.* Franklin D. Murphy Lectures, vol. 18. Lawrence, KS: Spencer Museum of Art, University of Kansas; Seattle: Distributed by University of Washington Press, 2003.

Sanford, James H., William R. La Fleur and Masatoshi Nagatomi, eds. *Flowing Traces: Buddhism in the Literary and Visual Arts of Japan.* Princeton NJ: Princeton University Press, 1992.

Schaap, Robert. *Kunisada: Imaging Drama and Beauty.* Leiden: Hotei, 2016.

Screech, Timon. *The Lens within the Heart: The Western Scientific Gaze and Popular Imagery in Late Edo Japan.* Honolulu: University of Hawai'i Press, 2002.

———. "The Meaning of Western Perspective in Edo Popular Culture." *Archives of Asian Art* 47 (1994): 58–69.

———. *Obtaining Images: Art, Production and Display in Edo Japan.* Honolulu: University of Hawai'i Press, 2012.

———. *Sex and the Floating World: Erotic Images in Japan, 1700–1820.* Honolulu: University of Hawai'i Press, 1999.

———. *The Shogun's Painted Culture: Fear and Creativity in the Japanese States, 1760–1829.* Envisioning Asia. London: Reaktion, 2000.

Seigle, Cecilia Segawa. *Yoshiwara: The Glittering World of the Japanese Courtesan.* Honolulu: University of Hawai'i Press, 1993.

Seo, Audrey Yoshiko, and Stephen Addiss. *The Sound of One Hand: Paintings and Calligraphy by Zen Master Hakuin.* Boston: Shambhala, 2010.

Shirahara, Yukiko, ed. *Japan Envisions the West: 16th–19th Century Japanese Art from Kobe City Museum.* Seattle: Seattle Art Museum, 2007.

Singer, Robert T. *Edo: Art in Japan 1615–1868.* Washington, DC: National Gallery of Art, 1998.

Smith, Henry DeWitt, II. *Hiroshige: One Hundred Famous Views of Edo.* Brooklyn Museum of Art; New York: G. Braziller, 1992.

———. "Hiroshige in History." In *Hiroshige: Prints and Drawings*, edited by Matthi Forrer, 33–45. London: Royal Academy of the Arts: 1997.

———. "Hokusai and the Blue Revolution in Edo Prints." In *Hokusai and His Age: Ukiyo-e Painting, Printmaking and Book Illustration in Late Edo Japan*, 234–69. Amsterdam: Hotei, 2005.

St. Louis Art Museum. *Ōkyo and the Maruyama-Shijō School of Japanese Painting: Saint Louis Art Museum, Seattle Art Museum.* St. Louis: Saint Louis Art Museum, 1980.

Takeuchi, Melinda. "Making Mountains: Mini-Fujis, Edo Popular Religion, and Hiroshige's *One Hundred Famous Views of Edo.*" *Impressions* 24 (2002): 24–45.

———. *Taiga's True Views: The Language of Landscape Painting in Eighteenth-Century Japan.* Palo Alto, CA: Stanford University Press, 1992.

———, ed. *The Artist as Professional in Japan*. Palo Alto, CA: Stanford University Press, 2004.

Thompson, Sarah E. "The Original Source (Accept No Substitutes!): Okumura Masanobu." In *Designed for Pleasure: The World of Edo Japan in Prints and Paintings, 1680–1860*. New York: Asia Society and Japanese Art Society of America, 2008.

Thompson, Sarah E., and H.D. Harootunian. *Undercurrents in the Floating World: Censorship and Japanese Prints*. New York: Asia Society Galleries, 1991.

Toby, Ronald. "Carnival of the Aliens: Korean Embassies in Edo Period Art and Popular Culture." *Monumenta Nipponica* 41:4 (Winter 1968): 415–56.

Tsuchiya, Noriko. *Netsuke: 100 Miniature Masterpieces from Japan*. London: British Museum Press, 2015.

Tsuji, Nobuo. *Lineage of Eccentrics: Matabei to Kuniyoshi*. Translated by Aaron M. Rio. Tokyo: Kaikai Kiki, 2012.

Vergez, Robert. *Early Ukiyo-e Master: Okumura Masanobu, Great Japanese Art*. Tokyo and New York: Kodansha International, 1983.

Waterhouse, David. "Hishikawa Moronobu: Tracking Down an Elusive Master." In *Designed for Pleasure: The World of Edo Japan in Prints and Paintings, 1680–1860*, 33–55. New York: Asia Society and Japanese Art Society of America, 2008.

Wattles, Miriam. *The Life and Afterlives of Hanabusa Itchō: Artist-Rebel of Edo*. Leiden: Brill, 2013.

Wilson, Richard L. *The Potter's Brush: The Kenzan Style in Japanese Ceramics*. Washington, DC: Freer Gallery of Art and Arthur M. Sackler Gallery, Smithsonian Institution, 2001.

Yamane, Yūzō, Masato Naitō, and Timothy Clark. *Rimpa Art from the Idemitsu Collection, Tokyo*. London: British Museum Press, 1998.

Yonemura, Ann, ed. *Hokusai*. 2 vols. Washington, DC: Freer Gallery of Art and Arthur M. Sackler Gallery, Smithsonian Institution, 2006.

Chapter 10 Modern to Contemporary Art

Akira, Tatehara. "Mono-ha and Japan's Crisis of the Modern." *Third Text* 16:3 (2002): 223–36.

Applin, Jo. *Yayoi Kusama: Infinity Mirror Room—Phalli's Field*. Cambridge, MA: MIT Press, 2012.

Asato Ikeda, Aya Louisa McDonald, and Ming Tiampo, eds., *Art and War in Japan and Its Empire, 1931–1960*. Leiden: Brill, 2013.

Brandt, Kim. "Objects of Desire: Japanese Collectors and Colonial Korea." *Positions: East Asia Cultures Critique* 8:3 (Winter 2000): 711–46.

———. *Kingdom of Beauty: Mingei and the Politics of Folk Art in Imperial Japan*. Durham, NC: Duke University Press, 2007.

Brown, Kendall H., and Sharon Minichiello. *Taisho Chic: Japanese Modernity, Nostalgia, and Deco*. Seattle: University of Washington Press, 2005.

Bryan-Willson, Julia. "Remembering Yoko Ono's Cut Piece." *Oxford Art Journal* 26:1 (2003): 99–123.

Buckland, Rosina. *Painting Nature for the Nation: Taki Katei and the Challenges to Sinophile Culture in Meiji Japan*. Japanese Visual Culture, book 8. Leiden: Brill, 2013.

Buntrock, Dana. *Japanese Architecture as a Collaborative Process: Opportunities in a Flexible Construction Culture*. London and New York: Spon Press, 2002.

——. *Material and Meaning in Contemporary Japanese Architecture: Tradition and Today*. New York: Routledge, 2010.

Charrier, Philip. "Taki Kōji, Provoke, and the Structuralist Turn in Japanese Image Theory 1967–1970." *History of Photography* 41:1 (2017): 25–43.

Christ, Carol Ann. "The Sole Guardians of the Art Inheritance of Asia: Japan at the 1904 St. Louis World's Fair." *Positions: East Asia Cultures Critique* 8:3 (Winter 2000): 675–709.

Chong, Doryun, ed. *From Postwar to Postmodern, Art in Japan, 1945–1989: Primary Documents*. New York: The Museum of Modern Art, 2012.

——. *Tokyo 1955–1970: A New Avant-Garde*. New York: The Museum of Modern Art, 2012.

Clark, John. *Modernities of Japanese Art*. Leiden: Brill, 2012.

Clark, Timothy. *Demon of Painting: The Art of Kawanabe Kyōsai*. London: The British Museum, 1993.

Conant, Ellen P. *Nihonga: Transcending the Past: Japanese-Style Painting, 1868–1968*. Saint Louis Art Museum; Tokyo: Japan Foundation, 1995.

——, ed. *Challenging Past and Present: The Metamorphosis of Nineteenth-Century Japanese Art*. Honolulu: University of Hawai'i Press, 2006.

Cort, Louise, and Bert Winther-Tamaki. *Isamu Noguchi and Modern Japanese Ceramics*. Washington, DC: Arthur M. Sackler Gallery, in association with University of California Press, Berkeley, 2000.

Croissant, Doris, Catherine Vance Yeh, and Joshua Mostow, eds. *Performing "Nation": Gender Politics in Literature, Theater, and the Visual Arts of China and Japan, 1880–1940*. Leiden: Brill, 2008.

Dower, John, and John Junkerman, eds. *The Hiroshima Murals: The Art of Iri Maruki and Toshi Maruki*. Tokyo and New York: Kodansha International, 1985.

Earle, Joe. *Contemporary Clay: Japanese Ceramics for the New Century*, Boston: MFA Publications, 2005.

——. *Contemporary Japanese Masters*. New York: Japan Society, 2008.

——. *New Bamboo: Contemporary Japanese Masters*. New York: Japan Society, 2008.

———. *Serizawa: Master of Japanese Textile Design*. New Haven, CT: Yale University Press, 2009.

Elliot, David. *Bye Bye Kitty!!! Between Heaven and Hell in Contemporary Japanese Art*. New York: Japan Society, 2011.

Faulkner, Rupert. *Japanese Studio Crafts and the Avant-Garde*. London: Laurence King and the V&A Museum, 1995.

Favell, Adrian. *Before and After Superflat: A Short History of Japanese Contemporary Art, 1990–2011*. Hong Kong: Blue Kingfisher, 2011.

Fischer, Felice. *The Art of Japanese Craft: 1875 to the Present*. Philadelphia Museum of Art; New Haven, CT: Yale University Press, 2008.

Foxwell, Chelsea. *Making Modern Japanese-Style Painting: Kano Hogai and the Search for Images*. Chicago: University of Chicago Press, 2015.

Fraser, Karen M. *Photography and Japan*. London: Reaktion, 2011.

Fukuoka, Maki. *The Premise of Fidelity: Science, Visuality, and Representing the Real in Nineteenth-Century Japan*. Palo Alto, CA: Stanford University Press, 2012.

Graham, Patricia J. *Japanese Design: Art, Aesthetics, and Culture*. Rutland, VT: Tuttle, 2014.

Guth, Christine. *Longfellow's Tattoos: Tourism, Collecting, and Japan*. Seattle: University of Washington Press, 2004.

———. "The Multiple Modalities of the Copy in Traditional Japanese Craft." *Journal of Modern Craft* 3:1 (March 2010): 7–18.

Guth, Christine, Emiko Yamanashi, and Alicia Volk. *Japan and Paris: Impressionism, Post-Impressionism and the Modern Era*. Seattle: University of Washington; Honolulu: Honolulu Academy of Arts, 2004.

Handy, Ellen. "Tradition, Novelty, and Invention: Portrait and Landscape Photography in Japan, 1860s–1880s." In *Timely Encounter: Nineteenth-Century Photographs of Japan*, edited by Melissa and Susan B. Taylor, 52–69. Wellesley College Museum; Cambridge, MA: Peabody Museum, 1991.

Hasegawa Yuko, "Performativity in the Work of Female Japanese Artists in the 1950s–60s and the '90s," In *Modern Women: Women Artists at the Museum of Modern Art*, edited by Cornelia H. Butler and Alexandra Schwartz, 335–51. New York: Museum of Modern Art, 2010.

Hein, Carola. "Hiroshima: The Atomic Bomb and Kenzo Tange's Hiroshima Peace Center," In *Out of Ground Zero: Case Studies in Urban Reinvention*, edited by Joan Ockman, 62–83. Temple Hoyne Buell Center for the Study of American Architecture, Columbia University; New York: Prestel, 2002.

Hein, Carola, Jeffry M. Diefendorf, and Yorifusa Ishida, *Rebuilding Urban Japan after 1945*. New York: Palgrave Macmillan, 2003.

Hirose, Mami, et al., eds. 2011. *Metabolism, The City of the Future: Dreams and Visions in Postwar and Present-Day Japan*. Tokyo: Mori Art Museum.

Hockley, Allen. "Cameras, Photographs, and Photography in Nineteenth-Century Japanese Prints." *Impressions* 23 (2001): 43–63.

Hu, Phillip, ed., *Conflicts of Interest: Art and War in Modern Japan*. St. Louis: Saint Louis Art Museum, 2016.

Ikeda, Asato, Aya Louisa McDonald, and Ming Tiampo, eds. *Art and War in Japan and Its Empire, 1931–1960*. Leiden: Brill, 2013.

Irvine, Gregory. *Japonisme and the Rise of the Modern Art Movement: The Arts of the Meiji Period, The Khalili Collection*. London: Thames and Hudson, 2013.

Ishigami, Aki, and Koto Sadamura. *Sex and Laughter with Kyōsai: Shunga from the Israel Goldman Collection*. Tokyo: Seigensha, 2017.

Ivy, Marilyn. "The Art of Cute Little Things: Nara Yoshitomo's Parapolitics." *Mechademia* 5 (2010): 3–30.

Kaneko, Maki. *Mirroring the Japanese Empire: The Male Figure in Yōga Painting, 1930–1950*. Leiden: Brill, 2015.

Kawakita, Michiaki. *Modern Currents in Japanese Art*. Translated by Charles S. Terry. The Heibonsha Survey of Japanese Art, vol. 24. New York and Tokyo: Weatherhill, 1974.

Kee, Joan, "Situating a Singular Kind of 'Action': Early Gutai Painting: 1954–1957." *Oxford Art Journal* 26:2 (January 2003): 123–40.

Kilpatrick, Helen. *Miyazawa Kenji and His Illustrators: Images of Nature and Buddhism in Japanese Children's Literature*. Leiden: Brill, 2012.

Kim, Gyewon. "Reframing 'Hokkaido Photography': Style, Politics, and Documentary Photography in 1960s Japan." *History of Photography* 39:4 (2015): 348–65.

Kinoshita, Naoyuki. "The Sideshow Called Fine Art." Translated by Michael P. Cronin. *Review of Japanese Culture and Society* 26 (December 2014): 165–88.

Koolhaas, Rem. *Project Japan: Metabolism Talks*. London: Taschen, 2011.

Kornicki, Peter F. "Public Display and Changing Values: Early Meiji Exhibitions and Their Precursors." *Monumenta Nipponica* 49:2 (1994): 167–96.

Kunimoto, Namiko. "Tanaka Atsuko's Electric Dress and the Circuits of Subjectivity." *Art Bulletin* 95:3 (September 2013): 465–83.

KuroDalaiJee. "Performance Collectives in 1960s Japan: With a Focus on the "Ritual School." *Positions* 21:2 (Spring 2013): 417–49.

LaMarre, Thomas. *Anime Machine: A Media Theory of Animation*. Minneapolis: University of Minnesota Press, 2009.

——. "Speciesism, Part I: Translating Races into Animals in Wartime Animation." *Mechademia* 3 (2008): 75–95.

Lloyd, Fran. *Consuming Bodies: Sex and Contemporary Japanese Art*. London: Reaktion Books, 2002.

McCarthy, Helen. *The Art of Osamu Tezuka: God of Manga*. New York: Abrams, 2009.

McNeil, Peter. "Myths of Modernism: Japanese Architecture, Interior Design and

the West, c. 1920–1940." *Journal of Design History* 5:4 (1992): 281–94.

Meech-Pekarik, Julia. *The World of the Meiji Print: Impressions of a New Civilization*. New York and Tokyo: Weatherhill, 1987.

Merritt, Helen. *Modern Japanese Woodblock Prints: The Early Years*. Honolulu: University of Hawai'i Press, 1990.

Ming Tiampo. *Gutai: Decentering Modernism*. Chicago: University of Chicago Press, 2011.

Ming Tiampo and Alexandra Munroe, eds., *Gutai: Splendid Playground*. New York: Guggenheim Museum, 2013.

Morris-Suzuki, Tessa. "Imprinting the Empire: Western Artists and the Persistence of Colonialism in East Asia," In *The Trans-Pacific Imagination: Rethinking Boundary, Culture and Society*, edited by Naoki Sakai and Hyon Joo Yoo, 89–138. Berkeley: University of California Press, 1998.

Mostow, Joshua S., Norman Bryson, and Maribeth Graybill, eds. *Gender and Power in the Japanese Visual Field*. Honolulu: University of Hawai'i Press, 2003.

Munroe, Alexandra. *Japanese Art After 1945: Scream Against the Sky*. New York: Abrams, 1994.

Murakami, Takashi. *Sūpā furatto = Super flat*. Tokyo: Madora Shuppan, 2000.

Napier, Susan Jolliffe. *Anime from Akira to Howl's Moving Castle: Experiencing Contemporary Japanese Animation*. New York: Palgrave Macmillan, 2005.

Newland, Amy Reigle, Maureen de Vries, and Chris Uhlenbeck. *Waves of Renewal: Modern Japanese Prints, 1900 to 1960: Selections from the Nihon no hanga Collection. Amsterdam*. Leiden: Hotei Publishing, 2016.

Orbaugh, Sharalyn. *Propaganda Performed: Kamishibai in Japan's Fifteen-Year War*. Leiden: Brill, 2015.

Oshima, Ken Tadashi. *Arata Isozaki*. London: Phaidon, 2009.

——. *International Architecture in Interwar Japan: Constructing Kokusai Kenchiku*. Seattle: University of Washington Press, 2009.

Reynolds, Jonathan M. "Ise Shrine and a Modernist Construction of Japanese Tradition." *Art Bulletin* 83:2 (2001): 316–41.

——. *Maekawa Kunio and the Emergence of Japanese Modernist Architecture*. Berkeley: University of California Press, 2001.

Rimer, J. Thomas. *Since Meiji: Perspectives on the Japanese Visual Arts, 1868–2000*. Honolulu: University of Hawai'i Press, 2011.

Rodner, William S. *Edwardian London through Japanese Eyes: The Art and Writings of Yoshio Markino, 1897–1915*. Leiden: Brill, 2012.

Rousmaniere, Nicole, ed. *Crafting Beauty in Modern Japan: Celebrating 50 Years of the Japanese Art Crafts Association*. London: British Museum Press, 2007.

Sato, Doshin. *Modern Japanese Art and the Meiji State: The Politics of Beauty*. Translated by Hiroshi Nara. Los Angeles: Getty Museum, 2011.

Sandler, Mark, ed. *The Confusion Era: Art and Culture of Japan during the Allied*

Occupation, 1945–1952. Washington, DC: Arthur M. Sackler Gallery, Smithsonian Institution, 1997.

Sas, Miryam. *Experimental Arts in Postwar Japan: Moments of Encounter, Engagement and Imagined Return.* Cambridge MA: Harvard University Press, 2011.

Shively, Donald H., ed. *Tradition and Modernization in Japanese Culture.* Princeton, NJ: Princeton University Press, 1971.

Szostak, John Donald. *Painting Circles: Tsuchida Bakusen and Nihonga Collectives in Early Twentieth-Century Japan.* Leiden: Brill, 2013.

Tankha, Brij, ed., *Okakura Tenshin and Pan-Asianism: Shadows of the Past.* Folkestone: Global Oriental, 2009.

Tomii, Reiko. "State v. (Anti-) Art: Model 1,000 Yen Note Incident Akasegawa Genpei and Company." *Positions* 10:1 (2002): 141–72.

——. *Radicalism in the Wilderness: International Contemporaneity and 1960s Art in Japan.* Cambridge MA: MIT Press, 2016.

Tucker, Anne. *The History of Photography in Japan.* Museum of Fine Arts, Houston; New Haven, CT: Yale University Press, 2003.

Tseng, Alice. *The Imperial Museums of Meiji Japan: Architecture and the Art of the Nation.* Seattle: University of Washington Press, 2008.

——. "Kuroda Seiki's *Morning Toilette* on Exhibition in Modern Kyoto." *Art Bulletin* 90:3 (2008): 417–40.

Usui, Emiko K., and Sarah E. McGaughey, eds. *A Much Recorded War: The Russo-Japanese War in History and Imagery.* Museum of Fine Arts, Boston, 2005.

Volk, Alicia. *In Pursuit of Universalism: Yorozu Tetsugorō and Japanese Modern Art.* Berkeley: University of California Press, 2010.

Vollmer, John Edward. *Re-envisioning Japan: Meiji Fine Art Textiles.* Milan: Five Continents Editions, 2016.

Wakita, Mio. *Staging Desires: Japanese Femininity in Kusakabe Kimbei's Nineteenth-Century Souvenir Photography.* Berlin: Reimer, 2013.

Weiss, Jeffrey S. ed., *On Kawara—Silence.* New York: Guggenheim Museum Publications, 2015.

Weisenfeld, Gennifer. "From Baby's First Bath: Kaō Soap and Modern Japanese Commercial Design." *Art Bulletin* 86:3 (September 2004): 573–98.

——. *Imaging Disaster: Tokyo and the Visual Culture of Japan's Great Earthquake of 1923.* Berkeley: University of California Press, 2012.

——. *Mavo: Japanese Artists and the Avant-Garde, 1905–1931.* Berkeley: University of California Press, 2002.

——. "Publicity and Propaganda in 1930s Japan: Modernism as Method." *Design Issues* 25, no. 4 (Autumn 2009): 13–28.

——. "Touring 'Japan-As-Museum': NIPPON and Other Japanese Imperialist Travelogues." *Positions* 8, no. 3 (2000): 747–93.

Wendelken, Cherie. "Putting Metabolism Back in Place: The Making of a Radically

Decontextualized Architecture in Japan." In *Anxious Modernisms: Experimentation in Postwar Architectural Culture*, edited by Sara Goldhagen and Réjean Legault, 279–99. Cambridge, MA: MIT Press, 2000.

Wichmann, Siegfried. *Japonisme: The Japanese Influence on Western Art in the 19th and 20th Centuries*. New York: Park Lane, 1985.

Winther-Tamaki, Bert. *Art in the Encounter of Nations: Japanese and American Artists in the Early Postwar Years*. Honolulu: University of Hawaiʻi Press, 2001.

———. "Embodiment/Disembodiment in Japanese Painting During the Fifteen Year War." *Monumenta Nipponica* 52, no. 2 (July 1997): 145–80.

———. *Maximum Embodiment: Yōga, the "Western Painting" of Japan, 1910–1955*. Honolulu: University of Hawaiʻi Press, 2012.

Yamamura, Midori. *Yayoi Kusama: Inventing the Singular*. Cambridge, MA: MIT Press, 2015.

Yoshimoto, Midori. *Into Performance: Japanese Women Artists in New York*. New Brunswick, NJ: Rutgers University Press, 2005.

Image Credits

Chapter 1

Fig. 1: Round-bottom deep vessel with linear relief from the Kamino site, Kanagawa prefecture, Incipient Jōmon period, earthenware, H. 22.2 cm, inside D. 23.5 cm, Yamato City Board of Education, Kanagawa prefecture.

Fig. 2: Illustration of cords and cord markings from Yamanouchi Sugao, *Nihon senshi doki no jōmon*, Tokyo: Senshi Kōko Gakkai, 1979, p. 19.

Fig. 3: Conical round-bottom deep vessel with shell appliqué from the Nakano A site, Hokkaido, Initial Jōmon period, earthenware, H. 30.5 cm, inside D. 25.0 cm, Hakodate City Museum, Hokkaido.

Fig. 4: Elaborately decorated vessel from the Kōjin'yama site, Nagano prefecture, Early Jōmon period, earthenware, H. 28.7 cm, Suwa City Educational Commission, Nagano prefecture.

Fig. 5: Katsusaka-type pot from the Takikubo site, Tokyo, Middle Jōmon period, earthenware, H. 36.8 cm, private collection. Image: TNM Image Archives.

Fig. 6: Barrel-shaped vessel from the Nakahara site, Yamanashi prefecture, Middle Jōmon period, earthenware, H. 58.6 cm, Idojiri Archaeological Museum, Nagano prefecture. Photo: Ogawa Tadahiro.

Fig. 7: Extended view of Fig. 6. Photo: Ogawa Tadahiro.

Fig. 8: Vessels found in a pit house at the Idojiri site, Nagano prefecture, Middle Jōmon period, from Fujimori Eiichi, ed., *Idojiri*, Tokyo: Chūō Kōron Bijutsu Shuppan, 1965, p. 97.

Fig. 9: Placenta pot from the Tsugane Goshomae site, Yamanashi prefecture, earthenware, H. 57.5 cm, Hokuto City Board of Education, Yamanashi prefecture.

Fig. 10: Umataka-type flame pot from the Sasayama site, Niigata prefecture, Middle Jōmon period, earthenware with applied lacquer, H. 46.5 cm, Tōkamachi City Museum, Niigata prefecture.

Fig. 11: Detail of Fig. 10.

Fig. 12: Yakemachi vessel from the Kawarada site, Nagano prefecture, Middle Jōmon period, earthenware, H. 48.4 cm, Asama Jōmon Museum, Nagano prefecture.

Fig. 13: Spouted vessel from the Shiizuka shell middens, Ibaraki prefecture, Late Jōmon period, earthenware, H. 21.8 cm, Tatsuuma Collection of Fine Arts, Hyogo prefecture. Photo: Benrido.

Fig. 14: *Dogū* from the Tanabatake site, Nagano prefecture, National Treasure, Middle Jōmon period, earthenware, H. 27.0 cm, Togari-ishi Archaeological Museum, Nagano prefecture.

Fig. 15: Standing *dogū* from the Nishinomae site, Yamagata Prefecture, National

Treasure, Middle Jōmon period, earthenware, H. 45.0 cm, Yamagata Prefectural Museum.

Fig. 16: Heart-shaped *dogū* from the Gōbara site, Gunma prefecture, Late Jōmon period, earthenware, H. 30.3 cm, private collection. Image: TNM Image Archives.

Fig. 17: *Dogū* with "coffee bean eyes" from the Kamegaoka site, Aomori prefecture, Final Jōmon period, earthenware, H.34.5 cm, Tokyo National Museum. Image: TNM Image Archives.

Fig. 18: Openwork clay earrings from the Chiamigaito site, Gunma prefecture, Final Jōmon period, earthenware, Minimum D. 9.0 cm, Kiryū Municipal Educational Commission, Gunma prefecture.

Fig. 19: Vessel with black-lacquer ground and red-lacquer cloud design from the Kamegaoka site, Aomori prefecture, Final Jōmon period, H. 6.7 cm, D. 20.5 cm, Aomori Prefectural Museum (Fūindō Collection).

Chapter 2

Fig. 1: Itazuke-type jar from the Itazuke site, Fukuoka prefecture, Early Yayoi period, earthenware, H. 14.3 cm, Meiji University Museum, Tokyo.

Fig. 2: Wide-mouthed jar with red lacquer from the Fujisaki site, Fukuoka prefecture, Middle Yayoi period, earthenware with lacquer application, H. 32.4 cm, Fukuoka City Archaeology Center.

Fig. 3: Jar with a long tapering neck from the Funahashi site, Osaka prefecture, Middle Yayoi period, earthenware, H. 27.0 cm, Kyoto National Museum.

Fig. 4: Jug-like vessel from the Niizawakazu site, Nara prefecture, Middle Yayoi period, earthenware, H. 21.8 cm, The Museum, Archaeological Institute of Kashihara, Nara prefecture.

Fig. 5: Hybrid-style vessel from the Umasaka site, Shizuoka prefecture, Middle Yayoi period, earthenware, H. 40.6 cm, Iwata City Archaeological Center, Shizuoka prefecture.

Fig. 6: Red lacquered hybrid jar from the Kugahara site, Tokyo, Late Yayoi period, earthenware, H. 36.3 cm, private collection. Image: TNM Image Archives.

Fig. 7: Jar with a modeled human face from the Izuruhara site, Tochigi prefecture, Middle Yayoi period, earthenware, H. 23.0 cm, Meiji University Museum, Tokyo.

Fig. 8: Bronze bells and halberds from the Sakuragaoka site, Mt. Rokkō, Hyogo prefecture, Middle Yayoi period, bronze, Kobe City Museum, Hyogo prefecture.

Fig. 9: Detail from one of the bells discovered at Mount Rokkō, Middle Yayoi period, bronze, H. 39.2 cm, Kobe City Museum, Hyogo prefecture.

Fig. 10: Triangular-rimmed mirror from the Kurozuka burial mound, Tenri, Nara prefecture, Early Kofun period, bronze, D. 22.4 cm, Agency for Cultural

Affairs, Japan. Photo: Anan Tatsuhide, photo courtesy of the Museum, Archaeological Institute of Kashihara, Nara prefecture.

Fig. 11: Large red lacquer decorated sarcophagus from the Fujinoki burial mound (coffin interior after cleaning), Ikaruga-chō, Nara prefecture, second half of 6th century, the Museum, Archaeological Institute of Kashihara, Nara prefecture.

Fig. 12: *Haniwa* of a falconer from Sakai-chō, Isesaki, Gunma prefecture, Late Kofun period, earthenware, H. 74.5 cm, Museum Yamato Bunkakan, Nara.

Fig. 13: *Haniwa* of a deer from the Hiradokoro site, Shimane prefecture, 6th century, earthenware, H. 92.0 cm, Shimane Prefectural Educational Commission.

Fig. 14: *Haniwa* of a boy playing a zither from the Asakura site, Gunma prefecture, Late Kofun period, earthenware, H. 72.6 cm, Aikawa Archaeological Museum, Gunma prefecture.

Fig. 15: Sue ware jar decorated with children from the Nishinomiya-yama burial mound, Hyogo prefecture, 6th century, stoneware, H. 37.4 cm, Kyoto National Museum.

Fig. 16: Mural from a tomb, Takehara burial mound, Wakamiya-chō, Fukuoka prefecture, second half of 6th century, H. 140.0 cm, Kyushu Historical Museum. Photo: Kyushu Historical Museum.

Fig. 17: Figures depicted near the head of the coffin, Chibusan burial mound, Yamaga, Kumamoto prefecture, 6th century, Yamaga City Board of Education, Kumamoto prefecture.

Chapter 3

Fig. 1: Standing Bodhisattva, 3rd–4th century, China, gilt-bronze, H. 33.1 cm, Fujii Saiseikai Yūrinkan, Kyoto.

Fig. 2: Standing Buddha, Longxing Si Relic Site, China, 6th century, limestone with light color and gold, H. 156.0 cm, Qingzhou Municipal Museum, Shandong province.

Fig. 3: Temple plans for Hōryū-ji (left), Shitennō-ji (center), and Asuka-dera (right), Nara.

Fig. 4: Great Buddha of Asuka, carved by Tori Busshi, 609 CE, gilt-bronze, H. 275.0 cm, Asuka-dera (Ango-in), Nara prefecture. Photo: Inoue Hakudō.

Fig. 5: Fukuyama Toshio's reconstruction of the main hall of Izumo grand shrine, from Obayashi Corporation Project Team, *Yomigaeru kodai daikensetsu jidai*, Tokyo: Tokyo Shoseki, 2002, pp. 279–81.

Fig. 6: Sakyamuni Triad, carved by Tori Busshi, 623 CE, gilt-bronze, center H. 87.5 cm, left H. 92.3 cm, right H. 93.9 cm, Kondō, Hōryū-ji, Nara. Photo: Benrido.

Fig. 7: Hōryū-ji temple complex. Photo: Benrido.

Fig. 8: Guze Kannon (Standing Kannon Bosatsu), first half of 7th century, wood, gold leaf, H. 180.0 cm, Hōryū-ji, Nara prefecture. Photo: Benrido.

Fig. 9: Detail of Guze Kannon. Photo: Domon Ken (Ken Domon Museum of Photography).

Fig. 10: Kudara Kannon (Standing Kannon), mid-7th century, wood and light color, H. 211.0 cm, Hōryū-ji, Nara prefecture. Photo: Nara National Museum.

Fig. 11: Jikokuten (Dhṛtaraṣṭra), one of the Four Guardian Kings, mid-7th century, wood, H. 133.3 cm, Hōryū-ji. Photo: Benrido.

Fig. 12: Hōkan Miroku (Maitreya in a half-lotus position), 7th century, wood, gold leaf, H. 123 cm, Kōryū-ji, Kyoto. Photo: Asukaen.

Fig. 13: Head of the Buddha, 685 CE, gilt bronze, H. 98.3 cm, formerly in the Tōkondō, Kōfuku-ji, Nara. Image: TNM Image Archives.

Fig. 14: Standing Bodhisattva, 7th century, camphor wood, H. 47.6 cm, Kinryū-ji, Nara prefecture. Image: Nara National Museum. Photo: Sasaki Kōsuke.

Fig. 15: Standing Kannon Bosatsu, late 7th century to early 8th century, gilt-bronze, H. 87.0 cm, Hōryū-ji, Nara prefecture. Photo: Nara National Museum.

Fig. 16: Lotus-pond design on the base plate of Lady Tachibana's private devotional shrine, late 7th century to early 8th century, gilt-bronze, Hōryū-ji, Nara prefecture. Photo: Nara National Museum.

Fig. 17: Tenjukoku Paradise Embroidery, 622 CE, silk, 88.8×82.7 cm, Chūgū-ji, Nara prefecture. Photo: Kyoto National Museum.

Fig. 18: Details of the Tenjukoku Paradise Embroidery.

Fig. 19: Tamamushi Shrine, mid-7th century, cypress and camphor wood with lacquer and color, H. 226.6 cm, Hōryū-ji, Nara prefecture. Photo: Nara National Museum.

Fig. 20: Detail of the *Jataka Tales* painted on the side panels of the Tamamushi Shrine, mid-7th century, lacquer and color on wood, 91.8×48.8 cm, Hōryū-ji, Nara prefecture. Photo: Nara National Museum.

Fig. 21: Mural painting of female attendants, Takamatsuzuka burial mound, late 7th century to early 8th century, color on kaolin-covered plaster wall, figures H. 40.0 cm, Asuka, Nara prefecture, Ministry of Education, Culture, Sports, Science and Technology, Japan.

Fig. 22: "Amida's Pure Land" from the *Pure Land Paradises of Four Buddhas*, late 7th to early 8th century, color on kaolin-covered plaster wall, panel 6 of the outer sanctum of the Kondō of Hōryū-ji, Nara prefecture (photo taken prior to fire damage). Photo: Benrido.

Chapter 4

Fig. 1: East Pagoda, 730, three stories with wood frame, tile roof and pent roof

on each level, 3×3 bay, Yakushi-ji, Nara. Photo: Inoue Hakudō.

Fig. 2: Yakushi Triad, late 7th to early 8th century, gilt-bronze, (Yakushi Nyorai; center) H. 254.7 cm, (Nikkō; right) H. 317.3 cm, (Gakkō; left) H. 315.3 cm, Yakushi-ji, Nara. Photo: Inoue Hakudō.

Fig. 3: Standing Shō Kannon, late 7th to early 8th century, gilt-bronze, H. 188.9 cm, Tōin-dō, Yakushi-ji, Nara. Image: TNM Image Archives.

Fig. 4: Attendant, 711, unfired earthenware with color, H. 47.2 cm, Five-Story Pagoda, Hōryū-ji, Nara prefecture. Photo: Benrido.

Fig. 5: Ashura, 711, unfired earthenware with color, H. 41.3 cm, Five-Story Pagoda, Hōryū-ji, Nara prefecture. Photo: Benrido.

Fig. 6: Ashura, 734, hollow dry lacquer with color, H. 153.4 cm, Kōfuku-ji, Nara. Photo: Asukaen.

Fig. 7: Standing Fukūkenjaku Kannon, mid-8th century, hollow dry lacquer with gold foil, H. 362 cm, Hokke-dō, Tōdai-ji, Nara. Photo: Inoue Hakudō.

Fig. 8: Detail of the *Lotus Treasury World* inscribed on the lotus pedestal, 8th century, bronze, Great Buddha Hall, Tōdai-ji, Nara. Photo: Inoue Hakudō.

Fig. 9: Seated Birushana, late 8th century, hollow dry lacquer with gold foil, H. 304.5 cm, Kondō, Tōshōdai-ji, Nara. Photo: Inoue Hakudō.

Fig. 10: Seated Senju Kannon, 8th century, hollow dry lacquer with gold foil, H. 131.3 cm, Fujii-dera, Osaka.

Fig. 11: Seated Ganjin Wajō, 763, hollow dry lacquer with color, H. 80.1 cm, Miei-dō, Tōshōdai-ji, Nara. Photo: Nara National Museum.

Fig. 12: Yakushi Nyorai, late 8th century, wood, H. 165.0 cm, Tōshōdai-ji, Nara. Photo: Nara National Museum.

Fig. 13: Standing Buddha, late 9th century, wood and clay molding, H. 154.0 cm, Tōshōdai-ji, Nara. Photo: Nara National Museum.

Fig. 14: *Kichijōten*, 8th century, ink, color and gold on ramie, Yakushi-ji, Nara. Photo: Asukaen.

Fig. 15: *Sakyamuni's Sermon under the Trees on Vulture Peak*, also known as *Hokke-dō konpon mandara*, 8th century, ink, color and gold on ramie, 107.0×143.5 cm, Museum of Fine Arts, Boston. Photograph © 2018 Museum of Fine Arts, Boston.

Fig. 16: *Illustrated Scripture of Cause and Effect*, 8th century, handscroll, ink and color on paper, 26.3×1536.3 cm, Daigo-ji, Nara.

Fig. 17: Shōsō-in Repository, mid-8th century, wood-framed storehouse with tiled hipped roof, 9×3 bay, Tōdai-ji, Nara.

Fig. 18: Five-stringed rosewood lute with mother-of-pearl inlay, 8th century, 108.1×30.9 cm (body), 30.9×13.3cm (plectrum guard), Shōsō-in Repository, Tōdai-ji, Nara.

Fig. 19: Musicians Riding an Elephant, detail of a maple lute with sappanwood plectrum guard with mother-of-pearl inlay, 8th century, ink and color on

leather, 40.5×16.5 cm, Shōsō-in Repository, Shōsō, Tōdai-ji, Nara.

Fig. 20: Tang-style sword mounting with gilded silver fittings and inlay, 8th century, 80.0 cm (scabbard), 17.0×2.7–3.4 cm (hilt), Shōsō-in Repository, Tōdai-ji, Nara.

Fig. 21: Litharge painted box, 8th century, wood with lacquer and color, 44.8×30×21.3 cm, Shōsō-in Repository, Tōdai-ji, Nara.

Fig. 22: Lacquered and gold painted incense burner pedestal, 8th century, wood with lacquer, color and gold, 17.0×56.0 cm, Shōsō-in Repository, Tōdai-ji, Nara.

Fig. 23: Detail of *Standing Women Decorated with Bird Feathers*, third panel, 8th century, six-fold screen, ink and color on paper, 136.0×56.0 cm, Shōsō-in Repository, Tōdai-ji, Nara.

Fig. 24: The Gigaku mask of the Drunken Barbarian King, 8th century, wood with color, 37.0×22.6 cm, Shōsō-in Repository, Tōdai-ji, Nara.

Chapter 5

Fig. 1: *Takao Mandala*, 829–34, pair of hanging scrolls, gold and silver on purple-dyed silk, 411.0×366.5 cm, Jingo-ji, Kyoto. Photo: Kyoto National Museum.

Fig. 2: Detail of the *Takao Mandala* (Fig. 1), Dainichi Nyorai (Mahāvairocana). Photo: Kyoto National Museum.

Fig. 3: *Sai-in Mandala*, second half of 9th century, pair of hanging scrolls, ink and color on silk, 185.1×164.3 cm, Tō-ji, Kyoto. Photo: Kyoto National Museum.

Fig. 4: "Taishakuten" (Indra), one of the *Twelve Devas*, mid-9th century, hanging scroll, ink and color on silk, 158.2×134.7 cm, Saidai-ji, Nara. Photo: Kyoto National Museum.

Fig. 5: "Imperial Rite of the Latter Seven Days of the New Year" in *Illustrated Scroll of Annual Events* (12th century), 1626 copy by Sumiyoshi Jokei and Gukei, handscroll, ink and color on paper, H. 45.3 cm, Tanaka Family.

Fig. 6: Central Dias of the Eight Petal Court in the center of the *Sai-in Mandala* (Fig. 3), Tō-ji, Kyoto. Photo: Kyoto National Museum.

Fig. 7: Seated Yakushi Nyorai, late 8th century, wood, H. 191.5 cm, Shin Yakushi-ji, Nara. Photo: Inoue Hakudō.

Fig. 8: Standing Yakushi Nyorai, early 9th century, wood, H. 170.6 cm, Jingo-ji, Kyoto. Photo: Yamamoto Michihiko.

Fig. 9: Zōchōten (Virudhaka), one of the Four Guardian Kings, 839, wood with lacquer, color and gold leaf, H. 182.5 cm, lecture hall, Tō-ji, Kyoto. Photo: Benrido.

Fig. 10: Hokkai Kokūzō, one of the Five Great Sky Store Bodhisattvas, first half of 9th century, wood with color, H. 100.9 cm, Hōtō-in, Jingo-ji, Kyoto.

Photo: Yamamoto Michihiko.

Fig. 11: Nyoirin Kannon, mid-9th century, wood with lacquer, color and metal fittings, H. 109.4 cm, Kanshin-ji, Osaka. Photo: Nara National Museum.

Fig. 12: Eleven-Headed Kannon, mid-9th century, wood with lacquer and color, H. 194.0 cm, Kōgen-ji, Kyoto. Photo: Nara National Museum.

Fig. 13: Eleven-Headed Kannon, first half of 9th century, wood, H. 100.0 cm, Hokke-ji, Nara. Photo: Nagano Rokumeisō.

Fig. 14: Bodhisattva seated in the half-lotus position, late 8th century, wood, H. 124.5 cm, Hōbodai-in, Gantoku-ji, Kyoto. Photo: Nara National Museum.

Fig. 15: Male *kami*, second half of the 9th century, wood with color, H. 97.3 cm, Matsuo grand shrine (Matsuo-taisha), Kyoto. Photo: Kyoto National Museum.

Fig. 16: Female *kami*, second half of the 9th century, wood with color, H. 87.6 cm, Matsuo grand shrine (Matsuo-taisha), Kyoto. Photo: Kyoto National Museum.

Fig. 17: Kūkai, letter to Saichō (*Fushin-jō*), first half of 810s, handscroll, ink on paper, 28.8×157.9 cm, Tō-ji, Kyoto. Photo: Kyoto National Museum.

Fig. 18: Saichō, letter to Kūkai (*Kyūkaku-jō*), 813, handscroll, ink on paper, 29.4×55.2 cm, Nara National Museum.

Fig. 19: Five-pronged vajra, 11th–12th century, gilt-bronze, H. 22.5 cm, D. 9.0 cm, Kōki-ji, Kyoto. Photo: Nara National Museum.

Fig. 20: Box for Buddhist surplices, 10th century, lacquer with *maki-e* on wood, 47.9×39.1×11.5 cm, Tō-ji, Kyoto. Photo: Kyoto National Museum.

Fig. 21: Standing Yakushi Nyorai, late 9th century, wood with color and metal fittings, H. 234.8 cm, Kondō, Murō-ji, Nara. Photo: Inoue Hakudō.

Fig. 22: "Kongōku Bosatsu," one of the *Five Mighty Bodhisattvas*, hanging scroll, ink and color on silk, 304.8×237.6 cm, 10th century, Yūshi Hachimankō Jūhachi Ka-in, Mt. Kōya. Photo: Kyoto National Museum.

Fig. 23: Five-story pagoda, 951, wooden flame, tile roof, 3×3 bay, Daigo-ji, Kyoto.

Fig. 24: "Gōzanze Myō-ō," one of the *Five Great Wisdom Kings*, 1088, hanging scroll, ink and color on silk, 138.0×88.0 cm, Kiburi-ji, Gifu prefecture. Photo: Nara National Museum.

Fig. 25: Detail of *Blue Fudō and Two Boy Attendants*, second half of 11th century, hanging scroll, ink and color on silk, 203.3×149.0 cm, Shōren-in, Kyoto. Photo: Kyoto National Museum.

Fig. 26: Phoenix Hall, 1053, single-story central hall with north, south, and tail wings, wood frame with hip-and-gable tile roof and pent roof, 3×2 bay (central hall), Byōdō-in, Uji, Kyoto prefecture.

Fig. 27: Reconstructed *shinden-zukuri* floor plan of the Higashi Sanjō Palace by Ōta Seiroku, 1941; from Chino Kaori, *10–13 seki no bijutsu, ōchō-bi no sekai* (The Beautiful World of Court Culture: Art of the 10th–13th Century). In

vol. 3 of *Iwanami Nihon bijutsu no nagare* (Iwanami Overview of Japanese Art) series. Tokyo: Iwanami Shoten, 1993.

Fig. 28: Amida Nyorai, carved by Jōchō, 1053, wood with gold leaf, H. 278.8 cm, Phoenix Hall, Byōdō-in, Uji, Kyoto prefecture.

Fig. 29: *Zaō Gongen*, 1001, line engraving on bronze, trefoil-shaped back panel, 67.0×78.4 cm, Nishiarai-daishi Sōji-ji, Tokyo.

Fig. 30: "Lower Grade of Rebirth, High Level," from the *Nine Grades of Rebirth in the Pure Land*, 1053, ink and color on wooden door panel, 374.0×137.5 cm, Phoenix Hall, Byōdō-in, Uji, Kyoto prefecture. Photo: Iwanami Shoten.

Fig. 31: *Buddha's Nirvana*, 1086, hanging scroll, ink and color on silk, 267.6×271.2 cm, Kongōbu-ji, Mt. Kōya, Wakayama prefecture. Photo: Kyoto National Museum.

Fig. 32: *Sakyamuni Emerging from the Golden Coffin*, 11th–12th century, hanging scroll, ink and color on silk, 160.0×229.5 cm, Kyoto National Museum.

Fig. 33: "Nagarjuna" from *Prince Shōtoku and the High-Ranking Monks of the Tendai Sect*, mid-11th century, hanging scroll, ink and color on silk, 128.8×75.8 cm, Ichijō-ji, Hyogo prefecture. Photo: Kyoto National Museum.

Fig. 34: Scene depicting Kannon from the *Lotus Sutra* on a sutra box, 11th century, lacquer with *maki-e* on wood, 23.3×32.7×16.4 cm, Fujita Museum of Art, Osaka.

Fig. 35: Detail from the *Gyokusen-jō*, calligraphy by Ono no Michikaze, 10th century, handscroll, ink on paper, 27.6×188.7 cm, Museum of the Imperial Collections (Sannomaru Shōzōkan).

Fig. 36: Detail from the *Onna Guruma-jō*, calligraphy by Fujiwara no Sukemasa, 982, handscroll, ink on paper, 30.5×105.7 cm, Shogei Bunka-in, Shunkei Memorial Shodō Bunko, Tokyo.

Fig. 37: *Kōya gire Kokinshū*, attributed to Ki no Tsurayuki, mid-11th century, handscroll, ink on paper, 25.7×40.9 cm, Gotoh Museum, Tokyo. Photo: Meikyō Katsuo.

Fig. 38: Landscape folding screen, second half of 11th century, six-fold screen, ink and color on silk, 110.8×37.5 cm (each panel), Kyoto National Museum (formerly at Tō-ji).

Fig. 39: Detail of Fig. 38, fourth panel picturing an elderly man in Chinese garb.

Fig. 40: Landscape folding screen, late 12th century or early 13th century, six-fold screen, ink and color on silk, 110.8×37.5 cm (each panel), Jingo-ji, Kyoto. Image: TNM Image Archives.

Fig. 41: Detail of Fig. 40, sixth panel picturing *shinden*-style residence.

Fig. 42: *Suiten (Varuna)*, one of the *Twelve Devas*, 1127, hanging scroll, ink and color on silk, 144.0×127.0 cm, Kyoto National Museum.

Fig. 43: *Shaka Nyorai*, first half of 12th century, hanging scroll, ink and color on silk, 159.4×85.5 cm, Jingo-ji, Kyoto. Photo: Kyoto National Museum.

Fig. 44: *Fugen Bosatsu*, mid-12th century, hanging scroll, ink and color on silk, 159.5×74.5 cm, Tokyo National Museum. Image: TNM Image Archives.

Fig. 45: *The Descent of Amida*, 12th century, hanging scrolls (triptych), ink and color on silk, center: 210.4×210.5 cm (center), right and left: 211.0×106.0 cm (right and left), Yūshi Hachimankō Jūhachi Ka-in, Mt. Kōya. Photo: Kyoto National Museum.

Fig. 46: Frontispiece, *Heike Nōkyō*, 1164, thirty-three handscrolls, ink and color on paper, 25.8×28.8 cm (frontispiece), Itsukushima shrine (Itsukushima-jinja), Hiroshima prefecture. Photo: Nara National Museum.

Fig. 47: "Courtier and girl reading a text," scroll 1, fan 9, from a fan-shaped album of the *Lotus Sutra*, mid-12th century, five albums, ink and color on paper, 49.4 cm (overall width), Shitennō-ji, Osaka.

Fig. 48: Volume dedicated to Kiyoharu no Mosuke, *Anthology of the Thirty-Six Poets*, 1112, thirty-seven albums, ink and color on paper, 20.0×15.7 cm, Nishi Hongan-ji, Kyoto.

Fig. 49: Painted folding fan, second half of 12th century, ink and color on wood, 30.0 cm (rib width), Itsukushima shrine (Itsukushima-jinja), Hiroshima prefecture. Photo: Kyoto National Museum.

Fig. 50: "The Law" from *Illustrated Scrolls of the Tale of Genji*, first half of 12th century, ink and color on paper, 21.8×48.3 cm, Gotoh Museum, Tokyo. Photo: Meikyō Katsuo.

Fig. 51: "Yūgiri" from *Illustrated Scrolls of the Tale of Genji*, first half of 12th century, ink and color on paper, 21.8×39.5 cm, Gotoh Museum, Tokyo. Photo: Meikyō Katsuo.

Fig. 52: "The Wealthy Man of Yamazaki" from *Illustrated Scrolls of the Legends of Shigisan*, first half of 12th century, set of three handscrolls, ink and color on paper, 31.5×872.2 cm, Chōgosonshi-ji, Nara prefecture.

Fig. 53: "The Rite of Spiritual Empowerment for the Engi-era Emperor" from *Illustrated Scrolls of the Legends of Shigisan*, first half of 12th century, set of three handscrolls, ink and color on paper, 31.5×1273.0 cm, Chōgo-sonshi-ji, Nara prefecture.

Fig. 54: "The Burning of the Ōtenmon" from *Illustrated Scrolls of the Courtier Ban Dainagon*, 12th century, set of three handscrolls, ink and color on paper, 30.4×851.1 cm, Idemitsu Museum of Art, Tokyo.

Fig. 55: "Rabbits and Monkeys Playing in the Water" from *Scrolls of Frolicking Animals*, mid-12th century, set of four handscrolls, ink on paper, 31.0×1189.0 cm, Kōzan-ji, Kyoto. Photo: Kyoto National Museum.

Fig. 56: "Hell of Pus and Blood" from *Hells Scrolls*, 12th century, handscroll, ink and color on paper, 45.3×435 cm, Nara National Museum.

Fig. 57: "Scene of Defecators" from *Scroll of Hungry Ghosts*, 12th century, handscroll, ink and color on paper, 27.3×384 cm, Tokyo National Museum. Image: TNM Image Archives.

Fig. 58: "Scene of a Man with an Eye Ailment" from *Scroll of Afflictions*, 12th century, handscroll, ink and color on paper, 25.9×27.7 cm, Kyoto National Museum.

Fig. 59: Inner Sanctuary Zaō Hall, early 12th century, National Treasure, Mitokusan Sanbutsu-ji temple, Tottori prefecture.

Fig. 60: Golden Hall with Amida Nyorai as the central icon, c. 1124, wood frame with lacquer, color and gold leaf, H. 62.3 cm (central icon), Chūson-ji, Iwate prefecture.

Fig. 61: Seated Nine Figures of Amida Nyorai, early 12th century, wood with gold leaf, H. 224.2 cm (central icon), Jōruri-ji, Kyoto. Photo: Naka Atsushi.

Fig. 62: Seated Thousand-Armed Kannon, 1154, wood with color and metal fittings, H. 31.5 cm, Bujō-ji, Kyoto. Photo: Kyoto National Museum.

Fig. 63: Seated Amida Nyorai from the Amida Triad, 1151, wood with color and glass eyes, H. 143 cm, Chōgaku-ji, Tenri, Nara prefecture. Photo: Kyoto National Museum.

Fig. 64: Chinese-style chest with a design of plovers, first half of 12th century, lacquer with *maki-e* and mother-of-pearl inlay, 30.6×40.0×30.0 cm, Kongō-bu-ji, Mt. Kōya, Wakayama prefecture. Photo: Kyoto National Museum.

Fig. 65: Small box with "carriage wheels in water" design, 12th century, lacquer with *maki-e* and mother-of-pearl inlay, 21.7×30.6×13 cm, Tokyo National Museum. Image: TNM Image Archives.

Fig. 66: Small box with a design of sparrows in a field, 12th century, lacquer with *maki-e*, 27.4×41.2×19.1 cm, Kongō-ji, Osaka. Image: TNM Image Archives.

Fig. 67: Mirror with a design of autumn grasses and cranes with sprigs of pine in their beaks, 12th century, copper, D. 24.9 cm, Agency for Cultural Affairs, Japan. Image: TNM Image Archives.

Fig. 68: Jar with autumn grass motif, 11th–12th century, Atsumi ware, H. 41.5 cm, D. 29.4 cm, Keio University, Tokyo.

Chapter 6

Fig. 1: Great South Gate, 1199, two stories with wood frame and hip-and-gable tiled roof, 5×3 bay, Tōdai-ji, Nara. Photo: Inoue Hakudō.

Fig. 2: Pure Land Hall, 1192, wood frame with square, hipped, and, and tiled roof, 3×3 bay, Jōdo-ji, Hyogo prefecture. Photo: Benrido.

Fig. 3: Amida Triad, carved by Kaikei, 1195, wood with lacquer and gold leaf, H. 530.0 cm (central Amida), H. 371.0 cm (Kannon and Seishi), Pure Land Hall, Jōdo-ji, Hyogo prefecture. Photo: Nara National Museum.

Fig. 4: Seated Fukūkenjaku Kannon, carved by Kōkei, 1189, wood with lacquer and gold leaf, H. 336.0 cm, Nan'en-dō, Kōfuku-ji, Nara. Photo: Asukaen.

Fig. 5: Seated Dainichi Nyorai, carved by Unkei, 1176, wood with lacquer and gold leaf, glass eyes, H. 98.2 cm, Enjō-ji, Nara. Photo: Kyoto National Museum.

Fig. 6: Seated Amida Nyorai, carved by Unkei, 1186, wood, H. 142.4 cm, Gan-jōju-in, Shizuoka prefecture. Photo: Nara National Museum.

Fig. 7: Standing Kongō Rikishi (Agyō and Ungyō), carved by Unkei and Kaikei, 1203, wood with color, H. 836.3 cm (Agyō), H. 838.0 cm (Ungyō), Great South Gate, Tōdai-ji, Nara. Photo: Bijutsuin.

Fig. 8: Right hand of Ungyō during restoration (Fig. 7). Photo: Bijutsuin.

Fig. 9: Head of Ungyō after restoration (Fig. 7). Photo: Bijutsuin.

Fig. 10: Seated Shunjō Shōnin (Holy Priest Chōgen), attributed to Unkei, first half of 13th century, wood with color, H. 82.5 cm, Shunjō-dō, Tōdai-ji, Nara. Photo: Domon Ken (Ken Domon Museum of Photography).

Fig. 11: Asanga, carved by Unkei, 1212, wood with color, glass eyes, H. 194.7 cm, Hokuen-dō, Kōfuku-ji, Nara. Image: TNM Image Archives.

Fig. 12: Vasubandhu, carved by Unkei, 1212, wood with color, glass eyes, H. 191.6 cm, Hokuen-dō, Kōfuku-ji, Nara. Image: TNM Image Archives.

Fig. 13: Standing Miroku Bosatsu, carved by Kaikei, 1189, wood with lacquer and gold leaf, glass eyes, H. 106.6 cm, formerly at Kōfuku-ji, Museum of Fine Arts, Boston. Photograph © 2018 Museum of Fine Arts, Boston.

Fig. 14: Bishamonten with Attendants, carved by Tankei, first half of 13th century, H. 166.5 cm (center: Bishamonten), H. 79.7 cm (right: Kichijōten), H. 71.7 cm (left: Zennishi Dōji), Sekkei-ji, Kochi prefecture. Photo: Nara National Museum.

Fig. 15: Demon Ryūtōki with Lantern, carved by Kōben, 1215, wood with color, glass eyes, H. 77.8 cm, Kōfuku-ji, Nara. Photo: Asukaen.

Fig. 16: Portrait of Seated Uesugi Shigefusa, second half of 13th century, wood with color, glass eyes, H. 68.2 cm, Meigetsu-in, Kamakura, Kanagawa prefecture.

Fig. 17: Portrait of Dajue Zen Master Lanxi Daolong, 13th century, wood, H. 83.2 cm, Kenchō-ji, Kamakura, Kanagawa prefecture. Photo: Kamakura Museum of National Treasures.

Fig. 18: *Butsugen Butsumo*, second half of 12th century, hanging scroll, ink and color on silk, 181.6×128.6 cm, Kōzan-ji, Kyoto. Photo: Kyoto National Museum.

Fig. 19: "Aspects of the Unclean Human Path" from *The Six Realms of Existence*, 13th century, set of fifteen hanging scrolls, ink and color on silk, 155.5×68.8 cm, Shōjuraikō-ji, Shiga prefecture.

Fig. 20: *White Path between the Two Rivers*, 13th century, hanging scroll, ink, color

and gold on silk, 116.7×62.7 cm, Kōsetsu Museum of Art, Kobe, Hyogo prefecture.

Fig. 21: *Welcoming Approach of Amida and Twenty-Five Bosatsu*, 13th century, hanging scroll, ink, color and gold on silk, 145.1×154.5 cm, Chion-in, Kyoto. Photo: Kyoto National Museum.

Fig. 22: *Amida Coming over the Mountain*, 13th century, three-fold screen, ink, color and gold on silk, 101.0×83.0 cm, Konkai Kōmyō-ji, Kyoto.

Fig. 23: *Amida Coming over the Mountain*, 13th century, hanging scroll, ink, color and gold on silk,120.6×80.3 cm, Kyoto National Museum.

Fig. 24: *Kasuga Shrine Mandala*, painted by Kanshun, 1300, hanging scroll, ink, color and gold on silk, 109.0×41.5 cm, Yuki Museum of Art, Osaka.

Fig. 25: *Kasuga Deer Mandala*, end of 13th century, hanging scroll, ink, color and gold on silk, 137.5×53.0 cm, Yōmei Bunko, Kyoto. Photo: Kyoto National Museum.

Fig. 26: *Nachi Waterfall*, end of 13th century, ink and color on silk, hanging scroll, 159.4×58.9 cm, Nezu Museum, Tokyo.

Fig. 27: *Dreamlike Manifestation of Kumano Gongen*, first half of 14th century, hanging scroll, ink, color and gold on silk, 114.0×51.5 cm, Dannō Hōrin-ji, Kyoto. Photo: Kyoto National Museum.

Fig. 28: *Portrait of Retired Emperor Go-Shirakawa*, attributed to Fujiwara no Takanobu, beginning of 13th century, hanging scroll, ink and color on silk, 134.2×84.5 cm, Myōhō-in, Kyoto. Photo: Myōhō-in.

Fig. 29: Portrait traditionally identified as Minamoto no Yoritomo, attributed to Fujiwara no Takanobu, 13th century, hanging scroll, ink and color on silk, 143.0×112.2 cm, Jingo-ji, Kyoto. Photo: Kyoto National Museum.

Fig. 30: Portrait traditionally identified as Taira no Shigemori, attributed to Fujiwara no Takanobu, 13th century, hanging scroll, ink and color on silk, 143.0×112.8 cm, Jingo-ji, Kyoto. Photo: Kyoto National Museum.

Fig. 31: *Illustrated Scroll of the Imperial Guard Cavalry*, attributed to Fujiwara no Nobuzane, c. 1247, handscroll, ink and color on paper, 28.6×236.4 cm, Okura Museum of Art, Tokyo.

Fig. 32: *Portrait of Priest Myōe*, attributed to Enichibō Jōnin, 13th century, hanging scroll, ink and color on silk; 146.0×58.8 cm, Kōzan-ji, Kyoto. Photo: Kyoto National Museum.

Fig. 33: *Illustrated Scroll of Toyo no Akari*, beginning of 14th century, handscroll, ink on paper, 23.0×742.0 cm, Maeda Ikutokukai Foundation, Tokyo.

Fig. 34: "The Gambler" from *Tōhoku-in Poetry Contest among Persons of Various Occupations*, first half of 14th century, handscroll, ink and light color on paper, 29.2×533.6 cm, Tokyo National Museum. Image: TNM Image Archives.

Fig. 35: *Illustrated Scrolls of the Latter Three Years' War*, scene 4, scroll 3, Hida

no kami Korehisa, 1347, set of three handscrolls, ink and color on paper, 45.7×1968.7 cm (scroll 3), Tokyo National Museum. Image: TNM Image Archives.

Fig. 36: *Tale of the Hapless Painter*, scene 1, first half of 14th century, handscroll, ink and color on paper, 30.3×786.6 cm, Museum of the Imperial Collections (Sannomaru Shōzōkan), Tokyo.

Fig. 37: *Illustrated Legends of the Kitano Tenjin Shrine* (Jōkyū-era version), scene 4, scroll 5, 1219, set of nine handscrolls, ink and color on paper, 52.0×926.0 cm (scroll 5), Kitano Tenman-gū, Kyoto.

Fig. 38: "Tale of Uisang" from *Illustrated Biographies of the Kegon Patriarchs*, scroll 4, first half of 13th century, set of six scrolls, ink and color on paper, 31.6–31.7×872.4–1612.9 cm, Kōzan-ji, Kyoto. Photo: Kyoto National Museum.

Fig. 39: *Illustrated Biography of the Saintly Ippen*, scene 3, scroll 7, painted by En'i, 1299, set of twelve handscrolls, ink and color on silk, 37.9×633.2 cm, Tokyo National Museum. Image: TNM Image Archives.

Fig. 40: *Portrait of Dajue Zen Master Lanxi Daolong*, 13th century, hanging scroll, ink and color on silk, 104.8×46.4 cm, Kenchō-ji, Kamakura, Kanagawa prefecture.

Fig. 41: Calligraphy by Shūhō Myōchō, 1329, hanging scroll, ink on paper, 66.7×61.8 cm, Daihon-zan Myōshin-ji, Kyoto.

Fig. 42: Calligraphy by Gulin Gingmao, 1327, hanging scroll, ink on paper, Chōfuku-ji, Kyoto. Photo: Kyoto National Museum.

Fig. 43: Relic Hall, first half of 15th century, single-story hall with wood frame, pent roof on four sides, and hip-and-gable shingled roof, 5×5 bay, Engaku-ji, Kamakura, Kanagawa prefecture.

Fig. 44: Red-braided armor, 14th century, H. 64.8 cm, H. 34.8 cm (shoulder guard), H. 12.0 cm (helmet), Kasuga grand shrine (Kasuga-taisha), Nara.

Fig. 45: Saddle with autumn rain motif and mother-of-pearl inlay, end of 13th to beginning of 14th century, wood with applied black lacquer, *maki-e*, and mother-of-pearl inlay, H. 30.0 cm (front), H. 35.0 cm (back), 41.5 cm (bar length), Eisei-Bunko Museum, Tokyo.

Fig. 46: Writing box with cormorant and sand beach motif, c. 12th century, wood with black lacquer and mother-of-pearl inlay, 27.2×27.3×5.8 cm, private collection. Photo: Kyoto National Museum.

Chapter 7

Fig. 1: Noh mask Magojirō, inscribed "Omokage," 15th–16th century, wood, 21.2×13.8×6.5 cm, Mitsui Memorial Museum, Tokyo.

Fig. 2: Noh mask of *beshimi* (demon), 1413, 21.1×15.7 cm, Naratsuhiko shrine (Naratsuhiko-jinja), Nara.

Fig. 3: Sanmon Gate, 1425, two-story gate with wood frame and hip-and-gable tiled roof, 5×3 bay, Tōfuku-ji, Kyoto. Photo: Benrido.

Fig. 4: Muqi, *Guanyin, Gibbons, and Crane*, 13th century (Southern Song), hanging scrolls (triptych), ink and light color on silk, 172.4×98.0 cm (center), 174.2×100.0 cm (right and left), Daitoku-ji, Kyoto. Photo: Kyoto National Museum.

Fig. 5: Attributed to Muqi, "Sunset Glow on a Fishing Village" from *Eight Views of the Xiao and Xiang Rivers*, 13th century (Southern Song), hanging scroll, ink on silk, 33.1×113.3 cm, Nezu Museum, Tokyo.

Fig. 6: Emperor Huizong, *Dove on a Peach Branch*, 1107, hanging scroll, ink on silk, 28.6×26.0 cm, private collection.

Fig. 7: Yan Hui, "Liu Hai" from the diptych *Liu Hai and Li Tieguai*, 13th-14th century (Yuan period), hanging scrolls (diptych), ink and color on silk, 161.0×79.8 cm, Chion-ji, Kyoto. Photo: Kyoto National Museum.

Fig. 8: *Daruma*, 1271, hanging scroll, ink and color on silk, 108.2×60.0 cm, Kōgaku-ji, Yamanashi prefecture.

Fig. 9: Mokuan, *Hōtei*, first half of 14th century, hanging scroll, ink on silk, 80.2×32.0 cm, MOA Museum of Art, Shizuoka prefecture.

Fig. 10: Kaō, *Priest Xianzi*, first half of 14th century, hanging scroll, ink on silk, 87.0×34.2 cm, Tokyo National Museum. Image: TNM Image Archives.

Fig. 11: Golden Pavilion (Relic Hall), 1398 (rebuilt 1955), three stories with wood frame and square hip tiled roof, Rokuon-ji, Kyoto.

Fig. 12: *Illustrated Scroll of the Night Procession of One Hundred Demons*, 16th century, handscroll, ink and color on paper, 33.0×741.1 cm, Shinju-an, Daitoku-ji, Kyoto.

Fig. 13: Kissan Minchō, *White-Robed Kannon*, beginning of 15th century, hanging scroll, color on silk, 600.0×400.0 cm, Tōfuku-ji, Kyoto. Photo: Kyoto National Museum.

Fig. 14: *New Moon over a Brushwood Gate*, 1405, hanging scroll, ink on paper, 129.4×43.3 cm, Fujita Museum of Art, Osaka.

Fig. 15: Attributed to Shūbun, *Reading in a Bamboo Grove*, c. 1446, hanging scroll, ink and light color on paper, 134.8×33.3 cm, Tokyo National Museum. Image: TNM Image Archives.

Fig. 16: Josetsu, *Catching a Catfish with a Gourd*, before 1451, hanging scroll, ink and light color on paper, 111.5×75.8 cm, Taizō-in, Myōshin-ji, Kyoto.

Fig. 17: Silver Pavilion, 1489, two stories with wood frame and square hip tiled roof, Jishō-ji, Kyoto.

Fig. 18: Nōami, *Birds and Flowers* screens, right screen, 1469, pair of four-fold screens, ink on paper, 132.5×236.0 cm (right screen), Idemitsu Museum of Arts, Tokyo.

Fig. 19: Daisen-in *Shoin* garden, first half of 16th century, Daitoku-ji, Kyoto.

Fig. 20: Writing box with Kasuga mountain design, second half of 15th century, lacquer with *maki-e* on wood, 23.9×22.1×4.8 cm, Nezu Museum, Tokyo.

Fig. 21: Gold and silver brocaded satin damask patchwork coat, second half of 16th century, gold and silver brocade on satin damask, L. 123.0 cm, 59.0 cm (spine to cuff), Uesugi shrine (Uesugi-jinja), Yamagata prefecture.

Fig. 22: Attributed to Jasoku, *Landscapes of the Four Seasons* sliding doors, c.1491, eight-panel sliding doors, ink on paper, 178.0×93.5–141.5 cm, Shinju-an, Daitoku-ji, Kyoto.

Fig. 23: *Landscape with Sun and Moon* screens, 16th century, pair of six-fold screens, ink, color and gold leaf on paper, 147.0×313.5 cm (each screen), Kongō-ji, Osaka.

Fig. 24: Tosa Mitsunobu, "The Green Branch (*Sakaki*)" from the *Tale of Genji Album*, 1509, fifty-four leaf album, ink, color and gold on paper, 24.3×18.1 cm, Arthur M. Sackler Museum, Harvard University Art Museums, Cambridge, Massachusetts. Bequest of the Hofer Collection of the Arts of Asia, 1985.352.10.A. Photo: Katya Kallsen.

Fig. 25: Attributed to Tosa Mitsuyoshi, "The Twelfth Month, Rolling Snow" from *Scenes of the Twelve Months*, first half of 16th century, ink and color on paper, 32.7×28.0 cm, Hoshun Yamaguichi Memorial Hall, Kanagawa prefecture.

Fig. 26: *Scenes in and around the Capital* (Rekihaku A version, formerly known as the Machida screens), first half of 16th century, pair of six-fold screens, ink, color and gold on paper, 138.2×381.0 cm (each screen), National Museum of Japanese History, Chiba prefecture.

Fig. 27: Sesshū Tōyō, *Long Handscroll of Landscapes in the Four Seasons*, handscroll, 1486, ink and light color on paper; H. 40.0× full scroll 1568.0 cm, Mōri Museum, Yamaguchi prefecture.

Fig. 28: Sesshū Tōyō, *Amanohashidate*, c. 1501–06, hanging scroll, ink and light color on paper, 89.4×168.5 cm, Kyoto National Museum.

Fig. 29: Sesson Shūkei, *Tiger and Dragon* screens, right screen, second half 16th century, pair of six-fold screens, ink on paper, 171.5×365.8 cm (right screen), Cleveland Museum of Art. © The Cleveland Museum of Art, purchase from the J. H. Wade Fund, 1959. 136. 1.

Fig. 30: Attributed to Nōami, *Pine Beach at Miho*, second half of 15th to first half of 16th century, set of six hanging scrolls (originally a screen), ink and gold on paper, 154.5×54.5–59.0 cm (each), Egawa Museum of Art, Hyogo prefecture.

Fig. 31: Kanō Motonobu, *Birds and Flowers of the Four Seasons* (two panels), first half of 16th century, set of eight hanging scrolls (originally eight sliding-door panels), ink and color on paper, 174.5×139.5 cm (each), Daisen-in, Daitoku-ji, Kyoto. Image: TNM Image Archives.

Fig. 32: Detail of large jar, Shigaraki ware (Fig. 33)

Fig. 33: Large jar, 15th century, Shigaraki ware, H. 51.0 cm, D. 17.3cm, D.38.0 cm (body), D. 17.8 cm (base), Miho Museum, Shiga prefecture.

Chapter 8

Fig. 1: Kanō Eitoku, "Plum Tree with Birds" from *Birds and Flowers of the Four Seasons* sliding doors, 1566, sixteen sliding door panels, ink and gold on paper, 175.5×74.0–142.5 cm, Jukō-in, Daitoku-ji, Kyoto. Photo: Benrido.

Fig. 2: Kanō Eitoku, detail from the right screen of *Scenes in and around the Capital*, (Uesugi version), 1574, pair of six-fold screens, ink, color, gold leaf on paper, 160.5×323.5, Yonezawa City (Uesugi Museum), Yamagata prefecture

Fig. 3: Kanō Eitoku, *Chinese Lions* screen, second half of 16th century, six-fold screen, color and gold leaf on paper, 224.2×453.3 cm, Museum of the Imperial Collections (Sannomaru Shōzōkan), Tokyo.

Fig. 4: Saddle and stirrups with reed design, 1577, pigmented lacquer on wood and iron with gold *maki-e* and silver inlay, 27.8×38.0 cm (saddle), 28.0×27.0×12.0 cm (stirrups), Tokyo National Museum. Image: TNM Image Archives.

Fig. 5: Noh costume decorated with snow-covered willows and swallowtail butterflies, second half of 16th century, L. 127.3 cm, 60.6 cm (spine to cuff), Seki Kasuga shrine, Gifu prefecture. Photo: National Noh Theater.

Fig. 6: Taian, 1582–83, wood frame, gabled roof, wood shingles, and extended eaves, 2 tatami mats (tea room), 1 mat with plank border (antechamber), 1 mat (*katte* service room), Myōki-an, Kyoto prefecture. Photo: Benrido.

Fig. 7: Chōjirō, "Great Black" (Ōguro), second half of 16th century, Black Raku ware teabowl, D. 10.7 cm, private collection.

Fig. 8: Paneled door with open relief flora, 1599, wood, Main Hall, Tsukubusuma shrine (Tsukubusuma-jinja), Shiga prefecture.

Fig. 9: Hasegawa Tōhaku and his studio, detail from *Sunset Hibiscus in Pines* (affixed in alcove), c. 1592, four panels, ink, color and gold leaf on paper, 335.0×354.0 cm, Chishaku-in, Kyoto.

Fig. 10: Hasegawa Tōhaku, *Pine Forest* screens, second half of 16th century, six-fold screens, ink on paper, 156.0×347.0 cm (each), Tokyo National Museum. Image: TNM Image Archives.

Fig. 11: Kanō Mitsunobu, detail from *Flowering Trees of the Four Seasons*, 1600, ink, color and gold leaf on paper, 179.0×116.5 cm, Kangaku-in, Onjō-ji, Shiga prefecture.

Fig. 12: Kaihō Yūshō, detail from *Dragons in Clouds* screens, right screen, beginning of 17th century, pair of six-fold screens, ink on paper, 149.5×337.5 cm (each screen), Kitano Tenman-gū, Kyoto.

Fig. 13: Kanō Sanraku, *Red Plum Trees* sliding doors, first half of 17th century, ink, color and gold leaf on paper, 185.0×98.5 cm, Daikaku-ji, Kyoto.

Fig. 14: *Crows* screens, early 17th century, pair of six-fold screens, ink and gold leaf on paper, 156.3×353.8cm (each screen), Seattle Art Museum, Eugene Fuller Memorial Collection, 36.21.1. Photo: Seiji Shirono, National Research Institute for Cultural Properties, Tokyo.

Fig. 15: Keep of Hikone Castle, keep completed c. 1607, three stories with basement and entrance annex, with wood frame and tiled roof, Shiga prefecture. Photo: Hikone City Board of Education Cultural Property Section.

Fig. 16: Kanō Naizen, *Hōkoku Festival* screens, left screen, first half of 17th century, pair of six-fold screens, ink, color, and gold leaf on paper, 167.5×365.0 cm (left screen), Toyokuni shrine (Toyokuni-jinja), Kyoto.

Fig. 17: Kanō Naganobu, *Merrymaking under the Cherry Blossoms* screens, left screen, first half of 17th century, pair of six-fold screens, ink, color and gold on paper, 149.5×348.0 cm (left screen), Tokyo National Museum. Image: TNM Image Archives.

Fig. 18: *Southern Barbarians' Arrival* screens, right screen, beginning of 17th century, pair of six-fold screens, ink, color and gold leaf on paper, 155.8×334.5 cm (right screen), Museum of the Imperial Collections (Sannomaru Shōzōkan), Tokyo.

Fig. 19: *Fifteen Scenes from the Life of Mary*, first half of 17th century, ink and color on paper, 75.0×63.0 cm, Kyoto University Museum.

Fig. 20: Detail from *Westerners Playing Musical Instruments* screens, left screen, end of 16th century, pair of six-fold screens, ink, color and gold on paper, 93.0×302.5 cm (each screen), MOA Museum of Art, Shizuoka prefecture.

Fig. 21: Ennan, 19th century, wood frame, staggered windows and stove window, Yabunouchi School of Tea, Kyoto.

Fig. 22: "Broken Pouch" (Yabure-bukuro), beginning of 17th century, water jar with handles, Iga ware, H. 21.4 cm, D. 11.2 cm (rim), D. 24.0 cm (body), Gotoh Art Museum, Tokyo. Photo: Meikyo Katsuo.

Fig. 23: Campaign coat with three leaf arrowhead design, second half of 16th–first half of 17th century, dyed wool, Nakatsu Castle (Okudaira Family), Oita prefecture.

Fig. 24: Peach-shaped helmet with applied black lacquer and water buffalo horn fittings, c.1600, H. 24.5 cm (bowl), H. 62.0 cm (fitting), Fukuoka City Museum. Photo: Fujimoto Tatsuhachi.

Chapter 9

Fig. 1: Upper chamber in the grand audience hall of the Ninomaru Palace, 1624–26, single story with wood frame and hip-and-gable tiled roof, Nijō Castle, Kyoto. Photo: Moto Rikyū Nijō Castle Jimusho.

Fig. 2: Yōmeimon gate, 1636, wood frame, hip-and-gable roof with Chinese gables on façade, copper simulated tile roof, adjacent short wall (*sodebei*), Nikkō Tōshō-gū Mausoleum, Tochigi prefecture.

Fig. 3: Kanō Tanyū, *Plum Tree, Bamboo, and Birds in the Snow* sliding doors, 1634, four sliding door panels, ink, light color, and gold on paper, 191.3×135.7 cm, north wall, third chamber of the Jōrakuden hall, Nagoya Castle, Nagoya.

Fig. 4: Kanō Sanraku and Sansetsu, *Birds amid Plum Trees* sliding doors (four panels), 1631, eighteen panels, ink, color and gold leaf on paper, 184.0× 94.0 cm (each panel), north wall, second chamber, upper room, abbots quarters, Tenkyū-in, Myōshin-ji, Kyoto. Photo: Benrido.

Fig. 5: Kanō Sansetsu, *Sea Birds along a Snowy Shore* screens, detail from right screen, first half of 17th century, pair of six-fold screens, ink, color and gold leaf on paper, 154.0×358.0 cm (right screen), private collection.

Fig. 6: Kōami Chōjū, Hatsune Dowry (detail), 1637, pigmented lacquer on wood with gold and *maki-e*, Tokugawa Art Museum, Nagoya. © The Tokugawa Art Museum Image Archives/DNPartcom.

Fig. 7: *Shoin* (study), Katsura Imperial Villa, 1615–62, Kyoto. Photo: Yomiuri Shimbun.

Fig. 8: Hon'ami Kōetsu, "Rainclouds" (Amagumo), Black Raku ware teabowl, first half of 17th century, H. 8.8 cm, D. 12.3cm (rim), D. 6.1cm (foot), Mitsui Memorial Museum, Tokyo.

Fig. 9: Tawaraya Sōtatsu and Hon'ami Kōetsu, *Anthology of the Thirty-Six Poets with Crane Design*, first half of 17th century, handscroll, ink, gold and silver pigment on paper, 34.1×1460.0 cm, Kyoto National Museum.

Fig. 10: Tawaraya Sōtatsu, *Wind God and Thunder God* screens, first half of 17th century, pair of two-fold screens, ink, color and gold leaf on paper, 154.5×169.8 cm (each screen), Kennin-ji, Kyoto. Photo: Kyoto National Museum.

Fig. 11: Tawaraya Sōtatsu, *Waves at Matsushima* screens, right screen, early 17th century, ink, pair of six-fold screens, color and gold on paper, 166.0×369.9 cm (each screen), Freer Gallery of Art and Arthur M. Sackler Gallery, Smithsonian Institution, Washington, D.C.: gift of Charles Lang Freer, F.1906.231-232.

Fig. 12: *Scenes in and around the Capital* (Funaki version), detail from right screen, first half of 17th century, pair of six-fold screens, ink, color and gold leaf on paper, 162.7×342.4 cm (each screen), Tokyo National Museum. Image: TNM Image Archives.

Fig. 13: *Hikone* screen, first half of 17th century, six-fold screen, ink, color and gold leaf on paper, 94.0×48.0 cm (each panel), Hikone Castle Museum, Shiga prefecture. Photo: Hikone Castle Museum/DNPartcom.

Fig. 14: *Women of a Public Bathhouse*, mid-17th century, hanging scroll, ink, color on paper, 72.5×80.1 cm, MOA Museum of Art, Shizuoka prefecture.

Fig. 15: Iwasa Matabei, *Handscroll of the Tale of Lady Tokiwa in the Mountains*, detail from the fifth scroll, first half of 17th century, twelve handscrolls, ink, color and gold on paper, 34.1×15031.0 cm (with all 12 scrolls), MOA Museum of Art, Shizuoka prefecture.

Fig. 16: Kusumi Morikage, *Enjoying the Evening Cool under the Moonflower Trellis* screen, second half of 17th century, two-fold screen, ink and pale color on paper, 149.1×165.0 cm, Tokyo National Museum. Image: TNM Image Archives.

Fig. 17: Hanabusa Itchō, *Leading a Horse at Dawn*, second half of 17th century, hanging scroll, ink and color on paper, 30.6×52.0 cm, Seikadō Bunko Art Museum, Tokyo. Photo: Seikadō Bunko Art Museum Image Archives/DNPartcom.

Fig. 18: Lidded jar, Kakiemon style, Hizen ware (Arita kilns, Saga prefecture), 1670–1700, porcelain with overglaze polychrome enamels, H. 31 cm, D. 16.0 cm, British Museum. © The Trustees of the British Museum.

Fig. 19: Tripod dish with underglaze cobalt blue design of herons and lotus leaf (Important Cultural Property), Nabeshima ware (Ōkawachi kilns, Saga prefecture), 1690–1710, D. 28.0 cm, H. 8.5 cm, F/B. 17.5cm, Kyushu Ceramic Museum, Saga prefecture.

Fig. 20: Dish with butterfly, peony, and tortoiseshell design in overglaze polychrome enamels, Kokutani style, Hizen ware (Arita kilns, Saga prefecture), 1640–1660, H. 8.8 cm, D. 40.5 cm (rim), D. 21.0 cm (foot).

Fig. 21: Nonomura Ninsei, tea jar with polychrome overglaze enamel design of Yoshino mountains, second half of 17th century, stoneware, H. 35.7 cm, Fukuoka City Museum (Matsunaga Collection). Photo: Yamazaki Shinichi.

Fig. 22: Ogata Kenzan, foliate bowl with overglaze polychrome enamel design of maple leaves in the Tatsuta river, 18th century, stoneware, H. 19.2 cm, D. 12.5 cm (rim), D. 7.5 cm (foot), Idemitsu Museum of Arts, Tokyo.

Fig. 23: *Kosode* with mandarin ducks on a black figured satin ground, 17th century, L. 161.0 cm, 63.6 cm (spine to cuff), Tokyo National Museum. Image: TNM Image Archives.

Fig. 24: Enkū, Dragon King Zennyo, 1690, wood, H. 158.2 cm, Seihō-ji, Gifu prefecture. Photo: Hirose Tatsuro, *Geijutsu Shincho*; Shinchosha Company.

Fig. 25: Enkū, Zenzai Dōji (Sudhana), 1690, wood, H. 157.1 cm, Seihō-ji, Gifu prefecture. Photo: Hirose Tatsuro, *Geijutsu Shincho*; Shinchosha Company.

Fig. 26: Hishikawa Moronobu, "Entertainers in a House of Assignation" from the series *Aspects of the Yoshiwara*, 1681–84, set of twelve sheets, monochrome

woodblock print on paper, 23.2×38.1 cm (horizontal ōban size), Tokyo National Museum. Image: TNM Image Archives.

Fig. 27: Ogata Kōrin, *Red and White Plum Blossoms* screens, first half of 18th century, pair of two-fold screens, ink, color, gold and silver leaf on paper, 156.0×173.0 cm (each screen), MOA Museum of Art, Shizuoka prefecture.

Fig. 28: Ogata Kōrin, *Irises* screens, detail from right screen, first half of 18th century, pair of six-fold screens, color and gold leaf on paper, 151.2×360.7 cm (each screen), Nezu Museum, Tokyo.

Fig. 29: Shōun Genkei, Seated Arhat, one of Five Hundred Arhats, c. 1695, wood with color, H. c. 85.0 cm, Gohyaku Rakan-ji, Tokyo.

Fig. 30: Ogawa Haritsu, Writing box, 1746, wood with brown lacquer, earthenware, ivory and shell, H. 5.0 cm, D. 25.0 cm, Victoria and Albert Museum © Victoria and Albert Museum, London.

Fig. 31: Hakogi House, second half of Muromachi period, wood frame, hip-and-gable thatched roof, Kobe, Hyogo prefecture.

Fig. 32: Ikeno Taiga, "Gathering at Longshan" from *Gathering at Longshan, Winding Stream at Lanting* (Important Cultural Property), 1763, a pair of six-fold screens, ink and light color on paper, 158.0×358.0 cm ("Gathering at Longshan" screen), Shizuoka Prefectural Museum of Art.

Fig. 33: Yosa Buson, *Snow-Clad Houses in the Night*, second half of 18th century, hanging scroll, ink and light color on paper, 28.0×129.5 cm, private collection.

Fig. 34: Maruyama Ōkyo, *Screens with Snow-Covered Pines*, right screen, pair of six-fold screens, second half of 18th century, ink and gold on paper, 155.5×362.0 cm (each screen), Mitsui Memorial Museum, Tokyo.

Fig. 35: Maruyama Ōkyo, detail from *Album of Sketches: Insects*, 1776, ink and light color on paper, 26.5×19.3 cm, Tokyo National Museum. Image: TNM Image Archives.

Fig. 36: Hakuin, *Daruma*, mid-18th century, hanging scroll, ink on paper, 130.8×56.4 cm, Eisei-Bunko Museum, Tokyo.

Fig. 37: Itō Jakuchū, "Chrysanthemums and Stream" from the series *Colorful Realm of Living Beings*, c. 1766, thirty hanging scrolls, color on silk, 142.8×79.1 cm, Museum of the Imperial Collections (Sannomaru Shōzōkan).

Fig. 38: Itō Jakuchū, *Birds, Animals, Flowers, and Plants* screens, second half of 18th century, pair of six-fold screens, color on paper, 167.0×376.0 cm (each screen), Etsuko and Joe Price Collection. Photo: Kyoto National Museum.

Fig. 39: Soga Shōhaku, *Chinese Lions*, right scroll, c. 1765, hanging scrolls (diptych), ink on paper, 225.0×245.3 cm, Chōden-ji, Mie prefecture.

Fig. 40: Soga Shōhaku, *The Four Sages of Mount Shang*, right screen, c. 1768, pair of six-panel folding screens, ink and gold on paper, 154.5×361.4 cm,

Museum of Fine Arts, Boston. Photograph © 2018 Museum of Fine Arts, Boston.

Fig. 41: Nagasawa Rosetsu, *Sliding Doors with Tiger* (four panels), c. 1786–87, six sliding door panels, ink on paper, 183.5×115.5 cm, Muryō-ji, Wakayama prefecture.

Fig. 42: Torii Kiyomasu, *Courtesan with a Bird and an Attendant Holding a Cage*, 18th century, hand-colored monochrome woodblock print on paper, 54.0×31.5 cm (ōōban size), Tokyo National Museum. Image: TNM Image Archives.

Fig. 43: Suzuki Harunobu, *Firefly Hunting*, mid-18th century, color woodblock print on paper, 27.9×21.0 cm (chūban size), Hiraki Ukiyo-e Foundation, Tokyo.

Fig. 44: Torii Kiyonaga, *Evening Cool on the Banks of the Sumida River*, left print, second half of 18th century, color woodblock prints (diptych), 39.0×25.6 cm (ōban size), Hiraki Ukiyo-e Foundation, Tokyo.

Fig. 45: Kitagawa Utamaro, *Picture Book: Selected Insects*, 1788, set of two color woodblock printed books on paper, 27.0×18.5 cm (cover), British Museum. © The Trustees of the British Museum.

Fig. 46: Kitagawa Utamaro, "Deeply Hidden Love" from the series *Anthology of Poems: The Love Section*, first half of 1790s, color woodblock print on paper, 39.0×26.1 cm (ōban size), Tokyo National Museum. Image: TNM Image Archives.

Fig. 47: Tōshūsai Sharaku, *Sawamura Sōjūrō III as Ōgishi Kurando*, 1794, color woodblock print on paper, 36.1×24.5 cm (ōban size), British Museum. © The Trustees of the British Museum.

Fig. 48: Urakami Gyokudō, *Snow Sifted through Frozen Clouds*, beginning of 19th century, hanging scroll, ink and light color on paper, 133.5×56.2 cm, Kawabata Yasunari Foundation, Kamakura, Kanagawa prefecture. Photo: Museum of Modern Japanese Literature.

Fig. 49: Watanabe Kazan, Study No. 2 for *Portrait of Satō Issai*, c. 1818–21, ink and light color on paper, 39.0×18.8 cm, private collection.

Fig. 50: Satake Shozan, *Exotic Bird in a Pine*, 1770s, hanging scroll, ink and color on silk, 173.0×58.0 cm, private collection.

Fig. 51: Shiba Kōkan, *A View of Mimeguri Shrine from the Sumida River*, 1783, hand-colored copperplate print on paper, 26.7×38.8 cm, Kobe City Museum, Hyogo prefecture. Photo: Kobe City Museum/DNPartcom.

Fig. 52: Sakai Hōitsu, *Screens with Summer and Autumn Grasses*, c. 1821–22, pair of two-fold screens, ink, color and silver leaf on paper, 164.5×182.0 cm (each screen), Tokyo National Museum. Image: TNM Image Archives.

Fig. 53: Katsushika Hokusai, "Plump Men and Women," from *Hokusai Manga*, eighth volume, 1817, fifteen volumes (1814–78), color woodblock printed

books on paper, 22.7×15.7 cm (cover), Hagi Uragami Museum, Yamaguchi prefecture.

Fig. 54: Katsushika Hokusai, "Under the Wave off Kanagawa" from the series *Thirty-Six Views of Mount Fuji*, c. 1830–32, color woodblock print on paper, 25.4×38.1 cm (ōban size), The Howard Mansfield Collection, Purchase, Rogers Fund, 1936 (JP2569), Metropolitan Museum of Art © The Metropolitan Museum of Art. Image: Art Resource, NY.

Fig. 55: Utagawa Hiroshige, "Evening Snow at Kanbara" from the series *Fifty-Three Stations of the Tōkaidō*, c. 1833–34, color woodblock print on paper, 22.6×35.3 cm (ōban size), Chiba City Museum of Art.

Fig. 56: Utakagawa Kuniyoshi, *The Spirit of Retired Emperor Sanuki Sends Allies to Rescue Tametomo*, c. 1850, color woodblock prints (triptych) on paper, 35.8×24.5 cm (ōban size, each sheet), Kanagawa Prefectural Museum of Cultural History.

Fig. 57: Hara Yōyūsai, *inrō* with design of squid, shells, and seaweed, early 19th century, wood with black lacquer, color, *maki-e*, mother-of-pearl and gold inlay (*inrō*), ivory carved with abstract design (*ojime* fastener), ivory carved in the shape of a crab (*netsuke* toggle), 8.3×5.1cm (*inrō*), Rogers Fund, 1913 (13.67.22), Metropolitan Museum of Art © The Metropolitan Museum of Art. Image: Art Resource, NY.

Fig. 58: Three-story pagoda, 1712, wood frame, copper-shingle roof, 3×3 bay, Narita-san Shinshō-ji, Chiba prefecture. Photo: PIXTA.

Fig. 59: Inner Palace (Okuden) of the Shōden Hall, mid-18th century, wood frame, hip-and-gable copper shingle roof, 3×3 bay, Menuma Shōdenzan Kangi-in, Saitama prefecture. Photo: Iida Photo Studio.

Fig. 60: Entsū Sansō-dō, 1796, hexagonal structure with wood frame and double-helix staircase, copper shingle roof, former Shōsō-ji, Fukushima prefecture.

Fig. 61: Mokujiki Myōman, Subhinda (right) and Nakula (left) from Sixteen Arhats, 1806, wood, 69.0–71.5 cm, Seigen-ji, Kyoto.

Fig. 62: Sengai, *Hotei Pointing at the Moon*, first half of 19th century, hanging scroll, ink on paper, 54.0×60.4 cm, Idemitsu Museum of Arts, Tokyo.

Fig. 63: Ryōkan, *Iroha Poem*, 1826–31, pair of hanging scrolls, ink on paper, 106.1×43.2 cm, private collection. Photo: Geijutsu Shinbunsha.

Chapter 10

Fig. 1: Takahashi Yuichi, *Courtesan*, c. 1872, oil on canvas, 77.0×54.8 cm, University Art Museum, Tokyo University of the Arts.

Fig. 2: Takahashi Yuichi, *Tofu*, 1877, oil on canvas, 32.5×45.3 cm, Kotohira-gū shrine, Kagawa prefecture.

Fig. 3: Utagawa Hiroshige III, *First Domestic Industrial Exposition Art Museum*, 1877, color woodblock print on paper, 24.6×36.2 cm, 1877, Kobe City

Museum, Hyogo prefecture. Photo: Kobe City Museum/DNPartcom.

Fig. 4: Hyakutake Kaneyuki, *Reclining Nude*, c. 1881, oil on canvas, 97.3×188.0 cm, Bridgestone Museum of Art, Ishibashi Foundation, Tokyo.

Fig. 5: Kanō Hōgai, *Merciful Mother Kannon*, 1883, hanging scroll, ink, color and gold on silk, 163.9×84.6 cm, Freer Gallery of Art and Arthur M. Sackler Gallery, Smithsonian Institution, Washington, D.C.: gift of Charles Lang Freer, F1902.225.

Fig. 6: Kanō Hōgai, *Ni-ō Capturing a Demon*, 1886, hanging scroll, ink, color and gold on paper, 123.5×62.7 cm, National Museum of Modern Art, Tokyo. Photo: MOMAT/DNPartcom. Photo: © Ueno Norihiro.

Fig. 7: Maeda Seison, *Chinese Lions* screens, 1935, pair of six-fold screens, ink, color and gold on paper; each 202.5×434.0 cm, Museum of the Imperial Collections (Sannomaru Shōzōkan), Tokyo.

Fig. 8: Yamamoto Hōsui, *Urashima*, 1893–95, oil on canvas, 121.8×167.9 cm, Museum of Fine Arts, Gifu.

Fig. 9: Kawamura Kiyoo, *Ceremonial Robes Preserved as Keepsakes* (*Airing of Robes*), after 1899, oil on canvas, 109.0×173.0 cm, Tokyo National Museum. Image: TNM Image Archives.

Fig. 10: Kawanabe Kyōsai, *Frogs Triumphing over a Snake and Lizards*, c. 1879, ink and color on paper, 37.0×53.0 cm, British Museum © The Trustees of the British Museum.

Fig. 11: Kobayashi Kiyochika, "View of Takanawa Ushimachi under a Shrouded Moon," from the series *Famous Places of Tokyo*, 1879, color woodblock print on paper, 24.6×36.2 cm (ōban size), Shizuoka Prefectural Museum of Art.

Fig. 12: Vincenzo Ragusa, *Japanese Woman*, c. 1891, bronze, H. 62.0 cm, University Art Museum, Tokyo University of the Arts.

Fig. 13: Former Glover residence, 1863, single story with wood frame, Nagasaki, Nagasaki prefecture.

Fig. 14: Former Saiseikan Hospital building, 1879, single story with wood frame and step tower, Yamagata, Yamagata prefecture. Photo: Yamagata City Board of Education.

Fig. 15: Former Kaichi School, designed by Tateishi Seijū, 1876, two stories with step tower, wood frame, Matsumoto, Nagano prefecture. Photo: Kaichi Gakkō Kanri Jimusho.

Fig. 16: Entrance porch of former Kaichi School, detail of Fig. 15.

Fig. 17: Former residence of Iwasaki Hisaya, designed by Josiah Conder, 1896, two stories with basement, wood frame and copper shingle roof, Tokyo. Photo: Tokyo-to Koen Kyōkai.

Fig. 18: Headquarters for the Bank of Japan, designed by Tatsuno Kingo, 1896, three stories with basement and dome, brick-masonry, Tokyo. Photo: The

Bank of Japan.

Fig. 19: Nagasawa Naganobu I, white vase decorated with basket weave effect and birds and flowers in high relief, c. 1877, porcelain, H. 58.5 cm, D. 32.3 cm (maximum), National Museum of Modern Art, Tokyo.

Fig. 20: Suzuki Chōkichi, one of the Twelve Hawks, 1893, cast in bronze, gold, and silver, National Museum of Modern Art, Tokyo.

Fig. 21: Miyagawa Kōzan, bowl in brown glaze with applied crabs, 1881, stoneware, H. 36.5 cm, D. 39.8 cm (mouth), D. 16.5 cm (base), Tokyo National Museum. Image: TNM Image Archives.

Fig. 22: Andō Rokuzan, *Persimmons*, 1920, dyed ivory, 12.9×27.7×22.4 cm, Museum of the Imperial Collections (Sannomaru Shōzōkan), Tokyo.

Fig. 23: Itaya Hazan, vase with auspicious flowers and peach sprays, c. 1925, porcelain, H. 29.3 cm, W. 23.0 cm, H. 4.5 cm (stand), W. 14.0 cm (stand), British Museum. © The Trustees of the British Museum, acquisition supported by the Brooke Sewell Bequest and the Art Fund.

Fig. 24: Kuroda Seiki, *Maiko*, 1893, oil on canvas, 81.0×65.2 cm, Tokyo National Museum Image: TNM Image Archives.

Fig. 25: Kuroda Seiki, *Lakeside*, 1897, oil on canvas, 69.0×84.7 cm, National Research Institute for Cultural Properties, Tokyo. Photo: Shirono Seiji.

Fig. 26: Kuroda Seiki, *Wisdom, Impression, Sentiment*, 1899, oil on canvas, 180.6×99.8 cm (each), National Research Institute for Cultural Properties, Tokyo. Photo: Shirono Seiji.

Fig. 27: Nakagawa Hachirō, *Farmers Returning in Snowy Woods*, 1897, charcoal on paper, 99.0×146.8 cm, private collection.

Fig. 28: Fujishima Takeji, *Butterflies*, 1904, oil on canvas, 44.5×44.5 cm, private collection.

Fig. 29: Aoki Shigeru, *Fruits of the Sea*, 1904, oil on canvas, 70.2×182.0 cm, Bridgestone Museum of Art, Ishibashi Foundation, Tokyo.

Fig. 30: Hishida Shunsō, *Fallen Leaves*, 1909, pair of six-fold screens, ink and color on paper, 157.0×362.0 cm (each screen), Eisei-Bunko Museum, Tokyo.

Fig. 31: Tomioka Tessai, *Two Divinities Dancing*, 1924, hanging scroll, ink and color on silk, 168.8×85.5 cm, Tokyo National Museum. Image: TNM Image Archives.

Fig. 32: Takeuchi Seihō, *Historic Spots of Rome*, 1903, pair of six-fold screens, ink and color on silk, 145.0×374.6 cm (each screen), Umi-Mori Art Museum, Hiroshima prefecture.

Fig. 33: Itō Chūta, "Chengdu, Sichuan Province" (November 8, 1902), from *Itō Chūta kenbun yachō: Shin koku III* (*Itō Chūta's Field Notes: Qing, Vol. III*), Architectural Institute of Japan, Tokyo; reproduced from *Itō Chūta kenbun yachō: Shin koku*, Vol. 2, Tokyo: Kashiwa Shobō, 1990, p. 48.

Fig. 34: Yorozu Tetsugorō, *Nude Beauty*, 1912, oil on canvas, 162.0×97.0 cm,

National Museum of Modern Art, Tokyo. Photo: MOMAT/DNPartcom. Photo: © Ueno Norihiro.

Fig. 35: Sekine Shōji, *Sorrow of Faith*, 1918, oil on canvas, 73.0×100.0cm, Ohara Museum of Art, Okayama prefecture.

Fig. 36: Kishida Ryūsei, *Dry Road in Winter* (*Sketched in the Vicinity of Harajuku, Sun on Red Soil and Grass*), 1916, oil on canvas, 60.5×80.2cm, The Niigata Prefectural Museum of Modern Art/The Niigata Bandaijima Art Museum.

Fig. 37: Kishida Ryūsei, *Natural Girl* (*Yadōjo*), 1922, oil on canvas; 64.0×52.0cm, entrusted to the Museum of Modern Art, Kamakura & Hayama.

Fig. 38: Nakamura Tsune, *Portrait of Vasilii Yaroshenko*, 1920, oil on canvas, 47.2×45.5 cm, National Museum of Modern Art, Tokyo. Photo: MOMAT/DNPartcom.

Fig. 39: Takehisa Yumeji, *Suichikukyo* (Dwelling amidst Water and Bamboo), 1933, ink and color on paper, 79.0×50.0 cm, Takehisa Yumeji Museum, Tokyo.

Fig. 40: Onchi Kōshirō, *Portrait of the Author of "Hyōtō"* (*Hagiwara Sakutarō*), 1943, color woodblock print on paper, 52.7×42.5 cm, National Museum of Modern Art, Tokyo.

Fig. 41: Ogiwara Morie, *Woman*, 1910, bronze, 98.5×47.0×61.0 cm, National Museum of Modern Art, Tokyo. Photo: MOMAT/DNPartcom.

Fig. 42: Takamura Kōtarō, *Hand*, 1918, bronze, 30.0×28.7×15.2 cm, Kure Municipal Museum of Art, Hiroshima prefecture.

Fig. 43: Horiguchi Sutemi, Shiensō 1926, formerly in Warabi, Saitama prefecture, no longer extant; reproduced from Bunriha Kenchiku Kai, ed., *Shiensō zushū*, Tokyo: Kōyōsha, 1927.

Fig. 44: Yasui Sōtarō, *Landscape at Sotobō*, 1931, oil on canvas, 20.2×69.4 cm, Ohara Museum of Art, Okayama prefecture.

Fig. 45: Umehara Ryūzaburō, *Autumn Sky over Beijing*, 1942, oil and mineral pigments on paper, 88.5×72.5 cm, National Museum of Modern Art, Tokyo. Photo: MOMAT/DNPartcom.

Fig. 46: Foujita Tsuguharu, *Spanish Beauty*, oil on canvas, 76.0×63.5 cm, 1949, Toyota Municipal Museum of Art © Fondation Foujita/ADAGP, Paris & JASPAR, Tokyo, 2018 E3000.

Fig. 47: Koide Narashige, *Female Nude on Chinese Bed* (*Female Nude* A), 1930, oil on canvas, 80.0×116.0 cm, Ohara Museum of Art, Okayama prefecture.

Fig. 48: Saeki Yūzō, *Gas Street Lamp and Advertisements*, 1927, oil on canvas, 65.0×100.0 cm, National Museum of Modern Art, Tokyo. Photo: MOMAT/DNPartcom. Photo: © Ueno Norihiro.

Fig. 49: Yokoyama Taikan, *Cherry Blossoms at Night*, left screen, 1929, pair of six-fold screens, ink and color on paper, 177.5×376.8 cm, Okura Museum of

Art, Tokyo.

Fig. 50: Yasuda Yukihiko, *God of Wind and God of Thunder*, 1929, pair of two-fold screens, ink and color on paper, 177.2×190.5 cm (each screen), Tōyama Memorial Museum, Saitama prefecture.

Fig. 51: Kobayashi Kokei, *Hair*, 1931, ink and color on silk, 172.4×107.4 cm, Eisei-Bunko Museum, Tokyo.

Fig. 52: Hayami Gyoshū, *Dancing in the Flames*, Important Cultural Property, 1925, ink and color on silk, 120.4×53.7 cm, Yamatane Museum of Art, Tokyo.

Fig. 53: Murakami Kagaku, *Calm Winter Mountain*, 1934, ink and color on paper, 44.1×62.9 cm, National Museum of Modern Art, Kyoto. Photo: The National Museum of Modern Art, Kyoto.

Fig. 54: Uemura Shōen, *Noh Dance Prelude*, 1936, hanging scroll, color on silk, 233.0×141.3 cm, University Art Museum, Tokyo University of the Arts.

Fig. 55: Kaburaki Kiyokata, *Ichiyō*, 1940, hanging scroll, ink and color on paper, 143.5×79.5 cm, University Art Museum, Tokyo University of the Arts.

Fig. 56: Kawai Gyokudō, *Evening in the Mountains*, 1935, hanging scroll, ink and color on silk, 76.3×102.7 cm, private collection.

Fig. 57: Fukuda Heihachirō, *Rain*, 1953, ink and color on paper, National Museum of Modern Art, Tokyo. Photo: MOMAT/DNPartcom. Photo: © Handa Kyūseidō.

Fig. 58: Murayama Tomoyoshi, *Construction*, 1925, oil paint on wood, paper, cloth and metal, 84.0×112.5 cm, National Museum of Modern Art, Tokyo. Photo: MOMAT/DNPartcom. Photo: © Ueno Norihiro.

Fig. 59: Koga Harue, *Sea*, 1929, oil on canvas, 130.0×162.5 cm, National Museum of Modern Art, Tokyo. Photo: MOMAT/DNPartcom. Photo: © Ueno Norihiro.

Fig. 60: Yasaki Hironobu, *Industrial Zone, Kōtō Ward*, 1936, oil on canvas, 97.0×130.3 cm, Chino City Museum of Art, Nagano prefecture.

Fig. 61: Okamoto Tarō, *Wounded Arm*, originally painted 1936, original lost to fire, repainted by the artist in 1949, oil on canvas, 124.0×162.0 cm, Taro Okamoto Museum of Art, Kanagawa prefecture.

Fig. 62: Foujita Tsuguharu, *Shattered Jewels of Attu Island*, 1943, oil on canvas, 193.5×259.5 cm, on indefinite loan to the National Museum of Modern Art, Tokyo. © Fondation Foujita/ADAGP, Paris & JASPAR, Tokyo, 2018 E3000. Photo: MOMAT/DNPartcom.

Fig. 63: Aimitsu, *Landscape with an Eye*, 1938, oil on canvas,102.0×193.5 cm, National Museum of Modern Art, Tokyo. Photo: MOMAT/DNPartcom.

Fig. 64: Matsumoto Shunsuke, *Bridge in Town Y*, 1943, oil on canvas, 61.0×73.0 cm, National Museum of Modern Art, Tokyo. Photo: MOMAT/DNPartcom.

Fig. 65: Ube City Watanabe-ō Memorial Hall, 1937, designed by Murano Tōgo,

Yamaguchi prefecture.

Fig. 66: Tsuruoka Masao, *Heavy Hand*, 1949, oil on canvas, 130.0×97.0 cm, Museum of Contemporary Art, Tokyo. Photo: Tokyo Metropolitan Foundation for History and Culture Image Archives.

Fig. 67: Kazuki Yasuo, *Black Sun*, 1961, oil on ramie, 116.7×72.8 cm, Yamaguchi Prefectural Art Museum.

Fig. 68: Miyazaki Shin, *Landscape of the Drifting Heart*, 1994, mixed media, 324.0×227.3 cm, Yokohama Museum of Art

Fig. 69: Higashiyama Kaii, *Road*, 1950, ink and color on silk, 134.4×102.2 cm, National Museum of Modern Art, Tokyo. Photo: MOMAT/DNPartcom. Photo: © Ōtani Ichirō.

Fig. 70: Munakata Shikō, "Joshin" (Goddess) from the series *Kegonpu* (Record of the Kegon Sutra), 1937, monochrome woodblock print, 53.0×72.5 cm, British Museum. © The Trustees of the British Museum.

Fig. 71: Inoue Yūichi, *Foolishly Adamant (Gutetsu)*, 1956, ink on paper, 187.0×176.0 cm, National Museum of Art, Osaka.

Fig. 72: Hibino Gohō, *Iroha Poem*, 1963, six-fold screen, ink on paper, 153.0×363.0 cm, Tokyo National Museum. Image: TNM Image Archives.

Fig. 73: Takamatsu Jirō, *Shadow of the Baby No. 122*, 1965, synthetic lacquer on canvas, 182.0×227.0 cm, Toyota Municipal Museum of Art, Aichi prefecture. © The Estate of Jirō Takamatsu, Courtesy of Yumiko Chiba Associates.

Fig. 74: Lee Ufan, *Relatum: Silence*, 1979/2005, iron plate, stone, Museum of Modern Art, Kamakura & Hayama.

Fig. 75: Tezuka Osamu, *Metropolis*, 1949. © Tezuka Productions.

Fig. 76: Chiba Tetsuya, *Tomorrow's Joe (Ashita no Jō)*. © Takamori Asao/Chiba Tetsuya/Kodansha.

Fig. 77: Ōtomo Katsuhiro, *Akira*, 1982–90. © Ōtomo Katsuhiro/Mushroom/Kodansha.

Fig. 78: Hagio Moto, *The Poe Family*, 1972–76. © Hagio Moto/Shogakukan.

Fig. 79: *Spirited Away*, 2001, directed by Miyazaki Hayao © 2001 Studio Ghibli・NDDTM.

Fig. 80: Satō Tetsuzo, *Sleet*, 1952–53, oil on canvas, 60.3×133.0 cm, entrusted to the Museum of Modern Art, Kamakura & Hayama.

Fig. 81: Yasui Nakaji, *Wandering Jew (Child)*, 1941, private collection. Photo: Shoto Museum of Art, Shibuya, Tokyo.

Fig. 82: Domon Ken, from *The Children of Chikuhō*, 1960, Ken Domon Museum of Photography, Yamagata prefecture.

Fig. 83: Komatsu Hitoshi, *Snow Wall*, 1964, ink and color on paper, 220.0×172.0 cm, Kyoto Municipal Museum of Art.

Fig. 84: Yokoo Tadanori, *Moat*, 1966, acrylic on canvas, 45.5×53.0 cm, Tokushima

Modern Art Museum.

Fig. 85: Murakami Takashi, *Tan Tan Bo Puking - a.k.a. Gero Tan*, 2002, acrylic on canvas, mounted on board, 36.0×72.0×77.0 cm, Courtesy Galerie Emmanuel Perrotin © 2002 Takashi Murakami/Kaikai Kiki Co., Ltd. All Rights Reserved.

Fig. 86: Yagi Kazuo, *Mr. Samsa's Walk*, 1954, stoneware, 27.5×27.0×14.0 cm, private collection.

Index

Abe Nobuya 阿部展也 (painter);
Starvation (Ue 飢え) 452

Académie Julian (Paris) 402, 425

academism: Western/European 387, 397,
402, 403, 404, 413, 425; Japanese 407

Action (artist group) 439

actor prints (yakusha-e 役者絵) 355,
359; Grafitti on the Storehouse Wall
(Nitakaragura Kabe no Mudagaki 荷宝
蔵壁のむだ書; Utagawa Kuniyoshi
歌川国芳) 363; Katsukawa Shun'ei
勝川春英 353; Katsukawa Shunchō
勝川春潮 353; Katsukawa Shunshō
勝川春章 351; Sawamura Sōjūrō III as
Ōgishi Kurando (Sandai-me Sawamura
Sōjūrō no Ōgishi Kurando 三代目沢村
宗十郎の大岸蔵人; Tōshūsai Sharaku
東洲斎写楽) 355; Torii Kiyonobu
鳥居清信 348; Torii Kiyomasu I 鳥居
清倍 348; Tōshūsai Sharaku 東洲斎
写楽 354–55; Utagawa Toyokuni I
歌川豊国 (初代) 360 (see also kabuki)

Admonitions Scroll (Joshishin zukan 女史
箴図巻) 431

adornment (see kazari)

aesthetics 18, 21, 22, 26, 29; Jōmon 縄文
30; Yayoi 弥生 29

Aesthetics of Ink (see Bokubi)

Afterglow (Higashiyama Kaii) 453

Aichi Prefecture Government Office
(Aichi Kenchō 愛知県庁; Nishimura
Yoshitoki and Watanabe Hitoshi) 448

Aimitsu 靉光 (Aikawa Mitsurō 靉川光郎;
painter) 444; Bird (Tori 鳥) 444;
Landscape with an Eye (Me no aru
fūkei 眼のある風景) 444

Ainu アイヌ 365

Airport (Kitawaki Noboru) 441

Aka Fudō 赤不動 (Red Fudō or Fudō
Myō-ō Ni Dōji-zō 不動明王二童子像;
Myō-ō-in, Mt. Kōya 高野山明王院)

hanging scroll 124

Akamatsu Rinsaku 赤松麟作 (painter)
403; Night Train (Yogisha 夜汽車) 403

Akasaka Palace (Akasaka Rikyū 赤坂離宮;
Tokyo; Katayama Tōkuma) 395

Akasegawa Genpei 赤瀬川原平 462–63;
Model Thousand-Yen Notes (Mosha
sen-en satsu 模写千円札) 463

Akira (Ōtomo Katsuhiro) 469–70

Akita Ranga 秋田蘭画 (Akita Western-style
painting) 358; Odano Naotake 小田野
直武 358; Satake Shozan 佐竹曙山
358

Akiyama Terukazu 秋山光和 146

American Beaux-Arts style (architecture)
412–13

Amida and Twenty-Five Bosatsu (Amida
Nijūgo-Bosatsu Raigō-zu 阿弥陀二十五
菩薩来迎図 or Haya Raigō 早来迎;
Chion-in 知恩院) hanging scroll
209–10

Amida hall (Amida-dō 阿弥陀堂) 175:
Chūson-ji 中尊寺 175–76; Ganjō-ji
願成寺 (Shiramizu Amida-dō 白水
阿弥陀堂, Fukushima prefecture) 177;
Hōkai-ji 法界寺 178; Hosshō-ji 法勝寺
152; Kanjizaiō-in 観自在王院 177;
Kōzō-ji 高蔵寺 (Miyagi prefecture) 177

Amida Nyorai 阿弥陀如来 125–126, 128
(see also Amida): Byōdō-in 平等院
132–33; Ganjōju-in 願成就院
194–95; Gansen-ji 岩船寺 (Kyoto) 131;
Hōkai-ji 法界寺 (Chōsei 長勢) 134,
178; Hosshō-ji 法勝寺 152; Jōruri-ji
浄瑠璃寺 177–78

Amida Triad (Amida Sanzon 阿弥陀
三尊; Fuetsu 普悦; Southern Song;
Shōjōke-in 清浄華院, Kyoto) hanging
scrolls 174

Amida Triad with Banner-Bearing Youths
(Amida Sanzon oyobi Jiban Dōji

阿弥陀三尊及び持幡童子像; Hokke-ji 法華寺) hanging scrolls 157

Amida Triad 阿弥陀三尊 Chōgaku-ji 長岳寺 **179**, 193; Hōryū-ji 法隆寺 58; Jōraku-ji 浄楽寺 (Unkei 運慶; Wada Yoshimori 和田義盛) 194; Kunwi grotto 軍威石窟 59; Lady Tachibana's private devotional shrine 橘夫人念持仏厨子 57–58; Sanzen-in 三千院 177

Amida 阿弥陀 (Amitabha) 64, 66, 191, 215–16; chanting the name of 126–27, 189; descent (raigō 来迎) 157–**58**, 135, 137, 200, 209–11; *Descent of Amida* (阿弥陀聖衆来迎図; Mt. Kōya 高野山) 157; Great Buddha (Daibutsu 大仏; Kamakura) 203; images 127; Nine Figures of Amida (Kutai Amida 九体阿弥陀; sculpture) 131, 177, 178; Pure Land of 浄土 64, 83, 126, 181, 198, 206; *Triptych* 246

Amitabha Preaching (Amida Seppō-zu 阿弥陀説法図; mural painting; Dunhuang) 64

Amogha (Amoghavajra, Fukū Kongō 不空金剛; monk) 96, 105

An'ami style (An'ami yō 安阿弥様) 200; Kaikei 快慶 200

An'na Incident 安和の変 94, 119

anagama 窖窯 (tunnel-shaped kilns) 242

Anchi 安知 (*see* Chōyōdō Anchi)

Ancient Temples and Shrines Preservation Law (*see* Koshaji Hozon Hō 古社寺保存法)

Andō Rokuzan 安藤緑山 (ivory artist) 397; *Persimmons* (Kaki okimono 柿置物) **397**

Andō Seikū 安東聖空 (calligrapher) 459

Andō Tadao 安藤忠雄 (architect) 465, 466; Rokkō Housing (Rokkō no shūgō-jūtaku 六甲の集合住宅; Hyogo prefecture) 465; Kitakyūshū Municipal Museum of Art (Kitakyūshū Shiritsu Bijutsukan 北九州市立美術館;

Fukuoka prefecture; Isozaki Arata) 465

animals/beasts 動物 26, 29, 377; architectural decoration 291; *Birds, Animals, Flowers, and Plants* screens (Chōjū Kaboku-zu byōbu 鳥獣花木図屏風; Itō Jakuchū 伊藤若冲) 344, **346**, 475; Buddhist sins 170, 206; Chinese painting 220, 253; *dogū* 土偶 14; glue (*nikawa*) 膠 350, 426; Hōjō-e 放生会 (Buddhist ceremony) 117; *haniwa* 埴輪 34, 36; horn 365; Jōmon pots 7; *jizai* 自在 365; *maki-e* 蒔絵 89; pictorial depiction of 38, 157, 167, 214, 311, 355, 441, 467; *chikushō* 畜生 (*rokudō* 六道) 169; sacred 28, 30, 32, 41; sculpture 390; *Scrolls of Frolicking Animals* (Chōjū Jinbutsu Giga 鳥獣人物戯画) 166, **168**, 467

anime (animation) 466, 469, 472: anime-inspired paintings 477; basic elements of 167; *Twelfth-Century Animation* 471

animism xv, xxvi, 114, 151, 344, 455, 464, 466, 469, 476

Annotations of the Sutra of Immeasurable Life (Kanmuryōju-kyō sho 観無量寿経疏; Shandao 善導) 206

Anthology of Poems: The Love Section (Kasen Koi no Bu Fukaku Shinobu Koi 歌撰恋之部 深く忍恋; woodblock print; Kitagawa Utamaro 喜多川歌麿) 353

Anthology of Thirty-Six Poets (Sanjūrokunin Kashū 三十六人家集) 144, 154, 160, 161, 162

Anti-Residential Appliance (Hokkaido; Mozuna Kikō) 465

Aōdō Denzen 亜欧堂田善 358; copperplate prints (*dōbanga* 銅版画) 358; *Famous Places in the Eastern Capital* (Tōto Meisho-zu 東都名所図) 358

Aoki Shigeru 青木繁 (painter) 398, 405, 416; *Escape from the Land of the Dead* (Yomotsu-hirasaka 黄泉比良坂) 405; *Fruits of the Sea* (Umi no sachi 海の幸)

405, **406**, 444; *Paradise under the Sea
(Wadatsumi no Iroko no Miya
わだつみのいろこの宮), Tenpyō Era
(Tenpyō jidai* 天平時代) 405

Aoyagi Masanori 青柳正規 6, 34

Arakawa Shūsaku 荒川修作 454, 462, 479

arhats (*rakan* 羅漢) 138, 140–41,
257, 368; Chōnen 奝然 119, 174;
Daitoku-ji 大徳寺 260; *Five Hundred
Arhats (Gohyaku Rakan-zu* 五百羅漢;
painting) 261, 339–40; *Five Hundred
Arhats (Gohyaku Rakan* 五百羅漢;
sculpture) **334**; Gohyaku Rakan-ji
五百羅漢寺 (Tokyo) 334; Manpuku-ji
万福寺 340; Shōjuraikō-ji 聖衆来迎寺
149; *Sixteen Arhats* (Jūroku Rakan
十六羅漢; painting) 149, 260; Sixteen
Arhats (Jūroku Rakan 十六羅漢;
sculpture) 119, 174, 370

Ariga Yoshitaka 有賀祥隆 94

Arishima Ikuma 有島生馬 (painter) 416

aristocratic culture 貴族文化 119, 180,
244, 258: aesthetics of **188**; circles 145;
residential architecture **128**

aristocratic society 貴族社会 120, 125,
126, 186, 487n21;

aristocrats 貴族 117, 160, 174, 186,
222, 223, 229, 306, 371, 466, 486n17;
Heian 平安 151, 174, 186, 248, 250;
patronage of 332

Arita 有田 kilns 324–**26**, 327; Yanbeta
山辺田 325

armor (*yoroi* 鎧) 26, **239**; braided armor
(*odoshi-yoroi* 威鎧) 239; "great armor"
(*ōyoroi* 大鎧) 239; *ōkuwagata* 大鍬形
("great stag beetle" ornament) 239;
"scale armor" (*kake-yoroi* 挂甲) 238–39

art (see *bijutsu*); *aato* アート 461–62, 464,
466, 472

Art Deco movement 422–24

art historians 美術史家 40, 41, 94, 231

art history 美術史 v, xxiv–xxvi, 2, 16, 40,
55, 329, 362, 447, 451

Art Nouveau 380, 398, 404, 422

Art of Today exhibition (Kyō no Bijutsuten
今日の美術展; 1956) 457

Asai Chū 浅井忠 (painter) 379, 380, 385,
387, 403, 425, 442: *Farmers Returning
Home* (*Nōfu kiro* 農夫帰路) 380,
Harvest (*Shūkaku* 収穫), *Vegetable
Garden in Spring* (Shunpo 春畝) 380

Asakura site 朝倉遺跡 (Gunma prefecture)
35; *haniwa* of a boy playing a zither
琴を弾く男児 **35**

Asanga 無著, 無着 (Kōfuku-ji Hokuen-dō
興福寺北円堂; Unkei 運慶) sculpture
199

ash glaze (*kaiyū* 灰釉) 185, **278**–80, 302,
487n27

ashide 葦手 ("reed-style") 239; *ashide-e*
葦手絵 (reed pictures) 159; saddle with
a design of autumn rain (*shigure raden
kura* 時雨螺鈿鞍) 239–**40**

Ashikaga shogunal collections 252–54,
266

Ashikaga Tadayoshi 足利直義: portrait
of 219

Ashikaga Takauji 足利尊氏 219, 244

Ashikaga Yoshimasa 足利義政 254, 258,
269, 270, 278, 322; Gotō Yūjō 後藤
祐乗 270; and Higashiyama villa 東山
山荘 (Jishō-ji 慈照寺 or Ginkaku-ji
銀閣寺) 265–66; and room decor
座敷飾り 268–69

Ashikaga Yoshimitsu 足利義満 153, 252,
253, 254, 258, 265; *Eight Views of the
Xiao and Xiang Rivers* (*Shōshō Hakkei*
瀟湘八景; Muqi Fachang 牧谿法常)
252; "Dōyū" seal "道有"印 252;
Rokuon-ji 鹿苑寺 (or Kinkaku-ji
金閣寺) 258–**59**; Shōkoku-ji pagoda
相国寺大塔 274; "Tenzan" seal
"天山"印 252

Ashikaga Yoshimochi 足利義持 258,
261; *Catching a Catfish with a Gourd*
(*Byōnen-zu* 瓢鮎図; Josetsu 如拙;
Myōshin-ji 妙心寺) 262, **264**

Ashikaga Yoshinori 足利義教 253, 254,

259; *Quails* 鶉図 (Li Anzhong 李安忠) 235; *Record of Decorations for the Imperial Visit to the Muromachi Palace* (*Muromachi-dono Gyōkō Okazari-ki* 室町殿行幸御錺記) 254, 258; "Zakkashitsu" seal "雑華室"印 235

Ashikaga 足利 245, 248, 265; family 262, 265; rule 244, 248, 258; shoguns 246, 254

Ashura 阿修羅 (Asura) 72, 169, 484n5; dry-lacquer statue at Kōfuku-ji 興福寺 72, **74**; clay statue at Hōryū-ji 法隆寺 72

Asia: Asia Minor 33; Central Asia 69, 86, 104; Central Asian 141; East Asia (*see* East Asia/East Asian); northern Asia 11; Southeast Asia 10, 15, 86, 301, 442–43; West Asia 71, 86

Asō Saburō 麻生三郎 (painter) 472

asobi あそび (*see* playfulness)

Aspects of the Yoshiwara (*Yoshiwara no Tei* よしはらの躰; Hishikawa Moronobu 菱川師宣) **331**

Association for Plastic Artists (*see* Zōkei Bijutsuka Kyōkai)

Association of Futurist Artists (Miraiha Bijutsu Kyōkai 未来派美術協会) 438

Astro Boy (Tezuka Osamu) 468

Asuka-dera 飛鳥寺 (Nara) **44**, 45, 47, 482n1; Great Buddha (Daibutsu 大仏) **45**

Asuka-kyō 飛鳥京 47

Asukabe no Tsunenori 飛鳥部常則 (court painter) 144, 232

Atsumi kilns 渥美窯 185, 241; jar with autumn grass motif (*Akikusa-mon tsubo* 秋草文壺) 185

Autumn Sky over Beijing (Umehara Ryūzaburō) **426**

Autumn through the Trees (Shimomura Kanzan) 408

avant-garde 438–40, 457–59

azekura 校倉造 (split log) architecture 85

Azuchi Castle 安土城 (Shiga prefecture)

153, 284, 287, 308; *Chronicles of Lord Nobunaga* (*Shinchōkō-ki* 信長公記; compiled by Ōta Gyūichi 太田牛一) 284–85; Kanō Eitoku 狩野永徳 285; Oda Nobunaga 織田信長 153, 284–85, 287

Baekje 百済 (Korea) 43–45, 59; style 45

Bai Juyi 白楽天 (poet) 149

baibaoqian (*hyappōgan* 百宝嵌) lacquer work 335

Baima Si 白馬寺 (Henan province) 42

Bakgang (Hakusukinoe 白村江), battle of 483n6

bakufu 幕府 188; Kamakura 鎌倉 188, 226, 235; Muromachi 室町 (Ashikaga 足利) 244–45, 255, 262; Tokugawa 徳川 310, 322, 337, 354, 357, 365, 374–75, 389

bakumatsu 幕末 360, 377, 389, 467, 477

bamboo 竹: baskets 籠 4; design of 183; stamps of 4–5; *sudare* blinds 簾 129

Ban Dainagon 伴大納言 (or Tomo no Yoshio 伴善男) 165, 166 (see also *Illustrated Scrolls of the Courtier Ban Dainagon*)

Bank of Japan headquarters (Nihon Ginkō *honten honkan* 日本銀行本店本館; Tokyo; Tatsuno Kingo) 394

Bansho Shirabesho 蕃書調所 (Institute for Dutch Studies, est. 1865) 375

basara daimyō ばさら大名 (daimyo of ostentatious taste) 249

Bathhouse Attendant (Tsuchida Bakusen) 433

Bathing Costume (Yorozu Tetsugorō) 415

Battle on the Banks of the Khalkha, Nomonhan (Foujita Tsuguharu) 442; Battles of Khalkhin Gol (Nomonhan Jiken ノモンハン事件) 442

benizuri-e 紅摺 (woodblock color prints) 350

Benzaiten 弁財天 (or Benten 弁天, Sarasvati) 75

Besson mandala 別尊曼荼羅 104

bianwen 変文 (*see* transformation texts)

bianxiang 変相 (*see* transformation tableaux)

Bigot, Georges 467

bijin-ga 美人画 (pictures of beauties) 349, 352, 353, 354

Bijutsu Shinpō 美術新報 (Art News) journal 419

bijutsu 美術 (art), as translation 378, 389, 461–62; *aato* (*see* art)

bingata 紅型 (Ryūkyū-produced dyed textiles) 365

Binglin Si 炳霊寺 (Gansu province 甘粛省) 43

Bird (Aimitsu) 444

bird-and-flower painting (*kachō-ga* 花鳥画) 252–254, 276, 396; Chinese 181, 253, 254, 335, 341, 344, 446; Northern Song 北宋 181, 183

Birds amid Plum Trees sliding doors (*Ume ni Yūkin-zu fusuma* 梅に遊禽図襖; Kanō Sanraku 狩野山楽) 311, **312**

birds and flowers (*kachō* 花鳥; theme) 181, 285, 396, 486n18; *Birds and Flowers* screens (*Kachō-zu byōbu* 花鳥図屏風) **267**; *Birds and Flowers of the Four Seasons* folding screens (*Shiki Kachō-zu* 四季花鳥図; Kanō Motonobu 狩野元信; Daisen-in 大仙院) 278–**79**; *Birds and Flowers of the Four Seasons* sliding doors (*Shiki Kachō-zu fusuma* 四季花鳥図襖) 285; Yong Xingling 永慶陵 (Liao Empire 遼 of the Khitans 契丹; tomb) 486n18

Birushana 毘盧遮那 (or Rushana 盧遮那, Vairocana) 77, 79, 152; Fengxian Si 奉先寺 77; Hosshō-ji 法勝寺 (Kyoto) 152; Tōdai-ji Great Buddha 東大寺大仏 77

Bishamonten 毘沙門天 (Vaisravana) 485n3: Ganjōju-in 願成就院 (Shizuoka prefecture; Unkei 運慶) 194; Sekkei-ji

雪渓寺 (Kōchi; Tankei 湛慶) 201–02; Tōdai-ji Middle Gate 東大寺中門 (Unkei 運慶) 194

biwa 琵琶 (*see* lute) 87

Bizen ware 備前焼 242, 301

Black Fan (Fujishima Takeji) 404

Black Sun (Kazuki Yasuo) **452**

Blonde ブロンド (Fujikawa Yūzō) 421

Blue Dragon Society (*see* Seiryūsha)

Blue Fudō and Two Boy Attendants (*Ao Fudō Myō-ō Ni Dōji-zo* 青不動明王二童子像, Shōren-in 青蓮院, Kyoto) hanging scroll 123–**24**

Bodhisattva on hemp (*mafu bosatsu* 麻布菩薩; Shōsō-in southern repository 正倉院南倉, Tōdai-ji 東大寺, Nara) 92

bodhisattvas (*see* Bosatsu)

Bodhidharma (Daruma 達磨) 232, 255, 343; *Daruma* 達磨図 (Kōgaku-ji 向嶽寺, Yamanashi prefecture) hanging scroll **255**; Hakuin Ekaku 白隠慧鶴 343–44; Kissan Minchō 吉山明兆 (Tōfuku-ji 東福寺 triptych) 260; Shōjū-ji 正宗寺 (Toyohashi, Aichi prefecture; Hakuin Ekaku 白隠慧鶴) 343; Manju-ji 万寿寺 (Oita prefecture; Hakuin Ekaku 白隠慧鶴) 344

Bodhidharma, Liu Hai, and *Li Tieguai* triptych (*Daruma, Gama Tekkai-zu* 達磨・蝦蟇鉄拐図; Kissan Minchō 吉山明兆; Tōfuku-ji 東福寺) hanging scrolls 260

Boki-e 慕帰絵 230; Kakunyo 覚如 (monk) 230

Bokubi 墨美 (*Aesthetics of Ink*) journal 458–59

Bokujin-kai 墨人会 459

bokuseki 墨蹟 (calligraphic inscriptions) 236, 237

Bonten 梵天 (Brahma) 75, 79, 111, 167, 484n3

book illustrations (*sashi-e* 挿絵) 327, 331, 355

Books (Takahashi Yuichi) 376

Bosatsu 菩薩 (bodhisattvas) 58, 70, 61, 70, 75, 112, 113, 132, 134, 138; Jizō 地蔵 176; in mandala 曼荼羅 102; Hōbodai-in 宝菩提院, Gantoku-ji 願徳寺 (Bodhisattva seated in the half-lotus position [bosatsu hanka-zō 菩薩半跏像]) 112–**13**; Hōtō-in 宝塔院, Jingo-ji 神護寺 110–111; at Tō-ji 東寺 (Mt. Kōya 高野山) 121–**22**, 135–136; as Hachiman 八幡大菩薩 214

box, small, with a design of sparrows in a field (nobe suzume maki-e tebako 野辺雀蒔絵手箱; Kongō-ji 金剛寺, Osaka) 181–**83**

box, small, with "carriage wheels in water" design (katawa-guruma maki-e raden tebako 片輪車蒔絵螺鈿手箱) 181–**82**

Brahma's Net Sutra (Bonmō-kyō 梵網経) 79

Braque exhibition (1952) 455

Bridge in Town Y (Matsumoto Shunsuke) **446**

Bridgens, Raphael P. (architect) 392

brocade tablecloth, white-chestnut, with the motif of a tree and a lion handler (shirotsurubami no ayanishiki no kijoku 白橡綾錦几褥; Shōsō-in southern repository 正倉院南倉, Tōdai-ji 東大寺, Nara) 92

Bright Star (see Myōjō)

"Broken Pouch" (Yabure-bukuro 破れ袋; Iga ware water jar) **302**

bronze 銅, 青銅: bells (see dōtaku bells); casting technique 28; mirrors (dōkyō 銅鏡) 28, 30; technology 21

Buddha (hotoke, butsu 仏): and sacred ornament (shōgon 荘厳) 41; forms of 135; (historical; Sakyamuni 釈迦牟尼) 42, 47, 61; kansō nenbutsu 観想念仏 126; of the Future 弥勒菩薩 5, 201; kami true identity (mishōtai 御正体) 214; relics memorial service (shari kuyō 舎利供養) 61; shrine's protective (honjibutsu 本地仏) 214

Buddha, death of: Buddha's Nirvana (Butsu Nehan-zu 仏涅槃図 or Ōtoku Nehan-zu 応徳涅槃図; Kongōbu-ji 金剛峯寺) 140, 151; Death of the Buddha (Nehan-zu 涅槃図; Kissan Minchō 吉山明兆; Tōfuku-ji 東福寺) hanging scroll 260; Death of the Buddha (Nehan-zu 涅槃図; Ryōzen 良全; Hongaku-ji temple 本覚寺) hanging scroll 255; Vegetable Parinirvana (Yasai Nehan-zu 野菜涅槃図; Itō Jakuchū 伊藤若冲) hanging scroll 344

Buddha's Nirvana (Butsu Nehan-zu 仏涅槃図 or Ōtoku Nehan-zu 応徳涅槃図; Kongōbu-ji 金剛峯寺) 140, 151

Buddhism 仏教: for protection of the state 68; introduction of 40

Buddhist deities 215; names of (myōgō 名号) 245

Buddhist narrative painting (bukkyō setsuwa-ga 仏教説話画) 205

Buddhist painting (butsu-ga 仏画) 101, 134–135, 138, 204–205, 209, 232, 246, 248; busshi 仏師 (buddhist sculptors) 232; Chinese 中国 83–84, 105, 174, 200; Daoist 道教 260; ebusshi 絵仏師 (Buddhist master of pictures) 232; Edokoro-za 絵所座 (organized painting studio) 232; Esoteric 密教 122; ninth-century 115; twelfth-century 123, 140, 154–57

Buddhist sculpture (butsuzō 仏像) 40–43, 72, 76, 118, 135, 203; Asuka period 飛鳥時代 52; busshi (buddhist sculptors 仏師) 232; Chinese styles 中国仏の様式 68; Hakuhō 白鳳 55–58; Jōgan 貞観 106, 109, 111–15; kibusshi 木仏師 (Buddhist masters of wood) 232; naturalization 和様化 121, **129**; Tenpyō 天平 82; Tori school 止利派 47

Buddhist-Daoist teachings 245

bunjin-ga 文人画 409

bunmei kaika 文明開化 (civilization and enlightenment) 375, 387, 389

Bunten 文展 (Monbushō Bijutsu Tenran-kai 文部省美術展覧会) 407, 408, 416, 428, 433

Burial (Kazuki Yasuo) 452

burial hill (*funkyū* 墳丘) 30; Kurozuka burial mound 黒塚古墳 (Tenri, Nara prefecture) 30

burial mounds (*kofun* 古墳) 30; decorative 装飾古墳 36–37

Burliuk, David 438

burnished (*togidashi*) maki-e 研出蒔絵 89, 180, 183

busshin 仏神 44

butsu-ga 仏画 260 (*see* Buddhist painting)

Butsugen Butsumo 仏眼仏母 (Buddhalocana) 204, 205

Butterflies (Fujishima Takeji) **404**

byōbu-e 屏風絵 146

Byōdō-in 平等院 (Uji, Kyoto prefecture) 127; panel paintings 壁扉画 137, 138, 211; Phoenix Hall (Hōō-dō 鳳凰堂)

calligraphers 書家 142, 144, 458–59; Chinese 中国の 92, 236, 249

calligraphy 書 84, 92, 161, 248–49, 302, 335, 447, 457, 458–59, 486n16: "Chinese-style" 335, 370; Hakuin 白隠 343; "reed-style" 葦手 239; Hon'ami Kōetsu 本阿弥光悦 315

Calm Winter Mountain (Murakami Kagaku) **435**

campaign coats (*jinbaori* 陣羽織) 302–03; campaign coat with three leaf arrowhead design (*omodaka monyō jinbaori* 沢瀉文様陣羽織; Nakatsu Castle 中津城, Oita prefecture) 303; Date Masamune 伊達政宗 302; Kobayakawa Hideaki 小早川秀秋 302; Tokugawa Ieyasu 徳川家康 302

camphor wood (*kusu* 楠) 49, 52, 53, 485n7

caricature 138, 169, 220, 221; Western-style 467

Carp (Fukuda Heihachirō) 436

Castle in the Sky (Miyazaki Hayao) 471

castles (*shiro* 城) 284, 287, 295–96, 308, 310

Catalogue of Imported Works (*Shōrai Mokuroku* 請来目録; Kūkai 空海) 97

Catalogue of Objects and Paintings in the Royal Collection (Gomotsu On-e Mokuroku 御物御画目録; Ashikaga shogunal collections) 254

Catalogue of Princely Treasures (*Kundaikan Sōchōki* 君台観左右帳記; Ashikaga shogunal collections) 254, 266

Catalogue of the Property of Butsunichi-an (*Butsunichi-an Kōmotsu Mokuroku* 仏日庵公物目録) 248, 254

celestials 飛天 64, 169, 176; Fifty-Two Celestials 雲中供養菩薩像 128, 132; *Flying Celestials* 飛天図 65

Cenotaph for the Victims of the Atomic Bomb (Genbaku Shibōsha Ireihi 原爆死亡者慰霊碑; Hiroshima; Tange Kenzō) 460

Central Library (Sōgō Toshokan 総合図書館; Tokyo Imperial University 東京帝国大学, present-day University of Tokyo 東京大学; Uchida Yoshikazu) 447

ceramics (*yakimono* 焼物) 3, 6, 11, 18, 22, 241–42; Chinese 87, 180–86 (*see also* porcelain, stoneware)

Ceremonial Robes Preserved as Keepsakes (*Airing of Robes*) (Kawamura Kiyoo) 381, 385, **386**, 387; Katsu Kaishū 勝海舟 485–86

chanoyu 茶の湯 459

Chen Hongshou 陳洪綬 346

Cherry Blossoms at Night (Yokoyama Taikan) **430**

Chiamigaito site 千網谷戸遺跡 (Gunma prefecture) 15–17; openwork clay

earrings (*sukashibori mimi-kazari* 透し彫り耳飾り; Late Jōmon 縄紋晩期) 15–**17**

Chiba Tetsuya ちばてつや: *Tomorrow's Joe* (*Ashita no Joe*) 468–**69**

Chibusan burial mound チブサン古墳 (Kumamoto prefecture) 37, **38**

Chigotsu Daie 癡兀大慧 (monk calligrapher) 237; Ganjō-ji 願成寺 (Kyoto) 237

Chijun 知順 (painter) 232

China 中国 vi, 16, 250; Eastern Han 後漢 43; Eastern Jin 東晋 116; Eastern Wei 東魏 43, 52; Five Dynasties 五代 149; Han 漢 36, 147; Ming 明 (*see* Ming China); Neolithic 新石器時代 16; Northern and Southern Dynasties 南北朝 53, 56, 483n2; Northern Qi 北斉 43; Northern Wei 北魏 43, 48, 50, 77; Qin 秦 36; Qing 清 (*see* Qing China); Shang 殷 22, 26; Six Dynasties 六朝 43, 45; Southern Dynasties 南朝 52; Sui 隋 46, 56, 59; Tang 唐 (*see* High Tang, Tang China), 483n2, 484n2, 485n7, 486n18; Wei 魏 28, 30, 482n7; Western Qin 西秦 43; Western Wei 西魏 43, 52; Yuan 元 (*see* Yuan China); Zhou 周 26

Chinese art 69, 189, **244**, **245**, **248**, 251; artists 78, 252, 337, 338, 346

Chinese Horoscope (Yamamoto Hōsui) 385

Chinese Lions (Maeda Seison) 383–**84**

Chinese Lions screen (*Karajishi-zu byōbu* 唐獅子図屏風; Kanō Eitoku 狩野永徳) 261, **287**

Chinese poetry (*kanshi* 漢詩) 115, 145

Chinese porcelain 398

Chinese Southern school landscapes 338

Chinese-style chest with a design of plovers (*sawa chidori maki-e raden kokarabitsu* 沢千鳥蒔絵螺鈿小唐櫃; Kongōbu-ji 金剛峯寺, Mt. Kōya) 180

Chinese-style gates (Karamon 唐門) 310;

Hōgon-ji 宝厳寺 290

chinzō 頂相 (portraits) 204, 236, 334; Gokū Keinen 悟空敬念 (Fujiwara no Nobuzane 藤原信実) 220; Lanxi Daolong 蘭渓道隆 (or Daikaku Zenshi 大覚禅師; Kenchō-ji 建長寺, Kamakura) **204**, 236; Ōbaku priests 黄檗僧 334; Wuxue Zuyuan 無学祖元 (or Bukkō Kokushi 仏光国師; Engaku-ji 円覚寺, Kamakura) 204, 236; Wuzhun Shifan 無準師範 (Tōfuku-ji 東福寺) 236; Zen portrait 220

Chōbunsai Eishi 鳥文斎栄之 351, 354

Chōen 長円 178

Chōgaku-ji 長岳寺 (Tenri, Nara prefecture) **179**, 193, 215

Chōgen 重源 (also known as Shunjōbo Chōgen 俊乗坊重源) 189–93, 195, **198**, 199, 204, 233; restoration of Tōdai-ji 東大寺修復 190; seated Shunjō Shōnin 俊乗上人坐像 (Tōdai-ji Shunjō Hall 東大寺俊乗堂; Unkei 運慶) **198**

Chōnen 奝然 (monk) 119, 174

Chōsei 長勢 134, 178; seated Amida Buddha (Amida Butsu *zazō* 阿弥陀仏坐像; Hōkai-ji 法界寺, Kyoto) 134, 178; Nikkō and Gakkō Bosatsu 日光菩薩、月光菩薩 (Kōryū-ji 広隆寺) 134; Twelve Guardian Generals (Jūni Shinshō 十二神将; Kōryū-ji 広隆寺) 134

Chōshūki 長秋記 (diary of Minamoto no Morotoki 源師時日記) 134

Chōyōdō Anchi 長陽堂安知 349

Christianity 229, 338; Christian missionary 406; Christian ritual implements 301

Chronicle of the Grand Pacification (*Taiheiki* 太平記) 249

Chronicles of Lord Nobunaga (*Shinchōkō-ki* 信長公記; compiled by Ōta Gyūichi 太田牛一) 284–85; Azuchi Castle 安土城 285

Chrysanthemums screens (Hayami Gyoshū) 432

Chūgaishō 中外抄 (record by Fujiwara no Tadazane 藤原忠実) 131

Chūgū-ji temple 中宮寺 (Nara prefecture) 58

Chūjō Seiichirō 中条精一郎 (architect) 413; Keiō University Old Library (Keiō Gijuku Kyū-toshokan 慶應義塾 旧図書館) 413

chūreitō 忠霊塔 (monument to loyal souls) 450

Chūson-ji 中尊寺 (Hiraizumi, Iwate prefecture) **176**; Fujiwara no Kiyohira 藤原清衡, Motohira 基衡, Hidehira 秀衡, Yasuhira 泰衡 176; Golden Hall (Konjiki-dō 金色堂) 176, 183; Nine Amida Hall (Kutai Amida-dō 九体 阿弥陀堂) 176

Cien, Great Master 慈恩大師 portrait of (Yakushi-ji 薬師寺, Nara) 141

civilization and enlightenment (see *bunmei kaika*)

classical style/form (see *hon'yō*)

clay statues (*sozō* 塑像) 59, 72, 75–77, 83; five-story pagoda of Hōryū-ji 法隆寺 五重塔 72; Tōdai-ji 東大寺 75

cloistered imperial rule (*insei* 院政) 94, 188, 217

Collection of Tales from Times Now Past (*Konjaku Monogatari Shū* 今昔物語集) 163

Collin, Raphaël 399

Conder, Josiah (architect, educator) 388, 393–95, 411, 413, 447; and Kawanabe Kyōsai 河鍋暁斎 394; Ueno Museum (Ueno Hakubutsukan 上野 博物館; Tokyo), Deer Cry Pavilion (Rokumeikan 鹿鳴館; Tokyo), former residence of Iwasaki Hisaya (Kyū Iwasaki Hisaya *tei* 旧岩崎久彌邸; Tokyo), Holy Resurrection Cathedral (Tokyo Fukkatsu Daiseidō Kyokai 東京復活大聖堂教会 also known as Nikolai-dō ニコライ堂; Tokyo), Mitsui Club (Tsunamachi Mitsui Kurabu 綱町三井倶楽部; Tokyo) 394

Confucian philosophy 儒教思想 245, 409

Construction (Murayama Tomoyoshi) **439**

Contemplation of Samantabhadra Sutra in Booklet Form (*Kan Fugenkyō Sasshi* 観普賢経冊子) 160

Contemporary Japanese Art Exhibition (*see* Gendai Nihon Bijutsu-ten)

continent 大陸 18, 21; culture from 40; origins 29

copyist (*hikkō* 筆耕) 332

copperplate engraving (*dōhanga* 銅版画) 358; Katsushika Hokusai 葛飾北斎 360

cord-marking 縄紋 3, 5, 6, 11

Corrected and Amended Documents of Old Paintings (*Zōho Kōko Gafu* 増補考古画譜) book 220

cosmetic box with a repeating design of round crests formed of three opened cypress fans (*hiōgimon chirashi tebako* 檜扇文散手箱) 241

cosmetic box with *fusenryō* design in mother-of-pearl inlay and *maki-e* (*fusenryō maki-e raden tebako* 浮線綾蒔絵螺鈿手箱) 240

cosmetic box with a design of scattered fans (*ōgi chirashi maki-e tebako* 扇散蒔絵手箱) 241

court painters 宮廷画家 105, 144, 154, 232, 322

Courtesan (Takahashi Yuichi) **376**

courtesans (*yūjo* 遊女) 367, 348; Yoshiwara 吉原 327, 355

courtier culture 58, 69, 244; Ban Dainagon 伴大納言 164–66 (*see also* aristocratic culture)

courtly arts 40, 86; crafts/decorative art 238, 332; culture 315, 351; elegance 316; elite 224; taste 238; style of tea 327

Crows screens (*Karasu-zu* 烏図) **295**

crystal inset eyes 玉眼 179, 193

cut-glass bowl, white (*hakururi no wan* 白瑠璃碗*;* Shōsō-in central repository 正倉院中倉) 92

Cypress; Villa Falconieri, Frascati (Fujishima Takeji) 404

Dada (or Dadaism) 438–40, 448, 462

Daibutsu-yō 246 (*see* Great Buddha style 大仏様; architecture)

Daigo-ji temple 醍醐寺 (Kyoto) 131, 200, 316, 317, 485n4; five-story pagoda 五重塔 121, 135; paintings 157, 174; scrolls 84

Dainichi Nyorai 大日如来 66, **98**, 102, 103, 104, 123; Enjō-ji 円成寺 (Nara; Unkei 運慶) 194–**95**; Hōjō-ji 法成寺 (Kyoto; Jōchō 定朝) 132

Daisen-in 大仙院 (Kyoto): *Birds and Flowers of the Four Seasons* (*Shiki Kachō-zu* 四季花鳥図; Kanō Motonobu 狩野元信; sliding doors) 278–**79**; *Eight Views of Xiao and Xiang Rivers* (*Shōshō Hakkei* 瀟湘八景; Sōami 相阿弥; sliding doors) 267, 278; *shoin*-style garden (*shoin* teien 書院庭園) **268**

Daitoku-ji 大徳寺 (Kyoto) 236; *Guanyin, Gibbons, and Crane* (*Kannon, Enkaku-zu* 観音・猿鶴図; Muqi Fachang 牧谿法常) hanging scrolls **251**; Jukō-in sliding door panels 聚光院襖絵 (Kanō Eitoku 狩野永徳, Kanō Shōei 狩野松栄) 285; Kanō Eitoku's 狩野永徳 paintings abbot's quarters at Tenzui-ji 天瑞寺 287; *Landscapes of the Four Seasons* sliding doors (*Shiki Sansui-zu fusuma-e* 四季山水図襖絵; Soga Jasoku 曽我蛇足; Shinju-an 真珠庵) 271; Mittan 密庵 (Ryōkō-in 龍光院) and Bōse 忘筌 (Kohōan 孤篷庵) by Kobori Enshū 小堀遠州 313; *Night Procession of One Hundred Demons* (*Hakki Yagyō Emaki* 百鬼夜行絵巻; Shinju-an 真珠庵) 259–60; *Pine Trees in the Four Seasons* screens (*Shiki*

Matsu-zu byōbu 四季松図屏風; Kanō Tan'yū 狩野探幽) 310; Shūhō Myōchō 宗峰妙超 (Daitō Kokushi 大燈国師) 236; *Sixteen Arhats* (*Jūroku Rakan-zu* 十六羅漢; Lin Tinggui 林庭珪, Zhou Jichang 周季常; hanging scrolls) 260 (*see also* Daisen-in)

Damjing 曇徵 (Goguryeo monk) 59

Dance in the Fire (Hayami Gyoshū) 433, **434**

danzō 壇像 (statues carved from aromatic woods) 106, 485n7; *byakudan-zō* 白檀像 485n7

Daoism 道教 41

Daoist deities 道教の神仙 41, 409

Daoist-Buddhist painting (*dōshakuga* 道釈画) 260

Daruma (*see* Bodhidharma)

datsu kanshitsu 脱乾漆 (hollow dry lacquer) 59; Four Guardian Kings (Shitennō zō 四天王像; Taima-dera 当麻寺) 59

Death Ship (Inoue Chōzaburō) 452

decoration (*see also* adornment) 4–9, 37, 42, 90, 186, 241, 254, 258, 270, 291, 295, 307, 367, 465, 466; burnished *maki-e* 研出蒔絵 117; porcelain 324; *chokkomon* 直弧文 (fractured spiral) 36, 482n11; Daigo-ji pagoda 135; Fujishima Takeji 藤島武二 404; interior 248–49; Meiji kitsch 392; metalwork 365; Nikkō Tōshō-gū 日光東照宮 309; Nishi Hongan-ji 西本願寺 309; sculptural 274; shrine architecture 274; textile 331; warrior taste 290

decoration: architectural 291

decorative sutras (*sōshoku-kyō* 装飾経) 155, **159**

decorative/decorated burial mounds (*sōshoku kofun* 装飾古墳; *see* tunnel tomb)

demons 53, 147, 170, 171, 201, 202, 226, 247, 383; *Night Procession of One Hundred Demons* (*Hyakki Yagyō*

百鬼夜行) vii, 246, 259, 260, 467

Dengaku masks (*dengaku-men* 田楽面)
246

Descent of Amida (*Amida Shōjū Raigō-zu*
阿弥陀聖衆来迎図; *Yūshi Hachimankō
Jūhachika-in* 有志八幡講十八箇院,
Mt. Kōya 高野山) hanging scrolls 157

design 473–74

design in overglaze polychrome enamels
(*iro-e kikkō botan chō-mon ōzara*
色絵亀甲牡丹蝶文大皿) **326**

Diamond World Mandala (*Kongōkai
Mandara* 金剛界曼荼羅) 100, 102

Diary of Murasaki Shikibu (*Murasaki
Shikibu Nikki* 紫式部日記) 430;
Illustrated Scrolls of 222

Diary of Things Seen and Heard (*Kanmon
Gyoki* 看聞御記; diary of Prince
Fushiminomiya Sadafusa 伏見宮貞成)
259

directions (cardinal) 四方 Chinese gods
of 四神 (Blue Dragon 青竜, Vermilion
Bird 朱雀, White Tiger 白虎, Black
Turtle-snake 玄武) 32, 62, 482n8;
Kitora burial mound キトラ古墳 (Nara
prefecture) 32, 62; Takamatsuzuka
burial mound 高松塚古墳 (Nara
prefecture) 32, 62

Discourse on the Three Faiths (*Rōko Shiiki*
聾瞽指帰; Kūkai 空海; Kongōbu-ji
金剛峰寺; calligraphy) 116

dōbōshū 同朋衆 254, 266–67; *Catalogue
of Objects and Paintings in the Royal
Collection* (*Gomotsu On-e Mokuroku*
御物御画目録) 254; *Catalogue of
Princely Treasures* (*Kundaikan Sōchōki*
君台観左右帳記) 254, 266; Geiami
芸阿弥 266–27; Nōami 能阿弥 254,
266; *Record of Decorations for the
Imperial Visit to the Muromachi Palace*
(*Muromachi-dono Gyōkō Okazari-ki*
室町殿行幸御餝記) 254, 258; Sōami
相阿弥 254, 267

Dōgen 道元 233–34; and Sōtō Zen

曹洞宗 189; founder of Eihei-ji
永平寺 (Fukui prefecture) 234

dogū 土偶 12–15, 23, 51; with "coffee
bean eyes" (*shakōki* 遮光器土偶)
14–15; heart-shaped 14–15; Jōmon
Venus 縄文のビーナス 12–13; standing
14

doha 土坡 (mound) 487n25

dōji 童子 (child-attendant deity) 164,
194; Gohō Dōji 護法童子 164, 471;
Kongara Dōji 矜羯羅童子 (Kimkara)
and Seitaka Dōji 制多迦童子 (Cetaka)
123; Zennishi Dōji 善膩師童子 201;
Zenzai Dōji 善財童子 (Sudhana) 168,
330

Dōji 道慈 (monk) 68, 73

Dōkyō 道鏡 (monk) 107, 485n8

Domon Ken 土門拳 50–**51**, 473–74;
Guze Kannon 救世観音 50–**51**;
Murō-ji Temple 室生寺 473; seated
Shunjō Shōnin 俊乗上人坐像 **198**;
The Children of Chikuhō (*Chikuhō
no Kodomotachi* 筑豊のこどもたち)
473–74

Dōmoto Inshō 堂本印象 (painter) 453

Dong Yuan 董源 (painter) 250

dōsojin 道祖神 (guardian deities for
travelers) 47; Ishigami site 石神遺跡
(Nara prefecture) 47

dōtaku bells 銅鐸 26–29; Kehi shrine
気比神社 (Hyogo prefecture) 26;
molds (Osaka prefecture) 26;
Sakuragaoka site 桜ヶ丘遺跡
(Hyogo prefecture) 26–**27**;
Shimane prefecture 27

Dove on a Peach Branch (*Momo Hato-zu*
桃鳩図; Emperor Huizong 徽宗)
hanging scroll 253

Dragon King (Ryū-ō 竜王) 159; daughter
of 159; *Zennyo Ryū-ō* 善女竜王 (Jōchi
定智; Kongōbu-ji 金剛峰寺) hanging
scroll 174; Zennyo Ryū-ō 善女竜王
(Enkū 円空 sculpture; Seihō-ji 清峯寺,
Gifu prefecture) **330**

Dreamlike Manifestation of Kasuga Myōjin (*Kasuga Myōjin Yōgō-zu* 春日明神影向図; Takashina Takakane 高階隆兼) hanging scroll 216; Takatsukasa Fuyuhira 鷹司冬平 inscription by 216

Dreamlike Manifestation of Kumano Gongen 熊野権現影向図 (Dannō Hōrin-ji 檀王法林寺) hanging scroll **216**

Dried Salmon (Takahashi Yuichi) 376

Drunken Barbarian King, Gigaku mask (Suiko-ō 酔胡王; Shōsō-in southern repository 正倉院南倉, Tōdai-ji 東大寺, Nara) **92**

dry lacquer (*kanshitsu* 乾漆) 58–59, 105, 109–10; boxes 117

dry landscape gardens (see *karesansui*)

Dry Road in Winter (*Sketched in the Vicinity of Harajuku, Sun on Red Soil and Grass*; Kishida Ryūsei) 416

dry-lacquer statues (*kanshitsuzō* 乾漆像) 72, 75–76, 82; *datsu kanshitsu* 脱乾漆 (hollow dry lacquer) 59, 483n4; Kōfuku-ji 興福寺 73; *mokushin kanshitsu* 木心乾漆 (wood-core dry lacquer) 483n4; Tōdai-ji 東大寺 75

Dunhuang 敦煌 43, 65, 76, 150–51, 483n8 and 483n2, 485n6; *Amitabha Preaching* 阿弥陀説法図 64; *Flying Celestials* 飛天図 64; Mogao caves 莫高窟 43; *Transformation Tableaux of the Lotus Sutra* 法華経変相図 150

dyes and dyeing 染: *chūgata* 中型 (medium-scale patterns) 364; *katagami* 型紙 (paper stencils) 364; *komon* 小紋 (small-motif patterns) 364; stencil dyeing (*kata-zome* 型染) 364; tie-dyeing (*shibori-zome* 絞染) 270, 327; *tsujigahana-zome* 辻が花染 (tie-dyeing with applied decoration and embroidery) 270, 288; *yūzen* 友禅染 dyeing technique 364–65

e-kotoba 絵詞 ("illustrated words/texts") 163

Early Summer Breeze (Kawakami Sumio) 421

earth mother worship 地母神信仰 12

East Asia/East Asian 東アジア vi, 42, 184; Buddhist arts **40**, 53; Buddhist sculpture 52; continent 18; cultural/artistic sphere 30, 118; paintings 65, 426; tradition of line drawing 432

ebutsu 絵仏, 画仏 (picture of Buddhist deity) 135

Echizen ware 越前焼 242

Edakumi no Tsukasa 画工司 (Bureau of Painters) 82, 232

eden 絵殿 (Hōryū-ji 法隆寺) 149

Edo Castle 江戸城 310, 322

Edokoro 絵所 (official court painting studio) 232

Edokoro-za 絵所座 (organized painting studio) 232

Ei-Q (Ei Kyū 瑛九) 473; "photo-dessins" (photo-sketches) 473

Eiga Monogatari 栄花物語 (*A Tale of Flowering Fortunes*) 141, 151, 210, 217

Eight Classes of Deities (Hachi-bushū 八部衆; Kōfuku-ji 興福寺) 73; dry-lacquer statues 73

Eight Famous Views of Kyoto (Maeda Seison) 431

Eight Masters Who Journeyed to Tang (Nittō Hakke 入唐八家) 97, 104, 125, 484n2

Eight Views of the Xiao and Xiang Rivers (*Shōshō Hakkei* 瀟湘八景); Ike no Taiga 池大雅 (screen) 340; Muqi Fachang 牧谿法常 (hanging scrolls) **252**; Yujian 玉澗 (hanging scrolls) 252

Eisai 栄西 (or Yōsai) 189, 233; *Healthy Living Through Drinking Tea* (*Kissa yōjō ki* 喫茶養生記) treatise 233; Jufuku-ji 寿福寺 (Fukuoka prefecture and Kamakura) 233

Eisenstein, Sergei 354

Eishinsha 盈進社 (craft company) 396
Eishōsai Chōki 栄松斎長喜 (ukiyo-e artist) 354
ekakibe 画部 (painting division)
Ekin 絵金 (*see* Hirose Kinzō)
Eleven-Headed Kannon (Jūichimen Kannon 十一面観音) 95, 106, 111, **112**, 113; details of carving (Tōshōdai-ji 唐招提寺) 82; Gumyō-ji 弘明寺 (Kanagawa prefecture) 134; Hokke-ji 法華寺 (Nara) 111, **113**; painting 156, 213; Rokuharamitsu-ji 六波羅蜜寺 131; Shido-ji 志渡寺 257; Shōrin-ji 聖林寺 (Nara prefecture) 82
Ema Saikō 江馬細香 (painter) 435
emaki 絵巻 (*see* illustrated handscroll)
Emperor Ankan 安閑天皇: burial mound of 92
Emperor Daigo 醍醐天皇 164
Emperor Genmei 元明天皇 68
Emperor Go-Hanazono 後花園天皇 259; *Record of Decorations for the Imperial Visit to the Muromachi Palace* (*Muromachi-dono Gyōkō Okazari-ki* 室町殿行幸御錺記) 254, 258
Emperor Go-Ichijō 後一条天皇 217
Emperor Go-Shirakawa 後白河天皇 152, 218; portrait of **217**
Emperor Huizong 徽宗 253–54, 259; Ashikaga shogunal collections 252–54, 266; *Catalogue of the Property of Butsunichi-an* (*Butsunichi-an Kōmotsu Mokuroku* 仏日庵公物目録) 248, 254; *Dove on a Peach Branch* (*Momo Hato-zu* 桃鳩図) **253**
Emperor Kameyama 亀山天皇 215
Emperor Kanmu 桓武天皇 95
Emperor Keitai 継体天皇 41
Emperor Kinmei 欽明天皇 41, 44
Emperor Meiji 明治天皇 374–75, 392
Emperor Monmu 文武天皇 68
Emperor Murakami 村上天皇 143
Emperor Nintoku's mausoleum 仁徳天皇陵 32, 46

Emperor Saga 嵯峨天皇 117; transcription of the precepts received by the monk Kōjō (*Kōjō Kaichō* 光定戒牒) 117
Emperor Seiwa 清和天皇 103
Emperor Shirakawa 白河天皇 151–53
Emperor Shirakawa, Retired 白河法皇 94, 160, 174–75; Hosshō-ji 法勝寺 (Kyoto) 152–53
Emperor Shōmu 聖武天皇 76–77, 78, 85; 483n1, 485n8
Emperor Shōwa 昭和天皇 383
Emperor Sujin's mausoleum 崇神天皇陵 31
Emperor Sutoku 崇徳天皇 487n21
Emperor Tenji 天智天皇 95
Emperor Tenmu 天武天皇 68, 70
Emperor Wu 武帝 of Han 147
Emperor Wuzong 武宗 97
Emperor Yuan of Liang Receiving Foreign Visitors (*Liang Yuan-di Fankeruchao-tu* 梁元帝蕃客入朝図) 220
Empress Jingū 神功皇后 115
Empress Jitō 持統天皇 68
Empress Kōmyō 光明天皇 73, 76, 85
Empress Saimei 斉明天皇 47
En school 円派 134, 202, 246
En'i 円伊 (monk) 228–30
Enchin 円珍 97, 103–04; Eight Masters Who Journeyed to Tang (Nittō Hakke 入唐八家) 484n2; *Essential Meditations on the Five Families of the Mind* (*Gobu Shinkan* 五部心観; Onjō-ji 園城寺, Shiga prefecture) 104; *Yellow Fudō* (*Ki Fudō* 黄不動; Onjō-ji 園城寺) 104
Engaku-ji 円覚寺 (Kamakura) 204, 234, 235, 236–38, 248; Relic Hall 舎利殿 (moved from former Taihei-ji 太平寺) 237
Enichibō Jōnin 恵日房成忍 221; *Portrait of Priest Myōe* (*Myōe Shōnin-zō* 明恵上人像; Kōzan-ji 高山寺, Kyoto)
Enjoying the Evening Cool under a Moonflower Trellis screen (*Yūgao-dana*

Nōryō-zu 夕顔棚納涼図; Kusumi Morikage 久隅守景) **323**

Enkū 円空 329, **330**, 334, 369; Dragon King Zennyo Ryū-ō 善女龍王 (Seihō-ji 清峯寺, Gifu prefecture) **330**; Shugendō 修験道 training at Mt. Ibuki 伊吹山 329; *sakubutsu hijiri* 作仏聖 ("Buddha-making holy men") 329; Twelve Devas (Jūniten 十二天; Nata Yakushi-dō 鉈薬師堂, Aichi precture) 334; Zenzai Dōji 善財童子 (Sudhana; Seihō-ji 清峯寺, Gifu prefecture) **330**

Enmaten 閻魔天 (Yama-deva; Daigo-ji 醍醐寺) hanging scroll 157, 174

Ennan 燕庵 (teahouse; Kyoto) **301**; Oribe-style (*Oribe-gonomi* 織部好み) 301

Enni 円爾 (Shōichi Kokushi 聖一国師) 234, 235

Ennin 円仁 97, 135; Eight Masters Who Journeyed to Tang (Nittō Hakke 入唐八家) 484n2

Enryaku-ji 延暦寺 (Mt. Hiei 比叡山, Shiga prefecture) 97, 117; Genshin at 源信 126, 206; Saichō 最澄 97

Ensei 円勢 (sculptor) 178

Entsū Sansō-dō 円通三匝堂 (Fukushima prefecture) 368; Ikudō 郁堂 368; Sazae-dō さざえ堂 (turbo-shell hall) 368

envoys to Tang China 遣唐使 68, 73, 95, 97, 119, 169; to Ming China 遣明使 248

Eri 会理 (monk) 131; Yakushi Nyorai 薬師如来 (Kami-Daigo Yakushi-dō 上醍醐薬師堂, Daigo-ji 醍醐寺) 131

Escape from the Land of the Dead (Aoki Shigeru) 405

eshi 画師, 絵師 (painter) 232, 332, 490n4; *goyō eshi* 御用絵師 (painter-in-attendance) 265, 278, 310, 323; *oku-eshi* 奥絵師 ("inner court painters") 322; *omote-eshi* 表絵師 ("outer court painters") 322; *ukiyo-eshi* 浮世絵師

(ukiyo-e artist) 331

Esoteric Buddhism (Mikkyō 密教) 76, 94–95, 109, 110, 114, 120

Essential Meditations on the Five Families of the Mind (Gobu Shinkan 五部心観; Onjō-ji 園城寺) 104

Essentials of Rebirth (see *Ōjō Yōshū*)

Eta Funayama burial mound 江田船山古墳 (Kumamoto prefecture) 33; gold and gilt-bronze burial accessories 33–34

Etō Shun 衛藤駿 181

etoki 絵解 (preaching with pictures) 150, 258

Evening (Uemura Shōen) 436

Evening at the Harbor (Wada Eisaku) 403

Evening Cool on the Banks of the Sumida River (Ōkawa-bata Yūsuzumi 大川端夕涼; Torii Kiyonaga 鳥居清長) **352**

Evening in the Mountains (Kawai Gyokudō) 436, **437**

Exhibition of Japanese Painting and Sculpture: 1953 USA (Amerika junkai Nihon kobijutsu tenrankai アメリカ巡回日本古美術展覧会) 455–56; 1958 Europe (Ōshū junkai Nihon kobijutsu tenrankai 欧州巡回日本古美術展) 456

Expressionism 415, 423, 448, 465; German 413, 420, 422, 438; Japanese Abstract 439, 457; "Nanga" 415

eye-opening ceremony (*kaigen kuyō* 開眼供養): Asuka-dera 飛鳥寺 44; Tōdai-ji 東大寺 77; Tō-ji 東寺 110; *see also* Tōdai-ji 東大寺

Eyeless Sutra (Menashi-kyō 目無し経 or Konkōmyō-kyō 金光明経) handscrolls 222

Fading Sunlight (Sakamoto Hanjirō) 427

Fallen Leaves 落葉 (Hishida Shunsō) **408**

Family of N (Koide Narashige) 427

Fan Daosheng 范道生 334; statue of Skanda (Idaten zō 韋駄天像; Manpuku-ji 万福寺, Kyoto prefecture)

Fan Kuan 范寛 (painter) 250

fans 扇 162, 265, 351; album (fan-shaped)
161; folding fans 扇 162; *hiōgi* 檜扇
162; oval fan (*uchiwa* or *dansen* 団扇)
162; paintings **160**; scattered (*ōgi
chirashi* 扇散し; motif) 241

Fantasmagorie (*Phantamagoria*; Emile
Cohl) short animation 469

Farmers Returning Home (Asai Chū) **380**

Farmers Returning in Snowy Woods
(Nakagawa Hachirō) 403

farmers 農民 289, 307, 329, 336, 402,
473; *Farmers Returning Home* (*Nōfu
Kiro* 農夫帰路; Asai Chū 浅井忠) 380;
Farmers Returning in Snowy Woods
(*Setsurin Kiboku* 雪林帰牧; Nakagawa
Hachirō 中川八郎) 403; *Sifting Red
Beans* (*Aka-azuki no Aoriwake* 赤小豆の
簸分; 黒田清輝 Kuroda Seiki) 402

Female Divers (*Ama*) (Tsuchida Bakusen)
433

Female Nude on Chinese Bed; *Female
Nude A* (Koide Narashige) **427**

Female Nude: *Resting Her Chin on Her
Hand* (Yorozu Tetsugorō) 415

Fengxian Si 奉先寺 (Longmen 龍門,
Henan province) 77

Fenollosa, Ernest xxv, 49, 352, 381–84,
409–10, 481n1; and Kanō Hōgai
382–84; and Okakura Kakuzō
岡倉覚三 406; *bijin* images by Torii
Kiyonaga 鳥居清長 352; Guze Kannon
救世観音 49; "A True Theory of Art"
(*Bijutsu shinsetsu* 美術真説) 381, 385,
406

Fifteen Scenes from the Life of Mary
(*Maria Jūgo Gengi-zu* マリア十五
玄義図; framed painting) 299, **300**; first
generation of Western-style paintings
(*dai ichiji yōfū-ga* 第一次洋画) 299

Fifty-Two Celestials (or Bodhisattvas
Making Offerings in the Clouds
雲中供養菩薩像 Byōdō-in 平等院)
128, 132

figurines (see *dogū*)

Firefly Hunting (*Hotaru gari* 蛍狩り;
Suzuki Harunobu 鈴木春信) **352**

First Sino-Japanese War (Nisshin Sensō
日清戦争) 442

Five Angry Deities (*see* Five Great
Wisdom Kings)

Five Great Sky Store Bodhisattvas (Godai
Kokūzō Bosatsu 五大虚空蔵菩薩;
Hōtō-in cloister 宝塔院, Jingo-ji
神護寺) 110

Five Great Wisdom Kings (Godai Myō-ō
五大明王, Godaison 五大尊) 66,
100, 104, 110, 122–124, 127, 131, 132,
156, 174; Hall of (Godai-dō 五大堂;
Hosshō-ji 法性寺) 127; Kiburi-ji
来振寺 123; Shingon-in 真言院 100

Five Hundred Arhats (Gohyaku Rakan
五百羅漢; sculpture): Shōun Genkei
松雲元慶 (Gohyaku Rakan-ji
五百羅漢寺) **334**

Five Hundred Arhats (*Gohyaku Rakan-zu*
五百羅漢図; painting): Ike no Taiga
池大雅 (Manpuku-ji 万福寺; sliding
doors) 339–40; Kissan Minchō
吉山明兆 (hanging scrolls) 261

Five Mighty Bodhisattvas (Godairiki
Bosatsu-zō 五大力菩薩像; Mt. Kōya
高野山) 121, 135

five-pronged *vajra* (*kondō sanmaya gokorei*
金銅三昧耶五鈷鈴; Kōki-ji 高貴寺,
Kyoto) **117**

five-story pagoda 五重塔: Hōryū-ji 法隆寺
72–73, 77; Daigo-ji 醍醐寺 121, 123,
135; Murō-ji 室生寺 120

Flame (Uemura Shōen) **436**; *Lady Aoi*
(*Aoi no ue* 葵の上) 436

flame pots (*kaen doki* 火焔土器) **10–11**;
Sasayama site 笹山遺跡 (Niigata
prefecture) **10–11**; Sōri site 曾利遺跡
(Nagano prefecture) 10

Flower Garland Sutra (*Kegon-kyō* 華厳経)
68, 79, 168, 212, 228

Flying Celestials (*Hiten-zu* 飛天図):

Dunhuang 敦煌 64; Hōryū-ji
法隆寺 64

Focillon, Henri (art historian) 405

folk art 民衆芸術 xi; Ainu アイヌ 365,

folklore (studies) 民俗 (学) 225, 231, 334,
476

Fontanesi, Antonio 379–81

Foolishly Adamant (Inoue Yūichi)
calligraphy **458**

Foujita Tsuguharu 藤田嗣治 (also known
as Foujita Tsuguji or Léonard Foujita;
painter) 426–27, 444; *Battle on the
Banks of the Khalkha, Nomonhan
(Haruha kahan no sentō* 哈爾哈河畔之
戦闘*)* 442; *Shattered Jewels (Attsutō
gyokusai* アッツ島玉砕*)* 444–45;
*Spanish Beauty (Utsukushii Supein
onna* 美しいスペイン女*)* **427**

Four Guardian Kings (Shitennō 四天王)
109–**10**: Hōryū-ji 法隆寺 52–**53**, 77;
Hokuen-dō 北円堂 (Kōfuku-ji 興福寺)
108; Taima-dera 当麻寺 59; Tōdai-ji
東大寺 75–77, 83; Tōdai-ji Great
Buddha Hall 東大寺大仏殿 (Unkei
運慶) 194; Tō-ji 東寺 **110**

Freer, Charles Lang 382

French Symbolism 420

Frogs Triumphing over a Snake and Lizards
(Kawanabe Kyōsai) 388

Fruits of the Sea (Aoki Shigeru) 405, **406**,
444

Fudō-Myō-ō 不動明王 66, 103, 104, 105,
123–**24**, 125, 131, 484n3; *Aka Fudō*
赤不動 or *Red Fudō* (or *Fudō Myō-ō
Ni Dōji-zō* 不動明王二童子像;
Myō-ō-in, Mt. Kōya 高野山明王院;
hanging scroll) 124; *Blue Fudō and
Two Boy Attendants (Ao Fudō Myō-ō
Ni Dōji-zō* 青不動明王二童子像;
Shōren-in 青蓮院, Kyoto; hanging
scroll) 123–24; Kanō Hōgai 狩野芳崖
383; Kōshō 康尚 (Dōju-in, Tōfuku-ji
東福寺同聚院, Kyoto) 131; *Takao
Mandala* 高雄曼荼羅 (Jingo-ji

神護寺, Kyoto) 103; Unkei 運慶
(Ganjōju-in 願成就院, Shizuoka
prefecture) 194; *Yellow Fudō (Ki
Fudō* 黄不動 or *Fudō Myō-ō gazō*
不動明王画像; Onjō-ji 園城寺,
Shiga prefecture; hanging scroll) 104

Fuetsu 普悦 (Pu Yue; painter) 174; *Amida
Triad (Amida Sanzon* 阿弥陀三尊;
Shōjōke-in 清浄華院, Kyoto) 174

Fugen and Ten Rasetsunyo 普賢十羅刹女
像図 (Samantabhadra and Rakshasis;
Rosan-ji 廬山寺, Kyoto; hanging scroll)
209; Dharani Chapter, *Lotus Sutra*
妙法蓮華経陀羅尼品 209

Fugen Bosatsu 普賢菩薩 (Samantabhadra)
157, 177–78; Takuma Eiga 宅間栄賀
255; Okura Museum of Art statue
178–79; Rosan-ji 廬山寺, Kyoto 209;
Tokyo National Museum painting **157**

Fugen Enmei Bosatsu 普賢延命菩薩像
(Life-Extending Fugen; Matsuo-dera
松尾寺, Kyoto prefecture) hanging
scroll 156

Fujikawa Yūzō 藤川勇造 (sculptor) 421;
Blonde ブロンド 421

Fujimaki Yoshio 藤牧義夫 (print artist)
420

Fujimori Terunobu 藤森照信 422,
490n5, 490n9

Fujinoki burial mound 藤ノ木古墳
(Nara prefecture) 32–**33**, 65; gold and
gilt-bronze burial accessories 32–33

Fujioka Sakutarō 藤岡朔太郎 307

Fujisaki site 藤崎遺跡 (Fukuoka
prefecture) 22–**23**; wide-mouthed jar
with red lacquer (*shusai hirokuchi tsubo*
朱彩広口壺; Middle Yayoi 弥生中期)
22–**23**

Fujishima Takeji 藤島武二 (painter) 398,
402, 403, *Black Fan (Kokusen* 黒扇),
Butterflies (Chō 蝶), *Cypress (Villa
Falconieri, Frascati) (Itosugi* 糸杉),
*Reminiscence of the Tenpyō Era (Tenpyō
no omokage* 天平の面影), *Rising Sun*

Illuminating the Universe (*Kyokujitsu shō rikugō* 旭日照六合), *Rough Seas at Daiōzaki* (*Daiōzaki ni uchiyoseru dotō* 大王岬に打ちよせる怒濤) **404**; *Tangled Hair* (*Midare-gami* みだれ髪; Yosano Akiko 与謝野晶子) 404

Fujiwara art 藤原美術 94, **118**, 120, 122, 128, 135, 154

Fujiwara clan 藤原氏 73, 94, 119–20, 125, 126–27, 131, 152; Kamakura period 鎌倉時代 213; Yamashina-dera 山階寺 (tutelary temple) 73 (*see also* Northern Fujiwara)

Fujiwara no Hirotsugu 藤原広嗣: rebellion of 76

Fujiwara no Kamatari 藤原鎌足 49–50

Fujiwara no Kintō 藤原公任 230; *Thirty-Six Poets* (*Sanjūrokkasen* 三十六歌仙) 320, 351

Fujiwara no Michinaga 藤原道長 129, 143, 177, 210; Hōjō-ji 法成寺 (Kyoto) 132; Tsuchimikado-dono 土御門殿 129

Fujiwara no Mitsuyoshi 藤原光能: portrait of (Jingo-ji 神護寺) 218

Fujiwara no Nakamaro 藤原仲麻呂: revolt of 85

Fujiwara no Nobuyori 藤原信頼 487n21

Fujiwara no Nobuzane 藤原信実 219–20; *Gathering at the Central Palace* (*Chūden Gyokai-zu* 中殿御会図) 219; *Illustrated Scroll of the Imperial Guard Cavalry* (*Zuishin Teiki Emaki* 随身庭騎絵巻) 219–20, 221; *Portrait* (*chinzō*) *of Gokū Keinen* 悟空敬念 220; *Portrait of Retired Emperor Go-Toba* (*Go-Toba-in Zō* 後鳥羽院像; Minase Jingū shrine 水無瀬神宮, Osaka prefecture) 219; self-portrait (mentioned in *New Gleanings of Japanese Poetry*) 220

Fujiwara no Sadaie (Teika) 藤原定家 186, 219; *Record of the Clear Moon* (*Meigetsuki* 明月記, diary of Fujiwara no Sadaie 藤原定家日記) 186

Fujiwara no Sukefusa 藤原資房 132; *Shunki* 春記 132

Fujiwara no Sukemasa 藤原佐理 (calligrapher) 142, 459; *Onna Guruma-jō* 女車帖 142–43; *Riraku-jō* 離洛帖 142

Fujiwara no Tadazane 藤原忠実 131; *Chūgaishō* 中外抄 131

Fujiwara no Takanobu 藤原隆信 218, 219; *Gyokuyō* 玉葉 (diary of Kujō Kanezane 九条兼実日記) 219; portraits at Jingo-ji 神護寺 218; sliding door panels at Saishōkō-in 最勝光院 219

Fujiwara no Yorimichi 藤原頼通 127, 129, 151; Phoenix Hall 鳳凰堂 (Byōdō-in 平等院) 127

Fujiwara no Yukinari 藤原行成 (calligrapher) 142; *Hakushi Shikan* 白氏詩巻 (calligraphy) 142

Fujiwara-kyō 藤原京 (capital) 68, 70

fukinuki yatai 吹抜屋台 ("blown-away roof view" of buildings) 164

Fukū Kongō (*see* Amogha)

Fukuda Heihachirō 福田平八郎 (painter) 436, 453; *Carp* (*Koi* 鯉) 436; *Peonies* (*Botan* 牡丹) 436; *Rain* (*Ame* 雨) 438; *Ripples* (*Sazanami* 漣)

Fukui Rikichirō 福井利吉郎 (art historian) 431; *Admonitions Scroll*, copying of 431

Fukūkenjaku Kannon 不空羂索観音 (Kannon of the Unerring Lasso, Amoghapasa) 75–76, 96, 193; Kōfuku-ji 興福寺 **194**

Fukuyama Toshio 福山敏男 46

Fukuzawa Ichirō 福沢一郎 440; *Widow and Temptation* (*Kafu to yūwaku* 寡婦と誘惑) 441; *A Good Cook* (*Yoki ryōrinin* よき料理人) 441

Funahashi site 船橋遺跡 (Osaka prefecture) 22–**23**: jar with a long tapering neck (*hosokubi tsubo* 細頸壺;

Middle Yayoi 弥生中期) **23**

Funaki screens 舟木本 318–**19** (*see also* "scenes in and around the capital")

funpon 粉本 (model books) 344

Furuta Oribe 古田織部 301, 313; Oribe-style (*Oribe-gonomi* 織部好み) 301

furyū (C: *fengliu*) 風流 161, 185–86, 232, 270, 350; elegant pursuits 161; *kazaru* 飾る風流 186; *kushi* (comb) 櫛風流 186

Fushimi Castle 伏見城 287, 295; Kanō Eitoku 狩野永徳 287; Toyotomi Hideyoshi 豊臣秀吉 287

Fusō Ryakki 扶桑略記 (Abbreviated Records of Japan) 41, 70, 152; Hosshō-ji 法勝寺 (Kyoto) 152; Shiba Tatsuto 司馬達等 41; Yakushi-ji East Pagoda 薬師寺東塔 (Nara) 70

fusuma-e 襖絵 (sliding door panel painting) 146

Futurism 438

Fuzankai フュウザン会 (Charcoal Sketching Society) 415

fūzoku-ga 風俗画 (genre painting) 272

gables 破風: Chinese-style (*karahafu* 唐破風) 367; "plover-wing" (*chidori hafu* 千鳥破風) 367

Gakkō Bosatsu 月光菩薩 70, 75, 76, 134

Gandhara 42–43

Gandharan style 43

Gangō-ji 元興寺 (Nara) 109, 119; standing Yakushi Nyorai 薬師如来立像 109

Ganjin Wajō 鑑真和上 (C: *Jianzhen*) 78–79, **80**, **106**, 229

Ganjōju-in 願成就院 (Shizuoka prefecture) 194–**95**; Amida Nyorai 阿弥陀如来, Fudō Myō-ō 不動明王, Bishamonten 毘沙門天 (Unkei 運慶) 194–**95**

gardens (*teien* 庭園) xiii, 41, 47, 127, 129, 151, 216, 233, 255, 344, **365**; daimyo gardens 大名庭園 368–69; Hōjō-ji

法成寺 garden described in *A Tale of Flowering Fortunes* (*Eiga Monogatari* 栄花物語) 151; Hyakkaen 百花園 369; image of the Shinsen-en imperial garden 神泉苑 115; Kairakuen 偕楽園 369; Kanjizaiō-in 観自在王院 (Iwate prefecture) 177; *karesansui* (dry landscape gardens) 枯山水 267; Katsura Imperial Villa (Katsura Rikyū 桂離宮) 314, 369; Kobori Enshū 小堀遠州 313; Koishikawa Kōrakuen 小石川後楽園 369; Kose no Kanaoka 巨勢金岡 144; *Maiko in a Garden* (*Bugi Rinsen* 舞妓林泉; Tsuchida Bakusen 土田麦僊) 433; *Nigiwaigusa* にぎはひ草 314; Pure Land garden (*Jōdo teien* 浄土庭園) 151; *Record of Garden Making* (*Sakuteiki* 作庭記) 151, 267; Rikugien 六義園 369; Ryōan-ji Hōjō teien 龍安寺方丈庭園 268–69; *shinden*-style residence 寝殿造 129, 151; *shoin*-style garden (*shoin* teien 書院庭園) at Daisen-in 大仙院 268; Shugakuin Imperial Villa (Shugakuin Rikyū 修学院離宮) 315; strolling garden (*kaiyū-shiki teien* 回遊式庭園) 314, 369; *The Tale of Genji* (*Genji Monogatari* 源氏物語) description of a garden 314; *Vegetable Garden in Spring* (*Shunpo* 春畝; Asai Chū 浅井忠) 380; Zen 禅 268; Zen'ami 善阿弥 267

Gas Street Lamp and Advertisements (Saeki Yūzō) 428

Gathering at Longshan/Winding Stream at Lanting screens (*Ryūzan Shōe/Rantei Kyokusui-zu byōbu* 龍山勝会・蘭亭曲水図屏風; Ike no Taiga 池大雅) **340**

Gathering at the Central Palace (*Chūden Gyokai-zu* 中殿御会図; Fujiwara no Nobuzane 藤原信実) hanging scroll 219

gathering hall (*kaisho* 会所) 258

Geiami 芸阿弥 266; *Viewing a Waterfall*
(*Kanbaku-zu* 観瀑図; hanging scroll)
267

gekokujō 下剋上 260

Genbō 玄昉 (monk) 69

Gendai Nihon Bijutsu-ten 現代日本
美術展 (Contemporary Japanese Art
Exhibition; Mainichi Newspaper)
454, 462

Genpei War (*Genpei-gassen* 源平合戦)
188

genre paintings (*fūzoku-ga* 風俗画) 115,
147, 272, 285, 287, 318–19, 327, 331,
377, 403

Genshin 源信 126, 131, 206; *Essentials of
Rebirth* (*Ōjō Yōshū* 往生要集) 126–27,
169, 206

Genzu Mandala 現図曼荼羅 103; Li
Zhen 李真 103

getsureizu byōbu 月令図屏風 (C: *yueling
tu pingfeng*) 486n18

giboku 戯墨 ("ink play") 254, 256

Gift of the Ebb Tide (*Shiohi no Tsuto*
潮干のつと; Kitagawa Utamaro
喜多川歌麿) 352; Tsutaya Jūzaburō
蔦屋重三郎 352

Gigaku 伎楽 (dance drama) 77; mask 92

Ginkaku-ji 銀閣寺 (Silver Pavilion, or
Kannon Hall 観音堂) 256–66 (*see also*
Jishō-ji 慈照寺)

Gion festival 祇園祭 (Kyoto) 56

Gion Nankai 祇園南海 339; literati
painting (Nanga 南画) 339

girls' manga (*shōjo manga* 少女漫画) 223,
469

glass 430; cut glass 32, 91

glazed bowl, two-colored (*nisai-bachi*
二彩鉢; Shōsō-in southern repository
正倉院南倉, Tōdai-ji 東大寺, Nara) 92

Glover residence, former (Nagasaki) 391

Go-Fukakusa-in Nijō 後深草院二条 223;
An Unsolicited Tale (*Towazu-gatari*
とはずがたり) 225

Go-Mizuno'o, Retired Emperor

後水尾上皇 315; Shugakuin Imperial
Villa 修学院離宮 315

Go-Shirakawa, Retired Emperor
後白河法皇 152–54, 164, 169, 175,
188, 203, 224, 254, 487n21; *Illustrated
Scrolls of Annual Events* (*Nenjū Gyōji
Emaki* 年中行事絵巻) 153; portrait
of (Myōhō-in 妙法院) 217, 218–19;
Paintings of the Six Realms (*Rokudō-e*
六道絵) 153, 154, 169; pilgrimages to
Kumano 熊野詣 153; popular songs
(*imayō* 今様) 153; Rengeō-in Treasury
蓮華王院宝蔵 153; *Secret Selections
of Songs to Make Dust on the Rafters
Dance* (*Ryōjin Hishō* 梁塵秘抄) 153

Go-Toba, Retired Emperor 後鳥羽上皇
219; portrait of 219

Gōbara site 郷原遺跡 (Gunma prefecture)
14–**15**; heart-shaped *dogū* 14–**15**

God of Wind and God of Thunder screens
(Yasuda Yukihiko) **431**

Goguryeo 高句麗 37, 38, 43–45, 59;
style 45

Gohō Dōji 護法童子 (Protector of the
Dharma) 164, 471

Gohyaku Rakan-ji 五百羅漢寺 (Tokyo)
334, 368; Seated Five Hundred Arhats
(*Gohyaku Rakan Zazō* 五百羅漢坐像;
Shōun Genkei 松雲元慶; Gohyaku
Rakan-ji 五百羅漢寺, Tokyo) **334**;
Sazae-dō さざえ堂 (turbo-shell hall)
368

Gokū Keinen 悟空敬念 (monk) 220;
chinzō 頂相 portrait (Fujiwara no
Nobuzane 藤原信実) 220

gold brocade (*kinran* 金襴) 269–70

Golden Bell Society (*see* Kinrei-sha)

Golden Light Sutra (*Konkōmyō Saishō-ō
kyō* 金光明最勝王経) 68

goldsmithing 黄金細工 33

goma 護摩 (fire ritual) 100

Gomi Fumihiko 五味文彦 231

Goncourt, Edmond de 353

gongen 権現 (avatars) 212

gongen-zukuri 権現造 309; Shōden-dō 聖天堂 (Kangi-in 歓喜院, Saitama prefecture) 366–67

Gongxian grottos 鞏県石窟 (Henan province, China) 43, 52

Gosai-e 御斎会 (ceremony) 100, 121

Goseda Hōryū 五姓田芳柳 (painter) 379

Goseda Yoshimatsu 五姓田義松 (painter) 379, 402; and Huysmans, Joris-Karl (art critic) 380; *Marionette* (*Ayatsuri shibai* 操芝居) 380

Gosen Wakashū (*Later Collection of Japanese Poems* 後撰和歌集) 315; Funabashi *maki-e* writing box (*Funabashi maki-e suzuri-bako* 舟橋蒔絵硯箱; Hon'ami Kōetsu 本阿弥光悦) 315

gōshō 迎接 177, 487n24 (see also *raigō*)

Goshun 呉春 (*see* Matsumoto Goshun)

Gotō Keiji 後藤慶二 (architect) 423; Toyotama Prison (Toyotama Kangoku 豊多摩監獄; Tokyo) 423

Gotō Yūjō 後藤祐乗 (sword ornaments 装剣) 270; high relief (*takaniku-bori* 高肉彫) 270

graffiti 466

Graffiti on the Storehouse Wall (*Nitakaragura Kabe no Mudagaki* 荷宝蔵壁のむだ書; woodblock print; Utagawa Kuniyoshi 歌川国芳) 363

Great Adventure of Horus, Prince of the Sun (*Taiyō no ōji Horusu no daibōken* 太陽の王子ホルスの大冒険) 469

Great Buddha Hall 大仏殿: Hōkō-ji 方広寺 193, 318; Tōdai-ji 東大寺 192

Great Buddha style (Daibutsu-yō 大仏様) 190–91, 193, 246; Pure Land Hall (Jōdo-ji 浄土寺浄土堂, Hyogo prefecture) 192;

Great Buddha 大仏 76–78, 85, 86, 196, 197; Asuka-dera 飛鳥寺 45, 47; Crown 大仏頂 104; Tōdai-ji 東大寺 69, 83; eye-opening ceremony 開眼供養 86; Kamakura (Kōtoku-in 高徳院) 203;

style (Daibutsu-yō 大仏様) 192–195, 249; Tōdai-ji 東大寺 46

Great Cessation and Contemplation (Mohe Zhiguan 摩訶止観; lectures) 126

Great Commander Wise King (Taigensui Myō-ō 大元帥明王) 100

Great Kantō Earthquake (Kantō Daishinsai 関東大震災) 424–25, 446

Great Meireki Fire 明暦の大火 322, 365

Great Ritual and Dance Performance (*Dai dengaku* 大田楽) of the Eichō 永長 era 153

Great South Gate (Nandaimon 南大門): Hosshō-ji 法勝寺 (Kyoto) 152; Tōdai-ji 東大寺 (Nara) **190–91**, 194, **196–97**, 201

grotto temples 石窟寺院 (China) 43

Guanyin, Gibbons, and Crane (*Kannon, Enkaku-zu* 観音・猿鶴図; Muqi Fachang 牧谿法常; Daitoku-ji 大徳寺) hanging scrolls 251; Ashikaga shogunal collections 252–54, 266; Ashikaga Yoshimitsu's 足利義満 "Dōyū" seal "道有"印 and "Tenzan" seal "天山"印 252

Gulin Gingmao 古林清茂 (Kurin Seimu) 236; Chōfuku-ji 長福寺 (Kyoto) 236; *Getsurin* 月林 236, **237**

Guo Xi 郭熙 (painter) 250

Gupta Buddhist art 42, 43, 56, 71

Gutai Bijutsu Kyōkai 具体美術協会 (Gutai Art Association) 457, 463

Guze Kannon 救世観音 (Standing Kannon Bosatsu 観音菩薩立像) **50–51**, 64, 107, 118; Fenollosa viewing 382

Gyōki 行基 112–14; funding for Great Buddha at Tōdai-ji 190

Gyokusen-jō 玉泉帖 (Ono no Michikaze 小野道風; calligraphy) 142–**43**

Gyokuyō 玉葉 (diary of Kujō Kanezane 九条兼実日記) 219

haboku 破墨 ("broken" ink-painting style) 83

Hachiman Manifesting in the Form of a Monk (*Sōgyō Hachiman-shin Yōgō-zu* 僧形八幡神影向図; Ninna-ji 仁和寺, Kyoto) hanging scroll 217

Hagio Moto 萩尾望都 (manga artist) 469; *The Poe Family* (*Pō no ichizoku* ポーの一族) 469–70

Haguro mirrors 羽黒鏡 (Dewa shrine 出羽神社, Yamagata prefecture) 184

Hair (Kobayashi Kokei) **432**

Haji earthenware (*hajiki* 土師器) 36, 482n10; *kofun* burial mounds 36

Hakogi House 箱木家 (*minka* 民家; Kobe, Hyogo prefecture) **336**;

Hakuba-kai (*see* White Horse Society) 400

hakubyō (白描 *baimiao*; "white painting") technique 104, 222–23, 250; *Essential Meditations on the Five Families of the Mind* (*Gobu Shinkan* 五部心観) 104; *Eyeless Sutra* (*Menashi-kyō* 目無し経) 222; *Illustrated Scroll of Toyo no Akari* (*Toyo no Akari Ezōshi* 豊明絵草紙) handscroll **223**; *Illustrations of the Mudras for the Susiddhi Ritual Procedure* (*Soshitsuji Giki Keiin-zu* 蘇悉地儀軌契印図) 104; *Romantic Story of Lord Takafusa* (*Takafusa-kyō Tsuya-kotoba Emaki* 隆房卿艶詞絵巻) 223

hakubyō-e 白描絵 (or *shira-e* 白絵, "white pictures") 222, 469

Hakuhō period 白鳳時代 36, 55

Hakuin Ekaku 白隠慧鶴 338, 343–44, 346, 369, 458, 467, 475; Shōin-ji 松蔭寺 343; *Bodhidharma* (*Daruma-zō* 達磨像) 343–**44**; *Bodhidharma* (*Daruma-zu* 達磨図; Shōjū-ji 正宗寺, Toyohashi, Aichi prefecture) 343; *Bodhidharma* (*Hanshin Daruma* 半身達磨; Manju-ji 万寿寺, Oita prefecture) 344

Hakuja den (see *Tale of the White Serpent*)

Hakushi Shikan 白氏詩巻 (Fujiwara no Yukinari 藤原行成; calligraphy) 142

Half-Dried Bonito (Takahashi Yuichi) 376

Hamada Chimei 浜田知明 (print artist): *Requiem for a New Recruit* (*Shonenhei aika* 初年兵哀歌) 451

Hamada Shōji 濱田庄司 (ceramicist) 478

Hamaguchi Yōzō 浜口陽三 (print artist) 455

Hamaya Hiroshi 浜谷浩 (photographer) 473

Han Yu 韓愈 (scholar) 249

Hanabusa Itchō 英一蝶 (painter) 323–24; *Leading a Horse at Dawn* (*Chōton Eiba-zu* 朝暾曳馬図) 323–24

Hand (Takamura Kōtarō) 422

haniwa 埴輪 23, 26, 32–35, 56, 72; boy playing a zither (*koto o hiku danshi* 琴を弾く男児; Asakura site 朝倉遺跡, Gunma prefecture) 35; deer (*mikaeri no shika* 見返りの鹿; Hiradokoro site 平所遺跡, Shimane prefecture) **34**; falconer (*takashō* 鷹匠; Sakai-chō, Isesaki 伊勢崎市境町, Gunma prefecture) **34**

Hanshan (Kanzan 寒山) 417

Harada Masayuki 原田昌幸 16

Harada Naojirō 原田直次郎 (painter) 385; *Kannon Riding a Dragon* (*Kiryū Kannon* 騎龍観音) 385

Hara Yōyūsai 原羊遊斎 364; *inrō* with design of squid, shells, and seaweed **364**

Harunari Hideji 春成秀爾 481n5

Harunobu (*see* Suzuki Harunobu)

Harvest (Asai Chū) 380

Hasegawa Kyūzō 長谷川久蔵 (painter) 291

Hasegawa Tōhaku 長谷川等伯 (formerly active as Shinshun 信春; painter) 291; *Pine Forest* screens (*Shōrin-zu byōbu* 松林図屏風) 291, **292**–93; Chichaku-in walls and sliding doors 智積院障壁画 **292**

Hashiguchi Goyō 橋口五葉 (woodblock print artist, painter) 419

Hashihaka burial mound 箸墓古墳 (Nara prefecture) 31

Hashimoto Gahō 橋本雅邦 (painter) 406, 407; *Screens with Tiger and Dragon* (*Ryūko-zu byōbu* 龍虎図屏風) 406

Hashimoto Osamu 橋本治 115

Hata no Chitei 秦致貞 150; *Illustrated Biography of Prince Shōtoku* (*Shōtoku-taishi Den E* 聖徳太子伝絵) screens 149–50

Hata Teruo 秦テルヲ (painter) 435

hatchet marks (*natame* 鉈目) 134

hatchet-carved sculptures (*natabori-zō* 鉈彫り像) 112, 134, 369

hatsuboku 溌墨 (splashed-ink) technique 252, 293–94; *Eight Views of the Xiao and Xiang Rivers* (*Shōshō Hakkei* 瀟湘八景; Yujian 玉澗) 252; Kaihō Yūshō 海北友松 293

Hatsune Dowry (Hatsune no chōdo 初音の調度) 312–**13**

haya-raigō 早来迎 (see *raigō*)

Hayami Gyoshū 速水御舟 (painter) 432–**34**; *Chrysanthemums* screens (*Kikka-zu byōbu* 菊花図屏風) 432; *Dancing in the Flames* (*Enbu* 炎舞) 433–**34**; *Kyoto Dancing Girl* (*Kyō no maiko* 京の舞妓) 432; *Scattering Camellia Blossoms* (*Meiju chiritsubaki* 名樹散椿) 433; *Sunflowers* (*Himawari* 向日葵) 432; *Tree* (*Juki* 樹木) 433

Hayashi Jikkō 林十江 (painter) 357

Hayashiya Tatsusaburō 林屋辰三郎 152–53

Head of the Buddha (Buttō 仏頭; Kōfuku-ji 興福寺, Nara) 55; Yamada-dera 山田寺 55

Healing Spirits (Maeda Seison) 431

Healthy Living Through Drinking Tea (*Kissa yōjō ki* 喫茶養生記; Eisai 栄西) treatise 233

heavenly being (*deva, ten* 天) 41

Heavy Hand (Tsuruoka Masao) 451

Heian-kyō 平安京 (Kyoto): transfer to 68, 94–95

heidatsu 平脱 (or *hyōmon* 平文, C: *pingtuo*) technique 89

Heiji Disturbance (Heiji no ran 平治の乱) 152

Heijō-kyō 平城京 (Nara) 40, 55, 68, 69, 70, 72; transfer from 95

Heike Nōkyō 平家納経 (Taira family sutras) 159; Devadatta Chapter (Daibadatta-bon 提婆達多品) 159

hell (*jigoku* 地獄) 225, 228: folding screens 206; Foujita Tsuguharu 藤田嗣治 444; *Hells Scrolls* (*Jigoku Zōshi* 地獄草紙) 169–70, **171**–72; *Hiroshima Panels* (*Genbaku no zu* 原爆の図) 452; in *Nine Grades of Rebirth* (*Kuhon Raigō-zu* 九品来迎図; Taishi-dō, Kakurin-ji 鶴林寺太子堂, Hyogo prefecture) 140; Rodin's *Gates of Hell* 413; in *rokudō* 六道 169; *Ten Kings of Hell* (*Jūō-zu* 十王図; Jōfuku-ji 浄福寺, Kyoto) 272; subdivisions of 126

Hell and Paradise folding screens (*Jigoku Gokuraku-zu byōbu* 地獄極楽図屏風; Konkai Kōmyō-ji 金戒光明寺, Kyoto) 206

Hells Scroll (*Jigoku Zōshi* 地獄草紙) 169, 170, 171

helmets, unusual (see *kawari kabuto*)

Heresy (Kobayashi Kokei) 430

Hi Red Center (Hai Reddo Sentā ハイレッド・センター) 462–63

Hibino Gohō 日比野五鳳 (calligrapher) 459; *Iroha Poem* screen (*Iroha uta* いろは歌) 459–**60**

hibutsu 秘仏 ("secret Buddha") 49, 104; *Yellow Fudō* (*Ki Fudō* 黄不動; Onjō-ji 園城寺, Shiga prefecture) 104

Hida no kami Korehisa 飛騨守惟久 (painter) 225; *Illustrated Scrolls of Latter Three Years' War* (*Go-sannen*

Kassen Emaki 後三年合戦絵巻)
224–25

Hideyoshi (*see* Toyotomi Hideyoshi)

Hieda Kazuho 稗田一穂 (painter) 472

Higashiyama culture 東山文化 244–45,
249, 265 ff

Higashiyama Kaii 東山魁夷 (painter)
453, 472; *Afterglow* (*Zanshō* 残照) 453;
Road (*Michi* 道) **453**

High Tang 盛唐 69, 72, 78, 82, 85, 485n7

Higo Bettō Jōkei 肥後別当定慶 (sculptor)
202; standing Shō Kannon Bosatsu
聖観音菩薩立像 (Kurama-dera
鞍馬寺, Kyoto) 202

hikime kagibana 引目鉤鼻 (slit for eyes,
hook for nose) 164

Hikone Castle (Hikone-jō 彦根城; Shiga
prefecture) 295–**96**

Hikone screens (*Hikone byōbu* 彦根屏風)
319, **320**

Himeji Castle (Himeji-jō 姫路城; Hyogo
prefecture) 296

Himiko 卑弥呼 25, 28, 30, 31; *Wei Zhi*
魏志 25,

Hinduism 95

Hiradokoro site 平所遺跡 (Shimane
prefecture) **34**; *haniwa* of a deer
(*mikaeri no shika* 埴輪 見返りの鹿) **34**

Hiraga Gennai 平賀源内 (pharmacologist/
author) 358

Hirai Terushichi 平井輝七 (photographer)
473

Hiraizumi 平泉 (Iwate prefecture) 176,
177; Golden Hall (Konjiki-dō
金色堂) 141; Northern Fujiwara
(Ōshū Fujiwara-shi 奥州藤原氏) 175

hiranuri 平塗 (flat application of paint)
477

Hirayama Ikuo 平山郁夫 (painter) 472

Hirō Gongen 飛滝権現 216

Hirō shrine (Hirō-jinja 飛滝神社,
Wakayama prefecture) 215; Nachi
grand shrine (Nachi taisha 那智大社)
214

Hirose Kinzō 広瀬金蔵 (or Ekin 絵金;
painter) 389

Hiroshima Panels (Maruki Iri and Maruki
Toshi) 452

Hiroshima Peace Memorial Museum
(Hiroshima Heiwa Kinen Shiryōkan
広島平和記念資料館; Tange Kenzō)
460

Hishida Shunsō 菱田春草 (painter) 407,
478; *Widow and Orphan* (*Kafu to koji*
寡婦と孤児) 407; *Fallen Leaves*
(*Ochiba* 落葉) **408**

Hishikawa Moronobu 菱川師宣 327,
331–32, 348, 351, 355; *Aspects of
the Yoshiwara* (*Yoshiwara no Tei*
よしはらの躰) **331**; Hishikawa
style (Hishikawa-yō 菱川やう) 331;
Minashiguri 虚栗 (Takarai Kikaku
宝井其角) 331

Historic Spots of Rome (Takeuchi Seihō)
410, 411

historicism (*rekishi shugi* 歴史主義;
architecture) 411–13, 422, 447, 490n5;
historicist architecture 450; historicist
approach 395

Hizen Nagoya Castle 肥前名護屋城
(Saga prefecture) 287; Kanō Mitsunobu
狩野光信 287; Toyotomi Hideyoshi
豊臣秀吉 287

Hōgen Disturbance (Hōgen no ran
保元の乱) 152

hōgen 法眼 (sculptor title) 132, 195,
486n15

hōin 法印 (sculptor title) 134, 201, 232,
486n15

Hōjō Sadatoki 北条貞時 234

Hōjō Takatoki 北条高時 188

Hōjō Tokimune 北条時宗 234

Hōjō Tokiyori 北条時頼 (portrait
sculpture) 203

Hōjō-ji 法成寺 (Kyoto; Fujiwara no
Michinaga 藤原道長) 132; Dainichi
Nyorai 大日如来 (Jōchō 定朝; Kondō
金堂) 132; garden described in *A Tale*

of *Flowering Fortunes* (Eiga Monogatari
栄花物語) 151; Kasuga shrine mandala
(*Kasuga miya mandara* 春日宮曼荼羅;
sliding doors) 212; Muryōju-in
無量寿院 (precursor of Hōjō-ji) 127,
131, 177; Nine Figures of Amida (Kutai
Amida 九体阿弥陀; Jōchō 定朝 and
Kōshō 康尚) 131; *raigō-zu* 来迎図
(Amida Hall 阿弥陀堂) 135

Hōjōki 方丈記 (Record of a Hut;
Kamo no Chōmei 鴨長明) 153

Hōkai-ji 法界寺 (Kyoto) 134, 178; seated
Amida Buddha (Amida Butsu *zazō*
阿弥陀仏坐像; Chōsei 長勢) 134, 178;
Amida Hall (Amida-dō 阿弥陀堂) 178

Hokke-dō 法華堂 (Lotus Hall): Tōdai-ji
東大寺 (former Hall of Kannon's
Unerring Lasso, Kenjaku-dō 羂索堂)
75

Hokke-ji 法華寺 (Nara): *Amida Triad with
Banner-Bearing Youths* (*Amida Sanzon
oyobi Jiban Dōji* 阿弥陀三尊及び
持幡童子像) 157; Eleven-Headed
Kannon (Jūichimen Kannon
十一面観音) 111, **113**

hokkyō 法橋 (sculptor title) 132, 486n15

Hōkō-ji 方広寺 (Kyoto): Great Buddha
Hall 大仏殿 193

Hōkoku Festival screens (*Hōkoku Sairei-zu
byōbu* 豊国祭礼図屏風; Kanō Naizen
狩野内膳; Hōkoku shrine 豊国神社,
Kyoto) 296–97

Hōkoku mausoleum (Hōkoku-byō
豊国廟) 291; Hōgon-ji 宝厳寺
Chinese Gates (Karamon 唐門) 290;
Toyotomi Hideyoshi 豊臣秀吉 291;
Tsukubusuma shrine 都久夫須麻神社
main hall (Chikubu Island 竹生島)
290–91

hollow dry lacquer (see *datsu kanshitsu*)

Holy Resurrection Cathedral 東京復活
大聖堂教会 (Nikolai-dō ニコライ堂;
Tokyo; Conder) 394

Hon'ami Kōetsu 本阿弥光悦 **315–17**;

Funabashi *maki-e* writing box
(*Funabashi maki-e suzuri-bako*
舟橋蒔絵硯箱) 315; "Rainclouds"
(Amagumo 雨雲; teabowl) **315**;
Otogoze 乙御前 (Otome Gozen;
teabowl) 315; "Late-Autumn Shower"
(Shigure 時雨; teabowl) 315; Mt.
Fuji (Fuji-san 不二山; teabowl) 315;
*Anthology of the Thirty-Six Poets
with Crane Design* (*Tsuru Shitae
Sanjūrokkasen Waka Kan*
鶴下絵三十六歌仙和歌巻) **316–17**

hon'yō 本様 (classical style/form) 132,
134, 179, 193

Hōnen 法然 189, 206; *Illustrated
Biography of Priest Hōnen*
法然上人伝絵巻 229, 257

Hongō Yayoi-chō 本郷弥生町 (shell
middens) 20; Yayoi earthenware
(Yayoi doki 弥生土器) 20

honji suijaku 本地垂迹 (theory) 212–14

honji-butsu 本地仏 (Buddhist divinity,
Buddhist identity) 212, 213, 216

honpa style 翻波式 (sculpture) 82, 106,
120–21

Horiguchi Sutemi 堀口捨己 (architect)
423; Shiensō 紫烟荘 (Purple Smoke;
Saitama prefecture) 423

Hōryū-ji 法隆寺 (Nara prefecture) 32, 45,
47, **50**, 52, 61, 72, 254, 382, 411; Great
Treasure Gallery 大宝蔵院 48, 52, 56,
57; murals of 63, 53; five-story pagoda
at 五重塔 77; statues of 48; Wakakusa
precincts 若草伽藍 45

Hosoe Eikō 細江英公 (photographer) 473

Hosshō-ji 法勝寺 (Retired Emperor
Shirakawa 白河法皇; Kyoto) 152–53,
177; Birushana 毘盧遮那 152; *Fusō
Ryakki* 扶桑略記 (Abbreviated Records
of Japan) 152; octagonal nine-story
pagoda 八角九重塔 152

Hosshō-ji 法性寺 (Fujiwara no
Tadahira 藤原忠平; Kyoto) 127, 131;
Fudō-Myō-ō 不動明王 (Kōshō 康尚;

currently at Tōfuku-ji 東福寺, Kyoto) 131

Hōsun 方寸 (An Inch Square) journal 420

Hotei 布袋 (Budai): Mokuan 黙庵 255–56; Sengai 仙厓 **317**; Takuma Eiga 宅間栄賀 255

hotoke (or *butsu*) 仏 135

hotoke no ezō 仏の絵像 135

hottate-style 掘立式 (architectural style) 336; Hakogi House 箱木家 (*minka* 民家) **336**

Huiguo (Keika 恵果; monk) 96, 97, 102, 103, 105

Huineng 慧能 232; *Platform Sutra of the Sixth Patriarch* 六祖壇経 232–33

Humane King Sutra (*Ninnō-kyō* 仁王経) 104, 121

hungry ghosts (*gaki* 餓鬼) 154, 169, 171–72; *Scrolls of Hungry Ghosts* (*Gaki Zōshi* 餓鬼草紙) 171–73

Huysmans, Joris-Karl (art critic) 380

Hwangryongsa 皇竜寺 (Silla) 484n7

Hyakkaen 百花園 (garden; Tokyo) 369

Hyakutake Kaneyuki 百武兼行 (painter) 381; *Reclining Nude* (Garahu 臥裸婦) **381**

ichiboku-zukuri 一木造 (single-wood-block sculptures) 49, 82, 106, 107, 112, 121, 132, 134

Ichigyō 一行 (Yixing) 105

Ichikawa Beian 市河米庵 (Confucian scholar/calligrapher) 369

Ichiyō (Kaburaki Kiyokata) **437**; Higuchi Ichiyō 樋口一葉 (author) 436

iconography 75–76, 96, 101, 123; Esoteric Buddhist 密教 76, 96–97, 132; non-Japanese 118

Ide Seinosuke 井手誠之輔 246, 488n1

Idera burial mound 井寺古墳 (Kumamoto prefecture) 482n11

Idojiri site 井戸尻遺跡 (Nagano prefecture) 6–8; Katsusaka-type pots 勝坂式土器 6; Middle Jōmon pit

house (*Jōmon chūki tateana jūkyo* 縄文中期竪穴住居) 7–8

Iga ware 伊賀焼 301–302

Igami Bonkotsu 伊上凡骨 (woodblock cutter) 489n4

Igarashi Shinsai 五十嵐信斎 (lacquer craftsman) 269

iji dōzu 異時同図法 (technique) 62, 166

ikakeji lacquer 沃懸地 (technique) 181, 183, 240

Ike no Taiga 池大雅 307, 338, 339, 343–44, 369; *Blue-and-Green Landscape Album* (*Seiryoku Sansui-chō* 青緑山水帖) 340; *Gathering at Longshan/Winding Stream at Lanting* screens (*Ryūzan Shōe/Rantei Kyokusui-zu byōbu* 龍山勝会・蘭亭曲水図屛風) **340**; *Red Cliff at Lake Dongting* (*Dōtei Sekiheki Zukan* 洞庭赤壁図巻) 340; *Eight Views of Xiao and Xiang* screens (*Shōshō Hakkei* 瀟湘八景) 340; *Five Hundred Arhats* (*Gohyaku Rakan-zu* 五百羅漢図) 340

Ikeda Masuo 池田満寿夫 (print artist, painter, sculptor) 455

iki ningyō 生人形 ("living dolls") xiii, 377, 378

Illustrated Bibliography of the Saintly Ippen (*Ippen Shonin Den Emaki* 一遍上人伝絵巻 or *Ippen Hijiri-e* 一遍聖絵) handscrolls 206, 228, **230**; 257; En'i 円伊 228, 231; Kankikō-ji 歓喜光寺 (Kyoto) 229; Shōkai 聖戒 229; Shōjōkō-ji 清浄光寺 (Kanagawa prefecture) 229

Illustrated Biographies of the Kegon Patriarchs (*Kegon Shūso Shiden Emaki* or *Kegon Engi* 華厳宗祖師伝絵巻 [華厳縁起]) handscrolls 228–29; Kōzan-ji 高山寺 (Kyoto); Myōe 明恵; Shanmiao 善妙 (Zennyō) 228; Uisang 義湘 (Gishō) 228; Wonhyo 元暁 (Gangyō) 228

Illustrated Biography of Priest Hōnen

(*Hōnen Shōnin Den Emaki*
法然上人伝絵巻; Chion-in 知恩院)
handscrolls 229, 257

Illustrated Biography of Priest Shinran
(*Shinran Shōnin Eden* 親鸞聖人絵伝;
Shōgan-ji 照願寺, Chiba prefecture)
handscrolls 257

Illustrated Biography of Prince Shōtoku
(*Shōtoku-taishi Den E* 聖徳太子伝絵;
Hata no Chitei 秦致貞) screens 149–50

illustrated books 絵本, 挿絵入り本 332,
376: Chinese 350; *ehon* 絵本 355–56:
kibyōshi (short comic novels) 黄表紙
355; *chōhōki* 重宝記 (general reference
books) 355; *kyōka-bon* 狂歌本
(anthologies of comic poems) 352–53;
hiinagata-bon 雛形本 (design books)
355; *shunpon* 春本 (*ehon* or *enpon*
艶本; sexually explicit books) 356;
travel guides (*dōchūki* 道中記/*saikenki*
細見記) 355; *yomihon* 読本 (long
multipart narratives) 355

illustrated handscrolls (*emaki* 絵巻) 85,
155, 163–67, 221–31, 257, 272; fictional
contests between teams of craftsmen
and laborers (*shokunin zukushi uta
awase* 職人尽歌合) 224; fictional tales
(*tsukuri monogatari* 作り物語) 222;
illustrated tales (*monogatari-e* 物語絵)
222; legendary origins and histories of
shrines and temples (*shaji engi-e*
社寺縁起絵) 222, 226; paintings of
great poets (*kasen-e* 歌仙絵) 222,
230–31; pictorial biographies of
eminent Buddhist priests and patriarchs
(*kōsōden-e* 高僧伝絵) 222, 228; poetry
contests (*uta awase-e* 歌合絵) 222–23;
popular narratives (*setsuwa-e* 説話絵)
222, 225–26; Song period 宋代 222;
war tales (*kassen-e* 合戦絵) 222, 224–25

*Illustrated History of the Eastern
Expedition* (*Tōsei Den Emaki*
東征伝絵巻; Tōshōdai-ji 唐招提寺)
handscrolls 229; Ganjin Wajō

鑑真和上 229

*Illustrated Legends of the Kitao Tenjin
Shrine* (*Kitano Tenjin Engi Emaki*
北野天神縁起絵巻) handscrolls 227;
Sugawara no Michizane 菅原道真 227

Illustrated Origins of Ishiyama Temple
(*Ishiyama-dera Engi Emaki* 石山寺
縁起絵巻; Ishiyama-dera 石山寺)
handscrolls 257

illustrated popular tales (*otogi zōshi emaki*
御伽草子絵巻) 225, 246, 257, 259;
Legends of Urashima Myōjin (*Urashima
Myōjin Engi* 浦島明神縁起*); Night
Procession of One Hundred Demons*
(*Hyakki Yagyō Emaki* 百鬼夜行絵巻)
246, 259; *Origins of Dōjō-ji Temple*
(*Dōjō-ji Engi* 道成寺縁起) 259; *Tale of
Ame-no-Wakahiko* (*Ame-no-Wakahiko
Sōshi* 天稚彦草子) 259; *Tale of
Wealth and Prosperity* (*Fukutomi Sōshi*
福富草子) 259

Illustrated Scripture of Cause and Effect
(*E Inga-kyō* 絵因果経) handscrolls 164

*Illustrated Scroll of the Imperial Guard
Cavalry* (*Zuishin Teiki Emaki* 随身
庭騎絵巻; attributed to Fujiwara no
Nobuzane 藤原信実) handscroll
219–**20**, 221

*Illustrated Scroll of the Legends of Kokawa
Temple* (*Kokawa-dera Engi Emaki*
粉河寺縁起絵巻) handscroll 168–69

*Illustrated Scroll of the Tale of Obusuma
Saburō* (*Obusuma Saburō Emaki*
男衾三郎絵巻) handscroll 223, 225

Illustrated Scroll of the Tales of Ise (*Ise
Monogatari Emaki* 伊勢物語絵巻)
handscroll 222

Illustrated Scroll of Toyo no Akari (*Toyo no
Akari Ezōshi* 豊明絵草紙) handscroll
223; *hakubyō* (白描) technique 222–23

Illustrated Scrolls of Annual Events
(*Nenjū Gyōji Emaki* 年中行事絵巻)
handscrolls 100, 153

Illustrated Scrolls of Minister Kibi's Journey

to Tang (*Kibi-no-Otodo* or *Kibi-Daijin Nittō Emaki* 吉備大臣入唐絵巻) handscrolls 169; Kibi no Makibi 吉備真備 169

Illustrated Scrolls of Sudhana's Pilgrimage (Zenzai Dōji Rekisan-zu 善財童子歴参図) handscrolls 168

Illustrated Scrolls of the Courtier Ban Dainagon (Ban Dainagon Ekotoba 伴大納言絵詞; attributed to Tokiwa Mitsunaga 常盤光長) handscrolls 154, 164, 166, 167, 224, 467

Illustrated Scrolls of the Diary of Murasaki Shikibu (Murasaki Shikibu Nikki Emaki 紫式部日記絵巻) handscrolls 222

Illustrated Scrolls of the Latter Three Years' War (Go-sannen Kassen Emaki 後三年合戦絵巻; Hida no kami Korehisa 飛騨守惟久) handscrolls 224–25

Illustrated Scrolls of the Legend of the Taima Mandala (Taima Mandara Engi Emaki 当麻曼荼羅縁起絵巻; Kōmyō-ji 光明寺, Kamakura) handscrolls 228; Princess Chūjō (中将姫) 228

Illustrated Scrolls of the Legends of Shigisan (Shigisan Engi Emaki 信貴山縁起絵巻) handscrolls 154, 155, 164, 165–66, 167, 467, 472; Chōgosonshi-ji 朝護孫子寺 (Nara prefecture) 164; Emperor Daigo 醍醐天皇 164; Gohō Dōji (Protector of the Dharma) 護法童子 164, 471; Myōren (monk) 妙蓮 164; *otoko-e* (men's pictures) 男絵 163–64; "The Rite of Spiritual Empowerment for the Engi-era Emperor" (second scroll) 延喜加持の巻 164; "The Wealthy Man of Yamazaki" ("Yamazaki Chōja no maki" 山崎長者の巻; or "Scroll of the Flying Storehouse" ["Tobikura no maki"] 飛倉の巻; first scroll) 164

Illustrated Scrolls of the Miracles of the Kasuga Deity (Kasuga Gongen Kenki Emaki 春日権現験記絵巻) handscrolls 215, 228

Illustrated Scrolls of the Mongol Invasion (Mōko Shūrai Emaki 蒙古襲来絵巻) handscrolls 225

Illustrated Scrolls of the Origin of Matsuzaki Tenjin Shrine (Matsuzaki Tenjin Engi Emaki 松崎天神縁起絵巻) handscrolls 227

Illustrated Scrolls of the Tale of Genji (Genji Monogatari Emaki 源氏物語絵巻) handscrolls 129, 143, 154, 164; *fukinuki yatai* 吹抜屋台 ("blown-away roof view" of buildings) 164; *hikime kagibana* 引目鉤鼻 (slit for eyes, hook for nose) 164; *onna-e* (women's pictures) 女絵 164; *tsukuri-e* つくり絵 ("produced paintings") 164

Illustrated Scrolls of the Tale of the Heiji (Heiji Monogatari Emaki 平治物語絵巻) handscrolls 224; "Battle of Rokuhara" 六波羅合戦の巻 224; "Night Attack on Sanjō Palace" 三条殿夜討の巻 224; "Removal of the Imperial Family to Rokuhara" 六波羅行幸の巻 224; "Tale of Shinzei" 信西の巻 224

Illustrated Scrolls of Visits to the Fifty-Five Kegon Masters (Kegon Gojūgo-sho Emaki 華厳五十五所絵巻) handscrolls (see *Illustrated Scrolls of Sudhana's Pilgrimage*)

Illustrated Tale of Sumiyoshi (Sumiyoshi Monogatari-e 住吉物語絵) 163

Illustrated Tale of Utsubo (Utsubo Monogatari-e 宇津保物語絵) 163

illustrated tales (*monogatari-e* 物語絵) 222

Illustrations of the Mudras for the Susiddhi Ritual Procedure (Soshitsuji Giki Keiin-zu 蘇悉地儀軌契印図; Tō-ji 東寺) handscroll 104; *hakubyō* (白描) technique 104; Shūei 宗叡 103–104

Imai Toshimitsu 今井俊満 (painter) 456

Imamura Shikō 今村紫紅 (painter) 432;

Tropical Lands handscroll (*Nekkoku no maki* 熱国の巻)

Imanishi House 今西家 (*minka* 民家; Nara prefecture) 336

Imari ware 伊万里焼 324

Imperial Academy of Art (*see* Teikoku Bijutsuin)

Imperial College of Engineering (Kōbu Daigakkō 工部大学校) 379, 393, 411

imperial court 宮廷 193, 252; culture of 宮廷文化 188, 244, 314; *e-dokoro azukari* 絵所預 272; painting academy 275; political control 238, 256;

Imperial Crown (*teikan* 帝冠) style architecture 447, 450

Imperial Palace (Kyoto) 310; Kanō Tan'yū 狩野探幽 310;

"In Praise of Shadows" ("In'ei raisan" 陰翳礼讃; Tanizaki Jun'ichirō 谷崎潤一郎) 438

In school 院派 of sculpture 202, 246

Inchō 院朝 (sculptor) 134

Independent Art Association (Dokuritsu Bijutsu Kyōkai 独立美術協会) 441

India 42, 43, 69, 95, 96–97, 102, 105, 140, 199, 412, 485n7

Industrial Zone, Kōtō Ward (Yasaki Hironobu) **443**

ink landscape paintings: Chinese 250

ink painting 水墨画 217, 248–56, 259, 265, 266, 403; Chinese 中国 248, 249–51, 260–61, 278, 291; *haboku* ("broken") style 破墨 83; Itō Jakuchū 伊藤若冲 344; Japanese 254–56; Kamakura 鎌倉 217; Kanō Eitoku 狩野永徳 285; *kara-e* 唐絵 249; Kissan Minchō 吉山明兆 260–61; Muromachi 室町 291, 310, 339, 346; Muqi Fachang 牧谿法常 291; Nakagawa Hachirō 中川平八郎 403; Sesshū Tōyō 雪舟等楊 275; Shūbun 周文 265, 275; Soga Shōhaku 曾我蕭白 346

Inoue Tadashi 井上正 111–112, 134

Inokuma Gen'ichirō 猪熊弦一郎 (painter) 456

Inoue Chōzaburō 井上長三郎 (painter) 452, 454; *Death Ship* (*Hyōryū* 漂流) 452

Inoue Shōichi 井上章一 449–50

Inoue Yūichi 井上有一 (calligrapher) 458, 459; *Foolishly Adamant* (*Gutetsu* 愚徹) **458**

inrō 印籠 364; *inrō* with design of squid, shells, and seaweed (Hara Yōyūsai 原羊遊斎) **364**

Insei art 院政美術 94

Insei period 院政時代 217; Insei-period culture 院政時代の文化 94, 151–55, 180

Institute for Dutch Studies (*see* Bansho Shirabesho)

Institute for Western Studies (*see* Yōsho Shirabesho)

Inten 院展 (Japan Art Institute Exhibition) 407, 429–30, 433, 453; revival of 429–33

Ippen Hijiri-e 一遍聖絵 (*see Illustrated Biography of the Saintly Ippen* scrolls)

Ippen, Priest 一遍上人 206, 221; *odori nenbutsu* 踊り念仏 488n5; "Renunciatory Saint" (*sute-hijiri* 捨聖) 488n5; *shujō ōjō* 衆生往生 488n5

Iroha Poem screen (Hibino Gohō) 459–60

iron-wire lines (*see tessen-byō*)

Ise 伊勢 (poet) 231; pictures of Thirty-Six Poets (*Sanjūrokkasen-e* 三十六歌仙絵), Gotoba-in scroll 後鳥羽院本 (Senshū-ji 専修寺, Mie prefecture) 231

Ishida Hisatoyo 石田尚豊 274

Ishigami site 石神遺跡 (Nara prefecture) 47; Asuka-period water clock (*mizu-dokei* 水時計) 47; *dōsojin* 道祖神 47

Ishii Hakutei 石井柏亭 (painter, woodblock print artist) 403, 414

Ishimoda Shō 石母田正 154

Isozaki Arata 磯崎新 191, 465–66, 488n1;

Great South Gate (Nandaimon 南大門, Tōdai-ji 東大寺, Nara) 191; Pure Land Hall (Jōdo-dō 浄土堂, Jōdo-ji 浄土寺, Hyogo prefecture) 191; Kitakyūshū Central Library (Kitakyūshu-shi Chūō Toshokan 北九州市中央図書館; Fukuoka prefecture) 465; Kitakyūshū Municipal Museum of Art (Kitakyūshū Shiritsu Bijutsukan 北九州市立美術館; Fukuoka prefecture) 465

Itaya Hazan 板谷波山 (ceramicist) 398; vase with auspicious flowers and peach sprays 398

Itazuke site 板付遺跡 (Fukuoka prefecture) 22; Itazuke-type jar (*Itazuke-shiki somon tsubo-gata doki* 板付式素文壺型土器; Early Yayoi 前期弥生) 22

Itō Chūta 伊東忠太 (architect) 411, 412; "A Philosophy of Architecture" ("Kenchiku tetsugaku" 建築哲学) (dissertation) 411; *Itō Chūta's Field Notes: Qing, Vol. III* (*Itō Chūta kenbun yachō Shin-koku III* 伊東忠太見聞野帖 清国III) 412; Okura Museum of Art (Ōkura Shūkokan 大倉集古館; Tokyo), Tsukiji Hongan-ji temple (築地本願寺; Tokyo) 412; "Report on the Architecture of Hōryū-ji Temple" (Hōryū-ji kenchiku ron 法隆寺建築論) 411; Yushima Seidō 湯島聖堂 (Tokyo) 412

Itō Jakuchū 伊藤若冲 307, 323, 338, 343, 344–45, 338, 467, 476; *Colorful Realm of Living Beings* (*Dōshoku Saie* 動植綵絵) **345**; *Golden Pheasant in the Snow* (*Setchū Kinkei-zu* 雪中錦鶏図) 476; *Roosters and Cactus* sliding doors (*Saboten Gunkei-zu fusuma-e* 仙人掌群鶏図襖絵) 344; *Screens with Plants, Birds, and Animals* 475; *Vegetable Parinirvana* (*Yasai Nehan-zu* 野菜涅槃図) 344; *Birds, Animals, Flowers, and Plants* (*Chōjū Kaboku-zu byōbu* 鳥獣花木図屏風) **346**, 475

Itō Shinsui 伊東深水 (woodblock print artist, painter) 419, 453

Itsukushima shrine (Itsukushima-jinja 厳島神社, Hiroshima prefecture) 159–60, 162, **163**, 181, 239, 407; *Heike Nokyō* 平家納経 159–60; *kaeshi odoshi-yoroi* with cherry blossoms (*kozakura kawa kikaeshi odoshi-yoroi* 小桜韋黄返威鎧) 239; painted folding fan (*sai-e hiōgi* 彩絵檜扇) 162–63; *Qu Yuan* (*Kutsugen* 屈原; Yokoyama Taikan 横山大観) 407; small Chinese-style chest with cranes with sprigs of pine in their beaks (*matsukui-zuru kokarabitsu* 松喰鶴小唐櫃) 181

Itsunen 逸然 (Ōbaku priest-painter) 338

ivory (*zōge* 象牙) 335, 365, 397

Iwasa Matabei Katsumochi 岩佐又兵衛勝以 318–20, **321**; Araki Murashige 荒木村重 319; *Handscroll of the Tale of Lady Tokiwa in the Mountains* (*Yamanaka Tokiwa Monogatari Emaki* 山中常盤物語絵巻) 319; *Handscroll of the Tale of Jōruri* (*Jōruri Monogatari Emaki* 浄瑠璃物語絵巻) 319

Iwashimizu Hachiman-gū shrine 石清水八幡宮 (Kyoto) 177

Izumi Takeo 泉武夫 134

Izumo grand shrine (Izumo-taisha 出雲大社; Shimane prefecture) 46, 523n5

Izuruhara site 出流原遺跡 (Tochigi prefecture) 25; jar with a modeled human face (*ganmen-tsuki tsubo-gata doki* 顔面付壺型土器; Middle Yayoi 弥生中期) 23, 25

Japan Art Institute (*see* Nihon Bijutsuin)

Japan Art Society (*see* Nihon Bijutsu-kai 日本美術会)

Japan Fine Arts Exhibition (*see* Nihon Bijutsu Tenrankai)

Japan Independent Exhibition (*see* Nihon Andepandan-ten)

Japan International Art Exhibition (*see* Nihon Kokusai Bijutsu-ten)

Japanese Pavilion (Nihonkan 日本館; 1936 Paris International Exposition; Sakakura Junzō) 449

Japanese poetry (*waka* 和歌) 119, 145

Japanese Secessionists (Bunriha Kenchiku-kai 分離派建築会; architecture) 423

Japanese Surrealism 425

Japanese Zen 禅 234; literary culture 235

Japonisme 370, 398

Jianzhen (*see* Ganjin Wajō)

Jien 慈円 239; *New Collection of Japanese Poems of Ancient and Modern Times* (*Shin Kokin Wakashū* 新古今和歌集) 239

Jikokuten 持国天 (Dhrtarastra; Unkei 運慶; Tōdai-ji Middle Gate 東大寺中門) 194

jimonbori 地紋彫 (geometric designs) 366–67

Jingan-ji 神願寺 (Kawachi, Osaka prefecture) 107, 485n8; Wake no Kiyomaro 和気清麻呂 107, 485n8

Jingo-ji 神護寺 (Kyoto) 106, 110; *A Short History of Jingo-ji Temple* (*Jingo-ji Ryakki* 神護寺略記) 218; Hōtō-in cloister 宝塔院 110; portraits of Fujiwara no Mitsuyoshi 藤原光能, Minamoto no Yoritomo 源頼朝, Retired Emperor Go-Shirakawa 後白河法皇, Taira no Narifusa 平業房, Taira no Shigemori 平重盛 (Fujiwara no Takanobu 藤原隆信) 218; Sentō-in 仙洞院 218; Yakushi Nyorai 薬師如来 107

Jishō-ji 慈照寺 (*see* Ginkaku-ji)

Jiun 慈雲 (priest/calligrapher) 369, 458

jizai 自在 (metalwork sculptures) 297, 365, 397; Myōchin 明珍 (metalworking studio) 396

Jizō Bosatsu 地蔵菩薩 (Ksitigarbha): Chūson-ji (中尊寺, Iwate prefecture) 176; Kasuga shrine mandala (*Kasuga miya mandara* 春日宮曼荼羅) 212

Jōchi 定智 174 (painter); *Zennyo Ryū-ō* 善女竜王 (Kongōbu-ji 金剛峰寺, Mt. Kōya 高野山) 147

Jōchō 定朝 (sculptor) 128, 129, 131–32, **133**, 134, 143, 174, 177–79, 193, 202; seated Amida Nyorai (Byōdō-in 平等院) 128, **133**, 178; *Chōshūki* 長秋記 (diary of Minamoto no Morotoki 源師時日記) 134; Dainichi Nyorai 大日如来 (Hōjō-ji 法成寺) 132; Five Great Wisdom Kings (Godaison 五大尊; Hōjō-ji 法成寺) 132; *hon'yō* 本様 (classical style/form) 132, 134, 179, 193; Nine Figures of Amida 九体阿弥陀 (Muryōju-in 無量寿院, later Hōjō-ji 法成寺) 131; *Shunki* 春記 (diary of Fujiwara no Sukefusa 藤原資房日記) 132; studio of (Fifty-Two Celestials 天人像, known as Bodhisattvas Making Offerings in the Clouds 雲中供養菩薩像; Byōdō-in 平等院)

Jōchō-style (Jōchō-yō 定朝様; sculpture) 179

Jōdo-ji 浄土寺 (Hyogo prefecture) 191–92; Amida Triad (Amida Sanzon 阿弥陀三尊: Amida 阿弥陀, Kannon 観音, Seishi 勢至; Kaikei 快慶) 191–**92**, 200; Isozaki Arata 磯崎新 191; Pure Land Hall (Jōdo-dō 浄土堂) **191**

Jōgan art (Jōgan bijutsu 貞観美術) 94, 105–113

Jōgan-style sculpture (Jōgan chōkoku 貞観彫刻) 81–82

Jōgū Shōtoku Hōō Teisetsu 上宮聖徳法王帝説 (biography of Prince Shōtoku) 61

Jōgyō 常暁 (monk) 100; Eight Masters Who Journeyed to Tang (Nittō Hakke 入唐八家) 484n2

Jōkaku 定覚 (sculptor) 194–95; standing Kongō Rikishi 金剛力士立像 (Tōdai-ji Great South Gate 東大寺南大門) 194–95, **196–97**

Jōkei 定慶 (sculptor) 201

Jōmon period 縄文時代 (excluding Chapter 1) xxiv, xxv, 20–22, 41, 47, 280, 336

Jōmon pottery (*Jōmon doki* 縄文土器): patterns 4–5, 11, 17; cord-marking 6; snakes 7

jōroku 丈六 (statue size) 59, 70, 82, 127, 131, 152, 153, 176, 178, 483n9

Josetsu 如拙 262, **264**, 265; *Catching a Catfish with a Gourd* (*Byōnen-zu* 瓢鮎図; Myōshin-ji 妙心寺) 262, **264**

"Joshin" ("Goddess" from the series *Kegonpu* (Record of the Kegon Sutra; Munakata Shikō) **456**

Ju Ran 巨然 (painter) 250

Jungle Emperor (Tezuka Osamu) 468

jūnihitoe 十二単 (or *kasane* 重ね, twelve-layered robes) 159, 161

Junmitsu 純密 (pure esotericism) 96–97

Jurakudai Palace 聚楽第 (Kyoto) 287, 295; Kanō Eitoku 狩野永徳 287; Toyotomi Hideyoshi 豊臣秀吉 287

kabuki 歌舞伎 (theater performances) 389: actor (*yakusha* 役者) 348, 366, 351, 355; *aragoto* 荒事 ("rough-style performances") 348; Ekin 絵金 (or Hirose Kinzō 弘瀬金蔵) 389; Ichikawa Danjūrō I 市川団十郎初代 366; Katsukawa Shunshō 勝川春章 351; Nakamura Konozō 中村此蔵 354; Narita-san Shinshō-ji 成田山新勝寺 366; ukiyo-e prints (*yakusha-e* 役者絵) 355, 359 (*see also* actor prints)

kabukimono 傾奇者 (male dandies) 327

kabuku かぶく (unconventional spirit) 301–302

Kaburaki Kiyokata 鏑木清方 (painter) 436; *Tsukiji Akashi-chō* 築地明石町 436; *Ichiyō* 一葉 436, **437**

Kagawa Prefectural Government Office (Kagawa Kenchōsha 香川県庁舎; Tange Kenzō) 461

Kaichi School, former (Kyū Kaichi Gakkō 旧開智学校; Nagano prefecture; Tateishi Seijū) 392–**93**

kaichō 開帳 (temple displays of treasures) 377

kaiga 絵画 (painting) xi

kaigen kuyō (*see* eye-opening ceremony)

Kaigetsudō Andō 懐月堂安度 349; Ejima Scandal (Ejima jiken 絵島事件) 349

Kaigetsudō Dohan 懐月堂度繁 349

Kaihō Yūshō 海北友松 293; Azai Nagamasa 浅井長政 293; *Dragons in Clouds* screens (*Unryū-zu byōbu* 雲龍図屏風) 293, **294**; *Landscape with Temples* (*Rōkaku Sansui-zu* 楼閣山水図) screens 293; screens with flowering plants (*Kaki-zu byōbu* 花卉図屏風*; Myōshin-ji 妙心寺) 294

Kaikei 快慶 194, 195, 200; An'amidabutsu Buddhist name 安阿弥陀仏 200; Amida Triad (Amida Sanzon 阿弥陀三尊: Amida 阿弥陀, Kannon 観音, Seishi 勢至) 191–**92**, 200; An'ami style 安阿弥様 200; standing Kongō Rikishi 金剛力士立像 (Tōdai-ji Great South Gate 東大寺南大門) 194–95, **196–97**; standing Miroku Bosatsu 弥勒菩薩立像 (formerly at Kōfuku-ji 興福寺) **200**; Hachiman in the form of a seated monk (僧形八幡坐像; Tōdai-ji) 200; standing Miroku Bosatsu 弥勒菩薩立像 (Sanbō-in 三宝院, Daigo-ji 醍醐寺) 200

Kainoshō Tadaoto 甲斐荘楠音 (painter) 435

Kairakuen 偕楽園 (daimyo garden, Ibaraki prefecture) 369

Kakiemon-style porcelain 柿右衛門様式磁器 325; *aka-e* 赤絵 (overglaze technique) 324; lidded jar **325**; *nigoshide* 濁手 325; overglaze polychrome enamel technique (*iro-e* 色絵) 324–26; Sakaida Kakiemon 酒井田柿右衛門 324–25

Kakumeiki 隔蓂記 (diary of Hōrin Shōshō

鳳林承章) 327; Omuro ware 御室焼 327

Kakurin-ji 鶴林寺 (Hyogo prefecture) 56; Main Hall 248; *Nine Grades of Rebirth* (*Kuhon Raigō-zu* 九品来迎図; Taishi-dō 太子堂) 140; Shō Kannon Bosatsu 聖観音菩薩 56

Kamakura Bunkakan Tsurugaoka Museum 鎌倉文化館鶴岡ミュージアム (Sakakura Junzō 坂倉準三) 460; Museum of Modern Art, Kamakura (Kamakura Kindai Bijutsukan 鎌倉近代美術館) 460

Kamegaoka site 亀ヶ岡遺跡 (Aomori prefecture) 14–15; *dogū* with "coffee bean eyes" (*shakōki dogū* 遮光器土偶) 14–15; vessel with black-lacquer ground and red-lacquer cloud design (*saimon urushi-nuri asabachi* 彩文漆塗り浅鉢; Final Jōmon 縄文晩期) 15–16

Kamegaoka-type urn 亀ヶ岡式壺 11, 12, 14, **15**, 16

kami 神 41, 44, 56, **114**–15, 217, 218, 240, 242, 273, 481n5, 485n8 and 486n12 and 13; and Buddhas 神仏 214; *honji-butsu* 本地仏 212; manifestation of 215–16; wood statues of 114; Yakushi-ji triad 三神像 115

kami triad (Sanshin-zō 三神像; Yakushi-ji 薬師寺, Nara) 115

Kamino site 上野遺跡 (Kanagawa prefecture) 4; round-bottom deep vessel with linear relief (*ryūkisenmon maruzoko fukabachi* 隆起線文丸底深鉢; Incipient Jōmon 縄文草創期) 4

Kamo (Aoi) festival 賀茂祭 (葵祭) 147, 177; *Yamato-e* やまと絵 147

Kamo no Chōmei 鴨長明 153; *Hōjōki* 方丈記 (Record of a Hut) 153

Kan'ei-era beauties (*Kan'ei bijin* 寛永美人) 418

kana syllabary (or *hiragana* 平仮名) 118, 142; calligraphy 142, 144, 161, 459

Kanamori Sōwa 金森宗和 (Hime Sōwa 姫宗和) 326–27

kanban kenchiku 看板建築 (signboard architecture) 447, 448

Kanbara Tai 神原泰 (painter) 438; *Action* 439; *On Scriabin's "Poem of Ecstasy"* (*Sukuriyabin no "ekusutashii no shi" ni daisu* スクリヤビンの〈エクスタシーの詩〉に題す) 439

Kanbun beauties (*Kanbun bijin* 寛文美人) 327; Hyōgo hairstyle (*Hyōgo-mage* 兵庫髷) 327

Kanbun kosode 寛文小袖 327–28

Kanga 漢画 (Chinese-style painting) 254, 311

Kanga-kai 鑑画会 (Painting Viewing Society) 383

Kaniman-ji 蟹満寺 (Kyoto prefecture) 71–72; seated Sakyamuni (Shaka Nyorai *zazō* 釈迦如来坐像) 71

Kanjizaiō-in 観自在王院 (Fujiwara no Motohira's wife 藤原基衡の妻; Iwate prefecture) 177

Kanno Seiko 菅野聖子 457; *World of Levi-Strauss* (*Levi-Strauss no sekai* レヴィ=ストロースの世界I) 457

Kannon Bosatsu 観音菩薩 (or Guze Kannon 救世観音; Hōryū-ji 法隆寺) 49, **50**–**51**; Standing (Yumechigai Kannon 夢違観音; Hōryū-ji 法隆寺) 56

Kannon Riding a Dragon (Harada Naojirō) 385

Kanō Eitoku 狩野永徳 260, 381; Azuchi Castle 安土城 285; *Birds and Flowers of the Four Seasons* sliding doors (*Shiki Kachō-zu fusuma* 四季花鳥図襖) 285; *Chinese Lions* screen (*Karajishi-zu byōbu* 唐獅子図屏風) 287; *Cypress Trees* (*Hinoki-zu byōbu* 檜図屏風) 287; Fushimi Castle 伏見城 287; Jukō-in sliding door panels 聚光院襖絵 (Daitoku-ji 大徳寺) 285; Jurakudai Palace 聚楽第 287; Osaka Castle 大阪城 287; saddle and stirrups with

reed design (*ashiho maki-e kura abumi* 芦穂蒔絵鞍鐙) 288–89; *Scenes in and around the Capital* screens (*Rakuchū Rakugai zu* 洛中洛外図) **286**, 318

Kanō Hideyori 狩野秀頼 287; *Maple-Viewing at Takao* (*Takao Kanpū-zu* 高雄観楓図屏風) 287

Kanō Hōgai 狩野芳崖 (painter) 382, 383, 384, 387, 406; *Merciful Mother Kannon* (*Hibo Kannon* 悲母観音) **383**; *Landscape: Scenes along the River* (*Kōryū hyakuri zu* 江流百里図), *Two Dragons* (*Hiryū giji zu* 飛龍戯児図) 382; *Merciful Mother* (*Hibo Kannon* 悲母観音), *Fudō Myō-ō* (不動明王図), *Ni-ō Capturing a Demon* (*Ni-ō sokki zu* 仁王捉鬼図) **383**

Kanō Masanobu 狩野正信 266

Kanō Mitsunobu 狩野光信 291, 293; *Flowering Trees of the Four Seasons* (*Shiki Kaboku-zu fusuma* 四季花木図襖; Kangaku-in 勧学院, Onjō-ji 園城寺) 292, **293**; Hizen Nagoya Castle 肥前名護屋城 (Saga prefecture) 287

Kanō Mitsuo 加納光於 (print artist) 455

Kanō Motonobu 狩野元信 276; *Birds and Flowers of the Four Seasons* (*Shiki Kachō-zu* 四季花鳥図; Daisen-in 大仙院; sliding doors) 278–79

Kanō Naganobu 狩野長信 296; *Merrymaking under the Cherry Blossoms* screens (*Kaka Yūraku-zu byobu* 花下遊楽図屏風) 296, **298**

Kanō Naizen 狩野内膳 296: *Hōkoku Festival* screens (*Hōkoku Sairei-zu byobu* 豊国祭礼図屏風; Hōkoku shrine 豊国神社) 296, **297**

Kanō Naonobu 狩野尚信 310

Kanō Sanraku 狩野山楽 **310**–12: *Birds amid Plum Trees* sliding doors (*Ume ni Yūkin-zu fusuma* 梅に遊禽図襖; Tenkyū-in, Myōshin-ji 妙心寺天球院) 311–12; *Red Plum Trees* sliding doors

(*Kobai-zu fusuma* 紅梅図襖; Daikaku-ji 大覚寺) **294**, 295; sliding-door paintings of peonies (*Botan-zu fusuma* 牡丹図襖; Daikaku-ji 大覚寺, Kyoto) 295

Kanō Sansetsu 狩野山雪 311: *Birds amid Plum Trees* sliding doors (*Ume ni Yūkin-zu fusuma* 梅に遊禽図襖; Tenkyū-in, Myōshin-ji 妙心寺天球院) 311–12; *Sea Birds along a Snowy Shore* screens (*Settei Suikin-zu byōbu* 雪汀水禽図屏風) 311–**12**

Kanō school 狩野派 (painters) 269, 322, 382

Kanō Shōei 狩野松栄 285; Jukō-in sliding door panels 聚光院襖絵 (Daitoku-ji 大徳寺) 285

Kanō Tan'yū 狩野探幽 308, 310, 313, 322, 337; *Plum Tree, Bamboo, and Birds in the Snow* sliding doors (*Secchū Baichiku Yūkin-zu fusuma* 雪中梅竹遊禽図襖; Jōraku Palace, Nagoya Castle 名古屋城上洛殿) 310–11; *Pine Trees in the Four Seasons* screens (*Shiki Matsu-zu byōbu* 四季松図屏風; Daitoku-ji 大徳寺) 310

Kanō Yasunobu 狩野安信 310

Kanokogi Takeshirō 鹿子木孟郎 (painter) 402, 425; Jean-Paul Laurens at the Académie Julian (Paris) 425

Kansai Art Institute (*see* Kansai Bijutsuin)

Kansai Bijutsuin 関西美術院 (Kansai Art Institute) 380

kanshi 漢詩 (Chinese poetry) 115, 145

Kanshin-ji 観心寺 (Osaka prefecture) 111; Golden Hall (Kondō 金堂) 248; seated Nyoirin Kannon 如意輪観音坐像 111–12

kanshitsu 乾漆 (*see* dry lacquer)

kanshitsuzō 乾漆像 (*see* dry-lacquer statues)

Kanshun 観舜 (painter) 213; *Kasuga Shrine mandala* 春日宮曼荼羅 (commissioned by Fujiwara no

Munechika 藤原宗親) **213**

Kantō Nanga 関東南画 357

Kaō 可翁 255–**56**; *Priest Xianzi (Kensu Oshō zu* 蜆子和尚図) 256

Kara-e 唐絵 (Chinese pictures) 146–47, 149, 249, 254, 338

karamono 唐物 (imported Chinese objects/foreign objects) 174, 189, 244, 248, 249, 324–25

Karatachi からたち (Iga ware flower vase) 301; Oribe-style (*Oribe-gonomi* 織部好み) 301

Karatsu ware 唐津焼 301

karayō 唐様 ("Chinese style"; calligraphy) 335

Karayō 唐様 ("Chinese style"; architecture) 193

karesansui 枯山水 (dry landscape gardens) 267; Musō Soseki's 夢窓疎石 gardens at Tenryū-ji 天竜寺 and Kōinzan in Saihō-ji 西芳寺洪隠山 (both Kyoto) 255; *Record of Garden Making (Sakuteiki* 作庭記) 151, 267; Ryōan-ji Hōjō teien 龍安寺方丈庭園 268–69; *shoin* garden (*shoin* teien 書院庭園) at Daisen-in 大仙院 268; *Scenes in and around the Capital (Rakuchū Rakugai zu* 洛中洛外図; Rekihaku A screens 歴博A本) 268

Kariteimo 訶梨帝母 (Hariti; painting; Daigo-ji 醍醐寺) 157, 174

karmic mandalas (*katsuma mandara* 羯磨曼荼羅) 109

kasen-e 歌仙絵 (pictures of great poets) 230

kassen-e 合戦絵 (war tales) 222, 224–25

Kasuga deer mandala (*Kasuga shika mandara* 春日鹿曼荼羅) 214

Kasuga grand shrine (Kasuga-taisha 春日大社) 181; *kenuki*-style large sword with mother-of-pearl on an *ikakeji* lacquer ground (*ikakeji raden kenukigata tachi* 沃懸地螺鈿毛抜形太刀) 181; *odoshi-yoroi* with red threads

(*akaito odoshi-yoroi* 赤糸威鎧) 239; Wakamiya-sha 若宮社 213

Kasuga shrine mandalas (*Kasuga miya mandara* 春日宮曼荼羅) 212–15; Hōjō-ji 法成寺 (Kyoto) 212; *Kasuga Shrine mandala* 春日宮曼荼羅 (Kanshun 観舜; commissioned by Fujiwara no Munechika 藤原宗親) **213**

Kasuga shrine-temple mandalas (*Kasuga shaji mandara* 春日社寺曼荼羅) 213

Kataoka Tamako 片岡球子 (painter) 476

Katayama Tōkuma 片山東熊 (architect) 395; Akasaka Palace (Asaka Rikyū 赤坂離宮; Tokyo), Kyoto Imperial Museum (Kyoto Teishitsu Hakubutsukan 京都帝室博物館) 395

Katsukawa Shun'ei 勝川春英 353

Katsukawa Shunchō 勝川春潮 353

Katsukawa Shunshō 勝川春章 351; *Fans of the East (Azuma Ōgi* 東扇) 351

Katsura Imperial Villa (Katsura Rikyū 桂離宮; Prince Hachijō-no-miya Toshihito 八条宮智仁親王; Prince Toshitada 智忠親王) **314**, 369; description of the garden in *Nigiwaigusa* にぎはひ草 314; strolling garden (*kaiyū-shiki teien* 回遊式庭園) 314

Katsusaka-type pots 勝坂式土器 6–7, 13; Idojiri site 井戸尻遺跡 (Nagano prefecture) 6; Takikubo site 多喜窪遺跡 (Tokyo) 7

Katsushika Hokusai 葛飾北斎 307, 358, 360, **361**–**62**, 387, 467; *Hokusai Manga* 北斎漫画 *ehon* 360–**61**; Katsukawa Shunrō 勝川春朗 360; *Strange Tales of the Crescent Moon (Chinsetsu Yumiharizuki* 椿説弓張月; *yomihon* novel illustrated by Kyokutei Bakin 曲亭馬琴) 360; "Under the Wave off Kanagawa" ("Kanagawa-oki Namiura" 神奈川沖浪裏) from *Thirty-Six Views of Mt. Fuji (Fugaku Sanjūrokkei*

富嶽三十六景) **362**

Katsushika Ōi 葛飾応為 (painter) 435

Kawabata Ryūshi 川端龍子 (painter) 433

Kawabata Yasunari 川端康成 (author) 441

Kawada Kikuji 川田喜久治
(photographer) 473

Kawai Gyokudō 川合玉堂 (painter) 436;
Evening in the Mountains (*Mine no yū*
峰の夕) 436, **437**

Kawai Kanjirō 河井寛次郎 (ceramicist)
478

Kawakami Sumio 川上澄生 (print artist)
421; *Early Summer Breeze* (*Shoka no
kaze* 初夏の風) 421

Kawakami Tōgai 川上冬崖 (painter) 375

Kawamura Jakushi 河村若芝 335;
Nagasaki Kanga school 長崎漢画派
335

Kawamura Kiyoo 川村清雄 (painter)
385; *Ceremonial Robes Preserved as
Keepsakes* (*Airing of Robes*) (*Katami
no hitatare* 形見の直垂 [*Mushi-boshi
虫干し*]) 381, 385, **386**, 387

Kawanabe Kyōsai 河鍋暁斎 (painter)
387, 388, 394; *Frogs Triumphing over
a Snake and Lizards* (*Kaeru to hebi no
tawamure* カエルとヘビの戯れ) **388**;
Conder, Josiah 393

Kawara On 河原温 479

Kawarada site 川原田遺跡 (Nagano
prefecture) **11**; Yakemachi vessel
(Yakemachi doki 焼町土器; Middle
Jōmon 縄文中期) **11**

kawari kabuto 変わり兜 (or *nari kabuto*
形冑; "unusual helmets") 302–**03**;
peach-shaped helmet with applied black
lacquer and water buffalo horn fittings
(*momonari ōsuigyū wakidate kabuto*
桃形大水牛脇立兜) **303**

Kawase Hasui 川瀬巴水 (woodblock print
artist, painter) 419

Kayama Matazō 加山又造 (painter) 477

kazari かざり (adornment) xiv–xv, 6, 41,
38, 69, 77, 90, 92, 154–55, 161–62, 234,
241, 244, 246, 284, 380; concept of 62;
zashiki kazari 座敷飾り 250–51, 282

Kazuki Yasuo 香月泰男 (painter) 451;
Burial (*Maisō* 埋葬) 452; *Black Sun*
(*Kuroi taiyō* 黒い太陽) 452

keep, castle (*tenshu* 天守) 284, 295–96,
310, 322, 337

Kegon-kyō 華厳経 (*see* Flower Garland
Sutra)

Kehi Jingū-ji 気比神宮寺 (Fukui
prefecture) 114

Kehi shrine (Kehi-jinja 気比神社; Hyogo
prefecture) 26; bronze bells (*dōtaku*
銅鐸; Middle Yayoi 弥生中期) 26

Kei school 慶派 (of sculpture) 193, 201,
202; Ni-ō 仁王像 (Kōfuku-ji 興福寺,
Nara) 201

keibutsu-ga 景物画 (paintings of scenic
views with seasonal references) 146–47,
149, 272, 486n12; *keibutsu* 景物 146,
186

Keichō *kosode* 慶長小袖 (robes) 313

Keika 恵果 (*see* Huiguo)

Keikokushū 経国集 (poetry anthology)
145

Keiō University Old Library (Keiō Gijuku
Kyū-toshokan 慶應義塾旧図書館;
Tokyo; Chūjō Seiichirō) 413

Keisai Eisen 渓斎英泉 360

keko 華籠 (flower basket) 184; gold- and
silver-plated flower basket with scrolling
floral design in openwork (*kinginto
hōsōgemon sukashibori keko* 金銀鍍
宝相華文透彫華籠; Jinshō-ji 神照寺,
Shiga prefecture) 184

kenchiku 建築 (architecture): xi, xiii; as
modern term 389; "Theory of Inartistic
Architecture" ("Kenchiku hi-geijutsu
ron" 建築非芸術論; Noda Toshihiko
野田俊彦) 423, 447

Kenchō-ji 建長寺 (Kamakura) 204, 234–
35, 237; portrait of Dajue Zen Master
Lanxi Daolong (Daikaku Zenshi-zō
大覚禅師像) **204**; *Portrait of Dajue*

Zen Master Lanxi Daolong (*Daikaku Zenshi-zō* 大覚禅師像) 235; portrait of Hōjō Tokiyori (*Hōjō Tokiyori-zō* 北条時頼像) 204

Kenshunmon-in 建春門院 219

keyhole burial mounds (*zenpō kōenfun* 前方後円墳) 30–32

Kibitsu shrine (Kibitsu-jinja 吉備津神社, Okayama prefecture), main hall 276

Kiburi-ji 来振寺 (Gifu prefecture) 122, **124**

Kichijōten 吉祥天 (Sri Mahadevi): Sekkei-ji 雪渓寺 201; Tōdai-ji 東大寺 75; Yakushi-ji 薬師寺 83–84

Kid Deko's New Picture Book: The Story of Imo-suke's Board Hunt (Shimokawa Hekoten) 469

Kiki's Delivery Service (Miyazaki Hayao) 471

Kikki 吉記 (diary of Yoshida Tsunefusa 吉田経房の日記) 217; portrait of Retired Emperor Toba 217

Kikuchi Yōsai 菊池容斎 (painter) 389

Kikutake Kiyonari 菊竹清訓 (architect) 461

kilns 窯 4, 185–186, 244, 281; Arita 有田 324–25; climbing 登り窯 301; Fujian 福建 282; Iga 伊賀 303; Sanage 487n27; Shigaraki 信楽 282; Sue ware 須恵器 482n10

Kimura Buzan 木村武山 (painter) 407

Kimura Ihei 木村伊兵衛 (photographer) 473

King Wonderfully Adorned Chapter (Gon'nō-bon 厳王品) 159; Kinryū-ji 金龍寺 (Nara) 56

Kinoshita Naoyuki 木下直之 377

Kinrei-sha 金鈴社 (Golden Bell Society) 416

kirei sabi 綺麗さび ("pure, elegant simplicity") 313–14

kirikane 切金 (gold leaf) 123, 140, 154, 155

Kiryū Kōshō Kaisha 起立工商会社 (craft company) 396

Kishida Ryūsei 岸田劉生 415, 416–17; *Dry Road in Winter (Sketched in the Vicinity of Harajuku, Sun on Red Soil and Grass)* (*Fuyugare no dōro* [*Hi no atatta akatsuchi to kusa*] 冬枯れの道路 [日の当たった赤土と草]), *Natural Girl* (*Yadōjo* 野童女), *Road Cut through a Hill* (*Dōro to dote to hei* [*kiritōshi no shasei*] 道路と土手と塀 [切通之写生]) 416, **417**; *Early Ukiyo-e Painting* (*Shoki nikuhitsu ukiyo-e* 初期肉筆浮世絵) 418; Fuzankai フュウザン会 415; Sōdosha 草土社 (exhibitions) 416

kisō-ha 奇想派 (eccentrics) 338

Kissan (or Kichizan) Minchō 吉山明兆 (Chōdensu 兆殿司) 257, 260–**61**; *Bodhidharma, Liu Hai, and Li Tieguai* (*Daruma, Gama Tekkai-zu* 達磨・蝦蟇鉄拐図; Tōfuku-ji 東福寺) 260; *Death of the Buddha* (*Nehan-zu* 涅槃図; Tōfuku-ji 東福寺) 260; *Five Hundred Arhats* (*Gohyaku Rakan-zu* 五百羅漢図) 261; *White-Robed Kannon* (*Byakue Kannon-zu* 白衣観音図; Tōfuku-ji 東福寺) **261**

Kitagawa Utamaro 喜多川歌麿 323, 351, 354; *Anthology of Poems: The Love Section* (*Kasen Koi no Bu Fukaku Shinobu Koi* 歌撰恋之部 深く忍恋) 353; *A Parent's Moralizing Spectacles* (*Kyōkun Oya no Megane* 教訓親の目鑑) 354; *Gift of the Ebb Tide* (*Shiohi no Tsuto* 潮干のつと) 352; *kyōka-bon* 狂歌本 (anthologies of comic poems) 352–53; *Picture Book: Selected Insects* (*Ehon Mushi Erami* 画本虫撰) 352–53; *Retired Regent and His Five Wives Viewing Cherry Blossoms East of the Capital* (*Taikō Gosai Rakutō Yūkan no Zu* 太閤五妻洛東遊観図) 353; *Ten Types in the Physiognomic Study of Women* (*Fujin Sōgaku Jittai* 婦人相学十躰) 353

Kitajima Setsuzan 北島雪山 335; *kara-yō* 唐様 ("Chinese style"; calligraphy) 335

Kitakyūshū Central Library (北九州市中央図書館; Fukuoka prefecture; Isozaki Arata) 465

Kitano Tenman-gū 北野天満宮 (Kyoto) 227

Kitawaki Noboru 北脇昇 (painter) 441; *Airport* (*Kūkō* 空港) 441

Kitayama culture 北山文化 244–45, 258 ff

Kitazawa Rakuten 北沢楽天 (manga artist) 467; *Jiji Manga* 時事漫画 467

Kitora burial mound キトラ古墳 (Asuka, Nara prefecture) 32, 62; four sacred animals of the four cardinal directions 32, 62

Kiyohara Einosuke 清原栄之助 (lacquer artist) 390

Kiyohara Tama 清原玉 (painter) 390

Kiyomizu-dera 清水寺 (Kyoto) 177

Kiyotosaku tunnel tomb 清戸迫横穴 (Fukushima prefecture) 38

kō 工 xiii; *shokkō* 織工 (weaver) xiii; *shikkō* 漆工 (lacquerer) xiii; *gakō* 画工 (painter) xiii, 332, 489n4; *chōkō* 彫工 (carver/woodblock cutter) xiii

Kōami Chōan 幸阿弥長晏 (lacquer artist) 291; Otamaya Hall, Kōdai-ji 高台寺霊屋 291

Kōami Dōchō 幸阿弥道長 (lacquer artist) 269; Ashikaga Yoshimasa 足利義政: patronage of 269

Kōami family 幸阿弥家 312; Hatsune Dowry 初音の調度 312–13; *takamaki-e* 高蒔絵 (high relief *maki-e*) 313; *Kōdai-ji maki-e* 高台寺蒔絵 291, 312–13

Kobayashi Kiyochika 小林清親 (ukiyo-e artist) 387, 388; "View of Takanawa Ushimachi under a Shrouded Moon" ("Takanawa Ushi-machi oborozuki kei" 高輪牛町朧月景) 389, 418

Kobayashi Kokei 小林古径 (painter)

430–31; *Admonitions Scroll*, copying of 431; *Hair* (*Kami* 髪) **432**; *Heresy* (*Itan* 異端) 430

Kobayashi Taichirō 小林太市郎 170

Kobayashi Tatsuo 小林達雄 12

Kobe *kana* style (*Kobe no kana* 神戸のかな) 459

Kōben 康弁 (sculptor) **201**

Kobori Enshū 小堀遠州 (tea master) 313–14; *kirei sabi* 綺麗さび 313–14; Mittan 密庵 (Ryōkō-in, Daitoku-ji 大徳寺龍光院) 313; Bōsen 忘筌 (Kohōan, Daitoku-ji 大徳寺孤篷庵) 313

Kōbu Bijutsu Gakkō 工部美術学校 (Technical Art School) 379–80, 390, 393

Kōbu Daigakkō 工部大学校 (*see* Imperial College of Engineering)

Kodai no kimi 小大君 (poet) 231; pictures of Thirty-Six Poets (*Sanjūrokkasen-e* 三十六歌仙絵), Gotoba-in scroll 後鳥羽院本 (Senshū-ji 専修寺, Mie prefecture) 231

Kōdai-ji maki-e 高台寺蒔絵 291, 312–13; *hiramaki-e* 平蒔絵 (flat *maki-e*) 291; Kōami Chōan 幸阿弥長晏 291; Kōami family 幸阿弥家 312

Kōfuku-ji Mandala 興福寺曼荼羅 214

Kōfuku-ji 興福寺 (Nara) 55–56, 69, 72, 73–75, 109; Asanga 無著 and Vasubandhu 世親 (Unkei 運慶) **199**; Ashura 阿修羅 74; demons Tentōki 天燈鬼 and Ryūtōki 竜燈鬼 201–202; Four Guardian Kings (Shitennō 四天王) at 109–10; Genbō at 玄昉 69; Head of the Buddha (Buttō 仏頭) 55–56; Seated Fukūkenjaku Kannon 不空羂索観音 194; Ten Major Disciples of Sakyamuni (Jūdai Deshi 十大弟子) 73, 75; Yamashina-dera 山階寺 (precursor of Kōfuku-ji) 73

Kofun culture 古墳文化 23, 30, 40; burial mounds 古墳 33

Koga Harue 古賀春江 (painter) 440; *Smoke* (*Enka* 煙火) 440; *Scene from the Circus* (*Sakasu no kei* サーカスの景) 441; *Sea* (*Umi* 海) **440**

kōgei 工芸 (craft) xi, 238; as modern term 389; and *kōgyō* 工業 395

Kōgen-ji 向源寺 (Kyoto) 111, **112**;

kohitsu-gire 古筆切 143

Koide Narashige 小出楢重 (painter): *Family of N* (*N no kazoku* Nの家族) 427; *Female Nude on Chinese Bed*; *Female Nude A* (*Shina shindai no rafu* 支那寝台の裸婦) **427**

Koishi Kiyoshi 小石清 (photographer) 473

Koishikawa Kōrakuen 小石川後楽園 (daimyo garden; Tokugawa Mitsukuni 徳川光圀; Tokyo) 369

Koiso Ryōhei 小磯良平 (painter) 444

Kojima Mandalas 子島曼荼羅 (Kojima-dera 子島寺, Nara) 121, 135

Kojima Zenzaburō 児島善三郎 (painter) 405

Kōjin'yama site 荒神山遺跡 (Nagano prefecture) 6; elaborately decorated vessel (*kessetsu chinsenmon fukabachi* 結節沈線文深鉢; Early Jōmon 縄文前期) 6

Kōjō 光定 (monk) 117

Kokawa-dera 粉河寺 (Wakayama prefecture) 168; *Illustrated Scroll of the Legends of Kokawa Temple* (*Kokawa-dera Engi Emaki* 粉河寺縁起絵巻) handscroll 168; Thousand-Armed Kannon 千手観音 169

Kōkei 康慶 (sculptor) 193, 194, 201

Kōkei Shōnin 光慶上人 (priest) 366; rebuilding of Tōdai-ji Great Buddha Hall 東大寺大仏殿再建 366

Kokin Wakashū (*Collection of Japanese Poems of the Past and Present* 古今和歌集) 143, 145, 269

Kokka 国華 (Flower of the Nation; journal) 406

Kokon Chomonjū 古今著聞集 (*Collection of Written and Spoken Tales from the Present and the Past*) 136; *Nine Grades of Rebirth in the Pure Land* (*Kuhon Raigō-zu* 九品来迎図; Byōdō-in 平等院) 136; Takuma Tamenari 宅間為成 136

Kokuga Sōsaku Kyōkai 国画創作協会 (Association for Creation of National Painting) 433

Kokuga Sōsaku Kyōkai 国画創作協会 (Association for the Creation of a National Painting) 416

kokuso urushi 木屎漆 53, 483n4

Kokutani-style 古九谷様式 325–26; dish with butterfly, peony, and tortoiseshell

Komai Tetsurō 駒井哲郎 (print artist) 455

Komaki Gentarō 小牧源太郎 (painter) 476

Komatsu Hitoshi 小松均 (painter) 476; *Snow Wall* (*Yuki kabe* 雪壁) **476**

komawari コマ割り (narrative panels; manga) 468

Kon Wajirō 今和次郎 (architect) 448; Barracks Ornamentation Society (Barakku Sōshoku-sha バラック装飾社) 448; *kōgengaku* 考現学 (modernology) 448

Kongō-ji 金剛寺 (Osaka) 181; *Landscape with Sun and Moon* screens (*Jitsu-Getsu Sansui-zu byōbu* 日月山水図屏風 271–72; small box with a design of sparrows in a field (*nobe suzume maki-e tebako* 野辺雀蒔絵手箱) 181–**83**

Kongōbu-ji 金剛峯寺 (Mt. Kōya) 109; *Buddha's Nirvana* (*Butsu Nehan-zu* 仏涅槃図 or *Ōtoku Nehan-zu* 応徳涅槃図) 138–39; child-attendant deity figures 八大童子 (Unkei 運慶) 194; Chinese-style chest with a design of plovers 180; *Discourse on the Three Faiths* (*Rōko Shiiki* 聾瞽指帰) 116

Kongōchi 金剛智 (Vajrabodhi) 105

Kongō Rikishi 金剛力士 (Ni-ō 仁王,

Vajravira): Agyō 阿形 ("Ah" figure)
195–96; Hosshō-ji Great South Gate
法勝寺南大門 152; Tōdai-ji Great
South Gate 東大寺南大門 (Jōkaku
定覚, Kaikei 快慶, Tankei 湛慶, Unkei
運慶) 194–95, **196–97**; Ungyō 吽形
("Un" figure) 195, **196–67**

Konkai Konmyō-ji 金戒光明寺 (Kyoto);
Hell and Paradise screens 地獄極楽図
屏風 206; *Yamagoe Raigō-zu*
山越来迎図 209–**211**

Kōno Bairei 幸野楳嶺 (painter, woodblock
print artist) 409, 410

Konoe Nobutada 近衛信尹 (calligrapher)
302, 459

Konoe Nobutada 近衛信尹 459

Konshō-ji 金鐘寺 (Nara) 74 (*see also*
Tōdai-ji)

Korea 朝鮮 vi, xxv, 29, 30, 37, 40, 51, 53,
65, 228, 242, 265, 301

Korean ceramics 301; Korean potters 301

Korean court 朝鮮王宮 47, 59

Korean peninsula 朝鮮半島 21, 22, 26,
32, 33, 43, 59, 118

Kōryū-ji 広隆寺 (Kyoto) 53, **54**, 58, 134

kōsaiga 膠彩画 (painting with glue-applied
colors) 478

Kose no Hirotaka 巨勢広貴 (painter) 143

Kose no Kanaoka 巨勢金岡 (painter) 115,
143

Kose no Ōmi 巨勢相覧 143; *Taketori
Monogatari Emaki* 竹取物語絵巻
(*Illustrated Scrolls of the Bamboo
Cutter*) 144; *The Tale of Genji*
(*Genji Monogatari* 源氏物語) 144

Koshaji Hozon Hō 古社寺保存法
(Ancient Temples and Shrines
Preservation Law) 381

Kōshō 康勝 (sculptor) **201**

Kōshō 康尚 (sculptor) 131, 132; Fudō-
Myō-ō 不動明王 (Dōju-in, Tōfuku-ji
東福寺同聚院, Kyoto) 131; Nine
Figures of Amida (Kutai Amida 九体
阿弥陀; Hōjō-ji 法成寺, Kyoto) 131

kōsō-ga 構想画 (well-composed painting)
400, 402

kosode with mandarin ducks on a black
figured satin ground (*kuro-rinzuji nami
oshidori moyō kosode* 黒綸子地波鴛鴦
模様小袖) 327–28

Kosode with Winter Trees (*Fuyuki Kosode*
冬木小袖; Ogata Kōrin 尾形光琳) 332

kosode 小袖 269; Noh costumes 能装束
288; Kanbun robes 寛文小袖 327–**28**;
Keichō robes 慶長小袖 313; Ogata
Kōrin 尾形光琳 332

kōsōden-e 高僧伝絵 222, 228

Kosugi Hōan 小杉放庵 (painter) 410

Kōtoku-in 高徳院 (Kamakura) 203

Kōya gire 高野切 143

Koyama Shōtarō 小山正太郎 (painter,
educator) 379, 447, 458

Kōyū 幸有 (sculptor) 203

Kōzan-ji 高山寺 (Kyoto) 167–68, 201,
204–**05**, **221**, 228–**29**

Kuchizusami 口遊 (Verbal Amusements)
46

Kudara Kannon 百済観音 (Hōryū-ji
法隆寺) 53, **52**,

Kudara no Kawanari 百済河成 (painter)
115, 143, 144, 232

Kudara Ōdera 百済大寺 47

Kudō Kōjin 工藤甲人 (painter) 472

Kudō Tetsumi 工藤哲巳 462

Kugahara site 久ヶ原遺跡 (Tokyo) 23, **25**;
red lacquered hybrid jar (*shusai tsubo*
朱彩壺; Late Yayoi 弥生後期) 23, **25**

Kūkai 空海 116, 117–18, 125, 316, 484n2,
485n7; calligraphy 書 116–17, 316;
Catalogue of Imported Works (*Shōrai
Mokuroku* 請来目録) 97; *Discourse on
the Three Faiths* (*Rōko Shiiki* 聾瞽指帰;
Kongōbu-ji 金剛峰寺; calligraphy)
116; Eight Masters Who Journeyed to
Tang (Nittō Hakke 入唐八家) 484n2;
Esoteric Buddhist teachings 94, 96–97,
99–100, 109; letter to Saichō (*Fūshinjō*
風信帖; Tō-ji 東寺; calligraphy) **116**;

mandalas 曼荼羅 102–103; paintings 105, 155; record of those who received esoteric initiation in Jingo-ji (*Kanjō Rekimei* 灌頂歴名; Jingo-ji 神護寺; calligraphy) 116; statues 110–111

Kumagai Morikazu 熊谷守一 (painter) 410, 472

Kumano 熊野 212, 216; Go-Shirakawa pilgrimages 後白河法皇の熊野詣 153; Hongū (Hongū taisha, main shrine) 本宮大社 215; Ippen 一遍 488n5; Kumano shrine mandala 熊野宮曼荼羅 215; Nachi grand shrine (Nachi taisha) 那智大社 215; Shingū (new shrine) or Hayatama grand shrine (Hayatama taisha) 速玉大社 215; *suijaku* painting 垂迹画 214

Kume Keichirō 久米桂一郎 (painter) 399, 400, 402

Kuninaka no Muraji Kimimaro 国中連公麻呂 76–77, 484n7

Kuniyoshi, Yasuo 国吉康雄 (painter, print artist, photographer) 455

Kunwi grotto 軍威石窟 (North Gyeongsang province) 59

Kuratsukuri no Tori 鞍作止利 (*see* Tori Busshi)

Kuroda Hideo 黒田日出男 231

Kuroda Seiki 黒田清輝 (painter) 398–99, 402–03, 425; *kōsō-ga* 構想画 400, 402; *Lakeside* (*Kohan* 湖畔) 400, **401**; *Maiko* (舞妓) 399, **400**; Morning Toilet (*Chōsō* 朝妝) 489n2; *Reading* (*Dokusho* 読書), *Woman/The Kitchen* (*Fujin-zō* 婦人像 [*chūbō* 厨房]) 399; *Wisdom, Impression, Sentiment* (*Chi, Kan, Jō* 智・感・情) 400, **401**; Raphaël Collin 399; *Sifting Red Beans* (*Aka-azuki no Aoriwake* 赤小豆の簸分) 402; *Talk on Ancient Romance* (*Mukashi-gatari* 昔語り) 402; Tenshin Dōjō 天真道場 400

Kurokawa Kisho 黒川紀章 (architect) 461

Kurozuka burial mound 黒塚古墳 (Tenri, Nara prefecture) 28, 30, 31, 482n7; triangular-rimmed mirror (*sankakubuchi shinjū kyō* 三角縁神獣鏡; Early Kofun 古墳前期) 28, 30, 31, 482n7

Kurth, Julius 354

Kusama Yayoi 草間彌生 479

Kushibiki Hachiman-gū 櫛引八幡宮 (Aomori prefecture) 239; *odoshi-yoroi* with red threads (*akaito odoshi-yoroi* 赤糸威鎧) 239

Kusube Yaichi 楠部彌弌 (ceramicist) 398

Kusumi Morikage 久隅守景 (painter) **323**; *Enjoying the Evening Cool under a Moonflower Trellis* (*Yūgao-dana Nōryō-zu* 夕顔棚納涼図) **323**

Kusunoki Masanori 楠木正儀 248

Kuwata Sasafune 桑田笹舟 (calligrapher) 459; *Sun and Moon* screens (*Jitsugetsu byōbu* 日月屏風) 459

Kūya 空也 (monk) 131, 201

Kyō-Kanō style 京狩野 311

Kyōgen masks 狂言面 246–47

Kyōhō reforms 享保の改革 307

Kyokutei Bakin 曲亭馬琴 360; *Strange Tales of the Crescent Moon* (*Chinsetsu Yumiharizuki* 椿説弓張月; *yomihon* novel illustrated by Katsushika Hokusai 葛飾北斎) 360

Kyōō Gokoku-ji 教王護国寺 (*see* Tō-ji)

Kyoto Advanced School of Industry (*see* Kyoto Kōtō Kōbu Gakkō)

Kyoto Dancing Girl (Hayami Gyoshū) 432

Kyoto Imperial Museum (Kyoto Teishitsu Hakubutsukan 京都帝室博物館; Katayama Tōkuma) 395

Kyoto Kōtō Kōbu Gakkō 京都高等工部学校 (Kyoto Advanced School of Industry) 380

Kyoto Prefectural Painting Academy (Kyoto-fu Gagakkō 京都府画学校) 408–409

Kyushu 九州 2, 17, 18, 186, 229, 235; ceramic-producing areas 303; elites

(*gōzoku* 豪族) 33; *kofun* (burial
mounds) 古墳 in 30, 36–37; mirrors
(*dōkyō* 銅鏡) 31; Nagasaki port 長崎港
298; Yamataikoku 邪馬台国 location
theory 28; Yayoi culture 弥生文化 20,
22

lacquer (*urushi*) 漆; use of 3, 15–16, 23,
26, 53; armor 26; red-lacquered (*shu
urushi nuri* 朱漆塗) 11–12, 22–**25**, **33**
(*see also* dry lacquer)

lacquer box with butterflies and
inlaid mother-of-pearl (*chō botan
karakusamon maki-e tebako*
蝶牡丹唐草文蒔絵手箱) 241

lacquered and gold painted incense burner
pedestal (*urushi kinpaku-e no ban*
漆金薄絵盤 or *kōinza* 香印坐; Shōsō-in
southern repository 正倉院南倉,
Tōdai-ji 東大寺, Nara) 90–**91**

lacquerware (*shikkōhin* 漆工品) 89, 116–
18 (see also *maki-e*) 239; Heian period
平安時代 241; Kamakura period 鎌倉
時代 241

Lady Tachibana's private devotional shrine
(*Tachibana-fujin Nenji-butsu Zushi*
橘夫人念持仏厨子; Hōryū-ji 法隆寺)
57–**58**, 62, 125

Lakeside (Kuroda Seiki) 400, **401**

Landscape at Sotobō (Yasui Sōtarō) **426**

Landscape of the Drifting Heart (Miyazaki
Shin) **453**

Landscape with an Eye (Aimitsu) **444**

Landscape with Sun and Moon screens
(*Jitsu-Getsu Sansui-zu byōbu*
日月山水図屏風; painting; Kongō-ji
金剛寺) **272–73**

landscape painting on hemp (*mafu sansui*
麻布山水; Shōsō-in central repository
正倉院中倉) 92

Landscape: Scenes along the River (Kanō
Hōgai) 382

Landscapes of the Four Seasons (*Shiki
Sansui-zu* 四季山水図; painting):

Sesshū Tōyō 雪舟等楊 (hanging scrolls)
275; *Long Handscroll of Landscapes in
the Four Seasons* (*Shiki Sansui-zukan*
四季山水図巻) 276; Soga Jasoku
曽我蛇足 (sliding doors; *fusuma-e*
襖絵; Shinju-an 真珠庵, Daitoku-ji
大徳寺) 271

Lanxi Daolong 蘭渓道隆 (Rankei Dōryū
or Daikaku Zenshi 大覚禅師) **204**,
234, **235**, 236; *chinzō* 頂相 portraits
204, 236 **204**, 236

latticework (or textured carving; *ukibori* 浮
彫り) 268; Ōsasahara shrine (Ōsasahara-
jinja 大笹原神社) 275

Laurens, Jean-Paul 402, 425

Leading a Horse at Dawn (*Chōton Eiba-zu*
朝暾曳馬図; Hanabusa Itchō 英一蝶)
hanging scroll 323–**24**

Leaning Woman (Yorozu Tetsugorō) 415

*Ledger of the Assets of the Tō-in at Hōryū-ji
Temple* (*Hōryū-ji Tō-in Shizai-chō*
法隆寺東院資財帳) 49; Guze Kannon
救世観音 50–51

Lee Ufan 李禹煥 454, 464; *Art of the
Empty Space* (*Yohaku no geijutsu*
余白の芸術) book 464; *Relatum:
Silence* (*Kankeikō: Sairensu*
関係項: サイレンス) 464–**65**

legal and criminal codes (see *ritsuryō*)

Legend of Kamui (Shirato Sanpei) 468

Legends of Urashima Myōjin (*Urashima
Myōjin Engi* 浦島明神縁起; Ura shrine
宇良神社, Kyoto prefecture) handscroll
259

Li Anzhong 李安忠 253; Ashikaga
shogunal collections 252–54,
266; *Quails* (*Uzura-zu* 鶉図) 235;
"Zakkashitsu" seal "雑華室" 印 235

Li Bai Composing a Poem (*Rihaku
Ginkō-zu* 李白吟行図; Liang Kai 梁楷)
hanging scroll 253

Li Cheng 李成 250

Li Di 李迪 253–54, 259; Ashikaga
shogunal collections 252–54,

266; *Catalogue of the Property of Butsunichi-an* (*Butsunichi-an Kōmotsu Mokuroku* 仏日庵公物目録) 248, 254; *Record of Decorations for the Imperial Visit to the Muromachi Palace* (*Muromachi-dono Gyōkō Okazari-ki* 室町殿行幸御鈔記) 254, 258

Li Gonglin 李公麟 (or Li Longmian 李竜眠) 220, 266; *Five Horses* 五馬図巻 handscroll 220

Li T'ang 李唐 253; Ashikaga shogunal collections 252–54, 266; Chinese landscapes

Li Zhen 李真 103, 105; Genzu Mandala 現図曼荼羅 103; *Seven Shingon Patriarchs* (*Shingon Shichiso-zo* 真言七祖像; Tō-ji 東寺) 105, 140

Liang Kai 梁楷 253, 259; *Li Bai Composing a Poem* (*Rihaku Ginkō-zu* 李白吟行図) 253; *Sakyamuni Descending from the Mountain* (*Shussan Shaka-zu* 出山釈迦図) 253; *Snowy Landscape* (*Sekkei Sansui-zu* 雪景山水図) 253

Life-Extending Fugen (*see* Fugen Enmei)

literati painting (*bunjin-ga* 文人画 or Nanga 南画): Chinese 307, 337–39; literati painting, criticism of 381, 409

literati 文人: 69, 249, 262, 346, 364, 370, 380–81, 429; Chinese painting 307, 311, 337–39; Kyoto 338, 356–57, 409; Nanga 337–39, 341, 356, 364, 415; Kantō Nanga 357

litharge painted box (*mitsuda saie no hako* 密陀彩絵箱; Shōsō-in central repository 正倉院中倉) 89–90

lithograph (*sekibanga* 石版画) 375, 388, 418

Little Prince and the Eight-Headed Dragon (*Wanpaku ōji no orochi taiji* わんぱく王子の大蛇退治) 469

Liu Hai and Li Tieguai (*Gama Tekkai-zu* 蝦蟇鉄拐図; Yan Hui 顔輝; Chion-in 知恩院) handscrolls, diptych 253

Lively Perpetual Motion (Yokoyama Taikan) 430

Longmen grottos 龍門石窟 (Henan province) 43, 48, 56, 77; Guyang cave 古陽洞 48; Middle Bingyang cave 賓陽中洞 48

Longxing Si 隆興寺 (Hebei province) 43, 48, 51

Lotus Pond (*Renchi-zu* 蓮池図; Hōryū-ji 法隆寺) mural 254

Lotus Sutra (*Hoke-kyō* or *Hokke-kyō* 法華経) 140, 141, 159, 209

Lotus Treasury World 蓮華蔵世界図 77

Lu Zhi 陸治 338; *Tan'yū Shukuzu* 探幽縮図 (Tan'yū's reduced-size copies of paintings) 336

lute (*biwa* 琵琶 and *genkan* 阮咸) 87, 88–89, 115; five-stringed rosewood lute (*biwa*) with mother of pearl inlay (*raden shitan no gogen biwa* 螺鈿紫檀五絃琵琶; Shōsō-in northern repository 正倉院北倉, Tōdai-ji 東大寺, Nara) 87–88; round rose wood ruan lute (*genkan*) with mother-of-pearl inlay (*raden shitan no genkan* 螺鈿紫檀阮咸; Shōsō-in northern repository 正倉院北倉, Tōdai-ji 東大寺, Nara) 87; sappanwood plectrum guard of a maple lute (*kaede suōzome raden no sō biwa* 楓蘇芳染螺鈿槽琵琶; Shōsō-in southern repository 正倉院南倉, Tōdai-ji 東大寺, Nara) 87

Lydians 33

Ma Yuan 馬遠 251, 252, 266, 278; Ashikaga shogunal collections 252–54, 266; formal (*shin* 真) brush style 278; "one-corner" composition "馬遠の一角" (*zanzan jōsui* 残山剰水) 251

machi-ganō 町狩野 (townsmen Kanō) 323

Maeda Seison 前田青邨 (painter) 430; *Admonitions Scroll*, copying of 431; *Chinese Lions* (*Karajishi-zu byōbu* 唐獅子図屏風) 383–84; *Healing*

Spirits (*Tōjiba* 湯治場) 431; *Eight Famous Views of Kyoto* (*Kyō meisho hachidai* 京名所八題) 431; *Yoritomo in the Cave* (*Dōkutsu no Yoritomo* 洞窟の頼朝) 432

Maekawa Kunio 前川國男 (architect) 449–50, 460

Mahavairocana Sutra (*Dainichi-kyō* 大日経) 96

Mahayana Buddhism 大乗仏教 95, 140

Maijishan grottos 麦积山石窟 (Gansu province) 43, 52

Maiko (Kuroda Seiki) 399, **400**

Maiko in a Garden (Tsuchida Bakusen) 433

Maitreya (*see* Miroku Bosatsu)

maki-e 蒔絵 (sprinkled gold) 89, 117–18, 141–42, 175, 180–84, 239–41, 265, 299, 332; *hiramaki-e* 平蒔絵 (flat *maki-e*) 291; *Kōdai-ji maki-e* 高台寺蒔絵 291, 312–13; *takamaki-e* (high relief) 高蒔絵 lacquer 241, 268, 288, 313

maki-e lacquer box for Buddhist surplices with a maritime motif (*kaifu maki-e kesa bako* 海賦蒔絵袈裟箱; Tō-ji, Kyoto) **118**

maki-e lacquer document case with floral and mythical bird motif (*hōsōge karyō binga maki-e sasshi bako* 宝相華迦陵頻伽蒔絵冊子箱; Ninna-ji 仁和寺, Kyoto) 117–18

Makimuku site 纏向遺跡 (Sakurai, Nara prefecture; large settlement; end of Yayoi–Early Kofun) 31

Man'yōshū 万葉集 73, 76

Manchurian Incident (Manshū Jihen 満州事変) 424, 449

Mandalas of the Two Worlds (Ryōkai Mandara 両界曼荼羅) 100, 101–05, 109, 118, 121, 212

mandalas 曼荼羅 101–103; karmic mandalas (*katsuma mandara* 羯磨曼荼羅) 109

mandorla (*kōhai*) 光背 47, 120, 156

manga 漫画, マンガ 346, 363, 383, **466**, 467, 468, 469, 472, 477; girls' manga 少女漫画 223, 469; Hokusai 360–63; *Jiji Manga* 時事漫画 467; manga film (*manga eiga*) 漫画映画 469; monster (*yōkai*) 妖怪漫画 467; sports manga スポーツ漫画 468

manga eiga 漫画映画 (manga film) 469

Manpuku-ji 万福寺 (Uji, Kyoto prefecture) 334, 340; *Five Hundred Arhats* (*Gohyaku Rakan-zu* 五百羅漢図; Ike no Taiga 池大雅; sliding door paintings) 340; Ōbaku sect 黄檗宗 334; statue of Skanda (Idaten zō 韋駄天像; Fan Daosheng 范道生) 334; Tagami Kikusha's (田上菊舎) poem 334; Yinyuan Longqi 隠元隆琦 334

Manual of Eight Categories of Painting (C: *Bazhong Huapu*; J: *Hasshu Gafu* 八種画譜) 339

Mao Song 毛松 253; Ashikaga shogunal collections 252–54, 266; *Monkeys* (*Saru-zu* 猿図) 253

Maple-Viewing at Takao (*Takao Kanpū-zu* 高雄観楓図屏風; Kanō Hideyori 狩野秀頼) 287

mappō 末法 127, 138, 487n26

Marionette (Goseda Yoshimatsu) 380

Maruki Iri and Maruki Toshi 丸木位里, 丸木俊 452, 454; *Hiroshima Panels* (*Genbaku no zu* 原爆の図) 452

Maruyama Banka 丸山晩霞 (painter) 402

Maruyama Ōkyo 円山応挙 307, 338, 341–43; *Album of Sketches: Insects* (*Konchū Shaseichō* 昆虫写生帖) **342**; *mokkotsu* 没骨 ("boneless") technique 343; *Screens of Fuji at Miho* (*Fuji Miho Matsubara-zu byōbu* 富士三保図屏風) 343; *Screens with Bamboo in Rain and Wind* (*Uchiku Fūchiku-zu byōbu* 雨竹風竹図屏風; Enkō-ji 円光寺, Kyoto) 341–43; *Screens with Snow-Covered Pines* (*Yuki*

Matsu-zu byōbu 雪松図屏風) 341–42; *Screens with Wisteria* (*Tōka-zu byōbu* 藤花図屏風) 341; *Sliding Doors with Pines and Peacocks* (*Matsu ni Kujaku-zu fusuma-e* 松孔雀図襖絵; Daijō-ji 大乗寺, Hyogo prefecture) 341

Maruyama-Shijō 円山四条派 (tradition of realism) 408–10

Masaoka Kenzō 政岡憲三 (animated film maker) 469; *Spider and Tulip* (*Kumo to chūrippu* くもとちゅうりっぷ) 469

masks (*men* 面): Dengaku 246; Gigaku 77, **92**; Kyōgen 246; mask-like 7; Noh 246–47; Noh Mask (*Noh-men* 能面) series (Sakamoto Hanjirō 坂本繁二郎) 428; Sarugaku 猿楽 246

Master of the Great Buddha (*daibusshi* 大仏師) 77, 484n7

Mathura 42, 43, 483n7

Matisse exhibition (1951) 454–55

Matsumoto Goshun 松本呉春 343; Herons in Willows screens (*Ryūro Gunki-zu* 柳鷺群禽図) 343

Matsumoto Kisaburō 松本喜三郎 xiv, 377–78; Record of Spiritual Experiences along the Thirty-Three Kannon Temples in Western Japan (*Saigoku junrei sanjūsankasho Kannon reigenki* 西国順礼三十三所観音霊験記) 377

Matsumoto Shunsuke 松本竣介 (painter) 446; *Bridge in Town Y* (*Y-shi no hashi* Y市の橋) **446**

Matsuo grand shrine (Matsuo taisha 松尾大社, Kyoto) 115; seated male *kami* (Danshin Zazō 男神坐像) **114**–15; seated female *kami* (Joshin Zazō 女神坐像) **114**–15

Matsuo Kōichi 松尾浩一 231

Matsuo-dera 松尾寺 (Kyoto prefecture) 156

Matsuoka Hisashi 松岡寿 (painter) 379

MAVO (art collective) 439, 448–49

Medicine Buddha (*see* Yakushi Nyorai)

Medicine King Chapter (*Yaku-ō-bon* 薬王品) 159

Meiji Art Society (*see* Meiji Bijutsu-kai)

Meiji Bijutsu-kai 明治美術会 (Meiji Art Society) 385, 400, 402

Meiji Restoration (Meiji Ishin 明治維新) 374, 382, 399

Meiji Romantic School 明治浪漫派 403 (*see* Romanticism)

Meiji Seimeikan 明治生命館 (Tokyo; Okada Shin'ichirō) 447

meisho-e 名所絵 (pictures of famous places) 285

Merciful Mother Kannon (Kanō Hōgai) **383**

metal: Yayoi 弥生 21; tools 15, 21; metalwork production 29, 44, 117, 238; metalwork technique 268, 270, 365; Myōchin 明珍 metalwork studio 396; sculpture (*jizai* 自在) 365, 397

metalwork 29, 44, 117, 62, 65, 238, 268, 270, 365, 396

Metropolis (Tezuka Osamu) 468

Mezurashizuka burial mound 珍敷塚古墳 (Fukuoka prefecture) 37

Middle Gate (Chūmon 中門): Hōryū-ji 法隆寺 411; Tōdai-ji 東大寺 194, 195

Miei-dō 御影堂 (Founder's Hall): Tōshōdai-ji 唐招提寺 79

Migishi Kōtarō 三岸好太郎 (painter) 440; *Sea and Sunshine* (*Umi to shakō* 海と射光) 441

Miki Tomio 三木富雄 462

Minamonoto no Morotoki 源師時 134; *Chōshūki* 長秋記 134

Minamoto clan (Genji 源氏) 188

Minamoto no Makoto 源信 165–66

Minamoto no Taka'akira 源高明 119

Minamoto no Yoritomo 源頼朝 94, 188; on Emperor Go-Shirakawa 後白河天皇 217; portrait of (Jingo-ji 神護寺) **218**

Minashiguri 虚栗 (Takarai Kikaku 宝井其角) 331; Hishikawa Moronobu 菱川師宣 331

Ming China 明代中国 244, 248, 250, 306, 325, 335, 369: art 244, 248, 333–35; bird-and-flower paintings 335, 344; celadon 280; decorative art 334–35; embassies to 265; painters 276; paintings 250, 255, 335, 340, 357; style/manner/modes 254, 335, 338–39, 340, 346; tea drinking 364; techniques 276, 334, 357; textiles 269; trade with 254, 306, 337

mingei 民芸 (folk craft) 365, 477

minka 民家 (private dwelling of commoners; townhouses and farmhouses) 335–37, 365; gasshō-zukuri 合掌造 ("praying-hands style") 337; honmune-zukuri 本棟造 337; L-shaped (magari-ya 曲家) 337; sennen-ya 千年屋 336

Mino ware 美濃焼 301

Miraiha Bijutsu Kyōkai (see Association of Futurist Artists) 438

Miroku Bosatsu (Bodhisattva Maitreya) 弥勒菩薩: 58–59, 64, 66, 212; An'ami style 安阿弥様 200; arrival of 212, 295; Jison-in 慈尊院 (Wakayama prefecture) 120; Kōfuku-ji 興福寺 (Nara) 199; Hōkan 宝冠弥勒 (Jewel Crowned; Kōryū-ji 広隆寺, Kyoto) 53, 54; Things Seen and Heard during the Keichō Era (Keichō Kenmon Shū 慶長見聞集) 295

mirror with a design of autumn grasses and cranes with sprigs of pine in their beaks (akikusa matsukui-zuru kyō 秋草松喰鶴鏡; formerly in Nishi Hongan-ji 西本願寺, Kyoto) 183–84

mirror, octagonal, with gold and silver embedded in lacquer (kingin heidatsu hakkakukyō 金銀平脱八角鏡; Shōsō-in northern repository 正倉院北倉, Tōdai-ji 東大寺, Nara) 87

mirrors 鏡 Asuka/Hakuhō 飛鳥白鳳 40–41; Byōdō-in 平等院 127; Dewa shrine (Dewa-jinja) 出羽神社 184 (see Haguro mirrors); formerly in

Nishi Hongan-ji 西本願寺 183–84; Kamakura period 鎌倉時代 238; Kofun period 古墳時代 28; Kongōshō-ji 金剛證寺 183–84; Shōsō-in 正倉院 87; triangular-rimmed mirrors 三角縁神獣鏡 28, 30, 31; Yayoi period 弥生時代 30–31, 34, 36

misemono 見世物 (sideshow entertainments) 377

Mishima grand shrine (Mishima taisha 三嶋大社, Shizuoka prefecture) 240; cosmetic box with a maki-e plum blossom pattern (ume maki-e tebako 梅蒔絵手箱) 240–41

Mitake shrine (Mitake-jinja 御嶽神社, Tokyo) 239; odoshi-yoroi (braided armor) with red threads (akaito odoshi-yoroi 赤糸威鎧) 239

mitate 見立 351; visual allusion 181; visual stand-in 149

mitsuda-e 密陀絵 (litharge technique) 62, 89, 90; litharge painted box (mitsuda saie no hako 密陀彩絵箱; Shōsō-in Repository 正倉院) 89–90; Tamamushi Shrine (Tamamushi no zushi 玉虫厨子; Hōryū-ji 法隆寺) 62

Mitsui Club (Tsunamachi Mitsui Kurabu 綱町三井倶楽部; Tokyo; Conder) 394

Mitsui House 三井組ハウス (later the First National Bank [Daiichi Kokuritsu Ginkō 第一銀行]; Tokyo; Shimizu Kisuke) 392

Mitsutani Kunishirō 満谷国四郎 (painter) 402, 442

miyabi 雅 326

Miyagawa Chōshun 宮川長春 349; bijin-ga 美人画 (paintings of beauties) 349, 352, 353, 354

Miyagawa Kōzan I 宮川香山 (初代) (or Makuzu Kōzan 真葛香山; craft artist) 397; bowl in brown glaze with applied crabs (katsuyū kani harituki daituki bachi 褐釉蟹貼付台付鉢) 397

Miyajima Shin'ichi 宮島新一 216

Miyamoto Saburō 宮本三郎 (painter) 444

Miyazaki Hayao 宮崎駿 (anime director) 471: *Castle in the Sky* (*Tenkū no Shiro Rapyuta* 天空の城ラピュタ), *Kiki's Delivery Service* (*Majo no takkyūbin* 魔女の宅急便), *My Neighbor Totoro* (*Tonari no Totoro* となりのトトロ), *Nausicaä of the Valley of the Wind* (*Kaze no Tani no Naushika* 風の谷のナウシカ); *Princess Mononoke* (*Mononoke-hime* もののけ姫), *Spirited Away* (*Sen to Chihiro no Kamikakushi* 千と千尋の神隠し) 471

Miyazaki Shin 宮崎進 (painter) 452; *Landscape of the Drifting Heart* (*Tadayou kokoro no fūkei* 漂う心の風景) **453**

Miyazaki Yūzen 宮崎友禅 332; *kosode hiinagata* design books 小袖雛形本 332; *yūzen* dyeing technique (*yūzen-zome* 友禅染) 332

Miyoshi Nagayoshi 三好長慶 285

Mizuno Keizaburō 水野敬三郎 199

Mo Shilong 莫是竜 338; *Tan'yū Shukuzu* 探幽縮図 (Tan'yū's reduced-size copies of paintings) 336

Moat (Yokoo Tadanori) **477**

Model Thousand-Yen Notes (Akasegawa Genpei) 463

modernism 475, 477, 490n5: in architecture 414, 421–23, 432, 447, 448–50; painting 435–36

modernization 近代化 370, 408–09, 411, 424, 429, 448

mokkotsu 没骨 ("boneless") technique 343, 431; *Eight Famous Views of Kyoto* (Maeda Seison 前田青邨) 431; *Healing Springs* (Maeda Seison 前田青邨) 431; *Screens of Fuji at Miho* (*Fuji Miho Matsubara-zu byōbu* 富士三保図屏風; Maruyama Ōkyo 円山応挙) 343

Mokuan 黙庵 (painter) 255, **256**; *Hotei* 布袋図 **256**; Liutong 六通寺 (Yuan China 元代中国) 255

Mokubei 木米 356, 364; Chinese-style *sencha* wares 煎茶器 364

Mokujiki Myōman 木喰明満 **369–70**; hatchet-carved sculpture 鉈彫り像 112, 134, 369; Nakula (Nakura Sonja 諾距羅尊者) **370**; *sakubutsu hijiri* 作仏聖 ("Buddha-making holy men") 329; Subhinda (Sohinda Sonja 蘇頻陀尊者) **370**

Momoyama art 桃山美術 307, 309; architecture 295, 322

Momoyama period 桃山時代 275, 284, 288, 291, 296, 301, 306, 311, 313, 315, 322, 337, 346, 430; decorative arts 288; gold-ground sliding doors 276, 278, 295; painting 310; playfulness 316; textiles 327; *Things Seen and Heard during the Keichō Era* (*Keichō Kenmon Shū* 慶長見聞集) 295

Monbushō Bijutsu Tenran-kai (Art Exhibition of the Ministry of Education) (*see* Bunten)

Mongol invasion 蒙古襲来: in China 234; of Japan 225

Monju Bosatsu 文殊菩薩 (Manjusri) 168, 204, 209, 213; clay statue at Hōryū-ji 法隆寺 72

Mono-ha もの派 ("School of Things") 464

Moonglow (*Tsukuhae* 月映 journal) 420

Morelli, Giovanni (art critic) 405

Mōri Hisashi 毛利久 56

Morita Shiryū 森田子龍 458–59

Moriyama Daidō 森山大道 (photographer) 475

mōrō-tai 朦朧体 (hazy style) 407

Morse, Edward Sylvester 3–4, 20; Ōmori shell middens 大森貝塚 (Tokyo) 3, 20;

mother-of-pearl (*raden* 螺鈿) 176, 180–83, 239–41, 299

Motonaga Sadamasa 元永定正 (painter) 457

Mōtsū-ji 毛越寺 (Fujiwara no Kiyohira 藤原清衡; Iwate prefecture) 177

Mount Sumeru 須弥山 47, 53, 61

Mozuna Kikō 毛綱毅曠 (architect) 465; *Anti-Residential Appliance* (*Han-jūki* 反住器; Hokkaido) 465

Mt. Asama 浅間山 339

Mt. Grdhrakuta (Vulture Peak) 61

Mt. Haku 白山 339, 367–68

Mt. Hiei 比叡山 97

Mt. Ibuki 伊吹山 329

Mt. Kinpusen 金峰山 (Yoshino 吉野) 212

Mt. Kōya 高野山 109, 114, 212; Kongōbu-ji 金剛峰寺 194

Mt. Mikasa 三笠山 212

Mt. Potalaka 補陀洛山 212

Mt. Rokkō 六甲山 26, 27

Mt. Tate 立山 339

Mt. Tiantai 天台山 97

Mt. Wutai 五台山 204

mudras 印相 100, 104, 132, 209; *raigō* 来迎印 177; *tempōrin* 転法輪印 209

Mukai Junkichi 向井潤吉 (painter) 472

Munakata Shikō 棟方志功 (woodblock print artist) 421, 455–56, 478; *Two Bodhisattvas and Sakyamuni's Ten Great Disciples* (*Ni Bosatsu Shaka Jūdai-deshi* 二菩薩釈迦十大弟子) 455; "Joshin" 女神 (Goddess) from the series *Kegonpu* 華厳譜 (Record of the Kegon Sutra) 456

Muqi Fachang 牧谿法常 (monk-painter) 251–52, 254, 259, 267, 278, 291; *Catalogue of the Property of Butsunichi-an* (*Butsunichi-an Kōmotsu Mokuroku* 仏日庵公物目録) 248, 254; *Guanyin, Gibbons, and Crane* (*Kannon, Enkaku-zu* 観音・猿鶴図; Daitoku-ji 大徳寺) 251; *Liutong* 六通口 (Yuan China 元代中国) 255; Muqi-style 255; *Record of Decorations for the Imperial Visit to the Muromachi Palace* (*Muromachi-dono Gyōkō Okazari-ki* 室町殿行幸御餝記) 254, 258; semi-formal (*gyō* 行) brush style 266; "Sunset Glow on a Fishing Village" (Gyoson Sekishō-zu 漁村夕照図) from *Eight*

Views of the Xiao and Xiang Rivers (*Shōshō Hakkei* 瀟湘八景) 252

Murakami Kagaku 村上華岳 (painter) 433, 459; *Calm Winter Mountain* (*Fuyubare no yama* 冬ばれの山) 435

Murakami Saburō 村上三郎 457

Murakami Takashi 村上隆 (artist) 384, 477, 479; superflat 477; *Tan Tan Bo Puking - a.k.a. Gero Tan* たんたん坊:a.k.a ゲロタン 478

murals 壁画 32

Murano Tōgo 村野藤吾 (architect) 448; Watanabe-ō Memorial Hall (Watanabe-ō Kinen Kaikan 渡辺翁記念会館; Ube, Yamaguchi prefecture) 448

Murayama Kaita 村山槐多 (painter) 415; *Woman beside a Lake* (*Kosui to onna* 湖水と女) 415

Murayama Tomoyoshi 村山知義 (painter) 439, 448; *Construction* コンストルクチオン 439

Murō-ji 室生寺 (Nara prefecture) 104–104

Muromachi period 室町時代 315; ink painting 室町水墨画 310

Muryeong 武寧 (Korean King) 33

Muryōju-in 無量寿院 (Kyoto) 127, 131, 177; *see also* Hōjō-ji 法成寺

Muryōkō-in 無量光院 (Fujiwara no Hidehira 藤原秀衡; Iwate prefecture) 177

musen shippō 無線七宝 (cloisonné wireless enamels) 397

Museum of Modern Art, Kamakura (Kamakura Kindai Bijutsukan 鎌倉近代美術館; Sakakura Junzō 坂倉準三) 460; Kamakura Bunkakan Tsurugaoka Museum 鎌倉文化館鶴岡ミュージアム 460

Musicians Riding an Elephant (*Kizō Sōgaku-zu* 騎象奏楽図) 87, 90; sappanwood plectrum guard of a maple lute (*kaede suōzome raden no sō biwa* 楓蘇芳染螺鈿槽琵琶; Shōsō-in

southern repository 正倉院南倉, Tōdai-ji 東大寺, Nara) 87

Muslims 96

Musō Soseki 夢窓疎石 255, 257, 266; *karesansui* 枯山水 garden at Tenryū-ji 天竜寺 and Kōinzan in Saihō-ji 西芳寺 洪隠山 (both Kyoto) 255; portrait of 257; Saihō-ji 西芳寺 257, 266

Mustard-Seed Garden Manual of Painting (C: *Jieziyuan Huazhuan*, J: *Kaishien Gaden* 芥子園画伝) 338, 339

Mutō Shūi 無等周位 257; portrait of Musō Soseki 夢窓疎石像 257; Saihō-ji 西芳寺 paintings (*Arhats* [Rakan 羅漢図], *Carp* [*Koi-zu* 鯉図], *Zenki-zu* 禅機図) 257

My Neighbor Totoro (Miyazaki Hayao) 471

Myō-ō 明王 (Wisdom Kings; Vidyaraja) 104

Myōchin 明珍 (metalworking studio) 396; *jizai* 自在 396

Myōe, Priest 明恵 205, **221**, 228; Kegon sect reviver 華厳宗復興 189; *Portrait of* (*Myōe Shōnin-zō* 明恵上人像; attributed to Enichibō Jōnin 恵日房 成忍; Kōzan-ji 高山寺, Kyoto) 221

Myōgi shrine (Myōgi-jinja 妙義神社, Gunma prefecture) 367

Myōjō 明星 (Bright Star) journal 404, 420

Myōren 妙蓮 (monk) 164

Myōshin-ji 妙心寺 (Kyoto); *Birds amid Plum Trees* sliding doors (*Ume ni Yūkin-zu fusuma* 梅に遊禽図襖; Kanō Sanraku 狩野山楽; Tenkyū-in 天球院) 311–**12**; calligraphy *Kanzan* 関山 by Shūhō Myōchō 宗峰妙超 **237**; *Catching a Catfish with a Gourd* (*Byōnen-zu* 瓢鮎図; Josetsu 如拙; Taizō-in 退蔵院) 262, **264**; Hakuin 白隠 343; Kaihō Yusho's 海北友松 screens with flowering plants (*Kaki-zu byōbu* 花卉図屏風) 294; Kanō Motonobu's 狩野元信 sliding

door paintings (Reiun-in 霊雲院) 278

Nabatake site 菜畑遺跡 (Saga prefecture) 22

Nabeshima domain kilns 鍋島藩窯 (Ōkawachiyama 大川内山) 324–25

Nabeshima ware 鍋島焼 324–**25**; official gifts (*kenjōhin* 献上品) 325; tripod dish with underglaze cobalt blue design of herons and lotus leaf (*sometsuke sagi-mon mitsuashi sara* 染付鷺文三脚皿) **325**

Nabeta tunnel tomb 鍋田横穴 (Kumamoto prefecture) 37

Nachi grand shrine (Nachi taisha 那智大社, Wakayama prefecture) 214

Nachi Waterfall (Nachi Taki-zu 那智滝図) hanging scroll 215, 488n3

Nagabodhi (Ryūchi 竜智) 105

Nagano Uheiji 長野宇平治 (architect) 412; Nara Prefectural Office (Nara Kenchō 奈良県庁) 412

Nagaoka Ryūsaku 長岡龍作 107

Nagaoka-kyō 長岡京 95

Nagarjuna (Ryūmyō 竜猛) 105, 140–41

Nagasawa Eishin I 永澤永信 (初代) 396; cast-bronze vase with a bird-and-flower design inlaid in gold and silver (*kachōmon kabin* 花鳥文花瓶), white vase with basket weave effect and birds and flowers in high relief (*hakuji kagome kachō haritsuke kazari-tsubo* 白磁籠目花鳥貼付飾壷) 396

Nagasawa Rosetsu 長沢芦雪 338, 343–44, **348**–49, 467; *Sliding Doors with Tiger* (*Tora-zu fusuma-e* 虎図襖絵) 348–49

Nageire-dō 投入堂 (*see* Zaō Hall)

Nagoya Castle 名古屋城 (Aichi precture) 296, 308, 310; *Plum Tree, Bamboo, and Birds in the Snow* sliding doors (*Secchū Baichiku Yūkin-zu fusuma* 雪中梅竹 遊禽図襖; Kanō Tan'yū 狩野探幽; Jōraku Palace 上洛殿) 310–**11**

Naikoku Kaiga Kyōshin-kai 内国絵画

共進会 (National Painting Exhibition) 385

naikoku kangyō hakurankai 内国勧業博覧会 (domestic industrial exposition) 378

Nakagawa Hachirō 中川八郎 (painter) 402, **403**; *Farmers Returning in Snowy Woods* (Setsurin kiboku 雪林帰牧) **403**

Nakagawa Kazumasa 中川一政 (painter) 410

Nakahara site 中原遺跡 (Yamanashi prefecture) 7; barrel-shaped vessel (*yūkō tsuba-tsuki doki* 有孔鍔付土器; Middle Jōmon 縄文中期) 7

Nakahara Teijirō 中原悌二郎 (sculptor) 421

Nakamura Fusetsu 中村不折 (painter) 402, 425; Jean-Paul Laurens at the Académie Julian (Paris) 425

Nakamura Gakuryō 中村岳陵 (painter) 453

Nakamura Ken'ichi 中村研一 (painter) 444

Nakamura Tsune 中村彝 (painter) **418**; *Portrait of Vasilii Yaroshenko* (Eroshenko-shi no zō エロシェンコ氏の像 Nakamura Tsune) **418**

Nakanishi Natsuyuki 中西夏之 462; *Unsettling Phenomenon* (*Kakuran genshō* 撹乱現象) 464

Nakano A site 中野A遺跡 (Hokkaido) 5; conical round-bottom deep vessel with shell appliqué (*kaigara chinsenmon sentei fukabachi* 貝殻沈線文尖底深鉢; Initial Jōmon 縄文早期) 5

Nakano Masaki 中野政樹 238

Nakatsukasa 中務 (poet) 231; pictures of Thirty-Six Poets (*Sanjūrokkasen-e* 三十六歌仙絵), Gotoba-in scroll 後鳥羽院本 (Senshū-ji 専修寺, Mie prefecture) 231

Namikawa Sōsuke 濤川惣助 (cloisonné artist) 397; cloisonné wireless enamels (*musen shippō* 無線七宝) 397

Nanban 南蛮 296, 299; Nanban folding screens (*Nanban-zu byōbu* 南蛮図屏風) 299

"Nanga Expressionism" ("Nanga-teki hyōgen shugi" 南画的表現主義; *see* Expressionism)

Nanga 南画 337–41, 356, 364, 415 (*see also* Southern School); Kantō Nanga 357

Nanpo Jōmin 南浦紹明 (monk) 235

Nara Prefectural Office (Nara Kenchō 奈良県庁; Nagano Uheiji) 412

Nara Yoshitomo 奈良美智 477

Narahara Ikkō 奈良原一高 (photographer) 473

Nata Yakushi-dō 鉈薬師堂 (also known as Iōdō 医王堂; Nagoya, Aichi prefecture) 334; Twelve Devas (Jūniten 十二天; Enkū 円空; sculpture) 334; Zhang Zhenfu 張振甫 334

National Museum of Korea 国立中央博物館 53

National Painting Exhibition (*see* Naikoku Kaiga Kyōshin-kai)

Natsume Sōseki 夏目漱石 (author) 428

Natural Girl (Kishida Ryūsei) **417**

Nausicaä of the Valley of the Wind (Miyazaki Hayao) 471

nenbutsu 念仏 126, 131, 189, 198, 201, 221, 229, 245; *kansō* 観想念仏 126; odori 踊り念仏 488n5

nenshi 念紙 (carbon paper) 64

netsuke 根付 364–65, 390

New Classicism 新古典主義 (painter) 435

New Collection of Japanese Poems of Ancient and Modern Times (see *Shin Kokin Wakashū* 新古今和歌集)

New Gleanings of Japanese Poetry (*Shin Shūi Wakashū* 新拾遺和歌集) 220; Fujiwara no Nobuzane's 藤原信実 self-portrait 220

New Moon over a Brushwood Gate (Saimon Shingetsu-zu 柴門新月図)

262–**63**; poetry-picture scroll (*shiga-jiku* 詩画軸) 261–62

New Production Association Exhibition (*see* Shin Seisaku-ha Kyōkai-ten)

new school (Shinpa 新派) 399; "purple school" (Murasaki-ha 紫派) or "school of natural light" (Gaikō-ha 外光派) 399

New Treasure Island series (Tezuka Osamu) 468

Nichiren, Priest 日蓮 189

Night Procession of One Hundred Demons (*Hakki Yagyō Emaki* 百鬼夜行絵巻; Shinju-an, Daitoku-ji 大徳寺真珠庵) 259–**60**, 467

Night Train (Akamatsu Rinsaku) 403

Nigiwaigusa にぎはひ草 (a collection of miscellaneous writings by Haiya Shōeki 灰屋紹益) 314; description of the garden at Katsura Imperial Villa 桂離宮 314

Nihon Andepandan-ten 日本アンデパンダン展 (Japan Independent Exhibition) 454

Nihon Bijutsu Tenrankai 日本美術展覧会 (Japan Fine Arts Exhibition), "Nitten" 日展 452

Nihon Bijutsu-kai 日本美術会 (Japan Art Society) 453

Nihon Bijutsuin 日本美術院 (Japan Art Institute) 407, 416

Nihon Kangyō Bank (Nihon Kangyō Ginkō 日本勧業銀行; Tokyo; Watanabe Setsu) 413

Nihon Kokusai Bijutsu-ten 日本国際美術展 (Japan International Art Exhibition) 454

Nihon Shoki 日本書紀 (*Chronicles of Japan*) 44–45, 47, 52, 59; Asuka-dera 飛鳥寺 (painters from Baekje) 59; Buddhist statue sent from Baekje 44; Hōryū-ji 法隆寺 44; large-scale civil engineering projects in Asuka 47; Tori Busshi 止利仏師 45; Yamaguchi no Ōguchi no Atai 山口大口費 52

Nihonga 日本画 (Japanese-style painting) 311, 384, 407, 408, 411, 416, 429–33, 436; Kyoto Nihonga 411, 433

Niizawa Senzuka burial mounds colony 新沢千塚古墳群 (Nara prefecture) 32; gold and gilt-bronze burial accessories 32–33

Niizawakazu site 新沢一遺跡 (Nara prefecture) 23–**24**; jug-like vessel (*mizusashi-gata doki* 水差形土器; Middle Yayoi 弥生中期) **24**

Nijō Castle 二条城 (Kyoto) 308, 318; Ninomaru Palace 二の丸御殿 **308**; Kanō Tan'yū 狩野探幽 310

Nika-kai 二科会 (Second Division Society) 416, 453

Nikaten 二科展 (*see also* Nika-kai) 453

Nikkō Bosatsu 日光菩薩 70, 75–76; Chōsei 長勢 (Kōryū-ji 広隆寺) 134

Nikkō Tōshō-gū shrine 日光東照宮 308, 366–67

Nikkō 日光 308–09

Nin'ami Dōhachi 仁阿弥道八 364

Nine Figures of Amida (Kutai Amida 九体阿弥陀): Jōchō 定朝 and Kōshō 康尚 (Hōjō-ji 法成寺 formerly Muryōju-in 無量寿院) 131, Jōruri-ji 浄瑠璃寺 (Kyoto) 177–78

Nine Grades of Rebirth (*Kuhon Raigō-zu* 九品来迎図; Taishi-dō, Kakurin-ji 鶴林寺太子堂, Hyogo prefecture) mural 140

Nine Grades of Rebirth in the Pure Land (*Kuhon Raigō-zu* 九品来迎図; Byōdō-in 平等院) 136; *Kokon Chomonjū* 古今著聞集 136; Takuma Tamenari 宅間為成 136

Nine-Headed Kannon (Kumen Kannon 九面観音) 485n7

Nineteen Appearances of Fudō for Contemplation (Fudō Jūkyū Sōkan 不動十九相観) 123

Ninja Book of Warrior Arts (Shirato Sanpei) 468

Ninna-ji 仁和寺 (Kyoto) 118, 119, 174, 178

Ninomaru Palace 二の丸御殿 **308**; Momoyama *shoin*-style palace architecture 308; banquet rooms (*ōhiroma* 大広間) 308; guard rooms (*tōzamurai* 遠侍) 308; studies (*kuro-shoin* 黒書院, *shiro-shoin* 白書院) 308

Ni-ō 仁王: Kōfuku-ji 興福寺 201

Ni-ō Capturing a Demon (Kanō Hōgai) **383**

nirvana (painting; *nehan-zu* 涅槃図) 72, 138

nise-e 似絵 (likeness pictures) 219–20, 231; Fujiwara no Nobuzane 藤原信実 219

Nishi Hongan-ji 西本願寺 (Kyoto) 143, 309

Nishikawa Sukenobu 西川祐信 351

Nishikawa Yasushi 西川寧 (calligrapher) 459

nishiki-e 錦絵 (polycolor prints) 350–51; picture-calendars (*egoyomi* 絵暦) 350; Suzuki Harunobu 鈴木春信 350–51

Nishinomae site 西ノ前遺跡 (Yamagata prefecture) 14; standing *dogū* (or Jōmon Goddess; *Jōmon no megami* 縄紋の女神) **14**

Nishinomiya-yama burial mound 西宮山古墳 (Hyogo prefecture) 36; Sue ware 須恵器 jar decorated with children (*sōshoku-tsuki kyaku-tsuki komochi tsubo* 装飾付脚付子持壺 **36**

Nishiwaki Junzaburō 西脇順三郎 (poet, literary critic) 440

Nitten (*see* Nihon Bijutsu Tenrankai)

Nōami 能阿弥 249, 254, 266–67; *Birds and Flowers* screens (*Kachō-zu byōbu* 花鳥図屏風) 267; *dōbōshū* 同朋衆 254, 266–67; *Pine Beach at Miho* (*Miho Matsubara-zu* 三保松原図) hanging scrolls 278–79

noborigama 登り窯 (climbing kilns): linked-chamber climbing kilns 連房式登り窯 302; Oribe ware 織部焼 302

Noda Toshihiko 野田俊彦 (architect) 447

Noguchi Magoichi 野口孫市 (architect) 413; Osaka Prefectural Library (Osaka Furitsu Toshokan 大阪府立図書館) 413

Noh costume decorated with snow-covered willows and swallowtail butterflies (*yukimochi-yanagi agehachō-mon nuihaku* 雪持柳揚羽蝶文縫箔; Seki Kasuga shrine 関春日神社, Gifu prefecture) 288–89

Noh Dance Prelude (Uemura Shōen) 436, **437**

Noh masks 能面 246; *beshimi* 癋見 (Naratsuhiko shrine 奈良豆比古神社, Nara) **247**; Magojirō 孫次郎 ("Omokage" オモカゲ; attributed to Kongō Ukyō Hisatsugu 金剛右京久次 also known as Magojirō 孫次郎) 247

Noh Mask series (Sakamoto Hanjirō) 428

Nomiyama Gyōji 野見山暁治 (painter) 472

Nonomura Ninsei 野々村仁清 **326**–27, 364; Omuro ware 御室焼 327; polychrome overglaze-enamel-decorated stoneware ceramics (*iro-e jiki* 色絵磁器) 326–27; tea jar with polychrome overglaze enamel design of Yoshino mountains (*iro-e Yoshino-yama zu chatsubo* 色絵吉野山図茶壺) **326**–27; tea jar with a design of wisteria in polychrome enamels (*iro-e fuji hana-mon chatsubo* 色絵藤花文茶壺) 327

Norakuro (Tagawa Suihō) 467

Northern and Southern courts 南北朝 258

Northern and Southern Dynasties period (China) 南北朝時代 53, 56, 483n2

Northern Fujiwara (Ōshū Fujiwara-shi 奥州藤原氏) 175; Chūson-ji 中尊寺 (Hiraizumi, Iwate prefecture) **176**; Fujiwara no Kiyohira 藤原清衡,

Motohira 基衡, Hidehira 秀衡, Yasuhira 泰衡 176; Kanjizaiō-in 観自在王院 (Motohira's wife 基衡の妻; Iwate prefecture) 177; Mōtsū-ji 毛越寺 (Kiyohira 清衡; Iwate prefecture) 177; Muryōkō-in 無量光院 (Hidehira 秀衡; Iwate prefecture) 177

Northern Song landscape paintings 250

Northern Wei (China) 北魏 43, 77; Northern Wei style 北魏の様式 50

Nude (Yamamoto Hōsui) 381

Nude Beauty (Yorozu Tetsugorō) 414

Nude with a Parasol (Yorozu Tetsugorō) 414

nudes 381, 400, 405, 414–15, 427, 432–33, 441, 448, 489n2; Hyakutane Kaneyuki 百武兼行 **381**; Koide Narashige 427–28; Yamamoto Hōsui 山本芳翠 381; Yorozu Tetsugorō 萬鉄五郎 **414–15**;

Nukina Kaioku 貫名海屋 (Confucian scholar/calligrapher) 369

nutmeg-yew (*kaya* 榧) 81, 485n7

Nyoirin Kannon 如意輪観音 (Wheel of the Wish-Granting Jewel Avalokitesvara) 111, **112**

Ōbaku sect 黄檗宗 334, 337–38, 392; Yinyuan Longqi 隠元隆琦 (Ingen) 334

Oda Nagamasu 織田長益 (or Urakusai 有楽斎) 301; daimyo style tea (*daimyo-cha* 大名茶) 301

Oda Nobunaga 織田信長 284, 288, 322; Azuchi Castle 安土城 (Shiga prefecture) 153, 284–85, 287; *Chronicles of Lord Nobunaga* (*Shinchōkō-ki* 信長公記; compiled by Ōta Gyūichi 太田牛一) 284–85; *Scenes in and around the Capital* screens (*Rakuchū Rakugai zu* 洛中洛外図) commissioned by 285–86

Ōdai Yamamoto I site 大平山元I遺跡 (Aomori prefecture) 4; earliest examples of Jōmon pottery 4

Odano Naotake 小田野直武 358; Akita Ranga 秋田蘭画 358

Ōe no Masafusa 大江匡房 153

Ogasawara Sae 小笠原小枝 161

Ogata Kenzan 尾形乾山 **326**, 327, 364; foliate bowl with overglaze polychrome enamel design of maple leaves in the Tatsuta river (*iro-e Tatsuta-gawa-mon sukashibori soribachi* 色絵龍田川文透彫反鉢) **326**; Ogata Korin 尾形光琳 collaboration with 332; overglaze polychrome enamel technique (*iro-e* 色絵) 324–26

Ogata Kōrin 尾形光琳 307, **331**, 332, 339, 455; *Irises* screens (*Kakitsubata-zu byōbu* 燕子花図屏風) 332–**33**; *kosode* with a design of winter trees (*Fuyuki Kosode* 冬木小袖) 332; *maki-e* 蒔絵 lacquer ware 332; Ogata Kenzan 尾形乾山 collaboration with 332; pattern books (*hiinagata-bon* 雛形本) 332; *Red and White Plum Blossoms* screens (*Kōhakubai-zu byōbu* 紅白梅図屏風) 332, **33**; writing box with an eightfold bridge design (*Yatsuhashi suzuri-bako* 八橋硯箱) 332

Ogawa Haritsu 小川破笠 **335**; *gisaku* 擬作 (imitations) 335; "Haritsu work" (*Haritsu zaiku* 破笠細工) 335; *ikkanbari* 一閑張 technique 335

Ogawa Usen 小川芋銭 (painter) 410

Ogisu Takanori 荻須高徳 (painter) 456

Ogiwara Morie 荻原守衛 (Ryokuzan 碌山) (sculptor) 421, **422**; *Woman* (*Onna* 女) 422

Ogura Yuki 小倉遊亀 (painter) 472

Oguri Sōtan 小栗宗湛 265–66

Ōjō Yōshū (*Essentials of Rebirth* 往生要集; Genshin 源信) 126, 169, 206

Okada Beisanjin 岡田米山人 356; literati painting 356

Okada Kenzō 岡田謙三 (painter) 457

Okada Saburōsuke 岡田三郎助 (painter) 400, 402; Tenshin Dōjō 天真道場 400

Okada Shin'ichirō 岡田信一郎 (architect) 447; Meiji Seimeikan 明治生命館 (Tokyo) 447

Okakura Kakuzō 岡倉覚三 (or Tenshin 天心; educator and thinker) 382, 398, 399, 406–407, 411, 416; disagreement over calligraphy 447, 458

Okamoto Ippei 岡本一平 (manga artist) 467

Okamoto Shinsō 岡本神草 (painter) 435

Okamoto Tarō 岡本太郎 2, 29, 30; "A Theory of Jōmon Pottery" (*Jōmon doki ron* 縄文土器論) 2, 29, 461; Okamoto Ippei 岡本一平 467; Salon de Mai exhibition criticism 454; *Tower of the Sun* (*Taiyo no Tō* 太陽の塔) 461; *Wounded Arm* (*Itamashiki Ude* 傷ましき腕) 442–43

Okamoto Tōki 岡本唐貴 (painter) 440

Ōkawa Naomi 大河直躬 367

ōkubi-e 大首絵 (half-length "large-head" portraits) 221, 351, 353; of actors (*yakusha* 役者) 221, 353; of beauties (*bijin* 美人) 353; prototype of 351

Okuda Eisen 奥田頴川 (Kyoto ware potter) 364; Chinese red overglaze enamel (*gosu aka-e* 呉須赤絵) 364

Okuda Gensō 奥田元宋 (painter) 472

Okudera Hideo 奥寺英雄 488n4

Okuhara Seiko 奥原晴湖 (painter) 435

Ōkuma Ujihiro 大熊氏広 (sculptor) 390; Ōmura Masujirō zō 大熊益次郎像 (Yasukuni shrine 靖国神社) 390

Okumura Masanobu 奥村政信 350; "lacquer pictures" (*urushi-e* 漆絵) 350

Okura Museum of Art (Ōkura Shūkokan 大倉集古館; Tokyo; Itō Chūta) 412

Old Monkey (sculpture, Takamura Kōun) 390

old school (Kyū-ha 旧派) 399, 416; "resin school" (Yani-ha 脂派) 399

Ōmori shell middens 大森貝塚 (Tokyo) 3, 20; *Shell Mounds of Omori* (Edward Sylvester Morse) 3

Omuro ware 御室焼 327; *Kakumeiki* 隔蓂記 (diary of Hōrin Shōshō 鳳林承章) 327; Nonomura Ninsei 野々村仁清 327

On Scriabin's "Poem of Ecstasy" (Kanbara Tai) 439

Onchi Kōshirō 恩地孝四郎 (print artist) 419; *Portrait of the Author of "Hyōtō"* (*Hagiwara Sakutarō*) ("*Hyōtō*" *no chosha* [*Hagiwara Sakutarō zō*] "氷島" の著者 [萩原朔太郎像]) 420; *Tsukuhae* 月映 (Moonglow) journal 420

Ondashi site 押出遺跡 (Yamagata prefecture) 15–16; Early Jōmon earthenware coated in lacquer 15

One Hundred Poems by One Hundred Poets (Hyakunin Isshu 百人一首) 351; Suzuki Harunobu 鈴木春信 350–52, 491

Ōnin War 応仁の乱 245; 265

Onjō-ji 園城寺 (Ōtsu, Shiga prefecture) 104, 292–93; *Essential Meditations on the Five Families of the Mind* (*Gobu Shinkan* 五部心観) 104; *Flowering Trees of the Four Seasons* (*Shiki Kaboku-zu fusuma* 四季花木図襖; Kanō Mitsunobu 狩野光信) 292, 293; *Yellow Fudō* (*Ki Fudō* 黄不動 or *Fudō Myō-ō gazō* 不動明王画像; Enchin 円珍; hanging scroll) 104

Only Yesterday (Takahata Isao) 471

Onna Guruma-jō 女車帖 (calligraphy by Fujiwara no Sukemasa 藤原佐理) 142–43

onna-e 女絵 (women's pictures) 164, 222; *fukinuki yatai* 吹抜屋台 ("blown-away roof view" of buildings) 164; *hikime kagibana* 引目鉤鼻 (slit for eyes, hook for nose) 164; *Illustrated Scrolls of the Tale of Genji* (Genji Monogatari Emaki 源氏物語絵巻) 164, 222; *tsukuri-e* つくり絵 ("produced paintings") 164

Ono Chikkyō 小野竹喬 (painter) 453

Ono no Michikaze 小野道風 (calligrapher) 142–**43**, 316; *Gyokusen-jō* 玉泉帖 142–**43**

Onosato Toshinobu オノサト・トシノブ (painter) 475; *Partitions* 1260 (*Bunkatsu*: 1260 分割―一二六〇）475

openwork (*sukashibori* 透し彫; pierced) 14, 238, 309

Origins of Dōjō-ji Temple (*Dōjō-ji Engi* 道成寺縁起) 259; Dōjō-ji 道成寺 (Wakayama prefecture) 259

Origins of Shido Temple (*Shido-ji Engi* 志度寺縁起) hanging scrolls 257–58; *etoki* 絵解き 150, 258; sacred tree worship 霊木 107, 112, 258

ornament (see *shōgon*)

Osaka Castle 大阪城 287, 295, 310; Kanō Eitoku 狩野永徳 287; Kanō Tan'yū 狩野探幽 310; Toyotomi Hideyoshi 豊臣秀吉 287

Osaka Club (Osaka Kurabu 大阪倶楽部; Yasui Takeo) 422

Osaka Expo '70 (Osaka Banpaku 大阪万博) 461

Osaka Prefecture Library (Osaka Furitsu Toshokan 大阪図書館; Osaka; Noguchi Magoichi) 413

Ōshita Tōjirō 大下藤次郎 (painter) 402

Ōtaki shrine (Ōtaki-jinja 大滝神社, Fukui prefecture) 367; Chinese-style gables (*karahafu* 唐破風) 367; "plover-wing gables" (*chidori hafu* 千鳥破風) 367

Ōtani Shōgo 大谷省吾 (art historian) 490n7

otogi zōshi 御伽草子 (popular tales) 225, 246, 257 (*see also* illustrated popular tales)

otoko-e 男絵 (men's pictures) 163–64; *Illustrated Scrolls of the Legends of Shigisan* (*Shigisan Engi Emaki* 信貴山縁起絵巻) handscrolls 154, 155, 164, 165–66, 167

Ōtomo Katsuhiro 大友克洋 (manga artist) 469; *Akira* 469–**70**

Ōtsu Castle 大津城 (Shiga prefecture) 295; Asano Nagamasa 浅野長政 295

Ōura Catholic Church (Ōura Tenshu-dō 大浦天主堂; Nagasaki) 391

Oyama shrine gate (Oyama-jinja Shinmon 尾山神社神門; Ishikawa prefecture) 392

Ōyamatsumi shrine 大山祇神社 (Ehime prefecture) 239; *odoshi-yoroi* with deep blue threads (*kon'ito odoshi-yoroi* 紺糸威鎧) 239

Ōzuka burial mound 王塚古墳 (Fukuoka prefecture) 37

Pacific Islands 太平洋諸島 10

Pacific Painting Society (*see* Taihei Yōga-kai) 402

Pacific Rim 環太平洋 12

Pacific War (Taiheiyō Sensō 太平洋戦争) 427, 441–42, 451, 472

Paintings of the Six Realms (*Rokudō-e* 六道絵) 153, 154, **169**, 172, 206–07; Retired Emperor Go-Shirakawa's 後白河法皇 collection at Rengeō-in 蓮華王院 153

Paintings of Warding off Evil (Hekija-e 辟邪絵) 170; Qiantapo (Gandharva) 乾闥婆王 171; Shenchong 神蟲 171; Tianxingxing 牛頭天王 171; Zhongkui (Shōki 鍾馗) 171

paper-joining craft (*tsugi-gami* 継紙) 161; cut-joining (*kiri tsugi* 切り継ぎ) 161; overlap-joining (*kasane tsugi* 重ね継ぎ) 161; torn-joining (*yabure tsugi* 破れ継ぎ) 161

Paradise under the Sea (Aoki Shigeru) 405

Parent's Moralizing Spectacles, A (*Kyōkun Oya no Megane* 教訓親の目鑑; Kitagawa Utamaro 喜多川歌麿) 354

Partitions 1260 (Onosato Toshinobu) 475

patterns 48, 56, 90; abstract 48; arabesque (scrolling grasses; *karakusa-mon* 唐草文) 49, 89, 90, 155; broken-branch (sprig; *ore-eda-mon* 折枝文)

155, 160, 181, 183; *chokkomon* 直弧
文 (fractured spiral) 36, 38, 482n11;
circular (*marumon* 丸文) 155; cloud
(*kumogata-mon* 雲形文) 11; cord-
marked (*jōmon* 縄紋) 4; eight wisteria
blossoms (*yatsufuji* 八つ藤) 155; facing
butterflies (*mukai-chō* 向かい蝶) 155;
figure-eight (*hachi-no-ji* 八の字) 11;
fingernail (*tsumegata-mon* 爪形文) 4;
flames (*kaenmon* 火炎文) 49; floral
(*kamon* 華文) 155; fractal 7; *fusenryō*
浮線綾 (floating twill; stylized floral
pattern) 155, 240; geometric 309, 325,
367; hail (*arare-mon* 霰文) 155; *hosōge-
mon* 宝相華文 (floral motifs) 87;
karakusa-mon 唐草文 (see arabesque);
medium-scale (*chūgata* 中型) 364;
linear relief (*ryūkisen-mon* 隆起線文)
4, 11; lozenge-shaped (*hishi-mon*
菱文) 155; meandering lines (*kōjimon*
工字文) 12; nested-petal (*kamon*
窠文) 155; overlapped hoops (*wa-chigai*
輪違い) 155; pierced (*shitotsu-mon*
刺突文) 5; rouletted (*nenshi-mon*
撚糸文) 5; sculpture 120; shell
(*kaigara-mon* 貝殻文) 5, 17; scattered
flowers (*sanka-mon* 散花文) 155;
"scattered motifs" (repeating patterns)
(*chirashi-mon* 散らし文) 241; slanted-
cross (*tasuki-mon* 襷文) 155; small-
motif patterns (*komon* 小紋) 364;
split-bamboo (*chikukan-mon* 竹管文) 5;
textile 92; tortoiseshell (*kikkō-mon*
亀甲紋) 155; billowing clouds
(*tatewaku* 立涌) 155; vine patterned
arabesque (*budō karakusa-mon*
葡萄唐草文) 71; wave (*ryūsui-mon*
流水文) 12; *yūsoku* (*yūsoku mon'yō*
有職文様) 155
Peacock Sutra (*Kujaku-kyō* 孔雀経) 104
Peacock Wisdom King (*Kujaku Myō-ō*
孔雀明王) 156; Ninna-ji 仁和寺
(Southern Song) 174
Peonies (Fukuda Heihachirō) 436

Perry, Matthew (commodore) 374–75
Persian 87
Persimmons (Andō Rokuzan) 397
perspective (*enkinhō* 遠近法) 137, 358;
linear perspective 379; one-point
perspective 341
Phoenix Hall (Hōō-do 鳳凰堂) 127–29,
141, 149; Fujiwara no Yorimichi
藤原頼通 127; seated Amida Nyorai
阿弥陀如来坐像 132–**33**; *Nine Grades
of Rebirth in the Pure Land* images
九品来迎図 138; 177, 178; sliding
door paintings 壁扉画 135, **137**, 145,
147, 211
photography (*shashin* 写真) 462, 473–74
Picasso exhibition (1951) 454–55
pictorial biographies (*eden* 絵伝) 228
pictorial expression 83, 155
pictorial handscroll (*see* illustrated scroll)
*Pictorial Index of the Lives of Japanese
Commoners as Depicted in Illustrated
Scrolls* (*Emakimono ni yoru Nihon
jōmin seikatsu ebiki* 絵巻物による
日本常民生活絵引) 231
Picture Book: Selected Insects (*Ehon
Mushi Erami* 画本虫撰; Kitagawa
Utamaro 喜多川歌麿) 352–**53**;
Tsutaya Jūzaburō 蔦屋重三郎) 352
*Picture Contest of Poems on the New
Famous Places in Ise* 伊勢新名所
歌合絵 223, 226
picture-calendars (*egoyomi* 絵暦) 350
pilgrimage mandalas (*sankei mandara*
参詣曼荼羅) 215
Pillow Book (*Makura no sōshi* 枕草子;
Sei Shōnagon 清少納言) 141, 146
Pine Beach screens (*Hamamatsu-zu
byōbu* 浜松図屏風; attributed to
Tosa Mitsumochi 土佐光茂) 272
Pine Trees in the Four Seasons (*Shiki
Matsu-zu byōbu* 四季松図屏風; Kanō
Tan'yū 狩野探幽; Daitoku-ji 大徳寺)
310
pit dwellings/houses (*tateana-shiki jūkyo*

竪穴式住居) 7, 8, 17, 21

pit-type burial (*tateana-shiki sekishitsu* 竪穴式石室) 36

placenta pot (*osan doki* お産土器) **9**

playfulness (*asobi* あそび) xxiv, 151, 153, 221, 301–302, 316, 327, 369, 385; *yuge* 遊戯 302

Plum Tree, Bamboo, and Birds in the Snow sliding door (*Secchū Baichiku Yūkin-zu fusuma* 雪中梅竹遊禽図襖; Kanō Tan'yū 狩野探幽; Jōraku Palace, Nagoya Castle 名古屋城上洛殿) 310–**11**

Pocket Monsters (*Poketto monstā* ポケットモンスター or Pokémon) 472

Poe Family, The (Hagio Moto) 469–**70**

Poetry Contest among Persons of Various Occupations in Thirty-Two Rounds (*Sanjūniban Shokunin Utaawase Emaki* 三十二番職人歌合絵巻) 224

Poetry Contest among Persons of Various Occupations on the Occasion of a Hōjō Ritual at Tsurugaoka Hachiman-gū shrine (*Tsuruoka Hōjō-e Shokunin Utaawase Emaki*) 鶴岡放生会職人歌合絵巻 224

poetry contest scrolls (*uta awase-e* 歌合絵) 222–24

poetry 詩歌 251; 331; amateur circles 352; anthologies 269, 145, 160, 220, 230; Chinese classical 408; *kanshi* 漢詩 (Chinese) 115, 145; and painting 251, 441; picture scrolls (*emaki* 絵巻) 261–62; poetry contest (*uta awase-e* 歌合) 222–24; screen poems (*byōbu-uta* 屏風歌) 486n17; *waka* 和歌 145

poetry-picture scroll (*shiga-jiku* 詩画軸) 261–62; *New Moon over a Brushwood Gate* (*Saimon Shingetsu-zu* 柴門新月図) 262–**63**

Pom Poko (Takahata Isao) 471

popular art 307; blended popular styles 475, 477; illustrated popular tales (*otogi zōshi* 御伽草子) 225, 246, 257, 259;

illustrated popular tales (*monogatari-e* 物語絵) 222; pictures of popular narratives (*setsuwa-e* 説話絵) 222, 225; popular audience 222; popular character 327; popular culture 354, 389; popular design 315; folklore 225; popular lectures 163; popular painters (*minshū gaka* 民衆画家) 346; popular painting (*minshū kaiga* 民衆絵画) 385; popular realm 419; popular songs (*imayō* 今様) 153; popular taste/appeal 332, 346, 363; woodblock-printed books 332; woodblock prints (ukiyo-e 浮世絵, nishiki-e 錦絵) 338–39, 350, 389, 391, 418, 442

popularization 163, 354, 356, 359, 364–66, 369; popularizing art 306 (*see also* secularization)

porcelain (*jiki* 磁器) 242, 324–37: Chinese 280, 324, 398; overglaze polychrome enamel technique (*iro-e* 色絵) 324–**26**,

Portrait of the Author of "Hyōtō" [*Hagiwara Sakutarō zō*] (Onchi Kōshiro) 420

Portrait of Vasilii Yaroshenko (Nakamura Tsune) 418

portrait sculptures 199 (see *chinzō*)

portraiture 217–18, 220, 236; formal 217; kabuki actors 歌舞伎役者 351; patriarchs 祖師像 97, 105, 122, **140**, 141, 195, 220, 222, 228; secular 217; *shōzō-ga* 肖像画 220; Western 354 (see also *nise-e*)

Post-Impressionism 413, 433

postmodernist architecture 447, 450, 464–66

Prayer at Time of Childbirth (Yasuda Yukihiko) 430

Prince Asaka's mansion (Asakamiya Tei 朝香宮邸; current Tokyo Metropolitan Teien Art Museum [Tokyo Teien Bijutsukan 東京庭園美術館]) 424

Prince Nagaya 長屋王 former residence of 167

Prince Shōtoku and the High-Ranking Monks of the Tendai Sect 聖徳太子及び天台高僧像 (Ichijō-ji 一乗寺, Hyogo prefecture) **140**

Prince Shōtoku 聖徳太子 47, 48–50, 59, 61, 140; Guze Kannon 救世観音 49; *Illustrated Biography of Prince Shōtoku* 聖徳太子伝絵 149–150; *Portrait of Prince Shōtoku* 聖徳太子御影 83; *Prince Shōtoku and the High-Ranking Monks of the Tendai Sect* 聖徳太子及び天台高僧像 140; Sakyamuni Triad (Shaka Sanzon 釈迦三尊) at Hōryū-ji 法隆寺 47

Prince Yongtai, the tomb of 永泰公主墓 (Shaanxi province) 63

Princess Mononoke (Miyazaki Hayao) 471

principal deity (*honzon* 本尊) 41, 70, 82, 100–101, 184; Great Buddha Hall, Tōdai-ji 東大寺大仏殿 77; Jingan-ji 神願寺 107; four shrines of Kasuga grand shrine 春日社四宮 212; Kokawa-dera 粉河寺 (Wakayama prefecture) 168; Sanbutsu-ji 三仏寺 (Tottori prefecture) 175; Jōruri-ji 浄瑠璃寺 (Kyoto) 177–78; Sanzen-in 三千院 (Kyoto) 178; Shin Yakushi-ji 新薬師寺 (Nara) 106; Tōshōdai-ji 唐招提寺 78,

printer (*surishi* 摺師) 332, 418, 489n4

produced object (see *tsukurimono*)

Proletarian Artists' League of Japan (Nihon Puroretaria Bijutsuka Dōmei 日本プロレタリア美術家同盟) 440

propaganda painting 427, 472

Pseudo-Western style (*Gi-yōfū* 擬洋風; architecture) 391; Mitsui House (First National Bank; Tokyo) 392; Oyama shrine gate (Ishikawa prefecture) 392; former Saiseikan Hospital (Yamagata prefecture) 392; former Kaichi School (Nagano prefecture) 392–93

publisher (*hanmoto* 版元) 332, 350, 388, 489n4; Tsutaya Jūzaburō 蔦屋

重三郎 352; Watanabe Shōzaburō 渡辺庄三郎 418

Pure Land (Jōdo) Buddhism 浄土宗 132, 189, 206; and Esoteric Buddhism 132; Ippen 一遍 488n5

Pure Land 浄土 art 73, 83, **125–28**, 135, 181, 182, 206, 209, 211, 213, 291; gardens 151; hall at Jōdo-ji 浄土寺 浄土堂 **191–92**, 200; Hōryū-ji 法隆寺 **64**; Ippen 一遍 488n5; mandala 曼荼羅 83, 228; of Kannon 観音浄土 212, 214; *Nine Grades of Rebirth in the Pure Land* 九品来迎図 **136–37**, 138; rebirth in 極楽往生 125–28; Tamamushi Shrine 玉虫厨子 58; Tōdai-ji 東大寺 83

Qian Xuan 銭選 259; *Record of Decorations for the Imperial Visit to the Muromachi Palace* (*Muromachi-dono Gyōkō Okazari-ki* 室町殿行幸御錺記) 254, 258

Qin Shi Huangdi 秦始帝 or 始皇帝, first emperor of China 32

Qin 秦 36; Western Qin 43

Qing China 清代中国 306, 325; bird-and-flower paintings 334–35; imports 365; *Itō Chūta's Field Notes: Qing, Vol. III* (*Itō Chūta kenbun yachō* 伊東忠太見聞野帖 清国III) 412; manner/modes/styles 338–40; painting 340, 357, painting techniques 334; tea drinking 364; trade with 337;

Qingzhuo Zhengcheng (Seisetsu Shōchō 清拙正澄, Daikan Zenshi 大鑑禅師) 235

Qu Yuan (*Kutsugen*; Yokoyama Taikan) 407

raden 螺鈿 (see mother-of-pearl)

Ragusa, Vincenzo 390

raigō 来迎 (welcoming descent) 209, 487n24; festival processions (*mukaekō* 迎講) 211; *gōshō* 迎接 177, 487n24;

haya raigō (speedy welcome) 早来迎 209; mudra 来迎印, 転法輪印 177, 209; *yamagoe* 山越 (Amida coming over the mountain) 209, 210; Amida descent paintings (*raigō-zu* 来迎図) 135, 157, **209**, 211

Rain (Fukuda Heihachirō) **438**

raised floor (*takayuka-shiki* 高床式): building 85; palaces 46; structures 21

Raku ceramic teabowls (*raku-jawan* 楽茶碗) 290

rakuchū rakugai zu (*see* "scenes in and around the capital") 272–75, 317, **319**

Rangaku 蘭学 (Dutch Studies) 358

rasetsuki 羅刹鬼 (peculiar-looking demon) 71

Raudraksa 牢度叉 (Rōdosha) 163

Reading (Kuroda Seiki) 399

realism (*shajitsu shugi* 写実主義) 36, 50, 72, 76, 154, 174, 217, 278, 306, 344, 354, 376, 416; Kamakura 鎌倉 199, 201, 209, 220; Maruyama-Shijō 円山四条派 408, 410; and Nihonga 日本画 436; Song 宋 217, 250–51; Western 西洋 334, 341, 357, 375, 379, 382; verisimilitude 220

rebirth (*ōjō* 往生) 58, **125**, 128, 136, 159, 210, 378; *Nine Grades of Rebirth in the Pure Land* 九品来迎図 136, 138

Reclining Nude (Hyakutake Kaneyuki) **381**

Record of Decorations for the Imperial Visit to the Muromachi Palace (*Muromachi-dono Gyōkō Okazari-ki* 室町殿行幸御餝記) 254, 258; Ashikaga shogunal collections (Yoshimitsu 義満 and Yoshinori 義教) 254; Ashikaga Yoshinori's 足利義教 room decor (*zashiki kazari* 座敷飾り) 258; Emperor Go-Hanazono's 後花園天皇 visit 258

Record of Garden Making (*Sakuteiki* 作庭記) 151, 267; Tachibana no Toshitsuna 橘俊綱 151

Record of the Clear Moon (*Meigetsuki* 明月記, diary of Fujiwara no Sadaie 藤原定家日記) 186

Record of the State's Rare Treasures (*Kokka Chinpō-chō* 国家珍宝帳) 85, 89, 91; Shōsō-in Repository 正倉院

Red Cliff at Lake Dongting (*Dōtei Sekiheki Zukan* 洞庭赤壁図巻; Ike no Taiga 池大雅) handscroll 340

Red Shaka (Aka Shaka 赤釈迦, *Shaka Nyorai* 釈迦如来; Jingo-ji 神護寺) hanging scroll 156

reed picture (*ashide-e* 葦手絵; see also *ashide*) 159

Rekihaku A screens 歴博A本 **274–75**, 318; *Scenes in and around the Capital* (*Rakuchū Rakugai zu* 洛中洛外図) **274–75**, 317–**19**

Relatum: Silence (Lee Ufan) 464–**65**

relic hall 舎利殿: Engaku-ji 円覚寺 237

Reminiscence of the Tenpyō Era (Fujishima Takeji) 404

repoussé technique (*uchidashi* 打出し) 61

Requiem for a New Recruit (Hamada Chimei) 451

Retired Regent and His Five Wives Viewing Cherry Blossoms East of the Capital (*Taikō Gosai Rakutō Yūkan no Zu* 太閤五妻洛東遊観図; Kitagawa Utamaro 喜多川歌麿) 353

Rikugien 六義園 (daimyo garden; Yanagisawa Yoshiyasu 柳沢吉保; Tokyo) 369; strolling garden (*kaiyū-shiki teien* 回遊式庭園) 369; Waka no Ura 和歌浦 369

Rikyū (*see* Sen no Rikyū)

Rinpa 琳派 359, 408; exhibition (1951) 455

Rinzai (Linji) Zen 臨済宗 233; Linji Yixuan 臨済義玄 233; samurai elite 189

Ripples (Fukuda Heihachirō) 436

Riraku-jō 離洛帖 (calligraphy by Fujiwara no Sukemasa 藤原佐理) 142

Rising Sun Illuminating the Universe

(Fujishima Takeji) 404

Rite of the Great Commander (Taigen no
hō 大元師法) 100

Rite of the Latter Seven Days
(Go-shichinichi no mishuhō
後七日御修法) 100

Rite of the *Peacock Sutra* (Kujaku-kyō hō
孔雀経法) 174

ritsuryō 律令 (legal and criminal) codes
55, 68; state 71

ritual implements 104, 117

rituals (*gishiki* 儀式) 12

Road (Higashiyama Kaii) **453**

Road Cut through a Hill (Kishida Ryūsei)
416, **417**

Rodin, Auguste 482n4; *Gates of Hell* 413

Rokkō Housing (*Rokkō no shūgō-jūtaku*
六甲の集合住宅; Hyogo prefecture);
Andō Tadao) 465

rokudō 六道 (six Buddhist realms) 169,
206, **207**, 228; hell paintings (*jigoku-e*
地獄絵) 225; hells (*jigoku* 地獄) 169
(*see also* hell); hungry ghosts (*gaki*
餓鬼) 169 (*see also* hungry ghosts);
beasts (*chikushō* 畜生) 169; fighting
warriors (*ashura* 阿修羅) 169; humans
(*hito* 人) 169; celestials (*tenjin* 天人)
169; *Rokudō-e* 六道絵 153, 154, 169,
172, 206–07

Rokuharamitsu-ji 六波羅蜜寺 (Kyoto)
131, 201

Rokumeikan 鹿鳴館 (Deer Cry Pavilion,
Tokyo; Conder) 394

Rolls of Cloth (Takahashi Yuichi) 376

Romantic Story of Lord Takafusa
(*Takafusa-kyō Tsuya-kotoba Emaki*
隆房卿艶詞絵巻) handscroll 223;
hakubyō 白描 technique 104, 222–23,
250

Romanticism (*rōman shugi* 浪漫主義 or
ロマン主義) 402–03, 419, 436; Meiji
Romantic School 明治浪漫派 403;
romantic passions 405; romantic
works 404; Taishō Romanticism

大正ロマンティシズム 419, 424, 441

room decor (see *zashiki kazari*)

Rouault exhibition (1953) 455

Rough Seas at Daiōzaki (Fujishima
Takeji) 404

Russo-Japanese War (Nichiro Sensō
日露戦争) 407, 424

Ryōjin Hishō 梁塵秘抄 (see *Secret
Selections of Songs to Make Dust on the
Rafters Dance*)

Ryōkan 良寛 (calligrapher) 369; *Iroha
Poem* いろは **371**

Ryōzen 良全 (painter) 255; *White Heron*
(*Hakuro-zu* 白鷺図; hanging scroll)
255; *Death of the Buddha* (*Hotoke
Nehan-zu* 仏涅槃図; hanging scroll;
Hongakuj-ji 本覚寺, Fukui prefecture)
255

Ryūchi 竜智 (see Nagabodhi)

Ryūchi-kai 竜池会 (Dragon Pond Society)
381

Ryūkyū 琉球 365

Ryūmyō 竜猛 (see Nagarjuna)

Ryūtōki 竜燈鬼 (demon with lantern and
dragon; Kōfuku-ji 興福寺) 201

sacred chants (*daimoku* 題目) 245;
"Praise the wondrous law of the Lotus
Sutra" (*Namu Myōhō Renge-kyō*
南無妙法蓮華経) 245

sacred trees (reiboku 霊木) 107, 112, 258

saddle and stirrups with reed design
(*ashiho maki-e kura abumi* 芦穂蒔絵
鞍鐙; Kanō Eitoku 狩野永徳) 288–89

saddle with a design of autumn rain
(*shigure raden kura* 時雨螺鈿鞍)
239–**40**

Saeki Yūzō 佐伯祐三 (painter) 428: *Gas
Street Lamp and Advertisements* (*Gasutō
to kōkoku* ガス灯と広告) 428

Sai-in Mandala 西院曼荼羅 (Tō-ji 東寺)
97, **99**, **102**–03, 123; Jimyō-in court of
the Womb World (Taizō-kai Jimyō-in
胎蔵界持明院) 123

Saichō 最澄 97, 109, 116, 117; Eight Masters Who Journeyed to Tang (Nittō Hakke 入唐八家) 484n2; letter to Kūkai (*Kyūkakujō* 久隔帖) 116

Saidai-ji 西大寺 (Nara) 105; pierced Buddhist reliquaries (Kondō *sukashibori* Sharitō 金堂透彫舎利塔) 238; *Twelve Devas* (Jūniten 十二天) 99; Zen school (of sculpture) 善派 202

Saigō Takamori statue (Takamura Kōun) 390

Saihō-ji 西芳寺 266; *Arhats* (Rakan 羅漢図), *Carp* (*Koi-zu* 鯉図), *Zenki-zu* 禅機図 (all by Mutō Shūi 無等周位) 257; *karesansui* 枯山水 garden 255; Musō Soseki 夢窓疎石 255, 266

Saiseikan Hospital, former (Kyū Kyūseikan 旧済世館; Yamagata prefecture) **392**

Saitō Gesshin 斎藤月岑 489n4; *Bukō Nenpyō* diary 武江年表 489n4; *Edo Meisho Zue* 江戸名所図会 (Famous Places of Edo) 489n4; *Tōto Saijiki* 東都歳時記 (Chronicle of the Year's Events in the Eastern Capital) 489n4; *Zōho Ukiyo-e Ruikō* 増補浮世絵類考 (Augmented and Revised Account of Ukiyo-e) 489n4

Saitō Jūrobei 斎藤十郎兵衛 354 (*see also* Tōshūsai Sharaku)

Saitō Kiyoshi 斉藤清 (woodblock print artist) 455

Sakafuneishi site 酒船石遺跡 (Nara prefecture) 47

Sakai Hōitsu 酒井抱一 (painter) 332, 359; *Screens with Summer and Autumn Grasses* (*Natsu Akikusa-zu byōbu* 夏秋草図屏風) 359–60

Sakai-chō, Isesaki 伊勢崎市境町 (Gunma prefecture) **34**; *haniwa* 埴輪 of a falconer (*takashō* 鷹匠) **34**

Sakaida Kakiemon 酒井田柿右衛門 324–25; *aka-e* 赤絵 (overglaze technique) 324; Kakiemon-style porcelain with polychrome enamel designs 柿右衛門

様式色絵磁器 **325**

Sakaki Hyakusen 彭城百川 (painter) 339

Sakakura Junzō 坂倉準三 (architect) 449–50, 460; Japanese Pavilion (Nihonkan 日本館; 1936 Paris International Exposition) 449; Kamakura Bunkakan Tsurugaoka Museum 鎌倉文化館鶴岡 ミュージアム 460; Museum of Modern Art, Kamakura (Kamakura Kindai Bijutsukan 鎌倉近代美術館) 460

Sakamoto Hanjirō 坂本繁二郎 (painter) 427–28; *Fading Sunlight* (*Usurebi* うすれ日) 427; *Noh Mask* (*Nōmen* 能面) series 428; *Woman with a Hat* (*Bōshi o moteru onna* 帽子を持てる女) 428

Sakazaki Otsurō 坂崎乙郎 (painter) 432

sakubutsu hijiri 作仏聖 ("Buddha-making holy men") 329; Enkū 円空 329; Mokujiki Myōman 木喰明満 **369–70**; Tanzei 弾誓 329

Sakuragaoka site 桜ヶ丘遺跡 (Hyogo prefecture) 26–27; bronze bells (*dōtaku* 銅鐸) and halberds (*dōka* 銅戈; Middle Yayoi 弥生中期) 26–27

Sakuteiki 作庭記 (see *Record of Garden Making*)

Sakyamuni Descending from the Mountain (*Shussan Shaka-zu* 出山釈迦図; Liang Kai 梁楷) hanging scroll 253

Sakyamuni Emerging from the Golden Coffin (*Shaka Kinkan Shutsugen-zu* 釈迦金棺出現図) 138

Sakyamuni Triad (Shaka Sanzon 釈迦三尊): Tori Busshi 止利仏師, Kondō at Hōryū-ji 法隆寺金堂 45, 47–48, 56; Tori school 止利派, Great Treasure Gallery (Dai-hōzōden 大宝蔵殿) at Hōryū-ji 法隆寺 48–49

Sakyamuni 釈迦牟尼 (Shaka Nyorai 釈迦如来 or Shaka 釈迦) 42, 45, 47, 61, 72, 84, 119, 138–39, 174, 207–08; Daian-ji 大安寺 (Nara) 59, 70; Jindai-ji

深大寺 (Tokyo) 56; Kaniman-ji 蟹満寺 (Kyoto prefecture) 71; Kōfuku-ji 興福寺 73; Seiryō-ji-style Sakyamuni 清凉寺式釈迦 174

Sakyamuni's Sermon under the Trees on Vulture Peak (*Shaka Ryōjusen Juka Seppō-zu* 釈迦霊鷲山樹下説法図) also known as *Fundamental Mandala of the Lotus Hall* (*Hokke-dō Konpon Mandara* 法華堂根本曼荼羅) 84

Salamander (Tsuge Yoshiharu) 468

Salon de Mai exhibition (1951) 454–55

Sanage kilns 猿投窯 185

sandalwood (*sendan* 栴檀) statue (danzō 檀像) 106, 174; statue of Sakyamuni brought back by Chōnen 奝然 (Seiryō-ji 清凉寺, Kyoto) 174

Sanjūsangen-dō 三十三間堂 (Hall of Thirty-Three Bays, Kyoto) 153, 202

sankei mandara 参詣曼荼羅 (pilgrimage mandalas) 215

Sanmon Gate 三門 (Tōfuku-ji 東福寺, Kyoto) 193, 246–**47**; Great Buddha style (Daibutsu-yō 大仏様) 193, 246; Zenshū-yō 禅宗様 (Zen style) architecture 193, 237, 246

Sannai Maruyama site 三内丸山遺跡 (Aomori prefecture; a large Jōmon dwelling site) 2, 17

Sano Toshitaka 佐野利器 (architect) 447

Santō Kyoden 山東京伝 (or Kitao Masanobu 北尾政演) 354

Sanzen-in 三千院 (Kyoto) 177

Sariputra (Sharihotsu 舎利仏) 163

Sarugaku masks 猿楽面 246

Sasaki Dōyo 佐々木道誉 248; *basara daimyo* ばさら大名 249; *Chronicle of the Grand Pacification* (*Taiheiki* 太平記) 249

Sasayama site 笹山遺跡 (Niigata prefecture) **10**–**11**; Umataka-type flame pot (*Umataka-shiki kaen doki* 馬高式火焔土器; Middle Jōmon 縄文中期) **10**–**11**

Sassanid 91

Satake Shozan 佐竹曙山 358; Akita Ranga 秋田蘭画 358; *Exotic Bird in a Pine* (*Matsu ni Karatori-zu* 松に唐鳥図) 358

Satō Chūryō 佐藤忠良 (Western-style painter) 472

Satō Issai 佐藤一斎 357; portrait by Watanabe Kazan 渡辺崋山 357

Satō Tetsuzō 佐藤哲三 (painter) 472; *Sleet* (Mizore みぞれ) **473**

Sawamura Sōjūrō III as Ōgishi Kurando (*Sandai-me Sawamura Sōjūrō no Ōgishi Kurando* 三代目沢村宗十郎の大岸蔵人; Tōshūsai Sharaku 東洲斎写楽) 355

Sazae-dō さざえ堂 (turbo-shell hall): Entsū Sansō-dō 円通三匝堂 (Fukushima prefecture) 368; Gohyaku Rakan-ji 五百羅漢寺 (Tokyo) 334

Scattering Camellia Blossoms (Hayami Gyoshū) 433

Scene from the Circus (Koga Harue) 441

"scenes in and around the capital" (*rakuchū rakugai zu*) 洛中洛外図 177, 231, 272, **274**–**75**, **286**, 317–**19**; Funaki screens 舟木本 (attributed to Iwasa Matabei 岩佐又兵衛) 318, **319**; Rekihaku A screens 歴博A本 274–75, 318; *Scenes of Kyoto* (*Kyōchu-zu* 京中図; Tosa Mitsunobu 土佐光信) 273; Uesugi screens 上杉本 (Kano Eitōku 狩野永徳) 285–86

Scenes of Kyoto (*Kyōchu-zu* 京中図; Tosa Mitsunobu 土佐光信) 273

Scenes of the Conquest of Māra (*Gōma Hen* 降魔変) 163

Scenes of the Twelve Months (*Jūnikagetsu Fūzoku-zu* 十二ヶ月風俗図; attributed to Tosa Mitsuyoshi 土佐光吉) 272, **273**

screen-poems (*byōbu uta* 屏風歌) 486n17

Screens with Bamboo in Rain and Wind (*Uchiku Fūchiku-zu byōbu* 雨竹風竹図屏風; Maruyama Ōkyo 円山応挙;

Enkō-ji 円光寺, Kyoto) 341–43

Screens with Snow-Covered Pines
(*Yuki Matsu-zu byōbu* 雪松図屏風;
Maruyama Ōkyo 円山応挙) 341–**42**

Screens with Tiger and Dragon (Hashimoto
Gahō) 406

Screw System (Tsuge Yoshiharu) 468

Scroll of Afflictions (*Yamai no Sōshi*
病草紙) 154, 169, 172, 173; Retired
Emperor Go-Shirakawa 後白河法皇
154, 169; *Paintings of the Six Realms*
(*Rokudō-e* 六道絵) 154, 169, 172

Scroll of Lord Haseo (*Haseo Sōshi*
長谷雄草紙) 226

Scrolls of Frolicking Animals (*Chōjū
Jinbutsu Giga* 鳥獣人物戯画) 166,
168, 467

Scrolls of Hell for Monks (*Shamon Jigoku
Zōshi* 沙門地獄草紙) 170

Scrolls of Hungry Ghosts (*Gaki Zōshi*
餓鬼草紙) 145, 171, 172, 173; Kōmoto
family version 河本家本 172

Scythians 33

Sea (Koga Harue) 440

Sea Birds along a Snowy Shore (*Settei
Suikin-zu byōbu* 雪汀水禽図屏風;
Kanō Sansetsu 狩野山雪) 311, **312**

Second Division Society (*see* Nika-kai)

Second Sino-Japanese War (Nit-Chū
Sensō 日中戦争) 424, 442

*Secret Selections of Songs to Make Dust on
the Rafters Dance* (*Ryōjin Hishō*
梁塵秘抄; Retired Emperor
Go-Shirakawa 後白河法皇) 153;
popular songs (*imayō* 今様) 153

Secret Teachings of the Hossō Sect (*Hossō-
shū Hiji Ekotoba* 法相宗秘事絵詞;
attributed to Takashina Takakane
高階隆兼) handscrolls 229; Xuanzang
玄奘三蔵 141, 230

secular paintings (*sezoku-ga* 世俗画) 115,
147, 172, 285, 287, 318, 377, 403

secularism 306

secularization 234, 369 (*see also*

popularization); genre painting
(*fūzoku-ga* 風俗画) 272; *meisho-e*
名所絵 285; Nanban art 南蛮美術 296

Segonkō burial mound 千金甲古墳
(Kumamoto prefecture) 36

Sei Shōnagon 清少納言 141, 146; *Pillow
Book* (*Makura no sōshi* 枕草子) 141,
146

Sei'i Taishōgun 征夷大将軍 (title):
Ashikaga Takauji 足利尊氏 244;
Minamono no Yoritomo 源頼朝 94,
188

Seiryō-ji 清凉寺 (Kyoto) 174; sculpture
brought back by Chōnen 奝然 174;
Seiryō-ji-style Sakyamuni 清凉寺式
釈迦 174

Seiryūsha 青龍社 (Blue Dragon Society)
433

Seishi 勢至 (Mahasthamaprapta) 177, 200

Seki Kazutaka 関和孝 368

Sekigahara, Battle of 関ヶ原の戦い 284

Sekine Nobuo 関根伸夫 454, 464;
Phase—Mother Earth (*Isō—daichi*
位相—大地) Contemporary Sculpture
Exhibition (Gendai Chōkokuten
現代彫刻展) 464

Sekine Shōji 関根正二 (painter) 415, 416;
Sorrow of Faith (*Shinkō no kanashimi*
信仰の悲しみ) 415

Sekkei-ji 雪渓寺 (Kochi) 201

Self-Portrait with Topknot (Takahashi
Yuichi) 375

Sen no Rikyū 千利休 288–90, 301, 313,
315; Tai-an 待庵 (Myōki-an 妙喜庵,
Kyoto) 288–**90**

Sengai 仙厓 (Zen priest) 369, 458, 467;
Hotei Pointing at the Moon (*Shigetu
Hotei Gasan* 指月布袋画讃) **371**

Senju Kannon 千手観音 (Thousand-
Armed Avalokitesvara) 79–**80**,
96, 169, 179, **180**, 203, 204, 217;
Bujō-ji 峰定寺 (Kyoto) 178; Eihō-ji
永保寺 (Gifu prefecture) 174; Fujii-
dera 藤井寺 (Osaka) 79; Kokawa-dera

粉河寺 (Wakayama prefecture) 169

sennen-ya 千年屋 (minka 民家) 336

senzui byōbu 山水屏風 (landscape folding screens) 147

Seong-Myeong 聖明王, King of Baekje 百済 41

Sesshū Tōyō 雪舟等楊 265, 275, 278; *Amanohashidate* 天橋立図 276; *Autumn and Winter Landscapes* (*Shūtō Sansui-zu* 秋冬山水図) 276; *Birds and Flowers* screens (*Shiki Kachō-zu byōbu* 四季花鳥図屏風) 276; *Landscapes of the Four Seasons* (*Shiki Sansui-zu* 四季山水図) 275; *Long Handscroll of Landscapes in the Four Seasons* (*Shiki Sansui-zukan* 四季山水図巻) 276; Ōuchi family 大内家 275

Sesson Shūkei 雪村周継 276, 278; *Wind and Waves* (*Fūtō-zu* 風濤図) 276; *Tiger and Dragon* screens (*Ryūko-zu byōbu* 竜虎図屏風) **277**

Seto kilns 瀬戸窯 242

Seto wares 瀬戸焼 301

setsuwa-e 説話絵 222–24

seven-panel robe of woven brocade (*shichijō kesa* 七条袈裟; Shōsō-in northern repository 正倉院北倉, Tōdai-ji 東大寺, Nara) 92

Seven Shingon Patriarchs (*Shingon Shichiso-zō* 真言七祖像; Li Zhen 李真 and other artists; Tō-ji 東寺) 105, 140; Kūkai 空海 105

Shadow Paintings (Takamatsu Jirō) 463

shamanism 25, 34, 41, 51; shamans 26

Shandao 善導 (monk) 206; *Annotations of the Sutra of Immeasurable Life* (*Kanmuryōju-kyō sho* 観無量寿経疏) 206

Sharaku 写楽 (*see* Tōshūsai Sharaku)

shasei 写生 (sketching from life) 220; *Album of Sketches: Insects* (*Konchū Shaseichō* 昆虫写生帖; Maruyama Ōkyo 円山応挙) **342**

shashin 写真 (verisimilitude) 220

Shattered Jewels (Foujita Tsuguharu) **444**

shell middens (*kaizuka* 貝塚) 3; Hongō Yayoi-chō 本郷弥生町 20; Ōmori 大森 20; Shiizuka 椎塚 12; Torihama 鳥浜 15

Shen Quan 沈南蘋 (Shin Nanpin) 338, 340, 344

Shen Zhou 沈周 337; *Tan'yū Shukuzu* 探幽縮図 (Tan'yū's reduced-size copies of paintings) 336

Shiba Kōkan 司馬江漢 352; *Shichirigahama Beach, Kamakura, Sagami Province* (*Sōshū Kamakura Shichirigahama-zu* 相州鎌倉七里浜図) 358; *View of Mimeguri Shrine from the Sumida River* (*Mimeguri no Kei-zu* 三囲景図) **359**

Shiba Tatsuto 司馬達等 (Sima Dadeng; sculptor) 41, 45; *Fusō Ryakki* 扶桑略記 (Abbreviated Records of Japan) 41

Shibata Zeshin 柴田是真 (lacquer artist, painter) 388

Shiensō 紫烟荘 (Purple Smoke; Saitama prefecture; Horiguchi Sutemi) 423

Shigaraki ware 信楽焼 242, **280–81**

Shigisan Engi Emaki 信貴山縁起絵巻 (see *Illustrated Scrolls of the Legends of Shigisan*)

Shiizuka shell middens 椎塚貝塚 (Ibaraki prefecture) **12**; spouted vessel (*chūkō doki* 注口土器; Late Jōmon 縄文後期) **12**

Shikan 思堪 235, 255; *Wild Geese Descending on a Sandbank* (*Heisa Rakugan-zu* 平沙落雁図) 235, 255

shiki sansui 四季山水 (landscape of the four seasons; C: *sishi shanshui*) 486n18

shiki-e 四季絵 146

Shimizu Kisuke 清水喜助 392; Mitsui House 三井組ハウス (later the First National Bank [Daiichi Kokuritsu Ginkō 第一銀行]; Tokyo) 392

Shimoda Kikutarō 下田菊太郎 (architect) 447

Shimokawa Hekoten 下川凹天 469: *Kid Deko's New Picture Book: The Story of Imo-suke's Board Hunt* (*Dekobō shingachō: Imosuke Inoshishi-gari no maki* 凸坊新畫帖 芋助猪狩の巻) 469

Shimomura Kanzan 下村観山 407, 408; *Autumn through the Trees* (*Ko no ma no aki* 木の間の秋) 408

Shimooka Renjō 下岡蓮杖 (photographer) 378

shin hanga 新版画 ("new prints") 418–19

Shin Kokin Wakashū 新古今和歌集 (*New Collection of Japanese Poems of Ancient and Modern Times*) 239, 311; *Sea Birds along a Snowy Shore* screens (*Settei Suikin-zu byōbu* 雪汀水禽図屏風; Kanō Sansetsu 狩野山雪) 311–12

Shin Seisaku-ha Kyōkai-ten 新制作派協会展 (New Production Association Exhibition) 453

Shin Shūi Wakashū 新拾遺和歌集 (see *New Gleanings of Japanese Poetry*)

Shin Wayō 新和様 (new Japanese style; architectural style) 193

Shin Yakushi-ji 新薬師寺 (Nara) 76, 106, **107**

shinbutsu shūgō 神仏習合 (union between kami and Buddhas) 212, 486n13

shinden-style residences (*shinden-zukuri* 寝殿造) 129–30, 149, 151, 266; Rokuon-ji 鹿苑寺 (Kinkaku-ji 金閣寺) 258, **259**; Tsuchimikado-dono 土御門殿 129

Shingon sect 真言宗 96, 97; portraits 105; patriarchs 祖師 105, 122

Shingon-in 真言院 99–100, 101

Shingū Susumu 新宮晋 454, 464

Shinkankaku-ha 新感覚派 ("new perceptionists") 441

Shino ware 志野焼 301

Shinohara Ushio 篠原有司男 462

Shinran 親鸞 189

Shinshō-ji 新勝寺 (Chiba prefecture) **366**

Shinto 神道 46, **114**, 203, **212**, 216, 217, 309, 329, 409

Shinzei 信西 (Minamoto no Michinori 藤原通憲) 487n21

shira-e 白絵 (see *hakubyō*)

Shiraga Kazuo 白髪一雄 (painter) 457

Shirai Seiichi 白井晟一 (architect) 461

Shiraishi Taichirō 白石太一郎 31

Shirakaba 白樺 (White Birch) journal 413, 419, 421

Shirakawa, Retired Emperor (see Emperor Shirakawa, Retired)

shiraki-zukuri 白木造 367

Shirato Sanpei 白土三平 468: *The Ninja Book of Warrior Arts: The Story of Kagemaru* (*Ninja bugei chō Kagemaru den* 忍者武芸帳影丸伝), *Legend of Kamui* (*Kamui den* カムイ伝) 468

Shitennō-ji 四天王寺 (Osaka) **44**, 153, 160, 161, 185

Shitsukongōshin 執金剛神 (Vajradhara) 75, 76

shitsurai 室礼 (room adornment) 248

Shō Kannon Bosatsu 聖観音菩薩 (Aryavalokiteśvara): Kakurin-ji 鶴林寺 56; Kurama-dera 鞍馬寺 (Kyoto) 202; Yakushi-ji 薬師寺 71

sho 書 (calligraphy) xi

Shōbō 聖宝 (monk) 131

Shōden-dō 聖天堂 (Kangi-in 歓喜院, Saitama prefecture) 366–**67**; *gongen-zukuri* 権現造 366

shōen 荘園 (estates) 152; *shōen-ezu* 荘園絵図 (pictorial maps of landed estates) 231

Shōgo-in Institute for Western Studies (see Shōgo-in Yōgaku Kenkyūjo)

Shōgo-in Yōgaku Kenkyūjo 聖護院洋学研究所 (Shōgo-in Institute for Western Studies) 380

shōgon 荘厳 (sacred ornament) 41, 69, 92

Shōgun Manpuku 将軍満福 (sculptor) 73; *Ten Major Disciples of Sakyamuni* 十大弟子 (Kōfuku-ji 興福寺) 73, 75

shogun 将軍 94, 188, 234, 244, 246,

252–54, 258–59, 261–62, 266, 269, 274, 312, 316, 322, 325, 349–50, 366, 369

shōhei-ga 障屏画 (wall or panel paintings, screens) 147

shōheki-ga 障壁画 (wall or panel paintings) 147

shoin (study) architecture (*shoin-zukuri* 書院造) 129, 249, 266, 287, 314; *yamatomune-zukuri* 大和棟造 337

shōji-e 障子絵 146

Shōjuraikō-ji 聖衆来迎寺 (Shiga prefecture) 149, 206

Shōkadō Shōjō 松花堂昭乗 (painter/calligrapher) 316

Shokō-ō 初江王 (King of the First River; Kōyū 幸有; Ennō-ji 円応寺, Kamakura) seated figure of 203

Shōkoku-ji 相国寺 (Kyoto): pagoda 大塔 153

Shōkū 証空 (monk) 488n5

Shōnen kurabu 少年倶楽部 (Boy's Club) magazine 467

Short History of Jingo-ji Temple, A (*Jingo-ji Ryakki* 神護寺略記) 218; identification of Jingo-ji 神護寺 (Sentō-in 仙洞院) portraits 218

Shōsō-in Repository 正倉院 76, 82, 85–92, 115, 118, 181

Shōtoku, Prince (*see* Prince Shōtoku)

Shōun Genkei 松雲元慶 334; Seated Five Hundred Arhats (Gohyaku Rakan Zazō 五百羅漢坐像; Gohyaku Rakan-ji 五百羅漢寺, Tokyo) **334**

shrine: architecture 21, 276; Buddhist artists at 234; cabinet (*zushi*) 厨子 57–58; isometric projection 231; Lady Tachibana's 橘夫人念持仏厨子 125; offerings to 241; patronage 205; mandala 宮曼荼羅 214–**215**, 216-217, 233; *shaji engi-e* 社寺絵縁起 228, 259; Tamamushi 玉虫厨子 61–62, 90

Shūbun 周文 (painter) 262, **263**, 265, 271, 275, 291; *Hue of the Water, Light on the Peaks* (*Suishoku Rankō-zu*

水色巒光図; hanging scroll) 265; *Reading in a Bamboo Grove* (*Chikusai Dokusho-zu* 竹斎読書図; hanging scroll) **263**

shūbutsu 繍仏 (Buddhist embroidery) 82; *Tapestry of Sakyamuni Preaching* (*Shaka Seppō-zu Shūchō* 釈迦説法図 繍帳) 82; *Tenjukoku Paradise Embroidery* (*Tenjukoku Shūchō* 天寿国 繍帳; Chūgū-ji 中宮寺) 59–**60**, 82

Shūei 宗叡 (monk) 103–04; Eight Masters Who Journeyed to Tang (Nittō Hakke 入唐八家) 484n2

Shugakuin Imperial Villa 修学院 離宮 315, 368; Retired Emperor Go-Mizuno'o 後水尾上皇 315

Shugendō 修験道 xv, 107, 109, 135, 175, 212, 214

shugo daimyō 守護大名 (military governors) 275

Shūhō Myōchō 宗峰妙超 (Daitō Kokushi 大燈国師) 235, 237; Daitoku-ji 大徳寺 236; *Kanzan* 関山 (Myōshin-ji 妙心寺) **237**

Shūhō' ō Bosatsu 衆宝王菩薩 (Tōshōdai-ji 唐招提寺) 81

Shūi Wakashū 拾遺和歌集 (Collection of Gleanings of Japanese Verses) 145, 220

shunga 春画 (*makura-e* 枕絵, *warai-e* 笑絵; sexually explicit pictures) 356

Shunjō 俊芿 (monk) 233; Sen'yū-ji 仙遊寺, 泉湧寺 (Kyoto)

Shunjōbo Chōgen 俊乗坊重源 (*see* Chōgen)

Shunki 春記 (diary of Fujiwara no Sukefusa 藤原資房日記) 132; statue of Amida 阿弥陀 by Jōchō 定朝 132

shunpon 春本 (*ehon* or *enpon* 艶本; sexually explicit books) 356

side-entry tomb (*yokoana-shiki sekishitsu* 横穴式石室) 36

Sifting Red Beans (Kuroda Seiki) 402

Silk Road 33, 42

silk (*kinu* 絹): silk damask (*donsu* 緞子)

249, 269–70; silk weaving 21

Silla 新羅 43, 53, 59, 68, 230

single-block wood sculpture (*ichiboku-zukuri* 一木造) 121, 132, 134

Six Dynasties period 六朝時代 (China) 43, 45

Six Patriarchs of the Hossō Sect (*Hossō Rokuso zō* 法相六祖像; Kōfuku-ji 興福寺, Nara) 193

Six Realms of Existence (*Rokudō-e* 六道絵) painting 206–07; Ryōsen-in, Yokawa 横川霊山院 206; Shōjuraikō-ji 聖衆来迎寺 (Shiga prefecture) 206;

Six Realms of Existence (see *rokudō*)

Six Standing Kannon Bosatsu 六観音 (Hōryū-ji 法隆寺) 56

Sixteen Arhats (*Jūroku Rakan-zu* 十六羅漢; painting): Daitoku-ji 大徳寺 (Lin Tinggui 林庭珪, Zhou Jichang 周季常; hanging scrolls) 260

Sixteen Arhats (*Jūroku Rakan* 十六羅漢; sculpture): statues brought back by Chōnen 奝然 119, 174; Mokujiki 木喰 (Seigen-ji 清源寺, Kyoto) 370

Sky-Store Bodhisattva (*Kokūzō Bosatsu* 虚空蔵菩薩) 156

Sleet (Satō Tetsuzō) **473**

Small Hut in Valley Shade (*Keiin Shōchiku-zu* 渓陰小築図; attributed to Kissan Minchō 吉山明兆; Konchi-in 金地院, Nanzen-ji 南禅寺, Kyoto) 262; "study" painting (*shosai-zu* 書斎図) 262; Taihaku Shingen 太白真玄 inscription by 262

Smoke (Koga Harue) 440

Snow Wall (Komatsu Hitoshi) **476**

Snowy Landscape (*Sekkei Sansui-zu* 雪景山水図; Liang Kai 梁楷) hanging scroll 253

so 塑 (clay-modeling compound) 58

Sōami 相阿弥: 249, 252, 254, 267; *dōbōshū* 同朋衆 254, 266–67; *Eight Views of Xiao and Xiang Rivers* (*Shōshō Hakkei* 瀟湘八景; Daisen-in 大仙院)

sliding doors 267, 278; *Eight Views of the Xiao and Xiang Rivers* (*Shōshō Hakkei* 瀟湘八景; Muqi Fachang 牧谿法常) **252**

sōan 草菴 (hut) 314

Sōdosha 草土社 (exhibitions) 416

Sōfuku-ji 崇福寺 333; main gate (Dai-ippōmon 第一峰門) 334

Soga Jasoku 曽我蛇足 270–71; *Landscapes of the Four Seasons* sliding doors (*Shiki Sansui-zu fusuma-e* 四季山水図襖絵; Shinju-an 真珠庵, Daitoku-ji 大徳寺) **271**

Soga no Iruka 蘇我入鹿 49

Soga no Otodo 蘇我大臣 48; Sakyamuni Triad (Shaka Sanzon 釈迦三尊, Hōryū-ji 法隆寺) 48–49

Soga Shōhaku 曾我蕭白 307, 338, 343–44, 346–47, 467, 477; *Chinese Lions* (*Karajishi-zu* 唐獅子図; Chōden-ji 朝田寺, Mie prefecture) **347**; *Screens with Immortals* (*Gunsen-zu byōbu* 群仙図屏風) 346; *Four Sages of Mount Shang* (*Shōzan Shikō-zu* 商山四皓図屏風) 346–48; *Sliding Screens of Dragon and Clouds* (*Unryū-zu* 雲龍図) 346

Sōgen-ga 宋元画 (Song-Yuan paintings) 254

Solar Eclipse (Yasuda Yukihiko) 431; *Classic of History* 史記 (C: *Shiji*, J: *Shiki*) 341; King Yu 幽王 431

Song 宋 (China) 119, 147, 154, 183, 189, 191–95, 206, 250, 256; art of 155, 174–79; architecture 191–95; Buddhist painting 157–58, 200, 202, 206–208, 218–19, 222, 231, 247, 255; ceramics 87, 282; Eisai 栄西 and 235; *karamono* 唐物 246; landscape painting 山水画 229; monks from 236–37; Northern 北宋 97, 175, 183, 252; sculpture 179, 201, 203, 205, 248; Southern 南宋 147, 175, 252, 264; style of 119, 268

Song Ziyan 宋紫岩 338

Sōri site 曾利遺跡 (Nagano prefecture) 10; flame pots (*kaen doki* 火焔土器) 10

Sorrow of Faith (Sekine Shōji) 415

sōsaku hanga 創作版画 ("creative prints") 419, 420

Sosei 素性法師 (monk) 145

sōshoku 装飾 (*see* decoration)

Sōtō (Caodong) Zen 曹洞宗 234; Dōgen 道元 233–34; Dongshan Liangjie 洞山良价 233; samurai elite 189; Tiandong Rujing 如浄 233

Southerly Wind (Wada Sanzō) 408

Southern and Northern courts 南北朝 245

Southern School (*nanzhoghua, nanshū-ga* 南宗画) 233, 338–39

Southern Song painting 南宋画 250; and Josetsu 如拙 262; Buddhist 174

Southern Song-style painting 408

sozō 塑像 (*see* clay statues)

Spanish Beauty (Foujita Tsuguharu) **427**

Spider and Tulip (Masaoka Kenzō) 469

Spirit of Retired Emperor Sanuki Sends Allies to Rescue Tametomo (*Sanuki-in Kenzoku o shite Tametomo o sukuu zu* 讃岐院眷属をして為朝をすくふ図; Utagawa Kuniyoshi 歌川国芳) 363

Spirited Away (Miyazaki Hayao) 471

spirits (*seirei* 精霊) 12

Springtime (Tsuchida Bakusen) 433

Standing Women Decorated with Bird Feathers screen (*Torige Ritsujo no byōbu* 鳥毛立女屏風; Shōsō-in Repository 正倉院) 91

Starvation (Abe Nobuya) 452

Stone Buddha of the Manji era (Manji no sekibutsu 万治の石仏; behind the Harumiya 春宮, Suwa grand shrine 諏訪大社, Nagano prefecture) 329

stoneware 36, 242, 278–80, 301, 326–27, 482n10

"study" painting (*shosai-zu* 書斎図) 262; *Small Hut in Valley Shade* (*Keiin Shōchiku-zu* 渓陰小築図) 262

Subaru スバル (Pleiades) journal 413

Sue ware (*sueki* 須恵器) 36, 185, 482n10; jar decorated with children (*sōshoku-tsuki kyaku-tsuki komochi tsubo* 装飾付脚付子持壺; Nishinomiya-yama burial mound 西宮山古墳, Hyogo prefecture) 36

Suga Kishio 菅木志雄 454

Sugawara no Michizane 菅原道真 115, 227, 235

Sugimoto Hiroshi 杉本博司 (photographer) 475

Sugiyama Sueo 杉山寿栄男 6

Sugiyama Yasushi 杉山寧 (painter) 453, 477

suijaku paintings 垂迹画 212, 214

sukiya style (*sukiya-fū* 数寄屋風) 422–23, 448

sukiya-style (*sukiya-zukuri* 数寄屋造) architecture: Katsura Imperial Villa (Katsura Rikyū 桂離宮) 314; Murano Tōgo 村野藤吾 448; Sumiya House 角屋 322; Sen no Rikyū's 千利休 Tai-an 待庵 289; Yasui Takeo 安井武雄 422; Yoshida Isoya's 吉田五十八 "new *sukiya* style" (*shinkō sukiya* 新興数寄屋) 423

sumi-nagashi 墨流し (technique) 181

Sumiya House 角屋 (Shimabara pleasure quarter 島原遊郭, Kyoto) 322; *sukiya*-style (*sukiya-zukuri* 数寄屋造) 322

Sun and Moon in the Four Seasons screens (*Jitsu-getsu Sansui-zu byōbu* 日月山水図屏風) 271

Sun and Moon screens (Kuwata Sasafune) calligraphy 459

Sunflowers (Hayami Gyoshū) 432

sutra box with the Merits of the Buddha illustrated in *maki-e* (*butsu kudoku maki-e kyōbako* 仏功徳蒔絵経箱) 141–**42**

sutra mounds (*kyōzuka* 経塚) 487n26

Sutra of the Arising of Worlds (*Kise-kyō* 起世経) 169

Sutra of the Pavilion of Vajra Peak and All Its Yogas and Yogins (*Kongōbu rōkaku issai yuga yugi kyō* 金剛峯一切楼閣瑜伽瑜祇経) 111

Sutra on the Right Mindfulness of Dharma (*Shōhōnensho-kyō* 正法念処経) 169

Sutras Dedicated by the Taira Family (*Heike Nōkyō* 平家納経) handscrolls 154

Sutras of Kunō-ji Temple (*Kunōji-kyō* 久能寺経) 159

Suzu ware 珠洲焼 242

Suzuki Chōkichi 鈴木長吉 396; *Twelve Hawks* (*Jūni no taka* 十二の鷹) **396**

Suzuki Harunobu 鈴木春信 307, 350–**52**, 419, 491; *Firefly Hunting* (*Hotaru-gari* 蛍狩り) **352**; *nishiki-e* 錦絵 ("brocade pictures") 350–51

Suzuki Kiitsu 鈴木其一 (painter) 359

sword (*tōken* 刀剣): decoration (*tōken sōshoku* 刀剣装飾) 89, 181, 270, 365; fittings 364; Gotō Yūjō 後藤祐乗 270; *kenuki*-style sword 毛抜形太刀 (Kasuga grand shrine 春日大社) 181; high relief (*takaniku-bori* 高肉彫) 270; Hon'ami Kōetsu 本阿弥光悦 315; metal 21, 26, 29, 33; Tang-style sword mounting (Shōsō-in Repository 正倉院) 89–90, 117

Tachibana no Toshitsuna 橘俊綱 151; *Record of Garden Making* (*Sakuteiki* 作庭記) 151, 267

Tachibana, Lady 橘夫人 57, **58**, 62, 125

Tachihara Kyōsho 立原杏所 (painter) 357

Tachihara Suiken 立原翠軒 357; portrait by Watanabe Kazan 渡辺崋山 357

Tada Minami 多田美波 454

Tagawa Suihō 田河水泡 (manga artist) 467; *Norakuro* ノラクロ 467

Tai-an 待庵 (Myōki-an 妙喜庵, Kyoto) 288–90; Sen no Rikyū 千利休 288–90

Taihei Yōga-kai 太平洋画会 (Pacific Painting Society) 402

Taihō legal and criminal codes 大宝律令 68

Taihō 大鵬 (Ōbaku priest-painter) 338

Taika Reforms 大化の改新 40

Taima-dera 当麻寺 (Nara prefecture) 59, 83, 211, 228; Four Guardian Kings (Shitennō zō 四天王像) 59; seated Miroku (Miroku *zazō* 弥勒坐像) 59; welcoming ceremony (*mukaekō* 迎講) 211; *Woven Taima Mandala* 綴織当麻曼荼羅 83, 228

Taira clan (Heishi 平氏 or Heike 平家) 189

Taira no Kiyomori 平清盛 188

Taira no Narifusa 平業房: portrait of (Jingo-ji 神護寺) 218

Taira no Shigehira 平重衡 77

Taira no Shigemori 平重盛: portrait of (Jingo-ji 神護寺) **218**

taisei hōkan 大政奉還 (return of the political authority back to the emperor) 374

Taishakuten (Indra) Mandala 帝釈天曼荼羅 (Murō-ji 室生寺, Nara prefecture) 104

Taishakuten 帝釈天 (Indra) 75

Taishō Democracy 424, 435

Taishō Romanticism (*see* Romanticism)

Taiyō no ōji Horusu no daibōken (see *Great Adventure of Horus, Prince of the Sun*)

Taiyū-in mausoleum 大猷院霊廟 (Rinnō-ji 輪王寺, Nikkō) 309; Tokugawa Iemitsu 徳川家光 308–09

Takahashi Kenzō 高橋健三 (governmental official, journalist) 406

Takahashi Yuichi 高橋由一 (painter) 375–79, 387, 416; Books (*Yomihon to sōshi* 読本と草紙), *Courtesan* (*Oiran* 花魁図), *Dried Salmon* (*Sake* 鮭), *Half-Dried Bonito* (*Namari* なまり), *Rolls of Cloth* (*Makinuno* 巻布) **376**; *Self-Portrait with Topknot* (*Chonmage sugata no jigazō* 丁髷姿の自画像) 375; *Tofu* 豆腐 377

Takahata Isao 高畑勲 (anime director) 471; *Only Yesterday* (*Omoide Poroporo* おもひでぽろぽろ), *Pom Poko* (*Heisei Tanuki Gassen Ponpoko* 平成狸合戦 ぽんぽこ) 471; *Twelfth-Century Animation* (*Jūni-seiki no Animēshon* 十二世紀のアニメーション) 471

takamaki-e 高蒔絵 lacquer 241, 268, 288, 313; Hatsune Dowry (Hatsune no chōdo 初音の調度) **313**

Takamatsu Jirō 高松次郎 454, 462; *Shadow Paintings* (Kage 影) **463**

Takamatsuzuka burial mound 高松塚古墳 (Asuka, Nara prefecture) 32, 62–**63**; four sacred animals of the four cardinal directions 32

Takamura Kōtarō 高村光太郎 (sculptor/ author) 413, 415, 421, 482n4; "A Green Sun" ("Midori-iro no taiyō" 緑色の太陽) 413, 421; *Hand* (*Te* 手) 421–**22**; Fuzankai フュウザン会 415

Takamura Kōun 高村光雲 (sculptor) 377, 390; *Old Monkey* (*Rōen* 老猿) 390, Saigō Takamori statue (*Saigō Takamori zō* 西郷隆盛像) 390

Takao Mandala 高雄曼荼羅 (Jingo-ji 神護寺) 97, **98**, 103, 121; Kūkai 空海 103

Takaosan-ji 高雄山寺 (Kyoto) 96, 107 (*see also* Jingo-ji)

Takashina Erika 高階絵里加 385

Takashina Shūji 高階秀爾 379, 400, 464

Takashina Takakane 高階隆兼 216, 228; *Dreamlike Manifestation of Kasuga Myōjin* (*Kasuga Myōjin Yōgō-zu* 春日 明神影向図) 216; *Secret Teachings of the Hossō Sect* (*Hossō-shū hiji ekotoba* 法相宗秘事絵詞) attributed to 229; Takehara burial mound 竹原古墳 (Fukuoka prefecture) 37

Takayama Tatsuo 高山辰雄 (painter) 472

Takeda Goichi 武田五一 (architect) 412; "Teahouse Architecture" ("Chashitsu kenchiku ni tsuite" 茶室建築について) 412

Takehisa Yumeji 竹久夢二 (painter, illustrator, poet) 419; Yumeji-style beauties (Yumeji-shiki 夢二式) 419

Takeno Jōō 武野紹鴎 (tea master) 288

Taketori Monogatari Emaki 竹取物語 絵巻 (*Illustrated Scrolls of the Bamboo Cutter*) 144; Kose no Ōmi 巨勢相覧 144; mention in the *Tale of Genji* (*Genji Monogatari* 源氏物語) 144

Taketori Monogatari 竹取物語 (*The Tale of the Bamboo Cutter*) 117; *maki-e* 蒔絵 technique 117

Takeuchi Seihō 竹内栖鳳 (painter) 410, 433; *Historic Spots of Rome* (*Rōma no zu* 羅馬之図) **410**, **411**

Takiguchi Shūzō 瀧口修造 (poet, art critic, painter) 440

Takikubo site 多喜窪遺跡 (Tokyo) 7; Katsusaka-type pot (*Katsusaka-shiki fukabachi* 勝坂式深鉢; Middle Jōmon 縄文中期) 7

Takisawa Kawara 滝沢川原 (Aomori prefecture) 11

Takuma Eiga 宅間栄賀 205, 255; *Hotei* 255; Bodhisattva Fugen 255

Takuma school 宅間派 (painters) 205, 232, 255; *Butsugen Butsumo* 仏眼仏母 (Kōzan-ji 高山寺) 205; Chōga 長賀, Eiga 栄賀, Ryōga 良賀, Shōga 勝賀, Shunga 俊賀, Tamehisa 為久, Tametō 為遠 205

Takuma Tamenari 宅間為成 136; *Kokon Chomonjū* 古今著聞集 136; *Nine Grades of Rebirth in the Pure Land* (*Kuhon Raigō-zu* 九品来迎図; Byōdō-in 平等院) 136

Tale of Ame-no-Wakahiko (*Ame-no-Wakahiko Sōshi* 天稚彦草子; attributed to Tosa Hirochika 土佐広周) 259

Tale of Flowering Fortunes, A (see *Eiga Monogatari*)

Tale of Genji (*Genji Monogatari* 源氏物語) 164, 430, 436; garden

described in 314; identification of the artist of *Taketori Monogatari Emaki* 竹取物語絵巻 144; illustrated scrolls 源氏物語絵巻 129, 144, 154, 164, **165**, 222; *Tale of Genji* album 源氏物語画帖 272–**73**

Tale of Saigyō (Saigyō Monogatari Emaki 西行物語絵巻) 229

Tale of the Hapless Painter (Eshi no Sōshi 絵師草紙) **226**, 257

Tale of the White Serpent (Hakuja den 白蛇伝) 469

Tale of Wealth and Prosperity (Fukutomi Sōshi 福富草子; Shunpo-in 春浦院, Kyoto) 259

Talk on Ancient Romance (Kuroda Seiki) 402

Tamamushi Shrine (Tamamushi no zushi 玉虫厨子; Hōryū-ji 法隆寺) 57, **61–62**, 89; *mitsuda-e* 密陀絵 (litharge painting) 89

Tamayori-hime no mikoto 玉依姫命 seated figure of 坐像 (Yoshino Mikumari shrine 吉野水分神社, Nara) 203; Sen'yōmon-in 宣陽門院 203; Zen school (of sculpture) 善派 202

Tamonten 多聞天 (Vaisravana) 52; Hōryū-ji 法隆寺 (Yamaguchi no Ōguchi no Atai 山口大口費) 52

Tan Tan Bo Puking - a.k.a. Gero Tan (Murakami Takashi) **478**

tan-e 丹絵 348, 350; Torii Kiyomasu I 鳥居清倍 (初代) 348–50

Tanabata 七夕 (Star Festival): flower arrangements (*shisseki hōraku* 七夕 法楽) 259; *Yamato-e* やまと絵 147

Tanabatake site 棚畑遺跡 (Nagano prefecture) 13; Jōmon Venus 縄文のビーナス (*dogū* 土偶) 12–**13**

Tanabe Saburōsuke 田邉三郎助 115

Tanaka Atsuko 田中敦子 (painter) 457

Tanaka Chōjirō I 田中長次郎 (初代) (potter) 290; "Great Black" (Ōguro 大黒; black Raku ware) **290**;

Muichimotsu 無一物 ("Void"; red Raku ware) 290; Shunkan 俊寛 (black Raku ware) 290

Tanaka Ikkō 田中一光 (graphic designer) 475

Tanaka Kyōkichi 田中恭吉 (print artist) 420

Tanba ware 丹波焼 242

Tang China 唐代中国 68, 69, 86, 94, 103, 105, 106, 119; aesthetic 90; art influence of 72; sculpture 82, 87

Tang Yin 唐寅 338; *Tan'yū Shukuzu* 探幽縮図 (Tan'yū's reduced-size copies of paintings) 336

Tange Kenzō 丹下健三 (architect) 450, 460; Cenotaph for the Victims of the Atomic Bomb (Genbaku Shibōsha Ireihi 原爆死亡者慰霊碑) 460; Hiroshima Peace Memorial Museum (Hiroshima Heiwa Kinen Shiryōkan 広島平和記念資料館) 460; Hiroshima Peace Memorial Park (Hiroshima Heiwa Kinen Kōen 広島平和記念公園) 460; Kagawa Prefectural Government Office (Kagawa Kenchōsha 香川県 庁舎) 461; "Plan for a Monument Commemorating the Foundation of Greater East Asia" (Daitōa Kensetsu Kinen Zōei Keikaku 大東亜建設記念 営造計画) 450; Tsuda College Library (Tsudajuku Daigaku Toshokan 津田塾 大学図書館) 460; Yoyogi National Gymnasium (Kokuritsu Yoyogi Kyōgijō 国立代々木競技場) 461

Tangled Hair (Midare-gami みだれ髪; Yosano Akiko 与謝野晶子; *tanka* 短歌 poem anthology) 404

Tang-style sword mounting with gilded silver fittings and inlay (*kinginden-kazari no karatachi* 金銀鈿荘唐太刀; Shōsō-in northern repository 正倉院北倉, Tōdai-ji 東大寺, Nara) 89–90, 117

Tani Bunchō 谷文晁 357; Kantō Nanga 関東南画 357; *Landscapes Painted*

during a Break in Public Service (*Kōyo Tanshō-zu* 公余探勝図) handscroll 357; *Portrait of Kimura Kenkadō* (*Kimura Kenkadō-zō* 木村蒹葭堂像) 357; Wu school 呉派 and Zhe school 浙派 357

Taninaka Yasunori 谷中安規 (print artist) 420

Tankei 湛慶 195, 201–02; Bishamonten with Attendants (毘沙門天及び両脇侍像; Kichijōten 吉祥天; Zennishi Dōji 善膩師童子; Sekkei-ji 雪渓寺, Kōchi) 201–02; standing Kongō Rikishi 金剛力士立像 (Tōdai-ji Great South Gate 東大寺南大門) 194–95, **196–97**; puppy (*kibori no kuji* 木彫の狗児) and deer (*shinroku* 神鹿) (Kōzan-ji 高山寺, Kyoto) 201

Tanomura Chikuden 田能村竹田 (painter) 357, 409

Tanomura Chokunyū 田能村直入 (painter) 409

Tantra for Wondrous Achievement in All Things (*Soshitsuji-kyō* 蘇悉地経) 104

Tantrism 95

Tanzei 弾誓 329; *sakubutsu hijiri* 作仏聖 ("Buddha-making holy men") 329

Tapestry of Sakyamuni Preaching (*Shaka Seppō-zu Shūchō* 釈迦説法図繍帳) 82; *shūbutsu* 繍仏 (Buddhist embroidery) 82

tarashikomi たらし込み ("dripping in") technique 316

Tateishi Seijū 立石清重 **393**; former Kaichi School 392–**93**

Tatsuno Kingo 辰野金吾 (architect) 394, 411; Bank of Japan headquarters (Nihon Ginkō Honten Honkan 日本銀行本店本館; Tokyo), Tokyo Station (Tokyo Eki 東京駅) 394

Tawaraya Sōtatsu 俵屋宗達 307, 315–**16**, 332, 359, 455; *Anthology of the Thirty-Six Poets with Crane Design* (*Tsuru Shitae Sanjūrokkasen Waka Kan*

鶴下絵三十六歌仙和歌巻) **316–17**; *Bugaku* screens (*Bugaku-zu byōbu* 舞楽図屏風; Daigo-ji 醍醐寺) 317; *Cedar Doors with Elephants* (*Zō-zu sugido-e* 象図杉戸絵; Yōgen-in 養源院) 316; collaboration with Hon'ami Kōetsu 本阿弥光悦 316; *eya* 絵屋 (independent painting studio) 316; *Farm House in Early Spring* (*Denka Sōshun-zu* 田家早春図; Daigo-ji 醍醐寺) 316; *Sekiya and Miotsukushi* screens 関屋澪標図屏風 316; *Waves at Matsushima* (*Matsushima-zu byōbu* 松島図屏風) 317–18; *Wind God and Thunder God* (*Fūjin Raijin-zu byōbu* 風神雷神図屏風; Kennin-ji 建仁寺) 316–17

tea (*cha* 茶) 233, 242, 280, 288–90, 301–302; daimyo style tea (*daimyo-cha* 大名茶) 301; *sencha* 煎茶 (or steeped tea) 364; *shoin daisu* 書院台子 ("study-room tea-stand" style) 288; tea gatherings 233; tea masters (*chajin* 茶人) 242; *wabi* tea (or *wabi*-style tea; *wabi-cha* 侘び茶) 280, 288, 301–02

tea ceramics (*chatō* 茶陶) 301, 315; *hyōgemono* 剽軽物 ("playful wares") 301

Technical Art School (*see* Kōbu Bijutsu Gakkō)

Teikoku Bijutsuin 帝国美術院 (Imperial Academy of Art) 416

Teiten (Academy of Fine Arts Exhibition) 416

Ten Major Disciples of Sakyamuni (Jūdai Deshi 十大弟子; Shōgun Manpuku 将軍満福; Kōfuku-ji 興福寺) 73, 75

Tendai sect 天台宗 97; Ippen 一遍 488n5

Tenjukoku Paradise Embroidery (*Tenjukoku Shūchō* 天寿国繍帳; Chūgū-ji 中宮寺) 59–**60**, 82; *Jōgū Shōtoku Hōō Teisetsu* 上宮聖徳法王帝説 (biography of Prince

Shōtoku) 61; Prince Shōtoku 聖徳太子
59; *shūbutsu* (Buddhist embroidery
繍仏) 82; Tachibana no Ōiratsume
橘大郎女 59

tenmoku teabowls (*tenmoku jawan*
天目茶碗) 280

Tenpyō Era (Aoki Shigeru) 405

Tenpyō period 天平時代 36, 40, 59,
68–69, 75–76, 78, 82, 118, 121, 483n1,
488n27; Buddhism 192; calligraphy
116; court 92; designs 105, 106,
154–55, 179; *maki-e* 180; sculpture
105–106, 179, 195

Tenshin Dōjō 天真道場 (private painting
academy, Tokyo) 399, 400

Tentōki 天燈鬼 (demon with lantern;
Kōfuku-ji 興福寺) 201

teriguma 照暈 123 Five Great Wisdom
Kings (Godaison-zō 五大尊像;
Kiburi-ji 来振寺) 123

Teshima Yūkei 手島右卿 (calligrapher)
459

tessenbyō (iron-wire lines) 鉄線描 65,
431; Kobayashi Kokei 小林古径 431;
Maeda Seison 前田青邨 431; murals
at Kondō, Hōryū-ji 法隆寺金堂壁画
64–65; Yasuda Yukihiko 安田靫彦 431

Tesshū Tokusai 鉄舟徳済 255; orchids in
ink (*bokuran* 墨蘭) 255

textiles 15, 59, 82, 86, 92, 174, 186, 268,
270: *bingata* 紅型 365; Edo period
江戸時代 313, 327; embroidery (*nui* 縫
and *shishū* 刺繍) 288; Keichō *kosode*
(robes) 慶長小袖 313; Ming China
明代中国 269; Momoyama period
桃山時代 288, 327; pasted metallic
leaf (*surihaku* 摺箔) 288; raised designs
(*uki-ori* 浮織); (*see also* dyes and dyeing)

Tezuka Osamu 手塚治虫 (manga artist)
467; *Astro Boy* (*Tetsuwan Atomu* 鉄腕
アトム) 468, 471; *Jungle Emperor*
(*Janguru taitei* ジャングル大帝);
Metropolis (メトロポリス) 467, **468**; *New
Treasure Island* series (*Shin Takarajima*
新宝島) 467

*Things Seen and Heard during the Keichō
Era* (*Keichō Kenmon Shū* 慶長見聞集)
295; arrival of Miroku Bosatsu 295;
Momoyama period 桃山時代 295

Thirteen Emperors Scroll 帝王図鑑
(attributed to Yan Liben 閻立本) 83

Thirty-Six Poets (*Sanjūrokkasen*
三十六歌仙) 320, 351; Fujiwara no
Kintō 藤原公任 230

Thirty-Six Poets handscrolls
(*Sanjūrokkasen emaki* 三十六歌仙
絵巻) 231; Agedatami scroll 上畳本,
Go-Toba-in scroll 後鳥羽院本
(Senshū-ji 専修寺, Mie prefecture),
Narikane scroll 業兼本, Satake scroll
佐竹本 231

Thousand-Armed Avalokitesvara (*see* Senju
Kannon)

Thousand-Armed Avalokitesvara (Senju
Kannon 千手観音; Southern
Song; Eihō-ji 永保寺, Tajimi, Gifu
prefecture) hanging scroll 174

Three Kingdoms 三国時代 (Korea) 33,
43–44, 47, 68

Tiandong Rujing 如浄 (Caodong monk)
233; Dōgen 道元 233–34; Sōtō
(Caodong) Zen 曹洞宗 234

Tianlongshan grottos 天竜山石窟 (Shanxi
province) 43

Tibetan Buddhism チベット仏教 97

Tō-ji 東寺 (Kyoto) 96, 101, 105, 116;
Kyōō Gokoku-ji 教王護国寺 (precursor
of Tō-ji) 96; lecture hall 111, 123

toba-e 鳥羽絵 467

Toba, Retired Emperor 鳥羽上皇 152,
217; *Kikki* 吉記 217; portrait of 217;
Twelve Devas (*Jūniten* 十二天; hanging
scrolls) 155

Tobari Kogan 戸張孤雁 (sculptor) 421

Tōdai-ji 東大寺 (Nara) 115: Chōgen
重源 190, 192; destruction of 190;
eye-opening ceremony 開眼供養 77,
86, 92; Great Buddha 大仏 77;

Gyōki 行基 190; Isozaki Arata 磯崎新 191; Konshō-ji 金鐘寺 (precursor of Tōdai-ji) 74; rebuilding in the Edo period 366; restoration 190, 192–93, 366; Shōsō-in 正倉院 76

Tōei Motion Picture Company (Tōei Dōga 東映動画) 469

Tōfuku-ji 東福寺 (Kyoto) 131, 235; Kaihō Yūshō 海北友松 293; Kujō Michiie 九条道家 235; Sanmon (Triple Gate) 三門 193, 246

Tofu (Takahashi Yuichi) **377**

Tōhoku-in Poetry Contest among Persons of Various Occupations (*Tōhoku-in shokunin uta-awase e*) 東北院職人歌合絵 224

Toki Tōbun 土岐洞文 (painter) 276; Muromachi-period warriors 276

Tokiwa Mitsunaga 常盤光長 164; *Gyokuyō* 玉葉 (diary of Kujō Kanezane 九条兼実日記) 219; *Illustrated Scrolls of the Courtier Ban Dainagon* (*Ban Dainagon Ekotoba* 伴大納言絵詞) 164; sliding door panels at Saishōkō-in 最勝光院 219

Tokoname kilns 常滑窯 185, 241

Tokoname ware 常滑焼 280

tokonoma 床の間 (display alcove) 478

Tokugawa Hidetada 徳川秀忠 316; Sūgen-in 崇源院 316

Tokugawa Iemitsu 徳川家光 308–09, 312; Taiyū-in mausoleum 大猷院霊廟 (Rinnō-ji 輪王寺, Nikkō) 309

Tokugawa Ieyasu 徳川家康 284, 302; Kanō Tan'yū 狩野探幽 311

Tokugawa shogunate 徳川幕府 306, 310 (see alse *bakufu*)

Tokugawa Tsunayoshi 徳川綱吉 366; rebuilding of Tōdai-ji 東大寺再建 366

tokushu kidai (special pedestaled vessels) 特殊器台 26, 34

Tokyo Bijutsu Gakkō 東京美術学校 (Tokyo School of Fine Arts) 399, 400, 402, 403, 406–407, 408, 482n4

Tokyo Chamber of Commerce and Industry Building (Tokyo Shōkō Kaigisho 東京商工会議所; Tsumaki Yorinaka) 395

Tokyo School of Fine Arts (*see* Tokyo Bijutsu Gakkō)

Tokyo Station (Tokyo Eki 東京駅; Tatsuno Kingo) 394

Tokyo Stock Exchange Building (Kabushiki Torihikijo 株式取引所; Tokyo; Yokogawa Tamisuke) 413

Tōmatsu Shōmei 東松照明 (photographer) 473

tombs (*see also* burial mounds) 30

Tomioka Tessai 富岡鉄斎 (painter) 409; *Two Divinities Dancing* (*Nishin kaibu-zu* 二神会舞図) 409, **410**; Wang Yangming school of neo-Confucianism (Yōmeigaku 陽明学) 409

tonseisha 遁世者 (semi-recluse) 249

Torazuka site 虎塚古墳 (Ibaraki prefecture) 37

Tori Busshi 止利仏師 (or Kuratsukuri no Tori 鞍作止利; sculptor) 45, 47; Great Buddha of Asuka (Asuka Daibutsu 飛鳥大仏 or Shaka Nyorai 釈迦如来) **45**, 47; Sakyamuni Triad (Shaka Sanzon 釈迦三尊) 45, 47, 48, 56

Tori school 止利派 of sculptors 40, 45, 47, 49, 51

Torihama shell middens 鳥浜貝塚 (Fukui prefecture) 15; Jōmon wooden artifacts 15

Torii Kiyomasu I 鳥居清倍 (初代) 348–50; *Courtesan with a Bird and an Attendant Holding a Cage* (*Kotori-mochi Bijin Kago-mochi Musume* 小鳥持美人籠持娘) **349**; *tan-e* 丹絵 348, 350

Torii Kiyonaga 鳥居清長 307, 351–53; *Evening Cool on the Banks of the Sumida River* (*Ōkawa-bata Yūsuzumi* 大川端夕涼) **352**; Ernest Fenollosa 352

Torii Kiyonobu I 鳥居清信 349; "legs like

gourds, and lines like worms" (*hyōtan-ashi mimizu kaki* 瓢箪足蚯蚓描; drawing technique) 349; "rough-style performances" (*aragoto shibai* 荒事芝居 or *aragoto kabuki* 荒事歌舞伎) 349

Tosa Hirochika 土佐広周 259; *Tale of Ame-no-Wakahiko* (*Ame-no-Wakahiko Sōshi* 天稚彦草子) 259

Tosa Mitsumochi 土佐光茂: *Origins of Kuwanomi Temple* (*Kunomi-dera Engi Emaki* 桑実寺縁起絵巻) 272; *Pine Beach* folding screens (*Hamamatsu-zu byōbu* 浜松図屏風): attributed to 272

Tosa Mitsunobu 土佐光信 266, 272–73, 278; *Origins of Kiyomizu Temple* (*Kiyomizu-dera Engi Emaki* 清水寺縁起絵巻) 272; *Scenes of Kyoto* (*Kyōchu-zu* 京中図) 273; *Tale of Genji Album* (*Genji Monogatari Gajō* 源氏物語画帖) 272–**73**; *Ten Kings of Hell* (*Jūō-zu* 十王図) 272

Tosa Mitsuyoshi 土佐光吉 272; *Scenes of the Twelve Months* (*Jūnikagetsu Fūzoku-zu* 十二ヶ月風俗図): attributed to 272–**73**

Tosa school 土佐派 (painters) 269, 278, 318

Tōshikaden 藤氏家伝 (History of the Fujiwara Family) 486; deity Kehi 気比の神 486n; Fujiwara no Muchimaro 藤原武智麻呂 485n12; Kehi Jingū-ji 気比神宮寺 485n12

Tōshōdai-ji temple 唐招提寺 (奈良) 69, 78–82, 106, 107, 168

Tōshūsai Sharaku 東洲斎写楽 221, 351, 354–**55**, 489n4; Saitō Jūrobei 斎藤十郎兵衛 354; *Sawamura Sōjūrō III as Ōgishi Kurando* (*Sandai-me Sawamura Sōjūrō no Ōgishi Kurando* 三代目沢村宗十郎の大岸蔵人) 355; sumo prints (*sumo-e* 相撲絵) 354

townspeople (*chōnin* 町人) 306, 331–32, 343; artistic style 306; as pictorial subject 351; as producers of arts 306–07, 315, 320, 322–23, 329, 337, 351; courtly culture 314, 351; culture of 359; decorative arts 364; gardens 369; *minka* 336; taste of 387

Toyama Masakazu 外山正一 (educator) 385

Toyotama Prison (Toyotama Kangoku 豊多摩監獄; Tokyo; Gotō Keiji) 423

Toyotomi family 豊臣氏 306

Toyotomi Hideyoshi 豊臣秀吉 121, 284, 287, 288, 310, 322; castles and palaces built by 287; Hōkoku mausoleum (Hōkoku-byō 豊国廟) 291; Otamaya Hall 霊屋, Kōdai-ji 高台寺 291; Shōun-ji 祥雲寺 290

trade: Ashikaga rule 足利幕府 250, 255; Dutch 306; Himiko and 卑弥呼 31; Jōmon period 縄文時代 18; Song China 宋代中国 119; renewed 175, 191; Zen monk brokers 252

transformation tableaux (C: *bianxiang* 変相) 162–63

Transformation Tableaux of the Lotus Sutra 法華経変相図 (Dunhuang 敦煌) 150

transformation texts (C: *bianwen* 変文) 162

Treasury of the True Dharma Eye (*Shōbō Genzō* 正法眼蔵; Dōgen 道元) 234

Tree (Hayami Gyoshū) 433

triangular-rimmed mirrors 三角縁神獣鏡 28, 30, 31

Tropical Lands handscroll (Imamura Shikō) 432

Tsubai Ōtsukayama burial mound 椿井大塚山古墳 (Kyoto prefecture) 482n7

Tsuchida Bakusen 土田麦僊 (painter) 433; *Bathhouse Attendant* (*Yuna* 湯女); *Female Divers* (*Ama* 海女) 433; *Maiko in a Garden* (*Bugi Rinsen* 舞妓林泉) 433; *Springtime* (*Haru* 春) 433

Tsuchimikado-dono 土御門殿 129; Fujiwara no Michinaga 129;

shinden-style residences (*shinden-zukuri* 寝殿造) 129–30

Tsuda College Library (Tsudajuku Daigaku Toshokan 津田塾大学図書館; Tokyo; Tange Kenzō) 460

Tsuda Seifū 津田青楓 (painter) 415

Tsugane Goshomae site 津金御所前遺跡 (Yamanashi prefecture) 9; placenta pot (*osan doki* お産土器 or *jinmen totte-tsuki fukabachi* 人面把手付深鉢; Middle Jōmon 縄文中期) 9

Tsuge Yoshiharu つげ義春 468: *Salamander* (*Sanshōuo* 山椒魚), *Screw System* (*Nejishiki* ねじ式) 468

tsugi-gami 継紙 (*see* paper-joining craft)

tsuina 追儺 (demon-dispelling) ritual 147; *Yamato-e* やまと絵 147

tsujigahana-zome 辻が花染 (tie-dyeing with applied decoration and embroidery) 270, 288

Tsukiji Akashi-chō (Kaburaki Kiyokata) 436

Tsukiji Hongan-ji 築地本願寺 (Tokyo; Itō Chūta) 412

tsukinami-e 月次絵 146

Tsukioka Yoshitoshi 月岡芳年 (ukiyo-e artist) 389

tsukuri-e つくり絵 ("produced paintings") 164, 487n23; *fukinuki yatai* 吹抜屋台 ("blown-away roof view" of buildings) 164; *hikime kagibana* 引目鉤鼻 (slit for eyes, hook for nose) 164; *Illustrated Scrolls of the Tale of Genji* (*Genji Monogatari Emaki* 源氏物語絵巻) 164, 222; *onna-e* 女絵 (women's pictures) 164, 222

tsukurimono つくりもの ("produced object") 186, 378, 484n28; *kushi fūryū* 櫛風流 186, 488n28

Tsumaki Yorinaka 妻木頼黄 (architect) 395; Yokohama Specie Bank (Yokohama Shōkin Ginko 横浜正金銀行), Tokyo Chamber of Commerce and Industry Building (Tokyo Shōkō Kaigisho 東京商工会議所) 395

Tsurugaoka Hachiman-gū 鶴岡八幡宮 (Kamakura) 224, 242, 460; gold lacquer box inlaid with mother-of-pearl chrysanthemums (*magaki ni kiku maki-e raden suzuri-bako* 籬菊蒔絵螺鈿硯箱) 240; Kamakura Bunkakan Tsurugaoka Museum 鎌倉文化館鶴岡ミュージアム (Sakakura Junzō 坂倉準三) 460; *Poetry Contest among Persons of Various Occupations on the Occasion of a Hōjō Ritual at Tsurugaoka Hachiman-gū shrine* (*Tsuruoka Hōjō-e Shokunin Utaawase Emaki*) 鶴岡放生会職人歌合絵巻 224

Tsuruoka Masao 鶴岡政男 (painter) 451, 454; *Heavy Hand* (*Omoi te* 重い手) **451**

Tsutaya Jūzaburō 蔦屋重三郎 352; *Gift of the Ebb Tide* (*Shiohi no Tsuto* 潮干のつと; Kitagawa Utamaro 喜多川歌麿) 352; *Picture Book: Selected Insects* (*Ehon Mushi Erami* 画本虫撰; Kitagawa Utamaro 喜多川歌麿) 352–**53**

tsuzumi drum, tricolor (*sansei kodō* 三彩鼓胴; Shōsō-in southern repository 正倉院南倉, Tōdai-ji 東大寺, Nara) 92

tsuzure-ori 綴織 tapestry 82; *Woven Taima Mandala* (*Tsuzure-ori Taima Mandara* 綴織当麻曼荼羅; Taima-dera 当麻寺) 83

tunnel tomb (*yokoana-shiki kofun* 横穴式古墳) 36–38; Chibusan チブサン 37–**38**; decorative/decorated burial mounds (*sōshoku kofun* 装飾古墳) 36–38; Kiyotosaku 清戸迫 37; Mezurashizuka 珍敷塚 37; Nabeta 鍋田 37; Ōzuka 王塚 37; Segonkō 千金甲 36; Takehara 竹原 **37**; Torazuka 虎塚 37

turbo-shell halls (*see* Sazae-dō)

Twelve Devas (*Jūniten* 十二天) 99–100, 104–05, 155–**56**, 334, 484n3; Nata

Yakushi-dō 鉈薬師堂 (Aichi prefecture; Enkū 円空; sculpture) 334; Rite of the Latter Seven Days (Go-shichi no Mishū Hō 後七日御修法) 100, 155; Saidai-ji 西大寺 (painting) 99; Toba, Retired Emperor 鳥羽上皇 155; Tō-ji 東寺 (formerly at; painting) **156**

Twelve Guardian Generals (Jūni Shinshō 十二神将): Kōryū-ji 広隆寺 (Chōsei 長勢) 134; Shin Yakushi-ji 新薬師寺 76

Twelve Hawks (Suzuki Chōkichi) **396**

Two Bodhisattvas and Sakyamuni's Ten Great Disciples (Munakata Shikō) **455**

Two Divinities Dancing (Tomioka Tessai) 409, **410**; Ame-no-uzume 天宇受売命 409; Sarutahiko 猿田彦 409

Two Dragons (Kanō Hōgai) 382

Uchida Yoshikazu 内田祥三 (architect) 447; Central Library (Sōgō Toshokan 総合図書館; Tokyo Imperial University 東京帝国大学, present-day the University of Tokyo 東京大学) 447; Yasuda Lecture Theater (Yasuda Kōdō 安田講堂; Tokyo) 447

Uchiyama Takeo 内山武夫 435

Ueda Sōkyū 上田桑鳩 (calligrapher) 459

Uehara Shōichi 上原昭一 107

Uemura Shōen 上村松園 (painter) 435; *Evening* (*Yūgure* 夕暮) 436; *Flame* (*Hono'o* 焔) 436; *Noh Dance Prelude* (*Jo no Mai* 序の舞) 436, **437**

Ueno Museum (Ueno Hakubutsukan 上野博物館; Tokyo; Conder, Josiah) 394

Uenohara site 上野原遺跡 (Kagoshima prefecture) 17; ritual site 17; shell-patterned vessels (*kaigaramon doki* 貝殻文土器; Early Jōmon 縄文早期) 17–18

Uesugi Kenshin 上杉謙信 270, 285; gold and silver brocaded satin damask patchwork coat (*kin gin ran donsu tō nuiawase dōfuku* 金銀襴緞子等縫合

胴服) 270; *Scenes in and around the Capital* screens (*Rakuchū Rakugai zu* 洛中洛外図) gift for 285–86

Uesugi Shigefusa (seated, portrait sculpture; Meigetsu-in 明月院, Kamakura) 上杉重房坐像 **203**

Uesugi shrine (Uesugi-jinja 上杉神社) 270; gold and silver brocaded satin damask patchwork coat (*kin gin ran donsu tō nuiawase dōfuku* 金銀襴緞子等縫合胴服) **270**

Uisang (Gishō) 義湘 228–29; *Illustrated Biographies of the Kegon Patriarchs* (*Kegon Shūso Shiden Emaki* or *Kegon Engi* 華厳宗祖師伝絵巻 [華厳縁起]) handscrolls 228–29

ukiyo 浮世 ("floating world") 319, 351

ukiyo-e 浮世絵 147, 156, 319, 323, 331–32, 339; Golden Age of 348–55; late Edo period 359–65, 377; modern 418–19, 467, 477, 489n4; quartet 323, 489n4 (*see also* woodblock prints)

ukiyo-eshi 浮世絵師 (ukiyo-e artist) 331–32, 351, 354–55, 467, 489n3; ukiyo-e designer (*eshi* 絵師/*gakō* 画工) 332, 489n4; Hishikawa Moronobu 菱川師宣 331

Umasaka site 馬坂遺跡 (Shizuoka prefecture) 23, **25**; hybrid-style vessel (*tsubo* 壺; Middle Yayoi 弥生中期) 25

Umataka-type flame pot 馬高式土器 **10–11**; Sasayama site 笹山遺跡 (Niigata prefecture) 11

Umehara Ryūzaburō 梅原龍三郎 380, 410, 425–26, 453; *Autumn Sky over Beijing* (*Pekin shūten* 北京秋天) **426**; Jean-Paul Laurens at the Académie Julian (Paris) 425

Umehara Takeshi 梅原猛 49

Umezu Jirō 梅津次郎 224

Unerring Lasso, Kannon of the (*see* Fukūkenjaku Kannon)

ungen-zaishiki 繧繝彩色 (gradient coloring, shading through) 76, 90, 122,

251

University of Tokyo (Tokyo Daigaku
東京大学) 3, 381; Tokyo Imperial
University (Tokyo Teikoku Daigaku
東京帝国大学) 447, 450

Unkei 運慶 (sculptor) 110, 154, 193–95,
199–200; Amida Nyorai 阿弥陀如来,
Fudō Myō-ō 不動明王, Bishamonten
毘沙門天 (Ganjōju-in 願成就院,
Shizuoka prefecture) 194; Amida
Triad (Amida Sanzon 阿弥陀三尊像;
Jōraku-ji 浄楽寺, Kanagawa prefecture)
194; Asanga 無著 and Vasubandhu
世親 (Kōfuku-ji Hokuen-dō 興福寺
北円堂) 199; Bishamonten 毘沙門天
and Jikokuten 持国天 (Tōdai-ji Middle
Gate 東大寺中門), flanking attendants
(両脇侍) and Four Guardian Kings
(Shitennō 四天王; Tōdai-ji Great
Buddha Hall 東大寺大仏殿) 194;
child-attendant deity figures
(八大童子; Kongōbu-ji Fudō Hall
金剛峰寺不動堂) 194; Dainichi
Nyorai, seated 大日如来坐像 (Enjō-ji
円成寺, Nara) 193–95; seated Shunjō
Shōnin 俊乗上人坐像 or Chōgen 重源
(Tōdai-ji Shunjō Hall 東大寺俊乗堂)
198; standing Kongō Rikishi 金剛力士
立像 (Tōdai-ji Great South Gate
東大寺南大門) 194–95, **196–97**

Unkoku Tōgan 雲谷等顔 295

Unsettling Phenomenon (Nakanishi
Natsuyuki) 464

Unsolicited Tale, An (*Towazu-gatari*
とはずがたり; Go-Fukakusa-in Nijō
後深草院二条) 223

Urabe Chintarō 浦部鎮太郎 (architect)
466; Kurashiki Ivy Square
倉敷アイビースクエア 466

Urakami Gyokudō 浦上玉堂 356; *Snow
Sifted through Frozen Clouds* (Tōun
Shisetsu-zu 凍雲篩雪図) **356**

Urashima (Yamamoto Hōsui) 385, **386**

urban culture (*toshi bunka* 都市文化)

307, 435

urushi-e 漆絵 (lacquer pictures) 350;
Okumura Masanobu 奥村政信 350

Usami Keiji 宇佐美圭司 454

uta awase-e 歌合絵 (*see* poetry contest
scrolls)

Utagawa Hiroshige 歌川広重 362–63,
379, 388, 400; *Fifty-Three Stations of the
Tōkaidō* (*Tōkaido Gojusan-tsugi*
東海道五十三次) 362–**63**; *One
Hundred Famous Views of Edo* (*Meisho
Edo Hyakkei* 名所江戸百景) 362

Utagawa Kunisada 歌川国貞 (Toyokuni
III 三代豊国) 360, 400

Utagawa Kuniyoshi 歌川国芳 363, 387,
467: *Grafitti on the Storehouse Wall*
(*Nitakaragura Kabe no Mudagaki*
荷宝蔵壁のむだ書) 363; *The Spirit
of Retired Emperor Sanuki Sends
Allies to Rescue Tametomo* (*Sanuki-in
Kenzoku o shite Tametomo o sukuu zu*
讃岐院眷属をして為朝をすくふ図) **363**

Utagawa Toyokuni I 歌川豊国 (初代)
354, 360

Utamaro (*see* Kitagawa Utamaro)

Vajrasekhara Sutra (*Kongōchō-kyo*
金剛頂経) 96, 104

Valignano, Alessandro 285

Van Gogh, Vincent 339

Vasubandhu (Seshin 世親) **199**; Kōfuku-ji
Hokuen-dō 興福寺北円堂 (sculpture
by Unkei 運慶) **199**

Vegetable Garden in Spring (Asai Chū)
380

View of Edo screens (*Edo-zu byōbu* 江戸図
屏風) 310; Chinese Gates (Karamon
唐門) 310; daimyo residences 310

*View of Takanawa Ushimachi under a
Shrouded Moon"* (Kobayashi Kiyochika)
389, 418

VIVO (photographer's association) 475

wabi tea or *wabi*-style tea (*wabi-cha*

侘び茶) 280, 288, 301–302
wabi わび 408
Wada Eisaku 和田英作 (painter) 402,
403; *Evening at the Harbor (Totō no
yūgure* 渡頭の夕暮) 403
Wada Sanzō 和田三造 (painter) 400;
Southerly Wind (Nanpū 南風) 408;
Tenshin Dōjō 天真道場 400
wafū 和風 (Japanese manner) 119
Waga 和画 (Japanese-style painting) 311
Wagner, Gottfried (scientist) 395
waka 和歌 (Japanese poetry) 119, 145,
223
Wakabayashi Isamu 若林奮 464
Wake no Kiyomaro 和気清麻呂 107,
485n8; Jingan-ji 神願寺 107
*Wakefulness at Night (Nezame
Monogatari-e* 寝覚物語絵) 222
Wakita Kazu 脇田和 (painter) 472
Wandering Jew (Yasui Nakaji) 473–74
Wanfo Si 万仏寺 (Sichuan province
四川省) 43
Wanfu Si 万福寺 (Fujian province
福建省) 334; Ōbaku sect 黄檗宗 334;
Yinyuan Longqi 隠元隆琦 334
Wang Xizhi 王羲之 (calligrapher) 92,
116–17, 142, 249
Wangheungsa 王興寺 (Baekje) 482n1
Wanpaku ōji no orochi taiji (see *Little
Prince and the Eight-Headed Dragon*)
Warner, Langdon xxv, 310, 479, 481n2,
489n1, 490n14
Warring States period (Sengoku jidai
戦国時代) 244–45, 265, 268, 272,
275, 284–85, 318
warriors 152, 169, 194, 203, 204, 225,
238, 246, 248, 249, 257, 269, 276, 285,
296, 301, 306, 313, 319, 332, 339, 354,
367, 371, 487n21; aesthetics 238, 285;
culture 244, 284; machismo 287;
monks 55; (people) 77, 203, 225, 270,
285, 293, 302; Muromachi-period 276;
taste 290, 310; temperament 194; *The
Ninja Book of Warrior Arts: The Story of*

Kagemaru 忍者武芸帳影丸伝 468
*Waseda Literature (Waseda bungaku
早稲田文学) journal 414
Watanabe Hitoshi 渡辺仁 (architect)
449; Aichi Prefecture Government
Office (Aichi Kenchō 愛知県庁; with
Nishimura Yoshitoki 西村好時) 448
Watanabe Kazan 渡辺崋山 357, 405;
*True Views of the Four Provinces (Shishū
Shinkei-zu* 四州真景図) 357; *Portrait of
Satō Issai (Satō Issai-zō* 佐藤一斎像
357; *Portrait of Tachihara Suiken
(Tachihara Suiken-zō* 立原翠軒像) 357
Watanabe Setsu 渡辺節 (architect) 413;
Nihon Kangyō Bank (Nihon Kangyō
Ginkō 日本勧業銀行; Tokyo) 413
Watanabe Shōzaburō 渡辺庄三郎
(publisher) 418
Watanabe Shūseki 渡辺秀石 335;
Nagasaki Kanga school 長崎漢画派
335
Watanabe-ō Memorial Hall (Watanabe-ō
Kinen Kaikan 渡辺翁記念会館; Ube,
Yamaguchi prefecture; Murano Tōgo)
448
watercolor (*suisai-ga* 水彩画) 380, 402–
03, 478
wax-resist dyed folding screens (*kōkechi-
zome byōbu* 纈纈染屏風; Shōsō-in
northern repository 正倉院北倉,
Tōdai-ji 東大寺, Nara) 92
wayō 和様 119, 129
Wayō 和様 (architectural style) 129, 193,
248; Tōfuku-ji 東福寺 abbot's quarters
方丈 at Ryōgin-an 龍吟庵 248
Wei Zhi 魏志 25, 28, 30; Himiko 卑弥呼
25; Yamatai kingdom (*Yamatai-koku*
邪馬台国) 28
Wei 魏, Chinese kingdom of: king of 28,
30; court 30
Wen Jia 文嘉 338; *Tan'yū Shukuzu*
探幽縮図 (Tan'yū's reduced-size copies
of paintings) 336
Wen Zhenming 文徴明 338; *Tan'yū*

Shukuzu 探幽縮図 (Tan'yū's reduced-size copies of paintings) 336

Western art (*seiyō bijutsu* 西洋美術) v, 42, 306, 374–75, 380, 398, 411, 425, 455–56, 458

Western Kings on Horseback screens (*Taisei-ōkō Kiba-zu byōbu* 泰西王侯騎馬図屏風) 299; first generation of Western-style paintings 299

Western Paradise 西方浄土 136, 210

Western-style paintings (*yōfū-ga* 洋風画): Akita Ranga 秋田蘭画 358; first generation of Western-style paintings (*dai ichiji yōfū-ga* 第一次洋風画) 299; second generation of Western-style paintings (*dai niji yōfū-ga* 第二次洋風画) 335, 489; Takahashi Yuichi 高橋由一 375; Yōga 洋画 375–76, 379, 380, 384–85, 388, 399, 402–03, 409, 425, 429, 435, 444 (*see also* Yōga)

Westerners Playing Musical Instruments folding screens (*Yōjin Sōgaku-zu byōbu* 洋人奏楽図屏風) 299, **300**; first generation of Western-style paintings 299

White Birch (see *Shirakaba*)

White Circle (Yoshihara Jirō) 475

White Heron (*Hakuro-zu* 白鷺図; Ryōzen 良全) hanging scroll 255

White Horse Society (Hakuba-kai 白馬会) 400, 402, 403, 404

White Path between the Two Rivers (*Niga Byakudō-zu* 二河白道図) hanging scroll 206, **208**

White-Robed Kannon (*Byakue Kannon-zu* 白衣観音図; Kissan Minchō 吉山明兆; Tōfuku-ji 東福寺) hanging scroll **261**

Widow and Orphan (Hishida Shunsō) 407

Wild Geese Descending on a Sandbank (*Heisa Rakugan-zu* 平沙落雁図; Shikan 思堪) hanging scroll 235, 255; Yishan Yining 一山一寧 (Issan Ichinei) 235

Wirgman, Charles (artist) 375, 380, 467

Wisdom, Impression, Sentiment (Kuroda Seiki) 400, **401**

Woman (Ogiwara Morie) 422

Woman beside a Lake (Murayama Kaita) 415

Woman Washing Her Feet (Yasui Sōtarō) 425

Woman with a Boa (Yorozu Tetsugorō) 414

Woman with a Hat (Sakamoto Hanjirō) 428

Woman/The Kitchen (Kuroda Seiki) 399

Womb World Mandala (Taizōkai Mandara 胎蔵曼荼羅) 100, 102, 111, 123; Jimyō-in 持明院 123

Women of a Public Bathhouse (*Yuna-zu* 湯女図) hanging scroll **319**

Wonhyo 元暁 (Gangyō, monk) 228

wood-core dry-lacquer 木心乾漆像 110

woodblock cutter (*horishi* 彫師) 332, 418, 489n4

woodblock printing 木版 (技術) 327, 331–32, 339, 418, 489n4

woodblock prints 331, 348–49, 360, 388–89, 418–19, 442, 455, 478; *chūban* 中判 (medium size) 351; full color 350, 400; modern (*mokuhanga* 木版画) 414, 419; *ōban* 大判 (large size) 351; *ō-ōban* 大大判 (extra large size) 348–49; ukiyo-e prints 浮世絵版画

world (international) expositions (*bankoku hakurankai* 万国博覧会 or *banpaku* 万博) 375, 376, 398, 449; Great Exhibition (London) 378; Paris (1867) 378; second Paris exposition (1884) 382; 1900 Paris 400; 1925 Exposition Internationale des Arts Décoratifs et Industriels Modernes 424; 1936 Paris 449; 1938 International Surrealist Exhibition, Paris 442; Vienna International Exposition (1873) 378, 396

World of Levi-Strauss (Kanno Seiko) 457

World War I (Dai-ichiji sekai taisen 第一次世界大戦) 424–25, 427, 435

World War II (Dai-niji sekai taisen 第二次世界大戦) 308, 450

Woven Taima Mandala (Tsuzure-ori Taima Mandara 綴織当麻曼荼羅; *Taima-dera* 当麻寺) 83, 228; *Illustrated Scrolls of the Legend of the Taima Mandala (Taima Mandara Engi Emaki* 当麻曼荼羅縁起絵巻) 228; *tsuzure-ori* 綴織 tapestry 82

writing box with a design of autumn fields (*akino-zu suzuri-bako* 秋野図硯箱) 241

writing box with cormorant and sand beach motif (*suhama u raden suzuri-bako* 州浜鵜螺鈿硯箱) **241**

writing box with Kasuga mountain design (*Kasuga-yama maki-e suzuri-bako* 春日山蒔絵硯箱) **269**

writing box with Shio-no-yama mountain design (*Shioyama maki-e suzuri-bako* 塩山硯蒔絵箱) 269

Wu Daozi 呉道玄 (painter) 111

Wu Zetian, Empress 則天武后 69, 77

Wuxue Zuyuan 無学祖元 (Mugaku Sōgen or Bukkō Kokushi 仏光国師) 204, 234, 236; *chinzō* 頂相 portraits 204, 236; Hōjō Tokimune 北条時宗 234; *Shaka hōden* 釈迦宝殿 236

Wuzhun Shifan 無準師範 (monk-painter) 235–36, 251; *chinzō* 頂相 portraits 236

Xia Gui 夏珪 251–52; Ashikaga shogunal collections 252–54, 266; "one-corner" composition "夏珪の一辺" (*zanzan jōsui* 残山剰水) 251

Xiangtangshan grottos 響堂山石窟 (Hebei province) 43

Xuanzang 玄奘三蔵 (Genjō Sanzō) 141, 230; *Secret Teachings of the Hossō Sect (Hossō-shū Hiji Ekotoba* 法相宗秘事絵詞) 229

Xutang Zhiyu 虚堂智愚 236

Yabe Tomoe 矢部友衛 440

Yabe Yoshiaki 矢部良明 185

Yagi Kazuo 八木一夫 (ceramicist) 478

Yakemachi vessels 焼町土器 10, **11**; Kawarada site 川原田遺跡 (Nagano prefecture) **11**

yakishime wares 焼き締め陶器 242

Yakushi Nyorai 薬師如来 (Bhaisajyaguru, Medicine Buddha) 83, 104, 106; Daigo-ji 醍醐寺 (Priest Eri 会理) 131; Gangō-ji 元興寺 109; Hōryū-ji 法隆寺 45; Jingo-ji 神護寺 106, 109; Kokuseki-ji 黒石寺 (Iwate prefecture) 113; Murō-ji 室生寺 120; Ninna-ji 仁和寺 178; Tōshōdai-ji 唐招提寺 107–108; Shōjō-ji 勝常寺 (Fukushima prefecture) 113;

Yakushi Triad 薬師三尊 70–**71**; Hōjōbō 宝城坊 (Kanagawa prefecture) 134

Yakushi-ji 薬師寺 (Nara) 70; East Pagoda 東塔 **70**, 128; *Fusō Ryakki* 扶桑略記 (Abbreviated Records of Japan) 70; *kami* triad (Sanshin-zō 三神像) 115

yamabushi 山伏 (mountain ascetics) 114

Yamada Dōan 山田道安 (painter) 276; Muromachi-period warriors 276

Yamada-dera 山田寺 (Nara prefecture) 55; Head of the Buddha 仏頭 (Kōfuku-ji 興福寺) 55; Soga no Kurayamada no Ishikawamaro 蘇我倉山田石川麻呂 55

Yamagoe Raigō-zu 山越来迎図 209, 216; Konkai Konmyō-ji 金戒光明寺 (Kyoto) 209–**211**; Zenrin-ji 禅林寺 (Kyoto) 209

Yamaguchi Kaoru 山口薫 (Western-style painter) 472

Yamaguchi Katsuhiro 山口勝弘 454

Yamaguchi no Ōguchi no Atai 山口大口費 (sculptor) 52; *Nihon Shoki* 日本書紀 52; Tamonten 多聞天 (Hōryū-ji 法隆寺) 52

Yamamoto Hōsui 山本芳翠 (painter) 381; *Chinese Horoscope (Jūnishi zu* 十二支図) 385; *Nude (Rafu* 裸婦) 381; *Urashima* 浦島 385–86

Yamamoto Kanae (print artist) 山本鼎

419, 420; *Fisherman* (*Gyofu* 漁夫), Brittany series 420

Yamane Yūzo 山根有三 271

Yamanouchi Sugiyama 山内清男 3, 4

Yamashina-dera 山階寺 73 (*see also* Kōfuku-ji 興福寺)

Yamashiro no Ōenomiko 山背大兄皇子 49; murder of 49

Yamashita Rin 山下りん (painter) 380

Yamashita Shintarō 山下新太郎 41

Yamatai (kingdom of; Yamatai-koku 邪馬台国) 25, 28; *Wei Zhi* 魏志 28

Yamato kingdom ヤマト王権 30, 33

Yamato-e やまと絵 87, 138, 144, 145, 146–49, 159, 162, 180, 186, 206, 217–21, 229, 257, 265, 270–72, 278, 294, 310–11, 316–17, 350–51, 409, 487n25; folding screens 265

Yan Hui 顔輝 253; *Liu Hai and Li Tieguai* (*Gama Tekkai-zu* 蝦蟇鉄拐図) 253

Yan Liben 閻立本 83; *Thirteen Emperors Scroll* 帝王図鑑 83

Yan Zhenqing 顔真卿 (calligrapher) 117

Yanagi Muneyoshi 柳宗悦 (also known as Yanagi Sōetsu) 365, 477; folk craft (*mingei* 民芸) 365, 477

Yanagisawa Kien 柳沢淇園 339; literati painting (Nanga 南画) 307, 337–339

Yasaki Hironobu 矢崎博信 (painter) 441; *Industrial Zone, Kōtō Ward* (*Kōtōku kōjō chitai* 江東区工場地帯) **443**

Yashiro Yukio 矢代幸雄 (art historian) 405

Yasuda Lecture Theater (Yasuda Kōdō 安田講堂; Tokyo; Uchida Yoshikazu) 447

Yasuda Raishū 安田雷洲 (print artist) 358; *Fifty-Three Stations of the Tōkaidō* (*Tōkaidō Gojūsan Eki* 東海道五十三駅; copperplate prints) 358

Yasuda Yukihiko 安田靫彦 (painter) 430, 431; *God of Wind and God of Thunder* screens (*Fūjin raijin* 風神雷神) **431**; *Prayer at Time of Childbirth* (*Osan no inori* お産の祈り) 430; *Solar Eclipse* (*Nisshoku* 日食) 431; *Yumedono Pavilion* (*Yumedono* 夢殿) 430

Yasui Nakaji 安井仲治 (photographer) 473; *Wandering Jew* (*Ryūbō Yudaya* 流氓ユダヤ) 473–74

Yasui Sōtarō 安井曾太郎 (painter) 380, 425, 453; Jean-Paul Laurens at the Académie Julian (Paris) 425; *Landscape at Sotobō* (*Sotobō fūkei* 外房風景) **426**; *Woman Washing Her Feet* (*Ashi o arau onna* 足を洗う女) 425

Yasui Takeo 安井武雄 (architect) 421, 422; Osaka Club (Osaka Kurabu 大阪倶楽部) 422

yatsushi やつし ("disguise") 351

Yi Fujiu 伊孚九 338

Yinyuan Longqi 隠元隆琦 (Ingen; Ōbaku priest) 334; Wanfu Si 万福寺 (Fujian province) 334

Yishan Yining 一山一寧 (Issan Ichinei) 234–35; Hōjō Sadatoki 北条貞時 234; Kenchō-ji 建長寺 234; Literature of the Five Mountains (*Gozan bungaku* 五山文学) 235

Yodo Castle 淀城 287; Toyotomi Hideyoshi 豊臣秀吉 287

Yōga 洋画 (Western-style painting) 384, 400, 407, 408, 424, 453, 472, 475, 478; Seishū 西宗 ("Western school") 409

yōgō-zu 影向図 (manifestation image) 216

yōkai manga 妖怪漫画 467

Yokogawa Tamisuke 横河民輔 (architect) 413; Tokyo Stock Exchange Building (Kabushiki Torihikijo 株式取引所) 413

Yokohama Specie Bank (Yokohama Shōkin Ginko 横浜正金銀行; Tsumaki Yorinaka) 395

Yokohama-e 横浜絵 ("Yokohama pictures") 391

Yokoo Tadanori 横尾忠則 (painter; graphic designer) 476; *Moat* (*Ohori* お堀) 477

Yokoyama Misao 横山操 (painter) 477

Yokoyama Taikan 横山大観 (painter) 407, 416, 430; *Cherry Blossoms at Night* (*Yozakura* 夜桜) **430**; *Lively Perpetual Motion* (*Seisei ruten* 生々流転) 430; *Qu Yuan* (*Kutsugen* 屈原) 407

Yōmeimon gate 陽明門 309

Yomiuri Independent Exhibition (Yomiuri Andepandan-ten 読売アンデパンダン展) 454, 462

Yonekura Michio 米村迪夫 218

Yonezawa Yoshiho 米沢嘉圃 250

Yong Xingling 永慶陵 (Liao Empire 遼 of the Khitans 契丹; tomb) 486n18

Yoritomo in the Cave (Maeda Seison) 432

Yorozu Tetsugorō 萬鉄五郎 (painter) 410, **414**, 416, 421; *Nude Beauty* (*Ratai bijin* 裸体美人), *Nude with a Parasol* (*Higasa no rafu* 日傘の裸婦) *Woman with a Boa* (*Boa no onna* ボアの女) 414; *Female Nude: Bathing Costume* (*Mizugi sugata* 水着姿), *Resting Her Chin on Her Hand* (*Hōzue no hito* ほお杖の人, *Leaning Woman* (*Motarete tatsu hito* もたれて立つ人) 415

Yosa Buson 与謝蕪村 338–39, 340–41, 343; *Crows and Kite* (*Tobi Karasu-zu* 鳶鴉図) 341; *haiku* 俳句 (or *haikai* 俳諧) 340; *Snow-Clad Houses in the Night* (*Yashoku Rōdai-zu* 夜色楼台図) **340–41**

yosegi-zukuri 寄木造 (assembled wood technique) 132, 195

Yoshida Hiroshi 吉田博 (painter, woodblock print artist) 403

Yoshida Isoya 吉田五十八 (architect) 423; "new *sukiya* style" (*shinkō sukiya* 新興数寄屋) 423

Yoshihara Jirō 吉原治良 (painter) 456, 475; *White Circle* (*Shiroi en* 白い円) 475

Yoshikawa Itsuji 吉川逸治 28

Yoshimura House 吉村家 (*minka* 民家; Osaka prefecture) 336; *yamatomune-*

zukuri 大和棟造 337

Yoshino 吉野 212

Yoshinogari site 吉野ケ里遺跡 (Saga prefecture; moated settlements [*kangō shūraku* 環濠集落]; Late Yayoi 弥生後期) 21, 28

Yōsho Shirabesho 洋書調 (Institute for Western Studies) 375

Yoyogi National Gymnasium (Kokuritsu Yoyogi Kyōgijō 国立代々木競技場; Tokyo; Tange Kenzō) 461

Yu'usu site 夜臼遺跡 (Fukuoka prefecture) 22

Yu'usu-type 夜臼式 22

Yuan China 元代中国 146, 204, 220, 234, 235, 244, **245**, 246, **248**, 250, 254, 255, 260, 266, 280, 446

Yuan painting 元画 146

Yueyi Lun 楽毅論 (Treatise on Yue Yi) 92; copy of Wang Xizhi's calligraphy (Empress Kōmyō 光明皇后; Shōsō-in northern repository 正倉院北倉, Tōdai-ji 東大寺, Nara) 92

yuige 遺偈 (calligraphy of deathbed poems of high priests) 237

Yuima 維摩 (Vimalakirti): clay statue at Hōryū-ji 法隆寺 72

Yujian 玉澗 (monk-painter) 252, 259, 266, 278; cursive (*sō* 草) brush style 266; *Eight Views of the Xiao and Xiang Rivers* (*Shōshō Hakkei* 瀟湘八景) 252; *hatsuboku sansui* 溌墨山水 ("splashed-ink" landscape) 294; *Record of Decorations for the Imperial Visit to the Muromachi Palace* (*Muromachi-dono Gyōkō Okazari-ki* 室町殿行幸御錺記) 254, 258

Yuki and Suki screens for Daijō-e 大嘗会悠紀主基屏風 147

Yumechigai Kannon 夢違観音 (Dream-Altering Avalokitesvara; Hōryū-ji 法隆寺) 56

Yumedono Hall 夢殿 Fenollosa viewing 382

Yumedono Pavilion (Yasuda Yukihiko) 430

Yungang grottos 雲崗石窟 (grotto temple complex, Shanxi province) 43, 46, 77, 412

Yushima Seidō 湯島聖堂 (Tokyo; Itō Chūta) 378, 412

yūsoku motifs 有職紋様 155

yūsui 幽邃 271

yūzen 友禅 (dyeing technique) 332, 365; Kaga *yūzen* 加賀友禅 365

Zadkine, Ossip 14

Zaō Gongen 蔵王権現 (Avatar Zaō) 135, 175

Zaō Hall, Inner Sanctuary (Oku-no-in Zaō-dō 奥院蔵王堂, Mitoku-san Sanbutsu-ji 三徳山三仏寺, Tottori prefecture) 175; hanging construction (*kaketsukuri* 懸造) 175

zashiki kazari 座敷飾り (room decor) 248, 280

Zeami Motokiyo 世阿弥元清 (Noh playwright) 247

Zen Buddhism 禅宗 232, 244; Chinese connection 189; Ōbaku sect 黄檗宗 337

Zen circles (*ensō* 円相) 475

Zen school (of sculpture) 善派 202; Saidai-ji 西大寺 (Nara) 202; seated figure of Tamayori-hime no mikoto 玉依姫命坐像 (Yoshino Mikumari shrine 吉野水分神社, Nara) 203

Zen-style (Zenshū-yō 禅宗様) architecture 193, 237, 246; *ebi-kōryō* (rainbow tie beams) 海老虹梁 238; Ginkaku-ji 銀閣寺 266; Kakurin-ji 鶴林寺 Main Hall 248; Kanshin-ji 観心寺 Golden Hall (Kondō 金堂) 248; Kinkaku-ji 金閣寺 258

Zen'en 善円 (sculptor) 202; Zen school (of sculpture) 善派 202

Zenki-zu 禅機図 257

Zenmui 善無畏 (Subhakarasimha) 140; *Prince Shōtoku and the High-Ranking Monks of the Tendai Sect* 聖徳太子及び天台高僧像 (Ichijō-ji 一乗寺, Hyogo prefecture) **140**; *Seven Shingon Patriarchs* 真言七祖像 (Li Zhen 李真 and other artists; Tō-ji 東寺) 105

Zenshun 善春 202; Zen school (of sculpture) 善派 202

Zenzai Dōji 善財童子: *Illustrated Scrolls of Sudhana's Pilgrimage* (*Zenzai Dōji Rekisan-zu* 善財童子歴参図) handscrolls 168; sculpture at Seihō-ji 清峯寺 (Enkū 円空; sculpture; Seihō-ji 清峯寺, Gifu prefecture)

Zhang Jizhi 張即之 (calligrapher) 236; *Fang zhang* (Hōjō) 方丈; *Shunjing* 書記

Zhou Fang 周昉 (painter) 83

Zhu Zhiyu 朱之瑜 (or Shu Shunsui 朱舜水) 369; Koishikawa Kōrakuen 小石川後楽園 (garden; Tokyo) 369; Tokugawa Mitsukuni 徳川光圀 369

Zōjishi 造寺司 (temple construction bureau): Tōdai-ji 東大寺 69, 77

zōkei (plastic art) 造形 xiv

Zōkei Bijutsuka Kyōkai 造形美術家協会 (Association for Plastic Artists) 439

Zōmitsu 雑密 (miscellaneous esotericism) 96

zushi 厨子 57; Lady Tachibana's private devotional shrine (Tachibana-fujin Nenji-butsu Zushi 橘夫人念持仏厨子; Hōryū-ji 法隆寺) 57–58, 62, 125; Tamamushi Shrine (Tamamushi no zushi 玉虫厨子; Hōryū-ji 法隆寺) 57, **61–62**, 89